EALING
REVISITED

Edited by Mark Duguid, Lee Freeman,
Keith M. Johnston and Melanie Williams

A BFI book published by Palgrave Macmillan

© British Film Institute 2012
Introduction and editorial arrangement © Mark Duguid, Lee Freeman, Keith M. Johnston, Melanie Williams 2012
Individual essays © their respective authors 2012

All rights reserved. No reproduction, copy or transmission of this publication may be made without written permission. No portion of this publication may be reproduced, copied or transmitted save with written permission or in accordance with the provisions of the Copyright, Designs and Patents Act 1988, or under the terms of any licence permitting limited copying issued by the Copyright Licensing Agency, Saffron House, 6–10 Kirby Street, London EC1N 8TS. Any person who does any unauthorized act in relation to this publication may be liable to criminal prosecution and civil claims for damages.

The authors have asserted their rights to be identified as the authors of this work in accordance with the Copyright, Designs and Patents Act 1988.

First published in 2012 by
PALGRAVE MACMILLAN

on behalf of the

BRITISH FILM INSTITUTE
21 Stephen Street, London W1T 1LN
www.bfi.org.uk

There's more to discover about film and television through the BFI. Our world-renowned archive, cinemas, festivals, films, publications and learning resources are here to inspire you.

Palgrave Macmillan in the UK is an imprint of Macmillan Publishers Limited, registered in England, company number 785998, of Houndmills, Basingstoke, Hampshire RG21 6XS. Palgrave Macmillan in the US is a division of St Martin's Press LLC, 175 Fifth Avenue, New York, NY 10010. Palgrave Macmillan is the global academic imprint of the above companies and has companies and representatives throughout the world. Palgrave® and Macmillan® are registered trademarks in the United States, the United Kingdom, Europe and other countries.

Front cover design: Marc Marazzi, BFI Design Studio
Main cover image: *It Always Rains on Sunday* (Robert Hamer, 1947), © STUDIOCANAL Films Ltd
Images used in this book, except where specified, are reproduced with the kind permission of STUDIOCANAL Films Ltd. Images on pp. 3, 5 (bottom), 6, 7, 11, 27, 28, 29, 35, 36, 37, 40, 59, 78, 93, 94, 95, 98, 102, 104, 109, 112, 116, 124, 126, 127, 166, 171, 177, 185, 196, 201, 206, 214 – BFI National Archive; p. 65 – British Postal Museum & Archive/BFI; p. 222 – BBC; p. 225 – Goldcrest Films International; p. 226 – Channel Four Television; p. 231 – Ealing Studios Enterprise Ltd
Designed by couch
Set by Cambrian/couch
Printed in China

This book is printed on paper suitable for recycling and made from fully managed and sustained forest sources. Logging, pulping and manufacturing processes are expected to conform to the environmental regulations of the country of origin.

British Library Cataloguing-in-Publication Data
A catalogue record for this book is available from the British Library
A catalog record for this book is available from the Library of Congress
10 9 8 7 6 5 4 3 2 1
21 20 19 18 17 16 15 14 13 12

ISBN 978-1-84457-510-7 (pb)
ISBN 978-1-84457-511-4 (hb)

CONTENTS

ACKNOWLEDGMENTS	v
NOTES ON CONTRIBUTORS	vii
INTRODUCTION: REVISITING EALING	1
1 A LAD, A LASS AND THE LOCH NESS MONSTER: THE PREHISTORY OF EALING *Steve Chibnall*	15
2 INSIDE EALING: THE EVIDENCE OF THE MICHAEL AND AILEEN BALCON COLLECTION *Janet Moat*	26
3 PEN TENNYSON: BALCON'S GOLDEN BOY *Martin Carter*	39
4 THE PEOPLE'S WAR: THE MAKING OF EALING *Andrew Roberts*	47
5 FROM TINSEL TO REALISM AND BACK AGAIN: BALCON, EALING AND DOCUMENTARY *Mark Duguid and Katy McGahan*	58
6 'MILD REVOLUTION'?: EALING STUDIOS AND THE POLITICAL AND SOCIAL CONSENSUS *Lee Freeman*	71
7 DARK SHADOWS AROUND EALING *Robert Murphy*	81

8 SELLING EALING 91
 Nathalie Morris

9 GEORGES AURIC: EALING'S FRENCH DRESSING 101
 Geoff Brown

10 ANTHONY MENDLESON: EALING'S WARDROBE WIZARD 111
 Catherine A. Surowiec

11 KIND HEARTS AND CAMPERY: THE EALING FAMILY PERVERTS 125
 Andrew Moor

12 THAT EALING FEELING: 'EALING COMEDIES' AND COMEDIES
 'MADE AT EALING' 135
 Tim O'Sullivan

13 AMBIGUITY AND ACHIEVEMENT: ALEC GUINNESS'S EALING
 PERFORMANCES 145
 James Walters

14 CHILDREN OF EALING 155
 Colin Sell

15 EALING'S AUSTRALIAN ADVENTURE 165
 Stephen Morgan

16 'WHO'LL PAY FOR REALITY?': EALING, DREAMS AND FANTASY 175
 Josephine Botting

17 A FEMININE TOUCH? EALING'S WOMEN 185
 Melanie Williams

18 'A RIOT OF ALL THE COLOURS IN THE RAINBOW': EALING STUDIOS
 IN COLOUR 195
 Keith M. Johnston

19 AGAINST THE GRAIN: KENNETH TYNAN AT EALING 206
 Charles Barr

20 THE LEGACY OF EALING 217
 Dylan Cave

NOTES 232
MICHAEL BALCON'S EALING STUDIOS: A FILMOGRAPHY 255
INDEX 282

ACKNOWLEDGMENTS

The editors were saddened to learn of the death of Jonathan Balcon not long before this book went to press. We remain grateful for his generous permission to access, cite and even reproduce material from the Michael and Aileen Balcon Special Collection held at the BFI. We would also like to thank the BFI Library and Special Collections for their invaluable input and assistance, and Rebecca Barden, Sophia Contento and all at BFI Publishing for shepherding the book so swiftly and efficiently from proposal to publication.

Our thanks also to Candy Vincent-Smith and her colleagues at Studiocanal for their generosity in allowing the many images in the book, for their commendable policy of releasing almost all of Ealing's films on DVD, and for giving the editors and contributors access to those Ealing films that have not yet been released.

Mark Duguid would like to thank his fellow editors for their dedication and enthusiasm, and those colleagues who contributed chapters to this book and made their mark on the wider Ealing project at the BFI: especially Jo Botting, Dylan Cave, Katy McGahan, Nathalie Morris, Nigel Algar and Bryony Dixon. Grateful thanks, too, to Stephen McConnachie and Patrick Fahy for their sterling work, against the clock, on the Ealing filmography, and to Nathalie (again), Jonny Davies and Nigel Arthur of the BFI's Special Collections. And for unstinting patience, support and encouragement, thanks as always to Eleni.

Lee Freeman would like to thank David Rolinson, Neil Sinyard, Melanie Williams and Alan Burton for their help and encouragement. For their continuous love and support, he would also like to thank all his family and friends, especially his mum, Lynne, his dad, Paul, and his brother, Martin.

Keith M. Johnston would like to thank Melanie Williams for inviting him on board this project, and for her continued support; Candy Vincent-Smith, Gill Fraser-Lee, Jody Thompson and Laura Cooper for helping to explore and promote his love of Ealing films; and, most importantly, Beccy for being an Ealing widow while he worked his way through ninety-five Ealing films.

The idea for a new collection of essays on Ealing Studios originated with a conference organised by Melanie Williams at the University of Hull in November 2006 and she would like to thank all the speakers and delegates who attended, her former colleagues at Hull, especially Lee Freeman, David Rolinson and Neil Sinyard, for their help in running the

event, and the University for its financial support. She would also like to thank her current colleagues at the University of East Anglia for their interest in and support for the project as it has changed and developed over the last few years. It goes without saying that she would like to thank her co-editors. She would also like to express her gratitude towards her family, Matthew and Lara, for their patience when she commandeered the DVD player (although they all enjoyed the George Formby films).

The editors would like to acknowledge their debt and gratitude to all the writers who have contributed chapters to this book, as well as all those others who have, over many years, defined the study of Ealing Studios – particularly Charles Barr, whose original book continues to serve both as inspiration and touchstone. This collection is both a revisitation and a reminder of the strength of all the work that came before.

Finally, thanks to all those who worked at Ealing Studios, past and present, for producing these marvellous films and for projecting such a potent idea of British cinema to the world.

NOTES ON CONTRIBUTORS

CHARLES BARR is Emeritus Professor of Film and Television at the University of East Anglia, and has also held Visiting Professor posts in St Louis, Dublin and Galway. His book on *Ealing Studios* was first published in 1977, with expanded editions in 1993 and 1999 (Cameron and Hollis). His other publications include *English Hitchcock* (Cameron and Hollis, 1999) and *Vertigo* (BFI Classics, 2002: expanded edition 2012). More recently, his essay on Ealing's representation of Ireland ('"Is it his war as well as hers?": The View from Ealing') was published in the *Irish Studies Review* vol. 19 no. 1 (February 2011).

JOSEPHINE BOTTING is a curator at the BFI National Archive with responsibility for the fiction film collections, focusing particularly on the 1950s. She contributes to the BFI's screenonline resource and regularly programmes archive screenings at BFI Southbank, past seasons including Deborah Kerr, Margaret Lockwood, Phyllis Calvert and costume designer Julie Harris.

GEOFF BROWN is Associate Research Fellow at De Montfort University's Cinema and Television History Research Centre and a music critic of *The Times*. Books include *Launder and Gilliat* (BFI, 1977), *The Common Touch: The Films of John Baxter* (BFI, 1989) and *Directors in British and Irish Cinema* (BFI, 2006; associate editor). Further writings on British cinema have appeared in journals and edited collections, including *Michael Balcon: The Pursuit of British Cinema* (MoMA, 1984), *The British Cinema Book*, 3rd edn (BFI, 2009) and the *Journal of British Cinema and Television*.

MARTIN CARTER is Principal Lecturer in Stage and Screen Studies at Sheffield Hallam University. His research interests include British cinema, particularly of the 1930s and 40s, and documentary. He is a contributor to *Vertigo* magazine and is co-editor of the forthcoming edited collection *21st Century British Cinema*.

DYLAN CAVE is a curator at the BFI National Archive where he develops the archive's fiction collection and leads in the acquisition of contemporary British film. He is co-programmer of the 'Projecting the Archive' strand at the BFI Southbank and, in 2011, curated a film season about the last days of the British Empire which attracted great audiences for Ealing's 1951

film *Where No Vultures Fly*. He regularly contributes to the BFI's screenonline and *Sight & Sound* and has written for the preservation journal *The Moving Image*.

STEVE CHIBNALL is Professor of British Cinema and Director of the Cinema and Television History (CATH) Research Centre at De Montfort University. He has written extensively on film in a number of journals and edited collections. His books include (as co-editor) *British Crime Cinema* (Routledge, 1999) and *British Horror Cinema* (Routledge, 2001), and the monographs *Get Carter* (I.B.Tauris, 2003), *Brighton Rock* (I.B.Tauris, 2004) and *Quota Quickies: The Birth of the British B Film* (BFI, 2006). His latest books (as co-author) are *The British 'B' Film* (BFI, 2009) and *The Historical Dictionary of British Cinema* (Scarecrow, forthcoming).

MARK DUGUID is a senior curator in the BFI National Archive, and the editor of (and a major contributor to) BFI screenonline, the BFI's online research and educational resource devoted to the history of British film and television. As a programmer, he has overseen a BFI Southbank season about contemporary British TV drama and an Ealing retrospective in 2012. He has written for *Sight & Sound* and the *Encyclopaedia of Television* (Routledge, 2004) and is also the author of *Cracker* (BFI, 2009).

LEE FREEMAN is working towards a PhD in Ealing Studios at the University of Hull. He has had reviews and poems published in a variety of journals and small press magazines.

KEITH M. JOHNSTON is a senior lecturer in Film and Television Studies at the University of East Anglia. His current research focuses on the interplay of technology, aesthetics and industry in British film of the 1940s and 50s, particularly around issues of colour, widescreen and 3-D. His research has been published in *Journal of British Cinema and Television*, *Film History*, *Journal of Popular Film and Television*, *Film International* and *Convergence*. He is the author of *Coming Soon: Film Trailers and the Selling of Hollywood Technology* (McFarland, 2009) and *Science Fiction Film: A Critical Introduction* (Berg, 2011).

KATY MCGAHAN is a curator at the BFI National Archive, with specialist expertise in the management and interpretation of the Archive's extensive non-fiction collections, and a particular interest in state-sponsored film-making. Published work includes chapters on film-makers Sarah Erulkar and Michael Orrom for *Shadows of Progress: Documentary Films in Post-War Britain* (BFI, 2010).

JANET MOAT was the first full-time curator of the BFI Special Collections, from 1992 until her retirement in 2008, during which she published several articles on the written archives and created a BFI website on the work of Sir David Lean. She co-edited *The British Cinema Source Book* (BFI, 1995) and was a contributor to *Directors in British and Irish Cinema: A Reference Guide* (BFI, 2006). She is currently working on a monograph, based on the Michael and Aileen Balcon papers at the BFI.

ANDREW MOOR is Reader in Cinema History at Manchester Metropolitan University. He is the author of *Powell and Pressburger: A Cinema of Magic Spaces* (I.B.Tauris, 2005) and

co-editor of *The Cinema of Michael Powell* (BFI, 2005) and *Signs of Life: Medicine and Cinema* (Wallflower, 2005). He has written a range of essays and articles on British cinema and queer cinema and is currently working on a monograph *Gay and Queer Cinema since Stonewall: Genre and Representation* (I.B.Tauris).

STEPHEN MORGAN is a freelance film researcher and archivist and a graduate of the University of East Anglia's Masters in Film Studies with Film Archiving. He has been involved in a number of archive-related projects in Australia and the UK, including work for the East Anglian Film Archive, Australian Network for Art & Technology and the London Underground Film Festival, and has contributed to *Studies in Australasian Cinema* (Intellect, 2012).

NATHALIE MORRIS is Senior Curator of the BFI's Special Collections. She has written for BFI screenonline and has contributed to the *Journal of British Cinema and Television*, *The Hitchcock Annual Anthology* (Wallflower, 2008), *British Women's Cinema* (Routledge, 2009) and *The Directory of World Cinema: Britain* (Intellect, 2012).

ROBERT MURPHY is Emeritus Professor in Film Studies at De Montfort University. His research interests are in British film and television and he has contributed articles and chapters to a wide range of journals and edited collections. His books include *British Cinema and the Second World War* (Continuum, 2000), *Sixties British Cinema* (BFI, 1992) and (as editor) *The British Cinema Book*, 3rd edn (BFI, 2009) and *Directors in British and Irish Cinema: A Reference Guide* (BFI, 2006).

TIM O'SULLIVAN is Professor of Media and Cultural History in the Faculty of Art, Design and Humanities at De Montfort University. He has contributed articles and chapters to a wide range of journals and edited collections. His books include (as co-author) *The Cinema of Basil Dearden and Michael Relph* (Edinburgh University Press, 2009) and *Studying the Media* (Bloomsbury, 2003) and (as co-editor) *The Family Way: The Boulting Brothers and British Film Culture* (Flicks, 2000) and *Liberal Directions: Basil Dearden and Postwar British Film Culture* (Flicks, 1997). His current research interests are the historical study of British television from 1946 to 1960 and film adaptations of the works of W. Somerset Maugham.

ANDREW ROBERTS is a historian, barrister and freelance writer and researcher on British cinema. He is currently working on his PhD on Middle Class Identity in 1950s British Cinema at Brunel University. His published work includes contributions to *British Comedy Cinema* (Routledge, 2012) and *The Encyclopedia of British Film* (Methuen, 2007). He has also written for *Sight & Sound*, BFI screenonline, *History Today*, the *Guardian*, the *Observer* and the *Independent*.

COLIN SELL is Senior Lecturer in Music and Media at East 15 Acting School, University of Essex. He has provided reviews for the *Historical Journal of Film, Radio and Television*. On the music side, he has composed scores for the RSC and award-winning Radio 3 and Radio 4 plays. His score for Brecht's *The Caucasian Chalk Circle* has been widely used. He is also the long-suffering pianist on Radio 4's *I'm Sorry I Haven't a Clue*.

CATHERINE A. SUROWIEC is an independent film historian, researcher and editor. Formerly with the film archive of the Museum of Modern Art, New York, she catalogued many of the BFI's designs holdings. Publications include (as contributor) *Michael Balcon: The Pursuit of British Cinema* (MoMA, 1984), (as editor) *The LUMIERE Project: The European Film Archives at the Crossroads* (1996), (as author) *Accent on Design: Four European Art Directors* (BFI, 1992) and (as associate editor) *This Film Is Dangerous: A Celebration of Nitrate Film* (FIAF, 2002). She has edited the catalogue of the Giornate del Cinema Muto (Pordenone) festival since 2000 and, in 2011, became the editor of FIAF's *Journal of Film Preservation*.

JAMES WALTERS is a lecturer in Film and Television Studies at the University of Birmingham. He has contributed chapters and articles to a number of edited collections and journals and is the author of *Fantasy Film: A Critical Introduction* (Berg, 2011), *Alternative Worlds in Hollywood Cinema* (Intellect, 2008) and (as co-editor) *Film Moments: Criticism, History, Theory* (BFI, 2010).

MELANIE WILLIAMS is Lecturer in Film Studies at the University of East Anglia. She is the co-editor of *British Women's Cinema* (Routledge, 2009) and *Mamma Mia!: Exploring a Cultural Phenomenon* (I.B.Tauris, 2012), and the author of *Prisoners of Gender: Women in the Films of J. Lee Thompson* (Dr Muller Verlag, 2009). She has contributed articles and chapters on British cinema to a large number of journals including *Screen, Cinema Journal, Historical Journal of Film, Radio and Television, Sight & Sound, Film Quarterly, Journal of British Cinema and Television, Feminist Media Studies* and *Quarterly Review of Film and Video* and numerous edited collections including *The British Cinema Book*, 3rd edn (BFI, 2009) and *Don't Look Now: British Cinema in the 1970s* (Intellect, 2010).

INTRODUCTION
REVISITING EALING

Mark Duguid, Lee Freeman, Keith M. Johnston and Melanie Williams

Why Revisit Ealing?

Ealing remains probably the most iconic and best-loved studio in British cinema history, with films that continue to attract and fascinate enthusiasts and scholars. Its continued importance within national and international perspectives on British cinema and society has been ably demonstrated by references in the popular press, regular DVD releases and film screenings, and a series of academic studies: overviews of the studio in Charles Barr's landmark book, *Ealing Studios*, and George Perry's *Forever Ealing*; a number of single-film studies, including Michael Newton's *Kind Hearts and Coronets*, Penelope Houston's *Went the Day Well?* and Colin McArthur's *Whisky Galore! and The Maggie*; a focus on one of the studio's key directors in Philip Kemp's *Lethal Innocence: The Cinema of Alexander Mackendrick*; while David Wilson's *Projecting Britain: Ealing Studios Film Posters* explored the studio's innovative approach to poster art.[1]

Ealing Studios' back catalogue is now more accessible than at any point in the studio's history, with over 70 per cent of the studio's films now available to own on Studiocanal DVDs. This allows both academics and general viewers to see a wider range of films than the handful that have long been in circulation on television, which has tended to foreground an established Ealing canon, mostly limited to comedies and war films, with rare additions such as *Dead of Night* (1945). The 2011 Ealing Studios eightieth anniversary celebrations saw the rerelease onto the cinema screens of a number of popular Ealing films and digitally remastered Blu-Ray editions of *Went the Day Well?* (1942), *Kind Hearts and Coronets* (1949), *Whisky Galore!* (1949) and *The Lavender Hill Mob* (1951). The national media covered these rereleases and the wider celebrations, which included Tally Ho! Cycle Tours (supported by Studiocanal and in conjunction with Wayne Hemmingway's Vintage festival at the Southbank centre), organised London bicycle tours of famous Ealing locations from *The Lavender Hill Mob*, *Hue and Cry* (1947) and *Passport to Pimlico* (1949). Such a level of activity is almost unheard of for a British film studio, particularly one whose main period of activity ended more than fifty years ago.

Ealing's unusual position in the national culture extends beyond viewing the films themselves. Writing in the *Observer* on 23 October 2011, Yvonne Roberts drew a

comparison between the Occupy London Stock Exchange protest that had begun its occupation of St Pauls Cathedral in the City and Ealing comedies. Praising the do-it-yourself ethos of the campaign, Roberts wrote:

> It has been that kind of occupation: full of characters, inventiveness, humour, enterprise and the kind of co-operation that money can't buy ... So far, the occupation is both uplifting and an almost nostalgic reminder of one of those admirable Ealing comedies, full of vicars, spinsters, pin-striped cads, sprightly young things and a rather muddled good-natured plot in which, sooner or later, the spirit of Britain in the Blitz is invoked.[2]

Roberts's comparison is illuminating on several fronts, drawing into sharp focus the enduring image of Ealing, reflecting both the studio's longevity and its continued presence within Britain's collective cultural consciousness. The nature of the occupation – its pitting of the small against the powerful, the disorganised against the organised and its promotion of community values as opposed to the interest of big business – represents a crystallisation of many recurring aspects of the Ealing ideal, and the St Paul's occupation and surrounding furore was described as having the 'flavour of a debased Ealing comedy'[3] by Marina Hyde in the *Guardian*.

The evocation of the Ealing spirit ought to come as little surprise as economically Britain in the early part of the 2010s throws up a number of similarities with the golden age of Ealing. Today's 'we're all in this together' rhetoric of national consensus, repeated hollowly by government ministers and spokespeople in defence of the Conservative/Liberal Democrat coalition's austerity programme, reminds us of an earlier austerity age: the 1940s–50s context of much of Ealing's output. The prime minister David Cameron's pet 'Big Society' project might seem to echo the community values evoked by so many Ealing films, but the reduced role for the state it fondly imagines is a continuation of policies that have their roots in the 1980s, not the 1940s, and share little with Ealing's idea of community, which grew from wartime radicalisation and is inextricably entwined with the same welfare state that the present government seems so determined to undermine.

References to Ealing Studios and its works still surface regularly in contemporary cultural discourse. A 2008 dispute between Ealing council and local protesters who were attempting to stop the removal of Victorian lampposts in Hanwell, west London, was described as 'like an Ealing comedy'[4] by the *Observer*. In May 2011, the *South Wales Evening Post* reported a dispute over feuding councillors which 'sounds like one of those old Ealing studios comedies',[5] while in the following February's *Scotland on Sunday*, the managing director of an Islay distillery suggested that overzealous security at the local airport 'would make a fantastic Ealing comedy'.[6]

These references confirm the studio's continuing hold on the nation's memory, and reaffirm that Ealing Studios is ripe for revisitation, particularly as such references display a selective memory: invariably 'Ealing' is twinned with 'comedy'. Yet there is much more diversity even in Ealing's comedies than seems to be widely recognised, and a great deal more to Ealing than comedy alone. One of the primary intentions of this book is to push aside simplistic stereotypes of 'classic' Ealing, to reassess those films that have been unfairly passed over in the creation of a narrow Ealing canon and to make a case for revisiting even the most apparently humble of the studio's output.

Ealing Studios: A Brief History

The history of Ealing Studios, the men who ran it and the films that it produced is inevitably more diverse than the popular assumptions about 'Ealing comedies' outlined above. As has been regularly noted, only a third of Ealing's output could be classified as comedy, and the other two-thirds contain a wide combination of generic identities (thriller, crime, melodrama, supernatural/horror, historical, fantasy, spy, epic – even, arguably, a Western), creative personnel and acting talent. Indeed, the description 'Ealing Studios' may itself be misleading, given it is possible to break that down into five distinct sections:

a) Films made at Will Barker's studio at Ealing Green from 1902 through 1929;
b) Films made at the refurbished Ealing studios (expanding out from Barker's site), between 1930 and 1938, under the ownership of Associated Talking Pictures;
c) Films made between 1938 and 1959 by a production company headed up by Michael Balcon (eventually titled 'Ealing Studios Limited') while at location (b);
d) Films and television programmes made at location (b) from 1955 on, by the BBC and other production companies;
e) Films produced by a modern company called Ealing Studios, many produced at a modernised location (b) since 2002.

Jack Hawkins and guard outside Ealing Studios

This book, and indeed almost every other study of Ealing Studios (most notably Perry's *Forever Ealing* and Barr's *Ealing Studios*), is concerned with definition (c). That is not to dismiss the films made before 1938 or after 1959 (Steve Chibnall and Dylan Cave's chapters in this collection, respectively, cover those periods), but to acknowledge that something special, something different, has continually been claimed for the company that Michael Balcon created when he arrived at the physical site of Ealing Studios in 1938 to produce *The Gaunt Stranger* with director Walter Forde. While the collection will necessarily expand on specific aspects of Balcon's 1938–59 tenure, it is worth summarising here some of the known and unknown aspects of Ealing Studios' history, to offer an overview of the time period Ealing operated in, the creative personnel who worked behind the scenes and the range of films they produced.

As noted above, production at Ealing began when 'retired commercial traveller' and photographer Will G. Barker bought property facing onto Ealing Green. Inspired by a trip to France, where he saw early Lumière shorts, Barker planned to make his own moving pictures, first outdoors (shooting between 9am and 3pm 'closest to the light intensity of high noon') and then in a photographic building or 'stage' made 'almost entirely out of glass'.[7] Barker was a great experimenter in British film production, allegedly creating Britain's first 'talkie' in 1908 when he filmed a sequence that was synchronised to a gramophone record, expanding his 'studio' out to three glass stages for the first screen version of *Hamlet* (1912), working with the great Shakespearian actor Sir Herbert Beerbohm Tree on *Henry VIII* (1911) and producing a series of 'topicals', short news features whose subjects included the funerals of Gladstone and Queen Victoria.[8] When Barker retired from film-making after World War I, his studio was sold to General Film Renters in 1920, bought by Union Studios in 1929 (who refurbished it for sound production) and then, finally, acquired by Associated Talking Pictures (ATP) in 1930.

The story of ATP – and its owner, Basil Dean – is covered in more detail in Steve Chibnall's chapter, but it is an important development to consider here due to the further investment and expansion of the studio facilities. Opened in November 1931, and designed to move into sound productions (for both ATP and the independent companies who would continue to hire the studio space through the 1930s), the smaller stage 1 and larger stage 2 were built first, followed by the largest stage 3 (usually split into stages 3A and 3B) in 1934, with a model stage (for special effects) added in 1944 and a dubbing stage added in 1949.[9] At the same time, ATP expanded the whole Ealing Studios site into a modern complex that included a powerhouse (providing electricity independent of the public supply), properties store, workshops, canteen, carpenter's shop and dressing rooms. Despite the scale this suggests, a journalist commented (several years later) that it was a 'little postage stamp of a studio … The studio's backlot is barely large enough to turn a car in.'[10]

Michael Balcon's 1938 arrival at this new Ealing complex was the serendipitous result of two parallel failures within the larger world of British cinema: his own, and that of Basil Dean. As chapters 1 and 2 of this volume cover in more detail, the introduction of 'Ealing Studios' was a result of Dean's resignation in April 1938 and Balcon's recent unhappy experience running Metro-Goldwyn-Mayer's British production unit, and his intention to return to independent film-making.[11] The transitional first few years of Balcon's reign at Ealing represented a studio with a production ethos and slate that was uncertain of its place and direction, although working towards Balcon's belief (fostered through his 1930s experiences) that 'a film, to be international, must be thoroughly national in the first

instance'.¹² Arguably, this transitional period only ended with the moral certainty of World War II and a broader understanding of how the 'thoroughly national' could fuel a series of films that claimed to represent (or construct) a national identity.

The first films produced after Dean's departure and as Balcon arrived continued in a similar vein to ATP's: low-budget thrillers *The Gaunt Stranger*, *The Ware Case* (1938) and *The Four Just Men* (1939); George Formby comedies *Trouble Brewing* and *Come on George* (both 1939); dramas *There Ain't No Justice* and *Young Man's Fancy* (both 1939); and comedies *Let's Be Famous* and *Cheer Boys Cheer* (both 1939). If these early films represented a transitional moment between the kind of productions ATP and Balcon's Ealing Studios would invest in, it was also transitional in terms of creative staff. Walter Forde, Robert Stevenson, Pen Tennyson (as discussed in Martin Carter's chapter) and Anthony Kimmins directed the bulk of the pre- and early World War II films; many were written by Stevenson, Kimmins, Sidney Gilliat, Roland Pertwee and Angus MacPhail; Ronald Neame is director of photography on eleven of the studio's first fifteen films; music is by Ernest Irving (featured in Geoff Brown's chapter); while publicity was handled by Monja Danischewsky (as discussed in Nathalie Morris's chapter). Of this transitional team, only Danischewsky, Irving and MacPhail would continue to work regularly with Ealing through the 1940s: given that MacPhail had writing or co-writing credits on forty of the ninety-five features produced at Ealing under Balcon, and gave 'script advice, often uncredited, on just about every script to pass through Ealing Studios', he remains one of the unsung creative forces of the Ealing Studios 'team'.¹³

The first Balcon-era Ealing film: *The Gaunt Stranger* (1938), featuring George Merrit, Sonnie Hale and Patrick Barr

The disappearance of many of the other creative individuals from the credits of later Ealing productions can, of course, be explained by the advance of World War II: many enlisted or were called up to fight and found new opportunities postwar. Wilfrid Shingleton, for example, was the art director for ATP who worked on all Ealing films from *Trouble Brewing* until 1941's *Ships with Wings*. He returned to the film industry, after wartime service, but not to Ealing, working on the likes of *Great Expectations* (1946) and *The African Queen* (1951). Some Ealing staff were offered opportunities by rival studios, in Britain or Hollywood (Forde and Stevenson both moved to America, Neame was DoP on 1942's *In Which We Serve* and 1945's *Blithe Spirit* before moving into directing with 1947's *Take My Life*). Charles Barr and George Perry note that two particular figures from this transitional period (Stevenson and Tennyson) are both great 'might have beens' within Ealing's history, individuals who (in association with Balcon) might have brought other projects and topics to future studio productions. Balcon himself dates the start of the 'Ealing tradition' to Tennyson's *There Ain't No Justice*, which was the first salvo in his plans to 'achieve the double aim of making a constructive British contribution to international kinema and of putting in our own theatres a product attractive in its own right'.¹⁴

Michael Balcon with Angus MacPhail, one of the unsung creative forces of Ealing

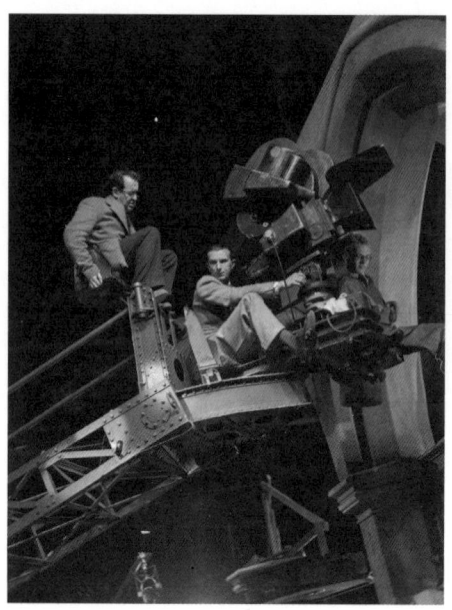

Alberto Cavalcanti, seen here with director of photography Gordon Dines on the set of *The Life and Adventures of Nicholas Nickleby* (1947), was a key figure in Ealing Studios during the 1940s

As is clear from his identification of Tennyson, Balcon needed to recruit new blood for these '"native" films'.[15] Between 1940 and 1947, the Ealing team grew to include familiar names who contributed to its legacy: Alberto Cavalcanti, Robert Hamer, Hal Mason, Charles Crichton, Charles Frend, Sidney Cole, Michael Relph, Douglas Slocombe, Harry Watt, T. E. B. 'Tibby' Clarke, Henry Cornelius, Seth Holt, Michael Truman, Alexander Mackendrick and Anthony Mendleson (the subject of Catherine Suroweic's chapter). These were the men (and it is noticeable that they are all men) who were involved in the regular round-table sessions to discuss new projects and ideas, and who took part in what appeared to be a communal decision-making process (although to those on the outside of this inner 'team' of film-makers, it would not have felt so democratic). As Robert Murphy notes in his chapter, many of Ealing's creative individuals talked of themselves as belonging to the same generation: with Clarke, Cole, Cornelius, Crichton, Danischewsky, Basil Dearden, Frend, Hamer, Mackendrick, Relph, Tennyson, Truman and Watt all being born between 1906 and 1916, and living through many of the same experiences.[16] Importantly, Balcon also saw Ealing as a place that could foster and grow talent. Many of these names were promoted through the Ealing ranks: Crichton (already an editor for Korda's London Films) edited Ealing war documentary *Yellow Caesar* (1941) and feature *Nine Men* (1943) before moving into directing with *For Those in Peril* (1944); Basil Dearden, one of the transitional team as ATP became Ealing, worked as a junior assistant, assistant director (with Will Hay on three of his Ealing films), assistant producer and then director on *The Bells Go Down* (1943); Hamer started as an editor on George Formby's final Ealing film, *Turned Out Nice Again* (1941) and stepped in as director on *San Demetrio, London* (1943) when Charles Frend fell ill, before directing a segment of *Dead of Night*. Alongside these famous names, Ealing's publicity department also emphasised the 'happy atmosphere' of the studio, where many employees (normally in the craft departments) remained with the studio for twenty years or more.[17]

The 'Ealing Studios' that these individuals helped to construct is one informed by the propaganda needs of World War II (notably the desire to represent a coherent and cohesive British national identity) and the introduction of several documentary film-makers (notably Cavalcanti and Watt, as well as documentary photographer Douglas Slocombe): the combination of these elements moved Ealing towards a drama-documentary aesthetic that emphasised Britain pulling together during wartime, the 'stiffened human pride, and the national solidity, inspired by World War II'.[18] Balcon described the commission of several Ministry of Information documentaries as dovetailing Ealing's production 'into a wartime pattern', films that 'rendered some public service. They were documentary in their approach.'[19] The combination of Balcon's commercial instinct, combined with the documentary school, 'provided the force from which emerged what are now thought of *en bloc* – though their variety is considerable – as the Ealing films'.[20]

The importance of the war within histories of Ealing Studios is, naturally, covered in the initial chapters of this volume: Martin Carter considers the start of the Ealing war film in Pen

Tennyson's films, Andrew Roberts looks at the notion of the 'people's war', Mark Duguid and Katy McGaham consider the route by which documentary entered Ealing's bloodstream, while Lee Freeman considers the political content of these wartime productions. Yet the war infiltrates almost all of Ealing's films, from the dramatised documentary of *San Demetrio, London* to the comedies starring George Formby, Will Hay and Tommy Trinder. These nine wartime comedies – setting aside Trinder's more dramatic turn in *The Foreman Went to France* (1942) and *The Bells Go Down*, or Hay's appearance in *The Big Blockade* (1942) – presented a broader form of comic propaganda, coherent in their mockery of German efficiency, militaristic culture and undercover work. Mistaken identities, British comics in German uniform and direct attacks on Hitler (most noticeably the Formby dream sequence in *Let George Do It!* from 1940) fuel these comic films, which Balcon retrospectively dismissed as providing 'some respite for a public that had known nothing but bad news for a long time'.[21] However, the films are a useful representation of the way Ealing Studios attempted to engage with star-led production. While the Formby films can be seen as a hangover from ATP, Hay and Trinder came to the studio on Balcon's watch, and their films (Trinder's particularly) follow a similar pattern to Formby's: a music-hall star with repetitive catch-phrases and established persona inserted into recognisable comedy narratives retooled for war. It is possible to read Trinder's status in the studio as Balcon's attempt to create a Formby-style star, a process that became more complex as the studio pushed the comedian into more straight performances in *The Bells Go Down* and *Bitter Springs* (1950), although both films (and their marketing materials) stressed links to established ideas of Trinder's star persona.[22]

Educational poster created by the Pictorial Charts Service for the release of *The Titfield Thunderbolt* (1953)

Ealing was rarely talked about as a star-led studio, and many of its wartime productions focused on a cast of individuals from different walks of life (and classes) pulling together for a common cause. These characters (and character types) were played by a range of recurring actors: Basil Radford, Meredith Edwards, Mervyn Johns, Raymond Huntley, Gladys Henson, Stanley Holloway, Gordon Jackson, Jack Warner, Guy Middleton, Derek Bond, Ralph Michael, Robert Beatty, Bernard Lee, Elliot Mason, John Laurie et al. These actors, and more (including a number of child actors, as considered in Colin Sell's chapter), formed a nascent repertory company whose presence helped to define Ealing's productions as a coherent and interconnected whole, as much as a diverse series of individual pleasures (the repertory model would reappear in later British cinema, most obviously in the *Carry On ...* series and Hammer's horror cycle). That is not to say that Ealing did not employ (or attempt to hone) stars in its films. It did, after all, produce films with Googie Withers, David Niven, Jack Hawkins, Dirk Bogarde, John Mills, Richard Attenborough and Alec Guinness (Balcon recalls being told he was 'out of your bloody mind' when he suggested Alec Guinness could be made into a film star[23] – Balcon's view was more than vindicated, as James Walters' chapter shows): but Ealing was not led by star performances. The studio preferred to work with a regular coterie of actors, returning again to ideas around the centrality of a collective body rather than an individual celebrity.

Ealing in wartime, then, was powered by a strong sense of creative teamwork, both in front of and behind the camera; an aesthetic combination of documentary and drama; and a belief in the (positive) social purpose of propaganda. During the war, Balcon proudly stated that 'ninety per cent of our wartime schedule has been devoted to films with a war background, and of these (comedies included) each has contained elements of propaganda in varying degrees'.[24] Ealing Studios had a strong sense of itself in wartime, as a purveyor (and, arguably, representation) of a particular form of British national identity, through a documentary-inspired aesthetic and approach. Writing in 1945, as the war drew to a close, Balcon launched a manifesto of what postwar British cinema should be:

> [T]he need is great for a projection of the true Briton to the rest of the world ... Britain as a patron and parent of great writing, painting and music; Britain as a questing explorer, adventurer and trader; Britain as the home of great industry and craftsmanship; Britain as a mighty military power standing alone and undaunted against terrifying aggression. ... Fiction films which portray contemporary life in Britain in different sections of our society, films with an outdoor background of the British scene, screen biographies of our great, screen adaptations of literary classics, films reflecting the post-war aspirations not of governments or parties, but of individuals.

It is a manifesto that described Ealing's own identity and plans. At the heart of the studio remained a coherent and consistent team that ensured continuity between wartime success and a new postwar identity, able to build on existing production techniques and approaches, to translate wartime 'realism' into commercial film-making. The studio remained much as it was in Basil Dean's day, a 'little postage stamp ... [whose] very smallness has worked in many ways to give Ealing's pictures their special character', but powered by Balcon's belief in national cinema.[25] The immediate postwar years demonstrated Ealing's intention to follow through on Balcon's 1945 statement: Dickens adaptation *The Life and Adventures of Nicholas Nickleby* (1947), a biography of ill-fated polar explorer Captain Robert Falcon Scott in *Scott of the Antarctic* (1948), explorations of contemporary British life in *It Always Rains on Sunday*

(1947) and *Hue and Cry*, and reflections on Britain in wartime in *The Captive Heart* (1946) and *Against the Wind* (1948). Almost all the films moved beyond the confines of the studio to explore the 'outdoor background' of Britain (and beyond, with Dublin in *Another Shore*, 1948, and Australia in *The Overlanders*, 1946). This expansion beyond the safe path of wartime productions was described by Balcon as a necessary step away to avoid the 'formation flying' and 'over-insistence on realism', a call for the industry as a whole to 'widen its horizon'.[26]

Part of this expansion was the production of a group of postwar comedies running from *Hue and Cry* in 1947 to *The Ladykillers* in 1955. It is with these comedies that Ealing remains most strongly associated: they have been understood as a subgenre in their own right and have come to be regarded among the highlights of the nation's cinematic heritage. Even by 1955 Kenneth Tynan was describing Ealing comedies as 'the regimental mascot of the British cinema'.[27] They shared, according to Balcon, the motif of 'mild anarchy'[28] befitting the national mood of the times. Although the cycle begins in 1947, its pinnacle came in the years 1949 – which saw the release of *Passport to Pimlico*, *Whisky Galore!* and *Kind Hearts and Coronets* – and 1951 – when *The Man in the White Suit* and *The Lavender Hill Mob* appeared. However, as Tim O'Sullivan's chapter in this collection points out, even considerations of that three-year span miss out *A Run for Your Money* (1949) and *The Magnet* (1950), and there are many other comedies made at Ealing that, for various reasons, have not been considered 'Ealing comedies'. Moreover, even a cursory look at what else was in production or released during Ealing's comedy heyday provides a salutary reminder of the diversity and range of Ealing's output; not at all restricted to comic modes. In 1948 the studio had pinned its hopes on two higher-budget prestige colour films, the costume drama *Saraband for Dead Lovers* and the heroic biopic *Scott of the Antarctic* (both discussed in Keith Johnston's chapter, along with other Ealing colour productions). Ealing's Australian enterprise (discussed by Stephen Morgan in this volume) continued from 1949 to 1951 with *Eureka Stockade* (1949) and *Bitter Springs,* as well as an exploration – again in colour – of the wide open spaces of the African nature reserve in *Where No Vultures Fly* (1951), one of Ealing's most commercially successful films.[29] Even more profitable was the studio's police drama *The Blue Lamp* (1950), which famously spawned television's *Dixon of Dock Green* (BBC, 1955–76). Jack Warner, star of both film and TV series and an Ealing stalwart, also appeared in the 1949 portmanteau film, *Train of Events*, about disparate people affected by a train crash, among them Warner's ageing train driver hoping for a cushy desk job married to long-suffering Gladys Henson, Peter Finch's murderous actor, Joan Dowling's desperate love-starved girl (secretly harbouring a fugitive POW) and Irina Baranova's coquettish pianist, who is the mistress of maestro John Clements until both are outsmarted by his wife Valerie Hobson. The breadth of character types and situations even in a standard production like *Train of Events*, now seldom revived, counsels against pigeonholing Ealing.

For popular magazine *Picturegoer*, reporting on the production of *Pool of London* (1951), Ealing's identity hinged not on comedy but on its 'difference' from the norm, which was

> nothing more or less than accenting and bringing the ordinary into perspective. Ealing pictures have no place for candy and cake; no room for subtleties of the drawing-room variety. Beyond their studios are the ordinary people. Toiling men, women hanging up the washing, girls setting off to the palais. There are kids playing hopscotch in the streets, there are beggars and vagabonds, wide boys and coppers on the beat. Around them all Ealing weaves its creditable, but unordinary tales.[30]

Balcon's opposition of 'realism' and 'tinsel' is often cited in discussions of British cinema, and the assumption is usually that audiences preferred the latter to the former – they longed for the 'candy and cake' that Ealing refused to offer – so it's interesting to find an endorsement of its realist ethos, and its attention to the ordinary, in a populist publication. However, even this characterisation of Ealing as a studio defined by realism – workers, washing lines and wide boys – is problematised if we take into account its recurrent use of fantasy motifs in a range of films, from the wish fulfilment of punching Hitler on the nose in *Let George Do It!* or the time travel frolics of *Fiddlers Three* (1944) to the supernatural compendium of *Dead of Night* or the consideration of premonitions and predestination in *The Night My Number Came Up* (1955). These, and other Ealing forays into the fantastic, are discussed by Josephine Botting in this volume.

Darkness and de-familiarisation are usually seen as aberrant qualities and alien to the Ealing ethos, but as both Robert Murphy's and Andrew Moor's chapters in this collection demonstrate, there was more of a heart of darkness to this apparently 'tight little studio' than is sometimes acknowledged. While Ealing undoubtedly was 'the studio with the team spirit' (a slogan painted on the studio wall during the Dean era which remained into Balcon's tenure), genuinely 'supportive and co-operative', as Philip Kemp has suggested, 'to a degree which sometimes seems hard to credit' nowadays, its group decision-making processes, overseen by 'benevolent headmaster' Balcon,[31] could exclude certain kinds of film-making. Indeed, the curtailing of several of Robert Hamer's cherished projects has sometimes been seen as contributory to his accelerated self-destruction through alcohol (for more on Hamer, see Moor's chapter). More recently, editor Jim Clark has presented a much less rosily nostalgic view of Ealing, having worked there in a very junior capacity. For Clark, it was 'class-ridden. You knew your station and stayed in it, or incurred wrath in high places … A big sign exhorted us to great effort, just like something you might have seen in China during the cultural revolution. It read, "The Studio That Pulls Together."'[32]

Ealing also had a reputation for resistance, as Geoff Brown has argued elsewhere, to anything resembling 'feminine pulchritude and intimations of desire' – 'our minds just don't seem to run in that direction', Balcon insisted when quizzed on this point[33] – but Ealing's 1950 release programme actually included two films centred on the romantic vicissitudes of attractive young women. Both *Dance Hall* and *Cage of Gold* make clear that the heroines have indulged in pre-marital sex. The poster for *Dance Hall* even features Diana Dors flashing her stocking tops, and the film's press book trumpets its casting of a starlet who is 'the most truly representative of the full-of-life, swing-keen youngster. She is as full of vitality as a dynamo; her exuberance positively leaps out from the screen!'[34] And, two years later, Ealing also found room for the 'sullen, electric presence'[35] of another teenage starlet, Joan Collins, in *I Believe in You* (1952). It may be true that Ealing seems to have been more comfortable with the matronly or dotty older woman (Gladys Henson or Edie Martin are the archetypes) kept safely at the margins, but as Melanie Williams's chapter in this collection demonstrates, the studio also made a significant number of films with a female focus, most notably those starring Googie Withers in the late 1940s.

Cage of Gold was distinctive not only in its focus on a female protagonist and its noir-ish tendencies but also in its foregrounding of continental connections, shuttling restlessly between foggy London and glamorous, licentious Paris; its press book boasted of a 'cosmopolitan cast', with French, Russian, Czech, Maltese and Danish actors alongside the Brits.[36] It was not a lone example of cosmopolitanism. Indeed, sometimes it seems that

Ealing's reputation as cosily parochial is quite misplaced, particularly when so many of its films feature cross-channel exchange, including Clifford Evans's journey in the self-explanatory *The Foreman Went to France*, the links (and intermarriage) between Breton and Cornish fisherfolk in *Johnny Frenchman* (1945) and the presence of Burgundy in Britain in *Passport to Pimlico* – 'French goings on in the heart of London!' exclaimed the poster – and the trip to Paris and the ecstatic tumble down the Eiffel Tower in *The Lavender Hill Mob*, not to mention the obvious Francophilia exhibited by Robert Hamer's directorial style, and the casting of actresses Francoise Rosay and Simone Signoret in Ealing productions. Geoff Brown draws our attention to another example of Ealing's French connections with his chapter on composer Georges Auric, who provided very French scores for some of the most canonical Ealing comedies, including *Hue and Cry, Passport to Pimlico, The Lavender Hill Mob* and *The Titfield Thunderbolt* (1953). As Brown suggests, despite its insular reputation Ealing 'was never a studio of Little Englanders wrapped in a Union Jack cocoon'. It wasn't just to France that it looked for inspiration and its workforce was notably international: one of its most celebrated writers, William Rose, was an American ex-pat; one of its most defining figures, Cavalcanti, was Brazilian and prodigiously well travelled; director Henry Cornelius was South African and had worked under Max Reinhardt and René Clair; and they were accompanied by a host of other international personnel employed in a variety of roles. Ealing's settings are also more geographically far flung than usually remembered, extending beyond the London suburbs or Scottish islands and Welsh valleys to encompass location shooting in several European, as well as Commonwealth, countries. Rather than staying within hidebound little communities, several of their films are set in liminal spaces such as

Aerial view of Ealing Studios, early 1950s

docks (*Pool of London*) and airports (1955's *Out of the Clouds*). Even the London-set comedies have exotic elements; *The Lavender Hill Mob* begins and ends in South America and we're also tricked into thinking we're there in the first few minutes of *Passport to Pimlico*.

However, the mantle of exemplary national cinema was encouraged, in part, by Ealing's own self-definition. The link between nation and cinema was forged during wartime and Balcon envisaged the postwar role of British cinema as that of influential overseas ambassador, if given a chance.[37] In a supplement to the trade magazine *Kinematograph Weekly* celebrating the studio's twenty-first anniversary in 1951, the coverage of the studio continually invokes national identity: 'makers of good British films'; 'Ealing for England'; 'holding up a mirror to the English way of life'; Reg Baker's insistence that 'the Ealing tradition is a really British one. We hold to the belief that we are better equipped to make films on subjects which we understand and which are inherent in the life, background and people of this country.' But, ironically, the best-known conjunction of Ealing and Britishness would also be a kind of epitaph: the plaque erected at Michael Balcon's request when the studio premises at Ealing were sold to the BBC in 1955 which spoke of 'films projecting Britain and the British character'. The sale was to pay off a large NFFC loan which Balcon had negotiated to keep the company afloat after Stephen Courtauld had withdrawn his steadfast and enlightened patronage in 1952. The previously cordial arrangement with the Rank Organisation had also become increasingly strained after the notoriously frugal John Davis took over the running of the corporation and starting asking awkward questions about 'minutiae such as plywood and canteen costs' and intervening more directly in production choices, to Balcon's annoyance.[38] But it was the selling off of the Ealing premises (which after all had given Ealing a name as well as a home) and the enforced relocation to MGM's British studios, which marked the point where decline shaded into fall. The new outfit – still badging itself 'Ealing' – protested its continuing vitality in press releases: 'if the reports of our death are not being exaggerated, there are some very healthy ghosts making Ealing films like *The Man in the Sky* and *The Shiralee*. We have changed our name from Ealing studios to Ealing films and our address from Ealing Green to Elstree but all concerned are still in the best of health.'[39] On the same day, Jill Craigie wrote an article for the *News Chronicle* with the headline 'Ealing is Ealing Still'.[40] But such emphatic insistence only pointed up the all-too-real problems Ealing faced in trying to keep going.

The Ealing of the mid- to late 1950s is frequently characterised as stagnant and inert, perhaps deservedly so when one compares the vitality of the early postwar comedies to the twee-ness of T. E. B. Clarke's *The Titfield Thunderbolt* or, later, *Barnacle Bill* (1957). As Charles Barr points out, this is the period when the studio begins to earn 'its now familiar identification with the old and the quaint'.[41] Mackendrick and Rose's *The Ladykillers* is often seen as a 'meta-film', a commentary not only on England but also on Ealing's own stagnation and refusal to move with the times, with Philip Kemp seeing its final shots, looking down at the little isolated Wilberforce house at the end of the street, as 'unmistakably valedictory',[42] coming from a director who was about to leave England for America, and comedy for film noir (1957's *Sweet Smell of Success*). But it's interesting to read Mackendrick's own retrospective vision of the film, which is much more celebratory of Mrs Wilberforce as a 'much diminished Britannia':

> Her house is in a cul-de-sac ... Dwarfed by the grim landscape of railway yards and screaming express trains, it is Edwardian England, an anachronism in the contemporary world. Bill Rose's sentimental

hope for the country that he and I saw through fond but sceptical eyes was that it might still, against all logic, survive its enemies. A theme, a message of sorts, one that I felt very attached to.[43]

Far from wanting the gang to triumph, Mackendrick asserts his support for the little old lady and all that she represents – by extension traditional Englishness *and* traditional Ealing. It seems that even the studio's most maverick voices were still wedded to a celebration of establishment values rather than the challenges posed to them by intellectuals (the professor), youth culture (the teddy boy), the working class (the heavy) or foreign influences (the European gangster). No wonder the studio lapsed into self-parody and repetition, symbolised by the pointless circuits of the lonely little girl's tricycle in *Mandy* (1952) before she's given a chance to communicate with the outside world, or the image of the circular train track that begins and ends *The Titfield Thunderbolt*; a closed circle of delusionary self-satisfaction. As Lindsay Anderson points out in his generally positive appraisal of Ealing around this time: 'There comes a point where consistency declines into sameness.'[44] But this is not the whole story of 1950s Ealing, and just as recent film scholarship has overturned the notion that the period 1952–58 was 'an extraordinarily dead one'[45] for British cinema, so Ealing's output during this period benefits from a revisionist perspective. Yes, there are moments of remarkable tedium – there's not much to say in favour of the turgid jockey story *The Rainbow Jacket* (1954), which even its makers, Dearden and Relph, didn't want to do[46] – but there are also films that indicate a studio trying to make the best of its straitened circumstances and to keep on innovating even in the face of its imminent demise. *Lease of Life* (1954), with its dignified country vicar (Robert Donat) who is diagnosed with a terminal illness which emboldens him to kick against the authorities – in a genteel way – could be seen as another Ealing *film à clef*, a wish-fulfilment fantasy for an institution suffering its own terminal illness. Balcon saw the studio's adoption of Thorold Dickinson's political thriller *Secret People* (1952), a project conceived outside the confines of Ealing, as 'a welcome blood-transfusion, a stranger bride in a family tending towards inbreeding'.[47] But the completed film failed to provide the shot in the arm or the addition to the gene pool that had been hoped for, instead being designated 'a mausoleum of good intentions'.[48] There was a more ambitious attempt to revive the ailing Ealing with the employment of controversial critic Kenneth Tynan, as discussed in Charles Barr's chapter, but ultimately this too was thwarted. Tynan's most palpable legacy comes in the shape of the 'least Ealing film ever made', *Nowhere to Go* (1958), scripted by Tynan and directed by Ealing insider Seth Holt, who would later be hailed by *Movie* as one of only three 'talented' directors in a generally moribund British cinema, along with his Ealing colleague (and brother-in-law) Robert Hamer and Karel Reisz.[49] But Holt's promise would have to be developed somewhere else; at Ealing there really was nowhere to go. After Ealing Films' six-picture association with MGM came to an end, and the prospect of renewal vanished, there was an aborted attempt to work under Associated British, but it resulted in just one film, *The Siege of Pinchgut* (1959) – Ealing's final film, made not in west London but on the other side of the world.

Light, Dark and Shades of Grey

There's never a bad time to re-evaluate the past, but this book comes at a time when the Ealing story is particularly ripe for rethinking. Partly inspired by the striking alignment of

key Ealing centenaries, the winter of 2012 sees a two-month season of Ealing films at BFI Southbank, as part of a focus on British film in the year of the London Olympics. The retrospective seeks to make its own re-evaluation of the studio's output, just as this book does, and to extend the canon of acknowledged classics by presenting a broader selection of Ealing films on the big screen than has been seen for some thirty years, while at the same time challenging the shorthand, one-dimensional view by presenting two faces of Ealing side by side, contrasting the qualities of 'Ealing light' – morally unambiguous, optimistic, consensus-seeking, sometimes utopian – with 'Ealing dark' – morally complex, socially critical, challenging, cynical.

Both the season and this book, like the DVDs and Blu-Rays, the restorations and cinema rereleases, and the periodic references and commentaries in print, on air and online, in lecture halls and seminars, contribute to a long and ongoing conversation about what Ealing Studios meant, and what it still means. Those meanings aren't fixed and never will be, and the films will always be there for us to revisit and debate, ensuring that the conversation will continue for many years to come.

1

A LAD, A LASS AND THE LOCH NESS MONSTER
THE PREHISTORY OF EALING

Steve Chibnall

The conventional history of the years in which Basil Dean ran the new studios at Ealing tells a tale of laughter and songs provided by two homely performers from Lancashire: a lad with a little ukulele, and a lass who sang as she went. The lad, of course, was George Formby, and the lassie from Lancashire was Gracie Fields. With the help of Basil Dean they took their place among the highest-paid performers in films, and the public loved them – particularly in the north of England. It is remarkable that a studio headed by a West End impresario, based in a London suburb, and that would later become so closely identified with metropolitan locales such as Pimlico, King's Cross and Southwark, should have been so successful in producing pictures that had them queuing north of Watford in the depths of the Great Depression.[1] But then, according to the well-used distinction of Charles Barr and George Perry, the Formby and Fields pictures were comedies made at Ealing studios, but were not 'Ealing comedies'. There were, apparently, no fully minted, twenty-four-carat Ealing films until Michael Balcon took over as studio head and, with war and austerity, provided the alchemy to turn the base into the precious. Nevertheless, if the films of Formby and Fields were not pure Ealing gold, they were certainly silver in comparison to another category of productions from the studios in the 1930s: the pictures made by independent producers using Ealing's facilities. Most of these, like some of the films made by Dean himself, were destined to be supporting features on the double bills that were virtually obligatory at the time. They constitute a truly subordinated category of the prehistory of the studios – the dinosaurs beneath the surface, fossils of an evolutionary dead end, not the Georgies or the Gracies but the 'Nessies'. It is appropriate, then, that one of these relics should have been titled *The Secret of the Loch* (1934).

Although film-making behind The Lodge on Ealing Green began in 1907 with Will Barker's glasshouse in the back garden, the studios where the Ealing classics were shot were the product of the twin stimuli of the 1927 'Quota' Act and the growing hegemony of sound films. Basil Dean and his business partners (the fabric manufacturer Stephen Courtauld and the accountant Reginald Baker) knew that the legislation protecting British production ensured at least a home market for their products, and that it was in the interests of Hollywood distributors to invest in their project. Dean also appreciated, despite having made the most popular British silent of 1928, *The Constant Nymph*, that the day of the silent

film was over. His new company was pointedly named Associated Talking Pictures (ATP) and, in the belief that they had the full backing of the giant American producer-distributors, RKO, to make quality international films, Dean and his partners committed to building modern sound stages at one of England's pioneer production sites at Ealing. Although it quickly became clear that their Hollywood associates were not prepared to invest in infrastructure to obtain their British quota films, ATP managed to raise funds to build studios in the garden of Ealing from City of London sources, and construction began in March 1931. Eight months later, after negotiating all of the pitfalls the worsening national economic situation could create, enough construction had been completed for production to begin at the fledgling Associated Radio Pictures (ARP) Studios. However, the first of the new Ealing films was not a big international production but a modest programme filler, *Nine Till Six* (1932), a 'women's picture' set in a fashion house and directed by Dean himself, who admitted that 'It was not an auspicious start to the Ealing adventure.'[2] Production conditions on the building site at Ealing hampered attempts to apply his formula for film-making in the era of sound: take a decently successful stage play, streamline its dialogue and enhance its visual impact by adding scenes shot on location using the old silent techniques. The approach had been largely successful in the case of the first collaboration between ATP and RKO, *Escape* (1931), an effective adaptation of John Galsworthy's play which was filmed at Beaconsfield with impressive West Country location footage.[3]

Unfortunately, the rush to get the half-built studios into action militated against the sort of expansive cinema that Dean might have preferred. *Nine Till Six* included most of the cast of the London stage production, thus saving on rehearsal time. The star of Ealing's second film, Arthur Wontner, was also well versed in playing his character on stage, and so brought little that was fresh to the portrayal of Sherlock Holmes in *The Sign of Four* (1932). The film was also not helped by being entrusted to Graham Cutts, a distinguished director of silent films but as yet uneasy with the sound medium. Probably intended as a first feature, the picture was poorly received: 'There is a burst of vigorous action in the final reel, but most of the story is told on strictly "talkie" lines,' said *Film Weekly*.[4]

The British approach to dialogue dismayed visiting American film-makers. Otto Ludwig, one of Radio's Hollywood editors, sent over to work on the Ealing efforts, found that there was 'too much dead footage' in English films: 'The good meat is hopelessly hidden by a lot of useless dialogue and action which is not helping the story at all. ... Directors have a habit of allowing a character to mention something – say the rain – and then they go and show a photograph of it as well.'[5] In his defence, Dean argued that the speed of action demanded by the critics was technically 'not yet possible on the talking screen'.[6] Undeterred and still fired by an excess of 'pioneering spirit', he went on gaily making pictures – 'well, if not gaily, at any rate with determination', as he put it.[7] He was determined to get back to more truly cinematic film-making by shooting on location, and planned to send a unit under Cutts to record scenes for an adaptation of Jerome K. Jerome's *Three Men in a Boat* (1933) on the Thames, and then to lead an expedition to Austria to shoot a sound version of his earlier hit, *The Constant Nymph*.[8] For the time being, however, his canvas remained more restricted on adaptations of two Sapper stories, *Love on the Spot* (Graham Cutts, 1932) and *The Impassive Footman* (Basil Dean, 1932). The latter is particularly interesting because it challenges the conventional wisdom that the universal message of British films in the 1930s was one of cheerful acceptance of the privations and inequalities of the prevailing social order. Ideologically, the bitterness of *The Impassive Footman* is a far cry from the cheerful stoicism

Class conflict in *The Impassive Footman* (1932), featuring master Allan Jeayes and servant George Curzon

of Dean's Gracie Fields vehicle, *Sing as We Go* (1934). Sapper (H. C. McNeile) is usually thought a reactionary writer, but as a veteran of the trenches, he could communicate a burning sense of injustice concerning World War I; and in its portrait of Marwood (Allan Jeayes), a selfish, domineering, hypochondriac magnate, and the alienation suffered by his wife and servant, his play offers both feminist and socialist critiques of the dominant order. When we first see the eponymous Footman (George Curzon) reading *The Decline and Fall of the Roman Empire* we know we are in for something a little more radical than usual, and the ending does not disappoint. In the Sapper tradition of rough justice, the downtrodden servant finally becomes a dark avenger, hectoring his scheming and mendacious employer with a furious speech that even provokes a fatal brain haemorrhage in Marwood. The Footman describes himself as 'Just one of the millions who went to that comic war and left everything behind', and criticises Marwood for preferring 'to stay at home and make money'. The Footman's wife had been one of the 'over-worked and under-paid' secretaries employed by Marwood and then pressured into sexual favours when she assumed her husband had been killed. But the Footman had survived, and returned to find his pregnant and diseased wife dying of 'shame and hunger' after being abandoned by her employer. Having extracted his revenge on behalf of all the people wronged by Marwood, the previously stiff and impassive servant walks out of the house with a swagger and a smile.

Dean took trouble to make as authentic as possible the film's melodramatic operating theatre scenes in which the lover of Marwood's wife, a surgeon, is obliged to operate on the

cuckolded husband to save his life. We even see the surgeon's scalpel slicing into the rump of a pig, an effect 'which sent shivers down some audience spines', according to the director.[9] He also recalled that these expressionist scenes won praise from critics in the USA when the film was eventually released there under the lurid title *Woman in Bondage* by ATP's American agent, the independent distributor Harold Auten (rather than by Dean's partner company RKO).[10] It also received the best of the British reviews of Ealing's early output, with *Kinematograph Weekly* not alone in forgiving its melodramatic plot and histrionic acting styles to describe it as 'a praiseworthy British effort' which should 'earn the plaudits of all types of audiences'.[11] In the light of its critique of the shirking of duty and of selfishness and degeneracy in high places, it is perhaps fitting that *The Impassive Footman* was the film on the floor at Ealing when HRH Edward the Prince of Wales paid the new studios a much publicised visit.

By the summer of 1932, ATP's tie-up with RKO was unravelling faster than a film spool in free spin as it became clear that its American partner would rather invest in lower-budget supporting features to fulfil its quota obligations than the sort of £20,000 pictures that Ealing was making. Like most Hollywood renting firms, it transpired, RKO would prefer to buy its British films outright as close as possible to the minimum cost for quota registration allowed in the Act – one pound per foot of film. This would mean that the average cost of their British films would be approximately 10–20 per cent of the Hollywood movies they would normally support. Dean's bitterness was palpable and public: 'The compulsory needs of American distributing firms in London have resulted in the making of scores of cheap indifferent quota offerings, which, under other circumstances, would not have been made at all.' Consequently, it seemed to him, 'No British film, apparently, is too bad for quota purposes.' The prestige of the national cinema, he argued, was being lowered by 'the shoddy rubbish which is made for quota purposes on lines which actually put a premium on slapdash inefficiency'. The only reason such films got bookings and risked 'the active derision of audiences', he felt, was 'the difficulty in getting better ones'.[12]

With so many of Ealing's film bookings attracting only the flat rate associated with second features, revenue from film distribution was well below expectations. As financial liquidity dried up, liquid poured from the sky, dampening the hopes of ever completing ATP's location-intensive *Three Men in a Boat*, which was adrift somewhere on the river near Marlow and Maidenhead.[13] With no further funds for production, Dean was obliged to rent the studios by the week to independent producers. The first let was for a relatively prestigious project starring Laurence Olivier and Hollywood's Gloria Swanson (*Perfect Understanding*, 1932), but it was a production constantly beset by problems and conflicts that belied its title, and was not immediately followed by others of its class.[14] The only positive legacy of what was an expensive flop for United Artists was the retention by Ealing of the editing services of Thorold Dickinson, who had come to the studios to work on the Swanson picture. Henceforth, Dickinson's editing and Soviet-influenced montages would add some much needed pace and panache to Dean's pedestrian directorial style, as the cutter recalled: 'In those days the editorial relief was the montage sequence which we used to introduce after a long dialogue scene for visual relief. A montage sequence was like a cadenza in a concerto. I used to enjoy making them.'[15] Dickinson's innovative techniques were seen at their most spectacular in the point-of-view defenestration in *Loyalties* (Basil Dean, 1933), Galsworthy's equivocal exploration of anti-Semitism.

Dickinson's job was to 'jazz up' the theatrical transcriptions for which Dean became notorious. 'He is years behind the times in his outlook,' complained an editorial in *Film Weekly*, responding to Dean's idea for a stock company of young actors and writers who would create plays for the Cambridge theatre and film adaptations at Ealing. 'He obviously regards the stage as the principal source of screen material [but] ... Dramatists must be encouraged to write direct for the screen, not to write for the stage and then "adapt" their plays into films. Mr Dean seems to be theatre-minded first and film-minded afterwards.'[16] And when Dean unveiled his film version of Dodie Smith's play *Autumn Crocus* (1934) the influential magazine went on the attack again:

> It has neither the dramatic strength nor the succession of interesting or exciting incident which might have justified its straightforward translation to the screen ... Basil Dean, who produced the original stage version, has made the film far too close a copy of the play. The pictorial atmosphere supplied by the introduction of genuine Tyrolean scenes is excellent, but it is not enough. Hardly anything happens in the film, and the dialogue is terribly prosy and theatrical. It should have been re-written in the pithy, naturalistic language of the cinema. The two principals often sound as if they were reciting from a book – as, indeed, they are.[17]

'Bloody but ... yet unbowed', Dean continued to defend the theatre as 'the finest training ground possible for the screen', adding: 'Moreover, no miracle is required to translate a good play into a good film.'[18] *Autumn Crocus*'s 'genuine Tyrolean scenes' were actually a triumph of Ealing's state-of-the-art back-projection technology. The actors never got within yodelling distance of the Alps, but process shots filmed by a location unit under Carol Reed allowed the illusion to be created.[19]

Still in dispute with his American partner in the autumn of 1932, Dean had briefly suspended operations at the studios rather than giving RKO the satisfaction of having him make cheap quota films for them. Instead, he took distribution into his own hands a few months later by setting up Associated British Film Distributors (ABFD) and announcing: 'Our business will in future be built upon entirely British lines, with an eye mainly to the British Empire market.'[20] Under the confident leadership of Ben Henry, the company would both release Dean's own productions and offer the service to independent film-makers using the Ealing studios. Forty-eight British films would be distributed by the company between 1934 and 1937.[21] After the unhappy experience with an American partner, ABFD placed the emphasis firmly on the 'British' part of its name, a policy that lies at the root of Ealing's reputation for 'projecting the nation':

> British authors have been approached in an effort to obtain story material that can be faithfully reproduced by the essentially British stars whose names appear on the ATP roster. This policy of BRITISH THROUGHOUT is not being carried out with narrow insular motives, but with the firm conviction that the country can supply story material and stars for National and Empire markets.[22]

Among the starts recruited were Edmund Gwenn, an English character actor who had enjoyed a Hollywood career but returned to star in J. B. Priestley's *Laburnum Grove* (Carol Reed, 1936), and Sir Cedric Hardwicke, a knight of Albion's theatre who was about to depart for Tinseltown. Youth was represented by Dean's ingénue wife, Victoria Hopper, for whom her husband designed starring vehicles such as *Lorna Doone* (Basil Dean, 1934), *The Lonely*

Road (James Flood, 1936) and the particularly ill-advised Mozart biopic *Whom the Gods Love* (1936), all without much box-office endorsement.[23] The same could not be said of an Ealing supporting player who would quickly rise to become the poster girl of British cinema: Margaret Lockwood. There was also the future compere of television's *Opportunity Knocks*, the boy actor Hughie Green, who took the title role in Carol Reed's first stab at solo direction, the salty adventure story *Midshipman Easy* (1935). Set construction for this film involved the building of a forty-foot-high man o' war, a potent emblem of British sea power, in Ealing's garden.[24] Construction was carried out to the design of Edward Carrick, one of the talented team of home-grown designers and technicians that gathered at Ealing. Perhaps the emphasis placed on cultural Britishness in the studios' self-promotion deterred the applications of the crowds of creative individuals who fled from Nazi Germany in the mid-1930s. Neighbouring Shepherd's Bush Studios seems to have been seen as a more welcoming environment.

The vertical integration of Dean's production and distribution businesses gave his enterprise greater stability. This was enhanced by the continuing box-office bonanza supplied by his star attraction, Gracie Fields. Considering that Fields found making films a particularly uncongenial activity, and that critics generally regarded the stories and direction she was given as unworthy of her talents, her triumph as Britain's most popular and highly remunerated performer is remarkable. Reviewing her Ruritanian romp *Love, Life and Laughter* (Maurice Elvey, 1934), for instance, *Film Weekly* noted that 'the story is atrocious; the production poor; but the comedienne herself is in characteristic form in spite of everything'. The blame for this anomaly was laid at the door of Dean:

> It is fortunate for the producers that Gracie Fields has a justly acquired and faithful public, who will seize the chance of seeing her in any circumstances. But the paucity of everything outside the star herself prompts the question why such a distinguished artist shouldn't be given a worthy context.[25]

Even Dean had to admit that this sort of criticism was not without some justification, and his response was to engage the esteemed author J. B. Priestley to write an original story for Gracie's next film, *Sing as We Go* – with rather similar results in *Film Weekly*'s judgment.[26] In this and her next film, *Look Up and Laugh* (Basil Dean, 1935), Priestley at least returned Gracie to her natural setting, the northern working-class milieu in which she could more easily communicate an artless, down-to-earth charm unspoilt by the '£2 per minute' she received for doing so. In truth, though, Fields's popularity and her formula of sentiment and simple humanity were impervious to the changes of other personnel involved with her films. The box-office receipts peaked with her final Ealing picture, the semi-autobiographical *The Show Goes On* (1937), in which she once again had Dean as her director, after an interlude under the directorial care of her second husband Monty Banks. Looking back on her films in 1939, the most astute member of London's film press corps, Graham Greene, pinpointed the consensual characteristics of Gracie's oeuvre:

> All Miss Fields' pictures seem designed to show a sympathy for the working class and an ability to appeal to the best circles: unemployment can always be wiped out by a sentimental song, industrial unrest calmed by a Victorian ballad, and dividends are made safe for democracy.[27]

Gracie Fields as people's heroine in *Sing as We Go* (1934)

The Lass left Ealing before her mentor, but the Lad outlasted Dean's tenure at the studios. The canny impresario snatched George Formby from under the nose of John Maxwell at Elstree when he was almost reluctantly forced to acknowledge that that the ukulele player had a personality 'that seems to bounce off the screen'.[28] Dean, however, never developed the affection for gormless George that he clearly had for Gracie. 'Like many of the music-hall personalities of that day,' he later wrote, Formby was 'a simple, uncomplicated person of limited talent' with a fixed grin that was 'part of a professional image, not an expression of warmth'.[29] Dean elected to team him with the northern realist writer Walter (*Love on the Dole*) Greenwood and the future Mr Fields, the Italian-American comedy director Monty Banks. The resulting film *No Limit* (1935), shot partly on location at the Isle of Man TT races and on a budget of £30,000, was in Dean's estimation the most financially successful comedy that Ealing ever produced, during or after his tenure.[30] As the audiences rocked with laughter, they were unaware of the fractious atmosphere behind the scenes on this and the follow-up film, *Keep Your Seats, Please* (Monty Banks, 1936), as the personalities of George's wife Beryl and leading lady Florence Desmond clashed violently.[31] By the time Dean departed two years later, George had become Britain's top male star, with an appeal that extended to parts of continental Europe (especially Italy and Spain) and even to the Soviet Union. A dedicated Formby production unit under Anthony Kimmins had been established that would be a major element of continuity between Dean's and Balcon's Ealing.

Few would disagree that the outstanding directorial discovery during Dean's Ealing was Carol Reed, who began his career as an assistant director on *Java Head* (1934), *Sing as We Go*

George Formby on motorbike in the most financially successful comedy that Ealing ever produced, according to Basil Dean: *No Limit* (1935)

and *Lorna Doone*, and who got his first experience of second unit direction on *Autumn Crocus*. After helping Robert Wyler to helm the bohemian romance *It Happened in Paris* (1934), he finally set sail as the captain of the ship with *Midshipman Easy*, appropriately the story of a young man who is suddenly obliged to shoulder considerable responsibility. Reed's ability to do more than keep the boat afloat was immediately recognised by Graham Greene.[32] However, like Margaret Lockwood, he was lost to Ealing after a few films and never had his critical reputation endangered by directing a Fields or Formby picture.[33]

The films of Gracie and George may be the solid backbone of Dean's prewar Ealing, but in numerical terms they constitute less than a quarter of the studio's output. In fact, the majority of films made at Ealing in the period were not even ATP productions. A few of these were prestige pictures with international stars and backing, among them the Ludovico Teoplitz production *The Beloved Vagabond* (Kurt Bernhardt, 1936), starring Maurice Chevalier; and the United Artists-backed *A Woman Alone* (Eugene Fenke, 1936), starring Anna Sten and Henry Wilcoxon. However, the large majority were low- to medium-budget films made by under-capitalised independent producers, such as Hugh Perceval, Sidney Morgan and Bray Wyndham.[34] Most would have been unkindly dubbed 'quota quickies', implying their cultural redundancy, but the technicians at Ealing fully appreciated their importance in ensuring continuity of employment and the development of skills. Sound recordist John Mitchell later confessed that 'Quota quickies did some good in offering a proving ground for many a director or technician whose first chance to gain experience would stand them in good stead for the future.'[35]

In spite of Dean's public condemnation of Hollywood companies' cynical approach to their quota obligations, Fox were allowed to make five 'quickies' at Ealing before establishing their own production facility at Wembley. The volatile Al Parker directed *The Right to Live* (1933), *The Third Clue* (1934) and the ironically titled *Rolling in Money* (1934) – quota quickies never were – the latter described by *Picturegoer* as 'a deafening, devastating and sustained orgy of high-pitched, high-pressure histrionics'.[36] The critical reception of Manning Haynes's *The Perfect Flaw* (1934) was typical: 'Worked out on uninspired lines and only likely to please the uncritical'.[37] The most interesting of the quintet was a Harry Cohen-produced comedy about a penguin's trip to the seaside, inspired by the antics of the lovable Oscar in Radio's *The Penguin Pool Murder* (1932).[38] The British Board of Film Censors issued warnings about showing the penguin's inebriation and objected to the original title, *To Brighton with a Bird*.[39] *To Brighton with Gladys* (George King, 1933) was deemed less suggestive; *Kinematograph Weekly* was charmed by its sense of 'harmless fun' and thought 'it should be guaranteed to liven up any programme'.[40] No longer, unfortunately, as the film is lost, as is the historic film made for MGM at Ealing. Unlike the picture whose title it lampooned, Bernerd Mainwaring's *The Public Life of Henry the Ninth* (1935) was not an 'historical', but it was historic because it was the first film from Hammer, the production company that would become even more internationally famous than Ealing.[41] Its first effort, dashed off in November 1934, featured the popular radio personality, Leonard Henry, as a devotee of the bar room. Its sound recordist, John Mitchell, recalled the furious pace of production:

> The whole film was shot in two weeks, and the Hammer logo with Bombardier Billy Wells (later the famous Rank man with the gong) was filmed one lunch hour. ... The background music for the film was recorded on a Saturday with the film being dubbed and re-recorded on the Sunday, taking twenty-four hours of non-stop work. Total production time to delivery was three weeks in spite of which it was a very successful box office draw with cinema patrons.[42]

Kinematograph Weekly judged it 'quite a useful supporting proposition for popular and industrial halls' that 'does in its modest way fill an hour quite pleasingly'.[43]

The most interesting batch of independent productions, however, was that put together by Bray Wyndham, a figure about whom very little is known. He was briefly active in the film industry between 1933 and 1935, producing a handful of pictures with exploitable themes before vanishing into obscurity. Wyndham is certainly a research project waiting to happen because his trio of films at Ealing have not only survived, but can still entertain and intrigue in their attempts to explore the censorable shores of forbidden territory, and even unintentionally amuse with their para-cinematic ineptitude. We have already seen that Wyndham gave Carol Reed his first opportunity to direct with the third of the Ealing trio *It Happened in Paris*, as racy a study of love between a slumming artist (John Loder) and his model (Nancy Burne) in the Latin Quarter as the BBFC would allow. Like classic American exploitation cinema of the period, the film's promotion promised much more than its content could deliver. The cover of the film's press book was adorned by a photograph of Miss Burne posing in her underwear, and (by way of legitimation) a line drawing of an artist's palette and brushes. The iconography of sexual freedom was less than subtle.

The first of the Wyndham trio had already alerted the attention of the censors when John Quinn's scenario for his thriller *Tiger Bay* (1934) had been submitted. This was particularly incendiary material because the eponymous bay was really Limehouse, a

polyglot district of London's dockland, which had become notorious over the previous two decades as a magnet for dissolute debutantes and flappers in search of an opium den. The BBFC were determined to prevent film-makers profiting from such notoriety, and tried to nip the project in the bud:

> The whole story is an exact replica of the worst type of American gangster films with the scene laid in London, amidst very low and sordid surroundings. The minor characters are drunken sailors and prostitutes of every race and colour. The dialogue savours strongly of American phrases and is not infrequently coarse. I do not consider that a film on these lines would be suitable for exhibition in this country, nor can I suggest any modifications which would make it acceptable.[44]

But Wyndham had already cast the exotic Anna May Wong as his leading lady and was not to be deterred. The Board agreed to his shifting the location to a South American port, removing all drunks, prostitutes and usage of firearms, and the cleansing of the dialogue.[45] Thus a story rooted in (admittedly sensational) social reality was transformed into fantastical and unconvincing fiction. The character Lui Chang (Wong) had real-life referents: Brilliant Chang, Limehouse's most notorious drug trafficker in the 1920s, and Annie Lai, a Limehouse prostitute and drug dealer who recorded a series of oral history interviews in the 1980s.[46] But verisimilitude was no defence as far as the Board was concerned. Six weeks after its scenario was first submitted, the completed film, edited by David Lean, was passed 'A' with only minor deletions. There had clearly been no time to make major alterations to the casting. Hence, the exotic dockside nightclub is run by a manageress who is more Blackpool landlady than Brazilian chatelaine, and terrorised by a gang of Cockney protection racketeers. Perhaps predictably, nobody seemed to notice the strong suggestion of lesbian desire in the way in which Lui Chang relates to Letty (Rene Ray), the girl she had saved from Chinese insurgents. At the end of the film Lui Chang kills the man who has abducted her ward and, faced with jail, commits suicide, declaring, 'Letty could never be happy knowing I was in prison.' But Lui's yearning, empty arms suggest that she cannot be happy knowing that Letty has fallen for Michael (Lawrence Grossmith), the young adventurer who has come to Tiger Bay in search of romance.[47]

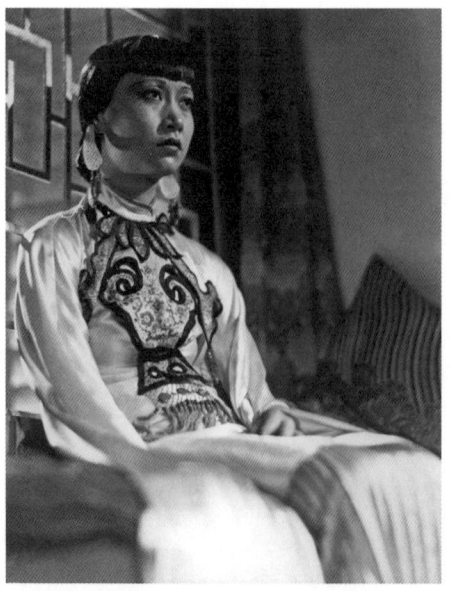

Anna May Wong smoulders in the fantastical fiction of *Tiger Bay* (1934)

Finally, we come to the Loch Ness monster. The middle film of the Wyndham trilogy has become a minor classic of bad film-making as Britain's first attempt to make a monster movie. At the time, RKO's *King Kong* (1933) was creating mayhem at the British box office, and it was inevitable that some opportunistic quota merchant would try his hand at a 'creature feature', undaunted by a miniscule budget for special effects. The irony is that it should be made at Ealing, the studio that had just extricated itself from a damaging association with RKO. Ealing's monster, however, was very British: the mythical denizen of Loch Ness. Made at the end of a series of reported sightings of the beast in 1933–34, *The Secret of the Loch* was both topical and timely in the wake of news of, and cinematic interest in, prehistoric survivals. It was directed by Milton Rosmer, an established

stage and silent screen actor, who went on to much more prestigious directorial assignments with Alexander Korda. Considering that it was also co-scripted by Hitchcock's favourite scenarist, Charles Bennett, and edited by David Lean, the picture really should have been more accomplished.

Monster of the deep: the Loch Ness monster according to *The Secret of the Loch* (1934)

Picturegoer had devoted a whole page to the making of the film, looking forward to the performance of the revered founder of the Aldwych Theatre, Seymour Hicks;[48] but when *The Secret of the Loch* actually surfaced for general release in time for Christmas 1934, it proved a huge disappointment to the magazine.[49] No one associated with the film seems sure if they are making a comedy or a chiller, least of all the director. The performances are often exaggerated to parodic levels, and the characterisation and dialogue never strive for originality when there is a cliché to hand. The gallery of 'types' includes a demented scientist (Hicks), competitive newsmen, a flirtatious barmaid (the debut of Rosamund John), bumbling academics and the inevitable drunken Scotsmen. Connoisseurs of Ed Wood movies might appreciate the comically bad model shots and the final revelation of the secret of the Loch, which turns out to be a back-projected iguana (supposedly underwater). Seymour Hicks gives a performance more monstrous than Nessie's. An exasperated *Film Weekly* reviewer commented, 'It would be kinder to say nothing of the acting. Seymour Hicks ... suffers like the others from the inept treatment of fundamentally weak situations.'[50]

It would be over twenty years before British cinema again dipped its toe into the murky waters of the monster movie. By that time, the studio that gave us a Lad, a Lass and *The Secret of the Loch* had achieved world fame. The irascible and autocratic Basil Dean had long since left the stage, a casualty of the crisis in film finance that surrounded the 1938 Cinematograph Films Act, the distraction of the theatre and loose economic discipline. The adaptation of stage successes that he had championed had been replaced by a faith in the original screenplay; but the defiant belief that success lay in the making of films that would be distinctive in their projection of traits, behaviour and lifestyles that were characteristically English was a legacy that originated with Dean's leadership.

2 INSIDE EALING

THE EVIDENCE OF THE MICHAEL AND AILEEN BALCON COLLECTION

Janet Moat

> The object of the proposed new company is not just to manufacture films for the purpose of employing studio Plant, or for the purpose of filling a distribution organisation, but its object is to foster the manufacture upon sane and economic lines of a limited number of real British films which, in the judgement of the practical personnel associated with the enterprise have proper qualities for successful exploitation and the return of money invested.[1]

This paragraph comes from one of the drafts of a memorandum drawn up by the prospective directors of the company which was to become known throughout the world as Ealing Films. It leaves the reader in no doubt that the main purpose of the 'enterprise' is to make money; the films will be as commercial as possible and made as economically – and 'sanely' – as possible. No wildly over-budget extravaganzas; everything will be accountable. What is especially interesting is the aspiration to make 'real British films', actually embedded in the statement of policy. What did the company directors mean by this? How successful were they and what light does the Michael and Aileen Balcon Archive, held by the BFI, shed on their efforts? Any personal archive will be selective, according to the importance of the component parts for its creator; it will shed light on some areas while leaving others frustratingly in shadow; it may have too much information on some topics and glaring omissions in just those subjects of particular interest to the film historian. All these are true of the Balcon archive, but it contains great riches and opens many windows onto the world in which the producers operated. This chapter will examine what kinds of material exist for the Ealing years in the archive, what themes can be teased out of it and how well it helps us to understand whether or not Balcon was successful in his aims.

The acquisition of the archive began in 1972, following a visit by BFI staff to the Balcon family to discuss a donation of stills. During that visit, staff noticed the plethora of production and business papers stored at the house, and began to negotiate for their acquisition. This was largely completed by the time of Balcon's death in 1977. The documentation covered everything from dope sheets and cross plots to budgets, accounts, casting deliberations, contracts, press cuttings and hundreds of letters and company memoranda, many of which to this day carry the aroma of a thousand cigarettes as they are removed from the files. Balcon was insistent that the archive be named for his wife Aileen as

Aileen and Michael Balcon with BFI director Keith Lucas, signing the donation agreement for the Balcon Papers, 1976

well as himself, to reflect the importance of her support throughout his working life. Within it can be found numerous 'stories', and I shall attempt to flesh out some of these in this chapter.

Balcon takes Charge

The 'Ealing Studios' brand that came into being in 1938 incorporated three pre-existing companies; Associated Talking Pictures, Associated Talking Pictures Studios and Associated British Film Distributors. Michael Balcon, who had successfully run both Gainsborough Studios and Gaumont-British for over a decade, had just spent an unhappy year overseeing production at the UK arm of Metro-Goldwyn-Mayer. Now freed from that contract, he was setting out to produce films again 'on his own account' from July 1938, and he began by renting the ATP studios at Ealing in west London. By the end of that year he had been invited to join the boards of the Ealing group of companies by existing board members Stephen Courtauld and Reginald Baker, and the three companies were merged into 'Ealing Studios' to carry the same name as the studio facility itself.

Balcon inherited two of Britain's biggest box-office stars from the outgoing production chief, Basil Dean: singer, comedian and ukulele player George Formby and the singer/actress Gracie Fields, both from the north of England, who were under contract to ATP. The archives do not tell us what Balcon personally thought of these artistes (although his autobiography indicates that he was not a fan of either), but they do contain contractual agreements with Formby, and documents relating to 'Formby no. 10' and 'Formby no. 11', which indicate,

INSIDE EALING 27

perhaps, how formulaic these films were perceived to be.² As it happened, neither star survived for long under the new regime. Although Formby made five films for Balcon, once war broke out, he became extensively committed to working for the Entertainments National Service Association (ENSA), run by his old boss Basil Dean. We know from other sources that relations between Formby and Balcon became severely strained, and *Turned Out Nice Again* (Marcel Varnel, 1941) would be his final film for Ealing. Meanwhile, Gracie Fields had become seriously ill with cancer in 1939, but upon recovery she too joined Dean at ENSA, before marrying the Italian comic actor and film director Monty Banks and leaving for America.

Balcon, of course, had other pressing problems on hand, chiefly finding ways of keeping British film production afloat with a war on. The failure of the industry to do this during World War I had allowed Hollywood to dominate the British market for the next two decades, and Balcon and his associates were determined that history would not repeat itself. Although the archives are silent on this matter, Balcon petitioned the Ministry of Information with a proposal to rationalise the film industry and create a programme of propaganda films, but the Ministry chose to ignore the plan, leaving Balcon to make Ealing one of only three major prewar studios to continue production, with films supporting the British war effort. And here, the archives attest to his success, with the sheer number of files on twenty-three specific films made at Ealing between 1939 and 1945.

Ealing productions programme for the second half of 1939

Ealing at War

Of particular interest is the focus on original screenplays, rather than existing books and plays, showing the efforts of not only the armed forces but also civilians, and including comedies such as *The Goose Steps Out* (Basil Dearden, 1942) and *Fiddlers Three* (Harry Watt, 1944), starring popular acts Will Hay and Tommy Trinder, respectively. *The Bells Go Down* (Basil Dearden, 1943) celebrated the work of the British Auxiliary Fire Service and the endurance of ordinary Londoners, while *They Came to a City* (Basil Dearden, 1944) looked forward to the kind of postwar world which might be created. There are literary contract files for the likes of Ted Willis, chiefly famous as the co-creator, with Jan Read, of *Dixon of Dock Green*, reviving the character introduced in Ealing's *The Blue Lamp* (Basil Dearden, 1950); Michael Pertwee and his father Roland Pertwee, who both later found fame as television dramatists; the novelist and playwright J. B. Priestley; and the short story writer and critic V. S. Pritchett.

Deliberate attempts were made to appeal to the American market, in the hope that America would be persuaded to enter the war, with such films as *The Proud Valley* (Penrose Tennyson, 1940), *Ships with Wings* (Sergei Nolbandov, 1941) and *San Demetrio, London* (Charles Frend, 1943) showing the courage and determination of Britain and her allies. *Return to Yesterday* (Robert Stevenson, 1940) tells the story of an English actor famous in Hollywood, who has to decide whether to stay on or return to play in a small theatre in England, neatly summarising the dilemma of those ex-pats living in America. One file details the Ealing production programme for 1939, including film costs – and an American-English dictionary.[3] Others feature names like Harry Watt and Cavalcanti, whose experience in the documentary film movement was to have a considerable influence on the films made at the studio. Already, an Ealing 'family' was forming, with some new names replacing veterans like Walter Forde and Robert Stevenson, who had worked with Balcon at Gainsborough and Gaumont-British; a younger generation of film-makers – Charles Frend, Basil Dearden and Charles Crichton, supplemented by Cavalcanti and Watt – were responsible for directing most of Ealing's output at this time.

Balcon's control over every aspect of production seems to have been near absolute; inevitably he had to delegate authority to his trusted team of associate producers and

Extract from an American–English dictionary compiled for the studio

Wardrobe estimate for *The Gaunt Stranger* (working title *The Ringer*, 1938)

department heads, but copies of everything passed his desk, whether casting plans, budgets, set costs, even costume choices, such as the 'estimates of clothes from Messrs Maison Arthur' for *The Gaunt Stranger* (Walter Forde, 1938).[4] This is one reason why the archive is so rich, of course. Balcon's older brother Chandos had been working for him since the early 1930s, and an internal memo to him regarding *The Bells Go Down* gives a good idea of Balcon's engagement with production, as well as his tone of voice:

> My first impression is that one of the main themes has not been properly developed. From the first assembly of our film, the AFS [Auxiliary Fire Service] seems like a kindergarten and it is a miracle that they were capable of doing what they were called upon to do, in view of the fact that they had fooled their time away for twelve months. Some of the fault lies in the playing of Finlay Currie (although not all of it).[5]

The files also show how Balcon kept a careful eye on audience and critical reaction: one *Ships with Wings* file includes several detailed reports on audience reception, while other film files include reviews from the trade press. There was even a radio adaptation of *The Next of Kin* (1942); everything was tried to appeal to the widest audience. The files also show that film premieres continued throughout the war years, keeping some glamour alive (albeit with an invite list swelled by military officers) while demonstrating the importance of what Ealing was doing. The files also highlight the few films being made to appeal to the female audience, despite the enormous contribution that women were making to the war effort, and the paucity of women employed in any meaningful way behind the camera. Screenwriter Diana Morgan was a rare exception: her name appears in several literary contract files but the films were either not made – *A Nightingale is Singing*, *Backstage Story* – or were made after the war, like *Dance Hall* (Charles Crichton, 1950). There are no other mentions of Morgan or these projects, despite her contributions to the screenplays for *Fiddlers Three*, *Ships with Wings* and *Went the Day Well?* (Cavalcanti, 1942).

The war did not stop Balcon from his habitual engagement in the issues facing the British film industry in general, and the smaller independent producer in particular. Between January and August 1944, the files reveal, he was in discussion with the Cinematograph Films Council concerning monopoly in the film industry – that is, the dominance of Rank in production, distribution and exhibition. This was a major issue towards the end of the war and many files in the archive are taken up with it. A thirty-two-page report was presented to the Council by Balcon and his associates at the British Film Producers Association, detailing the indispensable requirements needed for maintaining independent production, such as sufficient studio space for feature film production, finance and distribution, access to both home and overseas markets, and ways of counteracting the influence of Hollywood. Some quotes from the report give a flavour of the prevailing mood of frustration and anxiety: 'A cinematograph film represents something more than a mere commodity to be bartered against others. Already the screen has great influence both politically and culturally over the minds of the people.'[6] This is a theme which recurs throughout the archive, and is clearly something which had great importance for Balcon personally:

> The survival of independent British production is dependent on the Gaumont-British and Odeon circuits, ultimately controlled by a single person (Rank) and on the Controller of the ABC circuit. If these two persons should both decide not to book a film … the picture is almost certain to be a failure and the producer may in consequence be ruined.[7]

Also contributing to the discussion was the British Commonwealth Film Corporation, only six months old when a memo dated 20 January 1944 reported to Balcon on its recent and current activities and future plans. It was signed by Joseph Somlo, an independent producer whom Balcon had first met in 1931, and who had come to work with him in London when his position in Hitler's Germany became untenable:

> The comparative speed of our work [in editing and spotting] is good, but with the present inadequate equipment and the few technicians, it is simply impossible to prepare and deliver the necessary number of films for immediate exhibition in the continental countries … we have to organise our overseas business on such a scale as to be able to compete with the American companies … we have a unique opportunity now, with the quality of British films so greatly improved, and with the most important British Producing Companies united in our Corporation.[8]

In other correspondence, Balcon writes 'with reference to the unrest' and claims that: 'Mr Arthur Rank is on the defensive. Well he may be. The report on the monopoly tendencies by the Films Council committee of enquiry passes judgement on his activities' and 'it is not only in England that resentment is felt against existing film practice … the American tendency is to divorce production and distribution entirely from exhibition'.[9]

Ealing Abroad

Balcon continued to write articles and make public speeches on industry-related subjects throughout the war years, and the fact that he was already looking forward and making plans for production when the war ended is demonstrated by a report and survey on the film industry in Australia and New Zealand, with especial regard to British films, which was compiled by one S. Y. Gresham in 1944.[10]

By 1946, Ealing had leased Pagewood, a studio outside Sydney, and Eric 'Bungy' Williams had been sent out to run it, sending back reports to Balcon in London. After the claustrophobia and privations of the war years, and against a background of continuing rationing in England, Ealing was now intent on diversifying its film programme, and Australia was just the place to set stirring outdoor tales of cattle drovers and gold miners. In 1947, the Royal Empire Society awarded the first Australian Film Trophy to Ealing Studios for for Harry Watt's first antipodean film, *The Overlanders* (1946). Three further Anglo-Australian productions followed, beginning with *Eureka Stockade* (1949), also directed by Watt and co-written by Ralph Smart, who kept Balcon regularly up to date with progress. Watt wrote to Balcon:

> I presume you will be seeing the film in its entirety soon. I hope you will still feel keen about it. The actors have now all left, thank God. They have been a fearful nuisance with their conceits and egocentricities and I have no doubt that they will land on you with numerous complaints.[11]

There speaks the hardened documentary film-maker! Watt reported more generally on 9 January 1946:

> Australia is a very film conscious country. It has always had a desire to make films about itself and in point of fact, more than 60 films have been made. Unfortunately, very few of these have been of any

worth. Very seldom did they realise that the only way to create a national industry is to create a national feeling and atmosphere in their films. That, plus international polish, would enable them to gain an overseas market.[12]

There, in a nutshell, we have the Ealing Studios ethos.

Africa was another exciting foreign location during this period, and from 1951 Watt found himself in Kenya, working on *Where No Vultures Fly* (1951) and its sequel, *West of Zanzibar* (1954). Hal Mason's name now regularly appears in the files; he had joined Ealing during the war years and was progressing from first assistant director through studio manager to finally become production controller and company director. He too found himself in Africa in the early 1950s. Throughout the archive, 'backstage' figures such as Mason, Reginald Baker, Stephen Courtauld and 'Shan' Balcon are brought out of the shadows, their roles at Ealing spotlighted by the numerous memos and letters they exchanged with Balcon. In 1947 Balcon was instructing Mason with regard to the end of Cavalcanti's contract with Ealing. 'Will you please deal with the formalities such as his secretary, office accommodation etc. and find out when he wants to take away his personal possessions.'[13] Cavalcanti's departure hit Balcon hard. The files show they had always had a friendly and informal working relationship, but the Brazilian's manner of leaving seems to have left Balcon feeling a little aggrieved. Balcon wrote to him on 13 February 1947:

> As you know, the company is involved in substantial expenditure on the preparation of subjects planned for your direction. This means that we shall be suffering a considerable loss ... nevertheless, thank you very much indeed for your co-operation whilst we have been working together. It only remains for me to say that had the positions been reversed, I feel I would have handled the termination of these arrangements in a slightly different way.[14]

Balcon's dealings with Courtauld, by contrast, were always businesslike and straightforward, and Courtauld could be forthright in his turn. On 1 April 1947 he wrote, from Argyll:

> Dear Balcon, I now return the notes on the *Scott [of the Antarctic]* film locations. I agree with the observations made and conclusions reached ... I have read the scripts of *Against the Wind* and *It Always Rains on Sunday*. I think they are both good, specially the latter, an interesting and rather moving tale of 'low life' in the East End. The former seems a trifle pedestrian, but no doubt good direction by Crighton [sic] will ginger up the action and suspense. I should like more time to consider the *Saraband*, which on first perusal seems dubious. We saw *Nicholas Nickleby* before we left London, and I am afraid I thought it the worst film we have produced for years; there are criticisms to be made of the photography, lighting and acting (which I suppose boil down to the direction), and also of the script.[15]

At one point, Balcon also intended to make films in South Africa – Reginald Baker was writing to him there in 1948. The tragi-comedy *Another Shore* (Charles Crichton, 1948) was Ealing's first film shot on an Irish location. The same year, back at home, Balcon was contemplating making a film of George du Maurier's hit play *Trilby*, but this never materialised. The files contain many tantalising glimpses of films that might have been, but which were abandoned for one reason or another. In 1943, A. Forsyth Hardy wrote to Cavalcanti concerning one of these, titled *Second City*: 'the film, it seems to me, does not

recapture the spirit of Glasgow today. If it had been made in 1939 it would have been appropriate; but today there is a much more forward-looking mood.'[16]

Ealing's Golden Years

Ealing's films are fascinating for their sheer diversity, and the image of the studio that emerges from its less celebrated works can be surprising. The archive includes files not only on films which have retained a strong reputation, such as *Pink String and Sealing Wax* (Robert Hamer, 1945), *Dead of Night* (Cavalcanti, Charles Crichton, Basil Dearden and Robert Hamer, 1945) and *It Always Rains on Sunday* (Hamer, 1947), but also many which are often overlooked, such as *Cage of Gold* (Dearden, 1950), *Frieda* (Basil Dearden, 1947) and *Dance Hall*. Material for the really famous Ealing films, such as *The Lavender Hill Mob* (Crichton, 1951) and *Passport to Pimlico* (Henry Cornelius, 1949), which are still taught and venerated today, is patchy in the archive, though sometimes represented by correspondence with T. E. B. Clarke, William Rose, Alec Guinness and others. The minutes of the famous weekly production meetings are also frustratingly conspicuous by their absence.

Ealing's output at this time may have been popular in Britain, but across the Atlantic audiences were not so impressed. A 1949 report by Michael Truman, then an editor at the studios, reveals that American filmgoers were impatient with laborious character introduction and scene-setting, found leading actors lacking in sex appeal or glamour, and had difficulty in understanding their speech:

> Americans want to learn centuries of cultural heritage quickly. They have a great appetite for knowledge of other countries and other ways of life. Their interest in English and French books, painting, furniture, fabrics, music and ballet must tell an interesting story in terms of dollars. ... generally speaking, Americans quarrel with the first two reels in most of our pictures. They are impatient by nature. They are used to having their characters introduced in a couple of key lines, one or two tricks and a gag, then finding out more as the story develops.[17]

Much the same could be said of American and British TV drama today.

One film which is well represented in the archive is *Scott of the Antarctic* (Charles Frend, 1948), an unusually large-scale project for Ealing. The fact that so much material still exists in the archive, when, for example, there is hardly anything for *Kind Hearts and Coronets* (Robert Hamer, 1949), demonstrates how important it was to Balcon. Kenneth Tynan, writing in 1956, named it as one of Balcon's three favourite films, the others being *The Captive Heart* (Basil Dearden, 1946) and *The Cruel Sea* (Frend, 1953), all depicting a man's world of action and heroics. Does the paucity of material on the Hamer film indicate something of Balcon's feelings about it? We can only speculate. The Scott files reveal the trying conditions in Norway under which the cast and crew laboured to bring the heroic and tragic story to the screen, and how carefully it was researched. It contains heartfelt letters by John Mills, reporting from Hardanger in Norway in October 1947:

> Conditions here are undoubtedly difficult. The cold is intense working on the Glacier ... Charles [Frend] is doing his best to get as much done as possible in the face of odds. I feel – and please treat this –

confidentially that the organisation could be better. Yesterday we wasted *hours* on top of the Glacier (with good weather conditions for shooting) waiting for things and people that were *missing*.[18]

Balcon replied:

your letter of Sunday came rather as a shock to me. Of course I knew that the unit was facing difficulties. This has been obvious from the telephone conversations, production reports, etc. What does worry me however, is the suggestion that the organisation is not all that it should be. This is something we rather pride ourselves upon at Ealing.[19]

Some files are surprising. It seems that a musical stage version of *The Lavender Hill Mob* was being mooted in 1957, and that Jack Hylton wanted to televise it, but the whole proposal sank under various rights issues and 'because arrangements have already been made for the re-issue of our film'.[20] In the same year there was a complaint by representative of the recently appointed real Bishop of Matabeleland regarding the portrayal of a bishop of that name in *Kind Hearts and Coronets*:

We have to inform you that we have been instructed by the Bishop ... who is very aggrieved and indignant by the portrayal [in the film]. Our client appreciates that there was no Bishop of Matabeleland when the film was produced, but considers it should not have been exhibited in its present form after his appointment in 1953. [He] has endured extreme embarrassment in Southern Rhodesia.[21]

Innovation, Rank and the Last Days of Ealing

The archive shows how forward-looking and innovatory Michael Balcon could be, always searching for initiatives to discover new talent and to give opportunities to new film-makers. One such initiative was the Group production scheme, a new financial policy designed to establish a number of independent producers under the general control of the major studio-owning organisations, on a basis which freed them from financial worry. The objectives of the scheme were set out in a letter dated 1 January 1951 from Lord Reith, as chairman of the National Film Finance Corporation, to Harold Wilson, then President of the Board of Trade. Three companies were to be created, the last of which, Group Three, would enable young and untried producers to make a first feature film. John Grierson was one of the executives in charge.[22] In 1953, Balcon was looking at possible Anglo-Canadian production with a company called Frontier Films, and also proposing a trainee scheme for the studios, with the objective of developing 'top creative personnel':

Our proposal is that we should reach an understanding with the ACT enabling us to engage 8–10 trainees over (say) a three year period. We would engage such people for a probationary period of one year, at the end of which time, if the trainee is found to be unsuitable, his [sic] training would cease; if he is found to be suitable, we would like to have an understanding that he would be given a union ticket.[23]

Throughout the archive for the Ealing years runs a thread – the relationship with the Rank Organisation, with which the studio had a production and distribution agreement for over a decade.

As we have already seen, Rank's monopoly of the British film industry was a cause of concern for Balcon during the war years, and the relationship deteriorated further when accountant John Davis became the managing director in 1948. Davis was an unpopular man in the industry, often harsh in his dealings and antagonising those for whom the creativity of film-making was important. Balcon himself was a businessman above all else, but he often disagreed with what Davis was doing to the industry he loved, and the archive highlights many issues between them, mainly linked to Rank's domination of so many areas, including the British Film Producers Association. At first relations between Balcon and Davis seemed reasonably cordial, as evidenced by the presentation of a gold cigarette case to Balcon on behalf of Rank in 1952, but by 1955, Balcon was filing his correspondence with Davis under the heading of 'matters in dispute', and it is clear that things were getting personal. The two men simply could not see eye to eye, and Balcon came to feel increasingly offended and wrong-footed. Discussing the production programme for 1955, Balcon wrote on 4 November, 1954:

> I thought that the purpose of our conversation on Tuesday night at the Dorchester, was to exchange views rather than to formulate proposals, and I did not leave with the idea that any firm proposals had been made ... at this stage it would be impossible to deal with three specific subjects only, as we have already gone a long way beyond these three subjects and have substantial commitments on other subjects beyond them – for example, a substantial commitment to Benny Hill.[24]

On 9 May, 1955 Davis wrote:

> I appreciate that there are problems in VistaVision, Cinemascope, or any other of the new techniques, but personally I am satisfied that before long, unless they are used by Producers, the films which are not made with the aid of a new technique will be at a serious disadvantage at the box office to those which are.[25]

When Balcon subsequently pointed out that a commitment to these new technologies would have financial implications for Ealing, Davis interpreted this as a 'lack of interest' on Balcon's part. By June, Davis was writing:

> Thank you for your letter of the 10th instant. I am not going to answer it because the situation seems to hinge on this statement '... nearly always brings a form of reply which is wounding'. It is not my intention to wound you in any way and I am sorry that frank letters create such a view in your mind, so I will say nothing, but if you look at the correspondence again, I think you will see, being a fair-minded person, that there is my point of view in this matter, as well as your own. Such correspondence is wounding to me also.[26]

Rank's John Davis

The files detailing the last years of Ealing Studios are dominated by financial concerns, changes and upheavals. Balcon resigned from the board of the Rank Organisation, and the archive documents the meetings of Ealing's own board, weekly cost reports, production programme costs, studio

overheads breakdowns, financial restructuring plans and the repayment of the National Film Finance Corporation's loan to the studio. During 1954 and 1955, Balcon terminated Ealing's distribution and finance arrangement with Rank, and the studios were sold to the BBC in 1955 – the archive includes the catalogue of the auction. But it was not quite yet the end of Ealing Films. Balcon and Reginald Baker signed a production contract with MGM and, during the next three years, six films were produced at Borehamwood Studios, including *Dunkirk* (Leslie Norman, 1958) and the ill-fated *The Scapegoat* (Robert Hamer, 1958) both well documented (though *The Scapegoat* was not ultimately released by Ealing). And Balcon continued his policy of employing bright young men, engaging Kenneth Tynan as a script advisor from 1956 to 1958 (see Charles Barr's chapter in this collection). In 1955, Tynan had written an article about Ealing for the American magazine *Harper's*; it had clearly appealed to Balcon, who kept it on file. In it Tynan writes that it was no accident that films like *The Lavender Hill Mob* and *Kind Hearts and Coronets* came out of the same studio, as Sir Michael Balcon had made them all: 'if you praise Ealing, you are really praising Balcon. [Its] prejudices are his prejudices, its flaws and fine points are his writ large.'[27]

The archive records several intriguing projects with which Tynan was involved during this time, including possible vehicles for Ingrid Bergman, and by the time he left Ealing, Tynan was recommending a meeting with Nigel Kneale, of *Quatermass* fame. Balcon sometimes had to curb Tynan's enthusiasm:

> In my absence you must dovetail your conversations with Hal Mason because it must be remembered that we are unlikely to make more than three or four pictures in the next calendar year, and therefore there must be particular emphasis on the absorption of our own directors and other contractual commitments. *The Scapegoat* is a problem in itself.[28]

The files for this period also include a letter to Balcon in 1958 from one Kenneth Russell, seeking advice on how to make the transition from 'despised amateur' to professional film-maker.[29]

Ealing Films effectively ceased operations in 1958 and, that December, Balcon personally sent out farewells to all the staff, including those who were working on the final Ealing picture, *The Siege of Pinchgut* (1959), being made by stalwart Harry Watt in Australia. Balcon alludes to plans for productions he is trying to formulate 'in the remaining active years left to me',[30] and expresses his hope of working with the recipients again in the future. Hal Mason, as director and general manager of the studios, sent out his own letters to staff:

> I am writing to inform you that with the completion of our current production *The Siege of Pinchgut* our production programme as operated heretofore, will come to an end. Consequently, over the next few months, it will be necessary for us to terminate the employment of almost the whole of our staff. Many members ... have of course, long periods of service with the Company and consideration is being given to each individual in this regard.[31]

Michael Balcon

Conclusion

What kind of man is revealed by the Balcon archive? Someone who took his role very seriously – in his notes for a speech at a dinner marking his first twenty-five years in the industry, in 1947, he assessed the vital role of cinema in moulding public opinion, habits and character, and alluded to the social and national responsibility of the producer.[32] The archive

reveals the iron control which he exercised over all of the studios with which he was involved, and a workload which more than once caused him bouts of ill-health and nervous collapse.

The archive is full of speeches and articles in which he describes his role and his work. In 1952 he wrote an article, intended for circulation to either Rank America or Canada, describing the British approach to film production, as demonstrated by one of his favourite films, *The Cruel Sea*:

> If we could make successful Hollywood-type movies, we would not only be able to regain command at home, but compete also in the rich American market. This is a fallacy, that dies hard. It seemed to me that as long as we were imitators, we would rightly be considered second-best. If we wanted to succeed, we must do so in our own right, by offering films that were genuinely British, that no-one else could make. I therefore set out to build up at Ealing a group of young filmmakers who were 'native' and whose work was 'native'. The war gave a tremendous stimulus to this school.[33]

Like much of Balcon's speechifying, this has an almost Churchillian ring to its cadences.

In 1951, he took part in a programme in the BBC television series *Speaking Personally*, a transcription of which survives in the archive. In it, Balcon describes his work as a producer and the team at Ealing:

> I've been described, as you heard, as a film producer. I must apologise if I don't fit in with your conception of one. I loathe cigars, I haven't got a swimming pool, I have only been married once, I never make a snap decision, in fact, I am a mass of indecisions. I am a sort of conveyor-belt or clearing house, coping with the problems of films in embryo, films in the making, films finished – casting departments, production departments, temperamental stars, eccentric directors, egocentric writers.[34]

The archive is the personal archive of one individual, and it inevitably ranges across all of the many areas which interested him, and all of the institutions and personalities with which he was involved throughout his life. The Ealing years are only one part of it, but they are very substantially represented, and shed a great deal of light on production there under Balcon's management, as well as offering some occasionally surprising glimpses of Balcon the man.

3 PEN TENNYSON
BALCON'S GOLDEN BOY

Martin Carter

Penrose Tennyson had a brief but busy career at Ealing. Between 1939 and 1940 he directed three features: *There Ain't No Justice* (1939), *The Proud Valley* (1940) and *Convoy* (1940). All three have been overshadowed by more celebrated films made during British cinema's golden age of the 1940s; however, Charles Barr recognised the debt owed to Tennyson by British cinema in general and Ealing Studios in particular, judging him 'the most influential director in laying the foundations for what Ealing was to become'.[1] Tennyson had a uniquely close relationship with Michael Balcon that allowed him to move through the ranks of the British film industry with consummate ease during the 1930s, and, had he lived, he had the potential to have become one of the most influential British film-makers of his time.

Tennyson had an illustrious ancestry; his great-grandfather was Alfred Lord Tennyson, Victorian England's most famous poet laureate. The Tennysons did not regard themselves as well-off: 'upper-middle class, not high earners but comfortable'[2] was how their youngest son Hallam described their situation. But the family had a London home on Chelsea's Cheyne Row and a succession of country homes in Surrey, Oxfordshire and Suffolk, where their circle of friends included politicians, nobility and various captains of industry; Pen's father, Charles Tennyson, was for several years the director of the Federation of British Industries. A conventional route through prep schools and Eton led the young Pen to Balliol College in Oxford, but there a combination of ennui and sloth hindered his studies. Academia never suited him and although he had been, according to his father, 'the most attractive man of his generation at university', he found Balliol 'unable to stimulate his ambitions'.[3] He neglected his studies in favour of boxing for the University and attending debates at the Labour Club. His greatest passion was the cinema, and at Oxford he could take advantage of the University Film Society, and a repertory cinema as well as numerous theatres showing more popular fare. He secured himself a post as a film reviewer for the Oxford student magazine *The Isis*, which allowed him free entry to all the town's cinemas, though he delivered just four reviews during his two terms at Oxford. Even so, around the spring of 1932 he implored his parents to use their contacts to find him a position in the film industry. His mother duly had lunch with C. M. Woolf (the most powerful film distributor at the time), while his father got in touch with Michael Balcon (with whom he had collaborated on

drawing up the 1927 Cinematographic Act) and within weeks Tennyson had left Oxford to begin work at the Gaumont-British studios at Shepherds Bush.

Balcon would be crucial to the progress of Tennyson's career from then on. He took the nineteen-year-old under his wing, developing a closeness that he later described as 'second only to that with my own son'.[4] Over the next six years he would take his protégé with him as he moved from Gaumont-British to MGM and, finally, to Ealing. Tennyson would avoid the path of cheap 'quota quickie' productions trod by other talented newcomers such as Michael Powell; instead, under Balcon's guidance, he would serve a privileged apprenticeship on some of the most prestigious British productions of the 1930s. His first proper job at Gaumont was as a third assistant director on Victor Saville's lavish adaptation of Priestley's *The Good Companions* in 1933. As well as the normal mundane jobs on the production, Tennyson also managed to shoot some second-unit exterior footage, and on the strength of this went on to make two short travelogue films. Pleased with his progress, Balcon decided to reward him in 1934 by assigning him to Alfred Hitchcock's unit for *The Man Who Knew Too Much*. Tennyson was in very esteemed company; among Hitchcock's regular collaborators were scriptwriter Charles Bennett, editor Charles Frend, art director Alfred Junge and cameraman Bernard Knowles. It was *The Man Who Knew Too Much* that established Hitchcock as a genre specialist and set him on the path to Hollywood, but Tennyson's relationship with the director did not start well: Hitchcock ordered him off the set of on his first day, complaining that the boy was quite useless, and reluctantly agreed to take him back only after much cajoling and arm-twisting from Balcon. Evidently he eventually found favour, since he remained with Hitchcock (though uncredited) for his next four films

Few books on Hitchcock mention Tennyson, but there are several production stills from *The 39 Steps* (1935) and *Sabotage* (1936) that show the two working side by side on set. One story that does survive tells of Hitchcock, during filming of *The 39 Steps*, obliging his young assistant to double for Madeleine Carroll in the chase sequences across the Scottish moors. Tennyson was apparently done up in a skirt, stockings, high heels and a blonde wig, and then towed across the studio by Robert Donat.[5] Regardless of the occasional indignity, working with Hitchcock gave Tennyson a front-row view of some of the most innovative film techniques in Britain in the 1930s. Tennyson's last film with Hitchcock was *Young and Innocent* (1937), on which he began his romance with his future wife, Nova Pilbeam. But Balcon left Gaumont-British at the end of 1936 to head-up production for MGM British Studios, and, soon after arriving at the studio, gave Tennyson a job as assistant director to King Vidor on the adaptation of A. J. Cronin's *The Citadel* (1938). The film was a significant milestone for Tennyson, and was also the first time he was credited on-screen as 'Pen Tennyson'. But Balcon's tenure at MGM was to be shortlived; after a frustrating year of fighting against his bosses across the Atlantic, he took up a position at Associated Talking Pictures, ultimately emerging as head of production of the newly constituted Ealing Studios. One of his first moves was to recruit Tennyson and offer him the opportunity to direct his first feature.

Pen Tennyson (left), photographed a year before his tragic early death

As he took the helm of *There Ain't No Justice* in 1938, Tennyson became, at the age of twenty-six, Britain's youngest feature film director (Hitchcock was the same age when he directed *The Pleasure Garden* in 1925). A low-budget drama based on a novel by James Curtis, writer of a number of popular crime novels set in the London underworld, *There Ain't No Justice* tells the story of a young boxer, Tommy Mutch (Jimmy Hanley), keen to make a name for himself in the fight game. To please the censors the film had to sanitise much of the book's sex, violence and bad language, and to excise a major plotline that hinged on Tommy taking a dive to fund an abortion for his sister Elsie; the script adaptation (by Tennyson and Curtis) has him instead needing to pay off some debts. The violent and bitter tone of the book was softened into a domestic family drama that provided a far cosier view of the boxing game, its fighters and its promoters. Even so, the film, set against a background of working-class life in Notting Hill, was welcomed by many reviewers as a true slice of 'cockney life'. Although a little imprecise in its location of London's cockney community, the film can be seen as the start of Ealing's on-screen mapping out of London, a process that would continue throughout the next twenty years in such films as *Hue and Cry* (1947), *It Always Rains On Sunday* (1947), *Passport to Pimlico* (1949), *The Lavender Hill Mob* (1951), *Pool of London* (1951) and *The Ladykillers* (1955).

The Notting Hill of *There Ain't No Justice* is, unlike today, an area of deprivation and poverty; a place where, as Tommy puts it, 'There isn't room to breathe.' In contrast, we get a glimpse across the Thames at the leafier avenues of Putney, where Tommy dreams of living once he has made his fortune as a boxer. Thus, Tennyson gives us a vibrant picture of working-class life in a specific (and actual) part of the nation's capital. Unlike later Ealing films set in London, there is little location shooting and Notting Hill is almost entirely created in the studio, save for a few establishing shots at the start of the film. The rest takes place inside homes, gyms, cafés and boxing halls, with its few later exterior scenes also being shot on studio sound stages. That said, the film remains groundbreaking. Up until this time British feature films rarely delved into the lives of the working classes for any serious dramatic purpose. Tennyson's film is set entirely in a working-class community and does without any members of the middle or upper classes to provide an example to the lower orders. The film's publicity made much of this, declaring it 'The Film That Begs To Differ' and 'A picture of REAL people with NEW people for ALL people', foregrounding its cast of mostly young and little-known actors that included Michael Wilding, Jill Furse and Phylis Stanley. Its depiction of working-class life aims for (and achieves) a level of verisimilitude absent from most British films of the time. This allows a fully rounded and somewhat surprising portrait of the Mutch family; as shown when we realise that Tommy and Elsie are not the only offspring of Ma and Pa Mutch (Mary Clare and Edward Chapman), but that baby Lily of the Mutch household is in fact their sister, evidencing a healthy sex life for the middle-aged Mutch parents.

But *There Ain't No Justice* was not alone in presenting a new perspective on British life; nor was it the only adaptation of a James Curtis novel to go before the cameras that year. Arthur Woods's *They Drive by Night*, made for Warner Bros. First National, paints a far less cosy picture of life among London's working classes. Although it also had to soften its source material, the film's portrait of petty criminals, prostitutes and long-distance lorry driving is far bleaker than Tennyson's domestic drama. Woods's film is far more faithful, too, to the sleazy underworld of Curtis's fiction. Its story of Emlyn Williams's 'Shorty' Matthews, fresh out of prison but on the run for a murder he has not committed, allows its audience rare

Ealing's true slice of cockney life: Jimmy Hanley as the boxer Tommy Mulch in *There Ain't No Justice* (1939)

entry into the nocturnal world of roadside cafés and drab *palais de danse* on the trunk roads of 1930s Britain.

Tennyson's film has little in the way of stylistic flourish, but it is a solidly directed piece. It does, however, resolve itself with a neat personal touch. The film ends with a knockout victory for Tommy and a crowd invasion of the ring; Tommy's girlfriend Connie attempts to revive him after the exhausting bout he has just fought, but to no avail. She is advised to twist his ears to bring him round; a procedure that works immediately. This is exactly how Nova Pilbeam revives Derrick De Mornay after he has fainted in *Young and Innocent*; a trick that Pilbeam's character then goes on to reveal she picked up 'in a boxer's dressing-room'. This acknowledgment to both Hitchcock and his fiancée provided Tennyson with an elegant ending for his first film.

Although only a supporting feature, *There Ain't No Justice* secured a limited West End run at the Paramount Theatre in Tottenham Court Road before going on general release, and garnered a number of glowing reviews. The *Monthly Film Bulletin* declared it 'an extraordinarily vital and accurate picture of everyday working-class life as it is lived, not as it is imagined'.[6] But a dissenting opinion was voiced by Graham Greene in *The Spectator*:

> *There Ain't No Justice* is intended to be an English tough film, but somebody's nerve failed – and the rather winsome personality of Mr Jimmy Hanley. The etceteras – setting of bar rooms and coffee stalls – are admirable, but the whole picture breathes timidity and refinement.[7]

But Balcon's faith in Tennyson had been rewarded, and his future as a director was assured. His next assignment, *The Proud Valley* had a bigger budget and featured an established star, Paul Robeson. It is perhaps Tennyson's best-remembered film, but also his most compromised. The original script, based on treatments by Herbert Marshall and Alfredda Brilliant of the left-wing Unity Theatre group, was adapted by Tennyson as a scathing attack on conditions in the South Wales coalfields. Its intended title was *One in Five*, a reflection of the serious injury rate among miners, and the original script had a mining community seizing a closed pit back from unscrupulous owners and reopening it as a worker's cooperative. Such a storyline would always have been a difficult proposition, but, as Balcon later commented, it was 'obviously neither tactful nor helpful propaganda when the country is at war'.[8] The script was therefore emasculated, with the laid-off miners now joining forces with the mine-owners to make a near suicidal attempt to reopen the pit and support the war effort. The film remains, like *There Ain't No Justice*, a study of a working-class community, although with the presence of Paul Robeson as the resonantly named itinerant Black American, David Goliath, race is added to the mix. But Robeson's colour is much less of an issue than in the actor's earlier British pictures such as *Song of Freedom* (1936) or *Jericho* (1937); only once, during an argument between miners on whether David should be living in the village and allowed to join the colliery choir, is it directly tackled. The film defuses the conflict by having choirmaster (Edward Chapman) observe, 'Why damn and blast it, aren't we all black down that pit?'

The film was dogged by production problems. The premise and continual script revisions were known to mine-owners, and no cooperation was forthcoming from any Welsh pits for location shooting. As with *There Ain't No Justice*, the film's settings were created almost entirely in the studio, but *Proud Valley* presented a community very different to that of the earlier film. The pit-village of Blaendy is a world within itself, a close-knit community with little need to go outside its borders for anything. Not that the film depicts the miners as insular or lacking in ambition. The film gives a far more progressive representation of a Welsh mining community than the one offered up in King Vidor's *The Citadel* (with Tennyson as assistant director), which painted most miners as superstitious malingerers who gossiped and schemed against anyone from outside the village. Blaendy's villagers are resilient, supportive and willing to fight for themselves (their march to London is seen as an action taken to save the entire village and its pit by those best able to do so). The cohesion of the community through song is a recurring motif running throughout: Robeson's introduction to the village is marked by his singing in the street in accompaniment to the choir, the importance of the Eisteddfod in the village culture is highlighted and the film's signature song 'They Can't Stop Us Singing' is used at several rousing moments. The image of a tight-knit community binding together to overcome a shared problem would become a key Ealing motif.

The film began shooting on 23 August 1939, little more than a week before the outbreak of war, which led to some cast and crew members being lost in the call-up. More trouble would follow after the film completed shooting. Robeson left Britain well satisfied, feeling he had at last made a film worthy of his talents. However, after a difficult sea voyage back to

'They Can't Stop Us Singing': the miners begin their march to London; risking their lives in an effort to reopen the pit in *The Proud Valley* (1940)

New York he disembarked and made an angry speech to reporters defending the recently signed Nazi–Soviet pact and accusing Britain and France of having been appeasers. In Britain, an incensed Lord Beaverbrook, owner of the *Express* and *London Evening News*, readied a campaign against Robeson and his forthcoming 'socialist' film. Balcon made overtures to placate the press baron, but, although the smear campaign did not materialise, *The Proud Valley* was ignored in the Beaverbrook press and Robeson put on an unofficial blacklist. The film nevertheless garnered a clutch of excellent reviews, elsewhere, although Graham Greene (again) pointedly observed in *The Spectator* that 'colour prejudice is dragged in for the sake of Mr Paul Robeson who plays the part of a big black Pollyanna, keeping everybody cheerful and dying at the end'.[9]

After the film's completion, Tennyson married his fiancée Nova Pilbeam (by then one of British cinema's leading actresses) and, following a short honeymoon, returned to Ealing to commence work on his next film. *Convoy* would be the first example of what Balcon hoped British cinema would provide for its audience: a combination of entertainment and realism that reflected the actual lives of the British public. In a speech entitled 'Realism or Tinsel', given in 1943 to the Film Workers Association in Brighton (and later published in 1944 as a pamphlet), Balcon articulated the two poles between which British cinema exists and made specific reference to *Convoy* as being the first attempt by Ealing to create a 'balance between the strictly documentary and the story elements'.[10] It is significant that Balcon entrusted the first of these films to his studio's youngest film-maker.

Convoy was Ealing's first attempt to represent events of the ongoing conflict and the film reflects the fact that, for British forces, little direct combat had taken place on land by early 1940. The incident that had most captured the imagination of the British public had been the Battle of the River Plate in December 1939, when the Royal Navy had engaged the German pocket battleship *Graf Spee* outside Montevideo; the action resulted in the Germans scuttling the pride of their fleet and her captain committing suicide. Capitalising on this event, Tennyson's film is the story of a destroyer, HMS *Apollo*, escorting a convoy of merchant vessels in the North Sea and warding off attacks from German U-boats and a pocket battleship.

Despite Balcon's claims, *Convoy* is perhaps more a film of transition than a fully formed 'new type of film'. It is the first British combat film of a war which, in early 1940, was still in its 'Phoney War' stage; France had not yet fallen and the traumas of Dunkirk and the Blitz were still to come. The enemy in *Convoy* is clearly Germany but the film makes an explicit distinction between Germans and Nazis, as demonstrated very early on in the film when a British rating offers a tot of rum to a group of captured German sailors; one of them, an officer, refuses the grog – which is gratefully accepted by his fellow crew members – and instead performs a Hitler salute before being led away. The scene presents a moment of bonding between the British and German sailors – the working classes of both nations – of a kind that would soon be seen as inappropriate; by the end of 1940 Britain would stand alone and on a total war footing, and sympathy for the enemy was an unaffordable luxury.

Convoy's scenes below decks with the ratings have a genuine empathy and sense of communal spirit that provide an embryonic template for the British war films that would come. In the officers' mess, by contrast, hierarchy is strictly observed. The officers are exclusively upper class, and there is no hint of the more democratic relations between ranks of Ealing war films to follow. The film's claim to realism is somewhat hamstrung by an extremely contrived love triangle between the ship's captain (Clive Brook), his estranged wife (Judy Campbell) and her former lover (John Clements), who has been assigned to the *Apollo*. This melodramatic relationship takes up too much of the film's running time and, in the end, elevates individual heroism above collective endeavour, without delivering much in the way of emotional payoff. These are mistakes that Ealing will ultimately take steps to eliminate.

For all its faults, we can clearly trace in *Convoy* the approach and structure put to more effective use in *In Which We Serve* (1942), although Lean and Coward's film far more successfully integrated the social classes and ranks as a united national force, reflecting the far more serious reverses Britain had suffered by 1942. The need for the nation to overcome its divisions and bind together against a common enemy does eventually come through in *Convoy* but it is hampered by the class-bound narrative conventions of the previous decade. Balcon's desire to meld together something of the ethos of the British Documentary Movement with feature film production are tried out for the first time here, and, although there is still much to develop, *Convoy* showed that the British public was ready to respond to films dealing with the war and its consequences. The film was a huge critical and box-office success, becoming the top-grossing British film of 1940.

Nevertheless, Tennyson had already told Balcon that he intended to join the forces immediately after the film's release and, in August 1940, he took up a naval commission as Sub-Lt F. Penrose Tennyson. After an initial stint on board an anti-submarine vessel, he was assigned the job of running the Admirality's Instructional Film Unit. He accepted the position and launched himself into the task of bringing the unit's technical facilities and practices up to date. Balcon wanted him to negotiate leave in order to direct another feature at Ealing, but Tennyson was focused on getting the Navy's film unit going. In fact, his views on how film should be produced in Britain began to differ quite radically from those of his mentor. In the Winter 1940 issue of *Sight & Sound*, Balcon argued against any government control of the film industry.[11] A few months later, Tennyson wrote a piece for the July/August 1941 edition of *Cine-Technician* advocating the complete nationalisation of the industry in order to free it of purely commercial imperatives.[12] Such disagreements, though,

did nothing to lessen the bond between the two men. In one of his last letters to Balcon, in June 1941, Tennyson reiterated his feelings for the profession they both worked in: 'my head, feet and hands are kept pretty busy by the Navy, but my heart is undoubtedly still in the movies'.[13] Tennyson was obviously intent on returning to Ealing and directing feature films once the war was over. However, on 10 August 1941, returning to Rosyth from Scapa Flo where he had been shooting footage for Admiralty films, his plane crashed in bad weather with no survivors. He was twenty-eight years old.

His short career was acknowledged for a decade or so after his death. Dilys Powell wrote, in 1948, that, although his films might not stand the test of time, within them were 'the germs of a new movement in British Cinema; the movement towards concentration on the native subject, the move towards documentary truth within the entertainment film'.[14] All three of his films at Ealing are compromised and none could be regarded as a complete success, let alone a masterpiece. But the potential that he might have fulfilled is immense, and the films, taken together, were the first to identify the path which Ealing would travel. It would take nearly two years and the injection of new documentary blood to get Ealing back on that path; it is striking how far the studio's next war film, *Ships with Wings* (1941), directed by Tennyson's regular associate producer Sergei Nolbandov, repeated *Convoy*'s mistakes (comically inept Nazis, romantically heroic officers) while neglecting most of its advances. Had Tennyson lived, Ealing might have reached its destination earlier. Certainly, he would have fitted comfortably into the postwar Ealing environment of predominately Labour-leaning directors and technicians, and he would have shared the dream of a classless Britain that briefly seemed possible at the end of the war.

Tennyson's death had an immense effect on Balcon and in the following years he would often express how greatly he felt the loss both in personal terms and in regards to the British film industry. In 1942 Balcon contributed to *Went the Day Well*, a collection of essays commemorating a range of young, promising lives that had been lost in the war. Balcon's piece was, inevitably, on Penrose Tennyson, and it is a fitting way to end this brief study of Tennyson's career:

> There was ... a poetic quality inherent in Tennyson which sought expression in this new medium of films; I believe by his death British films have lost a craftsman whose achievements were already great and whose promise was greater. To the sense of personal loss which all of us feel who worked with him and loved him must be added the loss by an industry to which he was devoted and to which he contributed so generously in so short a space of time.[15]

4 THE PEOPLE'S WAR

THE MAKING OF EALING

Andrew Roberts

> The air raid warden and the shop steward were men of destiny, for without their ungrudging support for the war it might be lost; morale might be in danger.[1]

If there is a popular composite idea of an Ealing film, it's a story in which a mixed group of (more or less) ordinary individuals come together, with determination and good humour, to defend themselves against a more powerful external force. Like so much about Ealing, it's an image that was formed during the early years of World War II. Ealing's wartime output crystalised both the studio's self-image and its public reputation as a maker of films celebrating the power of community – and by extension Britain – to withstand an external threat, whatever form that might take.

Through an increasing adoption of a realist aesthetic which sought to promote national unity, Ealing became a key element in the promotion of the 'people's war' ideal. But the disparate elements of its archetypal war narratives took some time to develop. In 1940, Ealing was engaged in the production of a number of short propaganda films for the Ministry of Information, notably three films directed by John Paddy Carstairs for the MOI's 'Careless Talk Costs Lives' campaign.[2] In the same year the studio released its first two features directly connected with the war, *Convoy* and *Let George Do It!*. *Convoy*, directed by Penrose Tennyson, was the most popular British film of that year and a considerable critical success, selected as the *Documentary News Letter*'s film of the month for August 1940 and praised in the *Daily Mirror* as 'A magnificent spectacular and thrilling entertainment and wonderful publicity for the boys who sail the seas.'[3]

However, the dominant figures of *Convoy* are not so much the ordinary 'boys who sail the seas' as Clive Brook's patrician captain and his first officer and love rival (John Clements). For all that both *Convoy* and the following year's *Ships with Wings* (Sergei Nolbandov, 1941) devoted sympathetic screen time to the ordinary seamen, the effect of their plots was to reinvigorate the officer caste, with the unfortunate result in *Ships with Wings* that victory appears to be in the hands of overgrown sixth formers who could have strayed from the pages of a *Boy's Own* story. In *Ships with Wings*, Lieutenant Stacey (Clements again) takes his girlfriend's younger brother on a test flight in an unsafe aeroplane. The inevitable result is the lad's tragic death and so, cashiered and in shame for

his caddishness, Stacey exiles himself to a remote Greek island. He redeems himself by beating up sundry Nazi agents, rejoining the Navy and ultimately protecting the fleet at the cost of his own life. It's a story of individual heroism reminiscent of Korda's Empire epic *The Four Feathers* (1939), another film starring, yes, John Clements.

In sharp contrast, we have Marcel Varnel's *Let George Do It!*, whose narrative depends, like that of *Ships with Wings*, on the actions of an individual to impact for the greater good. But George Formby's persona is far closer to the template of the 'people as hero' than is Clements's. George is cheerful and resourceful, and never resorts to any form of self-pity. In *Convoy* and *Ships with Wings*, the audience is being exhorted to unify for the national good under upper-crust heroes who are prone to going it alone with their fists while offering such utterances as 'Get up, you filthy Hun, I want to hit you again!'. But Formby's working-class everyman manages to triumph over Garry Marsh's suave Nazi agent with none of the same over-privileged swagger.

The most famous sequence of *Let George Do It!* has George dreaming of flying into the Nuremberg Rally on a celestial baker's tray to beat up Hitler. But this moment is little more fantastical than the West End theatrical vision of service life in *Ships with Wings*. However, while the film critic of *The Spectator* went so far as to call *Let George Do It!* 'a manifestation of that social quality which in no small measure we are fighting to defend',[4] there was considerable evidence to suggest that, for audiences, Formby's popularity as a comedian trumped the plot's topicality.[5] Indeed, the success of all of Formby's wartime films cannot be divorced from the resourcefulness shown by his screen characters and the knowledge that the comedian himself worked tirelessly for wartime causes. Robert Murphy has claimed that:

> The ease with which George exposed traitors, unmasked spies, and prevented saboteurs from doing their dirty work in *Let George Do It* and *Spare A Copper* could be laughed at rather than sneered at by audiences who knew that their comic hero was sharing with them the real dangers of war.[6]

The logical development was to incorporate the comic hero within a group ethos, and after Formby left Ealing for Columbia-British in 1941 the studio's subsequent principal comedians had very different screen personae. The image of Will Hay from his radio and music-hall appearances was that of a seedy pedagogue, shifty, unsentimental and opportunistic. If his failed teachers, who delighted in their very dubious academic credentials, succeeded in defeating Nazis, as in Varnel's *The Ghost of St Michaels* (1941), and *The Black Sheep of Whitehall* and *The Goose Steps Out* (both Dearden/Hay 1942), it was more through pretence, bluster and opportunity than Formby's good-natured determination. Tommy Trinder also came with an established variety persona, that of a fast-talking Cockney, but although *Sailor's Three* (1940) saw the director Walter Forde exploiting Trinder's brash stage self, this took the form of an elongated variety sketch. Trinder's subsequent roles in Ealing's war films were as a character actor (albeit a wisecracking Cockney one) in two films that marked a genuine change in how the studio portrayed the conflict.

Ealing's change of approach was far from instantaneous. Balcon claimed in his memoirs that a turning point was *Ships with Wings*, a film that 'had its defects but considering the difficulties of production it was a considerable achievement'.[7] The film had substantial commercial success, but the critical response was decidedly mixed: the *Daily Telegraph*

referred to its 'wildly tiresome melodrama superimposed on a story that did not need it'.[8] Balcon paid particular attention to the negative comments of Noel Monks, a war correspondent for the *Daily Mail* who questioned the film's unconvincing depiction of war. Monks's criticism appears to have prompted a rethinking of Ealing's treatment of the conflict, with the studio subsequently aiming for greater realism in its productions. After talking to Monks, Balcon claimed that he became 'personally convinced that the approach must be realistic'; *Ships with Wings* would be 'the last film that could attract this particular type of criticism, because from then on we learned to snatch our stories from the headlines and they had the ring of truth'.[9]

But the means of portraying a realistic vision of wartime heroism was as important as the subject matter. Charles Frend's *The Big Blockade* (1942) offered the audience not so much a plausible storyline as an extended travelogue in which a narrator lectured them, in patronisingly jocular fashion, of the workings of the newly formed Ministry for Economic Warfare. The assumption seems to have been that, by listening attentively to the velvet tones of authority, the people of England could be made wise to the machinations of Robert Morley-shaped Nazis. But this approach was far less effective than feature films that combined a documentary concern for verisimilitude with storylines presenting diverse individuals working within the team for the common good. Four films – *The Foreman Went to France* (1942), *Nine Men* (1943), *The Bells Go Down* (1943) and *San Demetrio, London* (1943) – provided the template for much of Ealing's postwar work in both their depiction of wartime heroism and their ambition towards greater realism.

All of these productions aspired to as great an authenticity as commercial imperatives and straitened circumstances would allow – Harry Watt's *Nine Men* recreated the desert campaign on a Welsh beach on a budget of £20,000. Watt had arrived at Ealing from the Crown Film Unit to join his former GPO colleague Alberto Cavalcanti, and both men were vital in shaping the studio's new documentary-style approach. *The Foreman Went to France*, directed by Charles Frend, recreated France in Cornwall and was the first of Ealing's stories to be 'snatched from the headlines'. Progress reports in the trade press for Basil Dearden's *The Bells Go Down* noted the attention to detail of the art direction, with endorsements from the local fire chief. In each of these films the story, rather than the leading players, was the main attraction – in Frend's *San Demetrio, London* the eponymous ship is the star – and each established a firm sense of community within the opening reel, whether in terms of sense of place or enforced bonding.

Teamwork in these films beats dependence on any single individual. In *The Foreman Went to France* works manager Fred Garrick (Clifford Evans) assumes a kind of leadership over his group of orphaned children and displaced servicemen. Garrick is established almost from the outset as a dynamic, intelligent and strong-willed individual, who bravely and wisely defies his bosses and embarks on a solo cross-channel mission to rescue from the advancing Nazis vital military machines on loan to a French factory. Yet several times he almost fatally undermines his own mission thanks to his unquestioning trust of authority figures, almost all of whom turn out to be Nazi collaborators; each time, fortunately, his error is corrected by one of his associates. In *Nine Men* the story is related in flashback by a platoon sergeant, who stresses the contribution of each of his men and recounts their respective backgrounds before the war. In *The Bells Go Down* the fire station is a major element in a localised community, and leadership reflects skill and professionalism rather than an automatic sense of class deference. Finlay Currie's irascible station officer is an

Wartime heroism, sacrifice and community spirit in *The Bells Go Down* (1943)

exceptional firefighter, his second-in command (James Mason) is a seasoned professional from a lower middle-class family and one of the volunteers (Brookes, played by William Hartnell) is a veteran of the International Brigade.

Uniting these films is a sense of all classes stoically pulling together for the war effort. According to Charles Barr:

> It looks as though it had taken Balcon until around 1942 to pick and train a team which could respond to Britain's war experience with the type of inspirational feature most appropriate to it – films ... which embody classic British qualities of team spirit and good-humoured doggedness.[10]

San Demetrio, London is, for Barr, 'the culmination of Ealing's war programme'.[11] After the *San Demetrio* tanker is evacuated of all of its senior officers when the ship is bombed, the task of steering the hulk back to the UK falls to the young second officer Hawkins (Ralph Michael) and the resourceful chief engineer Charles Pollard (Walter Fitzgerald). The officers do their share of the hard work and much of the actual guidance is at the hands of Pollard rather than the younger but technically senior Hawkins. It is also Pollard who uses his ingenuity to fashion an ad hoc stove from the wreckage of the engine room and who reminds the less experienced man of the existence of auxiliary steering gear and who advises on how to trim the ship when it is in danger of floundering.

Like *The Foreman Went to France*, *San Demetrio, London* was based on a true event; in this case Ealing chose to add little in the way of embellishment to the story. The plot follows the official account by journalist F. Tennyson Jesse, which earned her a screenwriting credit, and the real Chief Engineer Pollard was drafted on to the production as technical adviser, while

Clifford Evans's work manager with Tommy Tinder in *The Foreman Went to France* (1942)

actual 'blueprints and plans loaned by the owner of the *San Demetrio*, the Eagle Oil and Shipping Company Ltd'[12] helped to ensure the film's authenticity. According to James Chapman, *San Demetrio, London*:

> shows that by the middle of the war Ealing had come full circle from the melodramatic heroics of *Convoy* and *Ships with Wings*. ... there were no star names in the cast; it focused on a group of working-class merchant seamen who did not depend on officers for inspiration; and their heroism is so understated as to be almost matter of fact, as if the events in the film were part of a routine voyage rather than an extraordinary adventure. It was ... yet another example of the convergence between studio narrative and documentary realism.[13]

In *Nine Men* it is Sergeant Jack Watson (Jack Lambert) who takes command following the death of the senior officer, and who inspires his ramshackle unit to pull together to defeat a barely seen foe in a film that is as much about solidarity as conflict. Deference for the sake of class is largely absent; Sergeant Watson is a humane disciplinarian who knows the right time to issue the welcome command: 'At the present moment, to hell with spit and polish!' The soldiers have trained and fought together; they are a cohesive unit who are comfortable taking orders from their sergeant and, within limits, sharing a joke with him. Meanwhile, the two Service Corps squaddies of *The Foreman Went to France* are engaged on a farcical mission for Major Morrison's curry powder and grumble about their treatment.

Modesty is a further element that bonds these characters; Fred Garrick sees his genuine heroism as an extension of his duties as works manager; Chief Engineer Pollard understands the need for 'small victories', risking his life to ensure hot tea and a cooked meal to improve

the morale of the men. When the Auxilary Fire Service (AFS) volunteers in *The Bells Go Down* are ridiculed by off-duty soldiers in a pub, they are rallied by a veteran, who tells them that 'our cities are still behind the lines. When someone starts to pin medals on us, it'll mean they've moved right up to the front. It'll mean another Rotterdam, another Warsaw, right here in England. They'll call us heroes if it comes to that. I'd rather they went on laughing.'

Each of these films illustrates the notion of a filmic 'family' which is flexible enough to allow for individualism to thrive within the collective, but which pulls together in order that an external foe may be effectively vanquished. The family is broad-minded enough to accommodate friendly outsiders, such as Robert Beatty's Yank in *San Demetrio, London*, and to tolerate a degree of idiosyncrasy, so long as the cohesion of the group is not at risk: Tommy Turk (Tommy Trinder), the joker of *The Bells Go Down*'s AFS station, never allows his minor battles against station discipline to compromise his sense of duty and hard-learned skills. Through following the guidance of professional leaders, newcomers can learn how to serve the wider community and discover hitherto unknown qualities in themselves; the redemptive powers of service can be seen in the way Mervyn Johns' petty thief in *The Bells Go Down* rescues the policeman who has tailed him throughout the film, and in the way two of his colleagues (including Trinder's Tommy Turk) lose their lives in trying to save a hospital.

The use of the same rotating pool of character actors, including Johns, Trinder and Frederick Piper – whose distinctive scowl enlivens *San Demetrio* and *Nine Men* – both emphasises the family feel and mirrors Balcon's insular attitude towards directorial talents; after the release of *The Foreman Went to France*, 'Ealing never looked outside its own staff for directors.'[14] Within the Ealing family, and in the surrogate families of the films, personal eccentricities are seen as a mark of identification from the monolithic foe, and are therefore tolerated, even encouraged, so long as they do not undermine the cohesiveness of the group's efforts.

Of this quartet of films, *The Bells Go Down* is the only one whose narrative unfolds against a recognisable background of England, and which deals directly with the Blitz (although a brief air raid sequence frames the main story of *The Foreman Went to France*). In his *The Myth of the Blitz*, Angus Calder argues that 'Heroic mythology fused with everyday life to produce heroism. People "made sense" of the frightening and chaotic actualities of wartime life in terms of heroic mythology, "selecting out" phenomena which were incompatible with that mythology.'[15] *The Bells Go Down* perfectly illustrates that process of myth creation. No firefighter goes AWOL, there is no looting and the pivotal figure is that of the spirited, mildly rebellious amateur Tommy Trinder rather than James Mason's grumpy professional fireman. It is Turk's death that provides the most shocking moment in the film as in many respects he is the lynchpin of the brigade; the mythological indomitable Cockney. As Robert Murphy has persuasively argued:

> Tommy's death serves no useful purpose – he saves McFarlane's life only to die with him moments later – but it expresses the spirit of the community, of pulling together with people one doesn't necessarily like, which is so clearly articulated in the film.[16]

The cost of defending the nation was fully explored by two films released in 1942 – *The Next of Kin*, directed by Thorold Dickinson, and Calvalcanti's Ealing feature debut, *Went the Day Well?*. The first, expanded from what was originally to be a military training film, repeatedly

and even brutally emphasises the need for personal responsibility in all levels of society, both military and civilian. 'This is the story of how YOU unwittingly worked for the enemy,' explains an opening title, preceding a narrative that demonstrates how a supposedly secret British plot to attack a relatively unguarded German U-boat in occupied northern France is fatally undermined by loose talk. The chief saboteur is played, in a piece of inspired casting, by Mervyn Johns, so often the embodiment of unassuming solidity for Ealing but here a chameleon-like figure of real malevolence, enticing the unobservant to confide in him seemingly minor details.

The Next of Kin demonstrates Ealing's often contrasting fortunes in its relationship with the government throughout the war. It was made with cooperation from the War Office, which granted access to official records and allowed servicemen, including Dickinson and scriptwriter Basil Bartlett, to set aside their military duties to work on the film. However, problems arose when military security discovered that Dickinson had fought for the Republicans in Spain and was therefore regarded as a 'premature anti-Fascist' and a potential security threat. Dickinson was eventually allowed to work on the film, but another threat came from Winston Churchill, who had seen the film prior to its release and, according to Balcon, thought that 'it would cause unnecessary alarm and sorrow' and argued for a delayed release.[17] Ealing had previously come into conflict with Churchill over *Ships with Wings*, which the Prime Minister also suggested ought to be delayed. The period between *Convoy* and the release of *San Demetrio, London* was characterised by an attitude of close cooperation combined with moments of intense dispute between Ealing and government, as Philip M. Taylor suggests:

> The simple fact of the matter was that any film which appeared on British cinema screens during the war could only do so if it had secured the approval of the British government, and in so far as the specific official body responsible was concerned, this meant the Ministry of Information. ... In effect no newspaper article, radio broadcast or clip of film was allowed to reach the public unless the British government, operating through the MoI, allowed it to do so. This is not to say that mistakes did not happen [and] examples of official displeasure at what was believed to be adverse publicity, or attempts to censor the media, did occur.[18]

Went The Day Well? was based on a short story by Graham Greene, and Cavalcanti carefully delineates the background as a form of rural arcadia not dissimilar to what Angus Calder calls 'Deep England': a composite English village which invariably incorporates 'a pleasant Anglican vicar, an affable squire, assorted professionals, tradesmen and craftsmen, many of whom will be "characters", plus a complement of sturdy yeomen and agricultural workers learned in old country lore'.[19] This is, in some ways, the realm later celebrated in Charles Frend's *Johnny Frenchman* (1945), in which age-old rivalries between Cornish and Breton fishing communities are set aside for the common good of both.

Went the Day Well? was initially conceived as a patriotic piece to encourage the country to be vigilant against the prospect of a Nazi invasion. But by the time the film was released such a threat was much diminished. However, the film contains many of the features of Ealing's other war releases in relation to the promotion of the people's war. Clive Coultass argues that:

> If British cinema had any collective purpose during the Second World War, it was that of putting forward – in features and documentary alike – the image of people working together with the kind of unity which Winston Churchill had asked from them ... What mattered was stoicism, resolution, togetherness.[20]

Such virtues are ably demonstrated in *Went the Day Well?*, with the villagers of Bramley End uniting to expel an outside threat to the community. But the village is led by a genial squire who turns about to be a Quisling, and the outsiders are Nazi troops in the guise of British Tommies. In many respects the plot is secondary to the film's theme of moral choices; many of the village's inhabitants, regardless of social class or gender, have their own moment of decisive action. Harry Fowler's quick-witted evacuee manages to raise the alarm, the vicar's daughter shoots the Quisling squire (for whom she harbours a secret love) and a redoubtable upper middle-class matron, in one of the most shocking moments, saves the life of a group of children by throwing herself, off-screen, on a grenade. Such a depiction of people of all classes uniting to fight the common enemy is a recurring feature of the people's war ideology and a crucial factor in the breakdown in class deference during the war. George Perry traces the emergence of this theme in Ealing's war output from 1942 on:

> The earlier common assumption of leadership and superiority that distinguishes the officers from the lower decks in *Convoy* and *Ships with Wings* has been replaced [in *San Demetrio, London*] by a democratic consensus – the big decisions ... are reached collectively. It is almost as if Ealing is saying that the officer class has let Britain down, and it is among them that the spies (*The Foreman Went to France*), the quislings (*Went the Day Well?*) and the pompous stuffed shirts (*Ships with Wings*) can be found.[21]

The postmistress brutally executes 'her' billeted Nazi in *Went the Day Well?* (1942)

Through such directorial flourishes as the squire's body falling to the ground in slow motion, the quick cutaways and dramatic close-ups (such as the shooting of the vicar),

Cavalcanti illustrates just how the community's formation as a defensive unit manifests itself in diverse fashions – the postmistress calmly makes 'her Nazi' his tea before throwing pepper into his face and putting an axe into him. Meanwhile, the shooting of the squire reduces the vicar's daughter to a state of shock.

Such a vision of the community's potential for violence would play only a limited role in Ealing's postwar output. Their extensive use of real locations captures scarred London in any number of films – Harry Fowler leading his gang across bomb-struck wastelands in Charles Crichton's *Hue and Cry* (1947), the bomb crater of *Passport to Pimlico* (Henry Cornelius, 1949) or Dearden's ravaged docklands of *Pool of London* (1951) – but it is the studio's definition of community that dominates so many of their films. By helping to define the ideal of preserving individual liberty for the common good, Ealing helped to render the experience of war comprehensible to a nation long after the war had ended, and in the process provided the template for its postwar films either to follow or to question.

Community is already being eulogised in one of Ealing's finest postwar war films, *The Captive Heart* (1946), a Dearden-directed POW drama which commenced production just after the end of the war. Within the confines of the camp, the prisoners' leader figures, Major Ossy Dalrymple (Basil Radford) and Corporal Ted Horsfall (Jack Warner), are approachable disciplinarians, while ostensibly antagonistic figures use their skills for the benefit of the group – Jimmy Hanley's initially selfish wide-boy, Private James H. Matthews, uses his prewar criminal skills to pick the locks on their manacles and leads a daring midnight burglary. The group's principal outsider, Michael Redgrave's Czech refugee Captain Hasek, finds a haven with the support of his fellow POWs.

Above all, *The Captive Heart* brilliantly contains any sense of personal emotion – or even violence – behind a mask of understated British *sang-froid*. When Roger Manvell claimed that in the best war films, 'the understatement of emotion – resolved by eloquent silences or by giving a certain pathos to the *clichés* of accepted behaviour, or by side tracking emotion to using laughter in its place – is indigenous as our green, sweet and rain-swept landscapes',[22] he could have named *The Captive Heart* alongside his own examples, *The Way Ahead* (1944), *The Way to the Stars* (1945) and *Brief Encounter* (1945). Throughout the film, we see Horsfall constantly but unostentatiously carving a wooden boat as a means of preserving his sense of individual dignity even under the most trying of circumstances. His sacrifice of it to fuel the prison camp fire is apparently minor but, as the subtle reaction shot illustrates, one with a heavy emotional cost. *The Captive Heart* shares with Ealing's mature wartime war films a refusal of melodramatic notes of false heroism.

Dearden's next film for Ealing, *Frieda* (1947), is both an ostensible celebration of how a small market town ('Deep England' again) eventually comes to accept a German refugee who married an RAF officer and an exploration of the bigotry of the family *pax Britannia* that is as grim as the vision of *Went the Day Well?*. Cavalcanti later said of that film that 'people of the kindest character, such as the people in that small English village, as soon as the war touches them, become absolute monsters'.[23] But Dearden seems less concerned at just how unpleasantly David Farrar's hero and the community behave towards the refugee who had risked death to help her future husband escape from a POW camp. Frieda's treatment leans so far towards the sadistic that the eventual plot resolution cannot help but seem unconvincing.

With *The Blue Lamp* (1950), Dearden further defines the idea of community by contrasting Jimmy Hanley's probationary constable, who sports a row of wartime campaign

Jack Hawkins stars in Ealing's postwar naval drama *The Cruel Sea* (1953)

medals on his police tunic, with Dirk Bogarde's Tom Riley, a cosh boy who exists in a film noir vision of neon-lit pinball joints remote from the warm community of the police station. Riley's shooting of Jack Warner's PC George Dixon is as big a shock to the audience as is the death of Tommy Turk, but here the enemies are not Luftwaffe incendiaries but uncontrolled desires. Dixon and his wife (Gladys Henson) are seen as controlled in their demeanor as 'they know who they are and everything in their world has its place',[24] whereas Riley is too immature and hysterical with his dreams of easy money to find acceptance even within the parallel criminal community. T. E. B. Clarke's screenplay for *The Blue Lamp* expands the theme of community as a bulwark against rampant consumerist desires, one that he had previously dealt with in *Passport to Pimlico*. In this classic Ealing comedy, Ealing's implication is that a return to wartime solidarity is essential to protect the community; Charles Barr has argued that this warning of the value of rationing and restrictions becomes 'truly romanticised'[25] in the course of the film.

Ealing produced comparatively few 'war films' after 1945, partly due to friction between Balcon and John Davis of the Rank Organisation.[26] However, the war was never far from its collective mindset, as the opening narration of the maladjusted veteran drama *The Ship That Died of Shame* (Dearden, 1955) suggests, speaking not only for its hero Bill (George Baker) but perhaps for Ealing itself: 'the beginning, like almost everything else about me, went back to the war'. *The Ship That Died of Shame* was adapted from a novel by Nicholas Monserrat, as was Ealing's major postwar war film, *The Cruel Sea* (1953). Although the

56 **EALING REVISITED**

John Mills in *Dunkirk* (1958)

earlier film is 'permeated by an air of middle-class professionalism',[27] and smugly invalids out the more working-class officer, Bennett (Stanley Baker), with a stomach ulcer before he's in danger of doing anything redemptive or noble, it does show the strain of maintaining the stiff upper lip. Captain Ericson (Jack Hawkins) gets drunk and breaks down after a particularly agonising decision resulting in the deaths of British seamen, and rails at 'the war. The whole bloody war. We've just got to do these things and say our prayers at the end.' Ealing went back to the war for its final prestige production, *Dunkirk* (1958), a painstaking recreation of the event hailed as a 'miracle' by Churchill. There are expressions of discontent at disorganisation – 'what a shambles we've made of this whole rotten business', says Bernard Lee's journalist at one point – but the epic concludes on an insistence of patriotic unity forged through war, with its narrator stating, 'No longer were there fighting men and civilians, there were only people. A nation had been made whole.'

When the Ealing brand died in 1959, the notion of People as Hero had ossified to the point that objects and characters, such as the pier in Frend's *Barnacle Bill* and the inept Harry Secombe in Michael Relph's *Davy* (both 1957), were being celebrated because of, not despite their defects. The template and vision of Ealing's classic wartime films had apparently been forgotten by the mid-1950s, as had the struggles and sacrifices of the likes of Tommy Turk and the villagers of Bramley End, who died trying to save their world from tyranny – not to preserve an increasingly moribund status quo.

5 FROM TINSEL TO REALISM AND BACK AGAIN
BALCON, EALING AND DOCUMENTARY

Mark Duguid and Katy McGahan

Early in 1939 I put my thoughts on paper in the form of a memorandum which might have been called 'How to put films to work in the national interest in wartime' and sent it to the proper quarter. Its impact on Whitehall was nil. (Michael Balcon)[1]

'[D]ocumentary' is not a label to be lightly attached to films of a specific, factual type; it is an attitude of mind toward film making. I had known at the back of my mind since *Man of Aran* that this was and should be the direction my own work should take. (Michael Balcon)[2]

Michael Balcon inherited a studio steeped in music-hall 'tinsel' and spent his first half-decade there steering it, 'in the national interest', towards documentary 'realism'. It was a direction confirmed with his luring to Ealing of two of the most gifted members of the documentary film movement, Alberto Cavalcanti, who joined the studio from the GPO Film Unit in 1940, and Harry Watt, who jumped ship from the GPO's successor, the Crown Film Unit, two years later. With their help and influence, Ealing's wartime films abandoned the clumsy, melodramatic and classbound stories of individual heroism of *Ships with Wings* (Sergei Nolbandov, 1941) and embraced a more inclusive and realistic approach that bore fruit in the likes of *Nine Men* (Harry Watt, 1943) and *San Demetrio, London* (Charles Frend, 1943).

Broadly, this is the account of Ealing's wartime evolution that has held since 1943, when Balcon himself set it down in his defining 'Realism and Tinsel' speech to the Film Workers' Association. But all but overlooked in this is the part in this progression played by a series of documentary and propaganda shorts made by Ealing from 1939 onwards. Individually and collectively these films add, at the very least, another layer to our understanding of Ealing's development during the war, and help to explain the mechanism by which the studio's turn from tinsel was achieved.

Between 1939 and 1945 the studio released some thirty short films, ranging in length from a little over five minutes to nearly an hour and embracing recruitment films, comic instructionals, campaign films, satire, story documentaries and varieties of propaganda. This section of Ealing's output, though it was acknowledged as early as Charles Barr's 1974 articles on the studio, has never satisfactorily been integrated into the overall Balcon/Ealing

story – with some reason, for the films are diverse, hard to see (several appear to be missing, others remain inaccessible) and information about some of them is thin. Some, perhaps several, may have involved nothing more than a grudging loan of studio facilities for official purposes. There are tantalising references, too, to films that may never have seen the light of day.

Ealing's first toe-dip into non-fiction film-making went into production during the summer of 1939. Commissioned by the Ministry of Labour's National Service department, *Happy Family* was designed to persuade Britain's able-bodied men to enlist, and starred Edmund Gwenn and John Mills, with direction by Walter Forde, the most prolific director of the early Balcon years. Its effect is hard to measure, since the release seems to have passed without comment. But it evidently did enough to encourage the view that commercial film producers could play a role in government propaganda, for later the same year Kenneth Clark, then director general of the Ministry of Information's Films Division, commissioned three ten-minute shorts from Ealing as part of the MOI's wider 'careless talk' campaign. The result was three 'mini-thrillers' directed by Ealing newcomer John Paddy Carstairs, costing around £2,000 apiece and distributed to some 20 million people in 2,000 cinemas. The three films, released in May 1940, follow a similar simple narrative, but vary in their characterisation and choice of locations to target audiences in different classes, a deliberate strategy on the part of the MOI.[3] *All Hands* was given the widest circulation and packs the hardest emotional punch with its tragic story of a young sailor (John Mills again) who unwittingly gives away strategic naval information to his sweetheart in a café in earshot of a gossiping waitress. The café's proprietress, a fifth columnist, passes the message to another agent in a dark cinema, and it ultimately reaches the Germans. Later that night, the young sailor's ship, HMS *Cambridge*, is torpedoed, with all hands lost. In *Dangerous Comment* the loose-tongued culprit is a high-ranking RAF officer (Jack Lawton) who, peeved at being overlooked for a bombing mission, offloads his irritation to his girlfriend, who lets slip the details in an upmarket cocktail bar in earshot of a traitorous waiter. It would have been screened in deluxe houses and London's West End. *Now You're Talking*, which demonstrates how the idle chatter of a beer-swilling lorry driver in his local pub leads to the bombing of an aeroplane factory, was written with the working classes in mind, and would have been

All Hands (left) and *Now You're Talking*: two-thirds of Ealing's 'careless talk' trilogy (1940) for the MOI

distributed in industrial areas. With its working-class protagonist and wry humour, it conjures something of the atmosphere of the pre-Balcon George Formby or Gracie Fields films (Carstairs' sole feature film credit for Ealing would be the Formby vehicle *Spare a Copper*, released later in 1940).

The films' reception challenged Balcon's conviction that Ealing really understood effective propaganda. *The Times* thought them well made, but wondered 'whether their obviously sensational quality will in some instances provoke incredulity'.[4] C. A. Lejeune, in the *Observer*, suggested that 'a better argument might have been put up at a smaller cost by using the ordinary people you meet in the streets, the trains, the restaurants'.[5] *Documentary News Letter*, stung that it was commercial producers, not documentarists, who had been assigned this work, was more critical:

> Could not the settings have been more real, the characters more life-like? The whole effect in films of this kind may be spoilt if they seem to take place not in real pubs or cocktail bars, but on conventional studio sets with the old familiar faces playing the old familiar parts.[6]

A later survey of the early war propaganda films by Mass-Observation, and printed in *Documentary News Letter*, reported that the films were better received by middle-class audiences than working-class ones, noting that 'in each of [them] the spy was a worker (barman, café proprietress, pub-crawler), while in two of them the gossipers were working class, though in only one was the cast, as a whole, working class'.[7]

The 'careless talk' trilogy preceded the launch, in July 1940, of a series of MOI-sponsored 'Five-Minute Films'. These short (usually slightly over five minutes) films were designed to carry pithy propaganda or instructional messages, and were distributed free of charge to cinemas on a weekly basis for screening as part of the regular programme. The films were commissioned from a mix of commercial producers, the GPO and independent documentary units, and Ealing had two films among the first half-dozen releases. *Food for Thought* (Adrian Brunel, 1940) was a light-hearted explanation of the nutritional value of various foods. At the outset of the war the Ministry of Agriculture and Fisheries launched a large-scale campaign to increase food production, which, it asserted, 'represents a vitally important aspect of national defence'.[8] Extra land was made available for ploughing and householders were encouraged to grow food in their gardens or allotments. With shortages and rationing limiting the amount and range of food stuffs available, guidance on nutrition was disseminated in the form of booklets, public lectures and films. *Food for Thought* uses the simple construct of a round-table discussion to air the necessary dietary information. Brunel's signature lightness of touch raises it above a mere educational listing, but again the film provoked mixed reactions. *Kinematograph Weekly* complemented its 'homely vein' and 'warm humour',[9] but the *Manchester Guardian* was less impressed:

> It suffers from the awful mistake of appealing by facetiousness to a public which is sensible enough to learn the facts without such heavy humour. The GPO Film Unit could have made a brilliant 'short' about food without so much effort.[10]

This last view was probably shared by the *Documentary News Letter*, which complained that 'with its poor dialogue and cheap jokes ... [*Food for Thought*] marks an all-time low level in cheap propaganda films'.[11]

Balcon eschewed his usual producer credit on *Food for Thought*, lending support to the suggestion that they were only a grudging Ealing contribution to the Five-Minute scheme; some time later Cavalcanti averred that Balcon had only leased Ealing studio space for the film, 'after protesting in vain that it should not be made'.[12] The same may also be true of Brunel's second five-minuter, released in August 1940, which like *Food for Thought* credits John Croydon, not Balcon, as producer.[13] *Salvage with a Smile* was an appeal to householders to save paper, bones and metal made on behalf of the Ministry of Supply. Using the simple construct of a discussion between a professor, his housekeeper, a dustman and a local middle-class volunteer, the importance of salvaging an array of household waste is conveyed. To the surprise of his housekeeper, the professor pours himself and the dustman a beer and expounds on how bones can be converted into soap, medicinal products or glycerine, used for making high explosives. The theme of inter-class unity addresses some of the flaws of the 'careless talk' films and anticipates the inclusiveness agenda that will become an Ealing hallmark as the war goes on, but in its awkward class relationships it still looks back – to (modestly progressive) 1930s attitudes – more than forward.

Sandwiched between Brunel's two films, however, was Ealing's most explicitly documentary project to date, and a film that, in a modest way, pointed forward. *Sea Fort* (1940) was directed by Ian Dalrymple – shortly to head up the newly established Crown Film Unit – and showed life on board a floating defence manned by the Royal Artillery, Royal Engineers and Royal Navy. Closer in character, if not, perhaps, in accomplishment, to Ealing's coming new direction, it was overlooked by reviewers and doesn't appear to have made much of an impact on audiences (Mass-Observation reported that it was 'criticised for vagueness'[14]). Dalrymple's connection with Ealing, like Brunel's, was brief; more significant is another credit on *Sea Fort* – 'produced by Cavalcanti'.

By 1940, the war was eating into Ealing's talent base, taking away key personnel for active service. Among them were directors Walter Forde, Anthony Kimmins, John Paddy Carstairs and Balcon's protégé Pen Tennyson, while at around the same time Robert Stevenson, a pacifist, decided to leave for America. Between them, these five had been responsible for all but one of the features released by the studio from Balcon's arrival until the end of 1940. Motivated perhaps as much by his need to replenish his team as by his professed admiration for the documentary, in the summer of 1940 Balcon made an apparent bid to take over the GPO Film Unit.[15] The bid was sternly rebuffed by the recently appointed head of the Ministry of Information Films Division (and former head of the Shell Film Unit), Jack Beddington, and this seems to have been a key factor in the souring of Balcon's relationship with the MOI.[16]

In the early months of the war the Films Division, under its first director, Sir Joseph Ball, had managed to offend both the commercial film industry (because of its slowness in recognising the need to keep studios and cinemas running, and its perceived failure to offer a clear policy for film propaganda) and the documentary film movement (because of its decision to sideline the GPO and go instead to the newsreels, advertisers and other commercial producers for its early commissions) and it had suffered repeated attacks in the media from supporters of both.[17] Beddington was the Division's third director, replacing Sir Kenneth Clark in April 1940, and was ultimately credited with steadying the ship. But he had a lot of ground to make up, and in the meantime Balcon's frustrations were growing. Ealing's first true war feature, *Convoy* (Pen Tennyson, 1940), was made without any MOI backing, a point not lost on observers. By December 1940, Balcon's relationship with the

MOI had broken down completely, and in public view. An Ealing press statement, printed in full on the front page of *Kinematograph Weekly*, announced that Ealing would henceforth sever its ties and fund its own independent series of propaganda shorts. The statement set out a catalogue of grievances against the MOI, apparently shared by others in the commercial industry:

> As commercial producers we resented the competition in production which a Government department was setting up with an Industry already faced with many obstacles and difficulties ... We disapproved of the free distribution of films to kinemas, believing that propaganda films of merit could still be sold in the ordinary way in the open market and get wide distribution. ... Nor in all these months, has there appeared to have been any planned or coherent programme of production.[18]

Ealing, the statement concluded, would now set aside some £35,000 towards its own slate of short films which 'will be a worthwhile contribution to our national propaganda at home and abroad', and fully expected to continue good relations with 'the Services and various Government departments' (presumably not including the MOI). Meanwhile, Balcon compounded the provocation by entering into partnership with another government department, the Ministry of Economic Warfare, for the feature film *The Big Blockade* (Charles Frend, 1942).[19]

The immediate manifestation of Ealing's new direction was Cavalcanti's appointment to head up a new Ealing Shorts Unit. The Brazilian's arrival at Ealing had been announced in the spring of 1940, though the arrangement initially seemed temporary.[20] Cavalcanti later said that his transition from the GPO to Ealing had been essentially seamless: 'the cooperation at Ealing was very similar to that at the GPO ... We insisted on continuing our documentary work at Ealing, which Mick [Balcon] accepted. I think we made films on the line of those we did for the GPO.'[21] Certainly he seems to have settled in at Ealing in a role analogous with that he occupied at the GPO under Grierson: as a creative facilitator and catalyst. At the GPO, he had been brought in to inculcate an understanding of film sound; at Ealing, his role was wider, educating a team who were largely (though by no means entirely) unversed in the art and skills of film documentary.

Mastery of the Sea and *Young Veteran* (both 1940): first releases of Cavalcanti's Shorts Unit

The first film to emerge from Cavalcanti's shorts unit was *Young Veteran* (1940), a tribute to British troops in training and under fire. It was followed by *Mastery of the Sea* (Cavalcanti, 1940), an explanation of the Royal Navy's convoy escort role with obvious parallels to Pen Tennyson's near-simultaneously released *Convoy*. The same film also brought another propitious new name to Ealing – editor Robert Hamer, who had followed Cavalcanti from the GPO (where the two worked together on *French Communique*, 1940). Early in 1941 came Cavalcanti's idiosyncratic satirical biography of Mussolini, *Yellow Caesar*, with a screenplay by journalists Frank Owen and Michael Foot – two-thirds of the pseudonymous 'Cato' who had authored the savage anti-appeasement tract *Guilty Men* (1940).[22]

Kinematograph Weekly, for one, recognised the advances that Cavalcanti was making at Ealing: 'the first fruits of the Shorts Department at Ealing Studios justify Michael Balcon's theory of the commercial value of short subjects which combine entertainment with propagandist flavour under the direction of Cavalcanti'.[23] The *Documentary News Letter*, reviewing *Young Veteran*, agreed. 'If this is a typical example, Cavalcanti's unit is assured of a distinguished future,' it said, commending the way the history of the war so far is told with 'sentiment' rather than 'dates and figures', and concluding, 'Cavalcanti has done what is perhaps the most difficult job of all, the recreation of feeling ... No one save Cavalcanti could have made this film.'[24] In lesser hands, *Young Veteran* might have merely applauded military successes as a means of maintaining public confidence in the defence of Britain, but Cavalcanti's intercutting of the successes and failures of Britain's military missions maximises the dramatic effect of his library (and some freshly shot) footage, while the decision to focus on the experiences of one young recruit, Bert, enhances its emotional impact, expressed in the poignant closing comments: 'We went to France young soldiers and came back veterans.' *Yellow Caesar* had a more mixed reception. *The Times*'s review was typical: 'not a well constructed film and certainly not a subtle one, but it hits extremely hard in its own hearty way and there is certainly very little of Mussolini left at the end of its 20 minutes'.[25] But the film is more innovative than contemporary reviewers seem to have recognised. A crudely assembled patchwork of library material, still photography, animation, satire, it is a breed apart from contemporary propaganda films, and in some ways recalls the avant-garde anti-rearmament film *Hell Unltd* (1936), directed by Norman McLaren and the sculptor Helen Biggar. Its playful, sometimes savage manipulation of existing footage now seems ahead of its time.[26]

The twenty-three-minute *Guests of Honour* (Ray Pitt, 1941), a history of the early part of the war and a tribute to those forces from occupied Europe who were fighting the resistance from London, was criticised as uncertain propaganda, but awarded points for its technical skills: 'The craftsmanship which one has learnt to associate so especially with Cavalcanti shines in almost every sequence,' said *Documentary News Letter*, and gave credit to the developing Ealing unit: 'the Cavalcanti–Pitt–[Douglas]Slocombe–[Charles]Crichton team is one to be reckoned with'.[27]

The following year's *Go to Blazes* (1942) was a belated entry in the soon-to-be terminated Five-Minute Films series, and Ealing's first commission for the MOI since mid-1940, suggesting something of a thaw in relations. A five-minute 'how to' film in which a comically inept Will Hay fails to deal with an incendiary bomb, leaving his wife and daughter (Muriel George and Thora Hird) to do the job for him, it had little if any connection with Cavalcanti's unit and is the least characteristic and most 'tinsel' of Ealing's wartime shorts. The film is credited on screen to Walter Forde, though he subsequently denied it.[28]

The unit's next film proper was its most expansive yet, a thirty-seven-minute instructional – a form practically shelved by producers by the late 1930s, but revived in wartime, when government departments recognised its potential as an efficient teaching tool for the expanding forces and commissioned a large number. *Find, Fix and Strike* (Compton Bennett, 1942), is a training film for new recruits to the Fleet Air Arm intended to explain the military strategy of the title (a slogan apparently invented by Nelson) – that is, sight the enemy; communicate with the torpedo carrier; strike the enemy. It is nicely photographed, with some effective flying sequences, but suffers from a pompous commentary and an underwhelming climax. Competent more than inspiring, it does, however, seem to have pleased the critics: 'An interesting, well-made and well-photographed film of a branch of the service of which little detail has heretofore been made public,' was the verdict of *Monthly Film Bulletin*.[29]

Charles Barr notes that Ealing's wartime features seem to be in dialogue – or in competition – with contemporary documentaries: most obvious in the similarities between *The Bells Go Down* (Basil Dearden, 1943) and *Fires Were Started* (Humphrey Jennings, 1943), and between *San Demetrio, London* and *Western Approaches* (Pat Jackson, 1944).[30] But another set of ties connects Ealing's own shorts programme to its features: *Find, Fix and Strike* with *Ships with Wings*, the 'careless talk' films to *The Next of Kin* (1942) (which was in turn recut for overseas distribution by its director, Thorold Dickinson, as *Raid on France*, 1942), *Mastery of the Sea* with *Convoy*, *Young Veteran* with *Nine Men*.

Perhaps none of the documentary and propaganda shorts made at Ealing during the war has any great distinction. Certainly none is much remembered; some have apparently

The Big Blockade (1942): Ealing's first awkward attempt to fuse documentary to the feature film

disappeared altogether. But their significance is too easily overlooked all the same. The Shorts Unit was the route by which Ealing was, for a time, colonised by documentary – though, crucially, it was a form of documentary that was, at Balcon's insistence, obliged to survive on commercial terms. It's striking how many of those who would be prolific names at the studio during the war and postwar years passed through, or had some engagement with, Cavalcanti's unit: directors Charles Crichton and Charles Frend (although Frend had already delivered three features – two of them produced by Cavalcanti – before he directed the 1944 short *Return of the Vikings*); cinematographers Douglas Slocombe, Ernest Palmer and Roy Kellino; editors Robert Hamer, Sidney Cole and Charles Hasse; art director/producer/director Michael Relph; composer Ernest Irving. Monja Danischewsky, Ealing's publicist, got his first on-screen credit on *Young Veteran*. Cavalcanti was responsible for inducting much of what would be Ealing's core team from the beginning of 1942 until well into the 1950s. Even Ealing's most prolific director, Basil Dearden, who had links back to Basil Dean's ATP and served a rather different directing apprenticeship on Will Hay comedies, could boast an 'assistant' credit on *Young Veteran*.

Ealing would continue its shorts work until 1945, perhaps later. But by 1942 the work of Cavalcanti's unit was beginning to inflect the studio's features programme. The first attempt to fuse documentary to an Ealing feature was *The Big Blockade*, released in January 1942. Directed by Charles Frend in close partnership with Cavalcanti as producer, it is an awkward mess. The two elements co-habit without really integrating, the narrative is episodic, both Nazis and heroes (including Will Hay as a minesweeper skipper) are cartoonish. Frend's *The*

Harry Watt's *The Saving of Bill Blewitt* (1937), made for the GPO, introduced the 'story-doc' form, which Watt and others developed at Ealing

Foreman Went to France, released just three months later, is a striking advance, but although (loosely) based on a real wartime story, it is not notably documentary-like in form or tone. Ealing still had some way to go to create a happy union: there remained something missing from the formula.

Joining Ealing in the summer of 1942 was another film-maker with deeper documentary roots: Cavalcanti's old GPO disciple Harry Watt. With his arrival Ealing's journey of some two years was nearly complete. Watt brought more to the studio than just more documentary authenticity; he was the principle architect of a form that offered just the union of the feature film and the documentary that Balcon – among others – had been looking for. At the GPO, Watt and Cavalcanti had been at the forefront of a group of dissenters from the Grierson orthodoxy who believed that documentary needed to lean towards the cinemas – instead of the non-theatrical venues that Grierson favoured – if it was to have the influence it craved.[31] The route to this end was an accommodation with the fiction film: 'our solution,' said Harry Watt later, 'was the story-documentary, taking actual true events, using real people, but also using "dramatic license" to heighten the tensions and the storyline'.[32] It was Watt, in *The Saving of Bill Blewitt* (1937), who had pioneered the story-documentary, developing the form in *North Sea* (1938) and the feature-length *Target for Tonight* (1941). The last was made for the Crown Film Unit, which, under Ian Dalrymple, continued to support the story-documentary after Watt's departure, most famously with Humphrey Jennings's *Fires Were Started* (1943) and Pat Jackson's *Western Approaches*.

A convergence of documentary and the feature film had enthusiastic support on both sides of the divide. In a letter to *Documentary News Letter* in 1941, John and Roy Boulting urged both commercial film-makers and documentarists to 'dispense with dogma' and work towards a 'synthesis' of 'passion and knowledge',[33] while a year earlier, an editorial in the same journal welcomed the first reports of Cavalcanti's move to Ealing as a good thing for all concerned:

> An interchange of documentary and studio film personnel has always appeared likely to yield greater realism in the story film, and to bring to documentary a more polished technique in the handling of those elements of personal drama which are appropriate to many subjects.[34]

The plea for 'personal drama' in the documentary might seem surprising given that the *Documentary News Letter* was the house magazine for the documentary film movement, counting Grierson, Edgar Anstey and Basil Wright among its editorial board. After all, the story-documentary's 'dramatic licence' could extend to partly or even wholly invented plots – as was the case in *Western Approaches*. But while this might have upset some of the more purist members of the documentary movement, it fell comfortably within Grierson's fluid definition of 'the creative treatment of actuality', which had always allowed a degree of reconstruction.

What was crucial to Watt, Cavalcanti and others involved in developing the story-documentary form was the use of 'real people' – that is, non-actors – to act out events that either had happened or at least could happen to them. A degree of narrative invention was defensible, but the use of non-actors was more than a badge of authenticity; it was what allowed the films to lay claim to the name of documentary at all. All the same, skilled non-actors, once discovered, could be put to reuse, and it's not uncommon to spot the same face in two or more GPO films. The pick of the GPO's non-actor discoveries was the Cornish postmaster and jack-of-all-trades Bill Blewitt (also credited as Blewett): having built his first

story-doc around him, Watt recast him in *North Sea*, and he became an emblem of the documentary influx at Ealing, appearing in *The Foreman Went to France*, Watt's *Nine Men*, *Johnny Frenchman* (1945) and *Painted Boats* (1945).

It was in the pages of *Documentary News Letter* that the approach found itself encouraged to abandon even this last attachment to documentary orthodoxy. In an article titled 'Are Actors Necessary?', actor Bernard Miles[35] argued that if the documentary was to go beyond merely describing social problems and begin to effect change, then it must break its taboo against emotional stories about individual people using professional actors:

> true social analysis can have only one object – action towards the solution of the problems analysed. ... these inescapable social and propagandist aims can best be served, from the screen point of view, by a marriage of documentary ... with a more and ever more human story value and by an ever-increasing concentration upon people. ... this can be best achieved by the isolation of particular typical people, and ... for this purpose actors trained to portray the development of human character and the intensification of thought and feeling that go with it, will have to be used more and more.[36]

It would be studios, and above all Ealing, that would put Miles's theory into practice – albeit without, perhaps, the same revolutionary zeal – and Harry Watt's *Nine Men* was its truest realisation. By 1943, Watt was evidently a convert to Miles's way of thinking, as he explained in an article for *Documentary News Letter* on the casting of *Nine Men*:

> To carry parts in a story film of an hour or more needs experience. Either that, or the immense natural acting abilities of a Bill Blewitt, which are so rare that it can be discounted. Professional actors are therefore necessary. ... If the documentary movement is going to influence the British film industry permanently, it must have documentary actors. The glamour of seeing the real people doing the real job has become outworn.[37]

Watt's experiment was well-received on the documentary side of the divide. *Documentary News Letter* surrendered two pages to *Nine Men* (including Watt's casting article) citing approvingly C. A. Lejeune's *Observer* review – 'Harry Watt was trained by John Grierson and when Grierson trains anyone they stay trained' – and saluted the film as 'the purest of the pure imaginative documentaries'.[38]

Documentary is part of Ealing's direction of travel, not its destination. After 1942, documentary elements are to be found, to one degree or another, in *The Next of Kin* – directed by another transitory Ealing figure, Thorold Dickinson, but with an Ealing crew – in Cavalcanti's *Went the Day Well?*, Dearden's *The Bells Go Down* and, especially, Charles Frend's third feature, *San Demetrio, London*, a far more faithful account of real-life heroism than *The Foreman Went to France* and perhaps the most archetypal distillation of Ealing's wartime ambitions. But Sergei Nolbandov's ill-timed Yugoslav resistance tale *Undercover* (1943) falls outside this model, as, mostly, do Dearden's fantastical *Halfway House* and *They Came to a City* (both 1944), never mind the comic vehicles for Will Hay and Tommy Trinder.

It's not quite true that, as Robert Murphy has it, Ealing's 'turn away from realism did not wait for the end of the war', or that only Charles Crichton's debut feature *For Those in Peril* (1944) – an understated air-sea rescue story with a keen documentary eye – 'appeared as a guilty reminder of Balcon's pledge to realism'.[39] Crichton's follow-up, *Painted Boats*, released a few months after war ended, is a not always successful fusion of surprisingly orthodox

Harry Watt's *Nine Men* (1943): the most authentic 'story-documentary' of Ealing's output. Second from left is Bill Blewitt, whose 'immense natural acting abilities' convinced Watt to bring him to Ealing

documentary practice, including illustrations, with the story-doc (and features the last recorded performance of Bill Blewitt). And Watt's first Australian venture, *The Overlanders* (1946), reconstructs a real wartime story as faithfully as does *San Demetrio, London*. But after these, documentary is absorbed into the fabric of Ealing, in the understated performances, in the studio's characteristic (if by no means all-pervading) low-key naturalism, and in its exit from the studio in search of tangibly real locations. Documentary's influence can be observed in the bustling East End of *It Always Rains on Sunday* (Robert Hamer, 1947), the docklands of *Pool of London* (Basil Dearden, 1951), the factory floor of *Dance Hall* (Crichton, 1950). In the comedies, too: the bombsites of *Hue and Cry* (Crichton, 1947) and *Passport to Pimlico* (Henry Cornelius, 1949), the derelict Liverpool pier of *The Magnet* (Charles Frend, 1950), even the abandoned warehouses of *The Lavender Hill Mob* (Crichton, 1951).

But the low-key realism recedes as the 1950s move on, as if driven out by the studio's increasing embrace of Technicolor. There are exceptions – *The Ship That Died of Shame* (Dearden, 1955) and *The Long Arm* (Frend, 1956), both shot in black and white, are meticulous in casting for locations reflecting postwar malaise – but there would be no late

reflowering of documentary principles at Ealing, even with the arrival of Pat Jackson, who continued the story-documentary tradition after his mentor Harry Watt's departure from Crown. Jackson's one and only Ealing film, *The Feminine Touch* (1956), which follows a group of novice nurses with as much attention their romantic as their professional lives, is closer to the near-contemporary TV soap *Emergency: Ward 10* (ITV, 1957–67) than it is to his own earlier hospital feature, the altogether leaner *White Corridors* (1951), which retained at least some traces of his documentary roots (and starred a post-Ealing Googie Withers). And however much *Nowhere to Go* (Seth Holt, 1958) carves out new territory for Ealing, the debt to Free Cinema claimed for it by Alan Burton[40] isn't easy to discern.

We can speculate that this dilution partly reflects the departure of Cavalcanti (who makes no further films for Ealing after 1947's *The Life and Aventures of Nicholas Nickleby*), or the centrality of comedy to the studio's postwar identity, or the increasing distance from war's propaganda imperatives. But it's also possible to detect in Michael Balcon a certain haziness about the history, nature and intent of documentary. In his autobiography, he credits the post-Grierson Crown Film Unit, not the GPO, for films such as *Coal Face* (1935) and *Night Mail* (1936).[41] Less forgivably, in his 1943 'Realism and Tinsel' lecture he gives praise to the newsreels, not Harry Watt or his former GPO colleagues, for the development of the story-documentary.[42]

By the early 1950s Balcon was identifying the feature film, and implicitly Ealing, as the true inheritor of the 'documentary tradition'. In a 1952 article, he begins by praising documentary and ends, very nearly, by burying it:

> the feature film has largely taken over from the documentary … [the documentarists'] propaganda has achieved its purpose: the beliefs of the few of the '30s are now widely held … their approach to the screen has been vindicated.[43]

The feature film, he continued, had learnt to use for its backgrounds 'parts of the contemporary scene such as made the subject matter of the past documentary: farm, slum, factory'; this was the 'the road we should continue to travel'. If the makers of feature films could 'become careful students of the contemporary world', he argued, 'then indeed we should have made documentary unnecessary'. But it's debatable by 1952, to what extent Ealing is still travelling the same road: there are one or two 'farms, slums and factories' in the studio's remaining films, but they hardly dominate. Tellingly, Balcon ends his article with a reference to Ealing's two upcoming releases: Dearden's *I Believe in You* and Hamer's *His Excellency* (both 1952) – the first a plausibly documentary premise (troubled delinquents and the induction of a novice probation officer) marred by some inapt casting, the second so far from the documentary path as to call into question Balcon's understanding of the term.

Almost as an afterthought, in 1954 Ealing made an unexpected return to documentary with the first of three travelogues co-presented by the Belgian-born naturalist and film-maker Armand Denis and his glamorous Yorkshire-born wife Michaela. *Under the Southern Cross* (1954), *On the Barrier Reef* (1955) and *Among the Headhunters* (1955) broke new ground with their depictions of wildlife and indigenous peoples on their expeditions across northern Australia, the Great Barrier Reef off eastern Australia and New Guinea, respectively. It was, though, an opportunistic rather than a planned enterprise on Ealing's part. While holidaying in England in 1953, the Denises had approached Ealing with a

proposal for three individual sixty-minute travelogues. Balcon warmed to them, and 'a deal was arranged almost at once'.[44] Having been disillusioned with RKO-Radio's severe edit of their previous travelogue, *Below the Sahara* (1953), which had reduced some 50,000 feet of their precious footage shot in Africa over a period of eighteen months to an eighty-minute feature, they were keen to adopt a more economic and planned approach with the Ealing commission, and completed each film within a self-imposed six-month deadline. The duo would shortly be adopted by television, with four successive BBC series between 1955 and 1965, but they are little more than a postscript to the Ealing story.

What, then, was Ealing's contribution to documentary? Ealing was the principal route by which documentary aesthetics infiltrated mainstream British cinema[45] – and in some ways served as a bridge between documentary aesthetics and concerns and the 1960s 'new wave'. But most of the traffic was one way: despite the eager anticipation with which the *Documentary News Letter* greeted Cavalcanti's appointment in 1940, Ealing took much from documentary, but gave relatively little back. Of Ealing's ex-documentary intake, only Thorold Dickinson would make any significant contribution to documentary after leaving the studio. The story-documentary blossomed briefly but eventually became so diluted as to lose its potency, as if to confirm the fears of the purists. What's more, by robbing the documentary movement of two of its most gifted and charismatic figures – Cavalcanti and Watt – Balcon and Ealing may even have helped undermine its long-term prospects. This seems to have been the view of Watt, who clearly had mixed feelings of his time at Ealing:

> The tragedy was that our story films made us interesting to commercial interests, and most of us were seduced away from documentary. Looking back, I regret this a lot. At the end of the war, the lack of old-stagers weakened documentary so much that the Crown Film Unit became an easy target for a stupid and unnecessary economic cut.[46]

It's too much to lay at Balcon's and Ealing's door alone the responsibility for the documentary film movement's postwar decline. The same internal tensions that drove Cavalcanti and Watt in Ealing's direction would continue after their departure from the movement, and Balcon wasn't the only commercial film producer to fish in documentary's waters. In any case, documentary itself would survive Crown's demise in 1952; the art of documentary arguably even flourished in the commercial film units that proliferated between the 1950s and the 70s.[47] But the coincidence of Ealing's interests and those of documentary was finite, and Balcon's first loyalty was to his studio and its business, even if that meant a partial reconciliation with tinsel.

6 'MILD REVOLUTION'?
EALING STUDIOS AND THE POLITICAL AND SOCIAL CONSENSUS

Lee Freeman

> If you think about Ealing ... we were middle-class people brought up with middle-class backgrounds and rather conventional educations. Though we were radical in our points of view, we did not want to tear down institutions ... We were people of the immediate post-war generation, and we voted Labour for the first time after the war; this was our mild revolution.[1]

Michael Balcon's characterisation of Ealing's personnel and their politics is instructive as it highlights the studio's progressive credentials while simultaneously admitting that there were limits to the studio's radicalism. Ealing has tended to be associated with the wartime transformation of British society that contributed to the Labour Party's historic electoral victory in 1945, where the shared experience of war helped to shape a new social and political consensus, increasingly democratic and egalitarian in nature. The wartime shift in social attitudes led the historian A. J. P. Taylor to describe the war years as 'the brief period when the English people felt they were a truly democratic community',[2] and Ealing's output during the period consistently engaged with the new consensus. In this chapter I will examine three films which highlight, in varying degrees, the emerging radicalism at the studio. *The Proud Valley* (1940), *San Demetrio, London* (1943) and *They Came to a City* (1944) are three key Ealing texts which deal with the pivotal issues of class, social democracy and postwar reconstruction in relation to the ethos of the people's war.

Pen Tennyson's *The Proud Valley* is set in the South Wales mining village of Blaendy just before the outbreak of the war.[3] An itinerant Afro-American, David Goliath (Paul Robeson), arrives at the village seeking employment and, on account of his tremendous singing voice, finds work at the local colliery, lodging with the choirmaster Dick Parry (Edward Chapman). However, after Dick dies in an explosion at the mine, the colliery is closed and unemployment and poverty soon begin to affect the community. Stirred on by Goliath, the miners decide to fight back and march to London, eventually convincing the owners to reopen the pit to aid the nation's war effort. Disaster then strikes again at the film's climax, when Goliath sacrifices his life in order to save the lives of his fellow mineworkers, an act that serves as a representation of the risks taken by the men who work underground and a forewarning of the ultimate sacrifice to be made in the ensuing conflict.

Upon its release *The Proud Valley* enjoyed largely favourable reviews, with contemporary commentators praising the film's authentic depiction of the mining community. However, the sentiment that the film evokes was most aptly summarised by Aubrey Flanagan's review for the *Motion Picture Herald*, which celebrated the film's realism for 'photographically recreating the struggles and the idealism, the tragedies and the pride, of the men and women who live by the coal, or die by the decay of the mines'. Complimenting its 'impassioned human sympathy' while declaring that although 'Paul Robeson is the ostensible star, the real stars are the miners themselves, and the wives who wait',[4] Flanagan highlights the film's engagement with a working-class milieu. Examined within this context, *The Proud Valley* is indicative of what Peter Stead described as wartime British cinema's fascination with depicting 'the people as stars'.[5]

One of the major features of *The Proud Valley* is its focus upon the centrality of the mining industry to both the local community and to the individual sense of dignity of the miners. The loss of self-respect experienced by the men after the colliery closure is evident throughout the film's narrative and this is related in a particularly striking sequence, which begins with a shot of a sign hanging over the mine entrance declaring 'No Hands Wanted'. This is followed by a cut to the labour exchange, where the miners, now cast in shadow to emphasise their decline, queue to look for work. The miners' dehumanisation in the face of mass unemployment is then further established as we see them scrambling over a slag heap in a desperate search for coal. In one poignant extreme long-shot, we see these once strong and proud men reduced to miniature figures in the distance, shrunk by unemployment and poverty, with one miner explaining that they now amount to 'no more than numbers on a labour exchange'. Although one might struggle to claim a definite comparison with Italian neo-realism, there are certain similarities to be made between these scenes in *The Proud Valley* and those in Vittorio De Sica's *Ladri di Biciclete/The Bicycle Thieves* (1948). As both films attempt to convey the poverty of their respective periods, it could justifiably be claimed that the scenes in *The Proud Valley* are as impressive as anything in the Italian neo-realist canon for their raw emotion and power, with the workers' individuality being eroded and the importance of work to the miners clearly evident. Thus, *The Proud Valley* manages to successfully combine two opposing aspects of working-class existence, with the positive nature of the villagers' solidarity contrasted with the negative reality of unemployment and poverty.

Film poster for Ealing's *The Proud Valley* (1940)

In many ways *The Proud Valley* provides a link between the pre-Balcon films made at the studio under the stewardship of Basil Dean and those that emerged during Balcon's reign. It was the earlier films, such as *Sing as We Go* (1934), starring Gracie Fields, that began to introduce the community ethic which would provide such an enduring theme for the studio until its demise. Similarly, another feature which makes *The Proud Valley* comparable to the earlier, music hall-inspired Ealing trope is the utilisation of music as a narrative device. The use of music throughout the film and its depiction of the choir as a functioning social

The Proud Valley: unemployment and poverty visit Blaendy as the miners scramble over the slag heaps in search of coal

unit symbolises the democratic and socialist ethic that the film is trying to convey, with choral singing operating as a narrative signifier relating to the themes of class unity and solidarity.

For those seeking to assert its radical ideology, *The Proud Valley* has a promising pedigree. It was based on a story by the communist Herbert Marshall and his wife, Alfredda Brilliant, who were both linked to the left-wing Unity Theatre. Marshall, who had previously worked in Russia under Sergei Eisenstein, wrote the initial script, but his treatment, which included a song concerning the revolutionary Joe Hill, was rejected. He was later removed as associate producer and the eventual screenplay was a collaboration between Tennyson and two further writers with left-wing allegiances: the novelist Louis Golding and the ex-miner Jack Jones. Tennyson was active in the promotion of the Association of Cine-Technicians union and his radicalism is emphasised by a letter he wrote in 1941 that was published in the *Cine-Technician* after his death. In the letter, Tennyson argues that private enterprise and the film industry are incompatible, while promoting a democratically accountable production council of the Association of Film-makers and forcibly stating the case for the nationalisation of the entire film industry.[6]

The final important individual contribution in *The Proud Valley* came in the towering form of Paul Robeson, a lifelong activist whose personal politics led him into frequent confrontations with authorities throughout his career. After completing filming on *The Proud Valley*, Robeson was interviewed in the USA for the magazine *New Masses*, where his

questioning of the imperialism of the allies and his pro-Soviet sympathies ensured that the Beaverbrook press refused to mention the film in its pages. Robeson had previously visited Wales in the 1930s to raise funds for the Republican cause in the Spanish Civil War, and had built such a rapport with the country that, when he was eventually stripped of his US passport during the McCarthy witch-hunts of the 1950s, the Welsh public rallied to his support.

However, despite *The Proud Valley*'s radical heritage and its sympathetic portrayal of the mining community, a conclusive reading of the film's radicalism becomes increasingly problematic. The film was initially envisaged to advocate workers' control of the mining industry by showing the miners take over the running of the pit, but as war was declared during the film's shooting the original ending was shelved for a more conciliatory conclusion with the mine owners agreeing to the reopening of the colliery. The film concludes with a final montage sequence of miners digging at the coalface, juxtaposed with shots of the coal chutes carrying coal to the surface, images of cheering villagers and the pithead decorated with Union flags. The climax is revelatory, as the scenes of celebration finally displace the issue of class conflict, evident through much of the earlier part of the film, in favour of a consensual denouement that prioritises the 'we're all in it together' ideology of the people's war. Michael Balcon explained the thinking behind the alteration as follows:

> In the original script the mines were shown defying the mine owners and opening up a disused pit on a co-operative basis to make a livelihood, but this was obviously neither tactful nor helpful propaganda when the country was at war [therefore] we amended the ending of the script to fit in with the national mood.[7]

The march to London sequence in *The Proud Valley* confirms the dichotomy of class and nation that lies at the heart of the film. On the one hand, the march can be viewed as a cinematic reconstruction of the 1930s hunger marches, with villagers gathering to cheer the delegation off and banners proclaiming 'Good Luck to Our Deputation' and 'We Want Work' in what Charles Barr describes as the film's 'moving expression of community feeling, directed solidly against the owners'.[8] The sense of solidarity is continued during the early part of the march but with the coming of war, depicted via a montage of newspaper headlines, the film begins to prioritise the national issue at the expense of its previous discourse upon the nature of class relations. At the very moment when the film is about to assert the strength of the organised working class there occurs an ideological shift, which is later confirmed when the delegation argue with the owners to reopen the pit. At this point in the narrative any pretence towards class struggle is abandoned for a purely national argument when the miners plead:

> We heard you say that tomorrow we may be at war. In that case you know the risks that will have to be taken in the trenches, in the sky, on the sea and by our wives and children in their houses. Coal in wartime is as much a part of our national defence as guns or anything else. So why not let us take our chance down the pit?

Therefore, *The Proud Valley* operates on two opposing ideological levels, simultaneously emphasising often conflicting issues of class and nation, before finally embracing the wartime ethos of class consensus, a vital component in the official promotion of the people's war.

The sense of national unity conveyed in *The Proud Valley*'s finale continued throughout Ealing's subsequent output, with most critics crediting *San Demetrio, London* as the highlight of the studio's war releases. This canonical Ealing production is based upon a true story which occurred during the autumn of 1940 when the merchant tanker the *San Demetrio*, escorted by the *Jervis Bay*, was returning to Britain with its cargo of petrol. The convoy was attacked on the 5 November by the German pocket battleship the *Admiral Von Scheer*, and the *Jervis Bay* was sunk. However, the *San Demetrio* remained miraculously afloat, initially abandoned by its crew only to be reboarded in life-threatening circumstances so the men could gallantly bring the ship home.

As a consequence of its involvement in the war, British cinema became a cornerstone of the war effort, disseminating propaganda into the public sphere and maintaining an ideology of war aims that encouraged the patriotic belief that sought to constantly link democracy with British national values. *Kinematograph Weekly* confirmed the official line, printing a letter from the Ministry of Information to the British Film Producers Association in 1942 which recommended that 'emphasis should be given to positive virtues of British national characteristics and the democratic way of life',[9] as the promotion of the perceived British value of democracy became an important feature of the nation's war propaganda.

British cinema's reluctance to marginalise the working class in order to promote the ethos of the people's war inevitably contributed to the emergent spirit of democratisation. The increasing sense of egalitarianism and a rejection of class hierarchical authority mirrored the changes occurring in society which brought Labour's leaders into the war cabinet and which would eventually culminate in Labour's electoral breakthrough. In *San Demetrio, London*, the process of class harmonisation is most clearly evident in the scenes which follow the German attack upon the convoy, when the crew take to the water in the *San Demetrio*'s three lifeboats. Eventually, two of the three lifeboats are rescued, but while the third continues to flounder at sea, the hierarchy of status within it begins to break down. As the crew are no longer confined to separate quarters according to rank, the deck hands, officers and chief engineer are thrown together by the gravity of the situation and teamwork becomes increasingly necessary. Although the division of labour is never completely abandoned and there always remains a hierarchy of rank, the situation necessitates the imposition of a meritocracy where each individual's skills and abilities are prioritised rather than their status. Notions of equality of sacrifice and effort which became integral to the nation's war consciousness are clearly evident throughout the film, as the *San Demetrio* tanker becomes a metaphor for the nation as a whole, increasingly representative of the ship of state of Great Britain.

The need for a more equitable distribution of resources in wartime is also conveyed in *San Demetrio, London*'s lifeboat sequences, with the crew, running desperately short of supplies, sharing cigarettes and water, and Second Officer Hawkins (Ralph Michael) rationing the few remaining biscuits among the men. It is interesting to note here that Hawkins maintains his command, but the simple act of sharing resources demonstrates the need for rationing in practice. Throughout the film, unity of action and sacrifice become paramount to the group's survival and this, combined with the socialist rationing of provisions, leads to a slight breakdown in the usual chain of command as the crew begin to democratically discuss their actions. Once the *San Demetrio* has been spotted, the crew discuss whether to reboard the vessel or to stay on the lifeboat and a majority decision is taken to reboard. At this point in the narrative there emerges an engagement with a form of

Ealing's depiction of the wartime spirit of unity in San Demetrio, London *(1943)*

political discussion and collective decision-making which continues throughout the remainder of the film.

Charles Barr described the crew aboard the *San Demetrio* as representing a form of 'democracy in action'.[10] As the crew battle to get the tanker fit to sail, the naval hierarchical order has loosened to such an extent that Hawkins again relinquishes his command, allowing the crew to reach a collective decision to sail home rather than return to the USA. Therefore, *San Demetrio, London*'s engagement with democratic processes, combined with the breakdown of the hierarchy and weakening of class division, can be regarded as a comment on the wartime political consensus that, despite allowing elements of war socialism to emerge through its narrative, ultimately adopts a process of class conciliation by prioritising national unity at the expense of division. Both *The Proud Valley* and *San Demetrio, London* are radical insofar as they display class-levelling tendencies which establish the working class as a vital force within society and promote social democratic values. However, by doing so as part of the official ideology of the people's war, their radicalism is often restrained by a more liberal consensual outlook, epitomising Balcon's seemingly contradictory declaration of Ealing's 'mild revolution'.

Balcon explained that during the war Ealing had been mainly content 'to put films to work in the national interest in wartime',[11] but the coming of peace meant that thoughts were turning to readjustment as Ealing began to ask questions about what form postwar society should take. Its radical depiction of a democratic and egalitarian society makes *They Came to a City* the major film made at Ealing to deal explicitly with the issue of reconstruction and to critique both the people's war ideology and the wartime consensus.

The National Film Archive records' note for *They Came to a City* describes it as 'an unusual film which represented the first attempt to carry out socialist propaganda in the British feature film'.[12] However, despite the film's historical and political relevance to postwar Britain, *They Came to a City* has suffered from being relegated to the margins of any serious analysis of Ealing studios, widely regarded as an oddity meriting little scrutiny. As a result the film's crucial importance to the social and political ethos of Ealing and the studio's progressive ideology has been largely overlooked.[13]

They Came to a City's narrative concerns the arrival at a strange, modernist city of nine characters from a variety of social backgrounds. Although the audience never gets the opportunity to see within the city walls, we learn that the society represents a type of democratic socialist utopia which is 'entirely owned and run by the people who live in it; a place where men and women don't work for machines and money, but machines and money work for men and women'. The main thrust of the drama concerns the ideological debates between the various characters and their differing reactions to what the city represents.

The characters represent a cross-section of British society. The working class is represented by a waitress, Alice Foster (Googie Withers), a charwoman, Mrs Batley (Ada Reeve) and a ship's hand, Joe Dinmore (John Clements). The lower middle class is represented by a bank employee, Malcolm Stritton (Raymond Huntley), and his wife Dorothy (Renée Gadd). There is a businessman, Cudworth (Norman Shelley), while the upper class are represented in the characters of Lady Loxfield (Mabel Terry), her daughter, Philippa Loxfield (Frances Rowe) and the aristocrat Sir George Gedney (A. E. Matthews). The film's narrative serves to subdivide the characters according to their background and status. Mrs Batley, Dinmore and Alice are all presented as battling to overcome their material circumstances and their shared experience is one of struggle and hardship. Dinmore is seen losing a fight aboard a ship after he criticises the owners, Alice has quit her job and Mrs Batley, suffering from old age and rheumatism, complains about her unending work. These three individuals are contrasted with the remaining characters from the middle and upper classes, all of whom are seen to lead more comfortable lives. Cudworth and Gedney talk about banks and the economic system and are represented as greedy and selfish stereotypes. Gedney is a depiction of the leisured aristocracy, out of touch with the social realities of those not from his class background, who acknowledges his misanthropic nature at the end of the film when he admits that he 'can't stand people'. Cudworth, on the other hand, regards the city as a business opportunity, seeking out the prospect of making some money. His greed is established when Dinmore asks what he needs money for and the businessman responds 'to make more money'.

It is not merely Cudworth's greed that is established at this point as the film utilises his attitude to establish a broader perspective on the materialistic nature of big business, allowing Cudworth's micro-story to comment upon the macro-issue of capitalist production. The film here implies that the economic system is utilised to accumulate profits, rather than provide for the needs of the people, in direct contrast to the society which the unseen city

(left) Nine characters articulate nine different responses to the socialist utopia and (right) the gate to the 'New Jerusalem' in *They Came to a City* (1944)

represents. Dinmore immediately recognises Gedney and Cudworth as 'typical specimens of the boss class' whose desire to 'grab, grab, grab' is their main motivation in life. Later, when Cudworth explains that he is an individualist, Dinmore responds by calling him a 'pirate', confirming Ealing's promotion of community values which, in films such as *Passport to Pimlico* (1949), *The Blue Lamp* and *Cage of Gold* (both 1950), would often equate material self-interest with criminality.

When Lady Loxfield first arrives at the city ramparts she stresses that 'we must all stick together', evoking the spirit of the people's war, which the remainder of the film will dismantle. Immediately the characters are brought together, a subdivision of the group and various alliances and tensions occur along class lines and these hierarchies are reinforced by the characters' later reactions to the city. Mrs Batley, sensing an opportunity to escape from her back-breaking labour, chooses to remain in the city, but Dorothy Stritton, Gedney, Cudworth and Lady Loxfield are all united in their hostility to the society they have witnessed. Lady Loxfield rejects the city because she would lose her aristocratic privileges, whereas Cudworth dislikes the society because it has called him a 'criminal'. They are immediately joined by Alice who, like Mrs Batley, has fallen in love with the city and its inhabitants and cannot understand why the others do not share her enthusiasm. When Dorothy expresses a desire to burn the city down, Alice reveals her latent revolutionary nature, responding vehemently:

> I could kill you for saying that. I was having the best day of my life. I was among people who were happy and I was happy. I was in a wonderful place and all you can do is spit on it. ... I didn't think that people could work together and play together like these people can. I'd do anything for these people. I'd die for these people.

There are two notable exceptions to a class-based analysis of the characters' reactions towards the socialist city. Philippa Loxfield, torn between wanting to stay and her loyalty to her overbearing mother, finally opts to remain, whereas the bank employee, Malcolm Stritton, is finally convinced to return home by his wife after initially deciding to stay.

78 *EALING REVISITED*

In depicting his positive reaction to the city, Stritton becomes Ealing's embodiment of that section of British society that was motivated to support the Labour government's ambitions towards a 'New Jerusalem'. For Alan Burton, Stritton represents the lower middle classes who were 'radicalised in wartime Britain' and 'like Balcon and his colleagues voted Labour for the first time in 1945'.[14] However, the dream of building the New Jerusalem is articulated most explicitly in the film by Joe Dinmore. At the outset, Dinmore represents the world-weary and cynical section of the working class who see the need for change but doubt its possibility. Soon after arriving at the ramparts, Joe and Alice gaze down towards the city and Alice asks, 'What if there is something wonderful down there, something different?' But Dinmore remains sceptical. 'I've seen places before,' he says, but rather than offer hope he describes the poverty he has witnessed with 'poor devils sitting about in rags' and 'kids crawling around the gutters with their faces covered in sores'.

Dinmore, initially at least, is the embodiment of the defeated radicalism of the 1930s. Although there is no suggestion that he fought in Spain, as has been suggested by Philip Kemp,[15] Dinmore does articulate the left's sense of defeat nevertheless. Spain, Germany and Italy had degenerated into reaction and fascism, leaving Dinmore as 'a revolutionary who can't believe in the revolution', reflected in his description of his ideological position as being 'nowhere'. Dinmore advances his personal ideology when he explains, 'I can't believe in the revolution because I've gone sour. ... The conditions are stinking, the system's bad but that still don't convince me that people can make anything good together. It just doesn't seem to happen that way.' However, the New Jerusalem within the city walls finally rejuvenates the revolutionary fervour within Dinmore, as he convinces Alice to return home and fight for social justice. Freed from his previous cynicism, Joe enthuses that he has witnessed 'a city full of happy people, healthy people and busy people. A real civilised city – a real city at last.'

The film concludes with one of the most stirring and passionate revolutionary calls to arms that the British cinema has ever dared to express. Alice describes the society that they must return to as 'a dogfight around a dustbin', before Joe makes his politically trenchant speech:

> It'll be a hard road. Some of them will laugh and jeer just 'cos they don't wanna understand. They're frightened of losing some miserable advantage they've schemed and worked for. They don't wanna lose the whip-hand they've got over somebody. They'd rather have their little privilege and prestige and an ashpit than take a chance and share alike in a new world ... We'll keep on hoping and every time we see a spark of vision or hope in anybody we'll blow it into a blaze. They'll say we can't change human nature, that's the oldest excuse in the world for doing nothing and it isn't true. We've been changing human nature for thousands of years and what you can't change ... is man's eternal desire and vision and hope of making the world a better place to live in ... Not every man or woman wants to ... cry out for it, to work for it, to live for it, if necessary to die for it. But there's one here and one there ... until you see there are millions of us – armies and armies of us – enough to build ten thousand new cities.

The *Daily Worker* described *They Came to a City* as 'one of the most enterprising efforts ever made in the British cinema ... a very definite reminder that the new Britain must be fought for and won despite all obstacles and discouragement'.[16] The fact that *They Came to a City* received such lavish praise from the paper of the British Communist Party is evidence of how far Ealing had travelled politically during the war years, securing Ealing's progressive

credentials and continuing the studio's endorsement of social democratic values. In its rejection of consensus, *They Came to a City* radicalises Ealing's political impulse evidenced in *The Proud Valley* and *San Demetrio, London* to such an extent that it becomes *the* most explicit statement in favour of fundamental social and political change made at the studio. The hostility displayed between the characters who gather at the city gates is the antithesis of consensus and a far remove from previous depictions of social unity and togetherness typical of both Ealing and British cinema in general during the war period. By foregrounding the issue of class division at the expense of national unity, *They Came to a City* champions what Ealing previously had only dared to hint at, showing the studio at its most defiantly idealistic and left-wing standpoint – a far cry from the cosy and consensual orthodoxy associated with much of the studio's output.

After *They Came to a City*, Ealing produced *Passport to Pimlico*, a film that manages to both nostalgically yearn for the unity of the war years while also progressively looking forward to comment upon the nature of the new postwar society that the Labour government was attempting to shape. Although not as radical, *Passport to Pimlico* does share certain similarities with *They Came to a City* as both films uphold Ealing's endorsement of the social democratic values that had begun to emerge as a consequence of the ethos of the people's war. By 1945, Ealing, like much of the rest of the nation, had made its political journey – via the consensus and unity of the war years – to stand at the walls of a prospective new city. They had, in Balcon's words, 'voted Labour for the first time'. Within their social and political engagement with issues of class and democracy, *The Proud Valley*, *San Demetrio, London* and *They Came to a City* show the studio in its most radical and progressive light. Collectively, the three films I have examined in this chapter are the most representative expression of Michael Balcon's – and Ealing's – 'mild revolution'.

7 DARK SHADOWS AROUND EALING

Robert Murphy

Disaster was never far away ... Robert killed himself with drink. Angus died a lonely death. Michael Truman committed suicide. Charles Frend never made another film after the friendly gates of Ealing closed, and a lifetime passed before Charles Crichton's great comeback. Sandy McKendrick directed one great American film 'The Sweet Smell of Success' then, plagued by ill health, retired to an academic post in California. For a time it seemed that Basil and I had survived in the outside world better than everybody – then Basil was killed in a car accident. (Michael Relph)[1]

Mavericks in the Mainstream

When I began thinking about this essay, I was planning to travel the route mapped out by Charles Barr, exploring how the films of Robert Hamer and Sandy Mackendrick presented a troubled alternative to the cosy ethos that seemed to envelop Ealing. Hamer's grim Victorian drama *Pink String and Sealing Wax* (1945), his less than jolly East End panorama *It Always Rains on Sunday* (1947) and his ruthless black comedy *Kind Hearts and Coronets* (1949), though not as deeply steeped in Stygian gloom as *The Spider and the Fly* (1950) and *The Long Memory* (1952), which he made outside Ealing, have little of cosiness about them. And Mackendrick's four comedies – *Whisky Galore!* (1949), *The Man in the White Suit* (1951), *The Maggie* (1954) and *The Ladykillers* (1955) – are more cruel than whimsical. Charles Drazin asserts that 'Balcon's belief that films should somehow be improving meant that the darker side of life was neglected at Ealing.'[2] But the bright, cheery Ealing which Hamer and Mackendrick supposedly rebel against and subvert now looks increasingly tarnished and difficult to define.

According to Barr, the mainstream of Ealing is represented by Charles Crichton, Charles Frend and Basil Dearden:

> These three stay at least fifteen years and between them direct forty-three films, close to half the entire Ealing total from 1938. They are continuously active on a wide range of projects without establishing any immediately identifiable consistency of theme or style.[3]

The idea that Ealing films have a group identity was not something invented by Barr. As early as 1951 Francis Koval, sitting in on one of Ealing's round table meetings, asked how it was that 'all the Ealing films (even the bad ones) had something distinctive about them, a signature immediately recognisable not only by the specialised film critic, but by the public at large'.[4] Robert Hamer, about to direct his disastrous fourth film at Ealing, *His Excellency* (1952), and leave the studio to pursue his journey to self-destruction, chirped up:

> the explanation may lie in the fact that we all – as it were – belong to the same film generation and consequently have the same general approach. We have all started at Ealing and have shared the same experiences for at least 5 or 10 years.[5]

This was met with general agreement, except from Charles Crichton, who disagreed with the whole idea of a studio identity:

> I don't accept the premise of this discussion implying that all our pictures have the same 'signature tune'. Bob's personal style is as different from mine as Charles Frend's from Basil's. We choose different kinds of subjects and treat them in a completely different way.[6]

Hamer the team player, Crichton the idiosyncratic auteur? Hamer is generally cast as a troubled genius who found it impossible to work within Ealing's narrow suburban confines; Crichton is supposed to have unquestioningly accepted the studio ethos.[7] But things are more complicated. Certainly after *Kind Hearts and Coronets* Hamer grew restless, and he was unable to persuade Balcon to back the projects he had lined up. But, apart from Charles Frend, he was Balcon's most favoured director. Along with Cavalcanti and Frend, Hamer helped to establish the fusion of documentary and entertainment in stories of everyday heroism and British indomitability such as *The Foreman Went to France* (1942) and *San Demetrio, London* (1943) that marked Ealing's contribution to wartime cinema. Balcon made every effort to keep Hamer at the studio and after Ealing's demise gave him his last chance with the MGM-backed *The Scapegoat* (1959).[8] Crichton, the only one of the five key directors not to work with Balcon after Ealing closed, was much less indulged and there are strange twists and turns in his Ealing career.

When Charles Barr published *Ealing Studios* in 1977, British cinema was still despised, neglected and under-explored. Now it is not difficult to disentangle the identity of Dearden, Frend and Crichton, the three 'mainstream' directors and identify consistency in their themes and styles. Collaboration was an essential ingredient of Ealing's success as a studio, but Crichton is right: individual 'signatures' are easy enough to decipher. It might be excusable to misremember Crichton's *The Divided Heart* (1954) as a Frend film, and parallels can be drawn between Crichton's last Ealing film *The Man in the Sky* (1957) and Frend's only major feature after leaving Ealing, *Cone of Silence* (1960), but they are very different directors. Crichton's facility for comedy is never emulated by Frend and Crichton hasn't the gravitas to handle Frend's patriotic epics. Some of the routine assignments accepted by Basil Dearden might have been directed without too much disturbance by one of his colleagues – *Out of the Clouds* (1955), for example, by Crichton, *The Gentle Gunman* by Frend; and either of them might have had more luck with the disappointing Benny Hill comedy *Who Done It?* (1956). But Dearden leaves a very distinct mark on films as varied as *Frieda* (1947), *Saraband for Dead Lovers* (1948), *The Blue Lamp* (1950), *I Believe in You* (1952) and *The Square Ring* (1953), and it is not one shared by other Ealing directors.

Crichton started off the comedy cycle with *Hue and Cry* in 1947, scored one of its greatest successes with *The Lavender Hill Mob* in 1951 and signalled its decline with *The Titfield Thunderbolt* in 1953. Few dark shadows here, but Crichton starts to seem less sunny and more complex once one looks at *Against the Wind* (1948) – a surprisingly harrowing film about European resistance to the Nazis – and his 1952 non-Ealing film *Hunted*, with its vision of a bomb-shattered, selfishly insular Britain. After *The Love Lottery* (1954), an effervescent musical comedy which Balcon detested and subsequent critics have dismissed, he made only two more films for Ealing – *The Divided Heart* and *The Man in the Sky* – both of them intensely serious, both extensively shot on location.

Charles Frend is now the most neglected of Ealing directors, though he was highly regarded by Balcon. *The Foreman Went to France*, *San Demetrio, London* and *Johnny Frenchman* (1945) were followed after the war by a trilogy – *The Loves of Joanna Godden* (1947), *Scott of the Antarctic* (1948) and *The Cruel Sea* (1953) – which best represent Balcon's plans for Ealing to make ambitious films celebrating Britain and the British character. In *The Long Arm* (1956), the last film Frend made before Balcon sold the studio and decamped to Borehamwood, the hero is a Scotland Yard detective and even the crook and his wife are middle class. But like his earlier, unfairly neglected films *The Magnet* (1950), set in the leafy suburbs of Birkenhead and the still bomb-damaged Liverpool docks, and *Lease of Life* (1954), *The Long Arm* seems to capture a feeling for British society at a particular moment of time with extraordinary resonance.[9]

A feeling for British society at a particular moment in time: Jack Hawkins in *The Long Arm* (1956)

There are pools of darkness in the Frend and Crichton films, but a much more pervasive gloominess settles around most of Dearden's films. Dearden (and his producer partner Michael Relph) made twenty-two films at Ealing, if one includes Dearden's contributions to *Dead of Night* (1945) and *Train of Events* (1949) and Relph's *Davy* (1957). None of them star Alec Guinness, none of them between *My Learned Friend* in 1943 and *Who Done It?* in 1956 are comedies. The group of films they made between 1945 and 1955 – particularly *The Captive Heart* (1946), *Frieda*, *Saraband for Dead Lovers*, *The Blue Lamp*, *Cage of Gold* (1950), *Pool of London* (1951), *The Ship That Died of Shame* (1955) and their episodes of *Dead of Night* and *Train of Events* – combine lushly melodramatic sequences with others characterised by a restrained realism. Their penchant for frenzied melodrama barred them from critical approval until the 1990s when critical preferences for realism over melodrama were reversed.[10]

The Strange Case of Alberto Cavalcanti

Writing about Robert Hamer's 'Haunted Mirror' episode of *Dead of Night*, Barr claims that 'Ealing does not enter this dark world again. It accepts constraint on energy: all kinds of energy, including sexuality and violence … Energy is sublimated into community spirit, social activity.'[11] This seems puzzling, even given Barr's exemption for the work of Hamer and Mackendrick. Sexuality and violence erupt disturbingly in several of Dearden and Relph's films – particularly in *Frieda*, *Saraband for Dead Lovers*, *Cage of Gold*, *Pool of London* and *The Ship That Died of Shame* – and their tendency towards chiaroscuro lighting, distorting angles, troubled characters and complex plots involving flashbacks and time shifts have encouraged critics to see them as crucial exponents of a British form of film noir.[12] Balcon's insistence on social responsibility and an avoidance of the sensational hampered Hamer, who had to go outside Ealing to make *The Spider and the Fly* and *The Long Memory*. But the crucial loss after 1945 is Alberto Cavalcanti, who directed two of the episodes of *Dead of Night*, 'The Christmas Party' and 'The Ventriloquist's Dummy'.

Cavalcanti joined Balcon at Ealing in 1940. He had achieved international acclaim for his city symphony *Rien que les heures* (1926), and pursued a successful career in the commercial French film industry before accepting an offer from John Grierson to work with the GPO Film Unit. Although he directed a handful of documentaries – notably *Pett and Pott* (1934) and *Coal Face* (1935) – his most important role was in inspiring and teaching the bright but inexperienced young film-makers Grierson had recruited. He encouraged avant-garde experiments – in *The Fairy of the Phone* (1936) and *Night Mail* (1936), for example – but was particularly interested in combining fictional narratives with actuality material performed by non-actors based on their own characters. The story-documentary was a form which proved particularly effective in wartime, reaching a peak of achievement in Harry Watt's *Target for Tonight* (1941), Jack Lee's *Close Quarters* (1943), Humphrey Jennings's *Fires Were Started* (1943) and Pat Jackson's *Western Approaches* (1944). At Ealing, Cavalcanti experimented further with Hamer, Watt, Crichton, Dearden and Frend to fuse documentary and fictional forms in films such as *The Foreman Went to France*, *The Bells Go Down* (1943), *Nine Men* (1943) and *San Demetrio, London*.

Balcon was inordinately proud of these films and Cavalcanti assumed a highly influential position at Ealing. According to Michael Relph:

It was he one had to get on one's side if we hoped to get a project approved. This was surprising in that Cav, as we called him, remained obstinately foreign – his English was almost incomprehensible – and his homosexual bohemianism might have been expected to offend Balcon's straight laced principles.[13]

Balcon valued Cavalcanti highly as a producer and organiser; he was less sure of him as a director. *Went the Day Well?* (1942), the first feature Cavalcanti directed at Ealing, disturbed Balcon and a majority of film critics with the savagery of its violence and its depiction of Germans as boorish and brutal.[14] His next two films were equally idiosyncratic but found a warmer reception. *Champagne Charlie* (1944), a carnivalesque celebration of popular culture, was made when the end of the war seemed in sight, and in Tommy Trinder's jovially cynical 'Everything Will be Lovely When the Pigs Begin to Fly' Cavalcanti perfectly captured the mood of muted optimism. *Dead of Night*, a macabre set of cleverly interlinked ghost stories, chilling though it was, impressed critics and pleased audiences. Barr is fascinated by the 'Haunted Mirror', but it was 'The Ventriloquist's Dummy' (based on Gerald Kersh's short story 'The Extraordinarily Horrible Dummy') that attracted most critical acclaim.

At what ought to have been a highpoint for Cavalcanti at Ealing, things started to go wrong. A return to Europe to supervise the location sequences of Dearden's *The Captive Heart* left him depressed and unsettled by the extent of the poverty, corruption and devastation he witnessed.[15] He was eager to continue his career as a director, but while his protégés all embarked on excitingly original films – Watt's *The Overlanders* (1946),

Ealing noir: Michael Redgrave in the most celebrated of Cavalcanti's episodes in *Dead of Night* (1945), 'The Ventriloguist's Dummy'

Crichton's *Hue and Cry*, Frend's *The Loves of Joanna Godden*, Dearden's *Frieda*, Hamer's *It Always Rains on Sunday* – Cavalcanti was saddled with an uninspired adaptation of Charles Dickens's *The Life and Adventures of Nicholas Nickleby* (1947).[16] Balcon – with some misgivings about the unsavoury subject matter – released him to make a film outside Ealing.

They Made Me a Fugitive (1947) embraced everything that Ealing cast out – a reckless and irresponsible hero, a blatantly sexy heroine (cool blonde Sally Gray), cruel violence (particularly against women), an unsavoury murder plot, a dangerously fascinating villain and a refusal to allow justice to triumph in the end. Though the film was highly successful at the box office and attracted good reviews in the trade press, 'quality' critics were outraged. Arthur Vesselo in *Sight & Sound* called it 'a tale of sordidness, corruption and violence almost unrelieved' and despite the fact that it was 'horrifyingly well-made', detected 'an unpleasant undertone, a parade of frustrated violence, an inversion and disordering of moral values, a groping into the grimier recesses of the mind'.[17] After the war, critics were concerned that the proliferation of spiv films and disturbing psychological melodramas uncovering the sordid underbelly of British society would endanger the project of building a better and brighter Britain.[18] But traumatic memories of the war combined with a traditional British fondness for dark and bloody melodrama to seep into the cinema of the period, and Siegfried Kracauer warned in his influential *From Caligari to Hitler* that cinema could amplify rather than exorcise those traumas.

Balcon was anxious to keep negative tendencies at bay. As he told Francis Koval: 'none of us would ever suggest a subject, whatever its box-office potentialities, if it was socially objectionable or doubtful'.[19] But there was a narrow dividing line between a commitment to realism and an unhealthy fascination with the dark side of life. *They Made Me a Fugitive* fell on the wrong side: Paul Dehn, generally a perceptive critic who went on to write the screenplays for *Goldfinger* (1964) and *The Spy Who Came in from the Cold* (1965), complained that 'Cavalcanti, one of our best directors of documentary turned suddenly bacteriologist – hauling muck to the surface and smearing it, for our minute inspection, under glass.'[20] By contrast Hamer's *It Always Rains on Sunday* was acceptable because of its meticulous attention to realist detail. Dehn enthused 'This bedroom lives because of its eiderdown; that front door, because of its post-war scaffolding; this wall because it has a cat on it; that newspaper, because the house-number has been pencilled on its top right-hand corner.'[21]

Barr argues that while Ealing was in tune with a society intent on consensus and communal values its mainstream films, such as *Passport to Pimlico* (1949) and *The Blue Lamp*, were resonant and significant. As the vision of a benevolent, egalitarian society faded and the spread of affluence and social tensions became more apparent, Ealing's films became introverted, nostalgic, timid, backward looking, tetchily hostile to new trends. But this is based on a very selective reading of the films and premised on a general decline in film-making creativity in the 1950s which is more evident outside Ealing – in the films of Powell and Pressburger and Launder and Gilliat, for example – than in. At Ealing, Mackendrick's emergence as a major director compensates for the loss of Hamer, and Frend, Dearden, Watt and Crichton obstinately refuse to show evidence of decline.[22]

Undoubtedly the team was weakened by the departure of Cavalcanti and Hamer, and had they stayed they might have added a sharper edge to Ealing's profile. But Balcon, under siege from Sir John Davis and his minions, determined to extract their pound of flesh for the deal Rank had signed with Ealing to guarantee its future, would have found it difficult to appease these two increasingly erratic and ambitious talents.[23] He was sensible to veto the three

projects Hamer had lined up to follow *Kind Hearts and Cornets*: a Soho melodrama likely to attract unfavourable attention after the furore over *No Orchids for Miss Blandish* (1948); a film about the Thompson-Bywaters murder case, starring Margaret Lockwood, which would have faced stiff competition from David Lean's similarly themed *Madeleine* (1950); and an adaptation of Richard Mason's *The Shadow and the Peak* to be shot on location in the West Indies with the temperamental Vivien Leigh. Probably to Balcon's relief after the expensive budget overruns on *Saraband for Dead Lovers* and *Whisky Galore!*, Ealing's earlier ventures outside the studio, Rank showed itself lukewarm in supporting such a big-budget, risky project. According to Harry Watt, when he heard the news that the film was not to go ahead, 'Robert Hamer went on the bottle, and he never recovered.'[24] This is a slight exaggeration as Hamer still had fourteen years and seven films to go, but refuge in drink in an industry where such disappointments were endemic proved fatal.[25] His subsequent films – apart from *The Spider and the Fly* and *The Long Memory* – only flickeringly display the talent revealed at Ealing, and at the end of the decade Balcon had difficulty convincing MGM that Hamer was capable of directing *The Scapegoat* without alcoholic assistance.

Cavalcanti achieved even less. *They Made Me a Fugitive* could perhaps have taken him to Hollywood, where other mavericks – Lang, Welles, Tourneur, Siodmak – were making brilliantly inventive films noirs. Instead, he stayed in Britain to make *The First Gentleman* (1948), a flaccid stage adaptation about the antics of the Prince Regent comparing poorly with Dearden and Relph's *Saraband for Dead Lovers*, which presents a much sharper picture of Hanoverian shenanigans. Raymond Durgnat praises *For Them That Trespass* (1949), his final film in Britain, 'for its mood of diffuse guilt and for Cavalcanti's sense, quite worthy of Carné, of the sad poetry of squalid, smoky streets'.[26] But in terms of performance, story, production values (it was made at ABPC's second-string Welwyn Studios), emotional resonance and plausibility it hardly matches Dearden and Relph's more clearly focused and better cast *Cage of Gold*.

Dark Realism

Cavalcanti saw realism as an essential element of the 'cinematic', 'a form of expression specific to the cinema'.[27] His protégés at Ealing had their own ideas on how realism should be handled. Frend had a tendency to cloak dramatic events in a patina of technical detail. In *The Cruel Sea*, the attempt to sink a U-boat is so concentrated on the problem of pinpointing its whereabouts that it only gradually becomes apparent that the real drama is over whether Ericson will choose to drop depth charges that he hopes will sink the U-boat – but that will certainly kill the shipwrecked seamen who are floating above it waiting to be rescued.

Dearden and Relph courted critical disfavour by spicing their realistic stories with melodramatic incidents. *The Captive Heart* was praised for its depiction of life in a German POW camp, but the main plot, in which a Czech soldier corresponds with (and falls in love with) the wife of the dead British officer whose identity he has stolen, was criticised as 'phony'.[28] *Frieda* was condemned for vitiating its attempt to tackle the serious issue of whether Germans should be forgiven with highly wrought sequences such as the unmasking of Frieda's brother as a Nazi and Frieda's attempted suicide. *The Blue Lamp* confounded expectations and disrupted the flow of the narrative by having Jack Warner's kindly copper PC George Dixon gunned down by a young hoodlum less than halfway through the film.

Mother and child reunion: Yvonne Mitchell and Martin Stephens in *The Divided Heart* (1954)

Crichton's Ealing films are only melodramatic in jest – the spooky shadows and sinister voices in *Hue and Cry*, the absurd car chase at the end of *The Lavender Hill Mob* – and by taking on the mantle of documentary realism when other directors were casting it aside, he condemned himself to critical oblivion. Barr dismisses *The Divided Heart*, the last film Crichton made at Ealing before it closed, as 'sober, academic, actressy, afraid of getting into any deep emotional water'.[29] But this is an upside-down way of looking at things. Cornell Borchers and Yvonne Mitchell give finely tuned performances as German and Slovene women who both claim a refugee child, and the film is cleverly structured to swing our sympathies between them. But Crichton's refusal to wallow in 'deep emotional water' in a story that inevitably generates pathos is one of the film's strengths. In *Hunted*, the odyssey of a child and a murderer through a Britain still in the throes of postwar austerity, the boy (Jon Whiteley) has to be endearing, a little lost and lonely, for Bogarde's killer to soften towards him and start seeing him as a responsibility rather than a burden. In *The Divided Heart* the boy is older – an annoyingly pushy ten-year-old – who effectively undercuts the heart-wringing torment of his two mothers. But in an ending which eschews sentimentality, he proves his resilience by leaving his idyllic family life in the Bavarian Alps to go off with a woman he hardly knows on a hazardous journey to a new life behind the Iron Curtain.[30]

The six films made at MGM's Borehamwood Studios after Balcon sold the studios to the BBC in 1955 are generally dismissed as a sad reminder of glories past, the final proof that Ealing's day was done.[31] The last two comedies, *Barnacle Bill* (1957) and *Davy*, haven't much sparkle, and Leslie Norman's *Dunkirk* (1958) and *The Shiralee* (1957) have yet to find their

champion. But the other two films, Seth Holt's *Nowhere to Go* (1958) and Crichton's *The Man in the Sky*, are among Ealing's finest.³² If *Nowhere to Go* looks forward to the rebellious realism of the British New Wave – a jazzy score (unprecedented in an Ealing film), an anti-hero, a disrespect for authority, an unresolved ending – *The Man in the Sky* is true to the older realist tradition that emerged during the war years.³³

Jack Hawkins's John Mitchell, like his Commander Ericson in *The Cruel Sea*, Superintendant Halliday in *The Long Arm* and Jim Fletcher in *Touch and Go* (1955), is a harried professional doing a difficult job. The story has a documentary-like quality enhanced by the extensive location shooting and the large, convincing aircraft interior set built at Borehamwood. Mitchell takes up a huge freight plane – loaded with a tractor and a Rolls-Royce – on a test flight. An engine catches fire and the crew and the plane's prospective buyer attach their parachutes and bail out. Mitchell puts the plane into a steep dive which quells the fire but he has too little control to make a safe landing. Knowing that the plane is uninsured and that its loss will mean the end of the company (and his job) he refuses to bail out. He is persuaded that he can boost his chances by burning off fuel and reluctantly agrees to circle the airfield for thirty-five minutes.

An anti-hero, a disrespect for authority, an unresolved ending: George Nader in *Nowhere to Go* (1958)

Here the film diverges from convention. Crichton stays in real time and refuses to fill it with flashbacks to wartime experience, memories of domestic bliss, or explanations of what might have caused the fire. Instead we are made to share Mitchell's fear and frustration as he sits at the controls of the wobbling, creaking plane, cutting away only to the control tower and the airfield where everyone has stopped work to gaze up at the circling plane. We are only allowed further afield for a brief but vital scene where Mitchell's wife confesses to her mother her anguish at being married to a test pilot and gets a call from the female canteen manager who tells her – after all the men refuse to – what her husband is doing.

The Man in the Sky is the sort of film that any national cinema ought to be proud of – sophisticated, economical, emotionally engaging, entirely convincing in character and action. Like Frend's *The Magnet* and Mackendrick's *Mandy*, it is a very middle-class film, the type of film Lindsay Anderson condemned for being 'emotionally quite frozen' (though his specific example was Hamer's *Kind Hearts and Coronets*).³⁴ Although it is set in the industrial Midlands, *The Man in the Sky*, with its modern semi-detached houses and a network of shops which includes a laundrette, is a world away from the working-class environment of the British New Wave films such as *Saturday Night and Sunday Morning* (1960), less than fifty miles away in Nottingham. If it initially seems emotionally frozen, cataclysmic cracks appear before the film ends. In *The Long Arm*, Halliday's wife is played by Dorothy Allison as a sensible, patient, supportive woman who gets annoyed when he doesn't phone her to tell her he'll be late for dinner but is otherwise resigned to her unhappy lot as a policeman's wife. Elizabeth Sellars' Mary Mitchell is a different kettle of fish entirely.

Sellars' intense, edgy beauty generally meant that she was cast as a bad woman. She is an adulterous wife in *The Shiralee* and *Hunted*; a fickle femme fatale in *The Gentle Gunman* and Hamer's *The Long Memory*. She reassures Mitchell that nothing is wrong, that she doesn't mind the fact that he can't provide her with the home she wants and that he creates constant tension through his dangerous job. But her flashing eyes and Amazonian breasts

The sort of film that any national cinema ought to be proud of? Jack Hawkins in *The Man in the Sky* (1957)

tell another story. When, against all odds, he lands the plane safely, picks up the laundry basket from the laundrette and returns home as if nothing has happened, she explodes with fury. Mitchell has to abandon all traces of stiff-upper-lip restraint to prove to her that his motives were inspired by love as much as by duty. After all passion is spent, he suggests that they 'live dangerously', stumps up the money for a house, and arranges to take Mary and her mother out for a meal. The emotional truth is as exact as that in *The Blue Lamp*, where Mrs Dixon learns that the husband she was getting ready to visit in hospital has died.[35]

The end of Ealing forced the team of directors (and everyone else who had enjoyed permanent and secure employment at the studio) to live more dangerously. Few of them fared well. The dark shadows around Ealing proved more welcoming than the bright lights of 'Swinging London', where the gentle comedy and sombre realism which had served Ealing so well was out of place. The films made between 1946 and 1953 are marvellous evocations of Britain at the beginning of the 50s, still gripped by austerity and unrecovered from the battering of the war. A handful of the later films, particularly *The Ship That Died of Shame*, *The Long Arm*, *The Man in the Sky* and *Nowhere to Go*, are equally effective at delving into the problems of a more affluent society but one troubled by social discontents, pressures for social mobility and an uncertainty of purpose as the Empire disintegrated and the economy fell behind the more dynamic ones of former enemies Germany and Japan. Their sometimes deliberate, sometimes inadvertent inclusion of dark and disturbing elements make them able to project a more complex vision of Britain and the British character than one might assume.

8 SELLING EALING

Nathalie Morris

Ealing Studios' approach to marketing was typical of its wider approach to making films. Quality and Britishness, or a 'British idiom',[1] were key, even if this meant the occasional compromise of commercial considerations. The studio frequently commissioned artists to design its advertisements, posters, press campaign books and souvenir brochures with the result that, for many years, Ealing's marketing artwork, and particularly that for its posters, was as well known and often more highly regarded by cultural commentators than the studio's own films.[2]

Ealing's posters have been productively discussed in two notable publications, *Projecting Britain: Ealing Studios Film Posters*, edited by David Wilson and with an informative introduction by art historian and biographer Bevis Hillier, and Sim Branaghan's more recent monograph, *British Film Posters*. This chapter is inevitably indebted to their work, but also utilises a wide range of primary source material held within the BFI's Special Collections to consider Ealing's posters within the wider context of the studio's publicity efforts. As well as an extensive collection of Ealing Studios posters, BFI Special Collections also holds a wealth of promotional material such as press books and souvenir brochures, to say nothing of the rich and unique paper archives of a number of Ealing personnel. The Michael and Aileen Balcon archive, discussed by Janet Moat elsewhere in this volume, has been particularly valuable in providing insights into the strategies, practicalities and obstacles faced by the Ealing publicity operation. Given constraints of space, and the volume and diversity of Ealing productions over two decades, what follows is very much an overview of some different aspects of Ealing's publicity operations carried out not only by its own advertising and publicity departments, but also in conjunction with its distributors, most notably the Rank Organisation, who distributed Ealing's films between 1945 and 1955.

A key personality in Ealing's publicity work is Monja Danischewsky. As Michael Balcon recalled in his autobiography, at the very beginning Ealing had 'no such thing as a [publicity] department', but simply a 'Publicity Man'.[3] Danischewsky was a White Russian former art student and journalist who had some previous experience in film, having worked with Max Schach in the 1930s. He joined Ealing in 1938 and, as director of publicity, was responsible for the overall direction of Ealing's press and advertising for the next decade. He was mercurial, witty and highly influential; according to Ealing art director-turned-producer

Michael Relph, 'Balcon could not move without him.'[4] In 1943 Danischewsky added screenwriting to his portfolio and S(ydney) John Woods, who took on responsibility for advertising, became the driving force in the shaping of the look and style of Ealing's marketing materials – especially after 1948, when Danischewsky moved to production and the publicity department was restructured into two sections, with Woods as advertising director and Pat O'Connor as publicity director.[5]

Both Danischewsky and Woods were in tune with Balcon's own tastes and cultural inclinations, which were, in turn, in keeping with (or indeed ahead of) a general shift within British art and culture in the 1930s and 40s. With its sense of cultural responsibility and in its concern with the British character and way of life, the output of Ealing Studios can be viewed, as George Perry suggests, as one part of British cinema most in touch with the prevailing wider culture of the time, a connection which was reinforced by the artwork and design with which the studio chose to promote itself.[6] Many of the artists chosen for Ealing's publicity artwork were part of movements that explored and celebrated British art, architecture, topography and traditions,[7] and their involvement was able to manifest Balcon and Dansichewsky's contention that 'since British films have become popular by becoming British, the appeal of the film should be carried on in the appeal of the poster – i.e. the poster must be British in character too'.[8]

The Press and Publicity

In its first few years as a producer, however, the bulk of Ealing Studios' energy was directed towards press publicity rather than advertising material, especially during the early period when its film were being distributed by Associated British Film Distributors. Studio publicity was a task to which Danischewsky was perfectly suited. The relationship between the press and the film industry was, and remains to this day, an important one. Paid advertising was (and is) one dimension of this relationship, but from the late 1910s there was an increasing recognition that film publicists needed to court the popular (as opposed to the film trade or fan) press and make it as desirable and as easy as possible for newspapers to devote column inches to movies.[9] Crucial to this was providing stories about a film that could be reported as soft news. Like Danischewsky, many publicists worked as journalists before entering the film industry and this experience, and their connections, stood them in good stead in their subsequent profession. After his move to Ealing, Danischewsky would return to the pubs of Fleet Street at the end of the working day and entertain his journalist friends with tales of the studio and its personnel. He was delighted when some of these stories turned up in the papers, noting that 'this proved a very successful way of putting over the image of Ealing in the press'.[10] Michael Balcon's public profile as Ealing's father figure and figurehead was largely built up (although not made up) by Danischewsky, whose great affection for his boss, aided by Balcon's uncontrived ability to provide 'natural "copy" at almost every encounter' greatly assisted him in his work to promote the studio.[11]

As a good publicist, Danischewsky shamelessly exploited as many story angles as he could to catch the imagination and sell Ealing's films. Balcon's protégé, Penrose Tennyson, was never mentioned without reference to his youth (at twenty-six he was Britain's youngest feature film director when he made his debut, *There Ain't No Justice*, in 1939) or his family

(he was the great-grandson of the Victorian Poet Laureate, Alfred, Lord Tennyson).¹² Then, as now, glamorous young royals were also good for a story and coverage of the Princesses Elizabeth and Margaret visiting the set of *The Life and Adventures of Nicholas Nickleby* (1947) made its way into the trade press and into the film's promotional material. Occasionally, Danischewsky also needed to keep stories out of the press, as when the Beaverbrook press planned to castigate Paul Robeson for his pro-Russian comments around the time that *The Proud Valley* (1940) was due to be released, a move that would have adversely affected the film's box-office chances.

Danischewsky also shrewdly understood how important carefully thought out showmanship, excellent hospitality and an element of sentimentality could be in enlisting the goodwill of the press and securing positive write-ups for Ealing's films. He took pride in the fact that Ealing press shows were talked about and anticipated as events in themselves and firmly believed that a well-planned preview could redeem even an indifferent film. At the press launch of *Ships with Wings* (1941), described by Danischewsky as a 'bad film', he hosted a lunch beforehand and produced a 'wonderful old sailor' who made 'a moving speech' about his experience of watching the film. As a result, Danischewsky claimed that the studio 'got a much better press for it on the whole than we deserved and than we would have got had [the press show] been handled in an ordinary way'. Likewise, a sparkling and mood-setting party was thrown before the screening of *Champagne Charlie* (1944) and the result was a 'sensational press'.¹³ Danischewsky was convinced that the cost of such events was worth more in press reviews than if the same amount had been spent on newspaper advertising (he claimed that the cost of the *Champagne Charlie* party was equivalent to that of one newspaper advert).

Elizabeth and Margaret Rose visit the set of *The Life and Adventures of Nicholas Nickleby* (1947)

As well as creating (or preventing) news stories, the job of the publicist and his or her department also involved devising tie-ups and other angles for film exploitation. Some of these would have been dreamt up by Danischewsky and Ealing's publicity department and some would have come from the distributors who produced campaign books to help cinema exhibitors boost their ticket sales. Press campaign books had been around in one form or another since the 1910s and by the 30s were highly sophisticated and well put together promotional tools. They were produced to provide exhibitors with ideas for advertising films and included synopses, credits, photographs and biographies alongside stories about the making of the film, taglines, suggestions for competitions, fashion and beauty tips, and details of additional materials available, such as stills, trailers (produced by and made available through the National Screen Service),¹⁴ lobby cards, posters and blocks for reproducing images for flyers and the local press.¹⁵ Tie-ups and tie-ins were important, if sometimes bafflingly obscure and far-fetched aspects of many films' publicity campaigns.

Book tie-ins for novels adapted into films had been staple items since the 1920s. Novels were sometimes redesigned and reprinted to coincide with the release of a film but even when this was not the case, press campaign books would suggest that cinema owners collaborated with local booksellers for mutual promotional opportunities. The press book

Advertisement for *A Film in the Making*, a tie-in book about the production of *It Always Rains on Sunday* (1947)

for *Another Shore* (1948), for instance, highlights the film's source in 'Kenneth Reddin's best selling novel' and urges cinema owners to 'make early contact with their local bookshop'.[16] Likewise, the press book for *Saraband for Dead Lovers* (1948) promoted the reissue of the original novel, which had a new cover depicting the film's stars Joan Greenwood and Stewart Granger.[17]

Other potential product tie-ins with both luxury and everyday goods were also frequently exploited. *Another Shore* star Robert Beatty smoked a Bewlay pipe throughout the film, and stills of Beatty posing with his pipe were specially produced and sent to stockists of Bewlays in advance of the film's release. Danischewsky even recalled persuading perfumers to give their new scents the names of Ealing films such as *The Captive Heart* (1946) and *Dead of Night* (1945).[18] Tie-ins could also have a social purpose: in keeping with Ealing's patriotic efforts during the war, exhibitors were encouraged to contact the Ministry of Information to obtain 'careless talk' posters to promote alongside *Next of Kin* (1942), the plot of which hinged on the potentially dire consequences of verbal indiscretion.

Accompanying merchandising was also often produced. As well as novel tie-in editions, Ealing collaborated on some 'making of' books for films such as *It Always Rains on Sunday* (1947) and *Saraband for Dead Lovers*. Collectable lead figures were created by Argosy to tie in with *Saraband for Dead Lovers*, and a toy Barnacle Bill was made to promote the 1957 film of the same name. *Barnacle Bill* also had an accompanying Fontana record release of 'a startlingly novel arrangement' of Bill's hornpipe, recorded by harmonica player Tommy Riley and accompanied by a fourteen-voice choir, three percussion players and a harpist, while *Champagne Charlie* had a record featuring the film's star Tommy Trinder singing the title song, as well as 'The Man on the Flying Trapeze', 'Come on Algernon' and several more.[19]

A Style of their Own

Most of the above are quite typical exploitation strategies and are not distinct to Ealing, as can be seen from a survey of other press campaign books and/or cinema scrapbooks from this time.[20] Where Ealing blazed a trail, however, was in its use of artists and designers to produce poster and other artwork for the promotion of its films. This was a direction instigated in 1943 by Michael Balcon and ably executed by Danischewsky and S. John Woods, who were given a free hand to engage artists such as Edward Ardizzone, Edward Bawden, James Boswell, Barnett Freedman, James Fitton, Leslie Hurry, John Minton and John Piper. As Sim Branaghan observes, this was something quite new: 'Few serious artists had worked on film posters in Britain prior to the war, partly due to the cinema's downmarket image, and partly because of the relatively poor pay in comparison with the rates offered by "respectable" companies like London Transport and Shell-Mex.'[21] Ealing was willing to spend money on its posters, both in terms of artists' fees and printing processes; in the early 1950s the average cost of commissioning and printing an Ealing poster was around £500.[22]

The idea of combining art with commercial interests was not a new one, although this was the first time it had been seriously applied to the British film industry. Enlightened industrial patrons had worked with artists from the 1920s and 30s with striking results, with Frank Pick at London Transport, Jack Beddington at Shell and Stephen Tallents at the GPO serving as the visionary forebears of Balcon, Danischewsky and Woods at Ealing. Artistic advertising was seen to have a cultural purpose and was democratic in its reach to the widest possible public. Ealing's posters continued this tradition and the studio was consequently lauded in journals and annuals such as *Art and Industry*, *The Architectural Review* and *Modern Publicity* throughout the late 1940s and into the 50s.

The studio's new strategy was launched in earnest with the commissioning of artist, illustrator and typographer Freedman to design a trademark for the studio. This was confidently simple and highly distinctive, featuring just the name of the studio in hand-drawn serif capitals (Roman type for 'Ealing' and with 'Studios' italicised underneath), flanked by two straight sprigs of laurel and surrounded by a capsule-shaped border. The classical connotations of the laurel – enlightenment, artistry and achievement – say much about Ealing's quiet confidence at this time.[23] This becomes particularly apparent when contrasted with other film company logos or idents from the time. Alexander Korda's London Films featured the concertedly patriotic image of a towering Big Ben, while the Rank Organisation chose the unusual and quite literally striking image of Bombardier Billy Wells hitting an enormous gong. In comparison, Ealing's logo was quiet, static and simple. It was emblazoned onto the fabric of the studio itself and was incorporated into many films' opening titles, but despite this, and perhaps in typical Ealing style, rigorous and consistent branding was not the order of the day. A number of Ealing's post-1943 films do not feature the logo in their credits and it was not part of the design strategy for its posters. Indeed, a

completely different logo was used on some material concurrently produced by the Ealing's advertising department.

S. John Woods joined Ealing in September 1943, and was soon put in charge of advertising, where he continued and developed the strategy introduced by Balcon and Danischewsky.[24] Not yet thirty, Woods was a well-connected young man. He had worked for Fox, British Movietone News and the Soviet Film Agency but had also been a designer, art critic and journalist, and had met European artists such as Hans Arp, Brancusi and Picasso. He knew British painters and sculptors such as John Piper, Barbara Hepworth, Ben Nicholson and Henry Moore, and eight years before joining Ealing had successfully melded art and the cinema (albeit in a very different way) by organising an exhibition of their work in the foyer of the Hampstead Everyman Cinema and Theatre.[25] Woods now set about his new job with zeal and enthusiasm. From Ealing House on Oxford Street, and later from studios on Curzon Street,[26] he handled 'the creation and production of posters, advertisements and all publicity material'.[27] The process usually took around three months for each film and Woods oversaw all aspects of the job, from choosing, commissioning and guiding artists and draftsmen, to taking a close interest in the finer technicalities of the printing process.[28] Because film posters had (and have) a relatively short life in the public eye, he strove to make them distinctive, aiming for maximum impact while capturing something of the essence of the film. Woods told Bevis Hillier that:

> I decided which artists to commission, both in relation to their work and in relation to what I thought was the feeling of the film. Some of the artists, such as Bawden, were experienced in lettering. But some of them were purely painters, and with them I worked closely on the lettering. Apart from that, I wanted the artists to give their own interpretation of the subject.[29]

Having carried out some early commissions for Danischewsky in 1943 (for trade adverts for *The Silent Village* and an advertisement and a(n unused) poster for *The Bells Go Down*, both in 1943), John Piper produced posters for *Painted Boats* and *Pink String and Sealing Wax* in 1945 (see colour section), and illustrations for a brochure for *Frieda* in 1947. While the earlier commissions tapped into Piper's concurrent work as a war artist (his image of a smouldering and defiant St Paul's for *The Bells Go Down* is particularly effective), the later ones were in tune with his enduring passion for English architecture and folk art. The poster for the Brighton-set *Pink String and Sealing Wax* harks back to Piper's 1939 series of Brighton Aquatints and features a photographic image of Googie Withers superimposed in front of a row of Regency neo-classical terrace houses, all underneath a Piper-esque dark and ominously glowering sky. The poster for *Painted Boats*, a docu-drama of life on the canals, depicts a traditionally decorated narrow boat and incorporates a rubbing Piper had taken from a slate tomb in the Midlands.[30]

While Woods was closely involved in the development of designs (and indeed designed some Ealing posters himself), he also had respect for his artists and their work. When questioned by Bevis Hillier on the photomontage technique of the *Pink String and Sealing Wax* poster, he asserted, 'there would certainly have been no question of superimposing a photographic image on a drawing submitted by John Piper: that must have been part of his design'.[31] Likewise, Edward Bawden, who designed posters for *Hue and Cry* (1947) (see colour section) and *The Titfield Thunderbolt* (1953), recalled that he 'was given a completely free hand'.[32] Bawden was an experienced designer, illustrator and print-maker whose work included

wallpapers and textiles, book illustrations and dust jackets as well as a series of posters and ephemera for London Transport. His witty and whimsical line drawings and skill with lettering were used to good effect in his work for Ealing, although he later wondered if he should have been given a little more guidance. He did not see either of the films being shot, or even the finished product before designing the posters, but did acknowledge that as well as being sent stills he also made several visits to the studios.[33] Despite Bawden's reservations, Charles Crichton, director of *Hue and Cry*, was delighted with the poster Bawden produced, feeling that it perfectly captured the type of atmosphere that he had tried to create in the film.[34]

James Fitton, who designed the posters for *Kind Hearts and Coronets* (1949) and *Meet Mr Lucifer* (1953), recalled that for the former he 'went down to the studios at Ealing and made sketches. I also had lunch in a pub with Alec Guinness and some of the other actors, and made more sketches.'[35] Sim Branaghan notes that Ealing's approach and 'this kind of involvement was almost unique in a business where illustrators were usually thrown a handful of stills and told to get on with it'.[36]

Woods's aim for quality was frequently carried over to the putting together of handsome brochures and other promotional materials for particular films (made in addition to the campaign books created by the distributors). There are numerous examples of these within BFI Special Collections. These brochures often had specially commissioned artwork and were beautifully and imaginatively designed, pulling together images, credits, synopses and biographies into one aesthetically appealing package.

Sometimes the artist who designed the poster would provide a series of additional illustrations for brochures, as in the case of Ardizzone with *The Life and Adventures of Nicholas Nickleby* and *The Magnet* (1950), Edward Bawden with *The Titfield Thunderbolt* (1953), and James Boswell with *It Always Rains on Sunday*, *The Blue Lamp* (1950) and *Pool of London* (1951) (see colour section). On other occasions, Woods would commission and license appropriate complementary work. For example, John Bainbridge designed the poster for prisoner of war drama *The Captive Heart*, but Woods used drawings by war artist and former POW Lieutenant John Worsley in the brochure for the film. Ronald Searle provided cartoon illustrations for the *Whisky Galore!* (1948) brochure although the film's distinctive poster was designed by Tom Eckersley. Women artists were not prominent at Ealing but the illustrator Rosemary Grimble contributed a series of line drawing portraits to the brochure for *Kind Hearts and Coronets* (poster designed by James Fitton) (see colour section).

The Commercial vs the Cultural

During the 1940s and 50s Woods was widely respected by the artists with whom he worked as well as by other artists and the critical establishment. Balcon credited him with making Ealing's posters 'a by-word equal almost to the reputation held by London Transport in the same field'.[37] The Ealing approach to advertising was not always appreciated within the industry though, and Danischewsky, Woods and their successors often had to defend their choices to the studio's paymasters. When Ealing Studios was initially formed as a production company its films were distributed through Associated British Film Distributors. There was then a short stint with United Artists, after which Ealing Distribution was set up in 1943. It had been launched with an eight-page trade advertisement (designed and lettered by Barnett Freedman) announcing it as 'a new force, as up-to-date, as vital and as lively as the

Covering note for a memo on the Rank Organisation and publicity from Monja Danischewsky to Michael Balcon, 1948

> **Ealing Studios Ltd.**
> **MEMORANDUM** from M. Danischewsky to Sir Michael Balcon
>
> 5th March 1948
>
> Dear Mick,
>
> The enclosed report is intended as <u>private and confidential</u> to yourself to help brief you in your discussions with John Davis. Clearly it cannot be passed on to the R. Arthur Rank Organisation in its present form. If you so wish, I could draft out a second report which could be, but it must needs be a watered down affair, and I feel that verbal representations to John Davis by yourself would have much greater effect.
>
> Yours,
>
> Danny.
>
> *It's my Swan Song!*

films it will handle ... an independent organisation that is a prelude to the post-war reconstruction of our industry'.[38] By the end of the following year, however, Balcon and Reginald Baker had decided that a partnership with the rapidly expanding Rank Organisation was necessary to safeguard the studio's future. By this time Rank controlled two of the three major British cinema circuits (Gaumont and Odeon) as well as the largest rental concern, General Film Distributors (GFD), and a new organisation, Eagle-Lion, that had been set up to distribute British films internationally. The deal with Rank enabled Ealing to avail itself of the larger organisation's rental facilities and guarantee that its films would be shown in Rank cinemas (essential if they hoped to recoup their costs in the domestic market). Rank also provided 50 per cent (and later 75 per cent) of the budget for Ealing's films. Described by Geoffrey Macnab as something of an 'unholy alliance', and not without its problems over the years, the deal nevertheless allowed Ealing to retain a high level of independence in the films it would make.[39]

How Ealing's films would be marketed under this deal was a key concern and Danischewsky recalled that an important aspect of the contract with Rank was a protective clause allowing autonomy in advertising.[40] Nevertheless, the studio's distinctive style often caused friction with Rank as many of its poster images were seen to be wilfully

uncommercial. Rank executives were extremely keen on star portraits being included on a film's poster and this frequently led to wrangles with Woods's advertising department and the rest of the Ealing team. As Danischewsky told his boss in a wonderfully frank memo held in the Balcon papers, what Rank's John Davis liked best in a film poster was 'a large kodachrome reproduction of the star or stars, stressing the sex appeal if possible'.[41] It was only with difficulty that Danischewsky resisted demands for portraits of Michael Redgrave and Rachel Kempson to be placed inside the winged heart on John Bainbridge's design for *The Captive Heart*. James Boswell's design for *It Always Rains on Sunday* (see colour section) was violently objected to by Davis, who was baffled by the idea of the two women in the painting not representing actual characters from the film.[42] Alternative posters were sometimes produced, as in the case of *The Captive Heart* (albeit not with the portraits of the stars inside the heart) and *The Cruel Sea* (1953) (see colour section), which saw Charles Murray's dark and moody seascape being supplemented by an alternative Colin Walkins design which still featured a tumultuous sea but crucially added an audience-friendly portrait of the film's star, Jack Hawkins.[43] Ealing's disregard for commercial considerations in its advertising was part of a deliberate strategy on Dansichewsky's part, as he admitted in the *Penguin Film Review* in 1948. Following the example set by Shell, Guinness and others, this assumed a certain complicity between producer and audience/consumer and shunned hyperbole and the hard sell in order to overcome 'the natural English resistance to advertising'.[44] In this respect, Ealing's approach towards publicity was in line with its approach towards film-making as it actively attempted to set itself and its product up in opposition to long and firmly established American models.

Different approaches were used for selling Ealing overseas and the studio's distributors did have entirely new posters designed for overseas markets (although posters always needed rethinking in any case due to format differences between the British quad and, for example, the US one-sheet). These distributor's posters are much more in keeping with the style of other cinema posters of the time and generally feature the all-important star portraits. Many were designed and executed by commercial artist Dudley Pout, who worked for Ealing throughout the 1940s and, despite being dismissed by Bevis Hillier in *Projecting Britain*, they are not all without interest.[45]

In spite of clashes with Rank, the Ealing team stuck to their guns, demonstrating, in George Perry's words, something of the studio's 'steadfastness of moral purpose'.[46] The sense of a cultural imperative behind the Ealing posters comes through in Balcon's autobiography in which he wrote that 'despite every possible opposition from "the trade", meaning distributors and exhibitors' Danischewsky and Woods 'raised the whole level of cinema advertising'.[47] Ealing's advertising department came under increasing pressure throughout the 1950s, prompting Woods to leave in 1955. After the studio came under the wing of MGM matters further declined. Charles Goldsmith of MGM British told Baker and Balcon that 'the cost[s] of poster designs on the Ealing pictures ... are frightening and seemingly extravagant'.[48] In reply, Balcon asserted his continuing belief in quality advertising and observed that:

> The difference of outlook between distributors' publicity departments and studio publicity departments is by no means new. It is a pity, but it seems to be implicit in the relationship which exists between producers and distributors.[49]

Conclusion

By the time of Ealing's last film, *The Siege of Pinchgut*, in 1959, the studio, and particularly Monja Danischewsky and S. John Woods, had made a remarkable contribution to the business of promoting films. While demonstrating a lively and imaginative attitude to press and publicity it is the studio's advertising, and particularly its posters, that has really left a mark. Like its films, Ealing's advertising sought to move away from the American model and create a body of distinctively British work. Before Ealing, cinema advertising had generally been viewed as ephemeral and of little interest in terms of art and design. Although there are other contemporaneous British posters that exhibit comparable qualities of design, invention and execution, Ealing was exceptional in its dedication to, and the scale of its belief in, film promotion as art. By the late 1940s, the studio's activities were watched with interest by curators, critics and other practitioners who recognised that it was taking film advertising in a new direction, and, as Ealing was winding down, Balcon was able to write that there were distinct signs of improvement in other companies' poster design (he cited British Lion and the Rank Organisation as examples).[50] Although the style of Ealing's posters fell out of critical fashion by the 1970s – Bevis Hillier quotes critic Richard Cork describing them as 'wayward, idiosyncratic and risibly genteel'[51] – the revival in their reputation began in earnest from the 1980s and they are now highly valued by galleries and collectors.

As a final positive coda, it is also worth noting that, despite the widely bemoaned decline of the film poster since the 1980s, there are still some excellent posters being produced, albeit using different practical techniques. It is fitting that examples of these include posters by Sam Ashby who was commissioned for the recent rerelease of the Ealing classics *Went the Day Well?*, *Whisky Galore!*, *Kind Hearts and Coronets* (see colour section) and *The Ladykillers*. While offering a new take on each title, Ashby's posters are very much in the spirit of both the films and their original artwork and are helping to ensure that Ealing Studios' legacy of good film poster design remains alive.

9 GEORGES AURIC
EALING'S FRENCH DRESSING

Geoff Brown

In part I blame the plaque affixed to the front of Ealing Studios early in 1956, the year when Balcon's Ealing team departed and BBC Television moved in. 'Here during a quarter of a century were made many films projecting Britain and the British character': without that statement prodding us, film historians and scholars might have been more assiduous in widening their gaze beyond Ealing's projection of national character and seeking the studio's place within the context of European film-making. Balcon's studio might not have been a Tower of Babel to rival Alexander Korda's London Films at Denham in the 1930s, but foreign personnel, influences and accents still played a significant part in shaping some of Ealing's most canonical films. For periods long or short this was the studio address of the cosmopolitan Brazilian Alberto Cavalcanti; of Monja Danischewsky and Sergei Nolbandov, key Russian helpmates; of the Austro-German cameramen Mutz Greenbaum and Günther Krampf; of actresses Françoise Rosay, Mai Zetterling and Simone Signoret; and of the distinguished French composer Georges Auric (1899–1983).

Auric first earned fame in the 1920s as the youngest member of the musical sprites gathered together in Paris into the group Les Six. He wrote the music for nine Ealing films between 1945 and 1954, a greater number than any British-born composer in the Balcon period: 1945: *Dead of Night*; 1947: *Hue and Cry*; 1947: *It Always Rains on Sunday*; 1948: *Another Shore*; 1949: *Passport to Pimlico*; 1950: *Cage of Gold*; 1951: *The Lavender Hill Mob*; 1953: *The Titfield Thunderbolt*; 1954: *The Divided Heart*. Most of these are major Ealing films, among them several long regarded as trophy comedies in the studio's projection of a national image, a status that has encouraged one modern commentator, Jan Swynnoe, to find Auric's Ealing employment freakish, unsuitable to a studio she describes as 'the supposed bastion of Britishness'. About *Dead of Night* Swynnoe writes: 'What contribution could a member of Les Six be expected to make to such a production that would in any way enhance its peculiarly British idiosyncrasies?' Her underlying drift seems be that only British passport holders should have scored Ealing's films; possibly someone with an English pastoral name like John Greenwood – a well-established film composer whose tally of Ealing scores only reached six. Further incriminating aspects listed by Swynnoe include the distracting density and complexity of Auric's musical textures (admittedly an occasional

Georges Auric and Ernest Irving consulting at a recording session

problem), and the constant repetition of rhythmic patterns and curt two-bar phrases. On top of all this, Auric knew almost no English.[1]

To be fair to Swynnoe, Auric's arrival at Ealing in the spring of 1945, the year when he also composed the score for Gabriel Pascal's *Caesar and Cleopatra* (1945), did create some anomalies, particularly in view of the character and musical preferences of Ernest Irving, Ealing's longstanding musical director. Irving had been a fixture at the studio since it opened late in 1931 as the production base of Basil Dean's Associated Talking Pictures, and remained a fixture until his retirement in 1953, six months before his death. Born in 1878, in some ways he seems to have paid only passing attention to the modern age. Balcon fondly remembered him in his autobiography as a 'Victorian figure living in Dickensian chaos'. Tall, spindly, suffering from asthma, a musicologist, classical scholar and chess obsessive with a general need for everything to be 'just so', he was a sufficiently notable studio character to be caricatured as the wheezing old magnate played by Ernest Thesiger in *The Man in the White Suit* (1951).[2] Most of the first half of his life since 1900 had been spent writing and conducting scores for West End theatres; his first direct association with cinema was in December 1924, when he arranged and conducted the music for the London presentation of Louis Mercanton's *Les Deux Gosses* (*The Two Little Vagabonds*). Irving's big musical god was Mozart, worshipped at close hand in Dean's culturally respectable but financially disastrous Ealing production *Whom the Gods Love* (1936), featuring multiple Mozart selections conducted by Sir Thomas Beecham. Minor deities included Handel, subject of GHW Productions' *The Great Mr Handel* (1942), for which Irving was loaned out as music director.

In search of authenticity, he consulted arcane musical sources and ordered the London Philharmonic Orchestra, in his words, to 'remove all the metal junk with which modern orchestral string-instruments are bedizened and to substitute gut [strings], as used in the days of our forefathers'.[3]

Auric's horizons were very different. He respected France's musical forefathers, but never went in for scholarly exhumation. Well learned across all the arts, and a noted music critic, he had been at the centre of Paris's musical life for over twenty-five years, becoming famous for writing sophisticated music in the Parisian manner generally associated with the composers of Les Six – often flippant, sometimes gnarled, featuring perky melodies liberally peppered with dissonances. In the mid-1920s he had composed three ballets for Diaghilev, *Les Facheux*, *Les Matelots* and *La Pastorale*, all presented in London; by 1929 in Britain his name had become enough of a talisman for musical modernism to be featured in Oswell Blakeston's novel *Extra Passenger* during a paragraph describing a bohemian party.[4] In France, Auric had leapt into the vanguard of cinema composers with his first two scores, one for René Clair's satirical comedy *À Nous la liberté* (1931), the other for the experimental *Le Sang d'un poète* (1932) by one of the godfathers of Les Six, Jean Cocteau – a film, Cocteau recalled, that Sigmund Freud had once compared to peeping through a keyhole at a man undressing.[5] To come were scores for *La Symphonie pastorale* (1946), Cocteau's *La Belle et la bête* (1946), John Huston's *Moulin Rouge* (1952) and many others until Terence Young's *The Christmas Tree* in 1969 – a total of some 120, composed with great technical facility, mostly at considerable speed. Perhaps the opium helped; he was a regular partaker, and told friends in France that to maintain a supply when in London a special dispensation had to be arranged, personally signed by King George VI.[6]

The Man in the White Suit (1951): Ernest Thesiger (left) as the industrialist Sir John Kierlaw, a character mischievously modelled on Ealing's music director Ernest Irving

By 1945, hiring prestigious composers to create new scores for British films was no novelty, though the most adventurous signings had happened outside Ealing. When Balcon took control of the studio in 1938, Irving was sixty years old, a musician's musician, appreciated as a master orchestrator, though without the wider musical curiosity of a younger, more dynamic figure like Muir Mathieson. Korda's music director in the 1930s, later in charge at the Rank Organisation, Mathieson had picked Arthur Bliss to score *Things to Come* (1936) and subsequently brought Vaughan Williams into films for *49th Parallel* (1941). At British and Dominion, at Dallas Bower's suggestion, Paul Czinner had secured William Walton for *Escape Me Never* (1935), while two of Auric's Les Six colleagues had already made their British debuts – Arthur Honegger in Gabriel Pascal's *Pygmalion* (1938) and Darius Milhaud in the GPO documentary *The Islanders* (1939). Irving, perhaps partly restricted financially, had followed a more cautious musical policy. There had been Mozart, safely dead; and two conservative living composers, Rutland Boughton and C. Armstrong Gibbs, contributors to Dean's *Lorna Doone* (1934). But most of Ealing's musical requirements until World War II had been relatively humble: some popular songs and incidental music for Gracie Fields or, latterly, George Formby; or atmospherics and bridging passages in modest ventures like the thriller *The Gaunt Stranger* (1938), written by Irving himself, or by anonymous hands under his supervision, and recorded by musicians unspecified.

Ernest Irving conducting the Philarmonia Ochestra at a recording session

Ealing's musical portfolio first broadened and deepened in 1941. Anxious, no doubt, for civilian 'war work', Geoffrey Wright and Richard Addinsell, both composers Irving knew from the theatre, wrote music for *Ships with Wings* (1941) and *The Big Blockade* (1942). Walton himself, after failing at ambulance driving, was charged by the Ministry of Information with composing for films deemed to be of 'national importance'. Along with Two Cities' *Henry V* (1944), these included Ealing's *Next of Kin* (1942), *The Foreman Went to France* (1942) and *Went the Day Well?* (1942). This was a signing which Irving certainly approved of – it was a 'grand thing', he wrote in his autobiography – though the hiring had been Balcon's idea, not his own. Benjamin Britten was also approached for Ealing duty, for a film about brass bands, but declined the offer.[7] Matching the rise in musical ambition, Ealing's screen credits from 1944 finally lifted the veil of anonymity from the musicians playing on the soundtrack. During 1944–45, Irving hired the London Philharmonic Orchestra; thereafter he used the newly formed Philharmonia Orchestra, regularly employed until *The Divided Heart* in 1954.[8] Such developments were part of a wider effort in Britain's musical and film culture of the 1940s to give film music serious attention, evident in print form in articles in the *Penguin Film Review* (1946–49), John Huntley's pioneering book *British Film Music* (1947), the British Film Institute's postwar publications, and writings in various outlets by the musicologist Hans Keller (a particular champion of Auric).[9] Irving himself contributed four columns to the specialist magazine *Tempo*, where he wrote, not impartially, about several Ealing film scores, Auric's included, clearly documenting along the

way his dislike of music's contemporary language ('the mazy depths of atonality ... the most ear-splitting cacophony').[10]

The particular conduit for Auric's employment in 1945 is not clear: it may have been the cosmopolitan Cavalcanti, formerly at the GPO Film Unit, then an associate producer at Ealing. Cavalcanti's Paris musical connections were strong, and he was sufficiently a composer's friend to be the dedicatee of scores by Maurice Jaubert and the German émigré Ernst Meyer, derived from music written for his films. Cavalcanti's cultural affinities with France aside, there were several practical reasons why hiring Auric made absolute sense, and we catch one of them in this vivid description from Marjorie Deans' book *Meeting at the Sphinx* of the composer at work on *Caesar and Cleopatra*:

> A big, loosely-built, rather indolent-looking man, Auric composes with an absent air, sitting humped over the piano with a cigarette dangling from his lips, under frowning, half-closed eyes, and plays his own melodies apologetically – '*Je ne suis pas pianist, vous savez!*' – with hands that look curiously large and inexpert on the keys. Can he really do this film-job, one wonders? Can he compose with the precision and accuracy demanded by this most exacting musical medium? He looks too relaxed and easy-going to be capable of so much strain and concentration. But he takes it all so easily, it presently appears, because it is so easy for him. So many feet of film, so many bars of music – '*Bien, bien! Entendu!*' He nods his head, and smokes, and strums a little; and very soon there it all is, graceful and effortless.[11]

Such effortless composing, precisely timed to fit the required footage, was an obvious asset for a company operating on tight budgets and production schedules. By 1945 he was already writing from long experience, using skills initially developed in his early ballets for Diaghilev. Several hallmarks are already present in *Les Facheux* (1923), a score in which Auric's style vaults backwards from the twentieth century to imitate an eighteenth-century French divertissement, with grinding 'wrong notes' and other modernisms added: a sprightly, chatty style that bore much film fruit, particularly in his music for *Hue and Cry*, perhaps the most French of Ealing's comedies. *Les Facheux* and its successors also signal Auric's early flair for shadowing visual action with clearly delineated musical moods and short motifs ingeniously manipulated. When writing music with grander aspirations to a purely abstract design, Auric's intelligence tended to impede fluency; when composing with a stop-watch, and writing to order, he was liberated.

Aside from Auric's technical facility, in the Britain of 1945 his very Frenchness also counted in his favour. By that date, the thinking British filmgoer's love affair with French cinema was long established. The comedies of René Clair, the poetic urban dramas of Marcel Carné and Jacques Prévert: these had been among London's biggest art-house successes in the 1930s. Conditions of war, and the eventual need to support the French Resistance, had generated their own bonds, cultural and political, furthered at Ealing in *The Foreman Went to France*, *Johnny Frenchman* (1945) and the French-language musical short *Trois Chansons de Résistance* (1943), all Cavalcanti productions. Auric himself had supported the French Resistance through membership of the Front National des Musiciens. So had Francis Poulenc, Auric's best friend among composers, who was in London himself early in 1945 for various concerts, some accompanying tenor Pierre Bernac at the piano. 'Georges will be the next to come to London – to do the music for two films,' Poulenc wrote to Milhaud on 27 March; 'they suggested I should take one on but it did not tempt me despite an enormous fee'.[12]

At Wigmore Hall in London, wartime amity had encouraged the audience to give Poulenc and Bernac an emotional standing ovation. Auric's arrival might not have been so dramatic, but his presence in Britain and his lineage were certainly respected. *Kinematograph Weekly* proudly informed readers that 'throughout the Occupation he refused to write a note of music that might be used by the Germans'; also that he was now part of France's commission examining the cases of collaborators.[13] And he was especially among friends at Ealing. Beside the Francophile Cavalcanti, there was Henry Cornelius, the progenitor and associate producer of *Hue and Cry*, who had worked with Clair as an assistant director. Robert Hamer, director of *It Always Rains on Sunday*, a film steeped in the French poetic realist tradition, was also an avid Francophile. In front of the cameras there was Françoise Rosay, who escaped from Occupied France, appeared in *The Halfway House* (1944) and *Johnny Frenchman*, and gave Balcon a photograph to hang in his office, signed 'Françoise Rosay – Frenchwoman'. Ealing in the mid-1940s, the period also of *Against the Wind* (1948) with Simone Signoret and *Frieda* (1947) with the Swedish Mai Zetterling, was never a studio of Little Englanders wrapped in a Union Jack cocoon.

By accident or design, Auric's characteristic musical manner also chimed with the subject-matter of various Ealing assignments. Had Freud been alive in 1949, he may not have characterised *Passport to Pimlico* as a keyhole peep at a man undressing; yet in their Ealing way the studio's comedies and dramas both dealt with emotions and dreams often hidden or suppressed. Auric's quick-changing textures, busy with scurrying strings, twinkling woodwinds and magical arpeggios spread up and down the harp, regularly beckoned the viewer and listener towards subverted reality, if not outright fantasy. Five years before his music for Cocteau's *Orphée* in 1950, where a mirror forms the passageway into the Underworld of Greek myth, Auric led audiences through another mirror in Hamer's *Dead of Night* episode, 'The Haunted Mirror'. There, the mirror becomes the passageway from a tidy bland life to a frightening world of glamour and overt sexuality, a world where Ralph Michael's character senses, in his own words, 'something evil, monstrously evil'. More benign dreams and fancies dominate the weak-kneed *Another Shore*, with Robert Beatty's Dubliner, accompanied by Auric's vivid music cues, constantly daydreaming about the South Seas, and the far meatier *Passport to Pimlico* and *The Lavender Hill Mob*, where postwar France figures in the plots as the happy repository of sunshine, economic plenty and freedom from rules and repression.

Auric's first Ealing assignment, *Dead of Night*, places a particularly large burden on the musical score. Written in Paris as the film was being shot, Auric's cues had to act as a principal bonding agent for the five episodes and linking story; they were also required to supply much of the phantasmagorical atmosphere. Stripped of Auric's surrounding accompaniment, the images of Mervyn Johns' architect driving towards Pilgrim's Farm tell audiences little of emotional significance. But we have already been unsettled by Auric's title music, ominous in mood, heavily orchestrated, its short motifs constantly writhing and metamorphosing. As we see Johns driving, Auric's music slips into neutral, as it were, only to change gear again when Johns, inside the house, experiences the full force of *déjà vu*, matched to sounds lightly scored and decoratively disembodied. Similarly eerie sounds appear throughout, sometimes coloured by the piano and tremulous strings. Elsewhere, Auric the chameleon busily keeps pace with the stories' demands: a burst of 1920s Parisian piano chatter for the children playing in *The Christmas Party*; comic-sardonic gestures with prancing xylophone for Basil Radford's ghostly game of golf – the sequence that proved the

most difficult to synchronise during the soundtrack's recording at HMV's Abbey Road studios. For the most dramatic episode of all, Cavalcanti's 'The Ventriloquist's Dummy', Auric mostly contributes telling silence – an ingredient which he approvingly found that English producers welcomed more readily than the French.[14]

Juggling fewer moods, with a straight narrative line, Auric's next Ealing job, *Hue and Cry*, gave him more opportunities to relax into cheerfulness, offering in the process a clearer demonstration of his virtues, and occasional vices. The opening music, close in mood to his ebullient *Ouverture* of 1938, bubbles and scampers in a manner entirely fit for a film about excitable East End children convinced that their favourite weekly comic sends coded messages to criminals. Colours and textures keep changing. Woodwinds predominate first; then strings. An out-of-tune piano jumps in, along with a horn, then strings again. Motifs are simple, short, almost childlike – a frequent practice with flightier works by Les Six, whose motivating aesthetic, in Cocteau's words, was the shunning of 'the colossal'. Complexity enters the title music with the motifs' treatment, repeated or reworked in different registers to a degree that borders on the fussy. Auric's lurking tendency to overload proves more damaging in the film's chase finale, when his music battles for dominance with sound effects, and the ear doesn't quite know where to turn.

Writing in his *Tempo* column, Irving professed himself delighted with the score that he conducted on the soundtrack: 'His music, characteristically French, gives our urchins a touch of the *gamin*, which, in my opinion, adds considerably to the appeal of the picture.'[15] And he was right. Watching *Hue and Cry* today we usually draw comparisons with the Ealing comedies that followed, but critics in 1947 properly saw the film as part of a continental tradition. Comparisons were made with two foreign imports also featuring massed urban children pursuing adventure: the German *Emil und die Detektiven* (1931), based on Erich Kästner's popular book, and the French film *Nous, les gosses* (1941). The visual surface of *Hue and Cry* could also with reason be called continental. The primary goal of Balcon, Cornelius and director Charles Crichton might have been to lead audiences towards semi-fantasy, but by training the camera so doggedly upon London's bomb-damaged streets they arrived at Ealing's equivalent of Italian neo-realism, a movement that made its UK debut with Rossellini's *Rome, Open City* (*Roma, citta apertà*), released in London six months after *Hue and Cry*.

In his posthumously published autobiography *Cue for Music*, Irving suggests that Balcon at Ealing had more money at his disposal for music than the 'pinched' Basil Dean, though the sums available clearly fluctuated.[16] To help balance the costs of a film never likely to be widely popular, the talkative film of Priestley's play *They Came to a City* (1944) was accompanied by existing classical material, drawn from Scriabin's symphony *The Divine Poem*. More beneficially, in a 1949 musical retrenchment, *Kind Hearts and Coronets* made acidly appropriate use of the poised elegance of a Mozart aria, supported by Irving's own insertions, while in *Whisky Galore!* and *A Run for Your Money* (1949) Irving fruitfully adapted Scottish and Welsh folk tunes. None of the composers needed paying. Even so, following Auric, Irving sought out further distinguished composing recruits to share the Ealing programme. After much activity in documentaries, Alan Rawsthorne applied his thoughtful chromatic touch to six dramatic Ealing features between 1946 and 1954, most notably the war drama *The Cruel Sea* (1953). John Ireland, a reluctant film collaborator, coloured the open Australian spaces of *The Overlanders* (1946), while Vaughan Williams, more committed to cinema, contributed idiomatic scores to the Kentish melodrama *The Loves of Joanna*

Godden (1947), another Australian adventure, *Bitter Springs* (1950) and, best of all, *Scott of the Antarctic* (1948). Significant new Ealing arrivals in the 1950s included John Addison, Malcolm Arnold and, from an older generation, William Alwyn and Benjamin Frankel, the last responsible for the wittily imaginative score to *The Man in the White Suit*. A more demotic, pop-oriented world, last decisively heard from in *Sailors Three* (1940) and the final Ealing films of George Formby, entered the soundtracks with the swing bands of Ted Heath and Geraldo in *Dance Hall* (1950): crucial ingredients in a film that needed neither Irving's scholarship nor Auric's continental finesse.

Yet Auric held his place among them all, not least for his music's emotional range and versatility – qualities on full display in his third Ealing film, the East End drama *It Always Rains on Sunday*. Once again, the film's European antecedents drew contemporary comment. *Sequence* magazine detected 'the method of pre-war French films', while the *Daily Telegraph* specified the Carné–Prévert dramas of 'mean streets and doleful characters'.[17] The Francophile director, Hamer, and the producer, Cornelius, would doubtless have concurred. Auric's music, rooted as Keller noted in the same keys, E and C, as his contemporary score for *La Belle et la bête*, is not overtly French, though there is something definitely un-English about the sheer heat and strength of his orchestra at full blast.[18] We're far here from the larkish spirit of *Hue and Cry*: the keynote is emotional turbulence, and the orchestration is often weighty, a phenomenon also in Auric's sibling film score for Independent Sovereign's *Silent Dust* (1948) and his 1950 ballet *Phèdre*. But there is room too for subtler cues, some mirroring the persistent rain (quavers in E minor), others bridging scenes with multiple renditions of a lively theme in dotted rhythms used in the establishing shots of street life. In the climactic chase scene in the train marshalling yards, Auric is happy for sound effects (clattering trucks, the whistle of steam) to take precedence over music. The sum total is both strident and delicate, and in either register compelling.

During this period, 1945–54, when he was busiest in England, at Ealing and elsewhere, Auric continued working on French films and stage works, though his British portfolio loomed large enough in his mind for him to describe himself humorously to French readers, circa 1950, as 'a very contented English composer of film scores'.[19] Some adjustments of style appear, possibly at Irving's suggestion. Over time the music's continental exuberance generally lessens: textures in *Passport to Pimlico* are notably leaner than those in *Hue and Cry*; while the melodramatic content of *Cage of Gold* (1950) – inadvertent bigamy, blackmail, murder – stirs relatively modest clamour from Auric's orchestra. In later films there are also fewer battles between music and sound effects. But the quicksilver, Gallic qualities never change; even with the British branch-line mania celebrated in *The Titfield Thunderbolt*, there's a particular French hue to the phrasing and instrumentation. Auric's French spirit found a more obviously natural home in the scripts of *Passport to Pimlico*, in which Burgundy law is applied to a pocket of postwar London, and *The Lavender Hill Mob*, where Bank of England gold is stolen and transformed into Eiffel Tower souvenirs. With these two films, critics' comparisons turned to the satirical fantasies of René Clair – a name repeatedly summoned in reviews, with the actual directors, Henry Cornelius and Charles Crichton, usually panting behind, viewed as lacking the master's light touch.[20]

When Auric's orchestrations are slimmed down, some of his texturing still remains too busy for the gags in these comedies to breathe. But on balance we gain more than we lose, and Auric's Gallic wink helps to save the films from seeming overtly parochial. He is particularly good with scenes pitched on the knife-edge between comedy and drama (Harry

Orchestral recording sessions traditionally took place outside Ealing, due to a lack of space: this scoring session for The Titfield Thunderbolt *(1953) took place at Denham Studios*

Fowler's Joe wrestling with Jago the furrier, early in *Hue and Cry*), and music expressing irony and parody, a dominant strain in *The Lavender Hill Mob*. There's a choice example when Alec Guinness's Bank of England stalwart is feted by his bosses for his fortitude during the robbery he himself helped to organise: a sequence of staccato rhythms, fast marching and delicious mock pomp. Auric copes well too with the more garishly obvious whimsy of *The Titfield Thunderbolt*, energising the film with Parisian bustle, and sustaining invention well enough to last seventy-five minutes before succumbing to the cliché of chug-chug-rhythms synched to the Thunderbolt's puffing and heaving, the kind of 'mickey-mousing' of which Keller elsewhere despaired.[21]

What did Ernest Irving, the Edwardian Englishman, Mozart devotee and friend of Vaughan Williams, really think of Ealing's French import? At this distance, and with scant paper documentation, it is hard to be sure. When I asked his daughter this question in a telephone interview in 2006 she worded her answer carefully: 'He was considered by my father to be a very good workman.' But, this implies, perhaps not a very inspired composer, or at least not one compatible with his own tastes. Maybe we find another hint in Irving's published comments on Auric's music for *Caesar and Cleopatra*, where he praised the Frenchman's 'delightful and appropriate score', a score 'equalling, *if not in any way excelling our British products*' (my italics).[22] 'British products', indeed, continued to remain the norm at Ealing throughout the 1950s; even the new composing recruits born abroad

(Rawsthorne's pupil and assistant Gerard Schurmann and the Catalan émigré Roberto Gerhard) were both British residents.

After Irving's retirement and death in 1953, Auric worked on one more Ealing film, *The Divided Heart*, before proceeding memorably to *Du Rififi chez les hommes*, *Lola Montès* (both 1955) and, among other British ventures, Jack Clayton's *The Innocents* (1961). Crichton's earnestly emotional drama about the personal consequences of war provided a sober Ealing finale. Haunted by a hymn-like tune first heard rising from turmoil, the score elegantly and economically serves the script's needs without ever scaling the imaginative peak of *It Always Rains on Sunday*.

He left Balcon's company at a difficult time of transition. In 1953 Irving had been succeeded as music director by Dock Mathieson, Muir Mathieson's younger brother. Within a few months of *The Divided Heart*'s release, the choice of soundtrack musicians passed from the established London orchestras to the smaller Sinfonia of London, a session band newly formed by Muir Mathieson in 1955 solely for soundtrack work. This was the year that ended with the Ealing unit's departure from the studio, an event that can only have encouraged the general scattering and destruction of the music department's manuscripts and paperwork. Vaughan Williams's full scores became safely lodged with the British Library, but he was unusually privileged, and complete material appears to exist for none of Auric's nine Ealing scores. When the composer and musicologist Philip Lane assembled material for the CD *The Film Music of Georges Auric* (Chandos, 1999) he had to build up and orchestrate sequences from *Hue and Cry*, *It Always Rains on Sunday*, *Passport to Pimlico*, *The Lavender Hill Mob* and *The Titfield Thunderbolt* from piano sketches in the care of the composer's widow, Madame Michèle Auric. For *Dead of Night*, he had to reconstruct the music entirely by ear, now a common task for all disseminators of vintage film music.[23]

The faintness of British film music's paper trail has not encouraged sustained research into the music provision at Ealing, or at other British studios. But the music on the soundtracks is too important to be ignored: if you don't attend to the music that dances round Ealing's words and images, you are neglecting half the story. In Auric's case you're also in danger of missing much of the individual colour and character in the studio's postwar output. 'Films projecting Britain and the British character': the plaque is correct up to a point, but Auric proves beyond a doubt that the projection is enriched by a European perspective.

10 ANTHONY MENDLESON
EALING'S WARDROBE WIZARD

Catherine A. Surowiec

> It was design for a *character, always*.[1]

There is a scene in *Another Shore* (1948) when Robert Beatty, the film's Dublin dreamer, finally really *sees* Moira Lister, the girl who has swept into his idle life, for the first time: 'That coat suits you,' he says admiringly; 'it makes you look what I call *piquant*'. A line of dialogue in an Ealing film devoted to a character's costume is rare. Here it is not only a turning point in the plot; her character, having sported a parade of fashions reflecting the postwar 'New Look', is wearing a striking velvet-trimmed coat with an elaborate hood. In a Dublin otherwise clothed in the drab and ordinary – and in Beatty's case, a rumpled raincoat – she immediately stands out from the crowd.

A simple dramatic point has been made in this scene by the design flair of Anthony Mendleson (1915–1996), Ealing's first resident costume designer and wardrobe supervisor. As the head of the studio's wardrobe department from 1947 until the company left Ealing in 1956, the prodigious Mendleson worked at a whirlwind pace behind the scenes, overseeing the clothes for virtually all of Ealing's schedule of productions – more than forty films – in the studio's heyday.

The accent at Ealing was not on glamorous gowns and furs, or beautiful and handsome stars in a dream realm beyond our reach, but on character, most memorably character of a particular home-grown variety. The best were drawn largely from everyday life, populated by a wide range of recognisable types and social classes: aristocratic eccentrics, country squires, vicars, workmen, pub owners, shopkeepers, office clerks, housewives, little old ladies, stiff-upper-lip naval officers, merchant seamen, bowler-hatted Whitehall functionaries, members of Dad's Army, dance-hall girls, floozies, safe-crackers, Cockney spivs, plain-clothes detective sergeants and the copper on the beat. Mendleson had to dress them all, playing a vital role in visualising the look of its now-illustrious gallery of characters, helping to define the Ealing stock-company 'family', especially in the Ealing comedies – from the multiple D'Ascoynes played by Alec Guinness in *Kind Hearts and Coronets* (1949), through the Todday Islanders and Home Guard of *Whisky Galore!* (1949), to the motley band of crooks and genteel old lady in *The Ladykillers* (1955).

Studio publicity shot: designer Anthony Mendleson fixes actress Eunice Gayson's string of pearls, *Out of the Clouds* (1954)

Ealing's films were tightly scripted and well cast, which were essential ingredients of their success. But often overlooked is the linkage of costume and set design, a bond apparent from the very start of Mendleson's Ealing tenure. That began in late 1946, when Mendleson, armed with a portfolio of designs from his theatre work, was hired to join the studio's creative team after being interviewed by production designer Michael Relph. Mendleson was completely new to films, and it would be the start of a distinguished career that would stretch into the mid-1980s.

Incredibly for a major studio, up to that point Ealing had never had a full-time costume designer on staff. Although Marion Horn, who had worked for Michael Balcon supervising Gaumont-British costumes at Shepherd's Bush in the 1930s (billed simply as 'Marianne'), working in tandem with a variety of designers, had stepped into the breach as wardrobe supervisor at Ealing during the war years. It was Horn's impending retirement that caused the studio to re-examine the situation. Studio head Michael Balcon had long been aware of the importance of design, demonstrated by two design initiatives when he ran Gaumont-British in the early 1930s. Top production designer Alfred Junge – Britain's first real supervising art director – ran a pioneering apprenticeship programme, which honed the talents of Michael Relph, among others. Fashion was not ignored: anxious to enhance the appeal and appearance of his stars, in 1933 Balcon appointed the American Gordon Conway (a woman, despite her name) as the head of the first studio costume department in the British film industry. But budget cuts and Conway's early retirement the following year due to overwork ended those ambitious plans. From that point onward Balcon's organisations, first at Gaumont-British, then at Ealing, never hired another regular costume head, instead relying upon a pool of outside talent, with contributions from fashionable couturiers as well as theatrical costume houses.

In 1946, after years of coping with wartime restrictions and other pressures, Horn announced she was ready to retire. Cue Michael Relph, by then head of Ealing's art department, and about to embark on a second career as one of Balcon's team of associate producers. A brilliant draughtsman and a master at designing sets planned for the camera's eye, Relph astutely saw the need to integrate costumes into the design process, and to hire a real designer. Horn's talent lay not in designing dresses, but in organising the costume supply, securing costumes from couture houses or costumiers – the essential shortcuts to a supply of character clothing for any British studio lacking the manpower and space to manufacture and store its own costume reserve.

The names of the costume firms still lingered on the credits in Mendleson's time: Horrockses Fashions (supplier of Googie Withers' clothes in *It Always Rains on Sunday*, 1947), Brenner Sports (Moira Lister's clothes in *A Run for Your Money*, 1949), Spectator Sports (Kay Walsh's in *The Magnet*, 1950). A particular favourite was B. J. Simmons (a bulk supplier for *Saraband for Dead Lovers*, 1948) – '*the* top when it came to period clothes'. There were numerous other firms behind the scenes: Morris Angels, reliable supplier of clothes civilian, military and naval; Berman's, a close collaborator with Mendleson; Samuels, blessed with valuable army surplus stock; Nathans (period clothes); Moss Brothers (modern clothes); Charles H. Fox (costumes and wigs); and Court and Theatrical Costumiers, whose Ealing association stretched back to Gracie Fields' films for Basil Dean in the 1930s.[2] These

firms had provided the foundation for Ealing's wardrobe requirements for years; only in special cases, like the period music-hall costumes designed for *Champagne Charlie* by the émigré stage designer Ernst Stern in 1944, had an outside designer been employed.

Once established at Ealing, Mendleson quickly became much more than a supervisor, supplementing the rented supplies with his own inventive decorative additions; or often designing an outfit from scratch, to be executed by the costumiers on a 'new-for-hire' basis and then returned to them after filming to form part of their rental stock, an arrangement economically mutually beneficial to both parties. On other occasions, especially for ladies' modern dresses, items were purchased directly from shops, off the peg, with the player concerned sometimes at hand. Whatever the route, the objective was always the same: to array the actors in clothes that expressed their characters, as laid down in the script and interpreted by the director.

Before coming to Ealing, Mendleson had fairly limited professional experience. In the 1930s in London he had attended evening classes in costume design at the Chiswick Polytechnic; studied art in Paris and Florence, and been much inspired by the productions of Colonel de Basil's Ballets Russes at Covent Garden, which left him with a burning desire to enter the design field, designing both costumes and scenery. Through a family connection he had also worked in a London bank, an experience that gave him intimate knowledge of business and office types, invaluable in dressing Alec Guinness as the bank clerk in *The Lavender Hill Mob* (1951) or the bureaucrats in *Passport to Pimlico* (1949). World War II put his dreams on hold: Mendleson enlisted in the Army; after a spell in the Royal Army Service Corps, working in transport and supply administration, he was put behind a War Office desk, working for a branch of MI5. Demobbed in peacetime, he found scattered outlets for his design skills in the theatre, drawing caricatures for several of Hermione Gingold's revues, designing some ballet costumes for Marie Rambert's Mercury Theatre, and co-founding the Manchester Intimate Theatre Group (later the Library Theatre), designing their first production in 1946, Chekhov's *The Seagull*: 'I and some friends of mine decided that rather than *wait* to get jobs, we would try and *make* jobs for ourselves. ... we made all the clothes for the women out of this cheap silk lining material, which worked extraordinarily well. The men's clothes, a lot of them were hired.' This go-ahead attitude and ingenuity, as well as Mendleson's obvious talent, won Relph over, and Mendleson joined 'The Studio with the Team Spirit' (a motto famously emblazoned on one of Ealing's soundstage walls since the days of Basil Dean in the 1930s).[3]

He learned on the job, and learned quickly. There were often several films in production at once in the tiny studio, which had five sound stages on a total of 6 acres. There was virtually no backlot, so a lot of inventive location shooting took place around London, especially for contemporary stories (these postwar glimpses of bomb-damaged London are particularly valuable social documents today). For the costume designer, life was a constant juggle of meetings, budgets, shooting schedules, shopping, fittings and wardrobe tests. Mendleson was based in a tiny office on the first floor adjacent to Stage 2. Nearby were the men's and women's wardrobes and artistes' dressing rooms, overseen by his trusty assistants Ernest Farrar and Lily Payne, both 'pillars of strength ... who had been there for *years*',[4] who in turn had their assistants, Ron Beck, Ben Foster and Edith Crutchley. He rarely went on location, and seldom on the studio floor during shooting, delegating that to his assistants. He was far too busy designing, planning, organising, consulting and coordinating with the film-makers and artistes on the overlapping productions, and he would also be dealing with pre-production on anything in the pipeline.

Shooting on his first production, *It Always Rains on Sunday*, Robert Hamer's poetic-realism slice of life in London's East End, began in February 1947. Working in a small compact studio under the special conditions of postwar austerity Britain, his ingenuity and imagination were immediately called upon to cope with the maze of restrictions concerning budgets, clothing coupons and fabrics. Britain had been particularly hard hit by the war. Clothes rationing had begun in June 1941, and lasted until 15 March 1949. (Food rationing didn't end until July 1954.)

You had to supply the costume list to the Board of Trade, and estimate how many coupons you needed. They were quite generous; they gave you quite a good supply of coupons. Then you were very careful how you handed them out, because you had to keep back quite a few: when you went out shopping suddenly to get something you had to have coupons with you to get anything. And you had to explain to the Board of Trade where they'd gone. I *hated* it.

(*Passport to Pimlico*, made the following year, must have given everyone a morale boost. The opening title of this send-up of English bureaucracy, 'Dedicated to the memory of', was illustrated with an image of ration coupons and a clothing ration book, surrounded by a black wreath with lilies. When the denizens of bombed-out Miramont Place discover that due to an ancient document they are entitled to be citizens of Burgundy, they gleefully tear up their ration books!)

Ealing realism: a tense moment for the Sandigate family, with the women clothed by 'Horrockses Fashions'. Googie Withers and Susan Shaw in the dress-tearing scene in *It Always Rains on Sunday* (1947)

For *It Always Rains on Sunday*, a film with a large cast and each character dressed individually, Mendleson recalled that the coupon allocation was under 3,000 – a moderate allowance, which was stretched further by the requirements for the scene where Googie Withers, desperate to prevent stepdaughter Susan Shaw from entering the bedroom containing John McCallum's escaped convict, tears Shaw's print dress at the shoulder. The furious Shaw then finishes off the dress herself by tearing it completely down the front, leaving her standing in her slip.[5] Five copies of the dress were needed for possible retakes, as well as takes tailored for America's censorship requirements. With dress-making factories temporarily shut because of that fierce winter's fuel shortage, Mendleson had to scurry around to find suitable supplies in London's West End stores.

The film also gave Mendleson a forceful introduction to the basic Ealing dress code: clothing rooted in everyday life. For inspiration, photographs were taken of the stallholders and crowds at Petticoat Lane market. *It Always Rains on Sunday* features its own Sunday market, teeming with extras in caps, overcoats and dowdy clothes, plus one prominent fur coat. Higher up the cast list, spivs and philanderers parade in wide-shouldered striped suits; detective sergeant Jack Warner wears a rumpled raincoat, good girl Patricia Plunkett a plain striped dress. Even the wardrobe for leading lady Googie Withers never strays beyond the humdrum, with ordinary, sensible dresses by Horrocks for her character of housewife Rose Sandigate. But Mendleson also knew when to add special touches: 'Some [men's suits] were made in the West End by tailors who were instructed to make them a

Spiv on the skids in his hideout, literally starting to unravel: dishevelled Dirk Bogarde in tattered sweater, with Peggy Evans and Patric Doonan in *The Blue Lamp* (1950)

little "larger than life". That is to say, that the outstanding features of the "spiv" suits were slightly exaggerated.'[6]

Along the way, Mendleson was also inducted into the mysteries of designing for a black-and-white film. He remembered using a small viewer; turning the lens would show how the scene would look in black and white. Sheer black was to be avoided: it absorbed light. So was sheer white: it reflected light. The range of tones required could be summoned more satisfactorily deploying colour; to summon up white, Mendleson used pale blue or pale yellow.[7] At the same time, the range of clothing had to mesh with the set designs of Duncan Sutherland (busy at Ealing since 1942; *It Always Rains on Sunday* was to be his last assignment). Functional, ordinary: these were Sutherland's goals in a drama whose main action centres on the working-class neighbourhood of Bethnal Green in London's East End, the film's vortex, where Rose's former lover seeks shelter.

Gritty realism and London locations were to be a theme of several Ealing films in this period, especially as practised by Basil Dearden and Michael Relph. *The Blue Lamp* (1950) offered a story of cops Jack Warner (the avuncular PC Dixon) and Jimmy Hanley (the young protégé he takes under his wing) on the beat in Paddington, confronting Dirk Bogarde's trigger-happy thief, climaxing in a car chase around Ladbroke Grove. Bogarde's character starts confidently in wide-shouldered striped suits, pulls a polo-neck sweater over his face for the big robbery that goes all wrong, and ends up in a tattered sweater with holes when he is reduced to hiding in a dingy flat. London's postwar ruins and bombed-out neighbourhoods also featured in *Pool of London* (1951), with its merchant seamen (cocky Bonar Colleano (Dan MacDonald) in zippered windbreaker, decent Earl Cameron (Johnny Lambert) with a wool jacket with patterned wide tie) on shore leave getting involved in a bank robbery, plus a subplot about interracial relations.

Looking back, Mendleson saw only benefits from Ealing's comparative lack of glamour and high fashion: 'If I had been thrown into a Hollywood studio, where they were all draped in mink and white fox fur, I wouldn't have known what to do. But because the essence of Ealing films was that people were presented as they were in the streets, it was a great challenge.'[8] In the early days, however, he was still learning this golden rule. Leaping ahead of British public taste in 1948, *Another Shore* featured New Look fashions for Moira Lister, highlighted in the film's publicity material with mouth-watering descriptions.[9] In retrospect, Mendleson realised it was a mistake to feature Christian Dior's New Look when it hadn't really reached England, much less Ireland.[10] He also encountered problems with a bathing suit. For the beach scene in which the two leading characters meet, Mendleson produced a striking two-piece ensemble, with a generous amount of bare midriff. It was the last word in modern bathing costumes. But the Irish experts shook their heads. No girl, they said, would wear a costume like that in Killiney, Ireland.[11] Lister ended up wearing a modest one-piece sun suit, with scalloped edges – bought 'off the peg' in Ireland.

Mendleson's major assignment in his first year at Ealing was the costume drama *Saraband for Dead Lovers*. This was a complete departure for the studio, a prestige romantic period melodrama on a grand scale, in Technicolor, with the dashing Stewart Granger, fresh

Studio fashion shot of Moira Lister wearing a smart 'New Look' ensemble featured in *Another Shore* (1948), with elegant striped touches by Mendleson

from the Gainsborough fold. Writing in the 'making of' book *Saraband for Dead Lovers: The Film and its Production*, Mendleson enthused about its lavish costume requirements:

> The spectacle of the rich varied costumes in *Saraband* is a pleasant change in these austerity days. ... Each woman's costume had to have, attached to a figure-fitting bodice, a voluminous overskirt cut up the front and looped back to reveal an embroidered underskirt underneath. All the sleeves were trimmed with three or four *real* lace frills and heavily starched petticoats, also trimmed with lace, had to be worn to ensure a correct silhouette. ... The men's clothes were equally exciting with their lace trimmed shirts, embroidered coats, and flowing cloaks.[12]

At the same time, the film about the doomed love affair of Princess Sophie-Dorothea (Joan Greenwood) and Philip, Count Königsmark (Stewart Granger), caught in the intrigues of the seventeenth-century court of Hanover, also posed many challenges. Shooting in Technicolor brought Technicolor's formidable 'colour supervisor' Natalie Kalmus and her assistant Joan Bridge onto the set, with specific instructions and caveats. The colour's registration kept varying; white shirts, ruffles, frills and stockings had to be dyed a special silver grey to avoid glaring under the arc lamps.[13] Colour photography also necessitated particularly close collaboration with the production designer, Michael Relph, whose richly detailed Baroque interiors remain one of the film's splendours.

Dressing the principal cast and crowds involved a mini-military campaign of its own: according to Ealing's publicity department, nearly 600 costumes were taken to the locations

Meticulously researched Hanoverian court finery in *Saraband for Dead Lovers* (1948): Françoise Rosay as Electress Sophia, seated in Michael Relph's magnificent library set, with Joan Greenwood as the ill-fated young Princess Sophie-Dorothea. The starched headdresses were based on period fashion plates

Duty vs romance: Françoise Rosay as Electress Sophia, with Stewart Granger as dashing soldier of fortune Königsmark in breastplate and furs in *Saraband for Dead Lovers*

used in Prague. Mendleson recalled that postwar privations brought other problems, like the soldiers' 300 uniforms, run up by Morris Angels from uncouponed scenic canvas, so stiff it was almost impossible to work with: 'When they had the [defeated Hanoverian army] return from the wars, and [the uniforms] all had to be ragged, ... we had to get blow-torches and *burn* them, so we could make them look *worn*.' Then there were the soldiers' 600 shoes, ingeniously concocted by Mendleson from wooden-soled garden clogs (sales stock from Gamages department store) crowned with convincing imitation buckles. But they made such a terrible racket on the cobblestones in Prague that he and his staff had to sit up all night, gluing felt on the soles.[14] All this for a sequence which lasts only seconds on screen!

For Mendleson, *Saraband for Dead Lovers* represented a triumph of ingenuity and organisation rather than design. He recalled that only one of his own designs was actually used – the costumes were chiefly designed by Frederick Dawson (the head of period specialist supplier B. J. Simmons) and Georges K. Benda, responsible for the dresses worn by Françoise Rosay. The rich Baroque court finery, with its silks, satins and brocades, and stiff starched women's headdresses, was right out of fashion plates of the period. Stewart Granger's Königsmark, the Swedish outsider, is dressed comparatively plainly, in dark, sombre colours, particularly when contrasted with Michael Gough's colourful silken finery,[15] except when Königsmark returns from the Morea campaign, in full soldier-of-fortune gear, complete with burnished breastplate and masculine furs.

118 **EALING REVISITED**

Saraband's most bravura sequence has to be that of the Hanover street carnival, a whirling digression worthy of Powell and Pressburger. Greenwood's shy princess, with her billowing cloak and elegant mask, is swept along by rowdy revellers, and confronted by inventive character masks and animal headdresses by Hugh Skillan[16] and Alexander Mackendrick (who also worked on the storyboards for the film).

Mendleson's next film in colour, *Scott of the Antarctic* (1948), was that year's Royal Film Performance and was another prestige production for Ealing. It required a much more functional wardrobe, but his design craft is still very much in evidence as John Mills and his fellow adventurers battle fate and the elements in outfits closely modelled on the surviving artefacts at the Scott Polar Research Institute in Cambridge, along with the precious expedition photographs of Herbert G. Ponting and assorted material provided by the explorer's widow Kathleen and others.[17] Mendleson's re-creations of the expedition party's oilskin tunics and trousers, cumbersome fur gloves, balaclavas, woollen scarves and sweaters, goggles and man-hauling harnesses look marvellously lived-in; one look, and you start to shiver. The art direction by the Swedish Arne Åkermark, supported by plentiful location shooting in Norway and Switzerland, with second-unit work in the Antarctic, fulfils the same realistic purpose. Yet Mendleson's flair for the decorative touch isn't entirely absent: in the scene of the party's embarkation, a large striped ribbon gaily floats from the back of the hat worn by Diana Churchill, as Kathleen Scott. And, even in the depths of Antarctica, Mendleson made sure Scott's party wore balaclavas of different colours: mustard, brown, blue, green – offering just enough variety to engage and differentiate, but not distract.

But the film that demonstrates Mendleson's subtle art more than any other is *Kind Hearts and Coronets*, an Ealing landmark and his own favourite among the many films he designed. For its dry humour to take wing, Robert Hamer's sophisticated black comedy, based on an Edwardian comic novel dating from 1907, needed to move in an atmosphere of exquisite artifice and irony – an atmosphere conjured as much by Mendleson's elegant costumes and William Kellner's meticulous set designs as by the dialogue, action, direction and photography. Supplemented by stock supplied by the ever-reliable firm of B. J. Simmons, Mendleson's costumes are unerringly right, pitched in time around 1900–10, and play a major part in developing character and narrative from the very beginning. Dennis Price's Louis Mazzini, now Duke of Chalfont, sits before us calmly in his prison cell, starting to write his memoirs while awaiting execution, in a velvet jacket with quilted silk collar, lapels and cuffs, a ruffled shirt, and bow-tie, as if he's the perfect wealthy Victorian, at leisure at home.

Once into the narrative's flashbacks, we can easily chart Louis's murderous upward journey from social outcast to aristocrat purely through his clothes. As a draper's assistant they are ill-fitting, but with increased money and status Louis becomes progressively better tailored. Soon he's cycling in knee breeches and a Norfolk jacket. By the time he's a business partner to Lord Ascoyne D'Ascoyne, his work outfit is a tailored grey suit with satin lapels, while at home he relaxes in a brocade dressing gown. Louis's clothes also serve at times as a deliberate costume, invaluable props in his plan to murder his way towards the D'Ascoynes' Chalfont dukedom: clerical garb for his impersonation of the Bishop of Matabeleland; a dandyish striped jacket with matching waistcoat and piping for a weekend at Maidenhead that finishes with him despatching the snobbish playboy Ascoyne D'Ascoyne.

Class differences in *Kind Hearts and Coronets* (1949): somberly dressed draper's assistant Louis Mazzini (Dennis Price) is confronted by imperious dandy Ascoyne D'Ascoyne (Alec Guinness)

Towering millinery for a *tête-à-tête* in *Kind Hearts and Coronets*: Louis (Dennis Price) with petite Joan Greenwood as Sibella, wearing an elaborate hat to give her height

In his multiple roles as eight branches of the D'Ascoyne family tree, Alec Guinness dons numerous guises. Interviewed in 1993, Mendleson downplayed the role of his costumes in characterising the D'Ascoynes ('It was mainly a question of make-up, the face and the wig. [Guinness] knew exactly how he wanted to play each part.'). But the clothes act as a witty accomplice to each comic creation, from Admiral Horatio D'Ascoyne's naval greatcoat and General Lord Rufus D'Ascoyne's regimental jacket and chest of medals, through the formidable Lady Agatha's suffragette garb, to the holy orders of the Reverend Lord Henry D'Ascoyne – the last in a lace chasuble 'so elaborate that it provoked a furious complaint from a retired Protestant missionary in Finland'.[18]

But Mendleson's elegant wit and flair for fantasy found their most eloquent outlet in the clothes for the two rival women, the lovely but priggish Edith and the honey-voiced, ambitious Sibella, so beautifully portrayed by Valerie Hobson and Joan Greenwood. Each outfit makes an impact, whether in furthering characterisation or minimising the practical problem of the two actresses' difference in height. Often the outfits do both. Greenwood's hats rise up in a profusion of flowers, fruit, miniature birds and butterflies, partly to make her appear taller, partly because flighty fanciful headgear suits the materialistic Sibella. Similarly, Hobson's considerably less flashy wide-brimmed hats, draped in lace, gauze and tulle, reflect Edith's more proper demeanour and have the useful effect of making a tall actress shrink.[19]

Not that the character of Edith is entirely sober: it is Hobson who wears Mendleson's wittiest creation, wielding a bow and arrow on the Henry D'Ascoyne lawn in a gown with arrow designs at the waist, neck and shoulders, and an arrow pierced through the flowers in her hat.[20] Nor is it coincidence that the vixenish Sibella, preparing to blackmail Louis, wears form-fitting, slinky black lace, trimmed with fur, cunningly suggesting something sinuously evil. Throughout, the playful artifice of Mendleson's costumes find their match in the elegantly placed bric-à-brac of Kellner's settings, the dry irony of the script (and its delicious vocal delivery), and Hamer's preference for short, elliptical, underplayed scenes, always artfully staged.

Design bull's-eye: Mendleson's witty archery costume for Lady Edith (Valerie Hobson) with arrow motifs in *Kind Hearts and Coronets*

A later Alec Guinness comedy like *The Lavender Hill Mob* shows Mendleson designing in a quieter register, but with the same close attention to detail and character. Guinness's Henry Holland may start and end with silk tie, handkerchief and generous cummerbund, dispensing largesse in South America. But much of the time in-between is spent in the conventional dress of a punctilious, seemingly honest Bank of England employee: sombre morning suit with striped trousers, celluloid collar, two pens clipped into his jacket's breast pocket, bowler hat, rolled umbrella. Stanley Holloway's Pendlebury, more raffish, begins in a chequered suit, with hat tipped at a jaunty angle, then dons a wrinkled corduroy jacket, ideal for this artist *manqué*. Alfie Bass's gear – ordinary working-class, cloth cap – is somewhat ambivalent, but Sid James's leather jacket, turtle-neck sweater and fedora immediately identify him as a professional crook. The Lavender Hill mob plot and execute their robbery against the realistic backgrounds provided by Douglas Slocombe's crisply

Artists of different sorts in The Lavender Hill Mob *(1951): Bank of England employee Henry Holland (Alec Guinness), in sober black suit and celluloid collar, tells corduroy-jacketed sculptor Pendlebury (Stanley Holloway) his idea for a more rewarding type of artistic adventure*

Splashing largesse in Rio: generous robbery mastermind Henry Holland with glamorous girlfriend Chiquita (Audrey Hepburn, in stylish white shirtdress with black gloves) in The Lavender Hill Mob

photographed shots of bomb-damaged London or William Kellner's persuasively everyday settings – bank, boarding house, garage workshop. Of glamour there is almost as little as there is in *Scott of the Antarctic*, but Mendleson makes the most of his chances in the South American framing scenes with Audrey Hepburn's brief and alluring appearance as Chiquita, wearing a fashionable New Look shirtdress with exaggerated lapels, tightly belted at the waist in black patent leather, and black gloves. A society woman also stops by Guinness's table; her grand manner is echoed by an incredible swooping black hat.[21]

Workaday realism also dominates most of Guinness's appearances as Sidney Stratton, the fanatic textile researcher in *Lavender Hill*'s successor, *The Man in the White Suit* (1951). Tweed jacket, V-necked pullover, rumpled collar: the typical absent-minded professor. But then Guinness dons the title's white suit, fashioned from Stratton's experimental fabric, indestructible and dirt-repelling, and he is transformed. It's tailored, yes, but what we notice most in Slocombe's photography is the suit's intense luminosity. It radiates gleaming whiteness, particularly in the chase finale through dark streets. It also, strikingly, disintegrates: an effect cunningly achieved by the costumiers Berman's by constructing a version from sheets of multilayered tissue paper used by pharmaceutical companies.[22] There is one nod to glamour: Joan Greenwood, as Daphne, daughter of Cecil Parker's smartly dressed factory owner, gets to wear what can only be seen as a successor to Sibella's snake dress in *Kind Hearts*, a black dress with long sleeves, tight bodice with plunging V neckline trimmed in fur and full flared skirt – another item custom-made for seduction.[23] Mendleson remembered director Alexander Mackendrick as 'Very visually minded in every way; he really did know how a character should look. ... He was the one who made me do the *hump* on Ernest Thesiger.' Thesiger's wizened, wily old industrialist Sir John is an unforgettable creation, peering out like a vulture from a huge black overcoat with a mountainous fur collar.

Next to these comedies' largely sober wardrobes, the dress code for Mendleson's last crime caper at Ealing, *The Ladykillers*, is markedly different, bolder and more fantastical. Here he is designing for Technicolor, which partly accounts for the change. But the clothes carnival also comes about because Mendleson, in tandem with art director Jim Morahan and director of photography Otto Heller, is pointedly fulfilling director Alexander Mackendrick's concept of a setting poised between caricature and fantasy. A sense of menace lurks in Mrs Wilberforce's (Katie Johnson) genteel terraced house, lined with rose-decorated wallpaper, with the shadows and off-kilter angles beloved of German Expressionism; though Mrs Wilberforce has a simple explanation for the pictures and photographs hanging askew: subsidence, due to wartime bomb damage and the fact that her house is perched over a busy railway line. Within the house's lop-sided surfaces, Mrs Wilberforce's loopy new lodger and his band of crooks are dressed in outfits signally diverse.[24] Alec Guinness's Professor Marcus is half dotty professor, half Germanic

master criminal, with cadaverous eyes, a long, trailing knitted scarf with several holes, a coat with an astrakhan collar, plus lank hair and protruding teeth – the last two, accidentally-on-purpose, echoing attributes of the drama critic Kenneth Tynan.[25] 'It was a matter of finding really eccentric clothes that looked right. It was great fun.' Herbert Lom's Louis is the caricature spiv gangster, his white tie set against a dark shirt and jacket. Cecil Parker's bogus Major is all natty tweed, with bow-tie and waistcoat, Danny Green's slow-witted 'One-Round' a hulking bulk of striped grey rumpled jacket and a shawl-collared sweater, while Peter Sellers' Harry, more flashily attired than the rest, is an exaggerated Teddy Boy in blue suit, green shirt and suede shoes.[26]

The Man in the White Suit (1951): inventor Sidney Stratton (Alec Guinness) shows off his white suit of miracle material to sceptical factory workers Vida Hope and Patric Doonan

Against this motley quintet stands Mrs Wilberforce, 'Mrs Lop-sided', indomitable in Edwardian finery and morality from another age, a pear-shaped vision of pastel-coloured gentility, adorned with flat floral hats, lace gloves and a cameo brooch, and sporting grey spats and a brolly for excursions. Brought up from the age of one by his fully Edwardian aunt and uncle, Mendleson clearly viewed both the character and the period with affection. There's a similarly dressed black-and-white edition of Mrs Wilberforce in Miss Evesham, the landlady from *The Lavender Hill Mob*, played by the diminutive character actress Edie Martin – featured in *The Ladykillers* as Lettice, one of Mrs W's equally pastel-attired lady friends, who cause the crooks more trouble and delay by arriving for a musical tea.

The house in *The Ladykillers* exerts a centrifugal force, trapping Guinness's gang as they struggle to escape with their musical instrument cases full of stolen banknotes. Professor Marcus's scarf, almost twice his height, is twice caught under Mrs Wilberforce's foot. The strap of One-Round's cello case gets jammed in the front door, and the jig is up. However, entrapment wasn't a plight faced by Mendleson and other creative talent at their Ealing home. The jig was also up for 'the studio with the team spirit'. Once the studio's sale to the BBC took effect in 1956, the leave-taking of personnel, in Mendleson's memory, was sudden, almost brutal. 'When the studio was sold,' he told Robin Buss in 1993, 'we were in a blissful state of ignorance; it was the one time when there weren't any rumours. There was no big party or celebration. You just walked out.'[27]

Mendleson's last assignment at the studio was the crime drama *The Long Arm*, which began production six months after *The Ladykillers*, in October 1955. Aptly, it was a grey subject, filmed in black and white, suited only to functional clothes, fit for a cast playing detective-superintendents, assorted constables, wives, workmen and a safe-cracker. Again, there were locations: London's Southbank, notably around the Royal Festival Hall.

Where next? Thereafter, Mendleson functioned exclusively as a freelance, designing for films until the mid-1980s. He never again worked for Michael Balcon, but did collaborate several times with his former Ealing colleagues Michael Relph and Basil Dearden, on *The Smallest Show on Earth* (1957), *Man in the Moon* (1960) and *The Mind Benders* (1963). In 1963, employed as 'wardrobe adviser', he brushed against the now-alcoholic Robert Hamer on Don Chaffey's *A Jolly Bad Fellow*, a black comedy with *Kind Hearts* elements, based on a Hamer script. But otherwise he followed his own path, working on a variety of films for Launder and Gilliat, Walt Disney, Richard Lester, Jack Cardiff, Guy Green, Anthony Asquith, Terence Young (*Thunderball*, 1965), Richard Attenborough,[28] Roman Polanski, Don Siegel

The Ladykillers (1955) studio publicity portrait: criminal mastermind Professor Marcus (Alec Guinness) and his gang (Danny Green, Cecil Parker, Herbert Lom and Peter Sellers) with Mrs Wilberforce (Katie Johnson), all dressed in character

and others, earning Oscar and Society of Film and Television Arts (SFTA, now BAFTA) nominations and awards[29] along the way. Comedies naturally featured, with stars such as Peter Sellers, Norman Wisdom, Terry-Thomas and Margaret Rutherford, as well as a Hope-Crosby 'Road' film (to Hong Kong). He continued his lifelong love affair with the arts, doing some theatre and television work, and painting in Britain and Corsica. But it is for his Ealing film work, particularly the now-classic comedies, that he will always be remembered.

In the 1960s, when Mendleson was working on the episode film *The Yellow Rolls-Royce* (1964), he met the legendary Hollywood designer Edith Head. When one of Shirley MacLaine's earrings broke, she said, 'Take this to your jewellery department, and get them to mend it.' When he told her there wasn't any such thing here, and never had been, she couldn't believe it: 'How do you manage?' 'So I explained it all to her. And she had to sit down and have a cup of tea afterwards, she was so shocked.'

Anthony Mendleson was the wardrobe wizard who worked miracles. In the Ealing years he proved he could conjure up anything. And did. One can just see the Ealing stock company waving their hats and handkerchiefs, cheering him on.

11 KIND HEARTS AND CAMPERY
THE EALING FAMILY PERVERTS

Andrew Moor

'Ealing' has long been popularly imagined as a family, watched over by a wise, rational (and prudish) father, Michael Balcon. By the early 1940s this image was tidily broadened to embrace ideals of community spiritedness, which by extension became a comfortably reassuring way of envisaging the nation collectively, at large and at war. As such, the values associated with Ealing were approachably familiar ways of fostering a sense of inclusion and participation. The ethos survived the war years too: a 1951 article on Ealing director Robert Hamer, for example, reports that he 'speaks of the studio always as "we", rather as if it were a family co-operative than an employer'.[1] Families, communities and nations, however, are not always so harmonious. They nurture and enable, but they also silence or demolish, and in Hamer's case, the chummy report leaves a lot unsaid. Louis Mazzini, his protagonist in *Kind Hearts and Coronets* (1949), enacts a fantastical revenge on his own family, the D'Ascoynes (though he remains deeply attached to his mother). As if to dramatise the family's lethal potential, the D'Ascoyne's seat, Chalfont Castle, is a medieval arsenal 'lavishly equipped with the instruments of violent death'.

Staying with the 'family' image, another wisdom about Ealing Studios is that a team ethos prevailed, and that the family ticked along producing films in a typically modest, realist style. Some of its habitués (principally Robert Hamer and the American-born Alexander Mackendrick) stood out as exceptional outsider figures whose cinematic renditions of English life were inflected with a more critical perspective. Structural cracks like these could eventually be acknowledged more openly. In the late 1960s, Balcon recalled that Hamer rarely 'came to terms with himself, and it almost seemed that he was engaged on a process of self-destruction'; he suffered 'great emotional stresses and strains'; and he 'was unable to impose upon himself an essential discipline'.[2] The second of Charles Barr's linked articles on Ealing confirms that Hamer's problems with the studio and his alcoholism were 'no secret', noting too that his films characteristically involve tensions between an attachment to and a violence against the family.[3] Centring on *Kind Hearts*, this chapter focuses on the semi-closeted discourses around same-sex desire in the periods before and after Gay Liberation in England, to see whether they inform our sense of how Ealing's aesthetic could make space for dissident desires.

The task is not about putting on record the surmised sexualities of personnel involved, disclosing them to have been 'really homosexual', and seeking evidence for it in their work, because if we think sexual categories are mobile, contingent and the result of a range of sexual possibilities at any one time, then there is no 'real' sexuality lying underneath to be revealed, and there is also no clear way of proving that it manifests itself in the work they produced. The history and vocabulary of same-sex desire is, however, figured around some recurring oppositions: assimilation/marginalisation, honesty/dishonesty, truth/acting, in/out. Terms like these inform the study of sexuality and they can also help unpack Ealing's familial image. In 1940s Britain there was little prospect of living as an 'out' gay man (the concept barely existed), so we look for oblique signs, traces and codes. Biographies should not be ignored, though, for what is often at stake are real experiences of personal difficulties (deftly handled, tacitly acknowledged, suppressed and sometimes calamitous).

There is a moving witness account of Robert Hamer's drinking and early death in *Between Hell and Charing Cross*, Pamela Wilcox's riches-to-rags memoir of her turbulent relationship with him and her own decline into alcoholism and homelessness.[4] Wilcox never addresses Hamer's sexuality, and her reliability might be doubted (she awards him a double first at Cambridge; history does not). Charles Drazin's account of Hamer's life is fuller: his conventional family; a scholarship to Corpus Christie; his scandalous 'rustication because of a homosexual affair';[5] an unsuccessful marriage to Jean Holt, another heavy drinker; a run of other shortlived relationships with women, including Wilcox. Significantly, Drazin recalls the screenwriter Diana Morgan, who was close to Hamer at Cambridge and Ealing, telling him that Hamer probably 'would have been happier to live as a homosexual'.[6] More recently, Michael Newton readily considers *Kind Hearts* in the light of its lead actor Dennis Price's homosexuality, but remains oddly silent on the question of Hamer's, though he does offer the latter's alcoholism, another half-secret vice, as evidence of his personal problems. Nevertheless, Newton's acute observation that 'Of all the Ealing directors, only Hamer experienced the allure of doubleness, the conforming rebellion of the outcast son' seems writ through with queer implication.[7]

Studio portrait of Robert Hamer

Barr warms to the theme of disorderly Ealing families in his book on the studios, drawing on a famous sketch of England as a family where, as George Orwell said, 'most of the power is in the hands of irresponsible uncles and bedridden aunts'.[8] Alistair Sim, Margaret Rutherford and others immediately spring to Barr's mind, like a roguish gallery of oddballs and eccentrics, strange fruit from what can easily be read as a fantastically queer family tree. Having conjured up this striking vision of familial peculiarity, Barr refrains from exploring all of its implications, and sensibly prioritises the central role that Ealing played during the war. This is a pity, and not only because Sim, Rutherford, Holloway, Grenfell, Greenwood, Malleson, Hawtrey, Thesiger and so many other actors of the period are magnetically dotty enough to warrant more attention. It is because what the nod to 'funny uncles' really flirts with but shies away from is Ealing's sense of queerness, and this really is worth exploring.

Michael Balcon, Hal Mason and Robert Hamer on set

Are the comedic and melodramatic impulses coming from a reputedly realist studio signs of a queer energy breaking out? More specifically, are the comedies' fantasies of liberation from a planned postwar England explicable in queer terms? Queerness has, after all, been understood to be something that resists normalised, formal structures, so much so that José Estaban Muñoz has recently emphasised its protean qualities and found it to be inherently utopian.[9] Are the eccentrics' exaggerated performance styles a comment on straitjacketed straightness? Queerness often exposes the way society schools us to behave, particularly in terms of gender and sexuality. Many an English character actor of the period could be said explicitly to 'act out' gender expectation's odd ways; drawing attention to the ways we are socially pigeonholed is one of the hallmarks of queerness. In a similar fashion, do the multiple appearances of the same actors in different roles from Ealing confound our understanding of identity? They may well trouble any sense of stable or fixed identity, and this would be emphatically queer. In terms of style, is the elegance of Robert Hamer's work the expression of what might later be called a gay sensibility? Are the contemporary reviewers' appreciations of this trademark elegance coded allusions to his sexuality? More poignantly, what do the profiles or life experiences of Robert Hamer, Dennis Price and Alec Guinness, who worked together on *Kind Hearts* and whose desires have been matters of public debate, say about sexuality in mid-century England?

One way into this is to follow the connotations of Ealing's family metaphor, for queers have families too and are nurtured within them: the family home is often the most complete of closets. Film scholars already have to hand a critical terminology to help frame

representations of troublesome families, and this is associated with one particular genre: domestic melodrama. This terminology rarely addresses issues of homosexual experience directly, but the sort of home life it renders often chimes remarkably with homosexual experience. Quite radically for mainstream cinema, domestic melodrama focuses on fault lines in bourgeois family life; on frustration, claustrophobia and non-achievement; on suffering female or impaired male characters; on the wish to escape and on frustrated desire. These last two attributes sound familiar *chez* Balcon, and are typical of some of the most interesting films he produced. Thomas Elsaesser's groundbreaking analysis of melodrama (originally from 1972) says that it:

> often records the failure of the protagonist to act in a way that could shape the events and influence the emotional environment, let alone change the stifling social milieu. The world is closed, and the characters are acted upon. Melodrama confers on them a negative identity through suffering, and the progressive self-immolation and disillusionment generally ends in resignation.[10]

I find it impossible to imagine this passage is not talking – at least in part – about lives blighted by the closet. It seems haunted by generations of men and women whose sadness is usually sidelined. When the domestic melodrama was being critically constructed and defined by film scholars like Elsaesser in the 1970s, the way the family was imagined served the needs of the feminist and Marxist critics of bourgeois family life who had set about defining the genre in the first place. If these models are silent on the topic of same-sex desire, it is because no one was really looking for it.

In the other most important account of the genre from the late 1970s, Geoffrey Nowell-Smith argues that 'undischarged emotion which cannot be accommodated within the action, subordinated as it is to the demands of family/lineage/inheritance, is traditionally expressed in the music, and … in certain aspects of the mise en scène'.[11] The narrative demands he cites happen to be the key action points in *Kind Hearts*, a family saga where genealogical purity is disturbed by a recklessly sentimental daughter's errant marriage to an Italian tenor. The tenor dies the moment his son, Louis, is born, precluding any hope that the infant might Oedipalise safely. Louis (Dennis Price) later sets about annihilating the family that turned its back on his beloved mother. Family lore exists to rationalise, regulate and endorse heterosexual relations and this fatal attack on customary tribal channels of inheritance and perpetuation strikes at the family's two key functions: property ownership and procreation. The narrative actively disdains sanctioned, marital, procreative heterosexual sex. We learn that the family's ducal title uniquely descends by the female line as well as the male, thanks to 'services rendered' by the first Duchess to King Charles II. This unusual detail wittily slices through notions of sanctified marriage and points to aristocratic hypocrisy, while it also manages to accuse Louis's ancestress of prostituting herself for her ennoblement (and being good at it). Louis twice expresses disgust at the thought of his extended family rutting and spawning like beasts. The collateral murder of an 'innocent' young lady alongside that of the snobbish relative who has been illicitly 'entertaining' her all weekend at Maidenhead is tempered by Louis's misgivings that she had already undergone a 'fate worse than death' in her lover's hotel room. They may, in fact, have been having sex at the moment of their murder. Later, the 8th Duke's brusque announcement that he has decided to marry Maude (Peggy Ann Clifford), a hefty broodmare, solely for her promising childbearing qualities clearly ruffles Louis's sense of refinement.

Louis's hope for the dukedom demands that he halt his family's procreation, and, yes, Louis himself 'plays the role' of romantic suitor to two women, Sibella (Joan Greenwood) and Edith (Valerie Hobson), but one is married so Louis's romance is illicit, and the other is a widowed prig and Louis's seduction of her is unconsummated. Neither of these women's marriages is endorsed. Hamer's first directorial credit, the 'Haunted Mirror' sequence of *Dead of Night* (1945), had told of a newly married man who receives an old mirror as a gift from his wife and is possessed by the malign bedroom image he sees in it (he is forced to confront his anxieties about what a chamber of horrors married life might be). Sibella's Italian honeymoon is almost as gruesome: she thought the Italian men attractive, was prevented from shopping by Lionel dragging her to more churches, and finds his advances repulsive. Edith's marriage to Henry (the second D'Ascoyne Louis murders) is queerer though. From the outset, Henry is inverted: we first see him upside-down through the lens of the still camera that Louis has acquired to attract his cousin, a keen photographer. When Edith naively reveals that Henry first got interested in photography on their honeymoon, the joke is that his attachment to cameras is a displacement activity to avoid sex with his wife, but when Henry marvels at Louis's 'Thornton-Pickard', boasts about his 'rapid rectilinear' and asks him to his house to see his 'Sanger-Shepherd', we have to wonder how far the *double entendres* will stretch. Henry does enjoy forbidden fruits of a sort (he drinks), and indulges this away from teetotal Edith in the closeted space of his darkroom. Louis is soon allowed into his private den to share his secret extra-marital tastes.

I would admit this to be a frivolously 'negotiated' reading if the opposition between marriage and photography had not been established so quickly, if the young men had not bonded so rapidly over it and if photography had not been used as a cloak for Henry's secret vice. Remembering Hamer's alcoholism and probable homosexuality, the two 'vices' come into alignment and the drinking motif in the film seems even more plausibly queer. As a side note, and with what looks like gravely comic prescience bearing in mind Hamer's own alcohol-related death, drink is the means by which two D'Ascoynes meet their ends: Henry's inability to resist a drop of 'developer' is what lures him to his darkroom and into Louis's trap; and the Reverend Henry's illicit weakness for port (a secret from his doctor) gives Louis easy means to poison him.

So much for the film's narrative material: what about style? According to Nowell-Smith's diagnosis, when film melodrama works over a storyline like this, 'undischarged emotion' is neurotically siphoned off into the music score. Think of the Rachmaninov in *Brief Encounter* (1945). Alternatively, contorted emotions bypass explicitly dramatic lines of action and manifest themselves in excessively loaded visuals, like hysterical symptoms, coded indices of unspeakable family problems. *Kind Hearts* may have the raw ingredients of melodrama and a similar process of reworking or transcription occurs in it: from the outset its story allies opera music with unruly sexuality. Stylistic displacement is crucial to it, but importantly this is not

Photography and secret vice: Alec Guinness as Henry D'Ascoyne in *Kind Hearts and Coronets* (1949)

A camp courtship: Louis woos Edith (Valerie Hobson) in *Kind Hearts and Coronets*

towards overblown, melodramatic audiovisuals but to ironic comedy, and its comedic and sexual charges are the result of aestheticisation. Gestures become mannered, life is performed, clothes become costumes, patterns are made, language is refined, eyebrows are raised and murder becomes wit.

There are two reasons for pronouncing this styling to be queer. Perhaps the first requires an unduly broad brush: realism foregrounds its referential quality; it claims to represent the world truthfully and denies that it is a style. It is saturated uncritically with its culture's common-sense, natural worldview, with its prejudices and blind spots, but the claim to Truth is maintained nevertheless. The real, the true and the natural: these are the terms through which heterosexuality is validated (hence they are the very terms some lines of the Gay Pride movement appropriated to authenticate same-sex relations). However, access to realistic, nuanced modes of representation has historically been the preserve of socially dominant groups. In 1940s cinema, *Roma, città aperta/Rome, Open City* (1945) offers an obvious test case of this. It uses 'authentic' location shooting in Rome's bombed streets, a freely moving camera style and relatively unstylised acting to situate its resistance fighters historically and geographically 'in the real world' and to associate them with truth and virility. In direct contrast, its scenes with Rome's Nazi occupiers are shot on a clearly inauthentic, artificial set with a decadent *mise en scène*, and its Gestapo officer Major Bergmann (Harry Feist) is an effete, preening homosexual stereotype whose Marlene Dietrich-like accomplice is a lesbian drug addict. From Rossellini's hetero-centric

perspective, artifice robs Nazism of a place in authentic history. Clearly there are good reasons for demonising the Third Reich, but Rossellini's homophobia is palpable. Fascist values and queer desires are, it seems, perversely coterminous, and the force of both is diminished by their unrealistic, negative representation. Realism is for 'straights' and 'good guys' (they amount to the same thing). In a different but related register, some of Ealing's comic output like *Hue and Cry* (1947) and *Passport to Pimlico* (1949) is visually similar to Italian neo-realist cinema – bomb damage is bomb damage – but bursting unnaturally out of the realist environment in *Hue and Cry* are its brief scenes with Alistair Sim as the comic book writer Felix H. Wilkinson. Sim's unattached 'creative sort' is one of the fruitiest funny uncles at Ealing's family party: the film's most comically expressive element, where realism is discarded, is distinctly coded as queer.

The second reason for associating stylisation with queerness takes us back towards *Kind Hearts*, and has to do with camp, precisely the quality that the film displays. Three brief explanations of camp will indicate why, and will also show what a modern film it is. Coming from before, during and after the gay identity politics associated with the 1969 Stonewall Riots, one explanation is homosexual, one gay and one queer. Camp's significance and scope have shifted since Susan Sontag's 1964 'Notes' on it, but hers is a good launch pad. She calls it 'a mode of aestheticism'[12] which goes beyond being merely serious, and beyond simple irony, by introducing 'a new standard: artifice as an ideal'.[13] Camp perpetuates the detached style of the 'dandy', and can express a 'snob taste', but since old aristocratic snob values no longer exist, the bearers of this style are now 'an improvised self-elected class, mainly homosexuals, who constitute themselves as aristocrats of taste'.[14] This is a fleeting observation in an essay which otherwise sidelines the tight bonds between homosexual subcultures and camp.

Flying the flag of the Gay Pride movement in 1977, Jack Babuscio sought to yoke ideas of camp more closely to 'the gay sensibility'. He too notes that 'irony, aestheticism, theatricality, and humour' are basic to camp, but he relates them to gay experience.[15] The incongruity that camp irony rests on draws from the notion that gayness is a 'moral deviation'; aestheticism holds the world at a distance and critiques it; to grasp camp is to see life as theatre and to appreciate role-playing, something which 'passing for straight' teaches all homosexuals; while humour provides 'a means of dealing with a hostile environment'.[16]

Jonathan Dollimore's 1991 reading of camp from a queer, postmodern perspective rejects the idea that there can be a 'homosexual' or 'gay' sensibility, because sensibilities connote inner feelings, truths and authenticity, and these are the straight world's totemic values, from which queerness is prohibited. Drawing from Oscar Wilde's use of paradox to invert and eradicate established bourgeois social mores, Dollimore senses that camp 'undermines the categories which exclude it, and does so through parody and mimicry … Rather than a direct repudiation of depth, there is a performance of it to excess.'[17] Camp masquerades, mimics and denaturalises.

Kind Hearts has snobbism and dandyism aplenty, in part because of its vaguely Wildean heritage, and here it should be remembered that *Israel Rank*, Roy Horniman's Edwardian source novel for the film, is self-consciously in the tradition of Wilde. Wilde's political self-fashioning of himself as a dandy, as an effeminate aesthete, was not at the time linked to same-sex passion, though it anticipates it, and the Wilde trial cemented the link in the popular imagination. The dandy was, instead, a way for the middle classes to consolidate their position by aping and, in Alan Sinfield's words, 'stigmatising upper-class pretensions'.[18]

Sontag correctly identifies that a mode of dandy-camp usurps the leisure-class decadence of the old aristocracy, and she locates it among coteries of tasteful, urban homosexuals. Louis's own dandified appearance (his fine clothes, for example) re-enacts the class shift that Wilde himself had performed from the 1870s onwards, and through his murderous campaign he both escapes the dull, straight suburbs and sees off the *ancien régime*.

The film's ironic play with aesthetic sensibility is further evidence of its campness. 'Sensibility' denotes a way of structuring our feelings, and the term derives from the late seventeenth century, when the middle classes began to redefine gentlemanly conduct, to claim it from the aristocracy, and to emphasise feelings, manners, taste and 'elegance' (the characteristic most often associated with Hamer). Effeminate values perhaps, they were taken up and developed as part of the dandy's style, as a badge of character. We can read the film's representations of scrupulous good manners as another way of marking the dandy's queer refinement, where Louis's cultured grace contrasts with some of his relatives' bluntness, but the film goes out of its way to parody the 'mode of sensibility' entirely. Edith is merely a D'Ascoyne by marriage, and she defines herself against the family she married into by operating her own modern regime of delicate manners, where her considered inner feelings are carefully expressed. Valerie Hobson's straightforward, prosaic underplaying of the role lets us see Edith's manners for what they are, and it is only her prudery and her ignorance of her husband's drinking which cause her to be the butt of a direct joke. Louis's ambush of her is clear and devastating: his voice-over recalls 'I decided to attack on her own ground and with her own weapons' and so he disarms her with an 'impersonation of a man of sterling character'. His feigned performance is precisely the sort of strategic mimicry that Dollimore identifies, and its target, middle-class morality, is just what radical camp sets out to eradicate.

Elsewhere, the film parodies genuine emotion. Louis's mother's brief death scene is presented as a posed tableau, and its *mise en scène* is a too carefully composed cliché of delicate sentiment (another 'performance to excess'), where real grief is banished and all we have is the pose; even the pose shatters when a heart-shaped marriage portrait drops out of the dying mother's hand. Repeated memories of Louis's, Sibella's and Lionel's (John Penrose) Clapham childhoods also nod to a similarly shabby scene of Victorian sentimentality (chestnuts roasted on the nursery fire) but Louis's bored disdain for the image is clear, and so another traditionally emotive scenario is hollowed out and left without significance. Even the film's opening prison sequence, before we flashback through Louis's memoirs, rests on a comic incongruity between Louis's sense of social niceties and his imminent hanging, though here too there is no space for genuine emotion: composure and artifice are everything.

Camp is an active strategy of theatricality and masquerade, so we should conclude by looking at the performances in the film. Together, Joan Greenwood, Alec Guinness and Dennis Price secure the film its queer status. Sibella is, like Louis, a manipulator, storyteller, deceiver and an actress, as Michael Newton notes, and Greenwood's performance is a fastidiously accomplished, doll-like piece of affectation, just like some of the hats she wears.[19] She purrs, pouts and swoons; her modulated voice slips nimbly, sometimes midword, between her light coquettish register and those deeper, huskier, sexier bass-notes. She acts 'grief' to bits at Louis's trial. Her dexterous rendition (or 'masquerade') of femininity is a devastatingly successful instance of gender transmuted to pure style. By repudiating all conventions of mimetic realism and performing femininity to excess, she challenges any common-sense understanding of what gender actually is: depth-models of identity evaporate in her complete display of surface detail.

The dandy leaves prison: Dennis Price as Louis Mazzini in Kind Hearts and Coronets

A solvent of identity, queerness implies mutability, elusiveness and playfulness. On these grounds, could Alec Guinness, 'the man of a thousand faces, or the man with no face at all', be any queerer?[20] By splintering into multiple D'Ascoynes he dramatises the idea that Louis's murderous repetitions seem endless and that the aristocracy's gene pool is shallow. In the process, Guinness is simultaneously everywhere and nowhere, giving cardboard character sketches which reformulate Greenwood's postmodern play with identity, though they keep sexiness at a distance. Tantalisingly, Guinness's sexuality also eludes his biographers. It is just out of Piers Paul Read's grasp, though the rumour of his arrest for importuning, his mainly celibate marriage and his conflicted affinity to handsome young men are recorded, and Read's most plausible summation is that despite his probable bisexuality, 'wayward passions and desires offended against Alec's sense of order'.[21]

Dennis Price is just romantic enough to imply depth of character (a character influenced by Wilde), and his meticulously intoned performance here is a model of decorum – Louis's fistfight with Lionel is a rare loss of cool. Price plays multiple roles too (Louis's father, Louis himself and his impersonation of the Bishop of Matabeleland), and the script stresses other performances (the 'stage lover', the 'man of sterling character'). Price's star status is also

queerly inflected, from his first film role as a cynical, metropolitan musician in *A Canterbury Tale* (1944), through to later appearances such as Calloway, a homosexual actor, in *Victim* (1960). The theme echoes through his personal life, which is similar to Hamer's: shadowing Noel Coward on stage, then marriage, divorce and a rather public suicide attempt (he tried to gas himself and was found unconscious). Gambling, drink and insolvency hampered his reputation's dogged recuperation, and he died in 1973. Press copy about Price had long traded on open secrets. Until a posthumous article in *Gay Times* in 1992, his sexuality was predictably hinted at (he is urbane, stylish, cool, sardonic, sensitive, refined ...), and news reports of the gassing delicately avoided the word 'suicide'.

When *Gay Times* came to name the boyfriends Price had in later life, and to report his distressed family's complaints to Oxford University Press about a frank new entry on him in the *Dictionary of National Biography*, a very different discourse is operating: Price is now 'gay', truth must out and his life under wraps was a 'tragedy'.[22] *Gay Times* is, of course, furthering the cause of gay liberation (and pandering to its readers) when it takes on Price's cause in the name of what might be called 'moral clarity': in/out; bad/good; lies/honesty: these apparently simple binaries are being deployed. In the more homophobic 1940s, with its murkily ambiguous tensions between surveillance and anonymity, expressions of same-sex desires were often communicated through nudges, subtexts and obliquity. *Kind Hearts* exists in a camp homosexual tradition of stylised amorality and knows it, which is why it resonates with queer culture today.

The Bells Go Down (1943) premiere ticket application

Poster for *Scott of the Antarctic* (1948), designed by S. John Woods

Poster for *Painted Boats* (1945), designed by Edward Bawden

Poster for *Pink String and Sealing Wax* (1945), designed by John Piper

Poster for *Hue and Cry* (1947), designed by Edward Bawden

Cover for *The Magnet* (1950) publicity brochure, artwork by Edward Ardizzone

The Titfield Thunderbolt (1953) publicity brochure artwork by Edward Bawden

Pool of London (1951) publicity brochure artwork by James Boswell

DENNIS PRICE *as the debonair Gentleman with killing ways*

Now one of the most popular male stars in British pictures, Dennis Price has his biggest and most difficult role yet in *Kind Hearts and Coronets*. Born on June 23, 1915, at Twyford, Berks, he was intended for the Church, but decided to become an actor. After touring, joined the Croydon Repertory Company in 1937. First West End appearance the same year in *Richard II*, and later returned to the Croydon Rep. and then the Oxford Repertory Company until service with the Royal Artillery as a gunner. Invalided out of the Army, he resumed his stage career. Spotted in *Springtime of Others* by film producer Michael Powell who gave him his first screen part in *A Canterbury Tale*.

JOAN GREENWOOD *as the Girl who was wed but wanton*

Joan Greenwood departs from her usual 'nice girl' parts to become a bad girl for the first time in *Kind Hearts and Coronets*, in which she plays the part of a thoroughly selfish, scheming young vixen. Born in Chelsea on March 4, 1921, daughter of the well-known artist, the late Earnshaw Greenwood, Joan had an early ambition to become a ballet dancer, but ill-health caused this plan to be discarded and she turned to acting instead. After studying at the Royal Academy of Dramatic Art, she played child roles for several years before going into repertory and developing into an adult actress. Stage work led her to the screen, first in supporting then in star parts.

Kind Hearts and Coronets (1949) publicity brochure artwork by Rosemary Grimble

Poster for *It Always Rains on Sunday* (1947), designed by James Boswell

Original poster for *The Captive Heart* (1946), designed by John Bainbridge

Distributor's poster for *The Captive Heart*

Original poster for *The Cruel Sea* (1953), designed by Charles Murray

Distributor's poster for *The Cruel Sea*

2011 re-release poster for *Kind Hearts and Coronets* (1949), designed by Sam Ashby

Kind Hearts and Coronets (1949): costume design by Anthony Mendleson for Valerie Hobson as Lady Edith D'Ascoyne. Edwardian gown, lace with rose. Gouache on board; signed, dated 1948. The dress worn in the proposal scene, below. This is a rare original design from the time of the film's production; most of Mendleson's originals were not returned after the costumes were made

D'Ascoyne parlour, proposal scene: Louis Mazzini (Dennis Price) seated with Lady Edith (Valerie Hobson). She is wearing the black dress with lace sleeves and neckline, as seen in the BFI's costume design above

Costume design by Anthony Mendleson for Lady Edith D'Ascoyne. Edwardian evening gown, with pearl necklace and fan. Gouache, watercolour and chalk on black paper; signed. Few of the original designs were returned; this is among several that were redrawn by Mendleson in later years

Cage of Gold (1950): costume design by Anthony Mendleson for Jean Simmons as Judith Moray. Swing coat, worn in the film's opening sequences. Ink and wash; signed, dated 1950

The Hanover Fair sequence from *Saraband for Dead Lovers* (1948) emphasised the creative potential of Technicolor film-making

A more restrained use of colour in Ealing's *Scott of the Antarctic* (1948)

The colourful content of Ealing's African adventure, *Where No Vultures Fly* (1951), is heralded by this poster

The appearance of the colourful gold, green and red engine in *The Titfield Thunderbolt* (1953) guarantees it victory over the rival coach company

Red telephone boxes populate the screen in Ealing colour films like *The Ladykillers* (1955)

Douglas Slocombe's belief in the 'Technicolor black' is put to good use in *Out of the Clouds* (1955)

Colourful costumes lead the eye across the image, as in this scene from *Davy* (1957)

12 THAT EALING FEELING

'EALING COMEDIES' AND COMEDIES 'MADE AT EALING'

Tim O'Sullivan

There is nothing I dislike more than people who say 'Make a Comedy' as if it was a question of setting a lever and then turning a handle. ... At Ealing we are always on the look-out for teams and, to make a successful comedy film, one must try and find the ideal combination of the comedy idea, the writer, the director and the player. This of course sets a limit to the number of comedies we can make and brings me back to my abhorrence of the sausage-machine technique and the dangers which may lead to creative exhaustion.[1]

Introduction: Ealing Core and Ealing Periphery

Ealing films have provided a rich seam for British film scholarship to mine over the past fifty years and this opportunity to 'revisit' and review both the films and the established conventional wisdoms that have condensed and coagulated around them is both timely and welcome. What follows develops a focus on the *comedy* films produced at Ealing, perhaps the most celebrated and fondly remembered genre and nostalgic legacy of the studio's output in its relatively brief postwar period of production. In particular, I am interested in exploring the extent to which Ealing comedies can be regarded as an *exclusive* and fixed category, distinguished, on the one hand, from the rest of Ealing's output of the time and, on the other, from the broader, more encompassing contours, pressures and tendencies of British comedy and film culture in the period. Against this background, I want to explore the classification of 'Ealing comedies' in the context of a number of film comedies 'made at Ealing'.

Ninety-five feature films were made at Ealing under the aegis of Michael Balcon's influential term as chief executive (1938–58) and just over one third of these can be regarded as comedies. Critics and film scholars have conventionally classified those films produced up to the mid-1940s as primarily *performance*-led films, vehicles which bore the hallmarks of Basil Dean's earlier reign, that sought to capitalise on and to translate into the cinema the popularity of the music-hall farce and appeal of established *stage* comedy stars, most obviously in the form of George Formby, Gracie Fields, Will Hay and Tommy Trinder.[2] These account for some sixteen films, beginning with *Let's Be Famous* (1939) and ending

with the historical extravagance of Cavalcanti's *Champagne Charlie* (1944) and the lesser celebrated, decidedly odd musical comedy *Fiddlers Three* (1944), directed by Harry Watt.

Two of the films from this early period deserve brief asides here, precisely because they do not easily conform to type and deserve to be 'revisited'. Both were directed by Walter Forde,[3] months before the outbreak of World War II. *Let's Be Famous* is a comedy which satirises the snobbish and patrician ethos of the BBC (radio) service of the time, faced with the 'upstart' incursions of regional (especially 'Northern') and commercial advertising culture. In many ways characteristic of the early 'performer' mode of Ealing comedy, the film tells the story of the intertwined fortunes of a gregarious Irish village shop-keeper, Jimmy Houlihan (Jimmy O'Dea), and Betty Pinbright (Betty Driver), a young singer from Liverpool, who are both determined to break out of their respective 'cages' and to become celebrities and stars. After various 'shenanigans', they both triumph by means of their talent and win public acclaim, if not romance; and the film fades out with everyone united in song. The script for the film was by Roger MacDougall,[4] and Ronald Neame and Gordon Dines were charged with the cinematography. Barr, in his particular summary, indicates that the film is a 'tedious experience'.[5] However, in its popular representation of the BBC snobbery and *generational* conflict, 'akin to that in so many Ealing films around this time', he admits that the film is worthy of further historical consideration.

Four months later, Forde directed another comedy film for Ealing, based again on a script by MacDougall with Neame in sole charge of cinematography. *Cheer Boys Cheer* (1939) was the precursor, if not prototype, for one of the key 'Ealing comedy' templates to emerge after the war.[6] 'An intoxicating story of two rival breweries' was how it was characterised some forty years later.[7] Barr was subsequently to identify the contrast drawn in the film between the small, traditional and harmonious family brewing company, 'Greenleaf', and its organic community, threatened by a take-over bid from the modern industrial giant, 'Ironside', as a metaphor for the looming war between England and Germany. He also employed and extended this inventively to characterise Ealing's own situation in the changing postwar cinematic world, indicating that the film was 'a startling fore-runner, a reminder that those later films were not a sudden inspiration but had roots and precedents'. However, he also notes: 'whether we should call it an Ealing Comedy is a nice academic point. It is a comedy made at Ealing.'[8]

Let's Be Famous and *Cheer Boys Cheer* (both 1939): comedies made at Ealing or Ealing comedies?

The comedies made at Ealing after the war,[9] some eighteen films in total, are by contrast distinguished much more by script and story-driven narratives. Although they do feature important performances, notably by Alec Guinness and recurrent ensemble casts, it is the scripts (eight by T. E. B. Clarke, four by William Rose and a number by other writers[10]), the directors (five by Crichton, four by Mackendrick, three by Frend and one by Hamer[11]), as well as the thematic and 'team' selection of what Kenneth Tynan was to characterise as 'the bizarre British' and their 'perfectly extraordinary situations',[12] which were to make the core of these films 'Ealing comedies' – not just 'comedies made at Ealing'.

Derived in the main from Barr's influential and enduring account, the core or canon of Ealing comedies is held to consist of eight *key* films produced between 1947 and 1955. Within this established critical orthodoxy, they are regarded as emblematic of the twin tropes of Ealing comedies. On the one hand, the conservative, but 'mildly anarchic' *daydreams*, fantasies epitomised by *Passport to Pimlico* (1949), *Whisky Galore!* (1949) and *The Titfield Thunderbolt* (1953), for instance, where the comedy emanates from the clash akin to 'Greenleaf' and 'Ironside', between gemeinschaft and gesellschaft; the organic traditions of the established community, the small British 'insiders' facing the threat of the powerful 'outsiders', agents of unfeeling, usually bureaucratic change and modernisation who are outwitted or compromised by the resolution of the film. On the other hand, much less sentimental and associated principally with Hamer and Mackendrick, films like *Kind Hearts and Coronets* (1949), *The Man in the White Suit* (1951) and *The Ladykillers* (1955), unleash transgressive *nightmares*, fables of subversive, maverick masculine obsession and action, where the repressed and vengeful bubble up to the surface and lead to resolutions which were only just contained in the moral strictures permissible in (Balcon's) Ealing cinema of the time.[13]

These eight films commence with the studio's first postwar comedy, *Hue and Cry* (1947). Full of juvenile fizz and energy, the film tellingly combines a youth versus adult fantasy (akin to an anglicised version of *Emil and the Detectives* (1935)) with the documentary realism of the settings and locations of the raw London bombsites, the territory of groups of young boys (and one girl) who join forces to outwit and overwhelm a gang of crooks.

The next three films were produced and released in the crucible of 1949, the *annus mirabilis* of postwar Ealing, as Barr has it.[14] *Passport to Pimlico* came first. Directed by Henry Cornelius, it is a comedy which plays with the contradictions between the heady freedoms of apparent local secession in the heart of the capital, meeting head-on with the unavoidable obligations of national, postwar unity. This mischievous 'mild anarchy'[15] shifted slightly in Mackendrick's *Whisky Galore!*, when the community of an isolated Scottish island undermines the military, bureaucratic bumbling of the state and its agents and subverts its attempts to take control of the storm-sent, carnivalesque spirits of its title. Hamer's *Kind Hearts and Coronets*, however, releases a very different, darker and superficially much less collective trajectory, as the dispossessed and vengeful Louis Mazzini 'comically' murders and philanders almost all the way to his D'Ascoyne birthright at the expense of the aristocratic class. Two years later, in 1951, *The Lavender Hill Mob*, directed by Crichton, features another tale of 'a worm that turns', as a downtrodden, long-serving bank clerk revolts against the chains that bind him and plans then pulls off a bullion robbery, to great comic effect and with apparent success, until the giddy spree reveals the handcuffs in its final scenes. 1951 also saw Mackendrick's *The Man in the White Suit* adventurously extending the Ealing satirical and ironic comedy agenda, as its hero, an eccentric *Candide*-like maverick scientist,

The mild comic anarchy of *Whisky Galore!*, part of Ealing's *annus mirabilis* of 1949

whose seemingly impossible, magical invention of an indestructible clothing fibre that repels dirt falls foul of the machinations of capital and labour, before romance and rain provide the ultimate resolution.

In 1953, *The Titfield Thunderbolt*, directed by Crichton, appeared. This mild but intensely nostalgic epitome of one of the principal tropes of Ealing configures a rural community, challenged by and responding to the alienating forces and associated mind-set of modernity. This, the first Ealing comedy filmed in (wonderful) colour, is a steam-driven, creaking, leaking and variable whimsy, and as a result has, understandably, not been unequivocally recognised in the first division of Ealing comedies. Finally, *The Ladykillers* (1955), the last film Mackendrick contributed to the studio, is a significant final milestone (or tombstone?) in the Ealing comedy oeuvre. An unnervingly dark and original British comedy which still retains its considerable power, which lies in the juxtaposition of the weird and sinister gang of bank-robbers and their less than musical activities with the sweet innocence of their elderly landlady (Katie Johnson) and all that she represents. The tour-de-force casting and Technicolor cinematography (by Otto Heller) complements the script by William Rose and its inexorable drive towards the grisly, increasingly hysterical and absurd conclusion. Although shot on location in the environs of St Pancras and Kings Cross, this film is many, many miles away from and inhabits a very different territory to that of *Passport to Pimlico* – made only six years earlier.

Borderlines?

If the eight films discussed above have commonly been understood as the 'first division' of the Ealing comedy, there are an additional four films which are regarded conventionally as having a more *liminal* and contested status. Generally less visible and celebrated, they are seen as somehow flawed, predictable, anti-climactic or simply as rather lame film comedies which fell short of delivering the full 'Ealing feeling' in their attempts to emulate the studio's more recognised successes. Barr, perhaps unfairly, notes that three of them were directed by Charles Frend, indicative of his 'unease with comedy'.[16] These begin with the fourth comedy film produced in 1949, *A Run for Your Money*, a tale of innocents abroad, as two miners from the South Wales valleys win a newspaper competition with a prize trip to London to watch the England–Wales Rugby International and, as a result, have to run the gauntlet of the metropolis, complete with its feminine wiles, sponging drunks and the totally inept management of their adventure. This was potentially promising Ealing material which included Alec Guinness as the ineffectual gardening correspondent charged with their care, but its merits have ultimately been overshadowed by its more illustrious precursors of that year. In a similar vein, *The Magnet* (1950) also fell short. In its attempt to recapture the childhood culture and the effervescent energy successfully featured three years earlier in *Hue and Cry*, the film

Donald Houston and Moira Lister star in the 'borderline' Ealing comedy, *A Run for Your Money* (1949)

founders on a convoluted and improbable plot, although Sue Harper and Vincent Porter offer a more sympathetic account of the film.[17]

The Maggie (Alexander Mackendrick, 1954), likewise, falls awkwardly between several stools. This was Mackendrick's penultimate and least successful film at Ealing and he also intervened in the scripting with William Rose. For some the film is a misread comic triumph, but for many critics, it emerged as an oddly flat and charmless 'Mac*Titfield*' twin, with elements of *Whisky Galore!* and associated dollops of Kailyardry thrown in, as a venerable old 'puffer', this time a cantankerous steam-driven cargo boat and its 'lovable' Scottish crew, engage mischievously with an American tycoon and attempt to profit from his money and mission.[18] This rather bedraggled quartet was completed, finally, by *Barnacle Bill* (1957), the film that configured Clarke's last screenplay for Ealing. His final 'what if' story concerns a curmudgeonly and sea-sick naval captain (Guinness, with multiple flashbacks to his distinguished forefathers, redolent of *Kind Hearts*), whose obstinate command of a seaside pier, which becomes detached from the land, ultimately leads to a reawakening of a separatist state à la *Pimlico*. 'Like the last twitching of the nervous system after death',[19] Barr was later to pronounce, without irony.

Beyond the Pale

> The New Film History does not distinguish between 'good' and 'bad' films.[20]

This final section discusses the six film comedies 'made at Ealing' which have been largely forgotten, overlooked or at best given cursory dismissal in established studies of the Ealing oeuvre. This should not be regarded as an attempt to 'rescue', 'redeem' or 'canonise' already denigrated films from their historical and critical assessment; they are not necessarily 'rather good films' that have been 'unfairly neglected'. However, what is of particular interest lies in how and in what ways these films failed to become elected and regarded as Ealing comedies; how and why did they fall short of the canon? They all present their own particular challenges to the latter-day viewer of the established Ealing norm and deviate from the mainstream of Ealing comedy films. In short, they seem to have failed to ignite the 'Ealing feeling' and this reputation has continued to characterise their reception and ensure their relative invisibility.

The year after the modest success of *Hue and Cry*, in 1948, *Another Shore* was released from Ealing, directed by Crichton with a script developed by Walter Meade based on the novel by Kenneth Reddin.[21] This is a strange and quirky comic fable, which is unsure of itself from the opening credits, in which a struggle takes place over a pencil on the screen – a man's handwriting defines the forthcoming film as a tragedy, only for a woman's to delete this and insert the word 'comedy'; finally, compromise appears to be achieved and the film is billed as a 'tragi-comedy'. This introductory ambivalence, unfortunately, persists throughout the film, which, as many of the reviews of the time were to conclude, ultimately emerges as neither a tragedy nor a comedy: 'flimsy whimsy' was how one critic was to summarise it.[22] For the modern viewer, the film's backgrounds and settings, which document daily life in the centre of Dublin in 1948, provide a welcome diversion from the improbable and contrived narrative, built around masculine daydreams of escapism in the South Seas, fuelled by motor accidents and alcohol, which are ultimately reined in by romance and a

resigned reappraisal of the world and what it might actually offer. Perhaps best regarded as an odd (misogynistic?) and maverick attempt at a comic experiment, the film, which stars Robert Beatty, Moira Lister and Stanley Holloway, clearly precedes the establishment of the Ealing comedy patterns ahead.

Meet Mr Lucifer (1953), directed by Anthony Pelissier,[23] is, in many ways, a landmark film, an Ealing attempt at a satirical present- rather than past-tense comedy, which examines the entry of television into the British home from a cinematic point of view. Released in the year when the Coronation in June became celebrated in part as the first major British civic event when TV viewers had out-numbered radio listeners, the film was certainly timely.[24] As television gradually became an accepted part of the household furniture in the 1950s, it began to 'leak' into British films in particular ways, initially as an extraordinary novelty or sign of modern sophistication but later as an index of the everyday, normal and domestic.[25] Predictably, in the film, television is presented as the agent of Satan – a destructive home-wrecking device capable of ruining domestic life 'as we have known it' – through the fortunes of one particular TV set, traced through three particular households. In the first, a recently retired old man becomes exploited by so-called friends

Moira Lister (again) alongside Robert Beatty in the self-styled 'tragi-comedy' *Another Shore* (1948)

THAT EALING FEELING 141

Ealing takes on a new enemy – television – in Meet Mr Lucifer *(1953)*

and neighbours and their fascination for his set. When he sells the TV to a young married couple, its presence and divisive aura quickly endangers their relationship and home life. Finally, when the television is passed on to a lonely bachelor, he becomes hopelessly unable to distinguish between his TV-induced fantasies, in the shape of 'Miss Lonely Hearts' (Kay Kendall), and his reality. The film outwardly presents a 'disguised' critique of the new broadcast medium and its 'invasion' of the home and its power to draw audiences away from the theatre, not cinema. However, in spite of the ending, which shows the devil's latest attraction to be 3-D film, the film represents a bitter harbinger of considerable anxiety, which was to gather pace and substance as Ealing (and the rest of the British industry) 'soldiered on' through the mid- to late 1950s.[26] As Barr notes, interestingly: 'The TV set is shown creating fake community, fake togetherness ... a parody of that *community* which is so important to Ealing.'[27] While they welcomed the topic and themes of the film, contemporary reviews generally found that the film had fallen short of the comedy standards of the studio; Paul Dehn in the *Sunday Chronicle* for instance, a self-confessed 'telly-phobe', began his review: 'What a golden opportunity Ealing have lost.'[28]

The Love Lottery (Charles Crichton, 1954) was another Ealing attempt to recognise and to reflect modern times. It was a satire on stardom and celebrity which, untypically for Ealing, featured David Niven[29] as swashbuckling Hollywood film idol Rex Allerton who, driven to distraction by the constant, intrusive attentions of his adoring female fans, seeks anonymity and sanctuary in a small Italian town overlooking Lake Como.[30] After an expensive visit to a casino, he is hoodwinked into becoming the star prize in an international 'Love Lottery' and this triggers an extraordinary tale of chance, romance and true love, which finally reconciles the ordinary with the spectacular when the winner finds that he is really nothing like his screen image and that she cannot abide the besieged life his fame has brought him. On its release, the film attracted considerable press attention and many of the critics' reviews of the time tried hard to rescue it by foregrounding the vibrancy of the Italian settings, its continental warmth and its tilt at and parody of Hollywood stardom. However, this support for the Ealing adventure could not disguise a deep, even terminal critical unease and impatience with the direction the film seemed to signal for Ealing. As Leonard Mosley, the *Daily Express* reviewer of the time, was to put it: 'Is it the last of the Ealing funny stuff? … Ealing Studios have reached the end of this particular line.'[31] The very few subsequent accounts of the film have been less than charitable; even Perry found the film an 'uneasy failure', 'a depressing indication that Ealing usually foundered when it tried to make a film with a feminine viewpoint'.[32] A more recent assessment of the film pulls no punches, characterising it as:

> an appalling farrago about a film star (David Niven) who is raffled off to his predatory fans. Garishly shot and vulgarly presented, *The Love Lottery* fails to convince at any level. Balcon was glumly aware of its short-comings, calling it 'one of the worst pictures we made for years'.[33]

A more chummy and domestic model of comedy drama was offered by *Touch and Go* (1955), directed by Michael Truman. Jack Hawkins[34] plays Jim Fletcher, a successful and progressive English furniture designer, who, as a result of his firm's 'hide-bound' dismissal and rejection of his 'contemporary' styles and modernist designs, decides unilaterally to uproot his family and emigrate to Australia and the promise of 'new horizons'. However, he is unable to carry this through, as the domestic ties of his known world – his daughter, her new found boyfriend, his neighbourhood and wife (and even the household cat) – conspire to hold him back from the new world 'down-under'. At the eleventh hour, a suitable compromise results when his old employer reverses his previous conservatism and offers a new improved salary and more autonomous status in the company. Suburban order, having been challenged, is therefore rather predictably restored.[35]

The final two comedies made under the Ealing Studios badge were *Who Done It?* (1956), directed by Basil Dearden, and *Davy* (1957), directed by his associate Michael Relph. Both are kinds of throwbacks to the earlier, Ealing 'performer' comedies associated with the prewar period, but had inevitably moved from the era of stage variety into the age of radio and television stardom.[36] In their first, if not only, leading film roles as television beckoned, Benny Hill (as an amateur sleuth who tracks down a ruthless Iron Curtain gang) and Harry Secombe (as the opera singer who-might-have-been if it were not for his poignant loyalties to the old family stage act) were the respective leads in these two rather sorry 'fag-ends' of Ealing comedy. Neither, however unfortunately, has been regarded as providing an especially funny ending to comedy at Ealing.[37]

Endnote

The six films briefly discussed above all deviate in a number of ways from the now almost 'sacred' and nostalgic norm of the Ealing comedy. Their teams and scripts are different, they feature unfamiliar casts and, in some cases, they attempt to deal with novel themes. They can all, in differing ways, be regarded simply as inferior efforts or oddities, merely perfunctory attempts to keep the Ealing production machine going, which fell short and were found wanting, and furthermore betrayed the 'creative exhaustion' which exercised Michael Balcon in his statement quoted at the beginning of this chapter. However, to counter this, they – or at least some of them – may be viewed as modest or even bold attempts at experiment or innovation, indicative of moves to inject *new* themes and influences into the moribund Ealing repertoire, and to change gear and mesh with shifting social and historical circumstances and the cultures of audiences and cinemagoing in the late 1950s. In these terms, they are less concerned with looking backwards to wartime and immediate postwar austerity and celebrating communities, and their mode is not whimsical nostalgia. Instead they represent Ealing's attempts to deal with new themes and more modern outlooks associated with affluence, consumerism and change – in particular in generational and gender relations. Perhaps herein are the roots of their difference and deviation.

Revisiting (and reviewing) 'Ealing comedies', as well as the lesser-known, unrecognised and uncelebrated 'comedies made at Ealing' is a sobering as well as pleasurable experience. Two particular issues are worthy of final reflection and consideration. First, it remains difficult to separate the production and development of British film comedies at Ealing from the studio's broader output and indeed from wider trends within British film production; neat generic, studio or other categories constantly fray at the edges, blur and intermingle. It is perhaps too easy to only focus on *Ealing* comedies or productions as if they were somehow hermetically sealed from everything else at the time. Such exclusivity has tended to over-unify the films and to play down significant differences within them. Second, re-viewing these films and reading their contemporary reviews, as well as their later dissections by subsequent waves of film scholars, provokes a number of stubborn and intransigent questions concerning methodology and generation. In short, what and how are we watching when we watch Ealing films now? Most of these films are now widely available on DVD, on internet sites and are often re-broadcast on TV channels; what *do* current viewers make of them?

13 AMBIGUITY AND ACHIEVEMENT
ALEC GUINNESS'S EALING PERFORMANCES

James Walters

> Here he is, then, the man in the white suit. It's a very powerful visual image, but image of what? What do we make of the suit, of the man in it, and of what happens to them now?[1]

Charles Barr's remarks concerning the spectacle of the indestructible suit that Sidney Stratton, played by Alec Guinness, has invented and wears in Ealing Studios' *The Man in the White Suit* (Alexander Mackendrick, 1951) are especially pertinent to an appreciation of the ambitions and achievements of this film, this actor and this studio. Barr's questions, in his landmark study of Ealing, lead him to formulate a detailed, chapter-length analysis of the film's symbolic and ideological strategies. It is striking that *The Man in the White Suit* prompts – perhaps demands – such a thorough response. It suggests that, once the film has concluded, there is still work to do, still questions left to answer. From a certain point of view, this might be regarded as something of a failure on the film's part. It may suggest an absence of clarity or an undesirable lack of definition in the work. This view has been expressed in certain accounts of *The Man in the White Suit*. In a book dedicated to the work and career of its star, John Russell Taylor finds both Guinness's performance and the film as a whole to be far from satisfactory. In an attempt to locate the root causes for his disappointment, Taylor speculates that 'Partly no doubt it is the way the character is written: apart from the unworldly idealism, we never really know what makes Sidney tick, and left without any noticeable physical or psychological disguise Guinness does not manage to invest him with much more than a shy, slightly idiotic charm.'[2] Leaving aside the curious assertion that this actor's accomplishments are somehow reliant upon the heaviness of his 'disguise', we might find legitimate cause to celebrate the ambiguity that Guinness's performance manages to create, but which Taylor finds cause to denigrate. Guinness achieves ambiguity through understatement and, while this may appear to be the kind of slight character investment that Taylor laments, it is equally possible to identify a subtle and delicate handling in the portrayal. Of further interest is the extent to which this definition of 'ambiguity through understatement' in Guinness's performance might be extended to characterise *The Man in the White Suit* as a whole and even an entire group of films produced by Ealing Studios and starring this actor. If such a case can be made, we begin to see a close relationship between the artistic ambitions of Alec Guinness, the film-makers he worked with and the studio that employed them.

Light and Dark: Alec Guinness's ambiguous characterisation in *The Man in the White Suit* (1951)

In defining these claims more precisely, we can return to Barr's reading of *The Man in the White Suit* and, particularly, the attention he pays to a crucial close-up of Alec Guinness's face. The film is nearing its conclusion and Sidney Stratton, wearing his luminous white suit, is attempting to hide from the joined masses of factory owners and workers that are pursuing him. (Both are threatened by Stratton's invention, as it spells the end not only for the perpetuity of the owner's profits but also for the continued employment of the workforce.) On the run, he turns a corner and recognises the elderly figure of Mrs Watson, his former landlady (Edie Martin). She holds a bundle of clothing that she is paid to wash but elects not to lend him an item to cover up his conspicuously radiant suit. She asks simply: 'Why can't you ... scientists leave things alone? What about my bit of washing when there's no washing to do?' In terms of understatement, the line is delivered exquisitely by the actress, allowing the most delicate tone of genuine desperation to linger without hyperbole or hysteria, leaving the slightest pause before the delivery of 'scientists' in order to register a subtle note of disdain. Guinness matches this understatement and intensifies it as the shot reverses to a close-up of Sidney's face. Guinness is almost entirely still as the image is held for nearly ten seconds. He focuses upon where Mrs Watson had just been standing (she departed in the previous reverse shot after her speech), before letting his gaze drop to an absolutely minimal, almost undetectable degree: the two points of his focus can be only millimetres apart. He expels a very small amount of breath, visible briefly as vapour in the cold, and the shot is ended. The crowds, which have been audible on the soundtrack during the close-up of Sidney, finally descend and we are led to the film's conclusion.

The move to close-up might conventionally be taken to signal a moment of revelation, bringing us closer to a character's interiority through our increased proximity to their physical form. In this case, however, the new intimacy does not bring about immediate access to the character's emotions and, instead, we are left to speculate as to what thoughts flash across Sidney's mind as he simply looks on. The data presented to us may be too sparse for immediate conclusions, but it is precisely Guinness's minimalist style that invites further engagement, contemplation and interpretation. In his account of the film, Barr reads the actor's stillness as recognition, leading on from the introduction of Mrs Watson. He suggests that:

> We can see her appearance simply as forcing on Sidney, for the first time, the fact of other people's existence as people, with their own motivations which can't be taken away from them. The long close-up of Sidney then implies not 'Yes, an unanswerable argument' ... but the dawn of a new recognition on Sidney's part: of society as a network of vested interests which, however narrow, sectional, and bloody-minded they may be, exist, and are part of the data ... In the close-up we can sense the machinery in his computer mind whirring and clicking as he feeds in the amazing new data.[3]

If we find Barr's analysis convincing, we must also pay tribute to the necessary interpretative work that has brought him to these conclusions. The reading of the moment is sophisticated, but it emerges from an effort to make sense of a performance style that is unemphatic, subdued, passive even. Had Guinness allowed a flicker of direct emotion to register in the close-up (remorse, reticence, relief?) then the moment would be given away too easily. It would seem to be an aim of the actor to keep this character ambiguous precisely through a strategy of underemphasis, so that even the slightest shift in expression might be taken to reference a change in emotion or intellectual perspective. This attitude to characterisation relies upon a certain degree of trust in the audience: that they will be equipped with a desire and an ability to interpret very slight data to comprehend the work's meaning and significance.

We might extend this approach as a means of understanding the film as a whole, noting that a definitive 'message' is resolutely avoided in *The Man in the White Suit*. We are encouraged to become swept up in the excitement and amusement of Sidney's experiments as he attempts to perfect his indestructible cloth, and we might get swept away further by the familiar narrative of the 'little man' succeeding against the odds. And yet, that enthusiasm is tempered as we are made to consider the consequences of such an invention, not only for the capitalist owners of the mills but also for the legions of workers that will be left without jobs. It would seem that the film has reached its moral judgment on these issues when Sidney's suit disintegrates in front of the massed crowds, and so the dilemma evaporates before us. Yet, *The Man in the White Suit* ends with this character dejected but heading towards a new dawn, apparently intending to resurrect his quest for the wonder-garment elsewhere. In this context, Guinness's blank gaze in the extended close-up might be yet more ambiguous than Barr allows for in his reading. If it does indeed represent Sidney's recognition, it also represents the dogmatic dedication of a man who can see the direct implications of his actions for others and yet dedicates himself anew to those actions regardless. In this sense, Guinness's subdued performance seems to encapsulate not only the character's dawning awareness in that moment but also the unswerving determination we see in the film's final seconds. The lowering of the gaze and expulsion of breath in the close-

Alec Guinness as the arrogant and condescending Ascoyne D'Ascoyne, Louis Mazzini's first murder victim in *Kind Hearts and Coronets* (1949) ...

up might then be read as Sidney's acknowledgment that his invention will bring hardship *and* his resignation to the fact he must carry on regardless of this. Here, then, the understatement of Guinness's technique implies light and dark in this man, bringing forth the character's moral ambiguity and, in turn, sealing the ambiguity of the film's defining moral tone.

In *The Man in the White Suit*, Guinness's performance style perfectly complements the film's dedication to moral ambiguity and understatement. We might broaden these claims to incorporate the actor's work in other films produced by Ealing Studios, thus advancing a sense of the studio's shared investment in those themes. Guinness's first film with Ealing, *Kind Hearts and Coronets* (Robert Hamer, 1949), provides the performance spectacle of the actor playing all eight members of the aristocratic D'Ascoyne family. The plot involves Louis Mazzini (Dennis Price), a direct descendent of the D'Ascoynes but made outcast through his mother's marriage to an Italian opera singer. After his mother's death in relative poverty, Louis embarks upon a plan to avenge her ill treatment at the hands of her family by murdering, one by one, those members standing between him and the D'Ascoyne title of Duke of Chalfont. In the course of this pursuit, Louis ascends from lowly shop draper to banker to dukedom, crossing class divides in the process. As a result of this, his actions might be regarded as a wider revenge against the antiquated English class system, lending a degree of radicalism and moral justification to his acts. The film avoids such straightforward attitudes, however, as Louis's words and actions gradually reveal an icy ruthlessness and social snobbery in many ways equal to the D'Ascoyne family he seeks to obliterate. These

... whereas Mazzini's second victim is the amiable and innocent Henry D'Ascoyne

qualities are inherent in Robert Hamer and John Dighton's meticulous screenplay, but it is also the case that Dennis Price's performance of Louis is uncompromising, never allowing the character a moment of sustained sentimentality or heroism.

Guinness's performances as the D'Ascoyne family members take their place alongside the achievements of Hamer, Dighton and Price. The actor resists the convenient attraction of imbuing each descendent with a shared set of abhorrent traits, which would risk portraying Louis's revenge as a laudable moral crusade. Instead, Guinness refuses to settle upon one defining tone, crafting a series of character sketches that, while briefly sustained, are distinct, textured and efficient. This balanced approach is evident in the first and second of his victims: the young Ascoyne D'Ascoyne and Henry D'Ascoyne. In the case of the former, Guinness creates an impression of arrogance, condescension and lasciviousness from the outset. We first encounter the young Ascoyne when he visits the drapers at which Louis is employed; he is standing with Louis behind the counter to his left (screen right) and a young female companion seated to his right (screen left). Guinness exploits this simple positioning with great care. He keeps his frame turned towards the seated female throughout the scene, looking down upon her and leaning in slightly as they converse, as though surveying her with lecherous anticipation (they discuss an illicit weekend retreat in hushed tones at one point). By turning towards his companion, Guinness also ensures that Louis is denied Ascoyne's attention and, in fact, as the customer has to turn and glance over his shoulder every time the draper engages with him, Guinness conveys succinctly the sense that these are inconvenient and unwelcome distractions for the character, breaking off abruptly at

AMBIGUITY AND ACHIEVEMENT 149

every opportunity. Vocally, he makes certain that Ascoyne's disdain for the shop worker is effortless by keeping his tones even and crisp, as though Louis were just an inconsequential feature of the environment that can be dismissed as casually as the negligee Ascoyne buys for his mistress. Such a portrayal guarantees that, when Louis disposes of the young Ascoyne, sorrow may not be our immediate response.

Louis's second victim, Henry D'Ascoyne, can be regarded as the reverse of his relative: genial and well mannered, he causes Louis to reflect ironically that 'he seemed like a very pleasant fellow and I regretted that our acquaintanceship should be so short'. Again, Guinness establishes the character's temperament immediately and with economy. Appearing at first framed upside-down in Louis's viewfinder as he exits the local inn (Louis is masquerading as a fellow camera enthusiast to win favour with his prey), Henry pauses and buttons up his jacket when he realises he is being photographed, as though attempting a more respectable appearance for the camera. Guinness adds to this small act of self-consciousness and expands upon it as Henry hesitantly makes his way towards Louis, the actor placing his hands behind his back and drawing out his footsteps to convey a slight degree of social apprehension. Indeed, when Henry addresses the stranger he bends his head to speak, lowering himself to Louis's level immediately and even affecting a slight bow as a greeting. As they talk, Guinness fixes his features into an amiable grin and idly fiddles with the cap held behind his back, giving Henry a boyish, innocent quality. When Louis accepts the invitation to view some of Henry's photographic equipment at the house, Guinness has his character engage in the superfluous task of folding away the camera's blackout cloth, hinting at a natural inclination to help others. Indeed, this moment of one D'Ascoyne striving to assist Louis is a perfect reversal of the encounter with the young Ascoyne, in which Louis's professional servitude was met with cold disdain. As the second murder victim after the young Ascoyne, Guinness's portrayal of Henry crystallises the notion that each member of this family does not necessarily represent a uniform set of values and attitudes, ensuring that any responses to their respective demises will vary.

The distinctions between these portrayals result in a pattern of fluctuating morals within the film's narrative. In the case of the young Ascoyne, we might find a degree of justification in Louis's murderous acts, given that this character appears to encapsulate precisely the D'Ascoyne family's superciliousness in their treatment of Louis's mother. And yet, the depiction of Henry revises such assumptions as Guinness immediately sets about reversing each characteristic that the young Ascoygne displayed, at once replacing cold condescension with amiable assistance. In common with *The Man in the White Suit*, *Kind Hearts and Coronets* retains an ambiguous moral attitude. Guinness is alive to these ambitions, insisting upon a crucial diversity within his brief portrayals of the D'Ascoynes, thus blurring distinctions of right and wrong, guilt and innocence. The lines of contrast are not drawn too heavily, however, so that we are never presented with caricatures that contradict too sharply: both Asgoyne and Henry are recognisably from the same family of class and privilege in Guinness's portrayals. Lacking overemphasis, the performances complement the film's overall strategy of restraint. Neither scene possesses an assertive visual style and, indeed, both Ascoyne and Henry die subdued deaths: the first one signalled by a rowboat gently tilting over a waterfall and out of sight, the second by a muffled bang and a plume of smoke glanced rising gently from behind a garden wall.

As was the case with *The Man in the White Suit*, we begin once more to identify ambiguity as a key strength in Guinness's work on *Kind Hearts and Coronets* and in his association with

Ealing more generally. A chief strength of Hamer's film lies in its hesitation over a definitive moral position. Even at its conclusion, the matter of Louis's punishment is left unresolved: wrongly accused but acquitted of killing a former love rival, his written confession to the murders of the D'Ascoyne family members remains inside the prison cell he occupied, while he stands outside the gates. We never discover whether he is found out or not. By this stage, the precise nature of guilt and innocence has perhaps become clouded and confused within the film: have we witnessed a radical act of social retribution or the most ruthless pursuit of personal ambition? Both possibilities are kept in play, and the subtle shifts of tone in Guinness's performances of the D'Ascoyne family members contribute significantly to the preservation of that ambiguity.

Given the achievements represented in *Kind Hearts and Coronets*, Guinness's second film of 1949 with Ealing, *A Run for Your Money* (Charles Frend), registers as something of an afterthought for both studio and actor. The film certainly lacks the nuanced intensity of Hamer's precise work and, although Guinness's performance of the prissy gardening reporter, Whimple, is adequate, its qualities are determined by a plot somewhat bereft of subtlety and depth. The story involves two Welsh miners who win a newspaper competition and travel to London to receive their prize. Complications ensue and the brothers, separated from each other, find themselves in the respective company of a washed-up Welsh harpist and a cockney female con artist. These sparse character descriptions perhaps illustrate the kinds of stereotypes the film deals in as it manages to poorly represent both the English and Welsh communities it seeks to depict. Perhaps it could be argued that such criticisms are not entirely appropriate for such a light comedy, but it is also the case that *A Run for Your Money* unfolds with a degree of thematic simplicity that often descends into pedestrianism. The performances take on this lack of definition, becoming functional and one-dimensional as actors deliver lines in order to progress the plot straightforwardly before we cut to the next scene. Certainly, there is little room for Guinness to develop a sustained character, especially as the film often strives for facile comic effect. So when, in one scene, Whimple enters a bar in pursuit of one brother, only to find that a brawl has broken out between English and Welsh rugby fans, Guinness's work is curtailed as the character's reaction is cut short: a leek is unceremoniously thrown in his face. The lack of ambition inherent in cheap laughs of this kind comes to define Frend's film, illustrating its lack of distinction against those other Ealing projects Guinness would be associated with during this period.

Released between *Kind Hearts and Coronets* and *The Man in the White Suit*, *The Lavender Hill Mob* (Charles Crichton, 1951) concludes with a greater degree of decisiveness than those other Ealing comedies featuring Alec Guinness. The film's closing scene depicts Guinness's character, Henry Holland, being led away in handcuffs having been arrested for the theft of £1 million-worth of gold from the Bank of England. The robbery was only partially successful, however, with Holland's partner having been arrested in England. Holland flees to Rio de Janeiro with £25,000-worth of gold (in the form of novelty Eiffel Tower statuettes) and lives the high life for a year before his capture. Unlike the two films discussed already, there is no hint of further pursuits (Sidney Stratton) or any hesitation over punishment (Louis Mazzini): when the words 'The End' appear on screen, their meaning is literal rather than ironic. If the fate of Henry Holland is clear-cut, however, the character remains somewhat enigmatic at the film's finish. Henry has been telling his story to an acquaintance in a Rio club. Only at the end is it revealed that this anecdote has been a confession, and the companion is in fact a detective: as the two men stand and begin to leave, we see for the

first time that they are handcuffed together. Shortly before this revelation, the British Ambassador in Rio approaches their table to congratulate Henry on an excellent party that he recently threw. The Ambassador's interjection completes a portrait of Holland being a well-liked and respected member of his new community. The film had opened with him warmly greeting a number of locals at his table and handing each a bundle of notes: wealth and personality have clearly secured their affections.

As the Ambassador departs their table, Henry is silent for a moment. In close-up, Guinness casts his gaze slightly downwards as he looks through his thick-rimmed glasses and takes a drag on the cigar he holds. As he exhales, he lifts and tilts his head upwards, blowing away the smoke. Guinness's lips are puckered as he performs this motion and the actor allows that expression to remain on his face, softening the tautness of his mouth and forming it into the strange little smile his character has worn at various points in the film. As he smiles, he looks down again before the detective asks Henry the simple question: 'Ready?' Guinness looks across at his fellow actor and nods slowly, replying 'Ready', the smile fading only slightly as he speaks. And then both men are departing, handcuffed together, Henry taking the cigar with him. Although lacking the same intensity as the close-up of Guinness's face in *The Man in the White Suit*, this moment is nevertheless sustained and accented enough within the scene to gain significance.

Guinness begins the sequence of small movements with the look downwards that might conventionally indicate reflection, an impression that gains weight as he takes a drag on his cigar. As he holds that pose for a second, this reflection takes on the appearance of regret,

Henry Holland's look of contented failure in *The Lavender Hill Mob* (1951)

but the rise of the head and puffing out of smoke seems to blow away that darker sentiment. The smile breaks with a twitch to transform the second lowering of the gaze into a gesture of fonder remembrance. He gradually withdraws himself from this reverie to answer the question posed, the gentle nod of the head signalling contentment to accompany preparedness. Guinness's set of expressions and movements suggest a character being carried away by his thoughts, as though silently continuing a small final section of the narration he had been delivering out loud to the detective only moments before. Indeed, the whole tone of the sequence is introspective: Henry thinking to himself, smiling to himself, losing himself. As the detective is cut off from an appreciation of these reflections, so we are distanced from the character through this performance of interiority. After an hour and a quarter of Henry's narrated recollections, we are suddenly left to ponder what might be occupying him now, in silence. His moment of reflection seems to be prompted by the Ambassador's parting words, 'Jolly good show', and we might speculate that Henry realises the entertainment has now ended, that his time has at last come. Guinness's skill is to allow both regret and satisfaction to play across his character's features, encapsulating a story in which a bank raid has been carried out with meticulous care and almost completed perfectly. Almost.

The trace of the smile that Guinness allows to form across his features faintly recalls Henry's moments of exhilaration with his partner in crime, Pendleberry (Stanley Holloway): the relief and joy when they embrace after the robbery, the giddy delight as they descend the spiral staircases of the Eiffel Tower, for example. By any conventional measure, the bank job is a failure: only a fraction of the gold is kept and the architects of the crime both face a future in prison. And yet, as Guinness blends contentment with his character's reticence, he leaves us with the impression that Henry acknowledges great success along with that failure. No trace of the wealth remains, of course, but those moments of elation and excitement still linger. Perhaps Henry's scrupulous mind has calculated that a year of luxury in Rio was worth nineteen years of drudgery in England's bank. This scene is preceded by one in which we see Henry back in London making his escape by disappearing into the masses of businessmen entering Waterloo Underground station. Dressed in his usual banker's suit and bowler hat, his unremarkable appearance is his salvation. We cross-fade to Henry in Rio, finishing his story, dressed in a casual light-coloured suit, cream shirt and tie, smoking his cigar. The transformation is emphasised in the editing and enlivened in Guinness's portrayal: Henry has become remarkable. Perhaps that was his only goal after all. And so, as the film closes, it leaves us with a series of questions rather than answers: what is money? What is ambition? What is happiness? Guinness's enigmatic performance of Henry in these concluding moments is readable, certainly, but any reading that is undertaken further complicates basic notions of character motivation. As some elements come into focus, others slip out again, and holding the portrait together is a significant critical challenge.

The defining paradoxical tone of contented failure, conveyed in Guinness's performance of Henry Holland, strikes an ambiguous note at the conclusion of *The Lavender Hill Mob*, uniting it thematically with *Kind Hearts and Coronets* and *The Man in the White Suit*. As with those earlier examples, Guinness's performance of this theme is defined by its unemphatic qualities, inviting the viewer to read the meanings that his actions, gestures and expressions have alluded to. A number of his performances reward this engagement, as do the films in which they occur. Defined by understatement and ambiguity, this trio of Ealing films ask questions of their audience and, in doing so, anticipate a level of perceptive appreciation.

In this way, they complement the practice of critical interpretation. I have suggested some meanings in this short discussion, but I am happy to accept that others exist, and that they might contradict my own. The achievement of these Ealing films starring Alec Guinness, I would maintain, is that they invite *multiple* interpretations.

As a final point, I would suggest that the three films I have chosen may represent the collaboration between actor and studio at its peak. They would be united again for *The Ladykillers* (1955) and *Barnacle Bill* (1957) – both films marking reunions, with directors Alexander Mackendrick and Charles Frend, respectively. Each film has its merits (the former celebrated for its dark, frenzied tone, the latter possessing a gentle charm with, admittedly, little bite) but both mark Guinness and Ealing following new trajectories. Between these films, Guinness had made *The Swan* (Charles Vidor, 1956) and *The Bridge on the River Kwai* (David Lean, 1957), both of which signalled the new internationalism his career would enjoy. The later work with Ealing seems to recall but perhaps not recapture the qualities of an earlier period in his career. Harlan Kennedy describes Guinness's performance in *The Ladykillers* as a 'dark-side-of-the-moon spoof of Alastair Sim'[4] and, while this sketch succinctly encapsulates the pleasures this screen depiction might contain, it also illustrates a different tenor of comedic performance to his work on *Kind Hearts and Coronets*, *The Lavender Hill Mob* and *The Man in the White Suit*. Certainly, we might argue that the performance doesn't possess equivalent degrees of depth or subtlety, and yet it can equally be said that Guinness responds successfully to the tone and style of Mackendrick's film. The implication is that the material itself did not present the actor with the same opportunities for understatement and, indeed, ambiguity. In terms of Guinness's broader career, Kennedy's description furthermore highlights the disparity between the high farce of Professor Marcus and the concentrated intensity of, for example, Colonel Nicholson in *The Bridge on the River Kwai*. It is possible to suggest that the actor had begun to invest those more traditionally 'dramatic' roles with the kind of nuanced achievements he had demonstrated in previous comedic roles for Ealing. For the studio itself, *The Ladykillers* and *Barnacle Bill* occur in a period of steady decline, both in output and quality. There is a sense of actor and studio moving away from each other in different directions: Guinness on the ascent, at least in terms of reputation, and Ealing on the decline. I've chosen relatively small moments from three films to illustrate my claims for achievement but, in the broader context of Guinness and Ealing's separating paths, these moments seem to take on an extra resonance; brief reminders of a performer and studio at the height of their powers.

14 CHILDREN OF EALING

Colin Sell

As a single studio – arguably more than other studios – Ealing produced an impressive variety of contemporary, recognisable images of children, which in turn helped to reinforce its varied reflections on British life in feature films. Christine Geraghty has observed the greater focus on children in postwar film, as if they autonomously create their own cinematic space, and Ealing children are strongly represented both in the postwar and war years themselves.[1] The studio's rich legacy of children on film is seen in a broadness of approach, due mainly to the freedom offered to Ealing film-makers by Michael Balcon. As a result, while there is no specifically identifiable 'Ealing child', the canon is rich, due partly to the exploration of childhood themes across a spectrum of films and partly to the range of strong individual child performers and the ways in which they are exploited. Added to this, the richness is all the more impressive when one considers that drama training was not available to young people, and most teen and pre-teen players were 'found' rather than schooled or coached beforehand.

Children in Ealing films fall into two categories. The first contains children who reinforce the image of the plucky, resourceful British youngster; the second reveals a more individualistic child, challenging and extending the stereotype, and assuming wider roles and contexts. They are characters who act, and who are acted upon, both in lead and supporting roles. These two categories apply throughout the Ealing era. It was not Balcon's agenda to introduce children as a filmic subgenre, nor was child-related subject matter the particular specialism of any single film-maker; they were simply incorporated in lead or cameo roles as part of Ealing's output. From the time Michael Balcon encouraged a studio style focusing on the British way of life at the end of the 1930s, children were reflections of, and incorporated in, Ealing's barometer of Britishness, through the uncertainties of the war years, postwar social readjustments and into the nation's more assured and confident mid-1950s. While children do not feature in all key Ealing films, their presence, when used, supports the broad raft of narrative concerns.

The introduction of children to show aspects of British social life and drama, to amplify the look of wartime and postwar Britain, as well as to examine generational differences, meant that youngsters were not only identifiable as character types but also enhanced Ealing motifs. In reality, the 'British' aspect tended to be contained in the Home Counties,

An early starring role for William (James) Fox, here with the infamous magnet from Ealing's *The Magnet* (1950)

with a few exceptions (Charles Frend's *The Magnet* (1950) is set in Liverpool, though the Brent family all speak unaccented BBC English); but the geographical part was to be taken as a reading for the whole. Class distinctions find expression in the diverse accents of the children in *Went the Day Well?* (1942), the cockney of the lads in *Hue and Cry* (1947) and the upper-middle clipped vowels of the sons in Frend's *The Magnet*, *The Long Arm* (1956) and *The Man in the Sky* (1957). Taken together, these representations amount to a status report on Britain's preoccupation with and deference to class.

It is worth opening up the argument here in relation to *The Magnet*, since William Fox's performance can be singled out as an example of a too-easy stereotype sidestepped. Ealing may have encouraged a return to positive British qualities (the film's central domestic setting resolutely disassociates itself from any hint of austerity), but in this film Fox and his director tread a careful line between the private school pupil with predictably privileged background and the William Brown elements of the true boy. Johnny (Fox) may be embarrassed by his mother kissing him goodbye in front of the taxi-driver, but he quickly allows himself to be assimilated by the Merseyside lads – all of whose acting matches the energy of Fox's performance. This character mix, at once wholesome yet humorous, allows Johnny to show a healthy, self-determining element in British boyhood (Fox is equally adept at demonstrating Johnny the amateur scientist, Johnny the scamp, Johnny the decent chap and so forth), whether mingling with his own class, working-class boys or immigrants. The

piece is typical of T. E. B. Clarke's whimsical yet sharply observed writing; it reflects something of the Disney charm when depicting children. Yet it is difficult to see what the target audience was for *The Magnet* in 1950. Perhaps the strength of Fox's playing combined with the parental problematic acted out in stiff-upper style by Stephen Murray and Kay Walsh was expected to appeal to children with a penchant for adventure and fair play, and to adults who would smile indulgently at the children and also identify with the parental dilemma. In the end, it may be that an Ealing film attracted an Ealing audience.

Children also help access Ealing tropes in terms of the effects and after-effects of war: the physical and psychological consequences of wartime separation and hostilities reflected on the Home Front – especially within the family – in *Went the Day Well?* and Basil Dearden's *The Halfway House* (1944) and *The Captive Heart* (1946). Even Crichton's *The Divided Heart*, made much later (in 1954), taps into national memory of the war period, reflecting on the emotional strains imposed on both adults and children. Such strains form the larger part of the narrative focus in Frend's *The Foreman Went to France* (1942), which movingly features the plight of French refugee children. Their suffering implies a dark future for the youth of all nationalities unless an Allied victory is secured. The lack of subtitles in this section heightens their helplessness for the English spectator. The young actors' apparently spontaneous performances do more than merely add support to the central story and comedian Tommy Trinder's antics, but carry a transcending truth of their own.

Thereafter, two films by Cavalcanti encapsulate postwar attitudes towards the young: his child-centred 'hide and seek' ghost story in *Dead of Night* (the portmanteau film of 1945), with its child revenant, suggests the tragedy of child fatalities and lost childhood in the war years; the same director's *The Life and Adventures of Nicholas Nickleby* (1947) achieves a similar affect with its maltreated boys. Children become crucially mediating elements in these films. The adult characters, sooner or later, are obliged to respond to them, the contemporary spectator cannot help but decode them. Their presence is suggestive of elements beyond those solely related to the young. Larky child activity runs through Crichton's *Hue and Cry* and initiates Henry Cornelius's *Passport to Pimlico* (1949), but the films go on to seriously explore the need for postwar reflection on communal morality and identity.

In particular, *Hue and Cry* is very noticeably a child-driven narrative, emanating from the boyhood world of the comic and maintaining a comic-like caper throughout. The working-class London lads employ native wit, individual and collective, to uncover the heart of gangland, emasculating the power of the too-familiar racketeer. Despite the dark element of the film – taking on practitioners of the black market – real danger to the boys is transient, the constant camaraderie of Joe (Harry Fowler, in fine, watchable form as a lead player) and his mates coupled with the interventions of the camply chaotic Wilkinson (Alastair Sim) reassuring the spectator that the safety of the everyday is never far away. Charles Crichton obtained strong performances from the boys, whose work alongside the experienced Sim (as the writer of the comic story) and Jack Warner (as Nightingale, the villain) stands up convincingly for their time. Crichton wrote in the *Penguin Film Review* that a child's 'ability to create out of an imagination unfettered by too much dull experience, and … to believe with a solid, concrete conviction' was 'very useful when it comes to making a film'.[2] With its quick-fire feel of postwar BBC radio comedy, Crichton works the lad-led pace to show youth – unruly and ill-mannered youth, but essentially big-hearted – as potential prime movers and shakers in tomorrow's postwar Britain.

Children in postwar Ealing films regularly played on and around bombsites, in *Hue and Cry* (1947, right), *Passport to Pimlico* (1949) and *The Blue Lamp* (1950)

Hue and Cry also features the popular space of child play and adventure, the bombsite. The brief but timely appearance of children in Dearden's *The Blue Lamp* (1950), coincides with *Hue and Cry* and *Passport to Pimlico* in referencing these still-existing bombsites as loci of child autonomy, sites which act not only as a reminder of recent wartime devastation to family homes, but more profoundly as a metaphor for fractured families and the potential disaffection and isolation of children.

It is also significant that, while children en masse feature in *Hue and Cry* and *Passport to Pimlico*, most appearances by individual children tend to be in films of weightier matter. Exploring such matter – the focus on the young and their place in the Britain of the future – preoccupied many studios during the 1940s and early 50s, not least of all Ealing. From the end of the 1930s 'the child' evolves in the British consciousness as deserving greater consideration than 'children' in general. The reassessed importance of young people was in the air, and many studios feature children in more challenging and unusual roles from this time. The reasons were many. A greater focus on children begins towards the end of the 1930s, with public awareness of their privations through the difficult economic period following the world slump. Added to this was the prospect of a war which, unlike World War I, would threaten children either in the form of air raids or land invasion or both. There had been little time after 1918 to nurture a new generation to forge a better future for Britain; evacuation plans for children were in place well before the first warning sirens in 1939. Wartime government measures – the mapping out of a national health service with considerable emphasis on provision for children, and a new education act in 1944 rejigging

school and college structures and curricula – reflected social concerns about children at a political level.

The period up to the early 1950s was the Ealing child's finest hour. Through the 50s Ealing continued to reference children in a changing Britain, though leading child roles were scarcer as the decade proceeded. This is probably the result of a resetting of the studio's sights: the new world and its aspirations saw Ealing more focused on adulthood adjusting to the vicissitudes of an innovative age, an age which incorporated not only the promise of industrial and domestic advances but which also reassessed everything from established institutions to sexual mores. All areas were open season for Ealing in comic or serious vein, but children are there largely as a leaven for the mix: perhaps they were seen as lending too much sentiment to what was becoming a more adult-biased output.

Dougie is caught between two worlds in *The Maggie* (1954)

By way of illustration, the character Tony (Michael Brooke) is the admiring and admired son in Frend's *The Long Arm*, but doing little more than amplifying the family image where the family as such is not directly involved in the true-to-life crime drama. Alexander Mackendrick's *The Maggie* (1954) shows teenage Dougie (Tommy Kearins) caught in the machinations between his captain and a businessman, a light comedy pitting the world of American commercial enterprise against the individual, eye-to-the-main-chance attitude of a Scottish trawlerman. Dougie's role is essentially that of the put-upon lad, maintaining the decorative comic edge but with little character development in a non-pivotal role. Crichton's *The Man in the Sky* builds domestic and professional narratives interdependently, with mutuality between parents and sons in the style of *The Long Arm*, but the focus is more on the parents' relationship than on the boys. In both these films there is a reading of family stability in which the role of the sons contributes to that of the wives, underpinning the domestic idealisation which acts as a bulwark against the fathers' work-related stress.

Only two Ealing films of the 1950s incorporating children in leading roles stand out. One of the results of Ealing's Australian venture was Leslie Norman's road film *The Shiralee* (1957), with an exceptional performance from Dana Wilson as the tough-nut Buster, the little girl whose presence is initially an irritant in her parents' relationship, and who is resilient in the face of the motley crowd encountered on her travels with her father. That the latter undergoes a change of attitude to his family relationships and his itinerant ways is due to Buster's intervention, achieved by Wilson with minimum sentimentality and considerable credibility. The concept of family is consolidated through the girl's agency. The other film is Mackendrick's *Mandy* (1952), which will be discussed in detail below, but which acknowledges many of the concerns that had arisen around children during and since the war – their place in family structures, their entitlement to understanding and the resolution of their problems, the need for mutual support from family members and society.

While not necessarily perceived as 'stars' by the public, Ealing child actors playing leads in key films – Harry Fowler, William Fox, Sally Ann Howes, Mandy Miller and Dana Wilson – were at least believable as ciphers, and at best (the best being Fowler, Miller and Wilson) convincing as deeper characters holding their own against seasoned adult players. To determine the extent to which child actors affected Ealing cinema, it is worth analysing two contrasting performers and the nature of their key films: Sally Ann Howes and Mandy Miller.

Sally Ann Howes: *The Halfway House*

Basil Dearden's *The Halfway House* problematises emotionally charged individuals living through a period of national emergency. Into this community is placed the schoolgirl, Joanna French (Sally Ann Howes), her character acting as a catalyst in what can be considered a key Ealing film of its time. It is a kind of portmanteau film (presaging *Dead of Night*), in the course of whose narratives we learn relevant background information about Joanna and her parents, and about the strain on the adult relationship. There is no child character in Denis Ogden's stage play on which the film is based, so Joanna is entirely a filmic construct. While Sally Ann Howes is not a charismatic actor (tending as she does towards the one-dimensional), she is no slouch at driving a scene along, and she embraces the qualities of her role professionally. Nuance is not her forte, neither in this nor in subsequent films (she is the lead in Cavalcanti's 'hide and seek' episode of *Dead of Night*, and she also appears in Ealing's *Pink String and Sealing Wax* directed by Robert Hamer in 1945: both roles are played as variations on Joanna French), but her sparkly ingenuousness meets the film's need for an innocent party who, by dint of informed reasoning combined with childlike simplicity, sets about engineering the reconciliation of her parents.

Joanna's narrative is distinct from the adults'; she arrives with generosity of spirit and altruistic purpose. Though Howes plays Joanna as a positive, hopeful youngster much in the Pollyanna vein, contemporary audiences would have recognised in the character the

Sally Ann Howes (near bottom left) and the rest of the cast of *The Halfway House* (1944)

common victim of so many faltering marriages during the war. For a fourteen-year-old actor, Howes manages to convince as adequately as most of the other actors in the film. But where Dearden succeeds in exploiting the character of the schoolgirl is in her quality of difference from the majority of children on British screens during the war. If one examines the children involved in lead roles in Anthony Asquith's *Cottage to Let* (Gainsborough, 1941), Lance Comfort's *Those Kids from Town* (British National, 1941), Herbert Mason's *The Back Room Boy* (Gainsborough, 1942), Maclean Rogers's *Gert and Daisy's Weekend* (Butcher's, 1942), Cavalcanti's *Went the Day Well?* or Bernard Miles's *Tawny Pipit* (Two Cities, 1944), it is a common theme that the displaced child from town – usually displaced due to evacuation, and the child usually Cockney: certainly working class, tinged with social deprivation – is challenged by and challenges the rural locale, and reveals a self-sufficiency and ingenuity which become instrumental in defeating some alien evil. Compared to the roles of, say, George Cole, Harry Fowler and Vera Francis, however, Sally Ann Howes in *The Halfway House* introduces an alternative aspect of the child on the wartime screen, but one which still highlights the admirable qualities of the young in time of crisis.

The fact that Howes's acting is not as convincing as George Cole's and the rest does not negate Dearden's alternative reworking of the child image via his young player. Joanna French is atypical of other wartime child portrayals, since she exhibits none of the physical toughness and low cunning of children in other films, is well educated (exemplified by her cut-glass accent) and, at a crucial point in the narrative, reveals a sophisticated thought process by solving the Priestley-ite temporal ellipsis which is central to the film. The girl's attractiveness and charm, plus the evidence of her cultured upbringing and expensive schooling, lend her a status on a par with, and finally above, the adult characters. Also, the maidenly young actor's pre-sexual quality enhances her role as diviner of the film's riddle. Certainly no other child character depicted on the British wartime screen could have unravelled the time mystery here with believability. Joanna French rationalises and succeeds where adults have panicked and failed. If the film contains resonances for its 1944 audience, it does so due to a young girl's mediation between reality and unreality for the enlightenment of her adult companions.

Joanna French may be a stereotype (the Home Counties, jolly-hockey-sticks class of schoolgirl), but this works in the film's favour. Howes's clear, uncomplicated performance offers the spectator an instantly recognisable youngster, intelligent, perceptive and sensitive, a child who falls victim to the breakdown in human relationships during the stress of war, yet whose courage and ingenuity restore the family unit. The character of Joanna is therefore key not just to the narrative's central conundrum, but also to a core reading in the whole film: the need to find strength through family bonding in order to face up to a collective haunted past.

Mandy Miller: *Mandy*

If *The Halfway House* is specifically of its time, Alexander Mackendrick's *Mandy* has a wider application. It examines challenges of parenting which have permanent relevance, and the film reverses the trope of its predecessor: parents focus entirely on, not away from, the child. The intensity with which the adults in *Mandy* do this reflects well-intentioned postwar aims to improve children's physical and psychological welfare, but this intensity also

highlights the fact that in the 1950s there is no rulebook, and that children's well-being is a matter of chance. What Humphrey Jennings had postulated in his 1945 documentary *A Diary for Timothy* – the child as exemplar of postwar national hope – assumed parenting skills founded on the normal family unchallenged and unencumbered by a child's afflictions.

The character of Joanna French in *The Halfway House* opens up the heartland of the plot, but in *Mandy* the kernel of the narrative – the little girl's deafness – is soon established by the parents, and the pivotal role of the child is largely passive while the adults act upon her. Therefore, it is more important here to analyse Mandy the girl from the outside, as it were, by seeing how society looks at itself via the child's story. Hence this section is less about child performance and more about the frames of reference within the film as a whole.

> [W]e are introduced to a shot which will become a leitmotiv: a point-of-view angle on the back of a character's head, suggesting not-hearing. At this point, the head is Mandy's; later, 'hearing' characters – Harry in particular – are shown, through the same shot, as incapable of hearing the truth.[3]

Annette Kuhn's comment on Douglas Slocombe's camerawork encapsulates the three-way problem of the child being deaf. Christine (Phyllis Calvert), the mother, is receptive to the offer of specialised caring and training for her daughter; Harry (Terence Morgan), the father, is bent on preserving an appearance of normality about the family and keeping Mandy at home; Mandy herself is caught in the middle (this is represented in the unhappy incident of her ball game as 'piggy in the middle'), perceiving atmospheres but not hearing. The first part of the film, in fact, deals with 'not-hearing' by all three, and the lack of listening and consultation between Christine and Harry sets up the conflict which will exacerbate Mandy's tantrums and divide the parents: a result both pathologically and sociologically damaging. The problem remains unresolved even at the end, since what reunites Christine and Harry is not amicable discussion but the small but important act that Mandy performs: she reveals her speech ability to her grandfather and, finally, begins to integrate with other children. *Mandy*'s extreme position of a tragic situation from the beginning encodes and explores parents' and children's difficulties across a wide range of British cinema at this time.

There is an onus on Mandy Miller as the interpreter of the focus character which requires her to give a performance to which all adult responses are believable. Even when she is off-screen, the fact of her existence needs to resonate, not simply as a child who is, sadly, deaf but more dramatically as a human being whose physical impairment influences, unites and threatens those closest to her. The film would flounder were Miller's performance only gestural. When another child's mother shouts 'She's insane – she's not fit to be with other children!' the spectator has to recognise the full impact of the girl's behaviour on other children. This also applies to Dick Searle's (Jack Hawkins) school, where Mandy is a disruptive influence on her peers: she cannot learn to learn, and Miller successfully articulates the girl's resistance.

By the same token, Mandy herself witnesses her father strike her mother and we have to read the pain in her response. The apparently placid nature of Miller's face is in fact susceptible to cinematic nuance, and Mackendrick

Mandy Miller, with co-stars Phyllis Calvert and Jack Hawkins in *Mandy* (1952)

exploits this fully. It is the increased vulnerability that we read in her face that reinforces the film's irony constructed around the imminent divorce proceedings, the unfeeling legal machinery menacing the child's domestic happiness. Mandy's threatened loss of happiness is not a sentimental ploy, but part of the film's steady accumulation of problem areas contingent on one child, and by extension contingent on the abilities of one child actor. Where sentiment does surface Mackendrick ensures it is earned. Mandy's classroom tantrum is built convincingly by director and actor until the girl harnesses her anger and produces the sound 'b'. She celebrates her achievement by running to her mother, the distance real and figurative emphasised by the long hallway where Christine waits. There is a permissibly moving moment here, as there is in the chess scene near the end. Both revolve around adult–child ties of tenderness.

Her innate quality of appeal had served Miller well in her previous film, *The Man in the White Suit*, also for Mackendrick at Ealing in 1951, in which the seeming innocence of her character, Gladdie, belies her ability to stay in control while adults around her have an excess of panic. The unruffled pace with which Miller played this part – see, for example, the scene in which she coolly misdirects Stratton's pursuers – is apposite for much of Mandy's/*Mandy*'s screen time. It is especially key to the scene where Mandy first begins to make sounds when in her domestic environment, and Miller and Mackendrick achieve a delicacy here which makes the grandfather's astonished response wholly credible. The grandfather, played by Godfrey Tearle, maintains a distance throughout, a man after a quiet life for whom the advent of an impaired grandchild is a mild inconvenience. But his non-intervention proves to be a vital catalyst, for it is in his presence that Mandy says the letter 'p' (for 'pawn'?), reading it from a postcard detailing a chess move. In a sequence where there has previously been great emotional intensity, the gentle grandfatherly arm round the little girl as he concentrates on the chessboard appears an unforced gesture, and this naturalness triggers the child's response – implying that the previous overt demonstrations of affection for Mandy have proved overwhelming for her. She needed time and space to develop, as is the case for all children. Her close ties to her mother to the exclusion of her father are here loosened as she allies herself with an adult male in the family. The grandfather is made to 'hear', not through argument or discussion, but by Mandy herself, who has found her voice literally and figuratively, and thereby become the instrument of her own salvation. It is her grandfather who now provides the impetus for Mandy to attend the school. This moment of revelation stemming from grandfather–granddaughter intimacy also plays on traditional family beliefs that children form strong affectionate bonds with their grandparents, and the manner in which the scene is played captures this in the sensitive acting of Godfrey Tearle and Mandy Miller.

There is what one may call a plethora of parenting in *Mandy*. All – parents, grandparents, Dick Searle – contribute to the final outcome by their bearing on Mandy's problems and on each other's problems up the chain, as it were. Indeed, the narrative seems top-heavy with related grown-ups offering or withholding advice, creating an oppressive atmosphere in the in-laws' house. The varied alliances and lack of harmony between the parties, and their attendant effect on Mandy, form a circular cause and effect, since the discovery that the child is deaf and dumb opens up fissures of weakness in husband/wife and son/daughter-in-law/parents/parents-in-law relationships, which in turn affect the daughter/granddaughter. The addition of an outsider – Dick Searle – further undermines family cohesion, despite the benefits it brings for Mandy. Mackendrick's skill is in filtering through these interactions a sustained focus on the girl, but it succeeds ultimately due to Miller's performance. At closure

the reunification of Christine and Harry and Mandy is shown as positive but incomplete, since the difficulties all three have experienced up to this point indicate more in the future.

The role of Mandy is demanding, since the actor needs to reveal extremes of often unreasoned emotion. Expertly directed, Mandy Miller takes centre stage convincingly alongside the experienced adults playing her relatives and her teacher. Her performance stands as one of the best given by a child actor in this period of British film, and is the more remarkable for sustaining the complicated trajectory of the character at her young age (seven when the film was made). Philip Kemp quotes Mackendrick's methodology with children – 'see that there is a really intense relationship between you, that you are both locked into the same make-believe'[4] – which suggests a capacity for engaging the child through trust without patronising.

Conclusion

The accumulation of child appearances is impressive when one recognises the contributing impact of child performances throughout Ealing's existence. Given the lack of actor training (film training even for adults does not begin in British drama schools until the 1960s), the results are usually watchable and in many films laudable. Certainly Alexander Mackendrick and Basil Dearden appear as the most gifted Ealing directors with children, eliciting performances which rank beside those in works by Carol Reed, David Lean and Anthony Pellissier. Even the more workaday child portrayals from Charles Frend, Alberto Cavalcanti and Charles Crichton add up to a variety of child types in terms of class, age and genre, reflecting the British modes that Balcon wished to explore.

There is a communal energy exerted by Ealing players which rubs off on the child actors, and throughout its history Ealing's child-casting was shrewd in this respect. Watching their performances, one senses that while children were hired for their engaging personalities, they were also taken on for their ability to measure up to the house style.

15 EALING'S AUSTRALIAN ADVENTURE

Stephen Morgan

Everything about Ealing was defiantly small. (Peter Ustinov)[1]

The abiding depiction of Ealing Studios as a producer of small, cosy, restrained films that (in Michael Balcon's famous phrase) 'projected' Britain from 1938 to 1959 overlooks the bigger, more ambitious and international scale of the studios' colonial film-making adventures. Alongside the well-known comedies and war films that have been used to canonise that dominant version of Ealing Studios lies a series of overseas productions in Australia and Kenya that endeavoured to capture contemporary and historical stories from throughout the Commonwealth. Between 1945 and 1959, these films attempted to find a balance between local stories and British perspectives towards life in its diminished Empire. Shot almost wholly on location and using local resources, yet always overseen by Michael Balcon and Hal Mason, and shot mostly by known Ealing contributors such as ex-GPO director Harry Watt, the films are fractured productions that are torn between their British origins of production and the rare cinematic representations they offer of largely unknown scenery, stories and 'other' national identities.

While there are potent links between the African and Australian productions, not least Watt's interest in location shooting, native stories and the compositional possibilities of the foreign landscape, this chapter will focus on Ealing's Australian venture: five films comprising *The Overlanders* (1946), *Eureka Stockade* (1949), *Bitter Springs* (1950), *The Shiralee* (1957) and *The Siege of Pinchgut* (1959). Representing two very different periods in the fortunes of Ealing Studios (immediate postwar success and late 1950s uncertainty), these films will be considered in terms of their production history, their critical reception in Australia (and its discussion of 'foreign' film-makers representing the country), the shift they represent from rural to urban narratives, and the balance that is struck between British and Australian sensibilities and interests. The films are also an important step towards disputing claims that Ealing Studios was inevitably small in scope or intent, demonstrating a wider set of generic pleasures (the epic, the colonial adventure film, the Western) than those normally associated with the studio.

'A mass of film subjects': *The Overlanders*, *Eureka Stockade* and *Bitter Springs*

Harry Watt was initially sent out to Australia in 1943 on behalf of the British Ministry of Information's Film Division to advise on how official propaganda could do more to highlight Australia's contribution to World War II. Michael Balcon's choice of Watt was due to his documentary experience with the GPO and Crown Film Units, his economic handling of Ealing wartime drama *Nine Men* (1941) and a reputation as the studio's inveterate adventurer. Already eager to film in Australia, and following Balcon's interest in setting up production there (while at Gaumont-British in the 1930s, Balcon had established an ill-fated partnership with Australian National Productions that only produced one film, *The Flying Doctor*, 1936), Watt stressed the need to 'assimilate the spirit' of the country.[2] However, on arrival, he found an under-skilled feature industry that had largely failed to address widespread dissatisfaction among Australians regarding how their country was being represented on film. Although he discovered a 'mass of film subjects', at the end of a five-month, 25,000 mile search, Watt felt the industry was too 'obsessed by the theatrical, commercial attitude', and all his film ideas were promptly scrapped.[3]

The choice of *The Overlanders*, therefore, can be seen as a reaction against the existing Australian feature industry and Watt's desire for a big topic that represented his experience of Australia: something that was 'very real and honest, and very Australian' which 'makes the outback people look the strong backbone of the country they are'.[4] While at the Ministry

Director Harry Watt and crew on location in Australia shooting *The Overlanders* (1946)

of Food in Canberra to talk about documentary film-making, Watt was told about a massive cattle drive across the north of Australia to avoid a potential Japanese invasion – a topic that fitted his requirements for a strong Australian story. Following months of research, preparation and location scouting, with a skeleton crew from Britain, a group of enthusiastic amateurs from Australia (organised by producer Ralph Smart, whom Watt was able to get released from the RAAF to help) and assistance from the Australian government, the project filmed between April and September 1945: first in Sydney and then in the outback, building roads and sets in Australia's 'dead heart' of Alice Springs, the Roper River and Elsey Station. The final film is delivered in the dramatised documentary style developed at Ealing in the war years, although it shares its focus on action, humour and romance with Watt's other work for the studio, including Kenya-set pictures *Where No Vultures Fly* (1951) and *West of Zanzibar* (1954). The film also embraces key tenets of many wartime films (including those made by Ealing), particularly the notion of group endeavour in which unassuming individuals band together to overcome an external threat.

Balcon and Watt's belief in the project, and in Australian production more generally, was confirmed when the film was released. A London preview in September 1946 for reporters, Australian officials and English film executives led to claims that the film would 'captivate both English critics and audiences', as well as 'increase the steady stream of migrants to Australia'.[5] The official world premiere was held the following week at the Lyceum Theatre in Sydney, with excited scenes inside and outside the auditorium that included 'squeals from bobby-soxxers' for actor Ron Randell and 'spontaneous applause for several of the landscape "shots" in Central Australia'.[6] Australian critics stressed the importance of Australian national identity through the film: 'the finest that has come from Australia', 'the emphasis is grasped and held throughout the film by the desert, bush, and mountains of the North'.[7] While overseas critical response from Europe, America and Britain was used to market the film in Australia, the film's British provenance was also downplayed by distributor British Empire Films, choosing to emphasise its 'Australian-ness' instead. Indeed, at least one Australian critic hailed it as 'an Australian picture' (rather than a British one), stressing that it 'has succeeded in expressing the underlying characteristics and atmosphere of this vast and potentially important country'.[8]

Central to this critical response was the depiction of Australian landscape and Australians on screen. Critic F. Keith Manzie suggested that 'for many years the conscientious Australian has felt a little ashamed of the way in which he and his native land have been depicted on the screen', and was one of several critics who noted Watt's patience in experiencing the country before making the film.[9] Watt had previously noted that the hard work of production would have been worthwhile 'if Australians accepted the film as an honest portrayal of an exciting episode in the history of their country'.[10] Critics praised the representations of 'general national character', with Chips Rafferty's portrayal of Dan McAlpine said to epitomise 'the Australian Everyman, in speech, action, and character', while the rest of the cast were lauded for containing 'the essence of the qualities that have built up a Commonwealth in 158 years'.[11] Arguably, the blend of characters in *The Overlanders* reflected Ealing's colonial ideologies too, showing that successful nationhood in the Dominions relied upon a blend of nationalities from across the Empire. The film's epic cattle drive is lead by Australians (McAlpine and another stockman and his family) but they receive ample assistance from a pair of indigenous jackaroos, a wiley Englishmen and an inexperienced but capable Scot. Such links demonstrate Ealing's concern about Britain and

Eureka Stockade (1949) continued to focus on Australia's history and wide open spaces

the colonies, but combine that with Australian stories and landscape: yet no critic appeared to address the problem of an outside presence narrating and presenting Australia in this way. Prime Minister Ben Chifley went further, stating it was 'fitting' that Britain should send film-makers to re-enact a dramatic episode of recent Australian history, believing the film would 'help greatly to publicise Australia throughout the world'.[12]

Back in Britain, Balcon and Watt were promoting the importance of Australia to British cinema more specifically. Watt noted that it would be possible to build an Australian film industry 'that would help to develop a national culture' and in *Picture Post* claimed that 'in the Dominions is the chance for the British film industry, already with its tail up, to consolidate its success against Hollywood ... I hope this empire film idea comes off, because I'm willing to stake my career and future on it.'[13] The success of *The Overlanders* made Australian film-making seem more attractive, with Ealing's production partner, the Rank Organisation, involved in several projects in the late 1940s: Balcon proposed a £250,000 investment in Australian production (claiming that with 'the proper equipment and qualified technicians, Australian films can compete with the world'[14]); Children's Entertainment Films (a Rank subsidiary, and precursor of the Children's Film Foundation) produced *Bush Christmas* (Ralph Smart, 1947), while Ken G. Hall, head of Australia's Cinesound Studios, announced a new partnership with Rank that included plans for more Ealing films in Australia. The importance of the *The Overlanders* cannot be overstated, then, creating interest and investment in Australian film production from British and native

168 *EALING REVISITED*

companies. As Watt stated in a report to Balcon in 1946, 'the prospects for a co-ordinated film production programme in Australia seem bright', and suggested that a series of three films over two years would be ideal.[15] Economic developments would intervene, however, stalling Ealing's efforts to pursue this Australian production schedule.

During the preparation of plans for Ealing's second Australian film, *Eureka Stockade*, the British government introduced a 75 per cent *ad valorem* duty on imported films: a move designed to combat both American dominance of the film industry and a wildly uneven postwar balance of payments. As Balcon noted in a letter to *The Times*, Australian films would also be subject to this duty which 'would appear to knock on the head any possibility of building up a native production industry there':[16] a sign that the shifting status of the Dominions now included them in a category that was increasingly foreign and 'not British'. Balcon and Ealing had real cause for concern: Watt had returned to Australia in November 1946 to begin pre-production on *Eureka Stockade* (the story of a miner's rebellion that Watt had heard about on his original trip), while *Bitter Springs* (about aboriginal land disputes) was scheduled to start filming in 1949. The *ad valorem* duties significantly delayed location shooting on *Eureka Stockade* but, although a solution was contrived where 'by importing some more artists and technicians, we could become a British film on location', this was a sign of problems to come for Ealing's larger Australian venture.[17] Both *Eureka Stockade* and *Bitter Springs* (directed by Ralph Smart after Watt's unhappy experience with his second Australian project) ran into trouble: shooting delays caused by weather conditions, broken equipment, cast and crew injuries, disputes with actors' unions and (in the case of *Bitter Springs*) controversy over changes to the film's ending and the treatment of its indigenous supporting cast, who were made to travel in covered railway goods vans without seating, sanitary or washing facilities.[18]

Watt's perspective on Australian production had changed by the end of *Eureka Stockade*: in a personal letter to Balcon, he expressed disillusionment with the venture, conceding his inability to cope with 'this continual strain' and claiming to have 'lost all enthusiasm for large scale feature film production'.[19] Watt's dissatisfaction may have contributed to the uneven nature of *Eureka Stockade*, where the documentary-realist style seems out of kilter with the portrayal of a miners' rebellion so firmly entrenched in national mythology. In striving for historical 'truth', Watt produced a film that lacked the dramatic rebellion promised by such nationalistic rhetoric and relied instead on the collective Empire endeavour narrative that was central to *The Overlanders* (the film features an Irish engineer, a German ex-officer, a 'fighting Scot who sought revenge' and an Italian 'stateless adventurer who became a fiery patriot'[20]). Watt was not the only one raising concerns, however: Eric Williams, Ealing's Australian-based production executive, expressed his dismay with the inconsistent nature of 'everything and everybody connected with production in Australia';[21] while Watt's replacement, Ralph Smart, was constantly at loggerheads with Ealing over *Bitter Springs*, largely around Tommy Trinder's inclusion, and a radical reworking of Smart's original ending, in which an all-out massacre of the aboriginals was replaced by a heavily sanitised conclusion in which they are transformed into 'easygoing sheep-hands'.[22] The positive experience of *The Overlanders*, and the opportunity offered by Australian production, was fast slipping away from Ealing Studios.

Bitter Springs (1950) proved problematic due to the casting of Tommy Trinder, and the treatment of its aboriginal subject and cast

Despite predicting large Australasian grosses for *Eureka Stockade* and 'excellent goodwill' from the local press, neither film was particularly well received.[23] *Eureka Stockade* was a costly failure, while *Bitter Springs* brought only partial hopes of a recovery. Importantly, neither film captured the imagination that had attracted earlier audiences for *The Overlanders*: Australian critics rejected Watt's second film as 'an uneven piece of work', that failed to recreate 'those colourful past days which still influence our design for living'.[24] Advertising and critical response for *Bitter Springs* focused on the indigenous cast members: 'the first time a large number of Australian natives had been used in a modern film of this kind', 'the aborigines have stolen the show'.[25] However, other reviewers criticised the film for its 'indecision as to whether to enlist sympathy for the blacks or the whites'.[26] Such lacklustre box-office performance and reception, along with the range of production problems encountered with these two films, appears to have influenced Ealing's decision to pull back from its Australian venture. While Michael Balcon's cable to the June 1950 *Bitter Springs* premiere announced that 'Ealing's policy of film-making in Australia has done much to promote understanding and goodwill between our countries' the studio appeared to have no future plans for Australian production.[27]

A Return to Oz? *The Shiralee* and *The Siege of Pinchgut*

While it may have tapered off by 1950, Ealing's initial foray into Australian film production had proved that an Australian feature film industry was a possibility. Yet it also revealed a range of hurdles inherent to that industry: under-skilled technicians, lack of suitable equipment and the sheer difficulty of producing films across the range of locations within the country. From December 1949, another hurdle appeared: Robert Menzies' Australian government prohibited the formation of public companies with capital exceeding £10,000, effectively ruling out feature film productions and any other capitalised projects deemed to be 'non-essential'.[28] In 1952, with local production investment quashed, Ealing finally terminated its long-term lease on Pagewood Studios in Sydney, while the beleaguered Ken G. Hall saw another attempt to establish co-production arrangements with British interests ruined.[29]

With issues in Britain – not least the economic rationalisation at the Rank Organisation under accountant John Davis – causing their own financial headaches, Ealing Studios may have been increasingly wary of the bigger international scope that had seemed within their grasp in the late 1940s (Harry Watt's two Kenyan films notwithstanding, Ealing's sights were turned back on domestic issues within Britain through the 1950s). Changing political and international pressures in the postwar landscape had increasingly dismantled the notion of Britain at the helm of a global Empire, which reduced the need for Commonwealth-fuelled propaganda. Ealing Studios itself was changing: the studios sold to the BBC, and Balcon relocating production to Metro-Goldwyn-Mayer's Borehamwood Studios. Yet despite this reduction in interest around the British Dominions, and Balcon's new relationship with an American company, it was at this point that Ealing films re-engaged with Australian film-making.

The Shiralee, based on D'Arcy Niland's 1955 novel, is a change of emphasis and focus for Balcon's revamped Australian venture: a realistic character piece, it focuses on Macauley (Peter Finch) a 'swaggie' forced to care for his young daughter after discovering the

Director Leslie Norman (right) and young star Dana Wilson on the set of *The Shiralee* (1957)

infidelities of his wife. Leslie Norman, who had worked on Ealing's earlier Australian productions, was given the task of adapting and directing the film on location in Australia. The uneventful production was split between Scone in the Hunter Valley region of New South Wales and Elstree Studios, and was the focus of positive publicity from British Empire Films, who were confident the film would be an 'outstanding success' given recent Australian-set films *A Town Like Alice* (1956) and *Smiley* (1956).[30] Reginald Baker, Ealing's managing director, also wrote to MGM's Australian distribution branch that the film would 'easily outgross anything we have yet done in the Australasian territory'.[31] This enthusiasm was not shared by MGM, however: the company's American distribution arm, Loew's, refused to release the film in the USA and caused difficulties in other territories.

The film had a strong reception at its world premiere in London (with five hundred 'genuine Australians' in attendance[32]) with critics reiterating earlier sentiments from *The Overlanders* about the use of location and rural verisimilitude: 'the strength of this film lies in … the picture it gives of Australian life as lived in the "outback"'.[33] Australian critics were mixed, noting that 'this simple and direct bit of Australiana is refreshing, but still somewhat below expectations', before adding the familiar refrain that 'little Dana Wilson rather steals the picture'.[34] A review in the *Australian Woman's Weekly* praised the film as a 'very human and touching experience', but questioned the excess of 'Australianness' in the script and the casting of so many English players, something few critics had picked up on in Ealing's earlier Australian efforts.[35] However, despite these critiques, the commercial success of *The Shiralee*

The Siege of Pinchgut (1959): Matt Kirk (Aldo Ray) holds Ann Fulton (Heather Sears) and her family hostage on Pinchgut Island, against the urban background of Sydney Harbour

reinvigorated Balcon's hopes for regular film output in Australia.[36] Yet *The Shiralee* also began a tentative move away from the dominant idea of Ealing's earlier Australian films (the focus on history and rural adventures, with a preference for sweeping landscapes and desolation): while the film is similar (a rural drama that emphasised its outback setting, location filming and use of landscape) it also introduced notions of the urban landscape and experiences.

Ealing's fifth (and last) Australian film, *The Siege of Pinchgut*, is a complete departure from those rural interests: gone are the sweeping panoramas of the Australian outback, vistas of kangaroos crossing bush-land and the individualistic heroism of Australia's past. In their place is an ambivalent contemporary thriller set in modern-day Sydney. Produced by Balcon under a new deal with the Associated British Picture Corporation,[37] *The Siege of Pinchgut* is the film that lured Harry Watt back into the Ealing fold, directing this fictional tale of an escaped prisoner (Aldo Ray) and his cohorts who hold Sydney to siege from a hideout at Fort Denison in Sydney Harbour.[38] Ealing stressed the importance of the urban setting: Watt explained that he had 'always wanted to make a film of this modern city';[39] while associate producer Eric Williams emphasised that this was the 'first modern picture to

be made of an Australian city'.[40] The shift from country to city is mirrored by a shift from the idealism and optimism of the earlier films to a mood of cynicism and pessimism: not just in its portrayals of Australians and Australian society, but in a general world view in which heroism, irreverence and a nation-building imperative is replaced by political posturing, violence and strident individualism. Here, as well, the collective imperial endeavour is reversed and becomes a social problem: migrants and locals join together to engage in illegal activities, not for the good of a community.

Despite being Britain's entry at the 1959 Berlin Film Festival, *The Siege of Pinchgut* was released with little fanfare in either London or Australia, perhaps a sign of Ealing's reduced status by the late 1950s. The film was not released in Australia until March 1960 (by Warner Bros.), but it attracted little interest and was quickly moved to suburban theatres: while admiring how the film brought 'exciting camera craft to the job of viewing everyday Sydney and its Harbour' the reviewer lamented the 'mediocre scripting and acting' and stated 'the tension isn't up to much'[41] (a common accusation in British critical reviews as well). Unlike in Britain, Australian critics appear not to have marked the passing of Ealing Studios as the end of a notable British institution, perhaps an unintentional echo of the reception of *The Overlanders* as an Australian film rather than an Ealing/British one. Yet given the commercial and critical reception of Ealing's first Australian film, and the potential it revealed within the Australian film industry of the 1940s, *The Siege of Pinchgut* demonstrates how far the studio's Australian fortunes had fallen over the course of fifteen years.

Conclusion

> I could never understand why it was considered necessary to make pictures in Australia. Arthur [Rank] was always keen on it, but I don't know why. (John Davis)[42]

Looking back over his career, Michael Balcon recalled the importance of *The Overlanders*: 'the Australians were well pleased with it and proud of the success this unusual film had all over the world'.[43] He also interpreted British reactions to the film in terms of the spatial opportunities offered by the Dominions in the aftermath of World War II, noting that 'years of difficulties and restrictions on travel had created a rather claustrophobic feeling [in Britain], and when they were over we felt an urgent need for the wide open spaces'.[44] With *The Overlanders*, *Eureka Stockade*, *Bitter Springs* and *The Shiralee* (and their distant cousins, Harry Watt's African films *Where No Vultures Fly* and *West of Zanzibar*), Ealing made that move to the bigger, wider spaces and challenged any notions that the studio was only ever concerned with cosy and small British narratives.

The success of the Ealing Australian films may have been shortlived, but each occupies a difficult (arguably compromised) position within histories of global film production: years before concepts of hybridised or transnational cinema were defined, Ealing was attempting to maintain a consistent production schedule halfway around the world, in a relatively 'backward' film-making environment, with varying degrees of success. Given these films have always existed on the geographic periphery of Ealing production, so they have been marginalised within historical studies of Ealing Studios. Yet this exclusion is troubling, both for broader understandings of Ealing's place within the international film industry and their

contribution to the national canon within British cinema studies. As stated in the introduction, these films are fractured, split between a desire to represent Australia and present imperial consensus: they can tell us about attitudes within, and about, Australia; and British responses to what Australia can be seen as offering (wilderness, huge open spaces). But if the British view of these films is complicated (where do they belong in a study of Ealing and British national identity?) then the Australian perspective is equally complex: earlier commentators may have claimed that the local industry 'gained nothing and learnt precious little', but more concessionary voices have emerged in recent years, accepting the films for what they are – hybrid representations of Australian narratives, told by British practitioners.[45]

In conclusion then, Ealing's Australian venture can be thought of in two analogous ways. First, in the Ealing comedy *Touch and Go* (1955), the attempt by Jim Fletcher (Jack Hawkins) to move his family to Australia is met with constant mishaps (economic, personal, natural). Despite his best efforts, Fletcher is defeated and accepts that he will always remain within his comfortable, safe, Chelsea cul-de-sac. It is tempting to see some of Balcon and Watt in the figure of Jim Fletcher, constantly tilting at the windmills of Australian production, but being consistently knocked back. Second, as Charles Barr has noted, it seems appropriate that 'the final image of any Ealing film is of a return to security and the embrace of the law', as criminals and hostages alike sit on a boat which returns them to the city community.[46] This element of *The Siege of Pinchgut* can be read as an admission that the Australian experiment, both in terms of producing 'uniquely' Australian stories and arguing for the British Empire and Commonwealth, hadn't necessarily worked out as expected. After years spent chasing an elusive vision of an Empire in development, in operation, in motion, it was time for all those involved to return to the safety and sanctity of Britain and reflect on Ealing's Australian adventure, and its role in the wider Ealing Studios story.

16 'WHO'LL PAY FOR REALITY?'
EALING, DREAMS AND FANTASY

Josephine Botting

Ealing Studios' chief strength is traditionally regarded as its ability to present Britain in a broadly realist, albeit rather idiosyncratic, manner. Charles Barr writes that 'Ealing's form of cinema ... is at home with ... the solidly realistic, not the abstract or stylised';[1] on this basis, those titles in its filmography which employ less naturalistic modes of representation are somehow regarded as not quite 'Ealing-esque', despite emerging from the same creative talents. However, this critical pigeon-holing has been contested by Julian Petley, who argues that Ealing has been mis-defined in its characterisation as 'a rather cosy, conventional, petit-bourgeois vision of England', asserting that this is 'hardly an adequate depiction of its entire range. Even a cursory glance will reveal discordant elements.'[2] Significant among Petley's alternative canon of Ealing is the studio's work in the fantastic mode.

David Butler defines fantasy as 'an impulse rather than a single coherent genre'; while many different genres can contain fantasy elements, 'there are ... a number of genres and subgenres in which the fantasy impulse is pushed to the fore'.[3] Science fiction and horror are two of these, while others – such as melodrama, animation and musicals – often contain fantasy elements. Jacqueline Furby and Claire Hines describe fantasy as a 'mode' dealing with 'matters of the imagination, with fancy, with the impossible, and that which makes the hidden or invisible visible'.[4] Ealing made use of fantasy to make 'real' the imagined; films such as *They Came to a City* (1944) and *The Love Lottery* (1954) employ fantasy to visualise imagined scenarios and dreams springing from the minds of the characters. Like the haunted mirror in *Dead of Night* (1945), cinema can reveal the hidden psychological depths of its protagonists and, as Petley has observed, expose 'all kinds of conflict ... seething just below the rationalist humanist surface'.[5]

Fantasy films can broadly be defined as ones which transport the viewer to imagined, strange locations or

Making real the imagined: Peggy Cummins dances with the severed head of David Niven in a fantasy sequence from *The Love Lottery* (1954)

portray occurrences which could not take place in the world as we know it. They have been popular since the early days of cinema, when the 'trick film' experimented with the potential of the medium to create impossible effects. Traditionally dismissed as nothing more than escapism, they have more recently been re-evaluated as a means of exploring 'truths about ourselves and our world'.[6] As I hope to demonstrate in this chapter, Ealing effectively used fantasy for more than merely escapist ends and its aim to reflect British society was well served by the mode.

During wartime, Michael Balcon wholeheartedly embraced realism, answering contemporary demands for 'first class war subjects realistically treated' with what he termed a 'departure from tinsel'.[7] However, as the war progressed, the Ministry of Information began to relax its recommendations and in 1944 Ealing released a cluster of three films that strayed from this realist path and experimented with fantasy in different ways. Although very different generically, *The Halfway House*, *Fiddlers Three* and *They Came to a City* share common ground in their employment of fantasy to comment on the war and its effects on British society. This fantastic strain returned in such postwar Ealing films as *Meet Mr Lucifer* (1953), *The Love Lottery* and *The Night My Number Came Up* (1955), again enabling a critique of societal trends.

Ealing made only one foray into an exclusively fantastic genre with *Dead of Night*, a horror film consisting of five separate stories with linking sequences. Jonathan Rigby describes the film's final nightmare montage as 'the most frightening thing produced in a British studio to that date', yet stresses that it was 'an aberration in Balcon's output'.[8] However, in its approach to the subject, the film has much in common with Ealing's other excursions into the supernatural, its dreamlike quality tempered by a rationalist voice, in this case a German psychiatrist. Although it didn't specialise in such genre film-making, neither did Ealing adhere rigidly to realism, and fantasy operates on different levels within several of its films.

The wartime drama *Went the Day Well?* (1942) imagines an alternative reality in which the Germans invade a small English village. It is lent a semi-documentary feel by a framing sequence set in an unspecified present, which leads into a flashback to the invasion. This kind of framing device is common in fantasy films, which often begin in the 'real' world before transporting the audience into the 'unreal' world created by the film. However, since the England depicted in *Went the Day Well?* corresponds to our knowledge and perception of it, the film can't be classed as fantasy, however incredible the events may seem.

Several of Ealing's postwar comedies feature ordinary people negotiating fantastic situations. Titles like *Passport to Pimlico* (1949) and *The Man in the White Suit* (1951) demonstrate the studio's approach to narrative, which Balcon described as hinging on the 'fanciful' interruption of 'the normal flow of events'.[9] In the second of these, Alec Guinness plays Sidney Stratton, a dreamer who invents a fabric which never gets dirty or wears out. This science-fiction concept develops into a commentary on capitalism and the delicate economic balance, whereby built-in obsolescence is shown to be crucial to both capital and labour. Anthony Lane writes that the film *should* play 'like a morality tale, a plea for balanced industrial relations, whereas the effect of watching it is actually to … pull you into a bad dream'.[10] This dreamlike quality is present in earlier Ealing films, such as the aforementioned surreal montage in *Dead of Night*. The carnival sequence in the historical romance *Saraband for Dead Lovers* (1948) is also uncharacteristically nightmarish, showing Sophie-Dorothea (Joan Greenwood) fighting her way through a crowd of hideously masked revellers.

The attempts of Ealing's fantasists to create a utopia, whether an escape from rationing or a world where clothes never wear out, are largely a reaction to privation in postwar Britain and are ultimately doomed to failure. However, *Another Shore* (1948) takes us to Ireland, land of fairies and leprechauns, where fantasies *can* become real. Gulliver Shields (Robert Beatty) is a professional dreamer, whose aim is to live out his days relaxing on the Pacific island of Raratonga. So detached from reality is he that he wades fully dressed into the rough Irish Sea, imagining himself on a tropical beach with sarong and spear. He is on the point of fulfilling his dream when the (apparently) English Jennifer (Moira Lister) brings him down to earth by persuading him to marry her. The film's denouement is something of a disappointment as Gulliver trades his exotic idyll for love and domesticity in Dublin.

Diverse characters drawn together in a supernatural setting: a séance in *The Halfway House* (1944)

These tales of dreamers and fantasists are all located firmly in realistic settings with solid points of reference. The Ealing comedies wear their Britishness with pride, not only in their use of familiar locations and institutions but also via their celebration both of the positive characteristics and the foibles of the British people. But this is also true of the films which use fantasy in a more overt way, bringing the characters out of their natural surroundings and confronting them with stranger worlds and possibilities.

By 1943 audiences had become tired of the staple diet of war films and Ealing spent several years experimenting with different genres in search of an identity. The three fantasy films it made during the conflict provide not just escapism but a different perspective on the country's situation, while also looking ahead to the possibilities of life in postwar Britain. These films may appear, like *Dead of Night*, somewhat incompatible with the rest of Ealing's output, but are perhaps not as out of kilter with the studio's aims as they first seem.

The Halfway House, released in February 1944, was based on the play *The Peaceful Inn* by Denis Ogden which opened in 1940. George Orwell pronounced the play 'the most fearful tripe' and remarked that 'it contained no reference … to the war'.[11] This omission had been rectified by the time the story reached the screen and the script by Diana Morgan and Angus MacPhail is set firmly in a Britain grappling with issues relating to the conflict, such as Irish neutrality, the loss of a son and the immorality of black-market profiteering. A group of diverse characters is drawn to the eponymous inn in the Welsh countryside which turns out to be a ghostly apparition (as are Rhys (Mervyn Johns) and Gwyneth (Glynis Johns), the landlord and his daughter), having been destroyed by a German bomb a year before.

While *The Halfway House* is initially set in a recognisable wartime Britain, the characters, and audience, are transported one year back in time and thus into an alternative reality. Locating the inn beyond the borders of the rather prosaic England glimpsed at the start adds an extra dimension to the fantasy; the programme notes for a screening at London's NFT, in a season on Welsh culture and history, observe that the film is 'set in that peculiar Celtic twilight between the subjective and the objective which is the natural home for fantasy'.[12] Wales seems far removed from the war; in fact the encroachment of the conflict on the valley is akin to the arrival of a mystical force of evil, Rhys describing a German plane 'hovering over the house like a bird of ill-omen'.

Each of the characters is at a turning point in his or her life, or reaches that point in the course of the film, finding a resolution through the intervention of the supernatural hosts. The first two arrivals can't see the house but it gradually materialises as they look for it through binoculars. The inn yields its secrets slowly – the register empty for a year, out-of-date newspapers, a landlord with no reflection. As these uncanny events unfold the film takes on an increasingly unsettling air, leavened by the humour and matter-of-factness of the characters' reactions to them.

Ealing commentator George Perry wasn't convinced by the film-makers' attempts at the supernatural, writing that 'the fantasy is hard to sustain and never develops beyond a theatrical morality tale'.[13] However, contemporary critics excused its emphasis on 'moral rehabilitation', *The New Statesman* opining that it 'goes a little deeper than the usual creepy thriller'.[14] Fantasy had been used as propaganda in the Boulting Brothers film *Thunder Rock* (1942), in which a lighthouse keeper is persuaded to join the war effort by a group of ghosts created from his own imagination. Two years later, *The Halfway House* employed fantasy to look ahead to a positive vision of postwar Britain in which conflicts, grief and criminality are overcome or eliminated. Several ghostly tales came to the screen during this period, such as *A Place of One's Own* (1945) and *Blithe Spirit* (1945), although most eschewed any political intent; as one commentator noted, 'the war had created among certain film-makers a more than usual interest in the might-have-been and the hereafter'.[15]

The two characters most in tune with the occurrences at the inn are not English: Welsh conductor David Davies (Esmond Knight) and Alice (Françoise Rosay), who is French. The terribly English Oakley (Alfred Drayton) and Fortescue (Guy Middleton) are the most dyed-in-the-wool pragmatists, dismissing Rhys as 'crazy as a coot' and, on hearing the year-old radio news, pronouncing the newsreader drunk. Davies, on the other hand, is in touch with the world of fantasy; when it's pointed out to him that Gwyneth casts no shadow, he jokingly remarks 'perhaps she's lost it, like Peter Pan'. Alice's spiritual side is apparent from her first appearance and, still mourning the death of her only son, she attempts to contact him via a séance.

The film uses little in the way of visual effects to sustain the uncanny atmosphere beyond a disappearing whisky bottle and the shadowless Gwyneth, relying mostly on the screenplay to set the scene. This is perhaps one of its weaknesses as a fantasy film, although some very effective moments are supplied by the ominous pronouncements of Rhys and Gwyneth. As if recounting a ghost story, Rhys begins his description of the bombing raid with, 'the old sirens start to bay like the hounds of hell themselves'. The score was written by British avant-garde composer Lord Berners, whose modernist style contributes to the film's air of strangeness (his 'séance theme' lending a particularly eerie tone), which is less well served by a script at times too self-conscious in its suggestiveness.

Suggestive in a very different way, the screenplay for *Fiddlers Three* allowed Morgan and MacPhail to indulge in some bawdy humour. The film opens with two sailors returning from leave (Tommy Trinder and Sonnie Hale) who give a lift to a Wren, Lydia (Diana Decker), on their tandem. Taking a shortcut via Stonehenge, they are transported back to Roman times. The circumstances of their temporal displacement (lightning striking Stonehenge at midnight on Midsummer's night) are scientifically dubious, but matter little given this comedy film's tenuous relationship with reality. The sailors are shipped off to Rome on suspicion of being Druids while Lydia is taken into slavery. The ensuing situation gives ample opportunity for such larks as cross-dressing, comic songs, topical jokes and general

clowning, culminating in the three being literally snatched from the jaws of death, arriving back in the present just as they're about to be eaten by lions.

Perry was unimpressed, describing the film as 'not of great consequence',[16] and most critics agreed. The *Daily Mail* critic wrote '[n]ot even the charm of Frances Day and Elizabeth Welch will persuade me that Ealing Studios are doing British pictures a good turn this time', possibly implying that it should stick to more serious features. Perhaps critics were not quite ready for such a drastic change in the studio's tone but, looked at for what it is, the film offers some enjoyable comic performances, entertaining songs (one penned by Robert Hamer) and lavish costumes and sets. By all accounts, box office was good, war weary cinemagoers no doubt ready for some escapist fare with no pretension to moral didacticism. Works of fantasy have traditionally been categorised as 'mere escapism', but, as Butler asks 'is escapism necessarily a bad or irresponsible thing?',[17] an idea explored ten years later in Ealing's *The Love Lottery*.

Sonnie Hale and Tommy Trinder enjoy the benefits of ancient Rome in *Fiddlers Three* (1944)

Although primarily 'tinsel', *Fiddlers Three* does make use of the time-travel device to make contrasts and comparisons with the situation left behind in Britain. Contemporary references abound – Nero comments to his wife 'you've got more than five inches of milk in that bath again', while Trinder describes Stonehenge as 'another government housing scheme gone wrong' and asks a group of heavily armoured Roman centurions if they're waiting to be collected for salvage. While Trinder and Hale manage to save themselves from sacrifice by 'predicting' the events which will befall Nero, uncertainty about Britain's future surfaces in the song 'You Never Can Tell'. Away from the bombings and food shortages, our heroes at first revel in the decadence of Nero's court, gorging themselves on fine food and enjoying the company of beautiful women. But as their situation gets more perilous, they begin to appreciate the things they've left behind and wartime Britain seems greatly preferable to Nero's dictatorship.

The third of Ealing's wartime fantasy films was, like *The Halfway House*, based on a stage production. J. B. Priestley's play *They Came to a City* had opened in April 1943 and most of the cast recreated their roles for the screen. The play was adapted for the screen by Priestley himself (Basil Dearden and Sidney Cole sharing the credit) and a book-end sequence was inserted which sets up the fantasy nature of what ensues.[18] The film corresponds to Furby and Hines's third type of fantasy film: 'a combination of the mundane world and a secondary world, where the story might begin in our everyday world and then the protagonist will happen upon a magical, fantasy space'.[19] However, it adds an extra layer to this device, opening with Priestley himself strolling across the hills where he comes upon a young couple in uniform arguing about how society will fare when war ends. He joins their conversation, describing a group of people from different walks of life transplanted to a city where everyone is equal. So begins the film within a film, as we meet each of his characters in their own 'everyday world', before they are engulfed by darkness and brought together in a misty tangled forest near a strange walled city. The city and the characters thus have no real 'existence', even within the world of the film, living purely in the imagination of Priestley and the couple.

'WHO'LL PAY FOR REALITY?' 179

Michael Relph's stylised set design for *They Came to a City* (1944)

The set emphasises their role as pawns in a game of Priestley's devising, the floor in front of the gate decorated like a huge chess board. Michael Relph (who also worked on *The Halfway House*) creates a simple yet dramatic set, a bare-walled rampart surrounded by mists, and the characters move around it, taking positions, both literally and metaphorically, shifting levels and planes as views are exchanged and altered. The backdrop is a cloud-filled sky, lit as if permanently at dawn. When the characters exit the fantasy world, the clouds signal their return to their old lives, some of them 'transformed by their escape into fantasy'.[20] While the film has been criticised as uncinematic, director Basil Dearden does experiment with composition, using the full width and depth of the frame to position the characters in a way which underlines and contrasts their social and ideological standpoints, pulling in for extreme close-ups at times of intense emotion.

The intensity of these moments is also heightened by the music chosen for the soundtrack: 'The Divine Poem' by Russian composer Scriabin, known for his atonal music system. It underscores certain dialogue sequences and rises to a crescendo at revelatory moments, such as when the door to the city silently swings open. Butler observes that 'the creative use of sound ... can transform our understanding of the image and perception of the ... diegetic world',[21] and the soundtrack creates further distancing from reality. When each of the first six characters disappears into the darkness, a gong is heard, signalling their cross-over into the fantasy world; when the audience finally sees this world, it is confronted by an impenetrable fog with the voices of the characters overlaid on the track, all talking at

once. Once they reach the city walls, their shouting voices echo and reverberate off the flat hard surfaces, adding to the otherworldly atmosphere.

Once gathered, the characters try to make sense of their situation; 'perhaps we're dead', ponders banker's wife Mrs Stritton (Renée Gadd), while the sailor, Joe (John Clements), seems to suggest it's some kind of reverie, quoting Walt Whitman's poem 'I Dream'd in a Dream'. The setting is dreamlike but the characters are surprisingly well drawn considering their representative (and imaginary) nature. The varying reactions they register to what they find inside the city reveal their attitudes to society and their place within it. Those with authority or money in the 'real' world are repulsed by the idea of losing their advantages and decide to leave, while those who hanker after a better life contemplate remaining.

The inside of the city is never actually shown; the *Evening Standard* reported that 'though they intended to show the city, it was found impossible to materialise in wood and plaster something which took a different shape in the mind of each character who saw it'. In fact, wood and plaster were never envisaged for these scenes, the shooting script stating that the 'shots in this sequence are impressionistic – the surroundings suggested by lighting, the use of cut-outs for shadow effects, etc. rather than by actual construction'. The city's inhabitants were to be represented by off-screen voices. Apparently, some of these sequences were shot but, in the end, Ealing wisely shied away from trying to visualise Utopia.

George Perry's criticisms of the film are based squarely around the received perceptions of the studio. He calls it 'one of Ealing's most unsatisfactory films, a venture into an area that would be fairly difficult for any film-maker, but one which for this studio, with its tradition of realism and a view of ordinary lives, was a disaster'.[22] While its theatrical origins are apparent in its lack of action, causing Barr initially to write it off as 'a dismal experience',[23] the film is surprisingly effective. Critics at the time were divided; while there were those who dismissed the film's 'words and histrionics' as 'dismally inadequate' for the screen (*Daily Mirror*, 9 February 1945), its political content also won praise, C. A. Lejeune finding it 'refreshing to exercise the mind on a piece of good dialectic' (*Observer*, 4 February 1945). The most overtly political of the Ealing fantasies, *They Came to a City* was brought to the studio by Sidney Cole, a committed socialist, and, like *The Halfway House*, looks towards a better society for postwar Britain.

Into the 1950s, all hopes of a utopian postwar world had been erased by lingering rationing and the steady entrenchment of capitalism. Ealing's series of black comedies began in 1949 but it continued to make the occasional foray into fantasy, generally using it to make 'the hidden or invisible visible' and convey 'the thoughts, desires and dreams of individuals'.[24] In 1953, it released another stage adaptation, *Meet Mr Lucifer*, a comic take on the evils of television. Stanley Holloway plays Sam Hollingsworth, an actor playing the devil in a down-at-heel pantomime with dwindling audiences. After a few drinks, Sam gets knocked out and finds himself in Hell, where the 'real' devil (also Holloway) recruits him to help propagate the 'devil's tool': television. The film thus employs a framework similar to that of *The Wizard of Oz* – the central story, in which Hollingsworth spreads misery by means of a TV set, being in the form of an alcohol-induced hallucination. Hollingsworth's dream, like Dorothy's, features characters already encountered in the 'real' world, and its theme echoes his drunken conversation in the pub, in which a fellow drinker claims that television is a form of spiritualism while Hollingsworth rejects its appeal as 'mass hypnotism'.

Charles Crichton's last comedy for Ealing, *The Love Lottery*, is also concerned with negative trends in postwar British society, this time laying the blame at the feet of

Hollywood. While film fantasy primarily occupies the realm of invented worlds with no connection to the 'real', fantasy is also 'a facet of ordinary existence'; as Walters asserts, 'the way that we interpret the events that shape our lives, the environments we encounter and the individuals we interact with, is dependent to a large extent upon processes of fantasizing'.[25] *The Love Lottery*, while not strictly a fantasy film, deals with the role of dreams and fantasy in contemporary life and their relation to reality, as presented by the film. Through the use of fantasy sequences to portray the dreams and nightmares of the main characters, it offers a commentary on stardom and the idolatry encouraged by the media industry.

Although Perry condemned these fantasy sequences as 'feeble',[26] their Technicolor lavishness makes them effective parodies of Hollywood cinema. David Niven is perfectly cast as cynical, frustrated star Rex Allerton, achieving just the right balance of conceit and self-mockery. The film takes a dig at Hollywood as dream factory and peddler of films as pure escapism. At one point Allerton demands of studio executive Stanton, 'Why does everything have to be an escape? … What about reality?' to which Stanton replies, 'Who'll pay for reality? They've got reality. They hate it.' This ironic exchange is the nub of the film – was Ealing admitting that its adherence to realism was out of kilter with the public appetite? Or is Allerton the voice of Balcon, speaking out against the shallow commercialism of Hollywood?

Allerton is duped by the sinister International Syndicate of Computation into offering himself as the prize in a 'love lottery'. Peggy Cummins plays Sally, a young secretary who is stepping out with Ralph (Gordon Jackson) but adores Allerton and is desperate to win the lottery. This set-up leads to the elaborate and humorous fantasy/dream sequences in which she imagines herself playing out romantic scenes with her screen idol, one of them a well-observed spoof of a Hollywood dance routine complete with exaggeratedly whimsical sets and frequent costume changes. However, reality is encroaching on her fantasies and, throughout the routine, Rex gradually ages until he is a grizzled old man, hobbling after her as she swirls round the dance floor. When her dream comes true and she wins the lottery, she finds that Allerton falls short of her fantasies and opts for reality, going back to Ralph at the end.

(left) A comment on stardom and idolatry: Peggy Cummins dances with a prematurely wizened version of her film star hero David Niven in *The Love Lottery* (1954); (right) Fear begins to infect Denholm Elliott and Alexander Knox in *The Night My Number Came Up* (1955)

Rex, on the other hand, endures a nightmarish vision of being attacked and dismembered by a mob of rampaging fans, all of whom are clones of Sally, even though, at this point, he has never met her. The sequence is comic yet also quite disturbing in its violence, particularly when Rex's disembodied head is thrown through the window of a cinema ticket office like a basketball. Another dream materialises in his dressing room mirror, which becomes a window onto a theatre auditorium. He is playing Romeo to Sally's Juliet but she, to his horror, breaks into a song and dance routine. This foretells Allerton's attempted return to the London stage, when he is told that audiences will only accept him in a light comedy musicals, not the 'theatre proper' he yearns for.

The predictive potential of dreams, touched on in *The Love Lottery*, is examined more comprehensively in *The Night My Number Came Up*. Based on an article purporting to recount a true story, Leslie Norman's film is set in Hong Kong, an exotic foreign location where mysterious forces are exerted over the characters. Establishing shots of crowded oriental streets lead into a gathering of Britons at the house of ex-pat Owen Robertson (Alexander Knox), who has spent many years in Asia. He explains to his guests that the Chinese 'allow their lives to be controlled by fears and superstitions that we laugh at as childish and medieval' and the conversation turns to the Chinese belief that 'dreams are a glimpse of the future'.

Mac (Denholm Elliott), secretary to Air Marshal Hardie (Michael Redgrave), remarks that Commander Lindsay (Michael Hordern) has had an interesting dream and Lindsay reluctantly recounts it to the rest of the party. He describes his vision of a Dakota plane, with thirteen passengers on board, crashing into a mountainside on a dark, snowy night, a vision the film recreates on screen. Some of those at the party are due to fly the next day and joke that it's lucky they are travelling in a Liberator; Hardie then announces that the plans have changed and they are now to go in a Dakota. Uncomfortable glances are exchanged and thus begins the nightmare as, one by one, the details of Lindsay's dream fall into place.

Some reviews expressed disappointment with the film's flashback structure – it begins with Lindsay pointing the authorities to the location of the missing Dakota, thus revealing that his dream does come true. However, the *how* is just as compelling and screenwriter R. C. Sherriff cleverly stages the gradual falling into place of the various elements. 'I've written a book which proves the absurdity of superstition,' Robertson announces, as he deliberately avoids walking under a ladder, yet he is the one most susceptible to fear of the dream coming true; Mac is the next to succumb to a creeping dread. While both characters are British (Robertson is Scottish), they are marked out as 'highly strung', Robertson affected by internment by the Japanese and Mac having suffered a nervous breakdown due to his wartime experiences. The other characters initially dismiss the possibility of a crash but by the time their plane has lost its way and is out of fuel no one is immune from terror.

The characters who dismissed with such condescension the Chinese and their 'irrational' beliefs gradually find themselves prey to suggestion and the film overturns the stereotype of the British as rational and pragmatic. Even the military men are affected and airmen, we are told, are particularly susceptible to the idea that a disaster foretold is likely to come true. The pilot experiences increasing panic and his attempt to land the plane on inhospitable terrain in a blizzard creates a tense climax to the film.

While not a fantasy film per se, *The Night My Number Came Up* engages in debate about the power of dreams, positioning them on the border between fantasy and reality. As in

Dead of Night, the characters spend much of the film reflecting on the nature of dreams and the film has some fun with the theme. At a dance which takes place on an overnight stay in Okinawa we hear a song entitled 'Everything in the Dream was Lovely', injecting humour into an otherwise tense scenario. Ultimately, the film shies away from committing itself on the subject of dreams as predictions – although the plane does make a crash landing, everyone survives, thus subverting the climax of the dream. The exotic setting in a culture with strange customs throws into relief the Britishness of the characters and causes them to doubt their own rejection of the supernatural. Does the belief that something is going to happen makes it more likely, and can a nagging doubt become an acceptance of the inevitable?

Looking at these films suggests that Ealing's reputation as a studio best served by a realist approach is not wholly justified. While it didn't sustain an interest in fantasy, the films it did produce within this mode exhibit a varied and sometimes experimental take on it. Social commentary is not the exclusive preserve of realism; in fact, fantasy can be an effective vehicle for exploring such avenues. Removing characters to a fantastical milieu or an alien culture permits an examination of elements of our national character away from the restrictive boundaries of everyday reality.

Ealing's forays into fantasy don't indulge in the visual flights of fancy seen in Powell and Pressburger's films of the period, nor the emotional peaks of Gainsborough's melodramas. The studio adopted a more self-reflexive tone, acknowledging, sometimes overtly, the impossible nature of what was being depicted and bringing to bear a degree of intellectualisation, along with a healthy dose of wit. By associating the supernatural more strongly with the non-English, the national stereotype of pragmatism is preserved and the characters respond to fantastic events by engaging in rational debate, more often than not leavened with humour.

Much of the criticism of these films has centred on the implicit argument that 'this isn't what Ealing did best', rather than offering an assessment of them on their own merits. The creative talents behind them used fantasy to explore political and societal hopes and fears as well as poking gentle fun at the British people. Rather than anomalies in the studio's filmography, they are equally successful at fulfilling Ealing's aim of 'projecting Britain and the British character'.[27]

17 A FEMININE TOUCH?
EALING'S WOMEN

Melanie Williams

> It has been said of me that the films I have produced have been mainly about men and that I don't know how to handle women. This is a little unjust.[1]

As Michael Balcon's slightly defensive comment quoted above suggests, criticisms of Ealing's attitude to women have certainly been legion. For instance, Kenneth Tynan, later an Ealing employee (see Barr's chapter in this volume), suggested that the studio's emphasis lay always on 'men at work, men engrossed in a crisis, men who communicate with their women mostly by post-card'.[2] Tynan was referring particularly to the all-male camaraderie of the likes of *Scott of the Antarctic* (1948) or *The Cruel Sea* (1953), a film which states from the outset an andro-centric credo which might apply more broadly to Ealing films: 'The men are the heroes. The heroines are the ships.' Charles Barr has suggested that 'we can't look back to the heyday of Ealing without asking questions about what it leaves out'[3] and detailed attention to female experience may constitute one of its most significant absences.

Boyish enthusiasm for intriguing machines and ingenious schemes is frequently the keynote of Ealing productions, and this applies across a variety of genres. In the canonical comedies, the mob from Lavender Hill is all male, as is the cohort of ladykillers, while females figure as antagonists in both films, from the argumentative schoolgirl who refuses to relinquish incriminating evidence in *The Lavender Hill Mob* (1951) to the unsinkable, all-destroying Mrs Wilberforce (Katie Johnson) in *The Ladykillers* (1955). The *Lavender Hill Mob* famously featured Audrey Hepburn in a tiny role as Alec Guinness's ill-gotten girlfriend but her star potential would remain unrealised at Ealing, unlocked a few years later by Hollywood. It's tempting to read their failure to launch her, even in a featured role in *Secret People* (1952), as absolutely typical of a company which really didn't 'know how to handle women'. Indeed, so commonplace was this idea of a certain contradiction between the words 'women' and 'Ealing' that, by 1956, film critic Jympson Harman could joke about it in his review of one of their rare female

Star potential unrealised by Ealing: Audrey Hepburn being made up for *The Lavender Hill Mob* (1951)

ensemble efforts, *The Feminine Touch* (1956): 'Now, now! What's all this going on here? Glamour girls prancing and waggling about in an Ealing picture!'[4]

On the other side of the camera too, male camaraderie dominated at Ealing. Their sole female contract scriptwriter, Diana Morgan, enjoyed working there immensely but described it as 'a very male studio',[5] where her colleagues' distinctly unchivalrous nickname for her was 'the Welsh bitch'.[6] And despite Ealing's reputation for nurturing new talent, attempts by talented women documentarists Kay Mander and Jill Craigie to break into direction at Ealing were politely but firmly rebuffed by Balcon, whose underlying instinct seems to have been that women lacked the necessary authority for the job.[7] It wasn't by chance that the popular industry nickname for Ealing Studios, coined by Monja Danischewsky, was 'Mr Balcon's Academy for Young Gentlemen'.[8] All the commentary on the studio emphasises a modus operandi centred on teamwork (exemplified by its round table meetings) and a collective outlook on the world partly determined, as Balcon was to admit, by shared 'middle-class backgrounds and rather conventional educations'.[9] From this, we might infer a similarly collective outlook on questions of gender, often manifesting in a palpable unease around feminine subject matter. Diana Morgan certainly thought so and identified Robert Hamer's films as the sole exception to that general rule: 'no other Ealing films give such parts to women. He was the only one who liked women, really.'[10]

So is Balcon's case for the defence – that self-deprecating coda of 'this is a little unjust' – totally unsupportable? It is undeniable that many of the comedies are dominated by male groups, but others present a more balanced vision of community. The female Burgundians of *Passport to Pimlico* (1949), Connie and Shirley Pemberton, Edie Randall and Molly (played by Betty Warren, Barbara Murray, Hermione Baddeley and Jane Hylton), as well as Professor Hatton-Jones (Margaret Rutherford), do carry equal narrative weight and significance to the men in that film, even if sometimes their characterisation verges on caricature.[11] Likewise, women may not participate directly in the acts of illegal salvage in *Whisky Galore!* (1949) but they play a major part in facilitating the plunder, especially Joan Greenwood's Peggy Macroon. And 'croon' is just the word to describe her style of telephone operating as she refuses to respond in kind to Captain Waggett's (Basil Radford) growing infuriation at the islanders' perfidy. Greenwood's distinctive vocal performance (could she give any other kind?) goes a long way in suggesting Peggy's poise, as does the film's visual presentation of her through striking close-ups, in sensual repose in the sand dunes or as the still centre of the whirling *reiteach* dance.

The girl in the black negligee meets the man in the white suit: Joan Greenwood and Alec Guinness in *The Man in the White Suit* (1951)

Greenwood would continue to exhibit a powerfully erotic presence in two further Ealing comedies, playing the key roles of Sibella in *Kind Hearts and Coronets* (1949) and Daphne in *The Man in the White Suit* (1951). In fetching Edwardian dress in the first film, she succumbs to Louis Mazzini's seduction with a very English combination of passionate desire and mocking irony. The second film pits the man in the white suit, Sidney Stratton (Alec Guinness), against the girl in the black negligee, Greenwood's Daphne Birnley. Her attempted seduction eventually fails but her ministrations have very nearly succeeded in tempting the virginal Stratton from his scientific mission. Of course, there is much more to Greenwood's comedy triumvirate,

Peggy, Sibella and Daphne, than their erotic appeal, not least the way the actress easily keeps pace with the considerable comic talents of Price and Guinness in her pitch-perfect performances. But the very fact that Greenwood's offbeat sexiness is embedded at the heart of Ealing's comic canon forcefully refutes the idea that the studio had no idea how to accommodate female talent.

Greenwood also got an opportunity in straight drama with the historical drama *Saraband for Dead Lovers* (1948) as the abused and manipulated Hanoverian princess Sophie-Dorothea, outmanoeuvred by the heartless female powerbrokers played by Flora Robson and Françoise Rosay, and left to describe her downfall from her deathbed in her 'letter from an unknown woman'. With its casting of Stewart Granger as love interest and sumptuous costuming, it was the closest Ealing came to Gainsborough territory, and although it has none of the vicariously enjoyable female rebellion of that other studio's period films, viewed today it has in its favour an unusually detailed iteration of patriarchal structures and the suffering of those trapped in them, both aggressor and victim.

Other striking women made their mark at Ealing, most notably Googie Withers; in terms of typology, a Wicked Queen to Greenwood's slinky little Tinkerbell. Once described by Brian McFarlane as 'perhaps the strongest, most commanding actress British films ever produced',[12] Withers excelled in a pair of Ealing films directed by Robert Hamer, playing formidable women ultimately thwarted by constrictive circumstances. In *Pink String and Sealing Wax* (1945), set in Victorian Brighton, Withers' brazen pub landlady Pearl deftly manipulates a young pharmacist with a crush on her (Gordon Jackson), using him to obtain strychnine for poisoning her bullying husband. The film lingers over her reaction to her husband's death, by turns both exultant and horrified, repeating the use of long take in the film's penultimate sequence in which a defeated Pearl commits suicide by throwing herself onto the rocks beyond the promenade. Indeed, for McFarlane, 'the very length of this tracking shot imposes on the audience an admiration for Pearl's courage'.[13] Pearl is not a good woman but her actions are accorded a kind of grandeur not matched by any of the film's other characters.

Before her next full role for Hamer, Withers took on another historical role as the eponymous 'feminist farmer'[14] – hardly a character type readily associated with Ealing – in *The Loves of Joanna Godden* (1947), directed by Charles Frend, although Hamer took over for a period when Frend was unwell. In the words of the film's press book, 'impetuous, self-willed, Joanna determined to defy the conventions of the time and – a mere inferior female – run the farm herself'[15] after inheriting it from her father. Along the way she encounters engrained prejudice, shepherd trouble, failures in her experiments with cross-breeding livestock, the death by drowning of her fiancé (Derek Bond) and the revolt of her snobbish brat of a sister (Jean Kent) before finally joining forces with neighbouring farmer Arthur Alce (John McCallum), a Gabriel Oak to her Bathsheba Everdene, whose proposal she had rejected at the beginning of the film.

At some levels, the film appears to uphold the idea mouthed by one of its male characters that Joanna is 'a filly that ain't properly been broke in'. However, other discourses around the film contradict this; for instance, I think we're directed to read the press book's phrase 'a mere inferior female' ironically rather than straight. Although it is possible to read the film's ending, as well as the various trials endured by the heroine, as punishment for feminist hubris, for daring to say 'I know what I'm doin' and expecting men to take orders from her, Joanna is on the whole depicted as an admirable figure, even if one critic found her unfortunately reminiscent of Edith Summerskill's 'rasping efficiency ... when she is disposing

of questioners who have the double misfortune to be male and stupid'.[16] Joanna is willing to get her hands dirty, and the film expresses far less disapproval towards the 'feminist farmer' than it does towards her more feminine younger sister, who is motivated by her desire for 'nice things', a longing that will continue to reverberate and disturb a number of Ealing's austerity-era productions and which is nearly always characterised as feminine.

Withers returned to Hamer and to the role of constrained suicidal wife, this time in a contemporary setting, as Rose Sandigate in *It Always Rains on Sunday* (1947) – in Barr's view 'the definitive Googie Withers role'.[17] Its narrative hinges on the unexpected reappearance into Rose's life of former love Tommy Swann (McCallum again), throwing into disarray her quotidian existence in rainy Bethnal Green as wife to a dull but reliable older man and stepmother to his two daughters. Flashbacks provide Rose and Tommy's romantic backstory and the contrast between Rose then (lively blonde) and Rose now (tight-lipped brunette) is a striking one. Ealing's publicity material for Googie Withers placed similar emphasis on the actress's own change of hair colour in the late 1930s, seeing it as symbolic of the shift in her career from being the 'Googie of pre-war days ... fair-haired Googie who stooged for George Formby' to the all-new serious brunette: 'It's difficult to visualise the present-day Googie Withers as being that same girl. The war has changed her probably more than any other star on the British screen.'[18] Blondes may have more fun but Ealing prefers the dark-haired postwar Withers, who suffers but endures. *It Always Rains on Sunday* is a film eloquently detailing female containment, of passion being relinquished, of settling down and making do; 'She will restrict her horizons,' as Barr sums up the film's ending.[19] It has been read alternately as an endorsement of that process, the woman's necessary accommodation to reality and community, *and* as a profound critique of the quashing of her vitality, and the film's ability simultaneously to support both perspectives may be one of the best indications of its depth and resonance.

Taking the larger view, it is possible to see Withers' starring roles at Ealing from 1945 to 1947 as a high-water mark of Ealing's engagement with the feminine. Whatever the ambivalence expressed towards the characters she plays, she is indubitably the star of those films. It was on the back of her Ealing work that Withers became the third most popular female British star after Anna Neagle and Margaret Lockwood by 1949.[20] However, she had

(left) Googie Withers gives out orders as the eponymous heroine of *The Loves of Joanna Godden* (1947); (right) The constraining family, with Withers' Rose at the centre, in *It Always Rains on Sunday* (1947)

left Ealing by then and, as Barr suggests, she 'leaves a gap which is not filled'.[21] Perhaps so, but one wouldn't want to ignore the presence of a number of other interesting actresses in postwar Ealing productions. Contemporaneous with the reign of Googie, the studio had also brought in some foreign stars for productions directly engaged with the war and its legacy. Swedish Mai Zetterling plays the title role in *Frieda* (1947), a demure German war bride brought home to England by David Farrar's war veteran. Her sense of anguish and despair at being ostracised by her husband and his community is forcefully presented, but the dramatic focus is aligned far more with Farrar's character. Another of Ealing's continental imports was Simone Signoret, whose Michele in *Against the Wind* (1948) is an impressive woman of late 1940s cinema. 'I am your commanding officer,' she confidently informs the young explosives expert (Gordon Jackson) with whom she eventually falls in love during their dangerous secret mission in occupied Belgium. That romance is perhaps the least convincing thing in the film, but far more persuasive is Signoret's evocation of a woman with a troubled romantic past who is also a highly competent military professional, most notably when Michele has to summarily execute the traitor in their midst, played by jolly Jack Warner. She does it promptly and without compunction, but also calls out his name to make him turn round from shaving rather than shoot him in the back, a concession to honour even in wartime's suspension of conventional morality. Although Ealing's postwar paeans to male heroism – the aforementioned *Scott of the Antarctic* and *The Cruel Sea* – are the better-known films, *Against the Wind* provides evidence that Ealing was also able to accommodate an image of female courage, through the likes of Michele and her doomed colleague Julie (Gisele Preville), drawn with a gravitas equal to their masculine counterparts.

Two Ealing films of 1950 directly addressed dilemmas faced by contemporary women. The first to be released was *Dance Hall*, which takes the ensemble mode often adopted by Ealing but this time with a young female focus. Fellow factory workers Eve (Natasha Parry), Mary (Jane Hylton), Carole (Diana Dors) and Georgie (Petula Clark) spend their spare time at a *palais de danse*, enjoying what the film's co-writer Diana Morgan described as the venue's 'swirl of colour and lights and music'.[22] The key story is Eve's, detailing the trouble she has adjusting to life as a housewife to a rather insensitive young man (Donald Houston) and the temptation posed not only by her smooth-talking ex-boyfriend (Bonar Colleano) but, more generally, by the attractions of her lively former social life centred on the *palais*. Isolated and alone at home, she is 'bored bored bored', she tells her husband, and as Christine Geraghty suggests, 'the complaint is taken seriously in the film'[23] rather than dismissed as unfounded. Geraghty classes the film as one of several 'women's pictures' made by Ealing in the immediate postwar years, despite the fact that this generic framework is not often applied to this particular studio, unlike its contemporary Gainsborough. Films such as *Dance Hall* and *It Always Rains on Sunday* don't just feature women as central characters, they 'also give them the narrative viewpoint ... we know why they do what they do'.[24]

This also applies to the second female-centred Ealing film of 1950, *Cage of Gold*, starring Jean Simmons. In its publicity material, the film's difference from the studio norm is repeatedly asserted: 'the new Ealing Studios production is a romantic thriller', the press book states before continuing, 'Ealing Studios, renowned for their production of the factual type of picture popularly known as "semi-documentary", state frankly that *Cage of Gold* breaks away completely from this style. It is emotional melodrama.'[25] Simmons' Judy, like Eve in *Dance Hall*, is a beautiful young woman faced with a choice between two men who represent starkly opposing possible futures. In Judy's case she is caught between Bill (David

Diana Dors jiving at the *palais* in *Dance Hall* (1950)

Farrar), the RAF veteran and playboy who can provide her with nights on the town, champagne and pink roses (more 'nice things') but who is also fundamentally untrustworthy, and Alan (James Donald), the sober, responsible but slightly less thrilling doctor for the fledgling NHS. The press book boasts of 'The Paris of glamorous women and exotic luxurious nightclubs', 'The drama of a girl threatened by her past' and 'Night clubs, bigamy and murder'; certainly a narrative taking in all of this as well as premarital sex and pregnancy, thoughts of abortion, attempted blackmail and currency smuggling is arguably 'not very Ealing' at all, and most critics responded to it accordingly: 'a British attempt to make a slick, synthetic melodrama of a type which Hollywood does far better. Why this should have been tried by the usually down-to-earth Ealing is a mystery.'[26]

Given this kind of negative reception, and the similarly dismissive one for *Dance Hall* – typical in sentiment, although slightly more pronounced in its misogynistic disgust, was the *Sunday Express*'s review: 'Four factory girls and their petty little romances in and out the dance hall. Story is trite but atmosphere authentic. I could almost smell the cheap scent and perspiration'[27] – it was unsurprising that productions of this kind waned henceforth at Ealing. When female popular culture was next touched upon at any length it would be in the scattergun satire of *The Love Lottery* (1954), where we are encouraged to side with the viewpoint of the film star Rex Allerton (David Niven), who is continually pursued by frighteningly ardent female fans – 'great grisly acres of women', he calls them – while the fan's own perspective, represented by Peggy Cummins's ordinary working girl Sally, is marginalised and spoofed.[28]

In Charles Barr's view, *Cage of Gold*, just like Googie Withers' departure from Ealing a few years before, marked another important watershed in the studio's approach to women, as 'virtually the last Ealing film to give a decent part to a woman (old ladies aside) – and there are 35 films to come'.[29] But Ealing still recognised the importance of female appeal. An ad in the trade magazine *Kinematograph Weekly* for their drama *The Gentle Gunman* (1952) insisted that 'shrewd exhibitors never underestimate the power of a woman!', quoting the film's positive review in *Woman's Own*, 'favourite magazine of more than a quarter of Britain's women cinemagoers – and that's a lot of feminine influence!'[30] This recognition of female appeal was also evident in the marketing campaign for another Ealing film of 1952, *Mandy*, about a little girl who is deaf and her parents' disagreement about the best way to educate her. Its publicity material makes much of its female-authored source material, previously serialised on BBC Radio's *Woman's Hour*, and a *Kinematograph Weekly* ad on positive word-of-mouth for the film depicts only women's lipsticked mouths in its accompanying imagery.[31] *Mandy*'s combination of documentary-inflected elements with tendencies more reminiscent of the woman's picture was to prove problematic for some critics, who felt that the subplot of marital conflict between Mandy's parents, Christine and Harry (Phyllis Calvert and Terence Morgan), and a burgeoning attraction between Christine and Mandy's teacher, Searle (Jack Hawkins), was 'a stupid story which is tacked on to the actual theme' of the education of deaf children.[32] However, approaching the film thirty-three years after its initial release, Pam Cook deemed it a 'powerful masterpiece',[33] a designation with which I wholly agree.

A girl and a gun: Jean Simmons in Ealing's 'emotional drama', *Cage of Gold* (1950)

The gradual development of the little girl from mute dependency to a tentative connection with the wider world ('it's like seeing the door of a cage beginning to open', says her mother) is supremely moving, and this has much to do with Mackendrick's direction, which puts us in Mandy's position, grants us her perspective on the world – as does Mandy Miller's poignant performance (discussed elsewhere in this volume by Colin Sell). Just as with those slightly older Ealing heroines of a few years before, in *Mandy* we know 'how the little girl feels and why she behaves as she does'.[34] This is equally true of Mandy's mother, Christine, played by Gainsborough veteran Calvert. I find little evidence for Harper and Porter's suggestion that the film exhibits 'an insistence on the untrustworthy nature of women'.[35] Instead, Christine struggles to do the best for her daughter, facing opposition from her husband and his family. Christine's accusation when Harry resists Mandy's schooling – 'you'd rather she remained dumb!' – may stretch beyond daughter to wife and women in general. The violence of Harry's reaction – a sharp slap which leaves a visible mark on his wife's face – suggests that Christine may have spoken an unpalatable truth.[36] As Philip Kemp points out, *Mandy* is a study 'not only of the deaf in a world designed for the hearing, but of women in a world designed for men'.[37] From this perspective, a story about a little girl slowly acquiring the power of speech, often through harnessing outbursts of rage and frustration, has a potent allegorical dimension.

A FEMININE TOUCH? 191

The love triangle of *Mandy* (1952): Terence Morgan, Phyllis Calvert and Jack Hawkins

In his autobiography, Michael Balcon states that 'the mother–child relationship' was 'a theme close to my heart and which, I recognise, was a recurring one in Ealing films'.[38] This is initially puzzling, since there does not seem to be an abundance of maternal melodrama among the studio's output, although there is *Mandy* and there is also *The Divided Heart* (1954), which eulogises maternal love, quoting approvingly the proverb 'Since God could not be everywhere, he made mothers.' Where *Mandy* focused on daughter and mother, *The Divided Heart* turns upon a son and two mothers. One is his Slovene birth mother (Yvonne Mitchell), a survivor of Auschwitz, who had to relinquish her son when he was still a baby. The other is his adoptive German mother (Cornell Borchers), who had been led to believe that the child was an orphan and raised him as her own, slowly gaining the trust of the terrified young boy, who is now ten years old. The mothers' competing claims to the child are evaluated in court during a custody battle, with their testimony inaugurating flashbacks detailing their very different experiences of mothering the same child. Their sensitivity in caring for and nurturing their son contrasts dramatically with the male judges' ham-fisted interrogation of the boy, reducing him to tears and eventually going against his stated wishes about who he wants to live with. It's true that this particular film sees female identity exclusively in terms of motherhood, and any desires outside the maternal are marginalised, but at the same time it accords proper respect to the maternal role through two female performances which evoke the paralysing anxiety of their situation and the terrible loss felt by the one who finally has to lose her son.

The Divided Heart was readily identified as having strong female appeal by critics, with the *Daily Mirror* calling it 'Ealing's gift to the girls ... a woman's picture [and] a thought-provoking weepie that most women will lap up,'[39] while Dilys Powell was more qualified in her labelling: 'The emphasis on maternal love ... has led some people to give the film the discouraging label of woman's film. I should prefer to call it an actresses' film.'[40] Charles Barr would later criticise *The Divided Heart* along those same lines, deeming it 'actressy, afraid of getting into any deep emotional water',[41] but the film was certainly an affecting experience for its initial reviewers, many of whom admitted weeping in the cinema, including the *Sunday Express*'s critic, who declared himself 'unmanned by Ealing Studios ... furtively snivelling in the circle'.[42] However, the film's campaign book suggested an audience response more clearly differentiated along gender lines, hailing it as 'a story of human dilemma that will touch women's hearts and compel men's sympathy'.[43]

Ealing's final female-centred film, *The Feminine Touch*, returned to British soil after the foreign excursion of *The Divided Heart* and marked a comeback for the female ensemble film they had previously tried out with *Dance Hall*. This time the women were a cohort of student nurses learning their new profession, encompassing comely girl-next-door Susan (Belinda Lee), slightly posher girl-about-town Pat (Delphi Lawrence), Roedean-educated Anne (Henryetta Edwards), Irish Maureen (Adrienne Corri) and Cockney Liz (Barbara Archer). The *Daily Worker* felt it was a wartime rehash, a kind of *The Way Ahead* (1944) in drag, detailing 'how a carefully chosen group of civilians ... gather together at the beginning of a training course, display their different backgrounds, are inspired by Leadership, depressed by Harsh Discipline, and finally fortified by the thought that it is all Worth While'.[44] As with many

female ensemble films, there are some interesting moments of feminine solidarity presented, as when we see them soaking their feet together in a mustard bath, chatting about men and sex – within the confines of Ealing respectability, that is. *The Feminine Touch* carefully eschews the more smutty tone adopted by other medical-themed films of the 1950s, such as the *Doctors* and the *Carry Ons*, restraining itself to one cheeky *double entendre*, Doctor Alcott's (George Baker) question to the curvaceous student Susan, 'What's your anatomy like?'

It details the grimmer aspects of nursing life, with plenty of scenes set in the sluice room (this got the film into trouble for infringing the US Production Code, as did the description of a colostomy operation[45]), and an accelerating montage detailing all the demands on the women, punctuated by a rising crescendo of voices crying 'Nurse!'. Even patient, polite Susan is moved to complain: 'Let the nurses do it, we haven't got a union, just a vocation,' and she later speaks of their work being taken for granted, of being 'everybody's dogsbody' in a complaint that seems to resonate not only in relation to nursing but also women's labour more generally in postwar Britain. But the more radical potential of these grievances is blunted. On the verge of revolt, the nurses are persuaded to stay by the wise and eloquent counsel of Matron (Diana Wynyard), who tells them that their reward is 'being close to birth, death ... the pulse beat of humanity', beatifying their toil by insisting on its spiritual transcendence, their closeness to God.

However, the film's attitude to working women has all the self-contradiction, doublethink and paradox we might expect from the 1950s. After building up a vision of the nursing profession as a profound calling, the Matron negotiates a sharp ideological U-turn when she discovers that Pat has secretly got married: 'What wonderful news!' she warmly

The cohort of student nurses, fronted by Belinda Lee, in *The Feminine Touch* (1955)

congratulates the bride. She then tells Pat and Susan the story of her own thwarted youthful romance and lets them know that 'love's important too, you can't always put it in cold storage ... your training, though uncompleted, won't be wasted'. In the words of the film's press book synopsis, Matron's 'advice makes a deep impression on Susan and helps her decide her problem. Her mind made up, she hurries off to share Jim's new career.'[46] Prior to this, Susan has had misgivings about continuing her training after becoming engaged to Alcott, and had resolved to give up, but then is torn between love and career when she manages to persuade a suicidal woman (Dorothy Alison) that she has a reason to live. When she had previously saved a man's life in association with Alcott, he had been full of praise for her, but this time, when she's acted alone, his attitude is scornful and he denigrates her achievement (which is, ironically, to return an errant unfaithful wife back to the 'respectable conjugality'[47] that Harper sees as Ealing's feminine ideal, an act of patriarchal endorsement which then causes ructions within Susan's own relationship).

On the one hand, the ending represents a new horizon for the heroine – leaving England for the wilds of Canada – but on the other hand, this can only be achieved because her professional career has been aborted. It seems that within the sexual politics of the 1950s, self-actualisation through work can only be truly ratified within marriage and domesticity. In fact, the critic for *Reynold's News* was quite explicit in seeing nursing training as housewife training in disguise: 'Nurses see men at their worst, ill, helpless, self-centred, and they are not likely, therefore, to expect their husbands to be a dreamboat combination of Johnnie Ray and Marlon Brando. That's why these little women make such good wives.'[48]

As with several of these other female-focused productions at Ealing, the marketing for *The Feminine Touch* makes clear that it aimed to appeal to women, with suggestions to cinemas to 'arrange a display board, with cuttings from national women's magazines with interesting items on fashion, beauty hints, recipes and, of course, stills from *The Feminine Touch*'.[49] And it was in relation to the very popular women's magazines of the period that film-maker Jill Craigie wrote a letter to Balcon in 1958, suggesting that the studio might be able to replicate their 'fantastic circulation' by appealing to the same demographic: 'young girls at work before they're married. They buy the records, they go out for their entertainment ... our films are made as though we're completely unaware of this new generation ... I am at least on the wavelength of youth, particularly young girls.'[50] Balcon's response to Craigie's letter ('there seems to be no immediate possibility of our working together on a picture. I mean, of course, in your capacity as a director'[51]) has been read by Sue Harper as 'testament to his deafness to the female voice',[52] and this is very persuasive, but the timing of the letter may also have been a factor. Balcon admits that Craigie's proposition is 'more than interesting' and that her wish to appeal more to young female audiences may offer 'a partial solution to the many problems that exist'. Mere politeness or genuine engagement with her suggestions? And without wanting to defend Balcon from all charges of chauvinism, he does at least ask Craigie to 'postpone' rather than cancel altogether her 'ideas of directing'. Bad timing may be the clinching factor; there are really no opportunities available for anyone or anything new at Ealing by 1958. It would limp on a little longer but even back in 1956 one critic was suggesting that *The Feminine Touch* represented 'Ealing Studios' dying gasp'.[53] It was certainly its dying gasp for making anything for or about women. Ealing's final prestige production was *Dunkirk* (1958), a war film which, with Balcon's approval, would feature 'no women characters of any importance'.[54] But during its postwar ascendency and even into its 1950s decline, Ealing had many moments of feminine focus that are worthy of revisiting.

18 'A RIOT OF ALL THE COLOURS IN THE RAINBOW'
EALING STUDIOS IN COLOUR

Keith M. Johnston

Ealing Studios has long been seen as the foremost purveyor of a British cinema focused on 'quality' realist and tasteful film-making, with films featuring documentary-based realism, recognisable characters, situations and locations, and a critical consensus built around terms such as 'authenticity' and a 'lack of sensationalism'.[1] While this current book serves as a challenge to, and development of, such themes, their continued dominance reasserts the established (and convenient) binaries around British cinema of the 1940s and 50s: Ealing's realism versus Gainsborough's melodrama, Ealing's tradition of black-and-white documentary film-making versus Powell and Pressburger's colourful flights of fantasy. The assumption that Ealing's realist conventions occur only in black and white (and never Technicolor) ignores the primary role that colour film-making played within Ealing's 1950s films. Given colour's ability to raise issues around reality and fantasy, drama and melodrama, art and spectacle, its absence from any history of Ealing Studios is problematic.

I have argued elsewhere that the analysis of colour film-making is a 'potent, though untapped, approach' to Ealing Studios,[2] and I want to develop that work here by focusing on the 1950s colour films produced by the studio, identifying whether these films contain the same 'riot of all the colours in the rainbow' claimed for *Saraband for Dead Lovers* (1948).[3] To do so, the chapter will explore how different creative teams chose to apply colour techniques, suggest how Ealing's attempt to create a colour aesthetic challenged contemporary debates around colour film-making (notably debates around realism, narrative and spectacle), and investigate how the films were critically received and discussed.[4] Central to this analysis will be the role of Ealing directors of photography Douglas Slocombe (*The Titfield Thunderbolt*, 1953; *Lease of Life*, 1954; *The Love Lottery*, 1954; *Touch and Go*, 1955; *Davy*, 1957), Otto Heller (*The Rainbow Jacket*, 1954; *The Ladykillers*, 1955), and Paul Beeson (*West of Zanzibar*, 1954; *Out of the Clouds*, 1955; *The Feminine Touch*, 1956) and whether Slocombe's initial theories on using Technicolor were developed into a more coherent colour aesthetic for the studio. Given that a quarter of Ealing films produced between 1950 and 1959 were in colour (thirty-nine films in total, eleven in colour), it is also hoped that this investigation will encourage a reappraisal of the role of colour within the studio's production practices, and a reassessment of several of these lesser-known films.

Colour Film-making in Britain

While most coverage of Technicolor has focused on how Hollywood film adapted to the new technology, British films were experimenting with Technicolor cameras as early as *Harmony Heaven* (1930, two-strip system) and *Wings of the Morning* (1937, three-strip system). During the 1940s, over twenty Technicolor films were produced in Britain, from companies as diverse as Two Cities Films (*Henry V*, 1944), Gainsborough (*Jassy*, 1947) and The Archers (*A Matter of Life and Death*, 1946). Ealing was not left out of this experimental move, producing two expensive Technicolor productions late in the decade that were part of the studio's larger project to engage with other genres and forms of film-making: the historical drama *Saraband for Dead Lovers* and patriotic epic *Scott of the Antarctic* (Frend, 1948). While the former was a costly failure for Ealing, it did allow the studio to begin to develop a colour aesthetic for later productions.

The British film industry had an uncertain attitude towards colour, unsure if audiences would pay more to see colour films, and if the additional costs were worthwhile.[5] Technicolor itself was often the source of contention: the company insisted all equipment was rented from them, they retained strict control over in-house processing (to which few non-Technicolor employees were allowed access), the colour process added additional production costs and Technicolor (through Natalie Kalmus and Joan Bridge) insisted on close involvement in the aesthetic application of Technicolor to any film production. The issue of the colour aesthetic, and the role of colour within British film, was at the centre of such debates: the addition of colour to certain 1940s genres (musicals, fantasies) was not seen as problematic, as they already highlighted visual spectacle and were rarely located within reality. Outside of such genres, however, British commentators were wary of using colour for spectacular purposes, expressing instead a belief that colour should always be subjugated to narrative, never overwhelming it.

In 1949, British cinematographer Guy Green argued that dramatic subjects filmed in colour could not be approached in the same way as existing colour genres such as the musical. Colour photography 'must reflect the emotional content of the scene ... It must not be a glorious spectacle all on its own ... it must be suppressed and made to lend itself to the subject dramatically.'[6] Green's words were echoed by Major A. Cornwall-Clyne, who noted that excessive colour could function as 'an intruder destroying the unity of the film ... usurping the proper functioning of other more important elements of the film'.[7] By stating that colour should always be subservient to narrative or character, Cornwall-Clyne asserted it as a less dominant and important area of film-making and, again, stressed the importance of the reality being constructed by the film (a reality that excessive colour would destroy).

Such debates within the 1940s British film industry, then, defined colour film-making as capable of offering both realism and fantasy (though in relation to specific generic options): and, while they accepted that colour could contribute to a realistic depiction of the world, raised the spectre of spectacular colour rupturing the cinema experience by disrupting narrative cohesion. As Steve Neale has noted, colour film was therefore stuck in a binary between discourses that privileged realism and 'natural' colour, and those that invoked debates around artifice, art and 'high' art.[8] This division informed Ealing's first colour film, *Saraband for Dead Lovers*, where the colour aesthetic developed by production designer Michael Relph and director of photography Douglas Slocombe was linked both to an idea of historical realism (accuracy of costume and authenticity of set design) and to visually

The Technicolor camera on location for the filming of *Saraband for Dead Lovers* (1948)

expressive lighting techniques that made reference to the use of colour by Rembrandt and Van Gogh.

While arguing that the 'realistic nature' of the film medium demands that lighting and design create a two-dimensional 'illusion of depth and solidity', Relph stated that film designers could learn about colour composition and lighting 'from the great painters': limiting colours in scenes with 'dramatic, strongly contrasted lighting' and limiting lighting contrast when using 'a wide range of bright colours'.[9] Despite establishing this concept of colour design, Relph also talks about the necessity of abandoning such a theory when a particular effect is required: he refers specifically to *Saraband for Dead Lovers*' Hanover Fair sequence, which plunges the main character (and, arguably, the viewer) into a colourful nightmare, a montage of exotic and grotesque masks and images. Relph says the scene 'was therefore packed with as many and varied colours as possible ... the effect was one of violent clash and conflict, the exact atmosphere we wanted to create at this point in the story'.[10]

Given its problematic relationship to Relph's main theory of colour, the more elaborate colour construction found in the Hanover Fair sequence may be more closely aligned to Douglas Slocombe's views. By 1948, Slocombe was an established director of photography at Ealing, and appeared more willing to abandon issues of realism, arguing that Technicolor composition should not be concerned solely with making hues that were 'true to life' but that cinematographers should make 'pleasing and dramatic use' of colour techniques. Slocombe, in opposition to Green and Cornwall-Clyne, favoured the more artistic and spectacular use of colour: but again, his opinion was closely tied to discourses around high

art. No one censured Van Gogh or Matthew Smith for 'the extreme violence of their colours'; cinematographers had their own 'palette', 'ready-mixed colours' and 'careful drawing'. Yet, for all his belief in colour cinematography, this was not a simplistic call for bolder, brasher colour palettes in British film: Slocombe cautioned that 'the addition of colour would not in itself help to disguise bad drawing' and that the 'violently contrasting and bright colours' of Hollywood 'would seem quite false' for 'a Sussex landscape or a London street scene'.[11]

Slocombe, then, was calling for a British colour aesthetic that could use colour creatively, and would not be easily subsumed within discourses around realism and narrative. Such a colour aesthetic would need to be sympathetic to the 'natural background provided by our country and climate' and not allow the eye 'to wander all over the screen'. Technicolor, to Slocombe, was a creative tool that offered a new range of aesthetic options. Yet, despite his passion for bold and expressive colour cinematography, he also saw the need for the Ealing colour aesthetic to be controlled and deliberate: colour should not be 'a child's kaleidoscope shaken up to the tune of a tango', but, equally, it should not be as constrained by narrative as Green and Cornwall-Clyne suggested. It should be an equal contributor to issues of theme, metaphor and meaning. This can be seen in his work on *Saraband for Dead Lovers*, where low-key lighting effects (notably an expressionist application of 'the Technicolor black' to cast areas of the screen into 'inky blackness') were used to 'bring the other colours into quiet relief' and, as in painting, guide the viewer 'to the focal point' of the frame.[12]

The colour aesthetic developed by Ealing during the filming of *Saraband for Dead Lovers*, then, fulfilled existing notions of what colour film-making was capable of, and pushed against them, suggesting other possible goals (helped by the more melodramatic nature of the chosen story). Whereas Relph was largely in agreement with other British industry commentators that colour should serve the narrative, enhance character and thematic issues, and only occasionally function as spectacle, Slocombe appeared to advocate a more creative and artistic use of colour cinematography. The evidence of *Saraband for Dead Lovers* provides examples of both approaches: many of the brighter-lit scenes feature the range of colours discussed by Relph, while the low-key lighting in the final sword-fight sequence emphasises Slocombe's belief in combining dark shadows with strong splashes of expressionist colour. The Hanover Fair (see colour section), meanwhile, showcases both approaches and offers the spectacle of colour as an illusionistic, dreamlike spectacle through which the central character stumbles.[13]

Ealing's second colour film, *Scott of the Antarctic*, features little of this debate around colour, or its application (see colour section). A patriotic epic celebrating the glorious failure of Captain Robert Falcon Scott (John Mills) to reach the South Pole, it featured three separate directors of photography (Osmond Borradaile, Geoffrey Unsworth and Jack Cardiff). But the film's main colour debate was less aesthetic, and more technological. The main issue was how to match the footage shot on different locations: a 'blue bias' from Borradaile's Antarctic footage (shot from a Technicolor monopack camera), 'weak amber light' and 'ink-blue' skies from Unsworth's Norwegian and Swiss shoots, and indoor exteriors filmed by Cardiff at Ealing Studios.[14] The desire for realism (and shooting conditions on location) appears to have outweighed a more creative use of Technicolor: despite Balcon's description of 'exciting and colourful backgrounds ... snow and ice are anything but black and white', the film features little overt experimentation with the colour aesthetic.[15] It may also be significant that of the three directors of photography who worked on *Scott*, none completed another film at Ealing (although Unsworth did work with Paul Beeson on *Where No Vultures Fly*): Slocombe and

Relph, however, would remain prominent members of Ealing's production inner circle over the next decade, and it appears their approaches to colour (as outlined above) informed the development of Ealing's colour aesthetic through the 1950s.

Ealing's Colour Films of the 1950s

Given its initial forays into Technicolor production were both large-scale, high-budget period epics, the eleven colour films produced by Ealing in the 1950s were more eclectic, and fit comfortably within the economical Ealing genres and production values of the time: colonial action-adventure (*Where No Vultures Fly*, *West of Zanzibar*) (see colour section), comedy (*The Titfield Thunderbolt*, *The Love Lottery*, *Touch and Go*, *The Ladykillers*, *Davy*) and contemporary dramas (*Lease of Life*, *The Rainbow Jacket*, *Out of the Clouds*, *The Feminine Touch*). By moving away from the fantasy of *Saraband for Dead Lovers*, Ealing created problems for its own developing colour aesthetic: that first film was largely set-based at a time when the studio was well known for filming on location; it could interpret the past in a more colourful fashion (albeit within the strictures of historical accuracy), while the move into melodrama allowed creative space for Slocombe's more adventurous colour experiments. Given that most postwar Ealing films have been claimed to share a 'broadly naturalistic aesthetic' that mixed 'location and studio production' to create a 'dominant visual style' that tended not to feature the 'kind of lighting contrasts available in studio cinematography', this would have impacted equally on

Location filming remained an important part of Ealing's 1950s colour film-making, as seen in *Touch and Go* (1955)

colour production.[16] Yet as Duncan Petrie has argued, many later Ealing films – notably those shot by Slocombe – transcend that sense of a 'limited' Ealing style.[17] The conflict between those positions is something that clearly informs many of the colour films discussed below.

These eleven colour films also represent the introduction of colour photography into modern-day locations: Titfield's green fields, the sun-dappled shores of Lake Garda, London's colourful streets, the blue skies of the West Riding of Yorkshire, Kenya's breathtaking game reserves. Despite a reduction in budget and scope, the changes in genre, location and time period did not restrict Ealing's colour aesthetic within modest terms of verisimilitude and authenticity. All eleven films contain aspects of Relph and Slocombe's original assertions about colour film-making: that colour can be used for 'pleasing and dramatic use', create a realistic and authentic *mise en scène*, add to narrative detail, stress thematic elements and (in places) offer a colour spectacle enhanced by expressionist techniques, including low-key black shadows and bright colours.

Colour and Realism

> British cameramen and art directors have moderated their use of colour to suit the natural background provided by our country and climate.[18]

Ealing's 1950s films feature numerous examples of colour cinematography that attempted to capture a naturalistic representation of British (and foreign) landscapes, an element that critics found most appealing. Technicolor reproduced 'the strong colour of the African landscape' in *Where No Vultures Fly*; the 'bright and cheerful' colour of *Touch and Go* accorded 'excellently with the setting of neat little Chelsea homes'; the 'documentary detail' and 'good-looking foggy Eastman Colour [sic] exteriors' was highlighted in *Out of the Clouds*; *West of Zanzibar* featured 'lush backgrounds in exquisite colour'; *The Love Lottery* was 'beautifully filmed in colour around Lake Como'; Technicolor was 'intriguing' and 'authentic' in *The Feminine Touch*.[19]

It is important to note, however, that while many critical reviews mentioned colour in relation to realism, most chose to focus on more traditional review elements of narrative, themes, stars or acting, and directors. Technicolor and Eastmancolor were rated as 'box-office appeals' by the British film industry's main trade papers, but often at the end of a longer list: *The Feminine Touch*'s appeals were listed as 'Fascinating subject, strong human angle, first-class acting, eager players, Technicolor and "U" certificate'.[20] Ealing's publicity department, however, were keen to stress the studio's colour production credentials and its suggestive link to realism (something that contemporary audiences would have associated the studio with): the press book for *Lease of Life* commented on the film's use of 'subtle colour' in 'location settings', while *The Love Lottery* publicity emphasised 'colourful sets and charming fashions', alongside the location filming in Menaggio and around the Italian lakes.[21]

This use of colour, offering an apparent record of location or studio filming, is perhaps the least suggestive analysed here and fits with Relph's idea of creating depth and solidity within the colour image: much of the time, the colour remains unobtrusive, a background element against which the narrative action is played out and which is rarely made spectacular by colour choice or composition. Such scenes are brightly lit and feature a range

of colours (though primary colours do tend to dominate: open blue skies, green fields), but little attention is drawn to those elements. George Perry has noted that such use of colour tended to evoke a 'pastoral English charm' in films such as *The Titfield Thunderbolt*, *Touch and Go* and *Lease of Life*.[22] While this can be seen as an extension of Ealing's traditional concerns about representing or projecting aspects of Britain (the verisimilitude of the countryside or town location), these films also feature more creative and dramatic uses of colour.

Colour and Narrative

Using colour as a source of narrative or thematic detail is central to Ealing's colour aesthetic. Both *The Titfield Thunderbolt* and *The Ladykillers* adopt strong primary colours that add to their individual narratives. Colour underpins the former film's narrative development, depicting the struggle between the old, juddery train (a grimy black engine) that serves Titfield and its new competitor, a coach service with modern, pastel-perfect cream and blue buses. In colour terms, the brighter hues of the coaches initially make them seem superior, paralleling one aspect of the narrative. Yet, when sabotage causes the old train to be replaced with a red, green and gold engine that gleams in the sunlight, the eventual victory of the train has been visually guaranteed (see colour section). *The Ladykillers* does not feature quite such an obvious narrative device, but colour continues to aid the film's themes and characterisation. Mrs Wilberforce's (Katie Johnson) house is a contrast in colours: her rooms are painted in pastel hues while the rooms she rents to the gang have more lurid, unnatural and expressionist hues (the arrival of the Professor (Alec Guinness), bathed in a violet-purple glow, instigates this change). The room where the gang 'practises' is blue, but the room beyond (where they plan the heist and stash the money) pulses a sinister red throughout. The colour scheme suggests something is wrong with the room – and when the film cuts inside, that slash of red is joined by an unnatural green tone – not only a contrast to Mrs Wilberforce's pastel tones, but a subtle link to the growing avarice and distrust within the gang.

The Ladykillers also uses colour (particularly strong splashes of red) for thematic concerns around modernity and communication. The bright red telephone and pillar boxes that litter the film's *mise en scène*, or the unseen danger caused by the red train signal that sits over the fateful railway bridge, suggest a further symbolic element to the film's use of colour (see colour section). The thieves' links to these stabs of primary colour may position them in the modern world, but also isolate them further from the muted (arguably realistic) colours of Mrs Wilberforce's realm. The 'design and colour styling' of the film can, therefore, be seen as a balance between the Relph and Slocombe versions of the Ealing colour aesthetic discussed above, creating a 'higgledy-piggledy Toytown … with intimations of the gothic':[23] outside the house, Relph's more realistic milieu is created (albeit one in which the colour red stands out); inside, the house is divided by colour, thematically split between the characters.

Director of photography, Douglas Slocombe, on location for the colour filming of *The Titfield Thunderbolt* (1953)

Redheads like Adrienne Corri (here in *Lease of Life* (1954) with Denholm Elliott) featured prominently in Ealing's colour films

The link between colour and modernity continues in both *Lease of Life* and *Touch and Go*. The association is more negative in *Lease of Life*, where the red telephone box is closely linked to the underhand tabloid reporter who makes a reluctant star out of Reverend William Thorne (Robert Donat); *Touch and Go*'s London streets are equally dotted with red telephone boxes and postboxes, but here they function as little more than set dressing. However, the film points to a tendency in 1950s Ealing films to emphasise youth culture with colour. Both *The Feminine Touch* and *Touch and Go* have dance sequences where all the younger characters wear bright colours, which stand in direct contrast to the duller palette found in, respectively, the hospital and the family home. That is not to say that the use of colour depicts these locations in a purely positively manner (Ealing films do tend to be uncertain about the changing youth culture of the 1950s), but that the colour does make them more vibrant and eye-catching than locations associated with older characters. Given that both films' narratives are about the generational collision of old and new opinions and desires, colour works to differentiate the different participants in such debates.

This association between colour and youth also informs the representation of younger female characters in these Ealing films, where they function as a problematic site of both realism and spectacle. There is a strong link between Technicolor spectacle and 'the spectacle of the female body':[24] the films have a tendency to feature redheads (Susan Thorne (Adrienne Corri) in *Lease of Life*; Peggy Fletcher (June Thorburn) in *Touch and Go*; Gwen Morgan (Susan Shaw) in *Davy*), while it is the female characters who get the most colourful

outfits: Mary Payton (Sheila Sim) has an array of bottle-green tops and pink polka-dot dresses in *West of Zanzibar* (more eye-catching than the colourful native dress), the showgirls of *Davy* (see colour section) are always shown in tight, red sparkling swimsuits, and Jane Dumois (Anne Vernon) has an array of green outfits in *The Love Lottery*. While the spectacle of colourful female outfits is not necessarily matched by rounded (or dominant) female characterisation, it offers a further example of how colour cinematography can complicate our existing understanding of Ealing, and lead the eye to other important aspects of the narrative.

Colour Spectacle and the 'Technicolor Black'

Douglas Slocombe's theory of gaining 'an extra dimension' by 'adding black and white to the colour range' to create low-key expressionist images remains visible in many of Ealing's 1950s colour films.[25] This element of the Ealing colour aesthetic is not limited to Slocombe alone: Paul Beeson noted the power of 'low key photography' when using Technicolor for *The Feminine Touch*.[26] Many such examples of combining colour and low-key lighting contribute to narrative events as discussed above, but can also be read as examples of visual spectacle through the combination of the Technicolor black with one or two strong colours.

Much of the colour in *Out of the Clouds* represents an accurate record of the production's time filming on location at London Airport (Heathrow), with blue-grey tones dominating in the terminal itself and pastel colours in the restaurant and waiting area (there are a few red areas in both, notably the 'thin red line' of rope that separates transit passengers from British ones). However, one central moment in the narrative emphasises the potency of strong colour composition (in Eastmancolor). During the landing of a malfunctioning plane in thick fog, the film cuts between model plane sequences (which feature little colour) and strong colour images – most notably red fire engines, preparing to race on to the runway, and a radar control centre bathed in red and green hues (see colour section). While some realism could be claimed for this sequence, it functions as a demonstration of how strong primary colours and shadowy low-key lighting can be combined to heighten the tension of a sequence. With individual faces and control screens depicted in unnatural reds and greens, and the rest of the room in complete darkness, the sequence jars with the normal, everyday colour scheme seen elsewhere. The juxtaposition of subdued tones with this extreme example of colour is a break with the aesthetic of the rest of the film, a tonal shift that creates a spectacular element that enhances the narrative.

Davy also features two striking uses of black within its colour palette: the first highlights Davy Morgan (Harry Secombe) during a stage performance. An oval beam of light frames his yellow-jacketed figure, recreating the effect of a stage spotlight, and plunging the rest of the screen into darkness. Later, when Davy is ushered into the Covent Garden Opera House for an audition, Slocombe's use of low-key black lighting and strong mono-colour creates a compelling image: as Davy and another singer, Jo (Adele Leigh), enter the auditorium in long shot, they are dwarfed by their surroundings, engulfed within the deep red tones of the seats and walls, which are consumed by the same 'inky blackness' that Slocombe espoused in relation to *Saraband for Dead Lovers*. Here, the effect is to impose the grandeur and scale of the opera house on the two singers who have come to audition, and the strong deep reds continue to enclose and define that space (and those figures) through the sequence.

The Feminine Touch uses its low-key lighting and strong colour effects to suggest the loneliness of the trainee nurses that the plot follows, particularly Susan (Belinda Lee). While the uniform reduces the main nurses to identically dressed blue-and-white figures, the film uses other colours to isolate Susan: in one scene, Susan sits alone from the other girls (who are discussing quitting their training), bathed in the orange-yellow tones of a sunset; in another, she sits at the end of a darkened shadowy ward, lit only by the blue-tinged light of a desk lamp. Given Susan's uncertainty about her chosen career throughout the film, the use of colour works to underline her seclusion, both from the others she has trained with (the rich tones of the sunset fade to muted blues as she tries to explain why she won't quit), and the patients she is now responsible for, alone in the darkness.

Finally, *The Love Lottery* offers perhaps the strongest example of Ealing's expressionist colour lighting techniques, in part because of its status as a broad comedy-fantasy that features several dream sequences. Colour is dominant throughout: Rex Allerton (David Niven) is regularly dressed in red clothes, Jane is almost always clothed in green, the Italian locations are bright and colourful, and the casino scenes stress red, black, green and yellow through set design. However, the film's most obvious use of colour is in its dream sequences: Rex and Sally (Peggy Cummins) both dream in particularly colourful ways. Rex's dreams are often violent, tinged with red, as his fans pursue him and tear him to pieces. Sally's feature bluer tones, either featuring Rex in a sword fight (that recalls *Saraband for Dead Lovers*' final sequence) or dancing in a ballet, where the camera emphasises housemaids with brightly coloured underskirts (yellow, red, pink and green) who dance around a giant pink/purple bed. This latter sequence foregrounds colour's role in creating fantasy in musical sequences but also reaffirms its spectacular properties, and the effectiveness of combining strong colour with low-key lighting elements.

Conclusion

The aesthetic and market values of colour were less certain, less predictable and less profitable.[27]

Over thirty years ago, George Perry challenged the idea that 'Ealing never took any chances and always played safe,' noting instead that 'Ealing often exposed itself to the risk of failure.'[28] Colour film-making was by no means a safe option for Ealing Studios in the 1950s: the British film industry did not fully embrace colour until the late 1960s, and it remained a more expensive option for production and distribution, even after the introduction of the cheaper Eastmancolor process in the early 1950s. Yet in 1954, as an Ealing press release makes clear, the studio's plans included 'the production of large-scale subjects, the majority of which will be in colour'.[29] Indeed, from 1953 to 1955, out of fourteen films on Ealing's production slate, eight were colour, a major investment for the studio in this technology.

Colour was not a safe road for economic reasons: as Sue Harper and Vincent Porter have pointed out, most of Ealing's 1950s films failed at the box office, as the studio struggled with Rank, distribution and with a broader awareness of what 1950s audiences wanted.[30] Yet Ealing continued down that road almost until the end of the studio itself. Any claims that Ealing, in the final nine years of the studio's existence, had become staid or was resting on the laurels of their past success have failed to take into account the studio's experimentation with, and use of, Technicolor, Eastmancolor and Technirama (Technicolor's

wide-screen process: *Davy* was the first British film to use the technology). Such willingness to take risks shows a studio that was still open to new ideas – partly as a result of the production climate they found themselves within, but also because these new technologies offered new stylistic paths for the studio.

As demonstrated above, the evidence of the colour films suggests that Michael Relph and Douglas Slocombe's experiments with colour while filming *Saraband for Dead Lovers* had a lasting influence on Ealing's overall colour aesthetic. Ealing films did not simply opt for realist colour photography, but expanded out from there to use colour for 'pleasing and dramatic' use, with distinct narrative and thematic purpose. However, while there is suggestive evidence for this, I would not want to claim that these films reveal a set colour palette or one dominant aesthetic within Ealing's colour films. Although I have set out some broad ideas about the commonalities of the Ealing approach to colour through this chapter, a more concerted viewing and analysis of Ealing's thirteen colour films will, of necessity, be able to consider whether each film offers its own unique approach to colour, and how the use of Eastmancolor, Technicolor and Technirama may have affected each film's individual aesthetic composition.

Although identifying a general Ealing colour aesthetic would advance the much-needed debate around Ealing Studios and colour in the 1950s, it may inevitably be more reductive than helpful. The debate I have begun to outline here is one that can go beyond easy binaries of realism versus spectacle, or black and white versus colour, in order to be more inclusive and specific to the details of each film. Some elements of these colour films (particularly the use of location filming) enhance the studio's documentary reputation, while others (the low-key expressive cinematography seen in *Saraband for Dead Lovers*, *The Ladykillers* and *Out of the Clouds*) suggest a more potent aesthetic understanding of the possibilities of colour. Both, however, demonstrate that Ealing Studios was not the cosy, whimsical place of legend, but a studio attempting to keep pace with developments in international film technologies, eager to experiment with the expressive opportunities of colour and happy to move beyond its own realist tradition. Ealing's 1950s films may not always live up to *Saraband for Dead Lovers*' reputation as 'a riot of all the colours in the rainbow',[31] yet they remain an opportunity to move beyond the black-and-white world that dominates studies of the studio to fully explore the range of Ealing's Technicolor fantasies.

19 AGAINST THE GRAIN
KENNETH TYNAN AT EALING

Charles Barr

Early in 1956, Ealing appointed a new script editor, Kenneth Tynan, drama critic of the *Observer* – a job in which he continued, while giving much of his time to Ealing throughout most of the next two years. Tynan welcomed the chance to, in his own words, 'act as a pipeline for the sort of blood transfusion I thought the British cinema needed'.[1] Ealing itself certainly needed one. The studio in West London had already been sold to the BBC, and the company's operations were being transferred to MGM's British base at Borehamwood. In retrospect, we know that this was the beginning of the end, and that Ealing's output would never regain the freshness and energy that had been steadily draining away since 1950, but Michael Balcon, after more than thirty years as a producer, half of them spent at the head of Ealing production, retained his own drive and optimism, and his appointment of Tynan was an imaginative one.

Kenneth Tynan

The two men seemed to have little in common other than that both came from Birmingham, where Balcon was born in 1896, Tynan in 1927. Balcon was famously puritanical; Tynan, when he achieved an entry in *Who's Who*, listed his recreations as 'sex and eating'. From the 1950s up to his death in 1980, he would hardly have needed an introduction; thirty years on, he probably does, since his work was so tied to its moment, although his legacy is preserved in volumes of collected essays, reviews, letters and diaries, as well as in biographies. Tynan was famous in his time, sometimes infamous, on three main counts: (1) as a theatre man, first as critic, and then as resident literary adviser to Laurence Olivier at the then-new National Theatre from 1963 to 1973; (2) as a flamboyant counter-culture figure: the first man to utter the word 'fuck' on British television (1965), the main force behind the staging on both sides of the Atlantic of the notorious, and commercially successful, 'erotic nude revue' *Oh Calcutta!*

(from 1969); (3) as a celebrity journalist, doing long features, towards the end of his life, on figures like Johnny Carson and Louise Brooks.

Most of this, when Ealing signed him, was in the future, but he was already a high-profile figure, primarily through the weekly *Observer* column in which he articulated a consistent and radical challenge to the complacencies of the West End theatre of the time and of many of its playwrights, actors, critics and audiences, being unafraid – far from it – to cause offence. Tynan had, however, always taken an interest in cinema as well as theatre. He never forgot the impact *Citizen Kane* (1941) made on him as a schoolboy; he wrote several brief articles for *Sight & Sound* in the early 1950s during the editorship of Gavin Lambert; and in the summer of 1955 he contributed to the American magazine *Harper's* a sympathetic study of Balcon and Ealing, under the title 'Tight Little Studio: Home of the Good British Movies'.[2] In it he wrote that 'Ealing has established itself as the most lively and exciting movie production outfit in England, and its chief, Sir Michael Balcon, as the most stimulating of English producers,' though he went on to note two main 'blind spots': its timid handling of sex, and its reluctance to hint at any criticism of British institutions. The article was quickly picked up and reprinted by the British monthly *Films and Filming*, whereupon, in the words of Philip Kemp, biographer of Alexander Mackendrick:

> Balcon, much taken with the piece and knowing Mackendrick to be a friend of Tynan's, asked him whether he thought the critic would consider becoming Script Editor. No doubt thinking that Tynan's cultural and sexual iconoclasm were just what the studio needed, Mackendrick actively encouraged the idea on both sides, and Tynan took up his job in the spring of 1956.[3]

So far, so promising. But Mackendrick judged the outcome to be 'a fair disaster', a verdict endorsed in the biography of Tynan by his widow Kathleen:

> He had no way of knowing, as Sandy Mackendrick recalls, 'the very subtle way Balcon would frustrate him' ... Ealing gave Ken his first major chance to explore his talents as an impresario and screenwriter, and his first taste of the awful frustration that comes when you are not your own boss.[4]

It is a fact that none of the various projects that he put forward at Ealing came close to being made. Soon after his time there ended, he poured out his feelings of frustration in the form of a long letter addressed to Balcon, printed in full in the Collected Letters.[5] It is hardly surprising that, apart from these references, the extensive Tynan literature virtually ignores the Ealing period; the entry on him in the *Dictionary of National Biography* has only a brief passing reference, misdating it by a year at either end as 1955–57.

His interaction with Ealing, however, invites closer study, particularly in the context of the present volume; the Tynan literature has, after all, been compiled from other perspectives, mainly theatrical. The Ealing work was not just a casual consultancy, whatever his initial expectation may have been: he told a publishing friend in late 1957 that 'I never imagined working for Ealing would be like this, but I've made the mistake of getting slightly wrapped up in the job.'[6] His normal routine for those two years, apart from occasional breaks, was to work four days a week for the company – three half-days from home, three half-days and one full day at the studio. A formal copy of this arrangement is found in the BFI's Special Collection of Michael Balcon's papers, which holds other useful material – though with significant gaps – both on Tynan's work there and on its context in the final years of Ealing production.[7]

The records suggest that it was not altogether a case of Balcon's conservatism defeating Tynan's dynamism; if that was the whole story, why had he been signed in the first place? Instead, both men can be seen as victims, within a more complex scenario. In the third (1999) revised edition of *Ealing Studios*, I added a new chapter, 'Balcon After Ealing', focusing on the five-year rise and fall of the Bryanston company, a consortium of British producers which he had gone on to chair, and suggested that 'As with late Ealing, the mechanics of its honourable failure make an instructive case study.' Going back to look at late Ealing itself from a fresh perspective, and with the help of the archival material that was available neither to me for the Ealing book nor to Tynan's own chroniclers, can likewise, I hope, add something to our understanding of the mechanics of its terminal decline.

The personal relationship between the two men, representing different generations and ostensibly such different values, is itself more complex than the standard account might suggest. Take Tynan's long letter of frustration to Balcon, referred to above. He starts by saying that he ought to pay his salary back, since in effect he achieved nothing, and goes on to explain how and why it worked out that way. But the letter evidently functioned less as a memo to Balcon than as one to Tynan himself, a conscious device for letting off steam: he never sent it, and he certainly never paid back the money. Around the same time (17 September 1958) he wrote and actually sent to Balcon a more conciliatory message, notifying his acceptance of an offer to work as drama critic for the *New York Times*:

> This means, I am afraid, that I cannot come back to work for you. I had an idea anyway that I was becoming a bit of a luxury, and in the midst of the moves I hear you are contemplating (or perhaps you have already made) I feel it would not materially help you to have someone constantly hissing in your ear about why don't you make a film of *Finnegans Wake*. Perhaps we can work together again sometime in the future. It was great fun and I only hope I am not letting you down in any way.

Balcon in reply (29 September) confirms the impending move from MGM to ABPC, 'whose intention, I believe, is to continue the Ealing production activities' – a belief that would, of course, rapidly be proved false. And he returns Tynan's warmth, proposing lunch, and ending: 'In the meantime thank you for everything and I am sure there will be opportunities of our working together again.'

I don't believe that these mutual courtesies were insincere. Balcon was split between loyalty to Ealing's traditions and personnel and a genuine – if at the same time cautious – openness to new ideas. Tynan in turn seems to have made a realistic effort to accommodate himself to Ealing practicalities, despite the joke about *Finnegans Wake*; among the ideas he would put forward were some surprisingly whimsical ones designed for the comedy actor Ian Carmichael, though Carmichael would not in fact make an Ealing film. James Joyce was never on his agenda, nor indeed was Bertholt Brecht, though he was already known as an outspoken partisan of Brechtian theatre. Soon after he joined Ealing, Balcon referred to him a letter received from Alberto Cavalcanti, an important figure in Ealing's history who was putting out feelers about a possible return after many years abroad: his main idea, based on his own friendship with Brecht, was a film of *The Caucasian Chalk Circle*, and another was a version of Defoe's eighteenth-century novel *Moll Flanders*, 'sex and all'. Tynan quickly responded (16 May 1956) that the Brecht 'is a simple and very effective play, but the similarity of its theme to "The Divided Heart" will at once occur to you. "Moll Flanders", which he also mentions, sounds a *much much* better idea ... Well worth discussing' (emphasis

in original). (*The Divided Heart* had been made by Ealing in 1954: like the Brecht play, it centres on the conflict between natural and adoptive mothers for possession of a child.) Neither the Brecht idea nor the *Moll Flanders* one, with or without the sex, was pursued.

That exchange was in any case a marginal one, since there was no serious question of Cavalcanti returning. Tynan's official job description had been announced in a press release: 'Under the guidance of Sir Michael Balcon he is to seek and develop new ideas for film stories as well as advising on the various stages of script preparation.' A third kind of input – for which he was paid extra, since it was not covered by the original deal – was the script, co-authored with director Seth Holt, for the penultimate Ealing release *Nowhere to Go*, which was not shown until December 1958, months after the links between Tynan and Ealing, and between MGM and Ealing, had ended. These three forms of input can be looked at successively.

Script Editing: *Dunkirk* and *The Scapegoat*

Of the various projects, besides *Nowhere to Go*, into which Tynan had the chance to offer some input, no more than four ultimately made it into production. On two of these, *Barnacle Bill* and *Davy* (both 1957), surviving records are sparse; this leaves *Dunkirk* and *The Scapegoat*, both of them considerably more substantial and ambitious films whose preparation is more fully documented. Both, for different reasons, had unusually long gestation periods. Scripting and then post-production of the ill-fated Daphne du Maurier adaptation *The Scapegoat* dragged on for so long that it was not released until after the deal with MGM ended, emerging in August 1959 as an MGM/Balcon production rather than an Ealing one.[8] *Dunkirk*, in contrast, was the most commercially successful of the late films; its elaborate and (by Ealing standards) expensive logistics meant that it was in preparation for more than two years ahead of its March 1958 premiere.

Tynan was involved in the early stages of the scripting of both films. The precise degree of influence he exerted is hard to judge, but he was kept consistently in the loop on both: his comments go to the heart of the weaknesses of the two projects, and may at least have had the effect of toning these down.

When he started at Ealing early in 1956, a *Dunkirk* script by R. C. Sherriff was already in circulation. Sherriff was an understandable choice to write the definitive saga of the Dunkirk evacuation of early summer 1940. Having made his name in 1928 with the classic play of the Great War, *Journey's End* – filmed soon afterwards by Michael Balcon's Gainsborough – he had gone on to script other successful war films such as *The Four Feathers* (1939) and *The Dam Busters* (1955), and he had recent Ealing experience as writer of *The Night My Number Came Up* (1955), directed by the man already assigned to *Dunkirk*, Leslie Norman. Tynan immediately weighed in with comments: while tactfully acknowledging that the script 'seems very promising', he offered one major criticism:

> The real hero of the Dunkirk story should be not the British army but Dunkirk itself ... We forget that Dunkirk is in France, because in the whole narrative we meet only one Frenchman ... I feel we should fade out on Dunkirk as it stoically awaits the arrival of the Germans. A devastated town, with a rumble of Panzer tanks in the streets: the end.

... Sherriff's present script is a a good adventure story [which could be called] 'The Big Retreat'. But it isn't 'Dunkirk'. I wonder what others think of this.[9]

This is exactly the kind of radical suggestion that might have been predicted from Tynan, the kind of thing he had been hired for. No less predictably, it was not followed: the film that emerged two years later gives virtually no sense of the town or its inhabitants. However, he also, over a period of months, picked up carefully on a number of detailed issues in the script; even though surviving memos are incomplete, we can see his points being taken on board by Norman and responded to by Sherriff – who before long walked out acrimoniously, and would have no more film credits for the remaining twenty years of his life. Tynan thus played at least a minor part in easing out an experienced and by now rather old-fashioned professional writer – a process comparable to the tendency of some of his more outspoken theatre criticism – and also in pushing the Dunkirk project away from Sherriff's 'adventure story' towards the notably downbeat and anti-triumphalist work that it became.

The case of *The Scapegoat* is comparable, in that an experienced screenwriter – here, Bridget Boland – was already assigned to the film when pre-production began, and Tynan would contribute to the pressures that eased her out. The project was in every way more problematic for Ealing, from the start, than the essentially safe and mainstream one of *Dunkirk*. It was initiated by the book's author, Daphne du Maurier, in collaboration with its star, Alec Guinness, and their joint company receives an eventual on-screen credit. MGM was happy to back the film because of the box-office value of both these names; the long association of Guinness with Ealing, combined with the newer Ealing–MGM association, made it natural for them to take it on. But the project became the cause of protracted tension and embarrassment for Ealing and for Balcon, caught as they were between the more powerful forces, on the one hand, of the du Maurier–Guinness alliance and, on the other, of MGM, compelled to meet the latter's deadline despite continuing problems with the script. These tensions became one of the many factors in, and symptoms of, the failure of the MGM–Ealing partnership – with Tynan closely involved.

The selling point, and also the problem, of *The Scapegoat* is the theme of the Double. Guinness plays a solitary, repressed English schoolteacher on holiday in France, who encounters his exact lookalike, a very unrepressed French aristocrat. The French Guinness contrives to administer a drug to the English Guinness and drop him into his own place, complete with wife, family and mistress, and predictable complications follow. Tynan was immediately alert to the problems both of the story itself, and of the way it had been adapted by Boland, who was initially presented as a non-negotiable part of the du Maurier–Guinness package. As with *Dunkirk*, he combines careful point-by-point comments on detail with a challengingly radical overall perspective. At an early stage in the process (24 October 1956): 'If the picture is shot in a wholly realistic style I can't see any audience swallowing this [plot] easily. It would have to be made in a "larger than life" and deliberately romantic manner.' This is something which is manifestly, from the start, hard to reconcile with the casting of Guinness. And coming back to it in the context of Boland's script
(16 July 1957): 'Every time I read this story it interests me less.' But:

> Only one director alive could impose on the story a visual style that would save it. ... That is the remarkable Swede Ingmar Bergman, whose work has the ornateness of Ophuls together with a

sinister glitter of its own. I was so deeply impressed by his film *Smiles of a Summer Night* that I am convinced that a similar treatment to *The Scapegoat* would have most exciting results. Otherwise, I confess, I fear the worst.

Like the suggestion of a French framework for Dunkirk, that idea, exciting as it is, could hardly have been seen as a realistic one for Ealing to pursue. Tynan did, however, get in touch, in the same month, with another and more realistic option as director, one with Hollywood experience – Laszlo Benedek:[10] he quickly supplied a thoughtful document offering comments on the script, both destructive – 'museum-like characters' – and constructive, and was taken seriously by Ealing as a possible director until MGM vetoed him.

To cut short what is indeed a long story: the relentless criticism, by Tynan and others, of the successive drafts by Boland finally persuaded Guinness and du Maurier to pay her off, and at Tynan's instigation, and with MGM's agreement, Gore Vidal took over – like Tynan himself, a controversial figure hardly in tune with Ealing's established image. But Ealing in the past had accommodated, and drawn energy from, its own non-conformists, prominent among them the Robert Hamer of *It Always Rains on Sunday* (1947) and *Kind Hearts and Coronets* (1949). When Balcon had difficulty finding an appropriate director for *The Scapegoat* either in Britain or America – and he had in desperation petitioned MGM to supply Cukor or Minnelli – he fell back upon Hamer. Although his career had declined since *Kind Hearts*, Hamer was a reasonable choice, a francophile who had worked with Guinness both at Ealing and elsewhere; and it was he who now adapted Vidal's work into the final script. Tynan, by now on the leave of absence from Ealing that would become permanent, wrote a supportive letter about this script (6 June 1958), but I have found no record of his response to the film itself, if he saw it. The first issue of the magazine *Movie* in May 1962, casting around for good things to say about any British film-makers, referred to *The Scapegoat* as 'the remains of a very good movie savaged by its distributor', though to me this is over-charitable.[11] In any case, it was a doomed film, and helped to doom Ealing.

'Ideas for Film Stories'

> I left Ealing last spring, ostensibly for six months leave, but really because I saw no concrete chance of any films that really interested me ever getting made there.

Tynan wrote this in a letter to a non-Ealing friend late in 1958.[12] It is the same point that he had recently developed at length in his unsent letter to Michael Balcon, and it would be reinforced on his behalf both by his widow and by Alexander Mackendrick. That letter lists a number of specific projects that were proposed and discussed but never reached the production stage. One that particularly stands out is John Osborne's *Look Back in Anger*, since Tynan himself was so closely identified with that play; he had famously written in his original *Observer* review of 13 May 1956 – by which time he was well settled in to the day job at Ealing – that 'I do not think I could love anyone who did not wish to see *Look Back in Anger*.' Balcon was not opposed in principle to taking on a film of it; he had some friendly meetings with John Osborne, and more than once pressed MGM to approve it as an Ealing project, sending an excited telegram (2 October 1957) when it created interest on its New York opening, but he continued to be firmly rebuffed. Soon after Ealing was wound up,

however, he would renew the Osborne association. As chairman of Bryanston, the consortium of independents that was not financially dependent on an American partner, he welcomed and supported the early productions of Osborne's company, Woodfall: *Saturday Night and Sunday Morning* (1960), *The Entertainer* (1960), *A Taste of Honey* (1961), *The Loneliness of the Long-Distance Runner* (1962). True, these did not have Balcon's name attached to them as producer, nor did they involve him in the day-to-day supervisory role that he had been accustomed to at Ealing, but it is clear that he was far from being a reluctant partner and that he felt genuine regret when *Tom Jones* (1963), scripted by Osborne, was judged too expensive for Bryanston and went to United Artists instead.[13]

From among that 'British New Wave' group, Karel Reisz and Lindsay Anderson also had dealings with late Ealing. Reisz submitted a one-hour project about 'Music Hall'; Tynan (27 March 1957) wrote a supportive memo, but had to admit to not having seen the Reisz–Richardson Free Cinema short *Momma Don't Allow* (1955); Balcon's quick response showed that he was ahead of him in having seen and admired this, and indeed he had personally backed it in his capacity as head of the BFI's Experimental Film Fund. But he had to say that there was no way that the new 'Music Hall' project could fit MGM's parameters, and he was clearly right. As for Anderson, Ealing bought for him the rights to a book about the casualty ward of a London hospital, and paid him to develop a script, but he failed repeatedly to get it together and soon gave priority to his theatre work; the letting-off-steam letter somehow blames Balcon for not having given Anderson the confidence to press ahead, but the documents of the time, including Tynan's own disappointed memos, suggest otherwise. In short, it is over-facile to see Tynan as wanting to bring in the 'new blood' associated with names like these, and Balcon as subtly blocking his efforts. (Even if the 'Casualty' film had reached the stage of being put up for approval to MGM, it is very possible that they would have refused, just as they turned down, on cost grounds, another more fully developed project, based on H. E. Bates's *The Jacaranda Tree*, described wistfully by Tynan, in the unsent letter, as 'that tough, unsparing account of a group of English residents escaping from wartime Burma'.)

This, then, is the wider context within which Tynan was working for Balcon, that of a partnership with MGM that was falling apart and would not last much longer – rather different from the more quirky and somewhat more autonomous Ealing which Tynan had written about affectionately in 1955, and within which Alexander Mackendrick had found effective ways of operating. Mackendrick had left Ealing after *The Ladykillers*, at exactly the point when the company was relinquishing its eponymous home and linking up with MGM – and he too, like the Woodfall people, would work for Balcon after he had re-established himself at Bryanston, on *Sammy Going South* (1963), the last film to have Balcon's name on it as a personal production. And it was Mackendrick who encouraged the deal between Balcon and Tynan, just at the point when he himself had, for his own very good reasons, departed. Looking back, we can see this as, to use a rugby football metaphor, something of a 'hospital pass', putting Tynan into a situation where he could hardly hope to prosper. As script editor, Tynan made sporadic efforts to find potential projects for Mackendrick himself. On 26 June 1957 he sent Balcon a list of subjects for consideration 'if there is any chance of Sandy's returning to make a movie for us': they included *The Cadillac Story* (a whimsical comedy), *I Claudius* ('I think of this because of Sandy's often-expressed desire to make an historical picture') and *The Lord of the Flies*. Ealing had bought the rights to William Golding's novel not long after its publication in 1954; plans were made for Leslie Norman to

direct from a script by Nigel Kneale; both Mackendrick and (in the unsent letter) Tynan blamed Balcon's timidity for the abandonment of the project and the selling on of the rights to Sam Spiegel; but again the records indicate that MGM lacked faith. If Balcon is blamed for being defeatist and not fighting for it more strongly, the same can be said of Mackendrick, who told Tynan that he would love to make *The Lord of the Flies* but that he could see no prospect of actually getting it made at Ealing.[14]

In effect we can see Tynan as having taken over from Mackendrick the role of resident Ealing subversive, in his absence and, by now, in a less congenial and flexible context. None of the projects that he suggests independently, or that he picks up and runs with from among the properties already bought or under discussion, comes even close to being realised. It is indeed, as both he and Mackendrick ruefully acknowledged, a record of failure – with the single exception of *Nowhere to Go*, co-scripted by Tynan himself in collaboration with its director, Seth Holt. This is the penultimate film with the Ealing name on it, the last MGM–Ealing film, not shown until December 1958, nearly a year after Tynan himself had left the studio.

Seth Holt and *Nowhere to Go*

Balcon had always been reluctant to bring in directors from outside Ealing. The established directors in permanent or intermittent employment during the two years of the MGM association were Leslie Norman, Charles Frend, Basil Dearden and Harry Watt, plus Michael Truman, who had not made a film since 1955 (the notably unsuccessful *Touch and Go*) and whom Balcon reluctantly let go when his personal project, *The Jacaranda Tree*, fell through. While he was open in principle to using outsiders like Peter Brook and Lindsay Anderson on specific new projects, the two new directors of the final years were, in the event, promoted from within the Ealing ranks: Michael Relph for *Davy* and Holt for *Nowhere to Go*. Such loyalty may seem perversely conservative, but the strategy of promoting insiders had worked well in the past, as Tynan acknowledged in the *Harper's* article that led to his own appointment; it was this strategy, after all, that had come up with both Hamer and Mackendrick. Relph, as his film confirms, was fully imbued with the orthodox Ealing ethos; on it he was continuing to work with his regular collaborator Basil Dearden, the director-producer roles simply being switched on this occasion. Seth Holt, however, was very different. He had been working away at Ealing for fifteen years on a wide range of films, as editor and then associate producer, but his most significant associations were with Hamer (his own brother-in-law) and with Mackendrick. He had worked on *Kind Hearts* as an assistant editor and found the experience inspiring; for Mackendrick, he had edited *Mandy* (1952) and produced *The Ladykillers*; and he now turned out to share their temperamental disposition to subvert the established Ealing norms from within. Given at last the chance to make a film of his own, he set out, with Tynan as an ideal collaborator, 'to do the least Ealing film ever made'.[15]

The documentation of this project, and of the Holt–Tynan collaboration, is frustratingly thin. In contrast to the negotiations over the *The Scapegoat*, there seems to be no record of the circumstances in which the original screenwriter, again Bridget Boland, was removed. The novel by Donald Mackenzie had already been bought by Ealing when Tynan arrived there; in the course of 1957, Boland completed her script, and soon after this Tynan was

The least Ealing film ever made: Seth Holt directs and Chris Waterson photographs George Nader in the Tynan-co-scripted *Nowhere to Go* (1958)

contracted to work on a new one. Always keen to keep the company's veterans occupied, Balcon made a gentle and tactful enquiry: 'I am quite content with the arrangement that you and Seth develop the script of *Nowhere to Go*, but it occurred to me that if by any chance you feel you do want assistance, have you thought of Tibby Clarke?' (7 March 1957). Clarke had by now got back from working with John Ford and Columbia on the Scotland Yard film *Gideon's Day* (1958), and would have the last of his many Ealing credits for the original script of *Barnacle Bill*. He was no stranger to the crime film, having done the final script for *The Blue Lamp* (1950). But you could hardly have made 'the least Ealing film ever' with Clarke on board.

In the *Screen* interview already quoted, Holt expressed his admiration for Fritz Lang and for the Hollywood crime film, as well as for Buñuel. There is, in fact, another link here to *The Blue Lamp*, in that the original writer of that film, Jan Read, had gone to the USA after the war to work first with Louis de Rochement, producer of such sharp urban thrillers as *Boomerang!* (1947), and then as Fritz Lang's assistant. But this experience was translated, on his return, into less hard-edged English terms in his *Blue Lamp* outline for Gainsborough,

where he had gone as script editor, and the concept was softened further when it was sold on to Ealing and given its final adaptation by Clarke.[16] In *Nowhere to Go* Holt sustains the hard edge, working not with Clarke but with Tynan, who was likewise a fan of the Hollywood crime film, and had written on Cagney for *Sight & Sound*.[17] As I wrote all those years ago in *Ealing Studios*, the film is remarkable, for Ealing, in being 'neither police-centred nor moralistic', as well as for the boldness of its formal experimentation. It opens with the elaborate springing of a prisoner (George Nader) from jail, after which he takes up occupation of the flat that has been rented as a place where he can lie low. The first shot of his entry into the flat runs more than two and a half minutes, with a lot of unobtrusively intricate camera movement, and it is not until halfway through this shot that the first significant lines of the film are spoken – more than nine minutes into its running time. There is nothing comparable with this in previous Ealing films, and little enough in the wider field of British cinema.

Nevertheless, *Nowhere to Go* can only be a footnote to the Ealing story. It was a one-off, leading nowhere for Ealing or for Tynan, though it did in time provide a useful 'show-reel' for Holt; it cannot ultimately be claimed to be more than an impressive minor genre film which gave a debut role to Maggie Smith. According to Holt, he basically wrote the action while Tynan wrote the dialogue, and the dialogue, though admirably spare and functional, is not the film's main distinction. Still, it meant that Tynan's time at Ealing was not entirely a story of personal frustration.

Conclusion: Ealing and MGM

It would be easy to see this 'least Ealing film ever made' simply as a last-minute act of defiance of Michael Balcon and his values, but Balcon himself, as producer, deserves some credit for it alongside Holt and Tynan. He had promoted Holt in line with his established Ealing system, he had expanded Tynan's terms of reference by giving him a contract to script it, and he had held back from imposing Clarke as a collaborator. And he had managed to get MGM's backing for it at a time when they were turning down most of Ealing's projects, even though he couldn't in the end stop them from cutting it down to fit more neatly into a double bill. By the time of its release, this MGM collaboration was over, which in effect meant the end of Ealing production, despite the brief hope that an association with ABPC might somehow enable them to carry on. In *Michael Balcon Presents ... A Lifetime of Films*, Balcon succinctly and without bitterness indicates how the optimism attached to the deal with MGM had quickly evaporated: as a result of boardroom upheavals, his friends within the company departed and 'we had little or no personal contact with the new management', men who had no particular interest in Ealing, nor an understanding of the reasons for which the deal had been made by their predecessors.[18]

The two remaining Ealing films of the Tynan period that did make it into production, *Barnacle Bill* and *Davy*, illustrate the resulting problems. The former especially must originally have seemed a safe bet for both partners: a whimsical comedy written by T. E. B. Clarke and starring Alec Guinness, who was an established draw in niche American markets and was now, after *Bridge on the River Kwai* (1957), more widely known. Balcon was especially hurt by the way MGM handled the two films, demanding cuts and revisions to each at the last minute and opting to give little or no US distribution to *Davy* after at first

having seemed enthusiastic. He was moved to write this (11 November 1957) to the man who had become his main MGM contact in the USA, Eliot ('Red') Silverstein:

> I should perhaps not go on to other matters in this formal letter, but I must say that your letter ... has thoroughly unnerved me. Our experience to date in regard to the release of our films in your domestic territory has been quite shattering and you have almost, but not quite, convinced me that after about 40 years I know very little about the production of films. I would not have mentioned this matter at this stage if we had not received from you a categorical statement as to the merits of this particular film and I was absolutely certain, as a result of our correspondence, that *Davy* would be released in the United States.
>
> I would be completely dishonest if I failed to advise you how we feel about this matter and the concern that we have in regard to the substantial investment we have in the films made under our contractual arrangements.

Of course, these two films are weak, and can be taken – as in *Ealing Studios* – to represent in a definitive way the company's decline. But throughout most of its two decades, Ealing had been making weak films alongside more vigorous ones; now, MGM had blocked a range of their bolder propositions, while encouraging these two more conventional ones and only picking up on their lack of popular appeal at the last minute. The sparse production records provide no evidence as to whether Tynan was closely involved with either, though a list survives of his ideas for possible alternative titles;[19] but there is no reason to assume he was hostile to them – his *Harper's* article is indulgent towards Clarke's line of Ealing comedies as well as to Mackendrick's, while *Davy* has striking similarities to the play with which John Osborne followed *Look Back in Anger*, *The Entertainer*.[20] And, as we have seen, and as Tynan could not know when he poured out his frustrations in the letter of late 1958, it was Balcon at Bryanston who would, not long afterwards, give support to the filming of *The Entertainer* as well as to the other early Woodfall films – with, incidentally, a further continuity from Ealing, in that Seth Holt returned temporarily to the job of editor both on *The Entertainer* and, before that, *Saturday Night and Sunday Morning*.

To sum up, then, it is altogether too facile to construct a narrative of Kenneth Tynan's two years with Ealing that positions him as a dynamic incomer who challenges, exposes and is ultimately blocked by the dogged conservatism of Michael Balcon. The reality is indeed more complex and more interesting.

20 THE LEGACY OF EALING

Dylan Cave

Across the top of Ealing Studios' current website, nestled next to the familiar but slightly revamped laurel logo, sits the proud strapline, 'From 1902 to the present day'.[1] It suggests a continuity of film-making practice that is slightly romanticised. Film-making and Ealing have had a long relationship, but the physical studio grounds have passed through many hands since 1902, when pioneering film producer Will Barker moved his Autoscope Company from Stamford Hill to the West London borough. Barker acquired the grounds' mansion and built three glass stages in 1907, but the studios in which some of the greatest and most cherished films of the 1940s and 50s were made did not get built until a decade after Barker retired. Former theatre impresario Basil Dean constructed the famous white building and studios in 1931 as a home for his new venture, Associated Talking Pictures. When Michael Balcon took over from Dean in 1938 he would inherit the studios and stamp their name on his productions. This would last for seventeen years, until 1955 when the studios were sold to the BBC. Ealing Studios didn't operate as a production entity again until the current owners, Uri Fruchtman and Barnaby Thompson, took over in 2001. In September 2002 they released an adaptation of Oscar Wilde's *The Importance of Being Earnest* (Oliver Parker), the first film under an 'Ealing' banner since *The Siege of Pinchgut* (Harry Watt, 1959) almost exactly forty-three years earlier.

In suggesting a continuity from 1902 to the present day, Fruchtman and Thompson's company connects itself to a long history of British film-making practice and, in particular, to the celebrated Balcon era. It's clear that they are proud of this association, but also that it was a business decision: 'the idea of rebuilding a famous brand seemed a smart thing to do', Barnaby Thompson has said.[2] The ambition in that statement is borne out elsewhere on Ealing's website, which details the company's diverse interests as a production company, studio facility and international sales agency. Fragile Films, Fruchtman and Thompson's pre-Ealing company, now operates as Ealing Studios' production arm. Its own dedicated webpage explains that 'Fragile Films formed part of a consortium that bought Ealing Studios intending to revive "the heart of the British film industry".' It adds, with appropriate understatement, 'Ealing was making movies once more.'[3]

This resurrection of a familiar but age-old brand reveals an acute awareness of the enduring respect and affection for Ealing's older films that is shared elsewhere. Rights

holders Studiocanal, for example, keep the most popular of the classic Ealing titles in circulation through DVD and even theatrical rereleases; distributors evidently see ongoing commercial potential in titles from the back catalogue, and television schedulers have been periodically dipping into the same catalogue over the past half-century. Academics, critics and journalists have kept the idea of 'Ealing' alive through research, celebration and, occasionally, disparaging references. The Ealing comedies in particular provide an apparently recognisable and understood body of work against which to compare other British films. The term 'Ealing-esque' is part of the critical language, a shorthand to describe films that seem to celebrate British eccentricity, or small communities that rally against big government or corporations.[4]

However, this conflation of Ealing into general British film culture is loose and the extent to which it holds any firm meaning is open to challenge. Geoffrey Macnab, writing in the *Independent* on the occasion of Ealing Studio's eightieth anniversary, points out the carelessness with which the 'spirit' or 'tradition of Ealing' has been invoked in reference to films that exhibit or discuss any form of collectivism over the past thirty years: from *Local Hero* (Bill Forsyth, 1983), through *Brassed Off* (Mark Herman, 1996) and *The Full Monty* (Peter Catteano, 1997) to Nigel Cole's *Calendar Girls* (2006) and *Made in Dagenham* (2010).[5] Even Joe Cornish's *Attack the Block* (2011) – about an extra-terrestrial invasion on a south London tower block estate – has attracted the same comparison.[6] For Macnab, the Ealing films 'have come to act as a huge millstone around the necks of future generations of British film-makers'[7] precisely because of their untouchable status: 'very infrequently', he adds, 'do film-makers come anywhere close to emulating the greatest Ealing comedies – often they're chastised for having even tried'.[8]

Macnab argues that these kinds of Ealing invocations are lazy, vague and, in some cases, actually damaging. But they can also be incomplete and inaccurate. Historians and academics grappling with the notion of national cinemas often search for patterns linking British films past and present. Brian McFarlane, discussing British cinema of the 1990s, suggests that 'the more things change, the more some things at least stay the same'.[9] He attempts to trace a range of aesthetic and thematic tropes that have emerged through British film history – the documentary tradition, for example, or notions of literary bias – as they permeate into films of the 1990s. Ealing films, and the Ealing comedies in particular, are a significant part of that history, but McFarlane strikes a cautionary note. In relation to *Brassed Off*, for example, he argues that 'critical invocations of Ealing comedy are both understandable and wide of the mark'.[10]

If it is 'understandable' to compare recent and contemporary film-making with a body of work that is now over fifty years old, we need an idea of how 'wide of the mark' these comparisons can afford to be if they are to still carry any critical relevance. What follows is an attempt to address some of the misleading inaccuracies to which Macnab and MacFarlane allude. Without being too prescriptive or exhaustive, it is possible to sketch out the pragmatic and thematic influences of the Balcon heyday of Ealing production and explore the ways in which this filtered into the industry after its passing. It seems to me that there are two main ways of considering this and another, less direct, third. The first is to trace the aftermath of the Ealing break-up, especially through the careers of the people who had been key participants, and to investigate the way they spread out into other parts of the industry. The second way is to evaluate some of the major British films that have been, fairly or not, described as 'Ealing-esque', to ascertain the extent to which they share the 'spirit' of Ealing.

Alongside these two I'd suggest a third, more speculative, way of thinking about legacy, namely the influence that Ealing as a working film company had on those that followed. The 'studio with the team spirit', reflecting and projecting Britain during a period of economic and social austerity, is a romantic image that is, to some extent, reflected in the way some post-Ealing companies have presented themselves. The significance here is not that Ealing's structure and working method influenced the people who worked there at the time, but that Ealing, as a company, came to represent a mode of working to be emulated – in Charles Barr's image, the idealised small business set against a soulless wider industry; small but exportable and stable for over twenty years.[11]

The People

As Barr argues in *Ealing Studios*, many of the creative team at Ealing came to artistic maturity there and were shaped by the experience of working at the studio.[12] It seems reasonable to expect that they would have carried some Ealing baggage into their subsequent work, despite the compromise and flexibility that a new working environment might have forced them to accept. A detailed biographical study of each of the main contributors to Balcon's Ealing would inevitably reveal thematic and stylistic traits that link some of their post-Ealing work to the studio. But it is the patterns and trends in the different career paths that merit the most attention: the connections made between departing personnel or the coincidences and continuations of working relationships that illustrate the ways in which an Ealing ethos may have carried on out of the studio.

Perhaps the best place to start is with two of the 1950s films often mistakenly attributed to Ealing. *The Smallest Show on Earth* (Basil Dearden, 1957) was written by William Rose and John Eldridge for Hallmark Productions, the shortlived company formed by two other major Ealing figures, Basil Dearden and Michael Relph, with Frank Launder and Sidney Gilliat. The film shares many Ealing traits – from the quirky characters to the central premise of a small cinema taking on a powerful rival and briefly outperforming it – but it was another 1950s film, *Genevieve* (1953), that Balcon himself regretted not making at Ealing.[13] *Genevieve* was directed by Henry Cornelius, who had left Ealing after directing *Passport to Pimlico* (1949), and also boasted a script by William Rose. Balcon was full of praise for the writer; in his autobiography, *Michael Balcon Presents ... A Lifetime of Films*,[14] he acknowledges Rose's Hollywood success with the Cinerama extravaganza *It's a Mad Mad Mad Mad World* (Stanley Kramer, 1963) and, later, an Academy Award for best original screenplay with *Guess Who's Coming to Dinner* (Stanley Kramer, 1967). But Rose's achievements were not the only examples of Hollywood interest in former Ealing staff.

From the mid-1950s the production outfit formed by Harold Hecht, James Hill and Burt Lancaster attempted to lure some of the Ealing team to the USA. T. E. B. Clarke worked for Hecht–Hill–Lancaster, although it was his scripts for Columbia and 20th Century-Fox – John Ford's *Gideon's Day* (1957) and *Sons and Lovers* (Jack Cardiff, 1960) – that were eventually made. John Dighton wrote two films for the partnership in the late 1950s: *The Devil's Disciple* (Guy Hamilton, 1958) and *Summer of the Seventeenth Doll* (Leslie Norman, 1960). Charles Crichton was apparently attached to their *The Birdman of Alcatraz* in 1962, before he was replaced by John Frankenheimer.[15] In the event, this relationship between some of the Ealing alumni and Hecht–Hill–Lancaster seems to have been a largely

disappointing affair, with the striking exception of Alexander Mackenderick's *Sweet Smell of Success* (1957). Yet here too the connection ran dry and Mackenderick didn't complete another feature until 1963's *Sammy Going South*, which he made with Balcon.

Charles Barr has suggested that *Sammy*, like Robert Hamer's Daphne du Maurier adaptation *The Scapegoat* (1958), can be described as quasi-Ealing. (*The Scapegoat* was actually started at Ealing but completed by MGM.)[16] But the connection goes only so far. *Sammy Going South*, in particular, is much more progressive in its depiction of the British Empire (then undergoing rapid decolonisation) than Ealing ever managed. The tale of a young boy, orphaned during the Suez crisis, who determines to travel south across the African continent to his aunt in Durban, it follows Sammy's path along Cecil Rhodes' 'Cape to Cairo red line' – the never-quite-achieved continuum of British control – down the eastern spine of the African continent. Unlike Harry Watt's Ealing/African films *Where No Vultures Fly* (1951) and *West of Zanzibar* (1954), *Sammy Going South* is cautiously aware of the changes happening on the continent, and the film links the boy's hopes of establishing independence to that of the continent he travels. Although Sammy shares something of the adventurous scamp Joe in *Hue and Cry* (Charles Crichton, 1947), he has more in common with the line of charming-but-tough (and even amoral) children that are a feature of Mackenderick's films, especially his later *A High Wind in Jamaica* (1965).

Basil Dearden and Michael Relph had perhaps the most consistent film careers outside Ealing. Moving into independent productions, including some with direct Ealing connections – *The Smallest Show on Earth* and the loose *Whisky Galore!* (Mackenderick, 1949) sequel, *Rockets Galore!* (Relph, 1958) – they joined with Richard Attenborough, Bryan Forbes, Guy Green and perhaps the pre-eminent actor of the later Ealing films, Jack Hawkins, to form the production consortium Allied Film Makers (backed, as Ealing was for much of its lifetime, by Rank). Allied scored a box-office hit with *The League of Gentlemen* (1960), a semi-comic crime caper that recalls the amiable amateur criminality of *The Lavender Hill Mob* (Crichton, 1951). But the Dearden–Relph partnership is best remembered for the social realist style that the pair developed at Ealing in films like *The Blue Lamp* (1950) and *Pool of London* (1951), and which they refashioned, post-Ealing, into a mini-genre of 'social problem films', including *Violent Playground* (1957), *Sapphire* (1959) and *Victim* (1961). Initially lauded for their tackling of pertinent social-political issues (in 1959 *Sapphire* won the best British Film Award, the precursor of today's Best Film BAFTA), they later fell foul of a critical consensus, led by the auteurist journal *Movie*, which rejected their aesthetic in favour of the emerging social realism found in the 'new wave' dramas of the early 1960s. Like Ealing, Dearden and Relph's style was judged out of step with the swiftly changing mores of the late 1950s, pre-'swinging 60s' era. But unlike their former studio they were able to adapt, moving on to bigger international productions with the likes of *Khartoum* (1966), for United Artists, and *The Assassination Bureau* (1969), for Paramount.

Dearden and Relph are untypical in maintaining such prolific cinema careers; cinema generally offered fewer opportunities to their former Ealing colleagues. After directing the last Ealing film, *The Siege of Pinchgut*, Harry Watt moved into television; several others from Ealing followed. As Barr notes, Ealing lost its physical home to the BBC but it 'infiltrated its conqueror'.[17] John Ellis has pointed to evidence that many of the Ealing technicians remained at the studios after the BBC bought them and continued to work there for many years.[18] But a significant number of the Ealing creative team went to ITV. Born in the same year as the Ealing studios passed to its rival, ITV was in the market for the skills and

experience that old Ealing hands had to offer. Producer and former editor Sidney Cole joined the independent television producer Sapphire Films in 1955 and served as associate producer, under Hannah Weinstein, for the entire run of *The Adventures of Robin Hood* (ITV, 1955–59). Whereas most television drama in the 1950s was performed live, *Robin Hood* and subsequent series in the same 'swashbuckling' genre were shot on film, allowing them to be sold internationally. Cole would be a significant figure in the ITV filmed dramas of the 1950s, producing episodes of *The Adventures of Sir Lancelot* (1956–57), *The Buccaneers* (1956–57) and *Sword of Freedom* (ITV 1958–60). Ralph Smart was another, directing and producing numerous episodes of *Robin Hood*, *The Buccaneers* and *William Tell* (1958–59). Cinematographer Ernest Palmer was a regular on *Robin Hood*.

It might be possible to identify a residue of Ealing values in these programmes' narrative stress on collective endeavour and on communities fending off powerful and oppressive forces, but Cole and the others probably influenced content less than form. The ITV films had a sheen and zest that few BBC productions of the time could match, and for this they could surely thank the influx of skilled craftsmen from Ealing and elsewhere in the film industry. ITV embraced film in the 1950s and early 60s in a way that the BBC couldn't or wouldn't, and as the vogue for men in tights gave way to detective and spy dramas, the Ealing diaspora, now swelled by Charles Crichton, Charles Frend, Michael Truman, Leslie Norman and even Basil Dearden, would help to shape such series as *Danger Man* (1960–67), *The Avengers* (1961–69), *The Saint* (1962–69), *Man in a Suitcase* (1967–68), *Department S* (ITV, 1969–70), *Randall and Hopkirk (Deceased)* (1969–70) and *The Persuaders* (1971–2), all of them filmed and sold abroad and projecting an idea of Britishness – exciting, intrepid, stylish, jetsetting – very different from that disseminated by Ealing's films just a few years earlier.

A more readily identifiable measure of the Ealing influence on television, however, is the sole television production that is directly linked to an Ealing film. First transmitted in the year that the BBC bought Ealing Studios, *Dixon of Dock Green* (1955–76) resurrected Jack Warner's murdered PC George Dixon from *The Blue Lamp* (Basil Dearden), and centred on the same operations of a local constabulary (Paddington Green). *Dixon* told stories of petty criminality – burglary, small-scale fraud, minor delinquency – of the kind that could be investigated, solved and tidied away with a neat moral lesson before the credits rolled.

We could view *Dixon of Dock Green* as a continuation of representations of community and family sanctity that come straight from *The Blue Lamp*, but what darkness there was in Dearden, Relph and Clarke's original is largely missing from the television series. However, it wasn't always quite as cosy as popular memory. Probably the most famous early episode, 'The Rotten Apple' (11 August 1956), took the daring step for the time of introducing a 'bent copper', even if it made clear that he was a very rare breed (the 'only bad copper I ever met', insists Dixon). But there was no place for the likes of Dirk Bogarde's Tom Riley, all swagger, snarl and sexual menace, in a Saturday evening slot on the 1950s BBC. Though the series was initially subtitled 'Some Stories of a London Policeman' and drew on co-creator and regular writer Ted Willis's close observation of everyday police work, the documentary elements that had been a feature of *The Blue Lamp*, showcasing the public service machinery (police and NHS) in efficient operation, would soon wear away. In their place was a still greater focus on the role of family, in line with TV's natural privileging of the domestic. This Dixon was a widower, but he had gained an adult daughter, Mary, and later a son-in-law, his young colleague Andy Crawford (Peter Byrne) – essentially the Andy Mitchell played by Jimmy Hanley in the film but promoted to CID for television.

A reminder of gentler times: Jack Warner as PC George Dixon in the BBC's *Dixon of Dock Green* (1955–76)

The most obvious difference between film and series is one of scale. The early *Dixon of Dock Green* isn't just *The Blue Lamp* shrunk for the small screen; it jettisons the richness of the film's topography, its sense of parallel Londons occupied by the police, the criminals and ordinary civilians, for a handful of modest sets and brief linking exteriors – the scenic currency of live television drama. In production terms, the series moved a little with its times – eventually embracing video recording and colour (while PC Dixon ultimately made it to sergeant) – but *Dixon of Dock Green*'s mammoth twenty-one-year run wasn't due to innovation, but to its dogged refusal to acknowledge the pace of a changing Britain, as depicted in the far tougher police series *Z Cars* (BBC, 1962–78) and *The Sweeney* (ITV, 1975–78). It was cherished as a reassuring reminder of apparently simpler, gentler times – and it preserved, consciously or not, a version of Ealing's world in its most modest and comforting form.

Jack Warner's embodiment of Dixon is the clearest example of an actor carrying a persona built at Ealing into post-Ealing work. It's a coincidence, but an interesting one, that William Simons, the young actor who plays Anthony Steele's son in Ealing's *Where No Vultures Fly* and *West of Zanzibar* (both Harry Watt) found most recognition much later as Alf Ventress, a grumpy desk sergeant in ITV's spiritual successor to *Dixon of Dock Green*, the nostalgic police drama *Heartbeat* (1992–2010). Elsewhere, Googie Withers retained her image as a tough, resourceful and self-possessed independent woman throughout her career, including in her biggest television role as prison governor Faye Boswell in LWT's *Within These Walls* (ITV, 1974–78). Gordon Jackson became a household name through popular television series *Upstairs Downstairs* (ITV, 1971–75) and *The Professionals* (ITV, 1977–83),

but television presented him as an austere authoritarian, a complete contrast to the sweet, naive lads that he played at Ealing. Sometime Ealing actor Bill Owen also found later fame on television in that virtual retirement home for many British actors, *The Last of the Summer Wine* (BBC, 1973–2010). Although Owen's Compo bore little relation to his Ealing charaters, the programme as a whole shared something of the rural eccentricity found in *The Titfield Thunderbolt* (Charles Crichton, 1953). Certain stars – Bogarde, Diana Dors, Sidney James, Joan Collins – passed through Ealing but developed screen personas that eclipsed those developed at the studio. Others – Jack Hawkins, Stanley Holloway or Tommy Trinder, say – found that their work at the studio marked the beginning of the end of their careers as major film stars and, as such, they probably brought more to the studio than they took out from it. Only Alec Guinness could be said to take a significant Ealing legacy – as a character actor of international repute – into the wider world, but it's one that was equally established by his work with Lean and others.

These examples serve to outline the ways in which the Ealing alumni infiltrated and spread into later film and television, taking with them some baggage from the studio which established them. As an extra consideration, it's worth noting the few examples of Ealing's entry into pedagogy. Ealing affiliate Thorold Dickinson established a film studies department at London's Slade School of Fine Art in 1960, while Charles Crichton was a visiting lecture at the London Film School during the same era. Mackenderick later took the Deanship of the Film School at California Institute for the Arts, moving to the National Film Schools (later the NFTS) in the late 1970s. Michael Relph became chair of the BFI Production Board in 1972 – a role he inherited from Michael Balcon. Without wanting to imply a strong link between Ealing staff and the students or young film-makers they encountered, it's not implausible that an element of the working influences acquired at Ealing may have been passed on to those they taught and sponsored.

Preserving Ealing

As Ealing receded further into the past, its more direct influences – the work of its former employees – became more dispersed and remote. Yet 'Ealing-esque' elements have been identified, to one degree or another, in much later films, usually without any direct input from former Ealing personnel. As Geoffrey Macnab observes, 'for any Brit making a low-ish budget, character-driven, ensemble comedy, Ealing is still the immediate and only point of reference'.[19] In discussing an Ealing influence, however, we need to be clear about what we are describing. Despite the range of films that were made at at Balcon's Ealing – ninety-five feature films – the element that is preserved through popular film culture is much smaller. The points of reference don't extend far beyond the famous postwar comedies.

Furthermore, as a body of work, the Ealing comedies themselves exhibit significant changes in tone and outlook as they go on. Writing about the classic Ealing output, Charles Barr asserts that the studio exhibits an 'allegiance to the ideal community ... stable, gentle, innocent',[20] but makes it clear that this community 'recedes inexorably into the past'[21] in the studio's later years. He argues that the studio's lack of dynamism – its failure to project and reflect a changing British society coming out of postwar austerity in the mid- to late 1950s – resulted in Ealing being outmoded and left behind. It's an analysis that raises interesting questions when considering the precise influence of Ealing on the British cinema

of a much later period. What, in the Ealing comedies, is being preserved? Is it the 'increasingly unreal and reactionary' tone that Barr suggests came to dominate later Ealing representations of community – less *Passport to Pimlico*, more *The Titfield Thunderbolt* or *Barnacle Bill* (Charles Frend, 1957) – or the narrative string of 'subversive daydreams' – fantasies of community rebellion – that invite the spectator to entertain ideas of gentle social upheaval?[22] The extent to which the traits that are summarised by Barr inform later 'Ealing-esque' films is crucial to understanding the validity of critical comparison.

When *Local Hero* was released in the UK in March 1983, Channel 4's *Visions* ran a review piece by critic Colin MacArthur, which took the form of a comparison with Alexander Mackendrick's *The Maggie* (1954).[23] MacArthur summarises the narrative of *The Maggie* like this: 'the hard nosed capitalist, symbol of all the Anglo-Saxon virtues, is brought into contact with the Celtic dream world of Scotland and emerges a changed man'. Arguing that *Local Hero* adopts a similar narrative strategy, MacArthur points out that, in both films, Scotland remains the preserve of the natural, whether manifested as the decrepit puffer ship that defeats *The Maggie*'s pompous businessman or as *Local Hero*'s oil refinery, which is overthrown for a marine study centre and observatory. For MacArthur,

> both *Local Hero* and *The 'Maggie'* lock into the historically dominant way of representing Scotland. This has become so natural over the last two centuries that it unconsciously guides the hand of anyone setting out to tell a story about Scotland. In a sense it shapes *Local Hero*.[24]

Alexander Mackendrick's *The Maggie* (1954) places businessman Calvin B. Marshall (Paul Douglas) in a Celtic dreamworld

Bill Forsyth's Local Hero (1983) shares Ealing's traditional depictions of Scotland

His point is to draw attention to and challenge this dominant image of Scotland as it is manifested in film: not just in *The Maggie* or Mackendrick's other Scottish film for Ealing, *Whisky Galore!*, but also the likes of *Brigadoon* (Vincente Minnelli, 1954) and *Laxdale Hall* (John Eldridge, 1953). Even so, his detailed comparison casts an interesting light on the way we might understand how Ealing may influence later films. His piece suggests that a film like *Local Hero* is fixed, like *Whisky Galore!* or *The Maggie*, in a certain narrative functionality that it cannot escape because of enveloping ideologies about Scotland that 'the Celts themselves begin to live within and accept as natural'.[25] *Local Hero* might be comparable to Mackendrick's Scottish comedies, but there is a wider ideology shaping all of them.

Elsewhere, John Ellis has argued that Ealing developed 'film as the language of the real',[26] through a combination of its particular working methods and its shared liberal social attitudes. Adapting MacArthur's argument, it is possible to make the case that Ealing, working within this specific climate, developed a cinematic model for tackling a range of sometimes challenging social subjects that could be reapplied by later film-makers. For example, *A Fish Called Wanda* (1988) – directed by Charles Crichton, then in his late seventies – borrows the underlying joke that forms the basis of *The Ladykillers* for its main subplot. Michael Palin's stuttering animal lover Ken is assigned the task of killing the little old lady who is the only witness to his gangster boss's diamond heist, but succeeds only in dispatching each of her three pet dogs, causing him great anguish. *Wanda* is more crude than Balcon would allow at Ealing but, in this subplot, the film shares the provocative fun found in the studio's darker comedies.

THE LEGACY OF EALING 225

This case for the 'cinematic model' applies to films from the 1990s too. Andrew Higson has observed that Ealing tends be positioned at one end of a fifty-year cinematic path, noting:

> a fairly well established line of argument that there has been a shift in representation in the last half century of British cinema, from images of homogeneity to images of heterogeneity. This can be exemplified in the journey from the Ealing films of the 1940s and early 1950s to the new British cinema of the 1980s and 1990s.[27]

Higson's purpose in identifying this trend is essentially to counter it, suggesting that consensus films of the 1940s, such as *Millions Like Us* (Launder and Gilliat, 1943) or Ealing's *San Demetrio, London* (Charles Frend, 1943), are comparable to later British films like *My Beautiful Laundrette* (Stephen Frears, 1985) or *Bhaji on the Beach* (Gurinder Chadha, 1993) in the way that they offer 'a vision of a plural, complex, heterogeneous and hybrid nation, and a sense of multiple "British" identities'.[28] Julia Hallam continues this line, discussing two successful 1990s comedies credited with (or dogged by) Ealing comparisons: *Brassed Off* and *The Full Monty*. Both use comedy to address contemporary issues in British society, specifically industrially declining Northern communities in the post-Thatcher 1990s. Hallam observes in both a 'hankering for the spirit of Ealing [in] that brief postwar period when a focus on whimsical characters in small communities pulling together for the common good projected an idealised image of a nation united by adversity'.[29] *Brassed Off* may have some mildly eccentric characters and an element of whimsy about its premise – the struggle of a colliery brass band to keep faith and carry on in the face of the closure of the local pit – but it also has a poignancy and melancholy reflecting the very real tragedies visited on communities recognisably like the one it depicts. The struggle between father and son Danny and Phil (Pete Postlethwaite and Stephen Tompkinson) at the centre of the film, along with the breakdown of Phil's marriage and the fractured relationships of the secondary characters, eventually lead to a restorative climax. But the denouement restores family, not community, and it is here that it parts company with Ealing. It may share the late Ealing's lament for times past, but it isn't reactionary.

In reference to *The Full Monty*, Hallam asserts that both it and *Brassed Off* have 'up-beat "feel-good" endings based on the abilities of the group to perform collectively' but, significantly, 'not as workers but as entertainers'.[30] This type of narrative closure is not reflective of the kinds of images of community that Ealing provides. The superficially triumphant ending of *The Full Monty*, with the six unlikely strippers performing before a wildly appreciative female audience, leaves very little actually changed. The community is still shattered by worklessness, and most of the protagonists are still unemployed: we aren't seriously asked to believe that they will become professionals. Ealing's comedies, and the performances in them, were never so direct in their evocation of real-life dilemmas. Characters in *The Ladykillers* or *Kind Hearts and Coronets* (Robert Hamer, 1949) operate on a level of reticence and subterfuge, not acting out one's heart on one's sleeve as the characters do in *Brassed Off* and *The Full Monty*, or in their spiritual successor *Billy Elliot* (Stephen Daldry, 2000).

Community and a lament for the past: *Brassed Off* (1996)

By contrast, another comedy noted for an Ealing influence – *Calendar Girls* – has a central premise that seems self-consciously to tear down the kind of cosy rural world that it borrows from Ealing. A story about members of the Women's Institute who pose nude for a charity-raising calendar, the film shares Ealing's fascination for the small amateur taking on the world. However, it deliberately refashions the 'Ealing-esque' milieu for the twenty-first century, reflecting contemporary social mores (a relaxed attitude to sexuality, nudity and swearing) and inserting, in it's second half, an exaggeration of the film's central dilemma, so that the conflict between social conservatism (represented by the WI) and liberal bravura (shedding all for charity) are projected onto an international scale as the calendar sales vastly exceed modest expectations and media interest takes them to Hollywood.

Grow Your Own (Richard Laxton, 2007), written by Frank Cottrel Boyce and Carl Hunter, seems comparable to Ealing for similar reasons. Reviewed as 'a likeable movie in the Ealing Films style, full of eccentric English types on an allotment coming face to face with asylum seekers',[31] *Grow Your Own* is, in fact, a fictionalised account of the Family Refugee Support Project, an initiative in which migrant families, traumatised by war and torture, were given allotments in the north of England. The project was previously the subject of three short documentaries directed by Hunter in 2005 for Channel 4's *Three Minute Wonder* slot.[32] *Grow Your Own* seems quite conscious of its debt to Ealing: its small, self-contained community of eccentrics unites to defeat an external threat in the form of a greedy telecommunications giant. It shares with *Brassed Off* and *The Full Monty* a yearning for lost community in the face of a visibly brutal modern capitalism. But *Grow Your Own* is willing to enter darker territory. The refugees whose ultimate acceptance into the community is the film's project are initially resented by their hosts, and as part of their adjustment they – and we – must learn something of the real horror of their experiences.

The journey of the film from documentary to feature film reinforces something quite interesting about the Ealing template: that it has come to be seen as the form appropriate to stories in which communities seek to fight against oppression. It isn't difficult to see the appeal of comedy to film-makers hoping to raise social and political issues before an audience that might steer clear of a more serious treatment. But it is open to question whether the Ealing-derived form, however much it is remodelled and updated for the purpose, is really sufficient to carry the political burden.

This is certainly an issue for Joel and Ethan Coen's largely unsuccessful remake of *The Ladykillers* (2004), which struggles because of the very elements that tempted the Coens to make the film in the first place. Joel Coen explained that he and his brother 'thought the bones of the story were really good',[33] and that from this they developed the basis for their changes:

> What was going to be the fundamental thing that would make it interesting to us? That was the idea of changing the character that Katie Johnson played in the original from an English tea-lady to a Southern black Baptist church lady. Once we had decided that, everything else flowed from that. The setting, the music, the other characters.[34]

As David L. G. Arnold notes, the Coens use their adaptation of *The Ladykillers* and the character of Marva Munson (Irma P. Hall) to explore race and gender structures in the USA.[35] Arnold makes a convincing defence of the numerous additions, digressions and inventions that seem to mar the Coens' adaptation: the long character introductions and

back stories, the newly added spiritual dimension (manifesting most absurdly in the image of Marva's late husband, whose portrait changes expression according to the action). And he is clear about the differences between Mackendrick's film and the Coens':

> Mrs Wilberforce prevails largely because her world is absurd. Marva, on the other hand, seems to draw upon deep reserves of personal and social strength to force the members of her society to see and do right, even if her conception of right sometimes leads her to startling conclusions.[36]

An early scene in the Coens' film shows Marva disciplining Gawain MacSam (the Coens' equivalent of Peter Sellers' Teddy boy Harry Robinson), who is played by Marlon Wayans as a foul-mouthed and brash hoodlum. Marva reprimands Gawain for swearing and slaps him unreservedly several times. According to Arnold, Marva 'assumes the position here of a veteran of the United States race wars and reminds us that her region is as much a scene of devastation, in its way, as Mackenderick's post-Blitz London'.[37] She may be as socially conservative as Mrs Wilberforce, but we are reminded that she is economically and socially at bottom rung. The mischievous impetus to kill her disappears and with it goes the heart of the film. But the well-argued case by Arnold again corroborates the view that Ealing provides a model, even if we agree that, ultimately, the Coens are unsuccessful in their employment of it.

Ethan Coen reportedly said that 'when people get all reverential about these wonderful old movies, we can't resist it'.[38] The implication of his comment is that certain Ealing films have become too precious to touch, a view perhaps supported by a more recent case. 2011 saw the opening of another adaptation of the same source, this time for the stage, by Graham Linehan, creator (with Arthur Mathews) of *Father Ted* (Channel 4, 1995–98) and of *The IT Crowd* (Channel 4, 2006–present). Linehan has made a career out of putting caricatured losers into impossible situations, and would seem a good prospect for a successful stage adaptation, but the writer found himself unwillingly called upon to defend his work against charges that West End theatres were too dominated by literary and cinema adaptations.[39] Nevertheless, Linehan's *The Ladykillers*, with Peter Capaldi in the Alec Guinness role, was greeted with universally warm reviews.

The Company and the Studio

In the long and often troubled history of the British cinema industry, Ealing makes an unusual case study as a studio that thrived, for a significant time, among much bigger rivals, both domestically and internationally. Michael Balcon was at least as much a businessman as he was a cultural figure, and the model he developed at Ealing – in its internal organisation and its external business relations – is one that we might expect later producers to have sought to emulate in the hunt for a successful business formula. Here we draw, again, on the structural areas outlined by Barr: the 'benevolent paternalism' of Balcon; the liberal-minded, 'round table' approach – a supposedly democratic engagement from a handful of key creative personnel: 'the studio with the team spirit'.[40]

Ealing's most obvious and immediate successor was Michael Balcon's own Bryanston Films, which financed or distributed a string of early 1960s British films, encompassing the Ealing-like (*The Battle of the Sexes* (Crichton, 1960)) and the Ealing-linked (Mackendrick's

Sammy Going South), but also films associated with another distinct phase of British cinema (*Saturday Night and Sunday Morning* (Karel Reisz, 1960) and *A Taste of Honey* (Tony Richardson, 1962)).[41] Bryanston's life as a production operation, however, lasted no more than half a decade.

So Ealing's success as a small and (mostly) stable set-up was successfully emulated by only a handful of British production companies. Of these, few could claim a comparable identity. One that made its mark was Handmade Films, co-created by ex-Beatle George Harrison to solve a funding problem for *Monty Python's Life of Brian* (Terry Jones, 1979), which produced a string of modest but critically and commercially well-received comedies – *The Missionary* (Richard Loncraine, 1981), *A Private Function* (Malcolm Mowbray, 1984), *Time Bandits* (Terry Gilliam, 1981), *Withnail & I* (Bruce Robinson, 1986) – alongside intelligent, distinctive thrillers – *The Long Good Friday* (John MacKenzie, 1979), *Mona Lisa* (Neil Jordan, 1986). Handmade can claim its own roster of British eccentrics, and its persistent examination of aspects of British character stands comparison with Balcon's Ealing. More or less contemporaneous with Handmade but with greater ambitions of scale, David Puttnam's Goldcrest produced a series of international hits that in their own way celebrate 'Britain and the British character', but of its films only *Local Hero* stands out as particularly Ealing-influenced. And there is Merchant Ivory, the production outfit that became its own genre, one synonymous with a backward-looking exploration of the disillusioned upper and middle classes. The company's views of Britishness are completely at odds with Ealing – one is internally wrecked but worldly, the other homogeneous but landlocked – but Merchant Ivory was perhaps the closest analogue to Ealing in its successful branding of both Britain and its own production company.

Merchant Ivory shares with another very successful British outfit, Working Title, the comparison to Ealing as a little company with a British identity on the international market with its own form of heritage cinema (though, clearly for Working Title, the model is of contemporary heritage cinema). Michael Balcon's 1944–56 deal with the Rank Organisation, which effectively gave Ealing the security to produce the films it wanted to make, has a modern parallel in the distribution deal struck between Working Title, the company established by Tim Bevan and Sarah Radclyffe in 1983 and subsequently run by Bevan and Eric Fellner, and the giant Universal Pictures. Working Title's string of international successful comedies – among them *Four Weddings and a Funeral* (Mike Newell, 1994) and *Notting Hill* (Roger Michell, 1999) – have their own line in underdogs and British character quirks, but their humour is both coarser and more romantic than Ealing's, while the communities they depict are more selective. Moreover, there is a difference between Rank's British money and Universal's American money in that Working Title's image of Britain seems packaged with overseas audiences as much as domestic audiences in mind. As such, it might more fruitfully be compared with Alexander Korda's London Films in the 1930s and 40s.

Animation studio Aardman, best known for its Wallace and Gromit films, is another contemporary operation that manages to compete internationally by packaging up a Britain – or more particularly, England – populated with eccentric characters embedded in small and cohesive communities. Aardman's world seems drawn from a self-conscious Englishness of the 1940s and 50s and there is a Tibby Clarke-style 'daydream' quality to its scenarios, as in the farmyard POW antics of *Chicken Run* (Peter Lord and Nick Park, 2000), while Wallace and Gromit's homespun inventions mirror those of, say, Sidney Stratton in *The Man in the*

White Suit (Mackenderick, 1951). But in content the studio is perhaps closer to the fantastical domestic adventures found in Roald Dahl's children's stories than to Ealing's more grounded imaginings.

Historically, only Hammer Films can compete with Ealing in sustaining a public profile from the mid-twentieth century to the present. Perhaps unsurprisingly, Hammer too has been resurrected as an active entity, co-producing *Let Me In* (Matt Reeves) in 2010 and *The Woman in Black* (James Watkins) in early 2012. Ealing and Hammer both exhibit the kind of signature attributed to the Hollywood majors of the 1930s and project an identifiable vision of Britain that has a consistency across a body of work.

The legacy of Ealing lies not just in the perceived influence of the company's methodology, positioning and outlook; it left behind more tangible assets too. Sue Harper and Vincent Porter note that in 1955 John Davis fought for and won the copyright of those Ealing films for which the Rank Organisation had paid.[42] Over time, the chain of rights moved through a variety of theatrical rights holders before being sold to Canal Plus Image UK, the British arm of French giant Studiocanal. In partnership with British distributor Optimum Releasing – the two have now merged – Studiocanal has ensured the continuing availability of the most famous Ealing titles on DVD and now Blu-Ray, gradually extending the number of titles available and, more recently, embarking on a programme of selective restorations and rereleases.

The other major Ealing asset – the studios themselves – remained in the BBC's hands until 1992, when they were bought by facilities group BBRK with the ambition to 'keep alive the Ealing tradition of very British Films'[43] by producing five features a year, around the same level of production Balcon was able to achieve. The BBC continued to use the studios as a facility – their celebrated adaptation of *Pride and Prejudice* (BBC, 1995) was partly filmed there – and BBRK attempted to move into production, launching Ealing Studios Productions (ESP) with a £500,000 development fund in September 1994.[44] However, within a month BBRK had collapsed. The studios went back to the BBC because BBRK had not yet paid the full original purchase price. They were sold again to the National Film and Television school in June 1995.[45] But the NFTS subsequently reviewed its expansion plans and ended up reselling in the late 1990s. They found a purchasing interest in a lobby group called 'Forever Ealing', which was set up after a number of mooted purchases had already fallen through, including a rumoured bid from building developers.[46]

Forever Ealing was led by Fragile Films, whose hit debut feature *Spice World* (Bob Spiers, 1997) had put the company in a position to buy the studios. Fragile soon became Ealing's production arm; its last feature film released before the purchase of Ealing Studios was an adaptation of Oscar Wilde's *An Ideal Husband* (Oliver Parker, 1999), and another Wilde title, *The Importance of Being Earnest*, would be the reincarnated Ealing's first project.

In an interview with *Screen International* following the April 2001 relaunch of Ealing Studios as a brand, Barnaby Thompson cited Balcon as a guiding influence in their plans for developing the site. His interviewer, Adam Minns, wrote that the company saw 'their vision of a media village as the 21st century version of Balcon's "community" of in-house craftsmen and internally-promoted executives'. Thompson was careful to limit expectations that the old Ealing was to be recreated in faithful detail, but he did stress a kinship with its ideals: 'No one is saying we are going to make films that are as good as *The Man in the White Suit* or *The Lavender Hill Mob*, but there are certain values. There was a certain kind of Britishness – a certain kind of comedy which is reflected in films that are culturally specific.'[47]

A scan through Ealing's productions since 2002 reveals a diverse range of influences from the history of British cinema, but also from Britain's literary and stage heritage. It can be seen in the predominance of Oscar Wilde productions – Ealing released a third, *Dorian Gray* (Oliver Parker) in 2009 – and in the adaptations of familiar British titles – Noel Coward's *Easy Virtue* (Stephan Elliott, 2008) – or stories – *Burke and Hare* (John Landis, 2010). Similarly, Ealing's resurrection of long-dormant film franchises, particularly its relaunch of *St Trinians* (Oliver Parker and Barnaby Thompson, 2007), demonstrates an interest in bygone British cinema as a source of viable film properties. Also, it's not without interest that Thompson, echoing Balcon's loyalty to key creative talent, has worked consistently with a single director, Oliver Parker.

But this is not Balcon's Ealing recreated for our times. Despite the intriguing coincidence that it, like its predecessor, is (now) operating in a climate of austerity, the conditions of the current film industry and the political climate in which it operates could not be more different. Geoffrey Macnab writes that 'Balcon's mild revolutionary fervour is something that the studios' successors and imitators can't hope to emulate, even if they try.'[48] The new Ealing isn't trying to emulate that 'mild revolutionary fervour', and it's questionable how far it would get if it did. All the same, its emergence has ensured there is life in the Ealing brand yet, and demonstrates an ambition to put Ealing back at 'the heart of the British film industry'[49] that would have brought a smile to Michael Balcon's face.

A certain kind of Britishness: *The Importance of Being Earnest* (2002)

NOTES

Introduction

1. Charles Barr, *Ealing Studios*, 3rd edition (London: Cameron and Hollis, 1999); George Perry, *Forever Ealing* (London: Pavilion, 1981); Michael Newton, *Kind Hearts and Coronets* (London: BFI, 2003); Penelope Houston, *Went the Day Well?* (London: BFI, 1992); Colin McArthur, *Whisky Galore! and the Maggie* (London: I.B.Tauris, 2003); Philip Kemp, *Lethal Innocence: The Cinema of Alexander Mackendrick* (London: Methuen, 1991), David Wilson, *Projecting Britain: Ealing Studios Film Posters* (London: BFI, 1982).
2. Yvonne Roberts, 'A little Bit of Ealing Around St Paul's', *Observer*, 23 October 2011.
3. Marina Hyde, *Guardian*, 28 October 2011
4. Jon Robins, *Observer*, 27 April 2008.
5. *South Wales Evening Post*, 27 May 2011.
6. Alastair Dalton, 'Security Galore Hits Island's Airport', *Scotland on Sunday*, 5 February 2012.
7. Graham Clarke, 'The Days Before ...', *Kinematograph Weekly* supplement, 4 October 1951, p. 13.
8. Ibid.
9. 'Architect's Eye View of Ealing', *Kinematograph Weekly* supplement, 4 October 1951, p. 25.
10. Arthur Knight, 'A Visit to Ealing', *Saturday Review*, 13 October 1951.
11. See Michael Balcon, *Michael Balcon Presents ... A Lifetime of Films* (London: Hutchinson, 1969), for more on Balcon's pre-Ealing career and his interaction with Mayer.
12. Ibid., p. 61.
13. Charles Drazin, *The Finest Years: British Cinema of the 1940s* (London: I.B.Tauris, 2007), p. 96.
14. Michael Balcon, 'A Style of Their Own', *Kinematograph Weekly* supplement, 4 October 1951, p. 25.
15. Ibid.
16. Francis Koval, 'Sir Michael Balcon and Ealing', *Sight & Sound*, Studio Supplement, Spring 1951, p. 9.
17. 'The Men of Yesterday Are Here Today', *Kinematograph Weekly* supplement, 4 October 1951, p. 23. Notably, there is one woman pictured among these 'men' of yesterday, but she is listed simply as 'M. Horridge, canteen'.
18. Raymond Durgnat, *A Mirror For England* (London: Faber & Faber, 1971), p. 120.
19. Balcon, *Michael Balcon Presents*, pp. 129–30.
20. Ibid., p. 131.
21. Ibid., p. 132.
22. Richard Farmer, '"Trinder's the Name": Tommy Trinder and the Art of Self-Promotion', *Journal of British Cinema and Television* vol. 8 no. 1 (2011), pp. 2–22.
23. Balcon, *Michael Balcon Presents*, p. 162.
24. Balcon, quoted in Drazin, *The Finest Years*, p. 105.
25. Knight, 'A Visit to Ealing'.

26. Michael Balcon, 'The Eye Behind the Camera', in Michael Balcon and Basil Dearden, *Saraband for Dead Lovers: The Film and its Production at Ealing Studios* (London: Convoy, 1948), p. 11.
27. K. Tynan, 'Ealing: The Studio in Suburbia', *Films and Filming*, November 1955, p. 4. They may even have been the last films ever to be screened on British television in the event of a nuclear attack, according to recently declassified government documents discussed by Matthew Sweet. See M. Sweet, *Shepperton Babylon: The Lost Worlds of British Cinema* (London: Faber, 2005), p. 153.
28. Balcon, *Michael Balcon Presents*, p. 159.
29. See S. Harper and V. Porter, *British Cinema of the 1950s: The Decline of Deference* (Oxford: Oxford University Press, 2003), p. 57.
30. D. Marlowe, 'Ealing in the Docks Again', *Picturegoer*, 17 March 1951, p. 11.
31. P. Kemp, *Lethal Innocence*, p. 15.
32. J. Clark, *Dream Repairman: Adventures in Film Editing* (Texas: LandMarc Press, 2011), p. 11. This view is supported by Erica Masters' BECTU interview (1995) in which she remembers the studio as 'wonderful' but 'very, very class conscious … there was a dining room for the directors and the producers and then there was a sort of middle management, you know, and then there were the sort of technicians … there was a very strong class structure. The directors bunched together and didn't want to know anybody else.'
33. G. Brown, 'A Knight and His Castle', in G. Brown and L. Kardish, *Michael Balcon: The Pursuit of British Cinema* (New York: Museum of Modern Art, 1984), p. 36.
34. Press book for *Dance Hall*, BFI Library. Alexander Mackendrick recounts a story of Dors' indignation on that film; when she was instructed to stuff her bra with cotton wool to prevent her nipples showing through her tight sweater, in the documentary *Typically British: A Personal History of British Cinema* (Stephen Frears, 1995).
35. Durgnat, *A Mirror for England*, p. 138.
36. Press book for *Cage of Gold*, BFI Library.
37. M. Balcon, 'Let British Films be Ambassadors to the World', *Kinematograph Weekly*, 11 January 1945, p. 31.
38. See Harper and Porter, *British Cinema of the 1950s*, pp. 57–73, for a detailed account of the changing economic and industrial fortunes of Ealing in the 1950s.
39. Ealing Films press release dated 11 June 1956, Ealing Studios cuttings file, BFI Library.
40. J. Craigie, 'Ealing is Ealing Still', *News Chronicle*, 11 June 1956.
41. Barr, *Ealing Studios*, p. 149.
42. Kemp, *Lethal Innocence*, p. 136.
43. A. Mackendrick (ed. Paul Cronin), *On Film-making* (London: Faber, 2004), pp. 104–5.
44. L. Anderson, *Making a Film: The Story of Secret People* (London: Allen and Unwin, 1952), p. 14.
45. Barr, *Ealing Studios*, p. 146. Revisionist scholarship of 1950s British cinema includes Harper and Porter, *British Cinema of the 1950s*, C. Geraghty, *British Cinema in the Fifties: Gender, Genre and the 'New Look'* (London and New York: Routledge, 2000) and I. MacKillop and N. Sinyard (eds), *British Cinema of the Fifties: A Celebration* (Manchester: Manchester University Press, 2003).
46. See Harper and Porter, *British Cinema of the 1950s*, p. 68.
47. Quoted in Anderson, *Making a Film*, p. 14.
48. M. Schulman, *Evening Standard*, 7 February 1952.
49. *Movie*, May 1962, p. 9.

1 A Lad, a Lass and the Loch Ness Monster

1. In fairness, Dean's six years as an actor manager in Manchester probably helped.
2. Basil Dean, *Mind's Eye: An Autobiography 1927–1972* (London: Hutchinson, 1973), p. 163. The name of the studios would be changed to ATP Studios in May 1933.
3. Although its hunting scene and exploitation of its Devonshire settings now compare favourably with most of its studio-bound contemporary competitors, *Escape* was voted into only nineteenth place in *Film Weekly*'s readers' choice of the best British films of 1931. *Film Weekly*, 29 April 1932, p. 12.
4. *Film Weekly*, 3 June 1932, p. 28.
5. *Kinematograph Weekly*, 8 October 1931, p. 48.
6. Dean, *Mind's Eye*, p. 168.
7. Ibid., p. 166.
8. *The Constant Nymph* (1934) was eventually directed by Dean for Michael Balcon at Gaumont-British

(the holders of the screen rights at the time), with interiors shot at Shepherd's Bush Studios rather than at Ealing.

9. Dean, *Mind's Eye*, p. 165.
10. Captain Auten, who had been awarded the Victoria Cross during World War I, became ATP's American representative in October 1932. In a letter dated 10 March 1931, Radio's Lee Marcus had admitted that the quota pictures that he encouraged Dean to produce were unlikely to receive distribution in the USA. Basil Dean Collection, BFI.
11. *Kinematograph Weekly*, 30 June 1932, p. 35.
12. 'More British Films – but Good Ones', *Kinematograph Weekly*, 30 March 1933, p. 4. Dean's solution was to call for a larger supply of quality British films, but this rather elided the crucial issue of the restrictive distribution practices of the major British producers with their own cinema chains. On ATP's ill-fated relationship with RKO, see Rachael Low, *Film-making in the 1930s* (Boston: Unwin Hyman, 1985), pp. 150–4.
13. For an account of the location filming on the Thames of *Three Men in a Boat*, see *Film Weekly*, 9 September 1932, p. 10. *Kinematograph Weekly* (1 June 1933) would eventually comment that, 'Within its limitations, the film makes pleasant, innocuous entertainment and can be safely exploited on the average two-feature programme.'
14. See Jeffrey Richards, *Thorold Dickinson: The Man and his Films* (London: Croom Helm, 1986), pp. 30–1.
15. *Film Dope* vol. 11, January 1977, p. 5. Thorold Dickinson later made his directorial debut at Ealing with the colonial murder mystery *The High Command* (1938).
16. *Film Weekly*, 16 February 1934, p. 3.
17. *Film Weekly*, 4 May 1934, p. 75.
18. Ibid., p. 64.
19. See the description of back projection use at Ealing in December 1933 in John Mitchell, *Flickering Shadows: A Lifetime in Film* (Malvern Wells: Harold Martin & Redman, 1997), pp. 18–20.
20. Quoted in Linda Wood, *British Films 1927–1939* (London: BFI, 1986), p. 30.
21. Ibid., p. 118.
22. 'ABFD Pictures of Quality with Box-office Appeal', *Kinematograph Weekly*, 9 January 1936, p. 51. The company also distributed American 'B' pictures via arrangements with Mascot and Grand National.
23. The expensive failure of *Whom the Gods Love* was disastrous in that Ealing's chief financial backer, Stephen Courtauld, lost confidence in Dean, but at least the film had given him the opportunity to do some more location work in Austria.
24. The height allowed the camera a sight line above the surrounding houses to create the illusion of a ship at sea. Mitchell, *Flickering Shadows*, p. 25.
25. *Film Weekly*, 20 April 1934, p. 37. Gracie Fields' Ealing films are discussed in David Sutton, *A Chorus of Raspberries: British Film Comedy 1929–1939* (Exeter: University of Exeter, 2000), pp. 185–95; and Jeffrey Richards, *The Age of the Dream Palace: Cinema and Society in Britain 1930–1939* (London: Routledge, 1984). Dean recalls them in *Mind's Eye*, pp. 203–11.
26. 'One would have expected a better plot from an author of Priestley's reputation than the tenuous and disjointed affair that serves (only just) to hold the picture together.' *Film Weekly*, 26 October 1934, p. 36.
27. Review of *Shipyard Sally*, *The Spectator*, 18 August 1939.
28. Dean, *Mind's Eye*, p. 211.
29. Ibid., pp. 212, 215. Formby's prowess as a genuine virtuoso of the ukulele has only recently been fully recognised.
30. Ibid., p. 213.
31. David Brett, *George Formby: A Troubled Genius* (London: Robson, 2001), pp. 41–51.
32. *The Spectator*, 3 January 1936. The other Ealing-made film that Greene singled out for praise was Edmund T. Greville's *Brief Ecstasy* (1937).
33. His last Ealing film was *Penny Paradise* (1938). Reed and Lockwood soon found themselves working together on Gainsborough's *Bank Holiday* (1938).
34. One of the best remembered is the motor-racing drama *Death Drives Through* (1935), a botched job by the American director Edward L. Cahn, but historically valuable for its incorporation of footage filmed on the Brooklands circuit.
35. Mitchell, *Flickering Shadows*, pp. 23–4.
36. *Picturegoer*, 21 April 1934, p. 19.
37. *Film Weekly*, 9 November 1934, p. 37.

38. Eliot Stannard's scenario from John Quinn's story was ready only a few weeks after an 'interview' with Oscar appeared in *Film Pictorial*, 3 December 1932, p. 27.
39. Scenario Report 107, 22 December 1932.
40. *Kinematograph Weekly*, 2 March 1933, p. 21.
41. The company was set up by theatrical agent and performer William Hinds (aka Hammer), and the company directors included the comedian George Mozart and the director James Elder Wills, who had just completed the Ealing-made *Tiger Bay* (1933). The story of the early Hammer productions is told in Wayne Kinsey, *Hammer Films: The Bray Studio Years* (Richmond: Reynolds & Hearn, 2002), and Marcus Hearn and Alan Barnes, *The Hammer Story* (London: Titan, 1997), pp. 8–9.
42. Mitchell, *Flickering Shadows*, p. 24.
43. *Kinematograph Weekly*, 7 February 1935.
44. Scenario 173, 14 June 1933.
45. Apparently the line that described modern literature as 'the product of effeminate Jews who have to dip their pens in disinfectant before writing', was considered acceptable. It was also clearly too late to change the trade announcements of the film, which described it as 'an original story of British dockland and the glamorous East'.
46. Annie Lai, Bob Little and Pippa Little, 'Chinatown Annie: The East End Opium Trade 1920-35: The Story of a Woman Opium Dealer', *Oral History Journal* vol.14 no.1, Spring 1986, pp. 18–30.
47. Stephen Bourne (*Brief Encounters* (London: Cassell, 1999), p. 22) does note the strong suggestion of lesbian desire. The larger posters to promote the film depicted the two women entwined in each other's arms.
48. *Picturegoer*, 7 April 1934, p. 30.
49. *Picturegoer*, 1 December 1934.
50. *Film Weekly*, 30 November 1934, p. 37.

2 Inside Ealing

All information and quotations used throughout this article are drawn from the Michael and Aileen Balcon Papers, held in BFI Special Collections, except where noted below.

1. Draft memorandum (1938), Michael and Aileen Balcon Papers, BFI Special Collections, E/2, p. 2.
2. Shooting schedule for 'Formby no. 10' and cast list for 'Formby no. 11', Balcon Papers, F/35.
3. Film programme and costs for 1939 and American-English Dictionary compiled by R. L. Corballis (1939) Balcon Papers, F/36.
4. Budget estimates (1938), Balcon Papers, F/32.
5. Michael Balcon to S. C. Balcon, 5 November 1942, Balcon Papers, F/37.
6. British Film Producers Association, 'Report to the cinematograph film council of the committee appointed to investigate tendencies to monopoly in the film industry' (3 July 1944), Balcon Papers, F/24, p. 2.
7. Ibid., p.14, and recited by Balcon in a note on 19 February 1945, Balcon Papers, 24/c.
8. Josef Somlo, Memorandum on British Commonwealth Film Corporation, 20 January 1940, Balcon Papers, F/26.
9. Michael Balcon, 'With Reference to the Unrest' (unpublished article), Balcon Papers, F/25.
10. S. Y. Gresham, 'Report and survey on the Motion Picture Industry in Australia and New Zealand, with especial regard to British Films' (1944), Balcon Papers, F/46.
11. Harry Watt to Michael Balcon, 5 August 1948, Balcon Papers, G/2.
12. Harry Watt to Michael Balcon, 9 January 1946, Balcon Papers, G/2a.
13. Michael Balcon to Hal Mason, 1947, Balcon Papers, G/17.
14. Michael Balcon to Alberto Cavalcanti, 13 February 1947, Balcon Papers, G/17.
15. Stephen Courtauld to Michael Balcon, 1 April 1947, Balcon Papers, G/79.
16. A. Forsyth Hardy to Alberto Cavalcanti, 11 March 1943, Balcon Papers, F/43.
17. Michael Truman, 'Report on American Reaction to Ealing Pictures', 3 October 1949, Balcon Papers, G/83; Truman's survey was mainly of filmgoers in New York rather than, say, the mid-West.
18. John Mills to Michael Balcon, undated (19 October 1947), Balcon Papers, G/79; emphasis in the original.
19. Michael Balcon to John Mills, 22 October 1947, Balcon Papers, G/79.
20. Leslie F. Baker to Robert Fenn, 21 October 1957, Balcon Papers, I/165.

21. Jacobson Ridley and Co. to Michael Balcon, 15 April 1957, Balcon Papers, I/204.
22. Lord Reith to Harold Wilson, 1 January 1951, Balcon Papers, G/105.
23. Hal Mason proposal to George Elvin, ACT, 5 November 1953, Balcon Papers, H/44.
24. Michael Balcon to John Davis, 4 November 1955, Balcon Papers, H/138.
25. John Davis to Michael Balcon, 9 May 1955, Balcon Papers, H/138.
26. John Davis to Michael Balcon, 14 June 1955, Balcon Papers, H/138.
27. Kenneth Tynan, 'Tight Little Studio: Home of the Good British Movies', *Harper's*, August 1955.
28. Michael Balcon to Kenneth Tynan, 28 August 1957, Balcon Papers, X/17.
29. Kenneth Russell to Michael Balcon, 28 August 1958, Balcon Papers, I/40.
30. Michael Balcon to Ealing staff, 30 December 1958, Balcon Papers, I/31.
31. Hal Mason to Ealing staff, December 1958, Balcon Papers, X/23.
32. Speech notes by Michael Balcon 'Survival of 25 years of production' (19 March 1947), Balcon Papers, G/15.
33. Michael Balcon article (7 November 1952), Balcon Papers, H/22.
34. *Speaking Personally*: Sir Michael Balcon (BBC, 27 October 1951) – transcription in Balcon Papers, H/25.

3 Pen Tennyson

1. Charles Barr, *Ealing Studios* (New York: Overlook Press, 1980), p. 18.
2. Hallam Tennyson, filmed interview in *The Dream That Kicks: Wales on Film* (HTV, 1986).
3. Charles Tennyson, *Penrose Tennyson* (London: A. S. Atkinson, 1943), p. 106.
4. Michael Balcon, *Michael Balcon Presents ... A Lifetime of Films* (London: Hutchinson, 1969), p. 161.
5. Tennyson, *Penrose Tennyson*, p. 120.
6. Review of *There Ain't No Justice*, *Monthly Film Bulletin*, July 1936, p. 136.
7. Graham Greene, *Mornings in the Dark: The Graham Greene Film Reader* (Manchester: Carcanet, 1993), p. 323.
8. Balcon, *Michael Balcon Presents*, p. 126.
9. Greene, *Mornings in the Dark*, p. 380.
10. Michael Balcon, 'Realism or Tinsel', in Monja Danischewsky, *Michael Balcon's 25 Years in Films* (London: World Film, 1947).
11. Michael Balcon, 'Rationalise!', *Sight & Sound*, Winter 1940–1, p. 62.
12. Penrose Tennyson, 'Pen Tennyson Writes a Letter', *Cine-Technician*, July/August 1941, pp. 82–4.
13. Tennyson, *Penrose Tennyson*, p. 147.
14. Dilys Powell, 'Films Since 1939', in *Since 1939* (London: Readers Union, 1948), p. 78.
15. Michael Balcon, 'Sub-Lieutenant F. Penrose Tennyson', in Derek Tangye (ed.), *Went the Day Well* (London: Harrap, 1942), p. 196.

4 The People's War

1. Angus Calder, *The People's War: Britain 1939–1945*, 2nd edn (London: Pimlico, 1992), p. 18.
2. For a discussion of Ealing's documentary films and their relationship with the studio's mainstream features see Mark Duguid's and Katy McGahan's chapter in this volume.
3. *Daily Mirror*, 5 July 1940.
4. *The Spectator*, 19 July 1940.
5. Jeffrey Richards and Dorothy Sheridan have claimed that 'the evidence goes to show that the film succeeded despite its topicality and not because of it'. Jeffrey Richards and Dorothy Sheridan, *Mass-Observation at the Movies* (London: Routledge, 1987), p. 337.
6. Robert Murphy, *Realism and Tinsel: Cinema and Society in Britain 1939–48* (London: Routledge, 1992), p. 168,
7. Michael, Balcon, *Michael Balcon Presents ... A Lifetime of Films* (London: Hutchinson, 1969), p. 133.
8. J. E. Sewell, *Daily Telegraph*, December 1941.
9. Balcon, *Michael Balcon Presents*, p. 238.
10. Charles Barr, *Ealing Studios* (Moffat: Cameron and Hollis, 1998), p. 22.
11. Ibid., p. 35. For a discussion of *San Demetrio, London*'s engagement with themes of democracy and national unity, see Lee Freeman's chapter in this volume.
12. *San Demetrio, London Exhibitors' Campaign Book* (BFI: London, 1943).

13. James Chapman, *The British at War: Cinema, State and Propaganda 1939–1945* (London: I.B.Tauris, 1998), p. 188.
14. Balcon, *Michael Balcon Presents*, p. 138.
15. Angus Calder, *The Myth of the Blitz* (London: Jonathan Cape, 1991), p. 5.
16. Murphy, *Realism and Tinsel*, p. 33.
17. Balcon, *Michael Balcon Presents*, p. 135.
18. Philip M. Taylor (ed.), *Britain and the Cinema in the Second World War* (London: Macmillan, 1988), p. 7.
19. Calder, *The Myth of the Blitz*, p. 188
20. Clive Coultass, 'British Cinema and the Reality of War', in Taylor, *Britain and the Cinema in the Second World War*, p. 99.
21. George Perry, *Forever Ealing: A Celebration of the Great British Film Studio* (London: Pavilion, 1981), p. 74.
22. Roger Manvell, 'Britain's Portraiture in Feature Films', *Geographical Magazine*, August 1953, p. 222.
23. Elizabeth Sussex, 'Cavalcanti in England', *Sight & Sound* vol. 44 no. 4, Autumn 1975, pp. 205–11.
24. Sue Harper and Vincent Porter, *British Cinema of the 1950s: The Decline of Deference* (Oxford: Oxford University Press, 2003), p. 60.
25. Barr, *Ealing Studios*, p. 104.
26. See Harper and Porter, *British Cinema of the 1950s*, pp. 64–5.
27. Robert Murphy, *British Cinema and the Second World War* (London: Continuum, 2000), p. 221.

5 From Tinsel to Realism and Back Again

1. Michael Balcon, *Michael Balcon Presents ... A Lifetime of Films* (London: Hutchinson, 1969), p. 123.
2. Ibid., p. 130.
3. *Manchester Guardian*, 10 February 1940, p. 4.
4. *The Times*, 21 March 1940, p. 5.
5. C. A. Lejeune, 'Anti-Gossip Campaign', *Observer*, 24 March 1940, p. 3.
6. *Documentary News Letter*, May 1940, p. 17.
7. Tom Harrisson, 'Social Research and the Film', *Documentary News Letter*, November 1940, p. 12.
8. *The Times*, 27 September 1939, p. 8.
9. *Kinematographic Weekly* no. 1737, 1 August 1940, p. 26.
10. *Manchester Guardian*, 30 July 1940, p. 6.
11. *Documentary News Letter*, August 1940, p. 2.
12. Cavalcanti, in a letter to *Documentary News Letter*, March 1943, p. 196.
13. Croydon was a new arrival at Ealing, but would stay until just after the war; he bowed out as the producer (or 'associate producer', since Balcon usually took the 'producer' credit) of *Dead of Night*.
14. Harrisson, 'Social Research and the Film', p. 12.
15. Robert Murphy, *British Cinema and the Second World War* (London/New York: Continuum, 2000), p. 128.
16. James Chapman, *The British at War: Cinema, State and Propaganda* (London: I.B.Taurus, 1998), p. 76.
17. Nicholas Pronay and Frances Thorpe, *British Official Films in the Second World War* (London: Clio, 1980), p. 31.
18. *Kinematograph Weekly*, 19 December 1940, p. 1.
19. Chapman, *The British at War*, p. 76.
20. *Documentary News Letter* reported that Cavalcanti had been 'released to make John and Marianne, a feature-length story of the Cornish and Breton fisherfolk' ('Reciprocity Achieved', *Documentary News Letter*, June 1940, p. 2). The film eventually emerged as *Johnny Frenchman*, directed by Charles Crichton and released in 1945; Cavalcanti was not credited.
21. Jim Hillier, Alan Lovell and Sam Rohdie, 'Interview with Alberto Cavalcanti', *Screen* vol. 13 no. 2, Summer 1972, p. 45.
22. Owen was a former Liberal MP who edited the *Evening Standard*, owned by the notoriously pro-appeasement Lord Beaverbrook. Foot, also a writer on the *Standard*, would become a Labour MP in 1945 and ultimately, of course, Labour leader. The third co-author of *Guilty Men* was Peter Howard, who wrote for Beaverbrook's *Daily Express*.
23. *Kinematographic Weekly*, 27 March 1941, n. 1771.
24. *Documentary News Letter*, December 1940, p. 9.
25. *The Times*, 28 February 1941, p. 6.

26. In this sense *Yellow Caesar* arguably prefigures later satirical efforts such as *That Was the Week That Was* (BBC, 1963–4).
27. 'Review: Guests of Honour', *Documentary News Letter*, September 1941, pp. 167–8.
28. Forde hadn't made a film at Ealing since 1940's *Sailors Three*; it might, therefore, have been directed by Basil Dearden and Hay, who co-directed two films in 1942, or by Hay alone.
29. *Monthly Film Bulletin* vol. 9 no. 105, September 1942, p. 111.
30. Charles Barr, *Ealing Studios*, 3rd edn (Moffat: Cameron and Hollis, 1998).
31. The same faction included Humphrey Jennings, Jack Lee and Pat Jackson.
32. Harry Watt, National Film Theatre programme note, 1975.
33. Roy and John Boulting, letter to *Documentary News Letter*, June 1941, p. 114.
34. 'Reciprocity Achieved', *Documentary News Letter*, June 1940, p. 2.
35. Miles himself was a familiar figure in wartime films, lending working-class authenticity to the likes of *In Which We Serve* (David Lean and Noel Coward, 1942) and *One of Our Aircraft is Missing* (Michael Powell and Emeric Pressburger, 1942) – both credited with importing story-documentary principles into feature films – and several MOI shorts. He had an Ealing connection, too, appearing in Charles Frend's *The Big Blockade* (1941) and Cavalcanti's *The Life and Adventures of Nicholas Nickleby* (1947) and providing the scenario for the Will Hay vehicle *The Goose Steps Out* (Marcel Varnel, 1942).
36. Bernard Miles, 'Are Actors Necessary?', *Documentary News Letter*, April 1941, pp. 70–4.
37. Harry Watt, 'Casting "Nine Men"', *Documentary News Letter*, February 1943, p. 180.
38. *Documentary News Letter*, February 1943, p. 179.
39. Murphy, *British Cinema and the Second World War*, p. 132.
40. Alan Burton, 'Balcon, Michael', in Iain Aitken (ed.), *Encyclopedia of Documentary Film* (New York: Routledge, 2005).
41. Balcon, *Michael Balcon Presents ...*, p. 130.
42. Michael Balcon, 'Realism and Tinsel, a Paper Delivered to the Workers Film Association at Brighton' (Brighton: F. W. Kahn, 1943), p. 4.
43. Michael Balcon, 'The Feature Carries on the Documentary Tradition', *Quarterly of Film, Radio and Television* vol. 6 no. 4, Summer, 1952, pp. 352–3.
44. Armand Denis, *On Safari; The Story of My Life* (New York: E. P. Dutton & Co., 1963), p. 279.
45. And perhaps television, where dramatised documentaries such as *Pilgrim Street* (BBC, 1952) – written by *The Blue Lamp*'s creators Jan Read and Ted Willis – were an early instance of the cross-fertilisation of drama and documentary forms, later associated with Ken Loach in the late 1960s and with Leslie Woodhead in the 70s.
46. Harry Watt, programme note for an NFT retrospective, 1975.
47. Patrick Russell and James Taylor (eds), *Shadows of Progress: Documentary Film in Post-War Britain* (London: BFI, 2000).

6 'Mild Revolution'?

1. Quoted in John Ellis, 'Made in Ealing', *Screen*, Spring 1975, p. 119.
2. A. J. P. Taylor, *English History, 1914–1945* (Oxford: Oxford University Press, 1992), p. 550.
3. For a review of Pen Tennyson's Ealing career see Martin Carter's chapter in this volume.
4. *Motion Picture Herald*, 27 January 1940.
5. See Peter Stead, 'The People as Stars: Feature Films as National Expression', Philip M. Taylor (ed.), *Britain and the Cinema in the Second World War* (London: Macmillan, 1988), pp. 62–83.
6. Pen Tennyson, 'Pen Tennyson Writes a Letter', *The Cine-Technician*, July–August 1941, pp. 82–4.
7. Michael Balcon, *Michael Balcon Presents ... A Lifetime of Films* (London: Hutchinson, 1969), p. 126.
8. Charles Barr, *Ealing Studios: A Movie Book* (London: Cameron and Hollis, 1998), p. 20.
9. *Kinematograph Weekly*, 30 July 1942.
10. Barr, *Ealing Studios*, p. 37.
11. Balcon, *Michael Balcon Presents*, p. 123.
12. Quoted in Barr, *Ealing Studios*, p. 195.
13. For an analysis of the fantasy elements within *They Came to a City* see Jo Botting's chapter in this volume.
14. Alan Burton, 'Ealing Studios Wartime "Mild Revolution": The Filming of J. B. Priestley's *They Came to a City*', *Anglistik: International Journal of English Studies*, September 2009, p. 161.

15. See Philip Kemp, 'Paradise Postponed: Ealing, Rank and *They Came to a City*', *Cinéaste*, July 1998, pp. 45–7. Although Kemp's view appears ill-founded in this instance, his article otherwise makes a strong claim for *They Came to a City*'s relevance towards an understanding of the politics of the studio and he makes a most strident case for the film's radicalism by claiming that 'as much as any Twenties agitprop production from Medvedkin or Dziga Vertov, [*They Came to a City*] is an unabashed, outspoken piece of socialist polemic – more so than any other feature ever produced in Britain or, quite possibly, anywhere outside the Communist bloc', p. 45.
16. Quoted in Jeffrey Richards 'Basil Dearden at Ealing', in Alan Burton, Tim O'Sullivan and Paul Wells (eds), *Liberal Directions: Basil Dearden and Postwar British Film Culture* (Trowbridge: Flicks, 1997), pp. 24–5.

7 Dark Shadows Around Ealing

1. Michael Relph, 'Inside Ealing', fragment of a memoir published in Alan Burton and Tim O'Sullivan, *The Cinema of Basil Dearden and Michael Relph* (Edinburgh: Edinburgh University Press, 2010), p. 327.
2. Charles Drazin, *The Finest Years* (London: Andre Deutsch, 1998), p. 107.
3. Charles Barr, *Ealing Studios* (Newton Abbot: David & Charles/Cameron and Tayleur, 1977), p. 46.
4. Francis Koval, 'Sir Michael Balcon and Ealing', *Sight & Sound*, Studio Supplement, Spring 1951, p. 9.
5. Ibid.
6. Ibid.
7. See, in particular, Charles Drazin's chapter on Hamer in *The Finest Years*, pp. 71–88. The best source for Crichton is the interview with him in Brian McFarlane's *An Autobiography of British Cinema* (London: Methuen, 1997), pp. 151–5, and the interview by Sidney Cole and Alan Lawson recorded in 1987 for the BECTU History Project; a full transcript is available in the BFI Library, London, and much of it is available on screenonline (http://www.screenonline.org.uk/audio/id/937841/index.html).
8. MGM's crass re-editing of *The Scapegoat* was as embarrassing to Balcon as it was painful for Hamer.
9. Barr suggests that there was 'an apparent sobriety, even melancholy in his temperament which never adjusts to comedy … indeed there seems, especially in *Lease of Life*, an "anti-Ealing" spirit in him struggling to get out'. 'Projecting Britain and the British Character Part 1', *Screen* vol. 15 no 1, Spring 1974, p. 114.
10. Raymond Durgnat in 'Dearden and Relph: Two on a Tandem', *Films and Filming*, July 1966, pp. 26–33, and Richard Dyer, 'Victim – Hermeneutic Project', *Film Form* vol. 1 no. 2, 1977, pp. 3–22, were way ahead of the field in recognising that there was more than cliché to Dearden. A thoroughgoing reassessment had to wait till the publication of Alan Burton, Tim O'Sullivan and Paul Wells (eds), *Liberal Directions. Basil Dearden and Postwar British Film Culture* (Trowbridge: Flicks, 1997), and Burton and O'Sullivan, *The Cinema of Basil Dearden and Michael Relph*. Barr's revised edition of *Ealing Studios* in 1993 also offers a more generous appreciation of Dearden's films, particularly *Halfway House* and *They Came to a City*.
11. Barr, 'Projecting Britain and the British Character Part 1', p. 109.
12. All of these films are included in Michael F. Keaney's, *British Film Noir Guide* (Jefferson, NC, and London: McFarland, 2008); see also Robert Murphy, '*Cage of Gold*', in Burton et al., *Liberal Directions*, pp. 154–61; Martin Hunt, 'New Labour, New Criticism: A Contemporary Re-Assessment of Ealing and The Archers', *Quarterly Review of Film & Video* vol. 19, pp. 261–9, for *Frieda* and *Pool of London*; Tony Williams, *Structures of Desire. British Cinema, 1939–1955* (New York: State University of New York, 2000), pp. 160–2, and William K Everson, 'British Film Noir', *Films in Review* vol. 38 no. 6/7, 1987, p. 343, for *Saraband for Dead Lovers*.
13. Michael Relph, 'Inside Ealing', p. 324. Balcon was good at turning a blind eye to the private lives of his team, never commenting on the heavy drinking that went on in the Red Lion pub outside the studio gates (both Hamer and Angus MacPhail were confirmed alcoholics) or on Hamer and Cavalcanti's homosexuality. However, this was perhaps as much due to naivety as tolerance. Charles Crichton jokes in the BBC documentary *Made in Ealing* (1986), 'I don't think he realised that some people were gay.'
14. It is now the best remembered of all Ealing's wartime films and the only one to have been included in the BFI Film Classics series. See Penelope Houston's meticulously researched *Went the Day Well?* (London: BFI, 1992).

15. See Charles Drazin's chapter on Cavalcanti in *The Finest Years*, p. 131. Drazin also points to the death of Cavalcanti's mother at the end of the war as a contributing factor to his unsettled and unhappy state.
16. See the interview with John Harrington and David Paroissien, 'Alberto Cavalcanti on *Nicholas Nickleby*', *Literature/Film Quarterly* vol. 6 no. 1, Winter 1978, pp. 48–56, for Cavalcanti's lack of enthusiasm for a project that had been delayed too long (because its young star, Derek Bond, had been called up for military service).
17. Arthur Vesselo, 'Films of the Quarter', *Sight & Sound*, Autumn 1947, p. 120.
18. Vesselo compares this fondness for 'morbid burrowing' to that underlying the German Expressionist films of the 1920s. 'Films of the Quarter', p. 120. Kracauer's *Caligari to Hitler* was published in Britain in 1947.
19. Koval, 'Sir Michael Balcon and Ealing', p. 9.
20. *Sunday Chronicle*, 29 June 1947. To be fair, Dehn never retreats into the squeamishness of critics like C. A. Lejeune. Later in the review he criticises Cavalcanti for being too soft on Clem and Sally and concludes that 'The Black Market has no room for heroics: but there was scope here for a film consisting entirely of villains and villainesses.'
21. *Sunday Chronicle*, 30 November 1947.
22. Like Barr, I have largely ignored Harry Watt, not because he is an insignificant film-maker, but because after 1944 his films – *The Overlanders* (1946), *Eureka Stockade* (1949), *Where No Vultures Fly* (1951), *West of Zanzibar* (1954) and *The Siege of Pinchgut* (1959) – were made on location in Australia or Africa and he had a very limited role in Ealing's team activities. Of the duds made by Frend and Crichton in the 1950s, *Barnacle Bill*'s forlorn surrealism is preferable to the Welsh whimsy of *A Run for Your Money*, and Crichton's *The Love Lottery* has a soufflé-like quality (which he borrows from René Clair) missing in the leaden humour of *Another Shore*. Dearden and Relph do suffer a dip after their impressive run of films up to *I Believe in You* (1952); perhaps the routine assignments they accepted served as a training ground for life beyond the safe shelter of Ealing.
23. See Sue Harper and Vincent Porter, *British Cinema of the 1950s: The Decline of Deference* (Oxford: Oxford University Press, 2003), pp. 63–8, which extracts invaluable information about Balcon's battles with Davis from the Michael and Aileen Balcon Collection held in the BFI Library, London. See Ian Aitken, *Alberto Cavalcanti: Realism, Surrealism and National Cinema* (Trowbridge: Flicks, 2000), pp. 123–5, for the conditions under which Cavalcanti was prepared to return to Ealing; Balcon would have had difficulty fulfilling them without facing similar demands from his other directors.
24. Harry Watt, interviewed in *Made in Ealing* (1985). A disappointingly flat version of Richard Mason's novel was filmed by Rudolph Cartier as *Passionate Summer* in 1958.
25. Philip Kemp contrasts Mackendrick, who found ways of manipulating his way around Balcon's disapproval, with Hamer, who was 'contrary and quick-tempered and courted confrontation'. 'He wanted to win publicly as well as privately, to have his right to make his kind of film officially conceded. It was a hopelessly unrealistic demand, even at Ealing, let alone any other post-war British studio.' 'The Long Shadow: Robert Hamer after Ealing', in Ian MacKillop and Neil Sinyard (eds), *British Cinema of the 1950s: A Celebration* (Manchester: Manchester University Press, 2003), p. 76. Drazin, *The Finest Years*, pp. 108–11, makes a similar point.
26. Raymond Durgnat, *A Mirror for England* (London: Faber & Faber, 1970), p. 24. Aitken, *Cavalcanti*, pp. 175–8, and Steve Chibnall, *J. Lee Thompson* (Manchester: Manchester University Press, 2000), pp. 21–3, both offer sympathetic accounts of *For Them That Trespass*.
27. 'Interviews with Alberto Cavalcanti and Gavin Lambert', *Screen* vol. 13 no. 2, Summer 1972, p. 33.
28. C. A. Lejeune, *Chestnuts in Her Lap 1936–1946* (London: Phoenix House, 1947), p. 178.
29. Barr, *Ealing Studios*, p. 192.
30. The script is credited to Jack Whittingham, though Richard Hughes protests, 'this is a screenplay by Hughes based on a draft screenplay by Whittingham: but it seems that they are under some sort of contractual obligation not to say so'. Richard Perceval Graves, *Richard Hughes* (London: Andre Deutsch, 1994), p. 354. One of the great things about Hughes's novel *A High Wind in Jamaica* is his insight into the capacity of children to manipulate situations to their own advantage, and it is likely that he was responsible for this pleasingly unsentimental ending.
31. Barr quotes T. E. B. Clarke's jaundiced view that 'There was little chance of the old team spirit being preserved now that we had ceased to be a self-contained unit, and the intimate atmosphere of our previous home was sadly missing from the bleak areas of characterless buildings.' *Ealing Studios*, p. 178.

32. *Nowhere to Go* has attracted some attention, but mainly because of Holt's claim that he intended it to be 'the least Ealing film ever made'; see Kevin Gough-Yates, 'Interview with Seth Holt', *Screen* vol. 10 no. 6, November/December 1969, p. 9. For Barr 'it represents a quite fresh and potentially fruitful line for Ealing, embarked on, however, far too late for it to have any influence'. *Ealing Studios*, p. 178. In fact there are marked similarities between *Nowhere to Go* and Crichton's two mid-60s films *The Third Secret* (1964) and *He Who Rides a Tiger* (1965).
33. Holt edited Karel Reisz's *Saturday Night and Sunday Morning* (1960) and was at one point slated to direct Lindsay Anderson's *If* *The Man in the Sky* – like Dearden and Relph's *The Smallest Show on Earth* (1957), their most 'Ealing-like' comedy despite being made for British Lion at Shepperton – was written by John Eldridge and William Rose and photographed by Douglas Slocombe.
34. Lindsay Anderson, talking to Joseph Gelmis, *Film Director As Superstar* (New York: Doubleday, 1970), p. 98.
35. Barr's analysis of *The Blue Lamp*, and particularly of this scene, looks as perceptive now as it did in 1977. *Ealing Studios*, pp. 82–9.

8 Selling Ealing

1. Lawrence Kardish, 'Michael Balcon and the Idea of a National Cinema', in Geoff Brown and Lawrence Kardish, *Michael Balcon: The Pursuit of British Cinema* (New York: Museum of Modern Art, 1984), p. 55.
2. Bevis Hillier, Introduction to David Wilson (ed.), *Projecting Britain: Ealing Studios Film Posters* (London: BFI, 1982), pp. vi–xiii.
3. Michael Balcon, *Michael Balcon Presents ... A Lifetime of Films* (London: Hutchison, 1969), p. 142.
4. Michael Relph, 'Inside Ealing', in Alan Burton and Tim O'Sullivan (eds), *The Cinema of Basil Dearden and Michael Relph* (Edinburgh: Edinburgh University Press, 2009), p. 323.
5. *Kinematograph Weekly*, 25 March 1948, p. 3.
6. George Perry, *Forever Ealing: A Celebration of the Great British Film Studio* (London: Pavilion/Michael Joseph, 1981), p. 10.
7. Balcon himself owned works by a number of these artists, including Graham Sutherland, Paul Nash and John Piper.
8. Memo from Monja Danischewsky to Michael Balcon, 5 March 1948, Michael and Aileen Balcon BFI Special Collection, MEB/G/52.
9. See, for example, an article by publicist Leila Lewis, 'The Position of the Lay Press', *Kinematograph and Lantern Weekly*, 10 April 1919, p. 75.
10. Monja Danischewsky, *White Russian, Red Face* (London: Gollancz, 1966), p. 128.
11. Ibid., pp. 128 and 131.
12. Ibid., pp. 138–9.
13. Danischewsky to Balcon, 5 March 1948, MEB/G/52.
14. For reasons of space, I do not discuss Ealing film trailers in this chapter. It is worth mentioning, however, that towards the end of Ealing's life, Balcon noted his longstanding antipathy towards trailers in a memo to his then publicity director, Jack Worrow, MEB/I/220b.
15. For more about press campaign books, see Janet Moat, 'Selling the Movies', BFI screenonline marketing tour, available at http://www.screenonline.org.uk/tours/marketing/marketingtour1.html
16. *Another Shore* press book, BFI Special Collections.
17. *Saraband for Dead Lovers* press book, BFI Special Collections.
18. Danischewsky, *White Russian, Red Face*, p. 141.
19. *Saraband for Dead Lovers*, *Barnacle Bill* and *Champagne Charlie* press books, all held in BFI Special Collections.
20. The Sidney Bernstein/Granada Cinema scrapbooks held in BFI Special Collections, for instance, show many ideas such as these in practice.
21. Sim Branaghan, *British Film Posters: An Illustrated History* (London: BFI, 2006), pp. 74–5.
22. S. John Woods to Michael Balcon, 2 July 1954, MEB/H/120.
23. The contemporary version of the logo, which gently bends the leaves round into a wreath, carries this association still further.
24. *The Cinema News and Property Gazette*, 10 November 1943, p. 3.
25. Frances Spalding, *John Piper, Myfanwy Piper: Lives in Art* (Oxford: Oxford University Press, 2009), pp. 83–4.
26. *Kinematograph Weekly*, 19 July 1945, p. 16.

27. *Today's Cinema*, 14 September 1943, p. 12.
28. James Laver, 'Ealing Studios Posters', *Art and Industry* vol. 46, January 1949, p. 17.
29. Hillier, Introduction, *Projecting Britain*, p. vii.
30. Ibid., p. ix.
31. Ibid., p. viii.
32. Ibid., p. x.
33. Ibid., pp. x–xi.
34. Monja Danischewsky to Michael Balcon, 5 March 1948, Michael and Aileen Balcon BFI Special Colllection, MEB/G/52.
35. Hillier, Introduction, *Projecting Britain*, p. viii.
36. Branaghan, *British Film Posters*, p. 77.
37. Balcon, *Michael Balcon Presents*, p. 143.
38. *Daily Film Renter*, 17 May 1943, p. 6.
39. Geoffrey Macnab, *J. Arthur Rank and the British Film Industry* (London: Routledge, 1993), p. 112.
40. Danischewsky, *White Russian, Red Face*, p. 150.
41. 5 March 1948, MEB/G/52.
42. Ibid.
43. The versions can be compared in Wilson, *Projecting Britain*, pp. 44 and 45.
44. Roger Manvell (ed.), *Penguin Film Review No. 5* (London and New York: Penguin, January 1948).
45. See Branaghan, *British Film Posters*, for more on Pout.
46. Perry, *Forever Ealing*, p. 10.
47. Balcon, *Michael Balcon Presents*, p. 142.
48. Charles Goldsmith to Reginald Baker, 12 June 1958, MEB/I/150.
49. Balcon to Goldsmith, 18 June 1958, MEB/I/150.
50. Ibid.
51. Hillier, Introduction, *Projecting Britain*, p. xii.

9 Georges Auric

1. Jan G. Swynnoe, *The Best Years of British Film Music, 1936–1958* (Woodbridge: Boydell Press, 2002), pp. 170–1.
2. Michael Balcon, *Michael Balcon Presents ... A Lifetime of Films* (London: Hutchinson, 1969), p. 147. See also Balcon's tribute after Irving died, published in *The Times*, 28 October 1953, p. 10. Another portrait of Irving is offered in Donald Brooks, *Conductors' Gallery* (London: Rockcliff, 1945). Thesiger's caricature is mentioned in Philip Kemp, *Lethal Innocence: The Cinema of Alexander Mackendrick* (London: Methuen, 1991), p. 47.
3. John Huntley, *British Film Music* (London: Skelton Robinson, 1947), p. 64.
4. Blakeston, Oswell, *Extra Passenger* (Territet: Pool, 1929), p. 65.
5. Jean Cocteau, *Cocteau on the Film: A Conversation Recorded by André Fraigneau* (London: Dennis Dobson, 1954), p. 60.
6. Ned Rorem, *Knowing When to Stop* (New York City: Simon and Schuster, 1994), p. 531.
7. Ernest Irving, *Cue for Music* (London: Dennis Dobson, 1959), pp. 145–6. The Britten proposal is mentioned in Balcon, *Michael Balcon Presents*, pp. 147–8.
8. Irving details his experience of the recording process in the entry on film music in *Grove's Dictionary of Music and Musicians*, 5th edn, vol. III, ed. Eric Blom (London: Macmillan, 1954), pp. 94–8.
9. See Hans Keller, *Film Music and Beyond: Writings on Music and the Screen, 1946–59*, ed. C. Wintle (London: Plumbago, 2006). A useful bibliography covering film music commentary of the period is given in John Huntley and Roger Manvell, *The Technique of Film Music* (London: Focal Press, 1957).
10. Ernest Irving, 'Music from the Films', *Tempo*, June 1946, p. 12.
11. Marjorie Deans, *Meeting at the Sphinx* (London: Macdonald, 1946), pp. 102–3.
12. Francis Poulenc, *Echo and Source, Selected Correspondence 1915–1963*, ed. Sidney Buckland (London: Victor Gollancz, 1991), pp. 152–3.
13. *Kinematograph Weekly*, 10 May 1945, p. 41. Poulenc and Bernac's warm reception in London is documented in Carl B. Schmidt, *Entrancing Muse: A Documented Biography of Francis Poulenc* (Hillsdale: Pendragon Press, 2004), p. 303.
14. Georges Auric, *Écrits sur la musique de Georges Auric*, vol. 1, ed. Carl B. Schmidt (Lewiston: Edwin Mellon

Press, 2009), p. 139. The musical production of *Dead of Night* is briefly detailed in Huntley's *British Film Music*, p. 71.
15. Irving, 'Film Music', p. 27.
16. Irving, *Cue for Music*, p. 145.
17. *Sequence*, no. 4, p. 12; Campbell Dixon, *Daily Telegraph*, 1 December 1947.
18. Hans Keller, 'Noise as Leitmotiv', in Keller, *Film Music and Beyond*, p. 78, n. 1.
19. Alain Lacombe and François Porcile, *Les Musiques du cinéma Français* (Paris: Bordas, 1995), picture caption between pp. 208 and 209.
20. Elspeth Grant, *Daily Graphic*, 29 April 1949; Dilys Powell, *Sunday Times*, 1 May 1949.
21. See his comments about *Another Shore* in Keller, *Film Music and Beyond,* pp. 187, 189. Auric's British/French personality is discussed in Huntley and Manvell, *The Technique of British Film Music*, pp. 134–5.
22. Irving, 'Film Music', p. 32.
23. Telephone interview with Philip Lane, 19 August 2006. The Chandos CD (CHAN 9774) also includes selections from *The Innocents*, *Moulin Rouge*, *Father Brown* and *Caesar and Cleopatra*, the only film for which Lane had at his disposal a complete orchestral score.

10 Anthony Mendleson

1. Anthony Mendleson, interview by the author, 15 March 1993; henceforth listed as Mendleson interview (1993) as required. All subsequent unidentified quotations from Mendleson in the text and notes come from this source.
2. Mendleson interview (1993), plus 'These Also Help to Shape the Ealing Style', *Kinematograph Weekly* supplement, 4 October 1951, pp. 33–4.
3. Kenneth Tynan, 'Ealing: The Studio in Suburbia', *Films and Filming*, November 1955, p. 4 (emphasis in original). Even as late as 1955, Tynan observed that 'Wartime co-operation still permeates peacetime Ealing.'
4. 'Lily Payne, the wardrobe mistress, was there during the Basil Dean days; she used to tell me stories about how she used to work with Gracie Fields.'
5. 'Lily Payne cut it and tacked it loosely, so that it all came away, like that. You've got to have so many things, because it *always* goes wrong. You've got to find them all, exactly the same. And everyone was getting *soaked*. So we had to have waterproof underclothes, under the clothes, in a lot of cases. It was *real* rain – *studio* rain, but it was *drenching*.'
6. 'Wardrobe Supervisor: Anthony Mendleson', in John W. Collier, *A Film in the Making* (London: World Film Publications, 1947), pp. 62–3.
7. 'From the Waist Up ... ', in Dick Richards (ed.), *Sunday Pictorial All-Star Annual 1950* (London: Sunday Pictorial, 1950), p. 129. See also Mendleson's comments in 'England's Dreaming', *Independent on Sunday* (London), 25 July 1993, p. 22.
8. BBC radio interview, 1977.
9. 'New Look Fashions for Moira Lister', publicity item in the *Another Shore* campaign folder.
10. 'That was a terrible trap. It took a long time to seep over here. I wasn't careful enough, and started using all those sort of pinched-in looks, and full skirts *before* they were accepted here. That's a case of being too clever by half.' This had changed by the time Mendleson dressed Jean Simmons in *Cage of Gold* (1950).
11. 'No Glamour', publicity item in the *Another Shore* campaign folder.
12. Anthony Mendleson, 'The Seventeenth Century Look', in *Saraband for Dead Lovers: The Film and its Production at Ealing Studios* (London: Convoy, 1948), p. 92 (emphasis in original).
13. The quirks of designing for Technicolor would continue, even with such an apparently straightforward subject as the nursing story *The Feminine Touch* (1956), one of Ealing's last productions. While filming on location at Guy's Hospital in London, the cast's uniforms were taken to task by a genuine Matron: 'I think those nurses' aprons are a *disgrace*. I would *never* allow them in *my* hospital!' Mendleson had to take her aside and explain that they had all been dyed a special Technicolor grey, to photograph white (Mendleson interview, 1993).
14. Details from Mendleson interview (1993) and 'The Seventeenth Century Look', pp. 92–3.
15. 'Colourful Costumes for *Saraband*', publicity article in *Saraband for Dead Lovers* exploitation folder.
16. Hugh Skillan often worked with the designer Oliver Messel, creating masks and headdresses for ballet, theatre, opera and film (*Caesar and Cleopatra*, 1946). He also made the headdresses for Princess Margaret's bridesmaids for her wedding to Antony Armstrong-Jones (Lord Snowdon) in 1960.

17. David James, *Scott of the Antarctic. The Film and its Production* (London: Convoy, 1948), pp. 36–9.
18. Mendleson, in Lindsay Anderson, *Making a Film: The Story of 'Secret People'* (London: George Allen and Unwin, 1952), p. 42.
19. Greenwood's 'staggering' hats inspired a publicity paragraph, 'Heads It Is', in the *Kind Hearts and Coronets* exploitation folder. The height difference is mentioned in 'From the Waist Up', *Sunday Pictorial All-Star Annual 1950*, p. 129. It seems that producer Michael Balcon had a particular interest in hats, judging from a comment by Alberto Cavalcanti in a June 1973 interview with Barry Levine in Cambridge, MA (Alberto Cavalcanti papers, BFI Special Collections): 'The only trouble with Mick was women's hats. Lady Balcon used to wear the most atrocious hats that any woman wore ... We always made tests of hats. Mick would look at them in a test reel – no, yes. Then he'd see the hat in the film and say, "That hat's impossible". "But you passed the test." "Yes, yes, but I changed my mind." Retakes! There are more retakes about hats in Ealing films than of anything else.'" Balcon's wife Aileen was obviously style conscious, and they moved in social circles. There is a striking photograph of her by society photographer Madame Yevonde, posing as Minerva, sporting a helmet and brandishing a revolver, as a stuffed owl looks on. This was part of a famous colour photo series of 'Goddesses', in the wake of an Olympian-themed charity costume party at Claridge's in 1935. (See Robin Gibson and Pam Roberts, *Madame Yevonde: Colour, Fantasy and Myth* (London: National Portrait Gallery, 1990)).
20. In a 1994 telephone conversation with the author, Valerie Hobson gave full credit to Anthony Mendleson's attention to detail, saying he had a flair for just the right theatrical touch, such as the arrow motif, and knew exactly when to exaggerate the width of a stripe or a ruffle.
21. Compare the clever opening of *Passport to Pimlico*, which through a shorthand of art direction, costume design and music creates a tropical atmosphere. This tongue-in-cheek prelude to its tale of London working folk sets the scene for the whimsy to come: simple props – a fan, Venetian blinds and a beach umbrella – segue to a girl glimpsed lounging lazily in a two-piece sun suit, sunglasses and straw sombrero. Only when the camera pans down from the rooftop to reveal a fish shop (as the radio cheekily announces 'You have been listening to a programme of lunchtime music by Les Norman and His Bethnal Green Bambinos'), do we come crashing to reality: we are in postwar austerity London. The heatwave sets in motion a series of incredible comic events for a community of ordinary people. Appropriately, this crafted fantasy comes to an end when it rains: welcome back to the reality of postwar Britain! Mendleson's character clothes are spot-on throughout.
22. Mendleson interview (1993), plus 'They Also Help to Shape the Ealing Style', *Kinematograph Weekly*, special Ealing Studios 21st anniversary supplement, 4 October 1951, p. 33.
23. Probably made by Elizabeth Curzon, a subsidiary of B. J. Simmons, per 'They Also Help to Shape the Ealing Style', ibid., p. 34.
24. Both the costumes and set are idiosyncratic enough to have been clearly referenced in Graham Linehan and Sean Foley's 2012 London stage version of the property designed by Michael Taylor.
25. Mendleson interview (1993).
26. For Mackendrick's own comments on the film's costume colours and design, see Philip Kemp, *Lethal Innocence: The Cinema of Alexander Mackendrick* (London: Methuen, 1991), pp. 110–36.
27. 'England's Dreaming', *Independent on Sunday* (London), 25 July 1993, p. 22.
28. Mendleson dressed Richard Attenborough's first films as a director (*Oh! What a Lovely War*, 1969; *Young Winston*, 1972; and *A Bridge Too Far*, 1977), before breaking that particular work chain after he balked at dressing *Gandhi*: 'Who wants to see a guy in a *dhoti*?' (Mendleson interview, 1993)
29. For *The Long Ships* (1964), *The Yellow Rolls-Royce* (1964), *Oh! What a Lovely War* (1969), *Macbeth* (1972), *Young Winston* (1972), *Alice's Adventures in Wonderland* (1972) and *The Incredible Sarah* (1976).

11 Kind Hearts and Campery

1. F. B. Lockhart, 'Interview with Hamer', *Sight & Sound*, October–December 1951, p. 74.
2. Michael Balcon, *Michael Balcon Presents ... A Lifetime of Films* (London: Hutchinson, 1969), p. 163.
3. Charles Barr, '"Projecting Britain and the British Character": Ealing Studios, Part II', *Screen* vol. 15 no. 2, 1974, p. 129.
4. Pamela Wilcox, *Between Hell and Charing Cross* (London: George Allen and Unwin, 1977).
5. Charles Drazin, *The Finest Years: British Cinema of the 1940s* (London: I.B.Tauris, 2007), p. 72.
6. Drazin, *The Finest Years*, p. 73.

7. Michael Newton, *Kind Hearts and Coronets* (London: BFI, 2003), p. 19.
8. George Orwell, quoted in Charles Barr, *Ealing Studios*, rev. edn (London: Studio Vista, 1993), p. 14.
9. José Estaban Muñoz, *Cruising Utopia: The Then and There of Queer Futurity* (New York: New York University Press, 2009).
10. Thomas Elsaesser, 'Tales of Sound and Fury: Observations on the Family Melodrama', in Christine Gledhill (ed.), *Home is Where the Heart is: Studies in Melodrama and the Woman's Film* (London: BFI, 1987), p. 55.
11. Geoffrey Nowell-Smith, 'Minnelli and Melodrama', in Gledhill, *Home is Where the Heart is*, p. 73.
12. Susan Sontag, 'Notes on "Camp"', in F. Cleto (ed.), *Camp: Queer Aesthetics and the Performing Subject: A Reader* (Edinburgh: Edinburgh University Press, 1999), p. 54.
13. Ibid., p. 62.
14. Ibid., p. 64.
15. Jack Babuscio, 'The Cinema of Camp (*aka* Camp and the Gay Sensibility)', in Cleto, *Camp*, p. 119.
16. Ibid., pp. 119–26.
17. Jonathan Dollimore, 'Post/modern: On the Gay Sensibility, or the Pervert's Revenge on Authenticity', in Cleto, *Camp*, p. 224.
18. Alan Sinfield, *The Wilde Century* (London: Cassell, 1994), p. 69.
19. Newton, *Kind Hearts and Coronets*, p. 70.
20. D. Hill, 'Man of Many Faces', *Sight & Sound* vol. 1 no. 5, 1955, p. 12.
21. Piers Paul Read, *Alec Guinness: The Authorised Biography* (London: Simon and Schuster, 2003), pp. 249–55.
22. Anon., 'Family Fight over Biographical Profile of Gay Star', *Gay Times*, November 1992, p. 25.

12 That Ealing Feeling

1. Michael Balcon, 'Comedy's A Serious Business', in Peter Noble (ed.), *Films of the Year 1955–1956*, (London: Express, 1956), p. 20.
2. See for instance Roy Armes, *A Critical History of British Cinema* (Oxford and New York: Oxford University Press, 1978), pp. 180–97; Ian Green, 'Ealing: In the Comedy Frame', in James Curran and Vincent Porter (eds), *British Cinema History* (London: Weidenfeld & Nicholson, 1983), pp. 295–302; Marcia Landy, *British Genres: Cinema and Society, 1930–1960* (New Jersey: Princeton University Press, 1991), pp. 334–62; Tim Pulleine, 'A Song and Dance at the Local: Thoughts on Ealing', in Robert Murphy (ed.), *The British Cinema Book* (London: BFI, 1997). pp. 114–21.
3. Forde was a versatile and prolific British film director whose work spanned the period from the late 1920s to the 40s. He moved with Balcon from Gaumont-British to make prewar films at Ealing but then failed to make his mark in the postwar Ealing era. His career is worth revisiting. See Robert Murphy (ed.), *Directors in British and Irish Cinema: A Reference Companion* (London: BFI, 2006), pp. 203–5, and Geoff Brown, *Walter Forde* (London: BFI, 1977).
4. MacDougall, who was a cousin of Alexander Mackendrick, was later to make considerable contributions to the Ealing universe, including, most famously, *The Man in the White Suit* (1951), but also *The Bells Go Down* (1943) and *The Gentle Gunman* (1952). Post-Ealing, he is also known for his script for *The Mouse that Roared* (1959).
5. Charles Barr, *Ealing Studios* (London: David & Charles/Cameron and Tayleur, 1977). Rev. edn (London: Studio Vista, 1993), p. 182.
6. It is interesting to note here that the roots of the 'community comedy' are not, in origin, the sole property of T. E. B. Clarke, although his early contact with Ealing was via his humorous 1938 book on British Pubs, *What's Yours?*, which was used as a reference source for the (almost comedy) thriller *Saloon Bar* also directed by Forde (1940). T. E. B. Clarke, *What's Yours? The Students Guide to Publand* (London: Peter Davis, 1938). See also Robert Murphy, *Realism and Tinsel: Cinema and Society in Britain 1939–48* (London: Routledge, 1989), p. 211.
7. Geoff Brown, 'Cheer Boys Cheer', National Film Theatre Programme Notes, circa 1977, BFI microfiche, undated.
8. Barr, *Ealing Studios*, p. 5.
9. Balcon was later to remark that (at Ealing) 'comedy as a film subject almost disappeared during the war years perhaps due to the fact that the film industry harnessed itself to the national effort. Perhaps we would have been serving the country better had we given people something at which to laugh rather than concentrate on serious subjects' (Balcon, 'Comedy's a Serious Business', pp. 21–2).

10. Clarke's contribution and influence is a notable thread of continuity not only in the comedies but in Ealing's output as a whole – he contributed to or solo scripted at least fourteen films there from 1944–57. See his enjoyable and informative biography, T. E. B. Clarke, *This is Where I Came In* (London: Michael Joseph, 1974), where he notes that his script for *The Lavender Hill Mob* won him an Oscar, but little more than the £1,500 he was paid when he wrote it. The other six comedy scripts drew on members of the Ealing team of regulars, including input from the respective directors, and Monja Danischewsky, John Dighton, Roger MacDougall, Angus McPhail and occasional 'interlopers', Harry Kurnitz and Walter Meade for instance. See Michael Relph, 'Inside Ealing', in Alan Burton, and Tim O'Sullivan, *The Cinema of Basil Dearden and Michael Relph* (Edinburgh: Edinburgh University Press, 2009), pp. 322–7.
11. The alert reader will have noticed that five films and their directors are missing: these are *Passport to Pimlico* (Henry Cornelius, 1949), *Meet Mr Lucifer* (Anthony Pellissier,1953), *Touch and Go* (Michael Truman, 1955), *Who Done It?* (Basil Dearden,1956) and *Davy* (Michael Relph, 1957).
12. Kenneth Tynan, 'Ealing: The Studio in Suburbia', *Films and Filming*, November 1955, p. 4, and 'Ealing's Way of Life', *Films and Filming*, December 1955, p. 10. Tynan also wrote an early study of Alec Guinness: Kenneth Tynan, *Alec Guinness* (London: Rockliff, 1953).
13. Tim O'Sullivan, 'Ealing Comedies 1947–57: "The Bizarre British, Faced with Another Perfectly Extraordinary Situation" ', in I. Q. Hunter and Laraine Porter (eds), *British Comedy Cinema* (London: Routledge, 2012).
14. Barr, *Ealing* Studios, p. 96
15. Michael Balcon, *Michael Balcon Presents ... A Lifetime of Films* (London: Hutchinson, 1969), p. 159.
16. Barr, *Ealing Studios*, p. 190. Frend is certainly remembered as a director at Ealing more for his work on story-documentary films, especially featuring masculine courage against wartime and other extreme odds: see his *San Demetrio, London* (1943), *Scott of the Antarctic* (1948) and *The Cruel Sea* (1953), for instance.
17. Sue Harper and Vincent Porter, *British Cinema of the 1950s: The Decline of Deference* (Oxford: Oxford University Press, 2003), pp. 61–2.
18. Philip Kemp provides the most carefully researched and written account of *The Maggie* and other Mackendrick films in his important study, *Lethal Innocence: The Cinema of Alexander Mackendrick* (London: Methuen, 1991), pp. 89–109. Ian Mackillop and Neil Sinyard provide a spirited defence of the film in the introduction to Mackillop and Sinyard (eds), *Celebrating British Cinema of the 1950s* (Manchester: Manchester University Press, 2003), p. 4. For an important critical reading of *The Maggie* and *Whisky Galore!*, building on previous work, see Colin McArthur, *Whisky Galore and The Maggie* (London: I.B.Tauris, 2003).
19. Barr, *Ealing Studios*, p. 165.
20. James Chapman, Mark Glancy and Sue Harper (eds), *The New Film History: Sources, Methods, Approaches* (Basingstoke: Palgrave Macmillan, 2007), p. 9.
21. In the same year, Ealing released *Scott of the Antarctic* , based on W. L. Meade's script. He had worked with Basil Dean at ATP (Ealing) in the prewar, pre-Balcon period, notably on *Penny Paradise* (1938). Reddin (1895–1967, aka Sarr) was an Irish republican novelist, playwright and judge.
22. 'E. H.', *News of the World*, 28 November 1948, BFI microfiche.
23. Pelissier was not one of the regular Ealing team of directors, but was drafted in to direct the film, initially entitled *Let's Put Out the Light*, because they were all otherwise fully engaged, either completing or involved in the development of other projects (see *Kinematographic Weekly*, 16 October 1952, p. 41). The screenplay was developed by Monja Danischewsky, who also produced, based on the play, *Beggar my Neighbour*, written by Arnold Ridley, much later to feature as Private Godfrey in *Dad's Army* (BBC, 1968–77).
24. In 1953, the number of television licences in the UK had just exceeded 2 million and the campaign for commercial TV was beginning to develop significant support. The BBC's own research indicated that some 56 per cent of the adult population viewed the Coronation Service on TV (not necessarily in their own homes, however). See Henrik Ornebring, 'Writing the History of Television Audiences: The Coronation in the Mass Observation Archive', in Helen Wheatley (ed.), *Re-Viewing Television History* (London and New York: I.B.Tauris, 2007), pp. 170–83.
25. Barr and Stokes both provide useful and detailed accounts of this film and the general context of the relationships between British TV and film in the 1950s and 60s. As they indicate, television could be shown, as in this case, from the point of view of the audience – usually implying some degenerative, hypnotic effect or anti-social consequence – or featured as a 'behind-the-scenes' setting, the TV studio and production, as for instance in *Simon and Laura* (1956). Charles Barr, 'Broadcasting and Cinema: 2:

Screens within Screens', in Charles Barr (ed.), *All Our Yesterdays: 90 Years of British Cinema* (London: BFI, 1986), pp. 206–24; Jane Stokes, *On Screen Rivals: Cinema and Television in the United States and Britain* (Basingstoke: Macmillan, 1999), pp. 93–110. See also Christine Geraghty, *British Cinema in the Fifties: Gender, Genre and the 'New Look'* (London and New York: Routledge, 2000), pp. 16–18.

26. In his review of the film for the *Daily Mail* (24 November 1953), Cecil Wilson noted that the film was a remarkably 'good-natured joke', given that TV 'had been blamed for reducing cinema attendances by 17,000,000 in the first quarter of this year' (BFI microfiche). See, for related discussion, John Spraos, *The Decline of the Cinema* (London: Allen and Unwin, 1962).
27. Barr, 'Broadcasting and Cinema 2', pp. 210–11 (emphasis in original).
28. 'Lucifer didn't Set Me on Fire', *Sunday Chronicle*, 29 November 1953, BFI microfiche.
29. Lord, in his biography, records that Niven was to remember the film as 'a dreadfully corny, ludicrous farce, one of the worst that he made'. Graham Lord, *Niv: The Authorised Biography of David Niven* (London: Orion, 2003), p. 178.
30. Apart from the glamorous 'international' locations, the cast also features Herbert Lom, Anne Vernon and, in a short cameo role, Humphrey Bogart. Harry Kurnitz, who scripted the film, was a prolific writer who had worked in Hollywood until, in 1946, he was forced into exile because of his membership of the Communist Party.
31. Leonard Mosley, *Daily Express*, 29 January 1954. See also other reviews of the film on BFI microfiche.
32. George Perry, *Forever Ealing: A Celebration of the Great British Film Studio* (London: Pavilion, 1981), p. 138.
33. Harper and Porter, *British Cinema of the 1950s*, p. 66. For a more positive assessment of the film, which emphasises its novelty and embodiment of Crichton's instinct to distance himself from the T. E. B. Clarke Ealing norm of the time, see Murphy in this volume.
34. Based on a wafer-thin script by William Rose, Hawkins was cast against type and certainly this rather humdrum tale contradicted his developing image as a leading heroic male either as a police, navy or military commanding officer. For relevant discussion, see Andrew Spicer, *Typical Men: The Representation of Masculinity in Popular British Cinema* (London and New York: I.B.Tauris, 2001). Not surprisingly, Hawkins made no reference to his part in this film in his autobiography, *Anything for a Quiet Life* (London: Coronet, 1973).
35. Harper and Porter suggest that the film is remarkable for 'the direct manner in which patriarchal power is presented' (*British Cinema of the 1950s*, p. 66). While this is undoubtedly the case, the hero's decision to emigrate fails largely as a result of his wife and daughter's subtle resistance to his crackpot, thoughtless scheme. See also reviews by Dilys Powell, *Sunday Times*, 2 October 1955, and C. A. Lejeune, *Observer*, 2 October 1955, both BFI microfiche.
36. See Burton and O'Sullivan, *The Cinema of Basil Dearden and Michael Relph*, for more detailed discussion and analysis of these two films.
37. *Who Done It?* was reviewed in *Kinematograph Weekly* as 'falling short of the Ealing high standard. It'll probably amuse the ninepennies, but is unlikely to get far without a substantial second or, rather crutch.' 5 April 1956, p. 15. Jympson Harman, writing in the *Evening News*, found *Davy* to be 'probably the most "corny", unsophisticated picture ever to slip through Sir Michael Balcon's academic sieve'. 2 January 1958, BFI microfiche.

13 Ambiguity and Achievement
1. Charles Barr, *Ealing Studios* (California: University of California Press, 1998), p. 137.
2. John Russell Taylor, *Alec Guinness: A Celebration* (London: Pavilion, 1985), p. 79.
3. Barr, *Ealing Studios*, p. 139.
4. Harland Kennedy, 'Sir Alec', *Film Comment* vol. 19 no. 4, p. 14.

14 Children of Ealing
1. See Christine Geraghty, *British Cinema in the Fifties: Gender, Genre and the 'New Look'* (London and New York: Routledge, 2000), pp. 133–54.
2. Charles Crichton, 'Children and Fantasy', in Roger Manvell (ed.), *Penguin Film Review* vol. 2 no. 7 (London: Penguin, 1948), p. 44.
3. Annette Kuhn, *Family Secrets: Acts of Memory and Imagination* (London and New York: Verso, 1995), pp. 23–4.
4. Philip Kemp, *Lethal Innocence: The Cinema of Alexander Mackendrick* (London: Methuen, 1991), p. 70.

15 Ealing's Australian Adventure

1. Peter Ustinov, 'Foreword', in George Perry, *Forever Ealing* (London: Pavillion, 1994), p. 7.
2. Harry Watt, 'Filming the Soldier: Australia's Turn Next', *Sydney Morning Herald*, 4 December 1943, p. 7.
3. Harry Watt, 'Our Failure in Films: Ideal Material, But Wrong Technique. Documentary Approach Needed', *Sydney Morning Herald*, 17 June 1944, p. 2
4. Harry Watt, 'Romance on Location', *Sydney Morning Herald*, 9 February 1946, p. 6.
5. 'Overlanders' Preview: Critical Audience Enthusiastic', *Sydney Morning Herald*, 19 September 1946, p. 3.
6. 'Stars of "The Overlanders" Had to Miss the Premiere', *Sydney Morning Herald*, 28 September 1946, p. 1.
7. 'New Films Reviewed', *Sydney Morning Herald*, 30 September 1946, p. 10.
8. F. Keith Manzie, 'An Australian Film That is Worth While', *The Argus* (Weekend Magazine supplement), 9 November 1946, p. 4.
9. Ibid.
10. Quoted in 'Stars of "The Overlanders" Had to Miss the Premiere', p. 1.
11. 'New Films Reviewed', p. 10.
12. Quoted in Bill Collins, 'The Overlanders', in Scott Hocking (ed.), *100 Greatest Films of Australian Cinema* (Richmond, VA: Scribal/Australian Film Commission, 2006), p. 158.
13. Watt, 'Romance on Location', p. 6; Harry Watt, 'The Overlanders', *Picture Post*, 18 May 1946, p. 12.
14. 'Australian Production Scheme', enclosed with correspondence from Michael Balcon to John Davis, 12 April 1946 (file G/12, Michael Balcon Collection: BFI).
15. Harry Watt, 'Report on Australia', 9 January 1946 (file G2/a, Michael Balcon Collection: BFI).
16. Michael Balcon, 'Letters to the Editor: Dollars For Films, Effect of New Duty', *The Times*, 12 August 1947, p. 5.
17. Harry Watt, 'You Start from Scratch in Australia', *Penguin Film Review* vol. 9, May (London: Penguin, 1949), p. 14.
18. 'Natives on Floor in Goods Vans', *Sydney Morning Herald*, 25 May 1949, p. 5.
19. Correspondence from Harry Watt to Michael Balcon, 11 February 1948 (file G/2, Michael Balcon Collection: BFI).
20. 'Ealing Studios present Eureka Stockade: Spectacular drama of Australia's Gold Rush' (press book) (London: Associated British-Pathé/Ealing Studios, 1949).
21. Correspondence from Eric Williams to Michael Balcon, 10 July 1948 (file G/1, Michael Balcon Collection: BFI).
22. Graham Shirley and Brian Adams, *Australian Cinema: The First Eighty Years* (Hong Kong: Currency Press, 1989), p. 183.
23. Correspondence from Michael Balcon to Eric Williams, 12 February 1948 (file G/1, Michael Balcon Collection: BFI); correspondence from Harry Watt to Michael Balcon, 5 August 1948 (file G/2, Michael Balcon Collection: BFI).
24. 'New Films', *Sunday Herald*, 8 May 1949, p. 9; Marjorie Beckingsale, 'Talking of Films: Eureka Stockade', *Australian Woman's Weekly*, 21 May 1949, p. 36.
25. '130 Aboriginal Tribesmen Steal Show in New Picture', *Sydney Morning Herald*, 24 August 1950, p. 13.
26. 'Reviews of New Films in Sydney', *Sunday Herald* (features section), 27 August 1950, p. 5.
27. '"Bitter Springs" Premiere Here Tonight; London Next Month', *The Advertiser*, 23 June 1950, p. 1.
28. Shirley and Adams, *Australian Cinema*, p. 183.
29. Ibid.
30. Correspondence from Gordon Ellis (British Empire Films) to Reginald Baker, 8 January 1957 (file I/175, Michael Balcon Collection: BFI).
31. Correspondence from Reginald Baker to N. Bernard Freeman (MGM Australia), 8 April 1957 (file I/175a, Michael Balcon Collection: BFI).
32. 'Free Seats at "Shiralee"' *Sydney Morning Herald*, 9 July 1957, p. 3.
33. 'The Shiralee: Film of Australian Life', *The Times*, 11 July 1957, p. 5.
34. 'Reviews of New Films: The Shiralee', *Sydney Morning Herald*, 25 August 1957, p. 75.
35. 'New Film Releases: The Shiralee', *Australian Woman's Weekly*, 4 September 1957, p. 71.
36. Perry, *Forever Ealing*, pp. 168–9.
37. Ibid., pp. 170–1.

38. Shirley and Adams, *Australian Cinema*, p. 206.
39. Harry Watt quoted in Josephine O'Neill, 'The Man Who Made "The Overlanders" Returns: Sydney Is His Set', *Sydney Morning Herald*, 22 February 1958, p. 17.
40. Eric Williams, quoted in David Burke, '"Shots" at Last from Old Pinchgut', *Sydney Morning Herald*, 2 November 1958, p. 37.
41. 'This Week's New Films: "The Siege of Pinchgut"', *Sydney Morning Herald*, 6 March 1960, p. 95.
42. John Davis, quoted in Geoffrey Macnab, *J. Arthur Rank and the British Film Industry* (London: Routledge, 1993), p. 114.
43. Michael Balcon, *Michael Balcon Presents … A Lifetime of Films* (London: Hutchinson, 1969), p. 151.
44. Ibid., p. 156.
45. Eric Reade, *History and Heartburn: The Saga of Australian Film, 1896–1978* (Madison: Fairleigh Dickinson University Press), p. 126.
46. Charles Barr, *Ealing Studios* (London: Cameron and Hollis, 1999), p. 194.

16 'Who'll pay for reality?'

1. Charles Barr, *Ealing Studios* (Berkeley and London: University of California Press, 1998), p. 53.
2. Julian Petley, 'The Lost Continent', in Charles Barr (ed.), *All Our Yesterdays: 90 Years of British Cinema* (London: BFI, 1986), p. 110.
3. David Butler, *Fantasy Cinema Impossible Worlds on Screen* (London and New York: Wallflower, 2009), p. 43.
4. Jacqueline Furby and Claire Hines, *Fantasy* (London and New York: Routledge, 2011), p. 28.
5. Petley, 'The Lost Continent', p. 111.
6. Furby and Hines, *Fantasy*, p. 40.
7. Michael Balcon, *Realism or Tinsel*, lecture given to the Film Workers' Association, 1943, p. 11.
8. Jonathan Rigby, *English Gothic* (Surrey: Reynolds and Hearn, 2004), p. 36.
9. Michael Balcon, *Michael Balcon Presents … A Lifetime of Films* (London: Hutchinson, 1969), p. 158.
10. Anthony Lane, *New Yorker*, 31 January 1994, accessed online at: http://www.thestickingplace.com/books/books/alexander-mackendrick/articles/no-illusions/
11. George Orwell, Diaries, accessed online at http://orwelldiaries.wordpress.com/tag/the-peaceful-inn/
12. Wayne Drew, programme notes for *The Halfway House*, March 1985, BFI microjacket.
13. George Perry, *Forever Ealing* (London: Pavilion, 1985), p. 76.
14. This and all other contemporary reviews quoted in the chapter are from the title microjackets held in the BFI Library.
15. Drew, programme notes.
16. Perry, *Forever Ealing*, p. 79.
17. Butler, *Fantasy Cinema*, p. 96.
18. For further analysis of this film, see James Chapman, 'Mr Priestley Goes to Ealing: *They Came to a City* (1944) and British Wartime Cinema', unpublished article (2008).
19. Furby and Hines, *Fantasy*, p. 46.
20. Ibid., p. 50.
21. Butler, *Fantasy Cinema*, p. 92.
22. Perry, *Forever Ealing*, p. 78.
23. Barr, *Ealing Studios*, p. 52. Barr came to revise that view in his updated 1993 edition of *Ealing Studios*, describing both *The Halfway House* and *They Came to a City* as 'bold, eloquent and powerful' (p. 185).
24. James Walters, *Fantasy Film: A Critical Introduction* (Oxford and New York: Berg, 2011), p. 95.
25. Ibid., pp. 95–6.
26. Perry, *Forever Ealing*, p. 138.
27. The famous inscription written by Balcon on the plaque put up at Ealing Studios in 1955. Quoted in Barr, *Ealing Studios*, p. 7.

17 A Feminine Touch?

1. Michael Balcon, *Michael Balcon Presents … A Lifetime of Films* (London: Hutchinson, 1969), p. 170.
2. Quoted Charles Barr, *Ealing Studios*, 3rd edn (Berkeley and London: University of California Press, 1998),

p. 77. Christine Geraghty provides an astute summary of feminist critiques of Ealing in *British Cinema in the Fifties: Gender, Genre and the 'New Look'* (London and New York: Routledge, 2000), pp. 76–92.
3. Barr, *Ealing Studios*, p. 58.
4. *Evening News*, 29 March 1956.
5. Quoted in Brian McFarlane, *An Autobiography of British Cinema* (London: Methuen, 1997), pp. 419–20.
6. M. Sweet, *Shepperton Babylon: The Lost Worlds of British Cinema* (London: Faber, 2005), p. 175. Some other notable women writers who worked for Ealing briefly include Bridget Boland, who wrote draft screenplays for *Nowhere to Go* (1958) and the Ealing-originated project *The Scapegoat* (1959), and Christianna Brand, who is credited with additional dialogue for *Secret People* in
L. Anderson, *Making a Film: The Story of Secret People* (London: Allen and Unwin, 1952), p. 131.
7. M. Box, *Odd Woman Out* (London: Leslie Frewin, 1974), p. 205. Kay Mander, interviewed on the Channel 4 documentary *Fifties Features* (28 September 1986). Correspondence between Jill Craigie and Michael Balcon, Michael Balcon Papers in BFI Special Collections (MEB I/45). Erica Masters worked as an uncredited assistant director on *The Titfield Thunderbolt*. Mary Habberfield worked at Ealing in sound editing in the 1940s and 50s.
8. Philip Kemp, *Lethal Innocence: The Cinema of Alexander Mackendrick* (London: Methuen, 1991), p. 15.
9. Balcon quoted in John Ellis, 'Made in Ealing', *Screen*, Spring 1975, p. 119.
10. Quoted in McFarlane, *An Autobiography of British Cinema*, p. 421.
11. See Barr on the script's character summaries for examples of this, *Ealing Studios*, pp. 99–100.
12. Brian McFarlane, 'Pink String and Sealing Wax', in B. McFarlane (ed.), *The Cinema of Britain and Ireland: 24 Frames* (London: Wallflower, 2005), p. 56.
13. Ibid.
14. Barr, *Ealing Studios*, p. 198.
15. Press book for *The Loves of Joanna Godden*, BFI Library.
16. *Daily Mail*, 13 June 1947.
17. Barr, *Ealing Studios*, p. 68.
18. Undated press release from Ealing Studios, Googie Withers microfiche, BFI Library. There's also a subplot about wifely respectability and the racy connotations of going blonde in George Formby's final comedy at Ealing, *Turned Out Nice Again* (1941).
19. Barr, *Ealing Studios*, p. 70.
20. According to the *Motion Picture Herald* poll cited in an article on Withers in *Leader*, 22 January 1949.
21. Barr, *Ealing Studios*, p. 70.
22. Morgan, interviewed on the Channel 4 documentary *Fifties Features* (28 September 1986). The fact that Ealing were willing to invest substantially in such films is suggested by the *Dance Hall* press book's statement that 'when built, the set occupied the whole of Ealing's largest sound stage'.
23. Geraghty, *British Cinema in the Fifties*, p. 89.
24. Ibid., p. 83.
25. Press book for *Cage of Gold*, BFI Library.
26. *Star*, 22 September 1950.
27. *Sunday Express*, 11 June 1950.
28. The same actress had already suffered similar typing as another gullible young woman in thrall to trivial mass media in the anti-TV broadside *Meet Mr Lucifer* (1953).
29. Barr, *Ealing Studios*, p. 150.
30. *Kinematograph Weekly*, 4 December 1952. Ealing's belief in women's bargaining power proved to be misplaced in this particular instance: the film was not a huge commercial success.
31. *Kinematograph Weekly*, 7 August 1952.
32. *The Times*, 4 August 1952.
33. Pam Cook, '*Mandy*: Daughter of Transition', in Charles Barr (ed.), *All Our Yesterdays: 90 Years of British Cinema* (London: BFI, 1986), p. 356.
34. Annette Kuhn, *Family Secrets: Acts of Memory and Imagination* (London: Verso, 1995), p. 30.
35. Sue Harper and Vincent Porter, *British Cinema of the 1950s: The Decline of Deference* (Oxford: Oxford University Press, 2003), p. 61.
36. Later in the film, Harry's divorce solicitors suggest with jocular misogyny, 'clocking the little woman is always a mistake even if she deserves it'.
37. Kemp, *Lethal Innocence*, p. 75.

38. Balcon, *Michael Balcon Presents*, p. 181.
39. *Daily Mirror*, 12 November 1954.
40. *Sunday Times*, 14 November 1954.
41. Barr, *Ealing Studios*, p. 205.
42. Richard Findlater, *Sunday Express*, 14 November 1954. The critics for the *Daily Sketch*, *Daily Express* and *Sunday Dispatch* also admitted crying.
43. Press book for *The Divided Heart*, BFI Library.
44. Thomas Spencer, *Daily Worker*, 31 March 1956.
45. MPAA memo on script of *The Feminine Touch*, dated 6 July 1955, in Michael Balcon papers (MEB I/327a), BFI Special Collections.
46. *The Feminine Touch* press book, BFI Library.
47. Harper, S., 'From *Holiday Camp* to High Camp: Women in British Feature Films 1945–51', in Andrew Higson (ed.), *Dissolving Views: Key Writings on British Cinema* (London: Continuum, 1996), p. 103.
48. *Reynolds News*, 1 April 1956.
49. Press book for *The Feminine Touch*, BFI Library.
50. Correspondence between Craigie and Balcon (MEB I/45).
51. Ibid.
52. S. Harper, *Women in British Cinema* (London: Continuum, 2000), p. 90.
53. Derek Granger, *Financial Times*, 3 April 1956.
54. See Balcon papers quoted in Harper, *Women in British Cinema*, p. 92.

18 'A riot of all the colours in the rainbow'

1. For examples of this trend, see: John Ellis (1975) 'Made in Ealing', *Screen* vol. 16 no. 1, pp. 78–127; Charles Barr, *Ealing Studios* (Woodstock, NY: Overlook Press, 1980); George Perry, *Forever Ealing* (London: Pavillion, 1981); John Ellis, 'The Quality Film Adventure: British Critics and the Cinema 1942–1948', in Andrew Higson (ed.), *Dissolving Views: Key Writings on British Cinema* (London: Cassell, 1996), pp. 66–93; James Chapman (2005) '"The true business of the British movie"? *A Matter of Life and Death* and British Film Culture', *Screen* vol. 46 no. 1, pp. 33–49; Geoffrey Macnab, *J. Arthur Rank and the British Film Industry* (London: Routledge, 1993); Duncan Petrie, *The British Cinematographer* (London: BFI, 1996); Sue Harper and Vincent Porter, *British Cinema of the 1950s: The Decline of Deference* (Oxford: Oxford University Press, 2003), pp. 57–73.
2. Keith M. Johnston, 'Ealing's Colour Aesthetic: *Saraband for Dead Lovers*', *Journal of British Cinema and Television* vol. 7 no. 1, pp. 21–33.
3. '*Saraband for Dead Lovers* review', *Daily Worker*, 11 September 1948.
4. The eleven films are *Where No Vultures Fly* (Watt, 1951), *The Titfield Thunderbolt* (Crichton, 1953), *The Love Lottery* (Crichton, 1954), *West of Zanzibar* (Watt, 1954), *The Rainbow Jacket* (Dearden, 1954), *Lease of Life* (Frend, 1954), *Out of the Clouds* (Dearden, 1955), *Touch and Go* (Truman, 1955), *The Ladykillers* (Mackendrick, 1955), *The Feminine Touch* (Jackson, 1956) and *Davy* (Relph, 1957).
5. Quoted in Steve Neale, *Cinema and Technology: Image, Sound, Colour* (London: Macmillan Education, 1985), pp. 135–9.
6. Guy Green, quoted in John Huntley, *British Technicolor Films* (London: Skelton Robinson, 1949), pp. 117–18; also quoted in Neale, *Cinema and Technology*, p. 149.
7. Major A. Cornwall-Clyne, 'What's Wrong with Colour?', in Huntley, *British Technicolor Films*, p. 194; also quoted in Neale, *Cinema and Technology*, p. 149.
8. Neale, *Cinema and Technology*, p. 147.
9. Michael Relph, 'Designing a Colour Film', in *Saraband for Dead Lovers: The Film and its Production at Ealing Studios* (London: Convoy, 1948), p. 78.
10. Ibid., pp. 83–4.
11. Douglas Slocombe, 'Colour Through the Camera', in *Saraband for Dead Lovers: The Film and its Production at Ealing Studios*, p. 86.
12. Ibid., p. 87.
13. For more on the use of colour in *Saraband for Dead Lovers*, see Johnston, 'Ealing's Colour Aesthetic'.
14. Jack Cardiff, *Magic Hour* (London: Faber & Faber, 1996), pp. 102–3.
15. Michael Balcon, 'The Technical Problems of *Scott in the Antarctic*', *Sight & Sound* vol. 17 no. 68, Winter 1948–9, p. 154.

16. Petrie, *The British Cinematographer*, pp. 34–6.
17. Ibid., p. 36.
18. Slocombe, 'Colour Through the Camera', p. 86.
19. '*Where No Vultures Fly* review', *Monthly Film Bulletin* vol. 18 no. 215, December 1951, p. 374; MMW, '*Touch and Go* review', *Today's Cinema* vol. 85 no. 7360, 26 September 1955, p. 12; PH, 'Out of the *Clouds* review', *Monthly Film Bulletin* vol. 22 no. 254, March 1955, p. 35; LHC, '*West of Zanzibar* review', *Today's Cinema* vol. 82 no. 6978, 25 March 1954, p. 6; Josh Billings, '*The Feminine Touch* review', *Kinematograph Weekly* vol. 468 no. 2539, 12 April 1956, p. 20.
20. Billings, '*The Feminine Touch* review', p. 20.
21. *Lease of Life* and *The Love Lottery* press books, BFI microfiche.
22. Perry, *Forever Ealing*, p. 163.
23. Tim Murphy, 'A Song and Dance at the Local: Thoughts on Ealing', in Robert Murphy (ed.), *The British Cinema Book*, 2nd edn (London: BFI, 2001), p. 83.
24. Neale, *Cinema and Technology*, p. 154.
25. David W. Samuelson, 'The Photography of *Julia*', *American Cinematographer* vol. 59 no. 3, March 1978, p. 251.
26. Paul Beeson, quoted in Tom Hutchinson, 'This Was Director's Dilemma', *Kinematograph Weekly* vol. 461 no. 2512, 18 August 1955, p. 23.
27. Neale, *Cinema and Technology*, p. 139.
28. Perry, *Forever Ealing*, p. 12.
29. 'Ealing Studios' Production Plans for 1954,' Ealing Studios Cuttings File, BFI collections.
30. Harper and Porter, *British Cinema of the 1950s*, pp. 57–73.
31. '*Saraband for Dead Lovers* review', *Daily Worker*, 11 September 1948.

19 Against the Grain

1. Kathleen Tynan, *The Life of Kenneth Tynan* (London: Weidenfeld and Nicolson, 1987), p. 140.
2. *Harper's* magazine, August 1955, pp. 52–5: reprinted in *Films and Filming*, slightly abridged and spread across two issues, November–December 1955. The *Harper's* title, 'Tight Little Studio', plays on the American release title, *Tight Little Island*, of *Whisky Galore!*, Mackendrick's first film as director.
3. Philip Kemp, *Lethal Innocence: The Cinema of Alexander Mackendrick* (London: Methuen, 1991), p. 135.
4. Tynan, *The Life of Kenneth Tynan*, p. 140.
5. Kathleen Tynan, *Kenneth Tynan Letters* (London: Weidenfeld and Nicolson, 1994), pp. 220–8.
6. Letter to Simon Michael Bessie, 22 October 1957: *Collected Letters*, p. 212.
7. Unless otherwise stated, material cited in what follows is drawn from this Michael and Aileen Balcon Collection.
8. According to Balcon, Ealing did not have a financial interest in *The Scapegoat* but 'serviced' it for MGM. See Michael Balcon, *Michael Balcon Presents ... A Lifetime of Films* (London: Hutchinson, 1969), p. 187. But Ealing personnel, including Balcon himself as producer and Tynan as script editor, were evidently as committed to it as to the other films of this period. See Piers Paul Read, *Alec Guinness: The Authorised Biography* (London: Simon & Schuster, 2003) for further discussion of *The Scapegoat*.
9. This memo of Tynan's on *Dunkirk* is undated, but follows closely on from one dated 20 February 1956.
10. Benedek's best-known film was *The Wild One*, with Marlon Brando (1953). Soon after this flirtation with Ealing, he directed the Anglo-American production *Moment of Danger* (1960).
11. From the editorial in *Movie* no. 1, 'written by V. F. Perkins on behalf of the editorial board'. Reprinted in Ian Cameron (ed.), *The Movie Reader* (London: November, 1972), p. 10. The same editorial makes positive reference to Mackendrick and to Seth Holt, as well to Hamer.
12. 22 October 1958, letter to screenwriter David Climie, from the small Climie Special Collection held at the BFI.
13. See Balcon, *Michael Balcon Presents*, p. 197.
14. Kemp, *Lethal Innocence*, p. 135.
15. Seth Holt, interviewed by Kevin Gough-Yates, in *Screen* vol. 10 no. 6, November 1969, p. 9.
16. For his work with de Rochemont and Lang, and on *The Blue Lamp*, see Jan Read, *Young Man in Movieland* (Oxford and Maryland: Scarecrow Press, 2004). Details supplemented by interview at Read's home in St Andrews, December 2011.

17. 'Cagney and the Mob', in *Sight & Sound* vol. 20 no. 1, May 1951, pp. 12–16
18. Balcon, *Michael Balcon Presents*, p. 187.
19. For their limited North American release, *Barnacle Bill* would be retitled *All at Sea* and *Davy* retitled *The Mad Morgans*. Tynan's suggestions had included, respectively, *All Visitors Ashore* and *Curtain Up*.
20. 'The Entertainer *and* Davy are perfectly complementary, equally expressive of their time.' Charles Barr, *Ealing Studios*, 3rd edn (London: Cameron and Hollis, 1999), p. 12.

20 The Legacy of Ealing

1. www.ealingstudios.com, accessed 31 January 2012.
2. Geoffrey Macnab, 'Ealing Hands', *Screen International* no. 1726, August 2010, p. 6.
3. www.ealingstudios.com/Production/Film.html, accessed 31 January 2012.
4. Take, for example, the following *Sight & Sound* reviews from around the year 2000: 'The Cup has begun to seem like an Ealing comedy in which a community draws together to achieve a shared objective.' Geoffrey Macnab, 'The Cup', *Sight & Sound*, December 1999, p. 42, or 'In this respect, House! follows a folksy, Ealing-comedy tradition of small-scale, ramshackle enterprises ranged against the soulless face of progress', Ed Lawrenson, 'House!', *Sight & Sound*, April 2000, p. 49, and 'a rosy outcome which would be next to heresy in the morally upright Ealingesque world director Nigel Cole consciously evokes', Ed Lawrenson, 'Saving Grace', *Sight & Sound*, June 2000, p. 53.
5. Geoffrey Macnab, 'The Shadow Cast by Ealing Comedies is No Laughing Matter', *Independent*, 15 July 2011, www.independent.co.uk/arts-entertainment/films/features/the-shadow-cast-by-ealing-comedies-is-no-laughing-matter-2313748.html, accessed 31 January 2012.
6. See, for example, Chris Tookey on *Attack the Block*. 'There are inevitably echoes of Shaun Of The Dead fighting off that unwelcome incursion of zombies in Finsbury Park, but the notion of uniting classes and races to resist a common enemy goes back to the heyday of Ealing comedy.' 'Hoodies You Want to Hug: A Teen Gang Fights Aliens in the Best Monster Movie since Shaun Of The Dead', *Daily Mail*, 13 May 2011, www.dailymail.co.uk/tvshowbiz/reviews/article-1386562/Attack-The-Block-review-The-best-monster-movie-Shaun-Of-The-Dead.html#ixzz1n7xnDTvL, accessed 31 January 2012.
7. Macnab, 'The Shadow Cast by Ealing Comedies is No Laughing Matter'.
8. Ibid.
9. Brian McFarlane, 'The More things Change ... British Cinema in the 90s', in Robert Murphy (ed.), *The British Cinema Book*, 3rd edn (London: BFI, 2009), p. 366.
10. Ibid., p. 370.
11. Paraphrased from Charles Barr, *Ealing Studios*, 2nd edn (London: Studio Vista, 1993), pp. 6–7.
12. Ibid., p. 39.
13. Michael Balcon, *Michael Balcon Presents ... A Lifetime of Films* (London: Hutchinson, 1969), p. 168.
14. Balcon, *Michael Balcon Presents ...* .
15. Philip Kemp, Reference Guide to British and Irish Film Directors via screenonline, accessed 27 January 2012.
16. Barr, *Ealing Studios*, p. 39.
17. Ibid., p. 180.
18. John Ellis, 'Made in Ealing', *Screen* vol. 16 no. 1, 1975, p. 106.
19. Macnab, 'The Shadow Cast by Ealing Comedies is No Laughing Matter'.
20. Ibid., p. 177.
21. Ibid.
22. Paraphrased from Barr, *Ealing Studios*, p. 177.
23. Colin MacArthur, 'Local Hero', *Visions* (3 March 1983).
24. Ibid.
25. Ibid.
26. Ellis, 'Made in Ealing', p. 113.
27. Andrew Higson, 'The Instability of the National', in Justine Ashby and Andrew Higson (eds), *British Cinema, Past and Present* (Oxford: Routledge, 2000), p. 37.
28. Ibid., p. 44.
29. Julia Hallam, 'Film, Class and National identity', in Ashby and Higson, *British Cinema, Past and Present*, p. 267.
30. Ibid., p. 266.

31. *Liverpool Daily Post*, www.icliverpool.icnetwork.co.uk
32. 'Putting Down Roots', *Three Minute Wonder*, Channel 4 (1–3 August 2005).
33. Simon Braund, *Empire*, July 2004, p. 45.
34. Ibid., p. 56.
35. David Arnold, 'On Ladies, Killing, and the Ethics of the Remake: The Coen Brothers Do The Ladykillers', *Postscript* vol. 27 no. 2, p. 140.
36. Ibid., pp. 130–1.
37. Ibid., p. 136.
38. Braund, *Empire*, p. 45.
39. Graham Linehan, 'My Today Programme Ambush', *Guardian*, www.guardian.co.uk/commentisfree/2011/jun/08/today-programme-the-ladykillers-graham-linehan, accessed 31 January 2012.
40. Paraphrased from Barr, *Ealing Studios*, pp. 6–7.
41. Bryanston and its relationship to Ealing is discussed in some detail in Barr's *Ealing Studios*.
42. Sue Harper and Vincent Porter, *British Cinema of the 1950s: The Decline of Deference* (Oxford: Oxford University Press, 2003), pp. 64–5.
43. Amanda Harrison, *Screen International*, 5 March 1993, p. 4, and *Broadcast*, 28 October 1994.
44. Amanda Harrison, *Screen International*, 23 September 1993, p. 16.
45. *Screen International*, 2 June 1995, p. 2.
46. Bob Allen, AMPS (the newsletter of the Association of Motion Picture Sound), Spring 1999, p. 12.
47. Adam Minns, *Screen International*, 11–24 May 2001, p.18.
48. Macnab, 'The Shadow Cast by Ealing Comedies is No Laughing Matter'.
49. www.ealingstudios.com/Production/Film.html, accessed 31 January 2012.

MICHAEL BALCON'S EALING STUDIOS
A FILMOGRAPHY

Note: Michael Balcon generally took a producer credit on Ealing releases (more occasionally he is identified as executive producer, or the film is 'presented by'). For reasons of space, these credits have been omitted, except where Balcon shares credit with another. Similarly, Ealing Studios' sole production company credit should be assumed for all releases with the following exceptions, all identified in the filmography: i) releases between 1938 and 1940 credited to CAPAD (Cooperative Association of Producers and Distributors); ii) comedy releases between 1939 and 1941 credited to Associated Talking Pictures; iii) wartime shorts where credit is shared with another production entity; iv) the seven releases following the sale of the studios at Ealing in 1955, where 'Ealing Films Limited' shares its credit with Metro-Goldwyn-Mayer or, for the final Ealing release, with Associated British Picture Corporation.

THE GAUNT STRANGER
(aka: The Phantom Strikes)
November 1938 / Black and white / 73 minutes
CREDITS: DIRECTOR: Walter Forde. PRODUCTION COMPANY: CAPAD. ASSOCIATE PRODUCER: S. C. Balcon. SCREENPLAY: Sidney Gilliat. *Based on the play* The Ringer *by*: Edgar Wallace. PHOTOGRAPHY: Ronald Neame. EDITOR: Charles Saunders. ART DIRECTOR: O. F. Werndorff.
CAST: Sonnie Hale (Samuel Cuthbert Hackett), Wilfrid Lawson (Maurice Meister), Louise Henry (Cora Ann Milton), Patrick Barr (Insp. Alan Wembury), Alexander Knox (Dr Antony Lomond), John Longden (Det. Insp. Bliss), Peter Croft (John Lenley), Patricia Roc (Mary Lenley), George Merritt (Sgt Carter), Arthur Hambling (Det. Sgt Richards), Charles Eaton (Col. Walford).

THE WARE CASE
December 1938 / Black and white / 78 minutes
CREDITS: DIRECTOR: Robert Stevenson. PRODUCTION COMPANY: CAPAD. ASSOCIATE PRODUCER: S. C. Balcon. SCREENPLAY: Robert Stevenson, Roland Pertwee, E. V. H. Emmett. *Based on the play by*: George Pleydell Bancroft. DIRECTOR OF PHOTOGRAPHY: Ronald Neame. EDITOR: Charles Saunders. ART DIRECTOR: O. F. Werndorff. MUSIC: Ernest Irving.
CAST: Clive Brook (Sir Hubert Ware), Jane Baxter (Lady Margaret 'Meg' Ware), Barry K. Barnes (Michael Adye), C. V. France (judge), Francis L. Sullivan (attorney-general), Frank Cellier (Skinner), Edward Rigby (Tommy Bold), Peter Bull (Eustace Edo), Dorothy Seacombe (Mrs Slade), Athene Seyler (Mrs Pinto), Elliot Mason (Mrs Smith), Wallace Evennett (Munnings), J. R. Lockwood (Denny), Glen Alyn (Claire), Peggy Novak (Lucy), John Laurie (Henson), Wally Patch (taxi driver), Alf Goddard (court attendant), Ernest Thesiger (Carter), Charles Paton (foreman of the jury).

LET'S BE FAMOUS
March 1939 / Black and white / 83 minutes
CREDITS: DIRECTOR: Walter Forde. PRODUCTION COMPANY: Associated Talking Pictures. ASSOCIATE PRODUCER: S. C. Balcon.

SCREENPLAY: Roger MacDougall, Allan MacKinnon. PHOTOGRAPHY: Ronald Neame, Gordon Dines. EDITOR: Ray Pitt. ART DIRECTOR: O. F. Werndorff. INCIDENTAL MUSIC: Van Phillips. SONGS: Noel Gay.
CAST: Jimmy O'Dea (Jimmy Houlinan), Betty Driver (Betty Pinbright), Sonnie Hale (Finch), Patrick Barr (John Blake), Milton Rosmer (Albert Pinbright), Lena Brown (Polly Pinbright), Basil Radford (Watson), Henry Hallett (Grenville), Garry Marsh (Walton), Alf Goddard (Battling Bulger), Hay Plumb (Randall), Franklin Bellamy (Ali Benali), Jack Vyvyan (Alfie).

TROUBLE BREWING
March 1939 / Black and white / 87 minutes
CREDITS: DIRECTOR: Anthony Kimmins. PRODUCTION COMPANY: Associated Talking Pictures. PRODUCER: Jack Kitchin. SCREENPLAY: Angus MacPhail, Michael Hogan, Anthony Kimmins. PHOTOGRAPHY: Ronald Neame. EDITOR: Ernest Aldridge. ART DIRECTOR: Wilfrid Shingleton. MUSIC AND LYRICS: George Formby, Harry Gifford, Fred E. Cliffe.
CAST: George Formby (George Gullip), Googie Withers (Mary Brown), Gus McNaughton (Bill Pike), Garry Marsh (A. G. Brady), C. Denier Warren (Maj. Alfred Hopkins), Beatrix Feilden-kaye (housekeeper), Joss Ambler (Lord Redhill), Ronald Shiner (Bridgewater), Martita Hunt (Madame Berdi), Esma Cannon (maid), Basil Radford (guest at Madame Berdi's), Hal Gordon (driver).

THE FOUR JUST MEN
(aka: *The Secret Four*)
June 1939 / Black and white / 85 minutes
CREDITS: DIRECTOR: Walter Forde. PRODUCTION COMPANY: CAPAD. ASSOCIATE PRODUCER: S. C. Balcon. SCREENPLAY: Angus MacPhail, Sergei Nolbandov, Roland Pertwee. *Based on the novel by*: Edgar Wallace. DIRECTOR OF PHOTOGRAPHY: Ronald Neame. EDITOR: Charles Saunders. ART DIRECTOR: Wilfrid J. Shingleton. COSTUMES: Ariana, Marianne. MUSIC: Ernest Irving.
CAST: Hugh Sinclair (Humphrey Mansfield), Griffith Jones (James Brodie), Francis L. Sullivan (Monsieur Léon Poiccard), Frank Lawton (James Terry), Anna Lee (Ann Lodge), Alan Napier (Sir Hamar R. J. Burrell), Athole Stewart (assistant commissioner), George Merritt (Insp. Falmouth), Arthur Hambling (Constable Benham), Garry Marsh (Bill Grant), Ellaline Terriss (Lady Woolford), Percy Walsh (prison governor), Roland Pertwee (Hastings), Eliot Makeham (Simmonds), Henrietta Watson (Mrs Truscott), Frederick Piper (pickpocket), Liam Gaffney (taxi driver).

HAPPY FAMILY
June 1939 / Black and white
CREDITS: DIRECTOR: Walter Forde. SPONSOR: Ministry of Labour
CAST: John Mills (Fred), Eva Moore (Gran), Edmund Gwenn (Dad), Joyce Barbour (Mum), Frank Lawton (Joe), Diana Beaumont (Elsie).

THERE AIN'T NO JUSTICE
August 1939 / Black and white / 81 minutes
CREDITS: DIRECTOR: Pen Tennyson. PRODUCTION COMPANY: CAPAD. ASSOCIATE PRODUCER: Sergei Nolbandov. SCREENPLAY: Penrose Tennyson, Sergei Nolbandov, James Curtis. *From the novel by*: James Curtis. PHOTOGRAPHY: Mutz Greenbaum. EDITOR: Ray Pitt. SETS: Wilfrid Shingleton. MUSIC: Ernest Irving.
CAST: Jimmy Hanley (Tommy Mutch), Edward Rigby (Pa Albert Mutch), Mary Clare (Ma Mutch), Edward Chapman (Sammy Sanders), Phyllis Stanley (Elsie Mutch), Jill Furse (Connie Fletcher), Nan Hopkins (Dot Ducrow), Michael Wilding (Len Charteris), Gus McNaughton (Alfie Norton), Mike Johnson Sr (Harry Dunn), Richard Norris (Stan), Michael Hogarth (Frank Fox), Richard Ainley (Billy Frost), Sue Gawthorne (Mrs Frost), Patsy Hagate (Patsy), John Boxer (Mr Short), Alfred Millen (Perce).

YOUNG MAN'S FANCY
August 1939 / Black and white / 77 minutes
CREDITS: DIRECTOR: Robert Stevenson. PRODUCTION COMPANY: CAPAD. ASSOCIATE PRODUCER: S. C. Balcon. DIALOGUE: Roland Pertwee. ADDITIONAL DIALOGUE: E. V. H. Emmett, Rodney Ackland. STORY: Robert Stevenson. PHOTOGRAPHY: Ronald Neame. EDITOR: Charles Saunders. EDITOR: Ralph Kemplen. ART DIRECTOR: Wilfrid Shingleton. COSTUMES: Molly Nicholson.
CAST: Griffith Jones (Lord Alban), Anna Lee (Ada), Seymour Hicks (Henry, Duke of Beaumont), Martita Hunt (Duchess of Beaumont), Edward Rigby (Gray), Billy Bennett (Captain Boumphrey), Meriel Forbes (Miss Emily Crowther), Felix Aylmer (Sir Caleb Crowther), Aimos (tramp), Francis L. Sullivan (Blackbeard), Phyllis Monkman (Esmée), Aubrey Dexter (Soames), Morton Selten (Mr Fothergill), Allan

Aynesworth (Mr Trubshaw), George Carney (chairman), Irene Eisinger (singer in café), Peter Bull (French soldier), Rognoni (hotel manager), George Benson (ticket seller), O. B. Clarence (guest at ball), Alf Goddard (doorman), Athene Seyler (dressmaker), George Merritt (park keeper).

CHEER BOYS CHEER
August 1939 / Black and white / 84 minutes
CREDITS: DIRECTOR: Walter Forde. PRODUCTION COMPANY: Associated Talking Pictures. ASSOCIATE PRODUCER: S. C. Balcon. SCREENPLAY: Roger MacDougall, Allan MacKinnon. STORY: Ian Dalrymple, Donald Bull. PHOTOGRAPHY: Ronald Neame. EDITOR: Ray Pitt. ART DIRECTOR: Wilfrid Shingleton. COSTUMES: Ariana.
CAST: Nova Pilbeam (Margaret Greenleaf), Edmund Gwenn (Edward Ironside), Peter Coke (John Ironside), Jimmy O'Dea (Matt Boyle), Ivor Barnard (Naseby), Jean Webster Brough (Belle), C. V. France (Tom Greenleaf), Alexander Knox (Saunders), Moore Marriott (Geordie), Graham Moffatt (Albert Baldwin), Walter Forde (pianist at wedding), Hay Plumb (Greenleaf employee).

COME ON GEORGE!
(aka: Bravo George)
November 1939 / Black and white / 89 minutes
CREDITS: DIRECTOR: Anthony Kimmins. PRODUCTION COMPANY: Associated Talking Pictures. PRODUCER: Jack Kitchin. ASSISTANT DIRECTOR: Basil Dearden. SCREENPLAY: Anthony Kimmins, Leslie Arliss, Val Valentine. PHOTOGRAPHY: Ronald Neame. EDITOR: Ray Pitt. ART DIRECTOR: Wilfrid Shingleton. MUSIC AND LYRICS: George Formby, Fred E. Cliffe, Harry Gifford, Allan Nicholson.
CAST: George Formby (George), Patricia Kirkwood (Ann Johnson), Joss Ambler (Sir Charles Bailey), Meriel Forbes (Monica Bailey), Cyril Raymond (Jimmy Armstrong), George Hayes (Bannerman), George Carney (Sgt Johnson), Ronald Shiner (Nat), Gibb McLaughlin (Dr Angus McGregor), Ronald Staggs (Squibb Johnson), Hal Gordon (stableboy), Davy Burnaby (Col. Bollinger), C. Denier Warren (barker), James Hayter (barker), Syd Crossley (police constable).

RETURN TO YESTERDAY
March 1940 / Black and white / 68 minutes
CREDITS: DIRECTOR: Robert Stevenson. PRODUCTION COMPANY: CAPAD. ASSOCIATE PRODUCER: S. C. Balcon. SCREENPLAY: Robert Stevenson, Roland Pertwee, Angus MacPhail. *Based on the stage play* Goodness, How Sad *by*: Robert Morley. PHOTOGRAPHY: Ronald Neame. EDITOR: Charles Saunders. ART DIRECTOR: Wilfrid Shingleton.
CAST: Clive Brook (Robert Maine), Anna Lee (Carol Sands), Dame May Whitty (Mrs Truscott), Hartley Power (Regan), Milton Rosmer (Sambourne), David Tree (Peter Thropp), Olga Lindo (Grace Sambourne), Garry Marsh (Charlie Miller), Arthur Margetson (Osbert), Elliot Mason (Mrs Priskin), O. B. Clarence (Mr Truscott), David Horne (Morrison), Frank Pettingell (Prendergast), Wally Patch (night watchman), Alf Goddard (attendant), John Turnbull (stationmaster), Eliot Makeham (Fred Grover), Mary Jerrold (old lady), H. F. Maltby (inspector), Ludwig Stössel (Captain Angst), Molly Rankin (Christine), Patric Curwen (guard).

THE PROUD VALLEY
March 1940 / Black and white / 77 minutes
CREDITS: DIRECTOR: Pen Tennyson. PRODUCTION COMPANY: CAPAD. ASSOCIATE PRODUCER: Sergei Nolbandov. SCREENPLAY: Pen Tennyson, Jack Jones, Louis Golding. *Based on the story by*: Herbert Marshall, Alfredda Brilliant. PHOTOGRAPHY: Glen MacWilliams, Roy Kellino. EDITOR: Ray Pitt. ART DIRECTOR: Wilfrid Shingleton. MUSIC: Mendelssohn, Evan James, Mai Jones, H. T. Burleigh, James James, Lyn Joshua. MUSICAL DIRECTOR: Ernest Irving.
CAST: Paul Robeson (David Goliath), Edward Chapman (Dick Parry), Edward Rigby (Bert), Simon Lack (Emlyn Parry), Janet Johnson (Gwen Owen), Rachel Thomas (Mrs Parry), Charles Williams (Evans), Dilys Thomas (Dilys), Jack Jones (Thomas), Dilys Davies (Mrs Owen), Clifford Evans (Seth Jones), Alan Jeayes (Mr Trevor), George Merritt (Mr Lewis), Edward Lexy (Commissionaire Jackson), Ben Williams (Morgan).

DANGEROUS COMMENT
May 1940 / Black and white / 13 minutes
CREDITS: DIRECTOR: John Paddy Carstairs. SPONSOR: Ministry of Information. SCREENPLAY: Roland Pertwee, Roger MacDougall. STORY: John Paddy Carstairs.
CAST: Frank Lawton (Gerald Conway), Penelope Dudley Ward (Mrs Conway), Milton Rosmer (Maj. Brett), Margaret Vyner (Pearl), Roland Culver (officer), Ian Fleming (official), Edward Lexy (Percival), Roddy Hughes (Charlie), Robert Rendel, Alec Clunes, Patrick Parsons.

NOW YOU'RE TALKING
May 1940 / Black and white / 11 minutes
CREDITS: DIRECTOR: John Paddy Carstairs. SPONSOR: Ministry of Information. SCRIPT: Jeffrey Dell, Basil Dearden, Roger MacDougall.
CAST: Sebastian Shaw (Charles Hampton), Dorothy Hyson (Mrs Hampton), Edward Chapman (Ralph Small), Judy Campbell (Doris), George Merritt (Fred Perkins), Lloyd Pearson (Jake), Alec Clunes (Harry), George Relph (spy), Gordon James (Tom), Richard Norris (Jim), Johnnie Schofield (man).

ALL HANDS
May 1940 / Black and white / 10 minutes
CREDITS: DIRECTOR: John Paddy Carstairs. SPONSOR: Ministry of Information. SCREENPLAY: John Paddy Carstairs.
CAST: John Mills (Jack), Leueen McGrath (Joan), Eliot Makeham (spy), Gertrude Musgrove (waitress), Carl Jaffe (German captain), Annie Esmond (manageress), Hans Wengraf (German), Ralph Roberts.

LET GEORGE DO IT!
(aka: Murder in Bergen)
July 1940 / Black and white / 82 minutes
CREDITS: DIRECTOR: Marcel Varnel. PRODUCTION COMPANY: Associated Talking Pictures / Ealing Studios. ASSOCIATE PRODUCER: Basil Dearden. SCREENPLAY: Angus MacPhail, John Dighton, Basil Dearden, Austin Melford. DIRECTOR OF PHOTOGRAPHY: Ronald Neame. EDITOR: Ray Pitt. ART DIRECTOR: Wilfrid Shingleton. MUSICAL DIRECTOR: Ernest Irving. MUSIC AND LYRICS: George Formby, Harry Gifford, Fred E. Cliffe, Eddie Latta.
CAST: George Formby (George), Phyllis Calvert (Mary), Garry Marsh (Mendez), Romney Brent (Slim), Bernard Lee (Neilson), Coral Browne (Iris), Helena Pickard (Mrs Neilson), Percy Walsh (Schwartz), Diana Beaumont (Greta), Torin Thatcher (U-boat commander), Donald Calthrop (Strickland), Hal Gordon (Arbuckle), Russell Waters (SS *Macaulay* radio operator), Alec Clunes (submarine officer), Ronald Shiner (clarinettist), Ian Fleming (intelligence officer), Albert Lieven (German radio operator).

CONVOY
July 1940 / Black and white / 91 minutes
CREDITS: DIRECTOR: Penrose Tennyson. ASSOCIATE PRODUCER: Sergei Nolbandov. SCREENPLAY: Patrick Kirwan, Pen Tennyson. PHOTOGRAPHY: Roy Kellino, Gunther Krampf. EDITOR: Ray Pitt. ART DIRECTOR: Wilfrid Shingleton. MUSIC: Ernest Irving.
CAST: Clive Brook (Captain Armitage), John Clements (Lt Cranford), Edward Chapman (Captain Eckersley), Judy Campbell (Lucy Armitage), Penelope Dudley Ward (Mabel), Edward Rigby (Mr Matthews), Charles Williams (Shorty Howard), Alan Jeayes (Cmdr Blount), Michael Wilding (Dot), Harold Warrender (Lt-Cmdr Martin), David Hutcheson (Captain Sandeman), George Carney (Bates), Al Millen (Knowles), Charles Farrell (Walker), John Laurie (Gates), George Benson (Parker), Hay Petrie (minesweeper skipper), Mervyn Johns (his mate), Albert Lieven (commander U.37), Hans Wengraf (Deutschland commander), Edward Lexy (merchantman skipper), John Glyn-Jones (mate), Stewart Granger.

FOOD FOR THOUGHT
July 1940 / Black and white / 10 minutes
CREDITS: DIRECTOR: Adrian Brunel. PRODUCTION COMPANY: Ealing Studios/D&P Studios. SPONSOR: Ministry of Information. PRODUCER: John Croydon.
CAST: Mabel Constanduros, Muriel George, Eliot Makeham, Hal Gordon, Phyllis Morris.

KITTEN ON THE QUAY
July 1940 / Animation / Black and white / 6 minutes
CREDITS: DIRECTOR: Robert St John Cooper. PRODUCER: Alberto Cavalcanti. SCREENPLAY: Robert St John Cooper.

SALVAGE WITH A SMILE
August 1940 / Black and white / 6 minutes
CREDITS: DIRECTOR: Adrian Brunel. SPONSOR: Ministry of Information/Ministry of Supply. ASSOCIATE PRODUCER: Alberto Cavalcanti. SCRIPT: Adrian Brunel. EDITOR: Ernest Aldridge.
CAST: Aubrey Mallalieu (professor), Ronald Shiner (dustman), Kathleen Harrison (housekeeper), Phyllis Morris (Mrs Green).

CABLE LAYING
October 1940 / 11 minutes
CREDITS: DIRECTOR: John Paddy Carstairs.

SALOON BAR
November 1940 / Black and white / 79 minutes
CREDITS: DIRECTOR: Walter Forde. ASSOCIATE

PRODUCER: Culley Forde. SCREENPLAY: Angus MacPhail, John Dighton. *Based on the play by*: Frank Harvey Jr. PHOTOGRAPHY: Ronald Neame. EDITOR: Ray Pitt. ART DIRECTOR: Wilfrid Shingleton. DRESSES: Ariana.
CAST: Gordon Harker (Joe Harris), Elizabeth Allan (Queenie King), Mervyn Johns (Charlie Wickers), Joyce Barbour (Sally Watson), Anna Konstam (Ivy), Cyril Raymond (Harry Small), Judy Campbell (Doris), Al Millen (Fred), Norman Pierce (Bill Hoskins), Alec Clunes (Eddie Graves), Mavis Villiers (Joan), Felix Aylmer (mayor), O. B. Clarence (Sir Archibald), Aubrey Dexter (major), Laurence Kitchin (Peter), Helena Pickard (Mrs Dorothy Small), Manning Whiley (evangelist), Gordon James (Jim), Annie Esmond (Mrs Truscott), Eliot Makeham (meek man with Christmas tree), Roddy Hughes (Dr Martin), Roddy McDowall (young carol singer), Judy Kelly (girl), Julie Suedo (girl), Robert Rendel (detective), Torin Thatcher (garage owner).

YOUNG VETERAN
November 1940 / Black and white / 23 minutes
CREDITS: PRODUCER: Alberto Cavalcanti. ASSISTANTS: Basil Dearden, Monja Danischewsky. COMMENTARY WRITER: Michael Frank. SUPERVISING EDITOR: Ray Pitt. EDITOR: Charles Crichton.
CAST: Michael Frank (commentator).

SIGNALS OFFICE (DIVISIONAL)
November 1940 / 37 minutes
CREDITS: DIRECTOR: John Paddy Carstairs. SPONSOR: British Army.

SIGNALS OFFICE (CORPS)
November 1940 / 32 minutes
CREDITS: DIRECTOR: John Paddy Carstairs. SPONSOR: British Army.

SAILORS THREE
(aka: Three Cockeyed Sailors)
December 1940 / Black and white / 85 minutes
CREDITS: DIRECTOR: Walter Forde. ASSOCIATE PRODUCER: Culley Forde. SCREENPLAY: Angus MacPhail, Austin Melford, John Dighton, Gordon Wellesley. PHOTOGRAPHY: Gunther Krampf. EDITOR: Ray Pitt. ART DIRECTOR: Wilfred Shingleton. DRESSES: Ariana. SONGS: Noel Gay, Frank Eyton, Harry Parr-Davies, Phil Park.
CAST: Tommy Trinder (Tommy Taylor), Claude Hulbert (Llewellyn 'Admiral' Davis), Michael Wilding (Johnny Meadows), Carla Lehmann (Jane Davis), James Hayter (Hans Muller), Jeanne De Casalis (Mrs Pilkington), Eric Clavering (bartender), John Laurie (McNab), Harold Warrender (Lewis), John Glyn-Jones (best man), Julien Vedey (resident of Tangiers), Henry Hewitt (Professor Jack Pilkington), Brian Fitzpatrick (Digby Pilkington), Victor Fairley (German petty officer), Hans Wengraf (German captain), Manning Whiley (German commander), Derek Elphinstone (British observer), Alec Clunes (British pilot), Allan Jeayes (British commander), Robert Rendel (British captain), Danny Green (nightclub doorman), E. V. H. Emmett (voice of newsreel commentator).

SPARE A COPPER
December 1940 / Black and white / 79 minutes
CREDITS: DIRECTOR: John Paddy Carstairs. PRODUCTION COMPANY: Associated Talking Pictures. ASSOCIATE PRODUCER: Basil Dearden. SCREENPLAY: Roger MacDougall, Basil Dearden, Austin Melford. PHOTOGRAPHY: Bryan Langley. EDITOR: Ray Pitt. ART DIRECTOR: Wilfrid Shingleton. DRESSES: Ariana. INCIDENTAL MUSIC: Louis Levy and His Orchestra. SONGS: Roger MacDougall, George Formby, Fred E. Cliffe, Harry Gifford.
CAST: George Formby (George Carter), Dorothy Hyson (Jane Gray), George Merritt (Edward Brewster), John Warwick (Shaw), Bernard Lee (Jake), Bryan Herbert (Williams), Warburton Gamble (Sir Robert Dyer), John Turnbull (Insp. Richards), James Woodburn (MacDermott), Eliot Makeham (Fuller), Ellen Pollock (Lady Hardstaff), Charles Carson (Admiral), Aubrey Mallalieu (manager of music store), Edward Lexy (nightwatchman), Jack Melford (dame), Hal Gordon (sergeant), Jimmy Godden (manager), Ronald Shiner (piano tuner).

SEA FORT
July 1940 / Black and white / 7 minutes
CREDITS: DIRECTOR: Ian Dalrymple. SPONSOR: Ministry of Information. PRODUCER: Alberto Cavalcanti. SCRIPT: Ian Dalrymple. PHOTOGRAPHY: Ernest Palmer. EDITOR: Ernest Aldridge.
CAST: Patrick Curwen (commentator).

MASTERY OF THE SEA
December 1940 / Black and white / 20 minutes
CREDITS: DIRECTOR: Alberto Cavalcanti.

YELLOW CAESAR
February 1941 / Black and white / 24 minutes
CREDITS: DIRECTOR: Alberto Cavalcanti.

ADDITIONAL SCENES: Adrian Brunel. SCRIPT: Frank Owen, Michael Foot, Adrian Brunel. COMMENTARY WRITER: Michael Frank. EDITOR: Charles Crichton.
CAST: Michael Frank (commentator), Douglas Byng (English sympathiser), Feliks Topolski (cartoonist), Lito Masconas (Italian radio announcer), Marcel King, Max Spiro, Sam Lee, Jack Warrock (Benito Mussolini).

THE GHOST OF ST MICHAEL'S
April 1941 / Black and white / 82 minutes
CREDITS: DIRECTOR: Marcel Varnel. ASSOCIATE PRODUCER: Basil Dearden. SCREENPLAY: Angus MacPhail, John Dighton. PHOTOGRAPHY: Derick Williams. EDITOR: E. B. Jarvis. ART DIRECTOR: Wilfred Shingleton.
CAST: Will Hay (Will Lamb), Claude Hulbert (Hilary Tisdaile), Charles Hawtrey (Percy Thorne), Raymond Huntley (Mr Humphries), Felix Aylmer (Dr Winter), Elliot Mason (Mrs Wigmore), John Laurie (Jamie), Hay Petrie (procurator fiscal), Roddy Hughes (Amberley), Manning Whiley (Stock), Charles Mortimer (Sir Ambrose), Derek Blomfield (Sunshine), Clive Baxter (Ritzy), David Keir (Dr Ritchie), Brefni O'Rorke (Sgt MacFarlan), Sydney Shaw.

TURNED OUT NICE AGAIN
August 1941 / Black and white / 81 minutes
CREDITS: DIRECTOR: Marcel Varnel. ASSOCIATE PRODUCER: Basil Dearden. ASSISTANT DIRECTOR: Hal Mason. SCREENPLAY: Austin Melford, John Dighton, Basil Dearden. *Based on the play* As You Are *by*: Hugh Mills, Wells Root. PHOTOGRAPHY: Gordon Dines. EDITOR: Robert Hamer. ART DIRECTOR: Wilfrid Shingleton. CONSULTING ART DIRECTOR: Alberto Cavalcanti. MUSIC: Ernest Irving, Bretton Byrd. SONGS: Eddie Latta, Roger MacDougall.
CAST: George Formby (George Pearson), Peggy Bryan (Lydia Pearson), Elliot Mason (Mrs Pearson), Edward Chapman (Uncle Arnold), O. B. Clarence (Mr Dawson), Mackenzie Ward (Gerald Dawson), Ronald Ward (Nelson), John Salew (Largos), Wilfrid Hyde White (removing man), Hay Petrie (drunk), Michael Rennie (diner), Macdonald Parke (businessman).

SHIPS WITH WINGS
November 1941 / Black and white / 102 minutes
CREDITS: DIRECTOR: Sergei Nolbandov. ASSOCIATE PRODUCER: S. C. Balcon. SCREENPLAY: Patrick Kirwan, Austin Melford, Diana Morgan. INTERIOR PHOTOGRAPHY: Mutz Greenbaum, Wilkie Cooper. EXTERIOR PHOTOGRAPHY: Roy Kellino, Eric Cross. EDITOR: Robert Hamer. DESIGN: Sergei Nolbandov. ART DIRECTOR: Wilfrid Shingleton. DRESSES: Digby Morton, LACHASSE, Maison Arthur, Molyneux et Cie, Norman Hartnell, Victor Stiebel, Dorothy Broomham. MUSIC: Geoffrey Wright.
CAST: John Clements (Lt Stacey), Leslie Banks (Vice Adm. Weatherby), Jane Baxter (Celia Weatherby), Ann Todd (Kay Gordon), Basil Sydney (Captain Fairfax), Edward Chapman (Papadopolos), Hugh Williams (Wagner), Frank Pettingell (Fields), Michael Wilding (Lt Grant), Michael Rennie (Lt Maxwell), Cecil Parker (German air-marshal), John Stuart (Cmdr Hood), Frank Cellier (General Scarappa), Morland Graham (CPO Marsden), Charles Victor (MacDermott), Hugh Burden (Sub-Lt Weatherby), Betty Marsden (Jean), George Merritt (surgeon commander), John Laurie (Lt-Cmdr Reid), Charles Stuart (Von Rittau).

GUESTS OF HONOUR
August 1941 / 23 minutes
CREDITS: DIRECTOR: Ray Pott. PRODUCER: Alberto Cavalcanti. COMMENTARY WRITER: Frank Owen. PHOTOGRAPHY: Douglas Slocombe. EDITOR: Charles Crichton.

YOUNG VETERANS
1941 / 25 minutes
CREDITS: DIRECTOR: Charles Crichton. PRODUCER: Alberto Cavalcanti. COMMENTARY WRITER: Michael Balcon.
CAST: Michael Balcon (commentator).

FREEDOM MUST HAVE WINGS
1941 / 7 minutes
CREDITS: DIRECTOR: Compton Bennett.

THE BLACK SHEEP OF WHITEHALL
January 1942 / Black and white / 80 minutes
CREDITS: DIRECTOR: Basil Dearden, Will Hay. ASSOCIATE PRODUCER: S. C. Balcon. SCREENPLAY: Angus MacPhail, John Dighton. DIRECTOR OF PHOTOGRAPHY: Günther Krampf, Eric Cross. EDITOR: Ray Pitt. ART DIRECTOR: Tom Morahan.
CAST: Will Hay (Professor Davis), John Mills (Bobby Jessop), Basil Sydney (Arthur Costello), Henry Hewitt (Professor Davys), Felix Aylmer (J. B. Crabtree), Owen Reynolds (Harman), Frank Cellier (Dr Innsbach), Joss Ambler (Sir John), Frank Allenby (Onslowe), Thora Hird (Joyce),

Margaret Halstan (matron), Barbara Valerie (Sister Spooner), Leslie Mitchell (BBC interviewer), George Woodbridge (male nurse), George Merritt (stationmaster), Aubrey Mallalieu (ticket collector), Dorothy Hamilton (Miss Rudge), Agnes Laughlan (Mrs Webster), Ronald Shiner (porter), Kenneth Griffith (butcher's boy).

THE BIG BLOCKADE
January 1942 / Black and white / 68 minutes
CREDITS: DIRECTOR: Charles Frend. ASSOCIATE PRODUCER: Alberto Cavalcanti. SCREENPLAY: Angus MacPhail. COMMENTARY WRITER: Frank Owen. PHOTOGRAPHY: Wilkie Cooper. EDITORS: Charles Crichton, Compton Bennett. ART DIRECTOR: Tom Morahan. MUSIC: Richard Addinsell.
CAST: Leslie Banks (Taylor), John Mills (Tom), Michael Redgrave (Russian), Michael Rennie (George), Will Hay (skipper), Bernard Miles (mate), Robert Morley (von Geiselbrecht), John Stuart (naval officer), David Evans (David), Peter De Greeff (RAF man), Morland Graham (dock official), John Boxer (press), Cyril Chamberlain (press), Owen Reynolds (press), Quentin Reynolds (press), Leif Nonow (Russian), Joss Ambler (Stoltenhoff), Frank Cellier (Schneider), Alfred Drayton (Direktor), Marius Goring (German propaganda officer), Albert Lieven (Gunter), Elliot Mason (stationmistress), George Merritt (Marshall), Austin Trevor (U-boat captain), Percy Walsh (German captain), Charles Minor (Quisling), Bernard Rebel (Quisling), George Woodbridge (Quisling), Lawrence Kingston (Quisling), Michael Wilding (captain), Ronald Shiner (agent), Manning Whiley (officer), Thora Hird (waitress), Mark Daly (driver).

THE FOREMAN WENT TO FRANCE
(aka: Somewhere in France)
April 1942 / Black and white / 85 minutes
CREDITS: DIRECTOR: Charles Frend. ASSOCIATE PRODUCER: Alberto Cavalcanti. SCREENPLAY: Angus MacPhail, John Dighton, Leslie Arliss. STORY: J. B. Priestley. PHOTOGRAPHY: Wilkie Cooper. EDITOR: Robert Hamer. ART DIRECTOR: Tom Morahan. MUSIC: William Walton.
CAST: Tommy Trinder (Tommy Hoskins), Constance Cummings (Anne Stanford), Clifford Evans (Fred Garrick), Robert Morley (mayor), Gordon Jackson (Jock), Ernest Milton (stationmaster), John Williams ('English army captain'), Paul Bonifas (prefect), Anita Palacine (barmaid), Francis L. Sullivan (French skipper), Owen Reynolds (Collins), Ronald Adam (Sir Charles Fawcett), Charles Victor (Jim), Bill Blewitt (roof spotter), Mervyn Johns (passport official), Eric Maturin (Home Office official), John Boxer (Ministry of Home Security official), Mrs Blewett (nun), Guy Mas (French sergeant), Tony Ainsley (American ambulance driver), Thora Hird (barmaid).

GO TO BLAZES
May 1942 / Black and white / 9 minutes
CREDITS: DIRECTOR: Walter Forde (disputed). SPONSOR: Ministry of Information. SCREENPLAY: Angus MacPhail, Diana Morgan. PHOTOGRAPHY: Ernest Palmer.
CAST: Will Hay (father), Muriel George (mother), Thora Hird (Elsie).

THE NEXT OF KIN
May 1942 / Black and white / 101 minutes
CREDITS: DIRECTOR: Thorold Dickinson. SPONSOR: Directorate of Army Kinematography. ASSOCIATE PRODUCER: S. C. Balcon. SCREENPLAY: Thorold Dickinson, Basil Bartlett, Angus MacPhail, John Dighton. DIRECTOR OF PHOTOGRAPHY: Ernest Palmer. EDITOR: Ray Pitt. ART DIRECTOR: Tom Morahan. MUSIC: William Walton.
CAST: Mervyn Johns (No. 23, 'Mr Davis'), John Chandos (No. 16), Nova Pilbeam (Beppie Leemans), Stephen Murray (Mr Barratt), Guy Mas (Captain Mercier), Basil Sydney (naval captain), Reginald Tate (Maj. Richards), Alexander Field (Pvt. Durnford), Jack Hawkins (Brigade Maj. Harcourt), David Hutcheson (intelligence officer), Brefni O'Rorke (Brigadier Blunt), Phyllis Stanley (Miss Clare), Richard Norris (Pvt. Jimmy), Geoffrey Hibbert (Pvt. John), Philip Friend (Lt Cummins), Mary Clare (Ma Webster), Torin Thatcher (German general), Thora Hird (ATS girl), Frank Allenby (Wing-Cmdr Kenton), Joss Ambler (Mr Vernon), Frederick Leister (colonel), Johnnie Schofield (lance-corporal), Charles Victor (Joe), John Williams (Gen. Cooper), Mary Malcolm (secretary), Basil Radford, Naunton Wayne (careless talkers), William Walton (soldier).

THE GOOSE STEPS OUT
August 1942 / Black and white / 75 minutes
CREDITS: DIRECTORS: Will Hay, Basil Dearden. ASSOCIATE PRODUCER: S. C. Balcon. SCREENPLAY: Angus MacPhail. SCREENPLAY: John Dighton. STORY: Bernard Miles, Reginald Groves. PHOTOGRAPHY: Ernest Palmer.

EDITOR: Ray Pitt. ART DIRECTOR: Tom Morahan. MUSIC: Bretton Byrd.
CAST: Will Hay (William Henry Potts/Muller), Charles Hawtrey (Max), Peter Croft (Hans), Barry Morse (Kurt), Peter Ustinov (Krauss), Anne Firth (Lena Schumann), Frank Pettingell (Professor Hoffmann), Leslie Harcourt (Vogel), Julien Mitchell (Gen. von Klotz), Jeremy Hawk (ADC), Raymond Lovell (Schmidt), Aubrey Mallalieu (rector), John Williams (Maj. Bishop), Laurence O'Madden (Col. Truscott), William Hartnell (officer).

WENT THE DAY WELL?
(aka: 48 Hours)
October 1942 / Black and white / 92 minutes
CREDITS: DIRECTOR: Alberto Cavalcanti. ASSOCIATE PRODUCER: S. C. Balcon. SCREENPLAY: John Dighton, Diana Morgan, Angus MacPhail. *From a story by*: Graham Greene. PHOTOGRAPHY: Wilkie Cooper. EDITOR: Sidney Cole. ART DIRECTOR: Tom Morahan. MUSIC: William Walton.
CAST: Leslie Banks (Oliver Wilsford), Elizabeth Allan (Peggy Fry), Frank Lawton (Tom Sturry), Basil Sydney (Maj. Ortler), Valerie Taylor (Nora Ashton), Mervyn Johns (Charlie Sims), Edward Rigby (Bill Purvis), Marie Lohr (Mrs Fraser), C. V. France (Vicar Ashton), David Farrar (Lt Jung), Muriel George (Mrs Collins), Thora Hird (Ivy), Norman Pierce (Jim Sturry), Harry Fowler (young George Truscott), Patricia Hayes (Daisy), Hilda Bayley (Cousin Maud Chapman), Johnny Schofield (Joe Garbett), Ellis Irving (Harry Drew), Philippa Hiatt (Mrs Bates), Grace Arnold (Mrs Owen), John Slater (German sergeant), Eric Micklewood (Soldier Klotz), Josephine Middleton (Mrs Carter), James Donald (German corporal), Gerard Heinz (Schmidt), Gerald Moore (Johnnie Wade), Robert MacDermot (BBC announcer), Charles Paton (Harry Brown), Arthur Ridley (Father Owen), Anthony Pilbeam (Ted Garbett), Lilian Ellias (Bridget), Kathleen Boutall (Mrs Sturry), Mavis Villiers (Violet), Josie Welford (June), Norman Shelley (Bob Owen), Irene Arnold (Mrs Drew), Leslie Gorman, Robert Bradford, Dean Braine, Wyndham Milligan, H. Victor Weske (German soldiers).

FIND, FIX AND STRIKE
September 1942 / Black and white / 37 minutes
CREDITS: DIRECTOR: Compton Bennett. PRODUCER: Alberto Cavalcanti. ASSISTANT PRODUCER: Charles Crichton. PHOTOGRAPHY: Douglas Slocombe, Roy Kellino.

MIGHTY PENNY
1942 / Black and white / 10 minutes
CREDITS: DIRECTOR: John Paddy Carstairs. SPONSOR: Red Cross Association.

RAID ON FRANCE
December 1942 / Black and white
CREDITS: DIRECTOR: Thorold Dickinson.
Re-edited footage from final two reels of Next of Kin.

NINE MEN
January 1943 / Black and white / 67 minutes
CREDITS: DIRECTOR: Harry Watt. ASSOCIATE PRODUCER: Charles Crichton. SCREENPLAY: Harry Watt. STORY: Gerald Kersh. PHOTOGRAPHY: Roy Kellino. SUPERVISING EDITOR: Sidney Cole. EDITOR: Eric Cripps. ART DIRECTOR: Duncan Sutherland. MUSIC: John Greenwood, Eric Coates.
CAST: Jack Lambert (Sgt Jack Watson), Gordon Jackson (the young 'un), Frederick Piper (Banger Hill), Grant Sutherland (Jock Scott), Bill Blewitt (Bill Parker), Eric Micklewood (Booky), John Varley (Dusty), Jack Horsman (Joe Harvey), Richard Wilkinson (Second Lt John Arthur Crawford), Trevor Evans (tank officer), Guilio Finzi (Italian mechanic).

SAVE YOUR SHILLINGS AND SMILE
January 1943 / Black and white / 6 minutes
CREDITS: DIRECTOR: Harry Watt. SPONSOR: National Savings Committee.
CAST: Tommy Trinder (himself).

DID YOU EVER SEE A DREAM TALKING?
January 1943 / Black and white / 7 minutes
CREDITS: DIRECTOR: Basil Dearden. SPONSOR: National Savings Committee.
CAST: Claude Hulbert (Claude Robinson), Enid Trevor (his wife).

THE SAVING GRACE
January 1943 / Black and white / 6 minutes
CREDITS: DIRECTOR: Charles Frend. SPONSOR: National Savings Committee.
CAST: Tom Walls, Mervyn Johns.

THE BELLS GO DOWN
April 1943 / Black and white / 89 minutes
CREDITS: DIRECTOR: Basil Dearden. ASSOCIATE PRODUCER: S. C. Balcon. SCREENPLAY: Roger MacDougall.

IN CONSULTATION WITH: Stephen Black. PHOTOGRAPHY: Ernest Palmer. SUPERVISING EDITOR: Sidney Cole. EDITOR: Mary Habberfield. ART DIRECTOR: Michael Relph. MUSIC: Roy Douglas.
CAST: Tommy Trinder (Tommy Turk), James Mason (Ted Robbins), Mervyn Johns (Sam), Philippa Hiatt (Nan Matthews), Finlay Currie (District Officer MacFarlane), Philip Friend (Bob Matthews), Meriel Forbes (Susie), Beatrice Varley (Ma Turk), Lesley Brook (June), Billy Hartnell (Brookes), Norman Pierce (Pa Robbins), Muriel George (Ma Robbins), Julien Vedey (Lou Freeman), Richard George (PC O'Brien), Victor Weske (Peters), Leslie Harcourt (Alfie Parrott), Frederick Culley (vicar), Stanley Lathbury (verger), Johnnie Schofield (Jack), Leo Genn (Narrator), Charles Victor (Bill), Ralph Michael (Bill's mate), Andrea Malandrinos (Benito Vanetti), John Salew (landlord).

THE SKY'S THE LIMIT
May 1943 / Black and white / 14 minutes
CREDITS: DIRECTOR: Alberto Cavalcanti. SPONSOR: National Savings Committee.
CAST: John Mills (Tom), Michael Rennie (George).

MY LEARNED FRIEND
June 1943 / Black and white / 74 minutes
CREDITS: DIRECTORS: Basil Dearden, Will Hay. ASSOCIATE PRODUCER: Robert Hamer, S. C. Balcon. SCREENPLAY: Angus MacPhail, John Dighton. DIRECTOR OF PHOTOGRAPHY: Wilkie Cooper. SUPERVISING EDITOR: Sidney Cole. EDITOR: Charles Hasse. ART DIRECTOR: Michael Relph. MUSIC: Ernest Irving.
CAST: Will Hay (William Fitch), Claude Hulbert (Claude Babbington), Mervyn Johns (Arthur Grimshaw), Lawrence Hanray (Sir Norman), Aubrey Mallalieu (magistrate), Charles Victor (Safety Wilson), Derna Hazell (Gloria), Leslie Harcourt (barman), Eddie Phillips (Basher Blake), G. H. Mulcaster (Dr Scudamore), Ernest Thesiger (Ferris), Lloyd Pearson (Col. Cudleigh), Gibb McLaughlin (Carstairs), Maudie Edwards (Aladdin Redfern), Ronald Shiner (man at Wilson's café), Ian Wilson (stagehand).

UNDERCOVER
(aka: Underground Guerrillas)
July 1943 / Black and white / 88 minutes
CREDITS: DIRECTOR: Sergei Nolbandov. ASSOCIATE PRODUCER: S. C. Balcon. SCREENPLAY: Monja Danischewsky.
SCREENPLAY: John Dighton, Milosh Sokulich. PHOTOGRAPHY: Wilkie Cooper. SUPERVISING EDITOR: Sidney Cole. EDITOR: Eily Boland. ART DIRECTOR: Duncan Sutherland. MUSIC: Frederic Austin.
CAST: John Clements (Milos Petrovitch), Godfrey Tearle (Gen. von Staengel), Mary Morris (Anna Petrovitch), Tom Walls (Kossan Petrovitch), Michael Wilding (Constantine), Stephen Murray (Dr Steven Petrovitch), Robert Harris (Col. von Brock), Rachel Thomas (Maria Petrovitch), Charles Victor (sergeant), Niall MacGinnis (Dr Jordan), Finlay Currie (father), Ivor Barnard (stationmaster), Ben Williams (Dragutin), George Merritt (Yugoslav general), Norman Pierce (Lt Frank), Eynon Evans (Lt Ranse), Terwyn Jones (Danilo), Eric Micklewood (Lt von Klotz), Stanley Baker (Peter).

SAN DEMETRIO, LONDON
December 1943 / Black and white / 105 minutes
CREDITS: DIRECTOR: Charles Frend. ASSOCIATE PRODUCER: Robert Hamer. SCREENPLAY: Robert Hamer, Charles Frend, F. Tennyson Jesse. PHOTOGRAPHY: Ernest Palmer. EDITING SUPERVISOR: Sidney Cole. EDITOR: Eily Boland. ART DIRECTOR: Duncan Sutherland. MUSIC: John Greenwood.
CAST: Ralph Michael (Second Officer Hawkins), Walter Fitzgerald (Chief Engineer Charles Pollard), Neville Mapp (Third Engineer Willey), Barry Letts (Apprentice John Jones), Michael Allen (Cadet Roy Housden), Frederick Piper (Boatswain W. E. Fletcher), Herbert Cameron (Pumpman Davies), John Owers (steward), Mervyn Johns (Greaser John Boyle), Gordon Jackson (Messboy John Jamieson), Robert Beatty (Yank Preston), James McKechnie (MacNeil), Arthur Young (Captain George Waite), Duncan MacIntyre (Seaman MacLennan), Charles Victor, John Coyle Rex Holt (deckhands), Lawrence O'Madden (Captain E. S. F. Fegen), James Donald (gunnery control officer), James Sadler (officer of the watch), Peter Miller Street (midshipman), David Horne (Mr Justice Langton), Nigel Clarke (R. J. E. Dodds), James Knight (Captain Smith), Diana Decker (shopgirl).

TROIS CHANSONS DE LA RÉSISTANCE
(aka: Songs before Sunrise / Trois Chants pour la France)
1943 / Black and white / 8 minutes
CREDITS: DIRECTOR: Alberto Cavalcanti.
CAST: Germaine Sablon.

THE GREEK TESTAMENT
1943 / Black and white / 45 minutes
CREDITS: DIRECTOR: Charles Hasse. PRODUCERS: Alberto Cavalcanti, Michael Balcon. SCREENPLAY: Monja Danischewsky. PHOTOGRAPHY: Douglas Slocombe. EDITOR: Sidney Cole. ART DIRECTOR: Michael Relph. MUSIC: Ernest Irving.
CAST: Vrasidas Capernaros (Petty Officer Leonides).

FLEET AIR ARM
1943 / Black and white
CREDITS: DIRECTOR: Compton Bennett. SPONSOR: Ministry of Information.

SHIP SAFETY
(aka: Watertight)
1943 / Black and white / 40 minutes
CREDITS: PRODUCTION COMPANY: Ealing Studios/Admiralty Instructional.

THE HALFWAY HOUSE
April 1944 / Black and white / 95 minutes
CREDITS: DIRECTOR: Basil Dearden. ASSOCIATE PRODUCER: Alberto Cavalcanti. SCREENPLAY: Angus MacPhail, Diana Morgan, Roland Pertwee, T. E. B. Clarke. *Suggested by the play by*: Denis Ogden. PHOTOGRAPHY: Wilkie Cooper. SUPERVISING EDITOR: Sidney Cole. EDITOR: Charles Hasse. ART DIRECTOR: Michael Relph. DRESSES: Bianca Mosca. MUSIC: Berners.
CAST: Mervyn Johns (Rhys), Glynis Johns (Gwyneth), Tom Walls (Captain Harry Meadows), Françoise Rosay (Alice Meadows), Esmond Knight (David Davies), Guy Middleton (Fortesque), Alfred Drayton (Oakley), Valerie White (Jill French), Richard Bird (Sq/Ldr Richard French), Sally Ann Howes (Joanna), Philippa Hiatt (Margaret), Pat McGrath (Terence), C. V. France (solicitor), Roland Pertwee (prison governor), Eliot Makeham (dresser), John Boxer (doctor), Rachel Thomas (landlady), Joss Ambler (Pinsent), Jack Jones, Moses Jones (Welsh porters).

FOR THOSE IN PERIL
June 1944 / Black and white / 67 minutes
CREDITS: DIRECTOR: Charles Crichton. ASSOCIATE PRODUCER: S. C. Balcon. SCREENPLAY: Harry Watt, John Orton, T. E. B. Clarke. DIRECTOR OF PHOTOGRAPHY: Douglas Slocombe. SUPERVISING EDITOR: Sidney Cole. EDITOR: Erik Cripps. ART DIRECTOR: Duncan Sutherland. MUSIC: Gordon Jacob.
CAST: David Farrar (Murray), Ralph Michael (Rawlings), John Slater (Wilkie), Robert Wyndham (Leverett), John Batten (wireless operator), Robert Griffith (Griffith), William Rodwell (navigator), Leslie Clarke (Pearson), Anthony Bazell (Overton).

THEY CAME TO A CITY
August 1944 / Black and white / 77 minutes
CREDITS: DIRECTOR: Basil Dearden. ASSOCIATE PRODUCER: Sidney Cole. SCREENPLAY: Basil Dearden, Sidney Cole, J. B. Priestley. *Based on the play by*: J. B. Priestley. DIRECTOR OF PHOTOGRAPHY: Stan Pavey. EDITOR: Michael Truman. ART DIRECTOR: Michael Relph. MUSIC SELECTIONS: Alexander Scriabin.
CAST: John Clements (Joe Dinmore), Googie Withers (Alice Foster), Raymond Huntley (Malcolm Stritton), Renée Gadd (Dorothy Stritton), A. E. Matthews (Sir George Gedney), Mabel Terry Lewis (Lady Loxfield), Frances Rowe (Philippa Loxfield), Ada Reeve (Mrs Batley), Norman Shelley (Cudworth), J. B. Priestley (himself), Ralph Michael (Sgt Jimmy), Brenda Bruce (WAAF).

CHAMPAGNE CHARLIE
August 1944 / Black and white / 105 minutes
CREDITS: DIRECTOR: Alberto Cavalcanti. ASSOCIATE PRODUCER: John Croydon. SCREENPLAY: Austin Melford, John Dighton, Angus MacPhail. PHOTOGRAPHY: Wilkie Cooper. EDITOR: Charles Hasse. ART DIRECTOR: Michael Relph. COSTUMES: Prof. Ernest Stern. MUSICAL DIRECTOR: Ernest Irving. SONGS: Alfred Lee, George Leybourne. NEW SONGS: Una Bart, Lord Berners, T. E. B. Clarke, Frank Eyton, Noel Gay, Billy Mayerl, Ernest Irving.
CAST: Tommy Trinder (Joe Saunders, 'George Leybourne'), Stanley Holloway (The Great Vance), Betty Warren (Bessie Bellwood), Austin Trevor (Edgar, Duke of Petworth), Jean Kent (Dolly), Guy Middleton (Tipsy Swell), Frederick Piper (Learoyd), Harry Fowler ('Orace), Robert Wyndham (Duckworth), Drusilla Wills (Bessie's dresser), Joan Carol (Cora), Billy Shine (Bill), Andrea Malandrinos (Gatti), Paul Bonifas (Targentino), Peter De Greeff (Tom, Lord Petersfield), Norman Pierce (landlord), Eddie Phillips (Tom Sayers), Leslie Clarke (Fred Saunders), Eric Boon (Clinker).

THE RETURN OF THE VIKINGS
September 1944 / Black and white / 54 minutes

CREDITS: DIRECTOR: Charles Frend. ASSOCIATE PRODUCER: Sidney Cole. SCREENPLAY: Charles Frend, Sidney Cole. PHOTOGRAPHY: Ernest Palmer. EDITOR: Carl Heck. ART DIRECTOR: Duncan Sutherland.
CAST: Leo Genn (Narrator), Stig Egede Nissen (Gunnar), Frederick Piper (Sgt Fred Johnson), Leo Genn (British colonel).

FIDDLERS THREE
(aka: While Nero Fiddled)
October 1944 / Black and white / 84 minutes
CREDITS: DIRECTOR: Harry Watt. ASSOCIATE PRODUCER: Robert Hamer. SCREENPLAY: Angus MacPhail, Diana Morgan. PHOTOGRAPHY: Wilkie Cooper. EDITOR: Eily Boland. ART DIRECTOR: Duncan Sutherland. COSTUMES: Elizabeth Fanshawe. MUSIC: Spike Hughes. MUSIC OF SONGS: Mischa Spoliansky, Harry Jacobson, Geoffrey Wright.
CAST: Tommy Trinder (Tommy Taylor), Frances Day (Poppaea), Sonnie Hale (The Professor), Francis L. Sullivan (Nero), Elisabeth Welch (Thora), Mary Clare (Volumnia), Diana Decker (Lydia), Ernest Milton (Titus), James Robertson Justice (centurion), Russell Thorndike (high priest), Frederick Piper (auctioneer), Alec Mango (secretary), Danny Green (Lictor), Frank Tickle (master of ceremonies), Kay Kendall (girl), Robert Wyndham (lion-keeper).

JOHNNY FRENCHMAN
August 1945 / Black and white / 105 minutes
CREDITS: DIRECTOR: Charles Frend. ASSOCIATE PRODUCER: S. C. Balcon. SCREENPLAY: T. E. B. Clarke. DIRECTOR OF PHOTOGRAPHY: Roy Kellino. EDITOR: Michael Truman. ART DIRECTOR: Duncan Sutherland. MUSIC: Clifton Parker. CONDUCTOR: Ernest Irving.
CAST: Tom Walls (Nat Pomeroy), Françoise Rosay (Lanec Florrie), Patricia Roc (Sue Pomeroy), Ralph Michael (Bob Tremayne), Paul Dupuis (Yan Kervarec), Frederick Piper (Zacky Penrose), Paul Bonifas (Jerome), Arthur Hambling (Steve Matthews), Richard George (Charlie West), Bill Blewitt (Dick Trewhiddle), James Harcourt (Joe Pender), Richard Harrison (Tim Bassett), Stanley Paskin (Sam Olds), James Knight (Tom Hocking), Leslie Harcourt (Jack Nicholas), John Stone (Sam Harvey), George Hirste (Dave Pascoe), Carol O'Connor (Mr Harper), Franklin Bennett (sergeant), Bernard Fishwick (exciseman), Herbert Thomas (Spargoe), Denver Hall (Billy Pomeroy), Alfie Bass (corporal), Vincent Holman (Truscott), Grace Arnold (Mrs Matthews), Beatrice Varley (Mrs Tremayne), Judith Furse (Jane Matthews), Drusilla Wills (Miss Bennett), Marcel Poncin (Theo), Henri Bollinger (Alain), Jean-Marie Balcon (Malo), Louis Gournay (Yves), Pierre Richard (mayor of Lanec), Jean-Marie Nacry (grandfather), Joseph Menou (Mathieu).

PAINTED BOATS
(aka: The Girl on the Canal)
September 1945 / Black and white / 63 minutes
CREDITS: DIRECTOR: Charles Crichton. ASSOCIATE PRODUCER: Henry Cornelius. SCREENPLAY: Stephen Black, Micky McCarthy. COMMENTARY WRITER: Louis MacNeice. PHOTOGRAPHY: Douglas Slocombe. EDITOR: Leslie Allen. ART DIRECTOR: Jim Morahan. MUSIC: John Greenwood.
CAST: Jenny Laird (Mary Smith), Bill Blewitt (Pa Smith), May Hallatt (Ma Smith), Robert Griffith (Ted Stoner), Madoline Thomas (Mrs Stoner), Grace Arnold (Ted's sister), Harry Fowler (Alf), Megs Jenkins (Gladys), John Owers (Bill), James McKechnie (narrator).

DEAD OF NIGHT
September 1945 / Black and white / 104 minutes
CREDITS: DIRECTORS: Alberto Cavalcanti, Charles Crichton, Basil Dearden, Robert Hamer. ASSOCIATE PRODUCERS: Sidney Cole, John Croydon. SCREENPLAY: John Baines, Angus MacPhail. ADDITIONAL DIALOGUE: T. E. B. Clarke. *Based on stories by*: H. G. Wells, John Baines, E. F. Benson, Angus MacPhail. LIGHTING: Stan Pavey, Douglas Slocombe. EDITOR: Charles Hasse. ART DIRECTOR: Michael Relph. DRESSES: Bianca Mosca, Marion Horn. MUSIC: Georges Auric.
CAST: *Linking Story*: Roland Culver (Eliot Foley), Mary Merrall (Mrs Foley), Barbara Leake (Mrs O'Hara), Renée Gadd (Mrs Craig). *The Hearse Driver*: Mervyn Johns (Walter Craig), Anthony Baird (Hugh Grainger), Robert Wyndham (Dr Albury), Judy Kelly (Joyce Grainger), Miles Malleson (hearse driver). *The Christmas Story*: Sally Ann Howes (Sally O'Hara), Michael Allan (Jimmy Watson). *The Haunted Mirror*: Googie Withers (Joan Cortland), Ralph Michael (Peter Cortland), Esmé Percy (Mr Rutherford). *Golfing Story*: Basil Radford (George Parratt), Naunton Wayne (Larry Potter), Peggy Bryan (Mary Lee). *The Ventriloquist's Dummy*: Frederick Valk (Dr Van Straaten), Allan Jeayes (Maurice Olcott), Michael Redgrave (Maxwell Frere), Elisabeth Welch (Beulah), Hartley Power (Sylvester Kee), Magda Kun (Mitzi), Garry Marsh (Harry Parker).

PINK STRING AND SEALING WAX
November 1945 / Black and white / 89 minutes
CREDITS: DIRECTOR: Robert Hamer. ASSOCIATE PRODUCER: S. C. Balcon. SCREENPLAY: Diana Morgan, Robert Hamer. *Based on the play by*: Roland Pertwee. DIRECTOR OF PHOTOGRAPHY: Richard S. Pavey. EDITOR: Michael Truman. ART DIRECTOR: Duncan Sutherland. DRESSES: Bianca Mosca. MUSIC: Norman Demuth. CONDUCTOR: Ernest Irving.
CAST: Mervyn Johns (Mr Sutton), Googie Withers (Pearl), Gordon Jackson (David), Mary Merrall (Mrs Sutton), Jean Ireland (Victoria), Sally Ann Howes (Peggy), Colin Simpson (James), David Wallbridge (Nicholas), John Carol (Dan), Catherine Lacey (Miss Porter), Garry Marsh (Joe), Pauline Letts (Louise), Maudie Edwards (Mrs Webster), Frederick Piper (Dr Pepper), John Owers (Frank), Helen Goss (Maudie), Margaret Ritchie (Mme Patti), Don Stannard (John Bevan), John Ruddock (judge), Ronald Adam (clerk of the court), Charles Carson (editor), Valentine Dyall (police inspector), David Keir (stage door keeper), Jane Wenham (Mary Truscott).

THE CAPTIVE HEART
(aka: Lovers' Meeting)
March 1946 / Black and white / 98 minutes
CREDITS: DIRECTOR: Basil Dearden. ASSOCIATE PRODUCER: Michael Relph. SCREENPLAY: Angus MacPhail, Guy Morgan. STORY: Patrick Kirwan. DIRECTOR OF PHOTOGRAPHY: Douglas Slocombe. EDITOR: Charles Hasse. ART DIRECTOR: Michael Relph. DRESSES: Mark Luker. MUSIC: Alan Rawsthorne. CONDUCTOR: Ernest Irving.
CAST: Michael Redgrave (Captain Karel Hasek/'Captain Geoffrey Mitchell'), Mervyn Johns (Pvt. Dai Evans), Basil Radford (Maj. Ossy Dalrymple), Jack Warner (Cpl Ted Horsfall), Jimmy Hanley (Pvt. James H. Matthews), Gordon Jackson (Lt David Lennox), Karel Stepanek (Forster), Ralph Michael (Captain Thurston), Derek Bond (Lt Stephen Hartley), Guy Middleton (Captain Jim Grayson), Jack Lambert (padre), Rachel Kempson (Celia Mitchell), Frederick Leister (Mr Mowbray), Meriel Forbes (Beryl Curtiss), Robert Wyndham (Lt-Cmdr Robert Marsden), Jane Barrett (Caroline Harley), Gladys Henson (Flo Horsfall), Rachel Thomas (Mrs Evans), James Harcourt (doctor), Elliot Mason (Mrs Lennox), Margot Fitzsimons (Elspeth McDougall), David Keir (Mr McDougall), Frederick Richter (camp commandant), Frederick Schiller (German MO), Jill Gibbs (Janet Mitchell), David Walbridge (Desmond Mitchell), Sam Kydd (Pvt. Rand).

MAN – ONE FAMILY
August 1946 / Black and white / 17 minutes
CREDITS: DIRECTOR: Ivor Montagu. PRODUCER: Sidney Cole. SCRIPT: Ivor Montagu. COMMENTARY WRITER: Dr Julian Huxley. EDITOR: Sidney Cole. ASSISTANT EDITOR: Seth Holt. MUSIC: Van Phillips.
CAST: Dr Julian Huxley (commentator), Frederick Valk (Saul).

THE OVERLANDERS
October 1946 / Black and white / 91 minutes
CREDITS: DIRECTOR: Harry Watt. AUSTRALIAN ASSOCIATE: Ralph Smart. SCREENPLAY: Harry Watt. PHOTOGRAPHY: Osmond Borradaile. SUPERVISING EDITOR: Leslie A. Norman. EDITOR: E. M. Inman Hunter. MUSIC: John Ireland. CONDUCTOR: Ernest Irving.
CAST: Chips Rafferty (Dan McAlpine), John Nugent Hayward (Bill Parsons), Daphne Campbell (Mary Parsons), John Fernside (Corky), Jean Blue (Mrs Parsons), Peter Pagan (Sinbad), Helen Grieve (Helen Parsons), Frank Ransome (Charlie), Stan Tolhurst (Bert Malone), Marshall Crosby (minister), John Fegan (police sergeant), Clyde Combo (Jacky), Henry Murdoch (Nipper).

HUE AND CRY
February 1947 / Black and white / 82 minutes
CREDITS: DIRECTOR: Charles Crichton. ASSOCIATE PRODUCER: Henry Cornelius. SCREENPLAY: T. E. B. Clarke. DIRECTOR OF PHOTOGRAPHY: Douglas Slocombe. EDITOR: Charles Hasse. ART DIRECTOR: Norman G. Arnold. MUSIC: Jack Beaver, Georges Auric. CONDUCTOR: Ernest Irving.
CAST: Alastair Sim (Felix H. Wilkinson), Jack Warner (Nightingale), Valerie White (Rhona), Frederick Piper (Mr Kirby), Harry Fowler (Joe Kirby), Douglas Barr (Alec), Heather Delaine (Mrs Kirby), Stanley Escane (boy), Ian Dawson (Norman), Gerald Fox (Dicky), Albert Hughes (Wally), David Knox (Dusty), Jeffrey Sirett (Bill), James Crabb (Terry), Joan Dowling (Clarry), Paul Demel (Jago), Alec Finter (Det. Sgt Fothergill), Bruce Belfrage (BBC announcer), Grace Arnold (Dicky's mother), Arthur Denton (vicar), Robin Hughes (Selwyn Pike), Howard Douglas (watchman), Henry Purvis (Larry the Bull),

Joey Carr (Shorty).

THE LIFE AND ADVENTURES OF NICHOLAS NICKLEBY
(aka: Nicholas Nickleby)
March 1947 / Black and white / 105 minutes
CREDITS: DIRECTOR: Alberto Cavalcanti. ASSOCIATE PRODUCER: John Croydon. SCREENPLAY: John Dighton. *Based on the novel by*: Charles Dickens. DIRECTOR OF PHOTOGRAPHY: Gordon Dines. EDITOR: Leslie A. Norman. ART DIRECTOR: Michael Relph. MUSIC: Lord Berners. CONDUCTOR: Ernest Irving.
CAST: Derek Bond (Nicholas Nickleby), Cedric Hardwicke (Ralph Nickleby), Mary Merrall (Mrs Nickleby), Sally Ann Howes (Kate Nickleby), Stanley Holloway (Vincent Crummles), Alfred Drayton (Wackford Squeers), Sybil Thorndike (Mrs Squeers), Cyril Fletcher (Mr Alfred Mantalini), Bernard Miles (Newman Noggs), Vera Pearce (Mrs Crummles), Cathleen Nesbitt (Miss Knag), Athene Seyler (Miss La Creevy), Cecil Ramage (Sir Mulberry Hawk), George Relph (Mr Bray), Emrys Jones (Frank Cheeryble), Fay Compton (Madame Mantalini), Jill Balcon (Madeline Bray), Vida Hope (Fanny Squeers), Aubrey Woods (Smike), Roy Hermitage (Wackford Squeers Jnr), Patricia Hayes (Phoebe), Una Bart (infant phenomenon), June Elvin (Miss Snevellici), Drusilla Wills (Mrs Grudden), James Hayter (Ned Cheeryble/Charles Cheeryble), Roddy Hughes (Tim Linkinwater), Michael Shepley (Mr Gregsbury MP), Tim Bateson (Lord Verisopht), Laurence Hanray (Mr Gride), Frederick Burtwell (Sheriff Mercury), John Salew (Mr Lillyrick), Arthur Brander (Mr Snowley), Eliot Makeham (postman).

THE LOVES OF JOANNA GODDEN
June 1947 / Black and white / 89 minutes
CREDITS: DIRECTOR: Charles Frend. ASSOCIATE PRODUCER: Sidney Cole. SCREENPLAY: H. E. Bates, Angus MacPhail. *From the novel* Joanna Godden *by*: Sheila Kaye-Smith. DIRECTOR OF PHOTOGRAPHY: Douglas Slocombe. EDITOR: Michael Truman. ART DIRECTOR: Duncan Sutherland. COSTUMES: Mark Luker. MUSIC: Vaughan Williams. CONDUCTOR: Ernest Irving.
CAST: Googie Withers (Joanna Godden), Jean Kent (Ellen Godden), John McCallum (Arthur Alce), Derek Bond (Martin Trevor), Chips Rafferty (Collard), Henry Mollison (Harry Trevor), Edward Rigby (Stuppeny), Frederick Piper (Isaac Turk), Sonia Holm (Louise), Josephine Stuart (Grace Wichens), Alec Faversham (Peter Relf), Fred Bateman (young Turk), Douglas Jefferies (Huggett), Gilbert Davis (Godfrey), Grace Arnold (Martha), Barbara Leake (Miss Luckhurst), Ronald Simpson (Reverend Brett), Ethel Coleridge (lighthouse keeper's wife), William Mervyn (Huxtable), Betty Shale (Miss Vennal), Ernie Flisher (Fuller), Charles Whiteley (Hook), Dive Turk (Wilson), Albert Thompson (Elphit).

FRIEDA
July 1947 / Black and white / 98 minutes
CREDITS: DIRECTOR: Basil Dearden. ASSOCIATE PRODUCER: Michael Relph. SCREENPLAY: Angus MacPhail, Ronald Millar. *Based on the play by*: Ronald Millar. DIRECTOR OF PHOTOGRAPHY: Gordon Dines. EDITOR: Les Norman. PRODUCTION DESIGNER: Michael Relph. ART DIRECTOR: Jim Morahan. DRESSES: Bianca Mosca. MUSIC: John Greenwood. CONDUCTOR: Ernest Irving.
CAST: David Farrar (Robert Dawson), Mai Zetterling (Frieda Dawson/Mannsfeld), Flora Robson (Nell Dawson), Glynis Johns (Judy Elizabeth Dawson), Albert Lieven (Richard Mannsfeld), Barbara Everest (Mrs Dawson), Gladys Henson (Edith), Milton Rosmer (Tom Merrick), Barry Letts (Jim Merrick), Barry Jones (Holliday), Ray Jackson (Tony Dawson), Patrick Holt (Alan Dawson), Gilbert Davis (Lawrence), Renée Gadd (Mrs Freeman), Douglas Jefferies (Hobson), Eliot Makeham (Bailey), Norman Pierce (Crawley), John Ruddock (Granger), D. A. Clarke-Smith (Herriot), Garry Marsh (Beckwith), Aubrey Mallalieu (Pop Irvine), John Molecey (Latham), Stanley Escane (post boy), Gerhard Hinze (Polish priest), Arthur Howard (official).

IT ALWAYS RAINS ON SUNDAY
November 1947 / Black and white / 92 minutes
CREDITS: DIRECTOR: Robert Hamer. ASSOCIATE PRODUCER: Henry Cornelius. SCREENPLAY: Angus MacPhail, Robert Hamer, Henry Cornelius. *From the novel by*: Arthur La Bern. DIRECTOR OF PHOTOGRAPHY: Douglas Slocombe. EDITOR: Michael Truman. ART DIRECTOR: Duncan Sutherland. DRESSES: Horrockses Fashions Ltd. WARDROBE SUPERVISOR: Anthony Mendleson. MUSIC: Georges Auric. CONDUCTOR: Ernest Irving.
CAST: Googie Withers (Rose Sandigate), Jack Warner (Det Sgt Fothergill), John McCallum (Tommy Swann), Edward Chapman (George Sandigate), Jimmy Hanley (Whitey), John Carol

(Freddie), John Slater (Lou Hyams), Susan Shaw (Vi Sandigate), Sydney Tafler (Morry Hyams), Alfie Bass (Dicey), Patricia Plunkett (Doris Sandigate), Betty Ann Davies (Sadie Hyams), Michael Howard (Slopey Collins), Jane Hylton (Bessie), Frederick Piper (Det Sgt Leech), Betty Baskcomb (barmaid), Hermione Baddeley (Mrs Spry), David Lines (Alfie Sandigate), Meier Tzelniker (Solly Hyams), Nigel Stock (Ted Edwards), John Salew (Caleb Neesley), Gladys Henson (Mrs Neesley), Edie Martin (Mrs Watson), Gilbert Davis (governor of the Two Compasses), Al Millen (Bill Hawkins), Vida Hope (Mrs Wallis), Arthur Hambling (yardmaster), Grace Arnold (Ted's landlady), John Vere (Reverend Black), Patrick Jones (Chuck Evans), Joe Carr (Joe), Fred Griffiths (Sam), Francis O'Rawe (Bertie Potts), David Knox (newspaper boy).

AGAINST THE WIND
February 1948 / Black and white / 96 minutes
CREDITS: DIRECTOR: Charles Crichton. ASSOCIATE PRODUCER: Sidney Cole. SCREENPLAY: T. E. B. Clarke, Michael Pertwee, Paul Vincent Carroll. *Based on a story by*: J. Elder Wills. PHOTOGRAPHY: Lionel Banes. EDITOR: Alan Osbiston. WARDROBE SUPERVISOR: Anthony Mendleson. MUSIC: Leslie Bridgewater.
CAST: Robert Beatty (Father Philip), Simone Signoret (Michele Denise), Jack Warner (Max Cronk), Gordon Jackson (Johnny Duncan), Paul Dupuis (Jacques Picquart), Gisèle Préville (Julie), John Slater (Emile Meyer), Peter Illing (Andrew), James Robertson Justice (Ackerman), Sybilla Binder (Malou), Helene Hensen (Marie Berlot), Gilbert Davis (commandant), Andrew Blackett (Frankie), Arthur Lawrence (Verreker), Eugene Deckers (Marcel Van Hecke), Leo De Pokorny (Balthasar), Rory MacDermot (Carey), Kenneth Villiers (Lewis), Kenneth Hyde (Captain Parker), Olaf Olsen (German officer), Philo Hauser (Joseph), Martin Bradley (Captain Rich), Sheila Carty (Bridie), Margot Lassner (Madame Meyer), Guy Deghy (German sergeant major), Jean Pierre Hambye (Blondel), George Kersen (Flour), Duncan Lewis (sergeant), Robert Wyndham (doctor), André Morell (abbot), René Poirier (Herremans).

SARABAND FOR DEAD LOVERS
(aka: Saraband)
September 1948 / Technicolor / 96 minutes
CREDITS: DIRECTOR: Basil Dearden. ASSOCIATE PRODUCER: Michael Relph. SCREENPLAY: John Dighton, Alexander Mackendrick. *Based on the novel by*: Helen Simpson. DIRECTOR OF PHOTOGRAPHY: Douglas Slocombe. EDITOR: Michael Truman. PRODUCTION DESIGNER: Michael Relph. ART DIRECTOR: Jim Morahan, William Kellner. COSTUMES: Anthony Mendleson, George K. Benda, B. J. Simmons & Co. WARDROBE SUPERVISOR: Anthony Mendleson. MUSIC: Alan Rawsthorne.
CAST: Stewart Granger (Königsmark), Joan Greenwood (Sophie-Dorothea), Flora Robson (Countess Platen), Françoise Rosay (Electress Sophie), Barbara Leake (Maria), Miles Malleson (Lord of Misrule), Anthony Lang (young Prince George), Edward Sinclair (Nils), Allan Jeayes (governor at Ahlden), Aubrey Mallalieu, Guy Rolfe (envoys at Ahlden), Frederick Valk (Elector Ernest Augustus), Peter Bull (Prince George-Louis), Anthony Quayle (Durer), Michael Gough (Prince Charles), Megs Jenkins (Frau Busche), Jill Balcon (Knesbeck), David Horne (Duke George William), Mercia Swinburne (Countess Eleanore), Cecil Trouncer (Maj. Eck), Noel Howlett (Count Platen), Rosemary Lang (young Princess Sophie), Margaret Vines (servant), Peter George (Anders), W. E. Holloway (lawyer), Miles Eason, Victor Adams, Peter Albrecht (soldiers), Janet Howe (Spanish singer).

ANOTHER SHORE
November 1948 / Black and white / 77 minutes
CREDITS: DIRECTOR: Charles Crichton. ASSOCIATE PRODUCER: Ivor Montagu. SCREENPLAY: Walter Meade. *Based on the novel by*: Kenneth Reddin. DIRECTOR OF PHOTOGRAPHY: Douglas Slocombe. EDITOR: Bernard Gribble. ART DIRECTOR: Malcolm Baker-Smith. COSTUMES: Anthony Mendleson. MUSIC: Georges Auric.
CAST: Robert Beatty (Gulliver Shields), Moira Lister (Jennifer), Stanley Holloway (Alastair McNeil), Michael Medwin (Yellow Bingham), Sheila Manahan (Nora), Fred O'Donovan (Coghlan), Maureen Delaney (Mrs Gleason), Dermot Kelly (Boxer), Irene Worth (Bucsy Vere-Brown), Bill Shine (Bats Vere-Brown), Muriel Aked (little old lady), Wilfrid Brambell (Arthur Moore), Michael Dolan (Twiss), W. A. Kelly (old Roger), Michael Golden (D. O. Broderick), Michael O'Mahoney (Officer Fleming), Madame Kirkwood Hackett (strange lady with Alpenstock), John Kelly (Larry), Desmond Keane (Parkes), Michael Brailsford (errand boy), Edie Martin (half crown lady), Grenville Darling (Mr B).

SCOTT OF THE ANTARCTIC
December 1948 / Technicolor / 111 minutes
CREDITS: DIRECTOR: Charles Frend. ASSOCIATE PRODUCER: Sidney Cole. SCREENPLAY: Walter Meade, Ivor Montagu, Mary Hayley Bell. DIRECTORS OF PHOTOGRAPHY: Jack Cardiff, Osmond Borradaile, Geoffrey Unsworth. EDITOR: Peter Tanner. ART DIRECTORS: Arne Åkermark, Jim Morahan. COSTUMES: Anthony Mendleson. MUSIC: Vaughan Williams.
CAST: John Mills (Captain Scott), Derek Bond (Captain Oates), Harold Warrender (Dr Wilson), James Robertson Justice (PO Taff Evans), Reginald Beckwith (Lt Bowers), Kenneth More (Lt Teddy Evans), James McKechnie (Surgeon Lt Atkinson), John Gregson (PO Crean), Norman Williams (Chief Stoker W. Lashly RN), Barry Letts (Apsley Cherry-Garrard), Clive Morton (Herbert Ponting FRPS), Anne Firth (Oriana Wilson), Diana Churchill (Kathleen Scott), Dennis Vance (Charles S. Wright), Larry Burns (PO Keohane), Edward Lisak (Dimitri), Melville Crawford (Cecil Meares), Christopher Lee (Bernard Day), John Owers (F. J. Hooper), Bruce Seton (Lt H. Pennell RN), Sam Kydd (Leading Stoker McKenzie), Mary Merrett (Helen Field), Percy Walsh (chairman), Noel Howlett, Philip Stainton (questioners), Desmond Roberts (Admiralty official), Dandy Nichols (Caroline), David Lines (telegraph boy), John Derrick (Simpson), Don Yarranton (Forde), Claude Spere (Archer), Leo Philips (Clissold), Kenneth Bellringer (Dickason), John Tathan (Campbell), Jock Ritchie (Williamson), Godfrey Harrison (Debenham), Geoffrey Crank (Murray-Levick), Peter Northcote (Taylor), Roy Kirkham (Abbot), Richard Power (Priestley), Kenneth Hanes (Browning), Donald Creswell (Nelson), Stig Egede Nissen (Dr Nansen).

EUREKA STOCKADE
(aka: Massacre Hill)
January 1949 / Black and white / 103 minutes
CREDITS: DIRECTOR: Harry Watt. ASSOCIATE PRODUCER: Leslie Norman. SCREENPLAY: Harry Watt, Walter Greenwood, Ralph Smart. PHOTOGRAPHY: George Heath. ART DIRECTOR: Charles Woolveridge. COSTUMES: Dahl Collings. MUSIC: John Greenwood. CONDUCTOR: Ernest Irving.
CAST: Chips Rafferty (Peter Lalor), Jane Barrett (Alicia Dunne), Jack Lambert (Commissioner Rede), Gordon Jackson (Tom Kennedy), Peter Illing (Rafaello Carboni), Ralph Truman (Governor Sir Charles Hotham), Sydney Loder (Frederick Vern), Peter Finch (John Humffray), Grant Taylor (Sgt-Maj. Milne), Kevin Brennan (George Black), John Fegan (Timothy Hayes), Reg Wykeham (Dr Charles Moore), Al Thomas (Jamie Scobie), John Fernside (grog seller), Betty Ross (Mary O'Rourke), Ron Whelan (Thomas Bentley), Perk Allison (Mrs Bentley), John Wiltshire (Father Smythe), Nigel Lovell (Captain Wise), Charles Tasman (Governor Charles Joseph La Trobe), Mary Ward (Lady Hotham), John Cazabon (Seekamp), John Clarke (Gregory), Paul Delmar (Ross), Leigh O'Malley (Nelson), Alex Cann (McGill), Jean Blue (Ma McGinty), Marshall Crosbie (Sullivan), Rex Dawe (auctioneer), Andrina Watton (little girl), Mickie Yardley (Kevan).

PASSPORT TO PIMLICO
April 1949 / Black and white / 84 minutes
CREDITS: DIRECTOR: Henry Cornelius. ASSOCIATE PRODUCER: E. V. H. Emmett. SCREENPLAY: T. E. B. Clarke. DIRECTOR OF PHOTOGRAPHY: Lionel Banes. EDITOR: Michael Truman. ART DIRECTOR: Roy Oxley. COSTUME DESIGNER: Anthony Mendleson. MUSIC: Georges Auric.
CAST: Stanley Holloway (Arthur Pemberton), Betty Warren (Connie Pemberton), Barbara Murray (Shirley Pemberton), Paul Dupuis (Duke of Burgundy), John Slater (Frank Huggins), Jane Hylton (Molly Reid), Raymond Huntley (Mr Wix), Philip Stainton (PC Ted Spiller), Roy Carr (Benny Spiller), Sydney Tafler (Fred Cowan), Nancy Gabrielle (Mrs Cowan), Malcolm Knight (Monty Cowan), Hermione Baddeley (Edie Randall), Roy Gladdish (Charlie Randall), Frederick Piper (Garland), Charles Hawtrey (Bert Fitch), Margaret Rutherford (Professor Hatton-Jones), Stuart Lindsell (coroner), Naunton Wayne (Straker), Basil Radford (Gregg), Gilbert Davis (Bagshawe), Michael Hordern (Bashford), Arthur Howard (Bassett), Bill Shine (Captain Willow), Harry Locke (sergeant), Sam Kydd (Sapper), Joey Carr (Dave Parsons), Lloyd Pearson (Fawcett), Arthur Denton (customs official), Tommy Godfrey (bus conductor), James Hayter (commissionaire), Masoni (conjurer), Fred Griffiths (Bill), Grace Arnold (pompous woman), Paul Demel (European).

WHISKY GALORE!
(aka: Tight Little Island / Whiskey Galore!)
June 1949 / Black and white / 82 minutes
CREDITS: DIRECTOR: Alexander Mackendrick.

ASSOCIATE PRODUCER: Monja Danischewsky. SCREENPLAY: Compton Mackenzie, Angus MacPhail. *Based on the novel by*: Compton Mackenzie. DIRECTOR OF PHOTOGRAPHY: Gerald Gibbs. EDITOR: Joseph Sterling. ART DIRECTOR: Jim Morahan. WARDROBE SUPERVISOR: Anthony Mendleson. MUSIC: Ernest Irving.
CAST: Basil Radford (Captain Paul Waggett), Catherine Lacey (Mrs Waggett), Bruce Seton (Sgt Odd), Joan Greenwood (Peggy Macroon), Wylie Watson (Joseph Macroon), Gabrielle Blunt (Catriona Macroon), Gordon Jackson (George Campbell), Jean Cadell (Mrs Campbell), James Robertson Justice (Dr MacLaren), Morland Graham (the biffer), John Gregson (Sammy MacCodrun), James Woodburn (Roderick MacRurie), James Anderson (Old Hector), Jameson Clark (Constable Macrae), Duncan MacRae (Angus MacCormac), Mary MacNeil (Mrs MacCormac), Norman MacOwan (Captain MacPhee), Alastair Hunter (Captain MacKechnie), Henry Mollison (Farquharson), Frank Webster (first mate), Compton Mackenzie (Captain Buncher), John Haggerty (exciseman), A. E. Matthews (Col. Lindsey-Woolsey), Finlay Currie (narrator).

KIND HEARTS AND CORONETS
(aka: Noblesse Oblige)
June 1949 / Black and white / 106 minutes
CREDITS: DIRECTOR: Robert Hamer. ASSOCIATE PRODUCER: Michael Relph. SCREENPLAY: Robert Hamer, John Dighton. *Based on a novel by*: Roy Horniman. DIRECTOR OF PHOTOGRAPHY: Douglas Slocombe. EDITOR: Peter Tanner. ART DIRECTOR: William Kellner. COSTUME DESIGNER: Anthony Mendleson. MUSIC: Mozart. CONDUCTOR: Ernest Irving.
CAST: Dennis Price (Louis Mazzini/Louis's father), Alec Guinness (Ethelred D'Ascoyne / Lord Ascoyne D'Ascoyne/ Rev Lord Henry D'Ascoyne / Gen. Rufus D'Ascoyne / Admiral Lord Horatio D'Ascoyne / young Ascoyne D'Ascoyne / young Henry D'Ascoyne / Lady Agatha D'Ascoyne), Valerie Hobson (Edith D'Ascoyne), Joan Greenwood (Sibella Holland), Audrey Fildes (Mrs Mazzini), John Penrose (Lionel Holland), Miles Malleson (Mr Elliott), Clive Morton (colonel), Cecil Ramage (crown counsel), Hugh Griffith (Lord High Steward), John Salew (Mr Perkins), Eric Messiter (Insp. Burgoyne), Lyn Evans (farmer), Barbara Leake (Miss Waterman), Peggy Ann Clifford (Maud Redpole), Anne Valery (Clothilde), Arthur Lowe (*Titbits* reporter), Laurence Naismith, Maxwell Foster, Stanley Beard (warders), Jeremy Spenser (Louis as a child), David Preston (Lionel as a child), Carol White (Sibella as a child), Cavan Malone (Graham as a child), Ian Collins (Dr Hallward), Harold Young (captain), Molly Hamley-Clifford (Lady Redpole), Leslie Handford (Hoskins), Gordon Phillott (clerk of parliament), Richard Wattis (Louis' counsel), Peter Gawthorne, Fletcher Lightfoot (peers), Ivan Staff (valuer), Nicholas Hill (sergeant-at-arms).

TRAIN OF EVENTS
August 1949 / Black and white / 89 minutes
CREDITS: DIRECTOR: Sidney Cole, Charles Crichton, Basil Dearden. ASSOCIATE PRODUCER: Michael Relph. SCREENPLAY: Basil Dearden, T. E. B. Clarke, Ronald Millar, Angus MacPhail. DIRECTOR OF PHOTOGRAPHY: Lionel Banes, Gordon Dines. EDITOR: Bernard Gribble. ART DIRECTORS: Malcolm Baker-Smith, Jim Morahan. COSTUME DESIGNER: Anthony Mendleson. MUSIC: Leslie Bridgewater. CONDUCTOR: Ernest Irving.
CAST: Jack Warner (Jim Hardcastle), Gladys Henson (Mrs Hardcastle), Susan Shaw (Doris Hardcastle), Patric Doonan (Ron Stacey), Philip Dale (Hardcastle's fireman), Miles Malleson (Johnson), Leslie Phillips (Stacey's fireman), Percy Walsh (district superintendent), Will Ambro (Lancashire railwayman), Valerie Hobson (Stella), John Clements (Raymond Hillary), Irina Baronova (Irina Norozova), John Gregson (Malcolm Murray-Bruce), Gwen Cherrell (Charmian), Jacqueline Byrne (television announcer), Neal Arden (compère), Thelma Grigg (harpist), Joan Dowling (Ella), Laurence Payne (Richard), Olga Lindo (Mrs Bailey), Denis Webb (clerk), Peter Finch (Philip Mason), Mary Morris (Louise), Laurence Naismith (Joe Hunt), Doris Yorke (Mrs Hunt), Michael Hordern, Charles Morgan (plain clothes men), Mark Dignam (Bolingbroke), Guy Verney (producer), Philip Ashley, Bryan Coleman, Henry Hewitt, Lyndon Brook (actors).

A RUN FOR YOUR MONEY
November 1949 / Black and white / 85 minutes
CREDITS: DIRECTOR: Charles Frend. ASSOCIATE PRODUCER: Leslie Norman. SCREENPLAY: Richard Hughes, Charles Frend, Leslie Norman. ADDITIONAL DIALOGUE: Diana Morgan. *Based on a story by*: Clifford Evans. DIRECTOR OF PHOTOGRAPHY: Douglas Slocombe. EDITOR: Michael Truman. ART DIRECTOR: William Kellner.

COSTUME DESIGNER: Anthony Mendleson. MUSIC: Ernest Irving.
CAST: Donald Houston (Dai Jones), Meredith Edwards (Twm Jones), Moira Lister (Jo), Alec Guinness (Whimple), Hugh Griffith (Huw Price), Clive Morton (Editor), Julie Milton (Bronwen), Peter Edwards (Davies), Joyce Grenfell (Mrs Pargiter), Leslie Perrins (Barney), Dorothy Bramhall (Jane Benson), Andrew Leigh (pawnbroker), Edward Rigby (Beefeater), Desmond Walter-Ellis (station announcer), Mackenzie Ward (photographer), Meadows White (guv'nor), Gabrielle Brune (crooner), Charles Cullum (powerful man), Ronnie Harries (Dan), Diana Hope (customer).

THE BLUE LAMP
January 1950 / Black and white / 84 minutes
CREDITS: DIRECTOR: Basil Dearden. ASSOCIATE PRODUCER: Michael Relph. SCREENPLAY: T. E. B. Clarke. TREATMENT: Jan Read, Ted Willis. ADDITIONAL DIALOGUE: Alexander Mackendrick. DIRECTOR OF PHOTOGRAPHY: Gordon Dines. EDITOR: Peter Tanner. ART DIRECTOR: Jim Morahan. COSTUME DESIGNER: Anthony Mendleson.
CAST: Jack Warner (PC George Dixon), Jimmy Hanley (PC Andy Mitchell), Dirk Bogarde (Tom Riley), Robert Flemyng (Sgt Roberts), Bernard Lee (Divisional Det. Insp. Cherry), Peggy Evans (Diana Lewis), Patric Doonan (Spud), Bruce Seton (PC Jock Campbell), Meredith Edwards (PC Taff Hughes), Clive Morton (Sgt Brooks), Frederick Piper (Alf Lewis), Dora Bryan (Maisie), Gladys Henson (Mrs Dixon), Tessie O'Shea (herself), William Mervyn (Chief Insp. Hammond), Charles Saynor (PC Tovey), Campbell Singer (station sergeant), Gwynne Whitby (Sgt Grace Millard), Anthony Steel (PC Lock), Sidney Pointer (Supt Harwood), Michael Golden (Mike Randall), Norman Shelley (Frederick Percival Jordan), Gene Neighbors (Queenie), Betty Ann Davies (Mrs Lewis), Glen Buckland (Larry), Jennifer Jayne (June), Doris Yorke (cashier at cinema), Renée Gadd (woman driver), Geoffrey Lumsden (Grant), Arnold Bell (solicitor), Muriel Aked (Mrs Waterbourne), Cameron Hall (drunk), Glyn Houston (barrow boy), Rowland Douglas (cinema doorman), Alma Cogan (extra).

DANCE HALL
June 1950 / Black and white / 80 minutes
CREDITS: DIRECTOR: Charles Crichton. ASSOCIATE PRODUCER: E. V. H. Emmett. SCREENPLAY: E. V. H. Emmett, Diana Morgan, Alexander Mackendrick. DIRECTOR OF PHOTOGRAPHY: Douglas Slocombe. EDITOR: Seth Holt. ART DIRECTOR: Norman Arnold. WARDROBE SUPERVISOR: Anthony Mendleson. SONGS: Joyce Cochrane, Christopher Hassall.
CAST: Donald Houston (Phil), Bonar Colleano (Alec Viners), Petula Clark (Georgie Wilson), Natasha Parry (Eve), Jane Hylton (Mary), Diana Dors (Carole), Gladys Henson (Mrs Wilson), Sydney Tafler (Jim Fairfax, *palais* manager), Douglas Barr (Peter), Geraldo and His Orchestra (themselves), Ted Heath and His Music (themselves), Wally Fryer, Violet Barnes, Robert Henderson, Eileen Henshall, Len Colyer, Dorice Brace, Robert Burgess, Margaret Baker (special dancers), Fred Johnson (Mr Wilson), Dandy Nichols (Mrs Crabtree), James Carney (Mike), Kay Kendall (Doreen), Eunice Gayson (Mona), Grace Arnold (Mrs Bennett), Thomas Heathcote (Fred), Harold Goodwin (Jack), Christopher Kane (American soldier), Tonie MacMillan (Mrs Hepple), Alec Finter (Palais instructor), Doris Hare (blonde), Michael Trubshawe (colonel), Hy Hazell (herself), Harry Fowler (New Year congratulator), Alma Cogan (dancer).

BITTER SPRINGS
July 1950 / Black and white / 86 minutes
CREDITS: DIRECTOR: Ralph Smart. ASSOCIATE PRODUCER: Leslie Norman. SCREENPLAY: W. P. Lipscomb, Monja Danischewsky. STORY: Ralph Smart. DIRECTOR OF PHOTOGRAPHY: George Heath. EDITOR: Bernard Gribble. ART DIRECTOR: Charles Woolveridge. MUSIC: Vaughan Williams, Ernest Irving.
CAST: Chips Rafferty (Wally King), Tommy Trinder (Tommy), Gordon Jackson (Mac), Jean Blue (Ma King), Michael Pate (Ransome), Nonnie Piper (Emma King), Charles Tingwell (John King), Henry Murdock (Black Jack), Nicky Yardley (Charlie).

CAGE OF GOLD
September 1950 / Black and white / 83 minutes
CREDITS: DIRECTOR: Basil Dearden. ASSOCIATE PRODUCER: Michael Relph. SCREENPLAY: Jack Whittingham. *Based on a story by*: Jack Whittingham, Paul L. Stein. DIRECTOR OF PHOTOGRAPHY: Douglas Slocombe. EDITOR: Peter Tanner. DESIGNER: Michael Relph. ART DIRECTOR: Jim Morahan. COSTUME DESIGNER: Anthony Mendleson. MUSIC: Georges Auric.
CAST: Jean Simmons (Judith Moray), David Farrar (Bill Glennon), James Donald (Dr Alan

Kearn), Madeleine Lebeau (Marie Jouvet), Maria Mauban (Antoinette Duport), Herbert Lom (Rahman), Bernard Lee (Insp. Grey), Grégoire Aslan (Duport), Gladys Henson (Waddy), Harcourt Williams (Dr Kearn), Léo Ferré (Victor), George Benson (assistant registrar), Martin Boddey (Sgt Adams), Arthur Hambling (patient), Campbell Singer (a policeman), Guy Verney (George), Sam Kydd (waiter), Anthony Britten (Nicky), Michael Balfour, Sonny Millar, Guy Kingsley-Poynter (American soldiers), Frank Royde (superintendent registrar), Jacqueline Charles (nightclub attendant), Arthur Howard (thin man), Ann Lancaster (cast), Arthur Lowe (short man).

THE MAGNET

October 1950 / Black and white / 79 minutes
CREDITS: DIRECTOR: Charles Frend. ASSOCIATE PRODUCER: Sidney Cole. SCREENPLAY: T. E. B. Clarke. DIRECTOR OF PHOTOGRAPHY: Lionel Banes. EDITOR: Bernard Gribble. ART DIRECTOR: Jim Morahan. COSTUME DESIGNERS: Anthony Mendleson, Spectator Sports Ltd. MUSIC: William Alwyn. CONDUCTOR: Ernest Irving.
CAST: Stephen Murray (Dr Brent), Kay Walsh (Mrs Brent), Meredith Edwards (Adam Harper), Gladys Henson (Nannie), Wylie Watson (Pickering), Thora Hird (Nannie's friend), Julien Mitchell (Mayor James Hancock), William Fox (Johnny Brent), Keith Robinson (Spike), Thomas Johnston (Perce), David Boyd (Mike), Geoffrey Yin (Choppo), Michael Brooke Jr (Kit), Anthony Oliver (policeman), Molly Hamley-Clifford (Mrs Dean), Harold Goodwin (pin-table attendant), Edward Davies (delinquent youth), Joan Hickson (Mrs Ward), Grace Arnold (Mrs Mercer), Jane Bough (Sally Mercer), Bryan Michie (announcer), Joss Ambler (businessman on train), Sam Kydd (postman), Russell Waters (doctor), Thea Gregson (nurse), Seumas Mor Na Feasag (tramp).

POOL OF LONDON

February 1951 / Black and white / 85 minutes
CREDITS: DIRECTOR: Basil Dearden. ASSOCIATE PRODUCER: Michael Relph. SCREENPLAY: Jack Whittingham, John Eldridge. DIRECTOR OF PHOTOGRAPHY: Gordon Dines. EDITOR: Peter Tanner. ART DIRECTOR: Jim Morahan. COSTUME DESIGNER: Anthony Mendleson. MUSIC: John Addison. MUSICAL DIRECTOR: Ernest Irving.
CAST: Bonar Colleano (Dan MacDonald), Susan Shaw (Pat), Renée Asherson (Sally), Moira Lister (Maisie), Earl Cameron (Johnny), Max Adrian (Vince Vernon/George Vernon), Joan Dowling (Pamela), James Robertson Justice (Trotter), Michael Golden (Andrews), John Longden (Insp. Williamson), Alfie Bass (Alf), Christopher Hewett (Mike), Leslie Phillips (Harry), George Benson (George), Mai Bacon (Ethel), Mavis Villiers (blonde in drinking club), Michael Corcoran (Sam), Sam Kydd (second engineer), George Merritt (captain of Dunbar), Rowena Gregory (Mary), Victor Maddern (bus conductor), Laurence Naismith (theatre commissionaire), Arthur Cortez (Jock), Russell Waters (police sergeant), Beckett Bould (watchman), Campbell Singer (station sergeant), John Warwick (Insp. Jim Moss), Michael Ward (pub pianist), Arthur Bentley (Pamela's boyfriend), Josephine Sullivan (barmaid), Ellis Irving (superintendent).

THE LAVENDER HILL MOB

June 1951 / Black and white / 78 minutes
CREDITS: DIRECTOR: Charles Crichton. ASSOCIATE PRODUCER: Michael Truman. SCREENPLAY: T. E. B. Clarke. DIRECTOR OF PHOTOGRAPHY: Douglas Slocombe. EDITOR: Seth Holt. ART DIRECTOR: William Kellner. COSTUME DESIGNER: Anthony Mendleson. MUSIC: Georges Auric.
CAST: Alec Guinness (Henry Holland), Stanley Holloway (Alfred Pendlebury), Sidney James (Lackery Wood), Alfie Bass (Shorty), Marjorie Fielding (Mrs Chalk), John Gregson (Farrow), Clive Morton (station sergeant), Ronald Adam (Turner), Sydney Tafler (Clayton), Edie Martin (Miss Evesham), Jacques Brunius (customs official), Paul Demel (customs official), Eugene Deckers (customs official), Andrea Malandrinos (customs official), John Salew (Parkin), Arthur Hambling (Wallis), Gibb McLaughlin (Godwin), Marie Burke (Senora Gallardo), Audrey Hepburn (Chiquita), William Fox (Gregory), Michael Trubshawe (British ambassador), Ann Heffernan (kiosk girl), Cyril Chamberlain (commander), Tony Quinn (deputy commander), Moultrie Kelsall (detective superintendent), Christopher Hewett (Insp. Talbot), Meredith Edwards (PC Williams), Patrick Barr (divisional detective inspector), David Davies (City policeman), Frederick Piper (café proprietor), Peter Bull (Joe the Gab), Patric Doonan (Craggs), Alanna Boyce (June Edwards).

THE MAN IN THE WHITE SUIT

August 1951 / Black and white / 85 minutes
CREDITS: DIRECTOR: Alexander Mackendrick.

ASSOCIATE PRODUCER: Sidney Cole. SCREENPLAY: Roger MacDougall, John Dighton, Alexander Mackendrick. *Based on a play by*: Roger MacDougall. DIRECTOR OF PHOTOGRAPHY: Douglas Slocombe. EDITOR: Bernard Gribble. ART DIRECTOR: Jim Morahan. COSTUME DESIGNER: Anthony Mendleson. MUSIC: Benjamin Frankel.
CAST: Alec Guinness (Sidney Stratton), Joan Greenwood (Daphne Birnley), Cecil Parker (Alan Birnley), Michael Gough (Michael Corland), Ernest Thesiger (Sir John Kierlaw), Vida Hope (Bertha), Howard Marion Crawford (Cranford), Miles Malleson (tailor), Henry Mollison (Hoskins), Patric Doonan (Frank), Duncan Lamont (Harry), Harold Goodwin (Wilkins), Colin Gordon (Hill), Joan Harben (Miss Johnson), Arthur Howard (Roberts), Roddy Hughes (Green), Stuart Latham (Harrison), Edie Martin (Mrs Watson), Mandy Miller (Gladdie), Charlotte Mitchell (mill girl), Olaf Olsen (Knudsen), Desmond Roberts (Mannering), Ewan Roberts (Fotheringay), John Rudling (Wilson), Charles Saynor (Pete), Russell Waters (Davidson), Brian Worth (King), George Benson (lodger), Frank Atkinson (baker), Charles Cullum (first company director), F. B. J. Sharp (second company director), Scott Harold (Express reporter), Jack Howarth (Corland Mill receptionist), Jack McNaughton (taxi driver), Judith Furse (Nurse Gamage), Billy Russell (nightwatchman), David Boyd (office boy).

WHERE NO VULTURES FLY
(aka: Ivory Hunter)
December 1951 / Technicolor / 107 minutes
CREDITS: DIRECTOR: Harry Watt. PRODUCED IN ASSOCIATION WITH: African Film Productions. ASSOCIATE PRODUCER: Leslie Norman. SCREENPLAY: W. P. Lipscomb, Ralph Smart, Leslie Norman. STORY: Harry Watt. DIRECTOR OF PHOTOGRAPHY: Geoffrey Unsworth. GAME PHOTOGRAPHY: Paul Beeson. SUPERVISING EDITOR: Jack Harris. EDITOR: Gordon Stone. MUSIC: Alan Rawsthorne. CONDUCTOR: Ernest Irving.
CAST: Anthony Steel (Bob Payton), Dinah Sheridan (Mary Payton), Harold Warrender (Mannering), Meredith Edwards (Gwil Davies), William Simons (Tim Payton), Orlando Martins (M'Kwongwi), Phillip Birkinshaw (district commissioner), Jack Arundel Mallett (chief game warden), Kenneth Augustus Jeremy (Watson), Wallace Needham-Clark (chief veterinary officer), Edmund Stewart (first hunter), John Lawrence (second hunter), Paul N'gei (Ondego), David Osieli (Kali), Johanna Kitau (Kimolo), Jafeth Ananda (Scarface), Bartholomew Sketch (Scarface's brother).

HIS EXCELLENCY
January 1952 / Black and white / 84 minutes
CREDITS: DIRECTOR: Robert Hamer. PRODUCER: Michael Truman. SCREENPLAY: Robert Hamer, W. P. Lipscomb. *Based on the play by*: Dorothy Christie, Campbell Christie. DIRECTOR OF PHOTOGRAPHY: Douglas Slocombe. EDITOR: Seth Holt. ART DIRECTOR: Jim Morahan. COSTUME DESIGNER: Anthony Mendleson. MUSIC: Handel. MUSICAL DIRECTOR: Ernest Irving.
CAST: Eric Portman (George Harrison), Cecil Parker (Sir James Kirkman), Helen Cherry (Lady Kirkman), Susan Stephen (Peggy Harrison), Clive Morton (Copeland, GOC), Alec Mango (Jackie), Geoffrey Keen (Morellos), John Salew (Fernando), Edward Chapman (Vice Adm. Barclay), Robin Bailey (Charles), Eric Pohlmann (Col. Don Dobrieda), Paul Demel (chef), Elspeth March (Katarina), Henry Longhurst (Lord Kynaston), Howard Marion Crawford (tea shop proprietor), Gerard Heinz (prime minister), Barbara Leake, Barbara Cavan (women in tea shop), Basil Dignam (district security officer), Laurence Naismith (first soldier), Victor Maddern (second soldier).

SECRET PEOPLE
February 1952 / Black and white / 96 minutes
CREDITS: DIRECTOR: Thorold Dickinson. PRODUCER: Sidney Cole. SCREENPLAY: Thorold Dickinson, Wolfgang Wilhelm. ADDITIONAL DIALOGUE: Christianna Brand. *Based on a story by*: Thorold Dickinson, Joyce Cary. DIRECTOR OF PHOTOGRAPHY: Gordon Dines. EDITOR: Peter Tanner. ART DIRECTOR: William Kellner. COSTUME DESIGNER: Anthony Mendleson. MUSIC: Roberto Gerhard. CONDUCTOR: Ernest Irving.
CAST: Valentina Cortese (Maria Brentano), Serge Reggiani (Louis Balan), Charles Goldner (Anselmo), Audrey Hepburn (Nora Brentano), Angela Fouldes (Nora as a child), Megs Jenkins (Penny), Irene Worth (Miss Jackson), Reginald Tate (Insp. Eliot), Norman Williams (Sgt Newcombe), Michael Shepley (manager of the British Pavilion), Athene Seyler (Mrs Reginald Kellick), Sydney Tafler (Syd Burnett), Geoffrey Hibbert (Steenie), John Ruddock (Daly), Michael Allan (Rodd), John Field (Fedor Luki), Charlie

Cairoli & Paul (speciality act), Hugo Schuster (Gen. Galbern), Lionel Harris (Frack), Rollo Gamble (Bentley), John Penrose (Bill), John Chandos (John), Michael Ripper (Charlie), Yvonne Coulette (woman on London committee), John Mansi, John Gabriel, Olga Landiak (Paris committee members), Frederick Schiller, Phaedros Antonio (Galbern's bodyguards), Gaston Richer (Queval), Derek Elphinstone, Edward Evans (plainclothes men), Jack McNaughton (postman), Ingeborg Wells (shoe shop girl), Bob Monkhouse (hairdresser), Helen Ford (scarf woman), Ann Lancaster (Gladys), Grace Draper (floozie), Bertram Shuttleworth (little man), Pamela Harrington (waitress), John Allen (valet), Bay White (nursing sister), Joe Linnane (Irish police inspector), Sam Kydd (Irish police sergeant), William Franklyn (surgeon).

I BELIEVE IN YOU

March 1952 / Black and white / 95 minutes
CREDITS: DIRECTOR: Basil Dearden. PRODUCER: Michael Relph. SCREENPLAY: Jack Whittingham, Michael Relph, Basil Dearden, Nicholas Phipps. *Based on the book by*: Sewell Stokes. DIRECTOR OF PHOTOGRAPHY: Gordon Dines. EDITOR: Peter Tanner. ART DIRECTOR: Maurice Carter. COSTUME DESIGNER: Anthony Mendleson. MUSIC: Ernest Irving.
CAST: Cecil Parker (Henry Phipps), Celia Johnson (Matty), Harry Fowler (Hooker), Joan Collins (Norma), George Relph (Mr Dove), Godfrey Tearle (Mr Pyke), Ernest Jay (Mr Quayle), Laurence Harvey (Jordie), Stanley Escane (Buck), Cyril Waites (Dai), Ursula Howells (Hon Ursula), Sidney James (Sgt Body), Katie Johnson (Miss Macklin), Ada Reeve (Mrs Crockett), Brenda De Banzie (Mrs Hooker), Alex McCrindle (Mr Haines), Laurence Naismith (Sgt Braxton), John Orchard (Braxton), David Hannaford (Braxton child), Herbert C. Walton (Frost), Gwynne Whitby (Policewoman Andrews), Fred Griffiths (Crump), Richard Hart (Eric Stevens), Gladys Henson (Mrs Stevens), Doris Yorke.

MANDY

(aka: The Story of Mandy / Crash of Silence)
July 1952 / Black and white / 93 minutes
CREDITS: DIRECTOR: Alexander Mackendrick. PRODUCER: Leslie Norman. SCREENPLAY: Nigel Balchin, Jack Whittingham. *Based on the novel by*: Hilda Lewis. DIRECTOR OF PHOTOGRAPHY: Douglas Slocombe. EDITOR: Seth Holt. ART DIRECTOR: Jim Morahan. COSTUME DESIGNER: Anthony Mendleson. MUSIC: William Alwyn.
CAST: Phyllis Calvert (Christine Garland), Jack Hawkins (Dick Searle), Terence Morgan (Harry Garland), Godfrey Tearle (Mr Garland), Mandy Miller (Mandy Garland), Marjorie Fielding (Mrs Garland), Nancy Price (Jane Ellis), Edward Chapman (Ackland), Patricia Plunkett (Miss Crocker), Eleanor Summerfield (Lily Tabor), Colin Gordon (Woollard Junior), Dorothy Alison (Miss Stockton), Julian Amyes (Jimmy Tabor), Gabrielle Brune (secretary), John Cazabon (Davey), Gwen Bacon (Mrs Paul), W. E. Holloway (Woollard Senior), Phyllis Morris (Miss Tucker), Gabrielle Blunt (Miss Larner), Jean Shepherd (Mrs Jackson), Jane Asher (Nina), Marlene Maddox (Leonie), Michael Mallinson, Doreen Gallagher, Doreen Taylor, Michael Davis, Joan Peters (children).

THE GENTLE GUNMAN

October 1952 / Black and white / 86 minutes
CREDITS: DIRECTOR: Basil Dearden. PRODUCER: Michael Relph. SCREENPLAY: Roger MacDougall. *From the play by*: Roger MacDougall. DIRECTOR OF PHOTOGRAPHY: Gordon Dines. EDITOR: Peter Tanner. ART DIRECTOR: Jim Morahan. COSTUME DESIGNER: Anthony Mendleson. MUSIC: John Greenwood. CONDUCTOR: Ernest Irving.
CAST: John Mills (Terence Sullivan), Dirk Bogarde (Matt Sullivan), Robert Beatty (Shinto), Elizabeth Sellars (Maureen Fagan), Barbara Mullen (Molly Fagan), Eddie Byrne (Flynn), Joseph Tomelty (Dr Brannigan), Liam Redmond (Connolly), James Kenney (Johnny Fagan), Michael Golden (Murphy), Jack MacGowran (Patsy McGuire), Gilbert Harding (Henry Truethorn), Michael Dunne (Brennan), Patricia Stewart (girl), Harry Brogan (Barney), Tony Quinn (ambulance attendant), Edward Byrne (ambulance attendant), Patric Doonan (sentry), John Orchard (sentry), Seamus Kavanagh (publican), Terence Alexander (ship's officer), E. J. Kennedy (telephone exchange official), Jean St Clair (Rosie O'Flaherty), Doris Yorke (English landlady).

THE TITFIELD THUNDERBOLT

March 1953 / Technicolor / 87 minutes
CREDITS: DIRECTOR: Charles Crichton. PRODUCER: Michael Truman. SCREENPLAY: T. E. B. Clarke. DIRECTOR OF PHOTOGRAPHY: Douglas Slocombe. EDITOR: Seth Holt. ART DIRECTOR: C. P. Norman. WARDROBE: Anthony Mendleson. MUSIC: Georges Auric.
CAST: Stanley Holloway (Mr Valentine), George Relph (Vicar Samuel Weech), Naunton Wayne

(Mr Blakeworth), John Gregson (Gordon Chesterworth), Godfrey Tearle (Bishop Olly Matthews), Hugh Griffith (Dan Taylor), Gabrielle Brune (Joan), Sidney James (Harry Hawkins), Reginald Beckwith (Coggett), Edie Martin (Emily), Michael Trubshawe (Ruddock), Jack McGowran (Vernon Crump), Ewan Roberts (Alec Pearce), Herbert C. Walton (Seth), John Rudling (Clegg), Nancy O'Neil (Mrs Blakeworth), Campbell Singer (police sergeant), Frank Atkinson (station sergeant), Wensley Pithey (a policeman), Harold Alford (guard), Ted Burbridge (engine driver), Frank Green (Ben).

THE CRUEL SEA

March 1953 / Black and white / 125 minutes
CREDITS: DIRECTOR: Charles Frend. PRODUCER: Leslie Norman. SCREENPLAY: Eric Ambler. *From the novel by*: Nicholas Monsarrat. DIRECTOR OF PHOTOGRAPHY: Gordon Dines. EDITOR: Peter Tanner. ART DIRECTOR: Jim Morahan. WARDROBE: Anthony Mendleson. MUSIC: Alan Rawsthorne.
CAST: Jack Hawkins (Ericson), Donald Sinden (Lockhart), Denholm Elliott (Morell), John Stratton (Ferraby), Stanley Baker (Bennett), Liam Redmond (Watts), Meredith Edwards (Yeoman Wells), Bruce Seton (Tallow), John Warner (Baker), Barry Letts (Raikes), Gerard Heinz (Polish captain), Fred Griffiths (Gracey), Glyn Houston (Phillips), Virginia McKenna (Julie Hallam), Megs Jenkins (Tallow's sister), June Thorburn (Doris Ferraby), Moira Lister (Elaine Morell), Alec McCowen (Tonbridge), Leo Phillips (Wainwright), Dafydd Havard (Signalman Rose), Laurence Hardy (Sellars), Sam Kydd (Carslake), John Singer (Gray), Barry Steele (Broughton), Gerik Schjelderup (Norwegian captain), Gaston Richer (French captain), Andrew Cruickshank (Scott Brown), Kenn Kennedy (Allingham), Harold Goodwin (ASDIC operator), George Curzon (admiral at party), Anthony Snell (RN lieutenant), Ronald Simpson (RN captain), Don Sharp (lieutenant commander), Herbert C. Walton (waiter), Jack Howard (a survivor), Russell Waters, Harold Jamieson (ARP wardens), Warwick Ashton (petty officer instructor), Walter Fitzgerald (warden), Alan Webb (Adm. Murray-Forbes), D. Gideon Thompson (ASDIC officer), Arthur Bentley (radar operator).

THE SQUARE RING

July 1953 / Black and white / 83 minutes
CREDITS: DIRECTOR: Basil Dearden. PRODUCER: Michael Relph. SCREENPLAY: Robert Westerby. ADDITIONAL DIALOGUE: Peter Myers, Alec Grahame. *Based on the play by*: Ralph W. Peterson. DIRECTOR OF PHOTOGRAPHY: Otto Heller. EDITOR: Peter Bezencenet. ART DIRECTOR: Jim Morahan. WARDROBE: Anthony Mendleson.
CAST: Jack Warner (Danny Felton), Robert Beatty (Kid Curtis), Maxwell Reed (Rick Martell), Bill Owen (Happy Burns), Joan Collins (Frankie), Kay Kendall (Eve Lewis), Bernadette O'Farrell (Peg Curtis), Eddie Byrne (Lou Lewis), Sidney James (Adams), Alfie Bass (Frank Forbes), George Rose (Whitey Johnson), Bill Travers (Rowdie Rawlings), Ronald Lewis (Eddie Lloyd), Michael Golden (Warren), Vic Wise (Joe), Joan Sims (Bunty), Vernon Kelso (Reynolds), Sydney Tafler (first wiseacre), Alexander Gauge (second wiseacre), Michael Ingrams (doctor), Ivan Staff (Mr Coleman), Madoline Thomas (Mrs Lloyd), Ben Williams (Mr Lloyd), Alf Hines (Deakon), Harry Herbert (DeGrazos), Joe Evans (MC), Joe Bloom (referee), Kid Berg (referee), C. H. Nicholls (timekeeper).

MEET MR LUCIFER

(aka: *Let's Put out the Light*)
November 1953 / Black and white / 81 minutes
CREDITS: DIRECTOR: Anthony Pélissier. PRODUCER: Monja Danischewsky. SCRIPT: Monja Danischewsky. *From the play by*: Arnold Ridley. PHOTOGRAPHY: Desmond Dickinson. SUPERVISING EDITOR: Jack Harris. EDITOR: Bernard Gribble. ART DIRECTOR: Wilfrid Shingleton. COSTUMES: Anthony Mendleson. MUSIC: Eric Rogers.
CAST: Stanley Holloway (Mr Hollingsworth/Mr Lucifer), Peggy Cummins (Kitty), Jack Watling (Jim), Barbara Murray (Patricia), Joseph Tomelty (Mr Pedelty), Humphrey Lestocq (Arthur), Gordon Jackson (Hector), Jean Cadell (Mrs Macdonald), Kay Kendall (Lonely Hearts singer), Charles Victor (Mr Elder), Gilbert Harding, Philip Harben, McDonald Hobley, David Miller, A. E. Matthews (themselves), Raymond Huntley (Mr Patterson), Ernest Thesiger (Eun McDonald), Frank Pettingell (Mr Roberts), Olive Sloane (Mrs Stannard), Joan Sims (Fairy Queen), Ian Carmichael (Man Friday).

THE LOVE LOTTERY

January 1954 / Technicolor / 89 minutes
CREDITS: DIRECTOR: Charles Crichton. PRODUCER: Monja Danischewsky. ASSISTANT DIRECTOR: Norman Priggen. SCREENPLAY: Harry Kurnitz, Monja Danischewsky. *Based on a*

story by: Charles Neilson Gattey, Zelma Bramley-Moore. DIRECTOR OF PHOTOGRAPHY: Douglas Slocombe. EDITOR: Seth Holt. PRODUCTION DESIGNER: Tom Morahan. COSTUME DESIGNER: Anthony Mendleson. MUSIC: Benjamin Frankel.
CAST: David Niven (Rex Allerton), Peggy Cummins (Sally), Anne Vernon (Jane), Herbert Lom (Andre Amico), Charles Victor (Jennings), Gordon Jackson (Ralph), Felix Aylmer (Winant), Hugh McDermott (Rodney Wheeler), Stanley Maxted (Oliver Stanton), June Clyde (Viola), John Chandos (Gulliver Kee), Theodore Bikel (Parsimonious), Sebastian Cabot (Suarez), Eugene Deckers (Vernet), Andrea Malandrinos (Fodor), Nicholas Stuart (American radio announcer), Michael Ward (hotel receptionist), Helena Pickard (Sally's mother), Marcel Poncin (priest), Alexis Chesnakov (Russian man), Nellie Arno (Russian woman), Gabrielle Blunt (Doreen), Mark Baker (Maxie), Boscoe Holder (witch doctor), John Glyn-Jones (Prince Boris), Humphrey Bogart (himself).

THE MAGGIE
(aka: High and Dry / Highland Fling)
February 1954 / Black and white / 91 minutes
CREDITS: DIRECTOR: Alexander Mackendrick. PRODUCER: Michael Truman. SCREENPLAY: William Rose. STORY: Alexander Mackendrick. DIRECTOR OF PHOTOGRAPHY: Gordon Dines. EDITOR: Peter Tanner. ART DIRECTOR: Jim Morahan. WARDROBE: Anthony Mendleson. MUSIC: John Addison. CONDUCTOR: Dock Mathieson.
CAST: Paul Douglas (Calvin B. Marshall), Alex MacKenzie (Skipper Peter MacTaggart), James Copeland (mate), Abe Barker (engineer), Tommy Kearins (wee boy), Hubert Gregg (Pusey), Geoffrey Keen (Campbell), Dorothy Alison (Miss Peters), Andrew Keir (Fraser), Meg Buchanan (Sarah), Mark Dignam (laird), Jameson Clark (Dirty Dan), Moultrie Kelsall (CSS skipper), Fiona Clyne (Sheena), Sheila Shand Gibbs (barmaid), Betty Henderson (Campbell's secretary), Russell Waters (hailing officer), Duncan McIntyre (hailing officer), Roddy McMillan (Inverkerran driver), Jack MacGuire (highland innkeeper), John Rae (constable), Jack Stewart (skipper), Eric Woodburn (skipper), Douglas Robin (inspector), R. B. Wharrie (inspector), David Cameron (hired car driver), Catherine Fletcher (postmistress), William Crichton (harbour master), Andrew Downie (aircraft pilot), Herbert Cameron (Gillie), Gilbert Stevenson (Davy MacDougall).

WEST OF ZANZIBAR
March 1954 / Technicolor / 94 minutes
CREDITS: DIRECTOR: Harry Watt. PRODUCER: Leslie Norman. SCREENPLAY: Max Catto, Jack Whittingham. STORY: Harry Watt. DIRECTOR OF PHOTOGRAPHY: Paul Beeson. EDITOR: Peter Bezencenet. ART DIRECTOR: Jim Morahan. MUSIC: Alan Rawsthorne. CONDUCTOR: Dock Mathieson.
CAST: Anthony Steel (Bob Payton), Sheila Sim (Mary Payton), Edric Connor (Ushingo), Orlando Martins (M'Kwongwi), William Simons (Tim Payton), Martin Benson (lawyer Dhofar), Peter Illing (Khingoni), David Osieli (Ambrose), Bethlehem Sketch (Bethlehem), Edward Johnson (half breed), Juma (Juma), Howard Marion-Crawford (Wood), R. Stuart Lindsell (Col. Ryan), Sheik Abdullah (dhow captain), Joanna Kitau (Ketch African), Roy Cable (senior official), Fatuma (Tana), Delene Scott.

THE RAINBOW JACKET
(aka: Newmarket Heath)
May 1954 / Technicolor / 99 minutes
CREDITS: DIRECTOR: Basil Dearden. PRODUCER: Michael Relph. SCREENPLAY: T. E. B. Clarke. DIRECTOR OF PHOTOGRAPHY: Otto Heller. EDITOR: Jack Harris. ART DIRECTOR: Tom Morahan. WARDROBE: Anthony Mendleson. MUSIC: William Alwyn. CONDUCTOR: Dock Mathieson.
CAST: Robert Morley (Lord Logan), Kay Walsh (Barbara Crain), Edward Underdown (Geoffrey Tyler), Fella Edmonds (Georgie Crain), Bill Owen (Sam Lilley), Charles Victor (Voss), Honor Blackman (Mrs Tyler), Wilfrid Hyde White (Lord Stoneleigh), Ronald Ward (Bernie Rudd), Howard Marion Crawford (Travers), Sidney James (Harry), Michael Trubshawe (Gresham), Colin Kemball (Archie Stevens), Sam Kydd (Bruce), Herbert C. Walton (Adams), George Thorpe (Ross), Michael Ripper (Benny Lowder), Eliot Makeham (Jenkins the valet), Frederick Piper (Lukey), Brian Roper (Ron Saunders), Bernard Lee (Fenwick), Joy Wood (Mrs Travers), George Sharpe (Wilkins), Roy Sone (stable boy).

LEASE OF LIFE
October 1954 / Eastmancolor / 94 minutes
CREDITS: DIRECTOR: Charles Frend. ASSOCIATE PRODUCER: Jack Rix. SCREENPLAY: Eric Ambler. *Based on a story by*: Frank Baker, Patrick Jenkins. DIRECTOR OF PHOTOGRAPHY: Douglas Slocombe. EDITOR:

Peter Tanner. ART DIRECTOR: Jim Morahan. WARDROBE SUPERVISOR: Anthony Mendleson. MUSIC: Alan Rawsthorne. CONDUCTOR: Dock Mathieson.
CAST: Robert Donat (Reverend William Thorne), Kay Walsh (Vera Thorne), Adrienne Corri (Susan Thorne), Denholm Elliott (Martin Blake), Walter Fitzgerald (dean), Cyril Raymond (headmaster), Reginald Beckwith (Foley), Robert Sandford (boy with book), Frank Atkinson (verger), Alan Webb (Dr Pembury), Richard Wattis (solicitor), Frederick Piper (jeweller), Vida Hope (Mrs Sproatley), Beckett Bould (Mr Sproatley), Richard Leech (Carter), Jean Anderson (Miss Calthorp), Edie Martin (Miss Calthorp's friend), Mark Dignam (Mr Black), Russell Waters (Russell), Mark Daly (Spooner), Charles Saynor (policeman), John Salew (doctor), Sheila Raynor (mistress of ceremonies), Amanda Coxell (child on bus).

THE DIVIDED HEART
November 1954 / Black and white / 89 minutes
CREDITS: DIRECTOR: Charles Crichton. PRODUCER: Michael Truman. SCREENPLAY: Jack Whittingham, Richard Hughes. DIRECTOR OF PHOTOGRAPHY: Otto Heller. EDITOR: Peter Bezencenet. ART DIRECTOR: Edward Carrick. WARDROBE SUPERVISOR: Anthony Mendleson. MUSIC: Georges Auric. CONDUCTOR: Dock Mathieson.
CAST: Cornell Borchers (Inga), Yvonne Mitchell (Sonja), Armin Dahlen (Franz), Alexander Knox (chief justice), Geoffrey Keen (Marks), Eddie Byrne (second justice), Liam Redmond (first justice), Theodore Bikel (Josip), Andre Mikhelson (Professor Miran), Michel Ray (Toni aged ten), Martin Keller (Toni aged two), Krystyna Rumistrzewicz (Mitzi), Mark Guebhard (Max), Gilgi Hauser, Maria Leontovitsch (Sonja's daughters), Martin Stephens (Hans), Ferdy Mayne (Dr Muller), Pamela Stirling (Mlle Poncet), Marianne Walla (matron), Dorit Welles (nurse), Philo Hauser, Guy Deghy (schoolteachers), Carl Duering (postman), Dora Lavrencic (interpreter), Richard Molinas (Herr Pieter), John Welsh (chief marshal), John Schlesinger (ticket collector), Nicholas Stuart, Alec McCowen, Orest Orloff, Ilona Ference, Randal Kinkead, Hans Elwenspoek, Frederick Schrecker (reporters), Hans Kuhn (foreman), Howard Knight (orphan).

ARMAND AND MICHAELA DENIS UNDER THE SOUTHERN CROSS
(aka: Under the Southern Cross)
December 1954 / Eastmancolor / 67 minutes
CREDITS: DIRECTOR: Armand Denis. COMMENTARY WRITER: E. V. H. Emmett. PHOTOGRAPHY: Des Bartlett. SUPERVISING EDITOR: Jack Harris. EDITOR: Adrian De Potier. MUSIC: James Stevens.
CAST: E. V. H. Emmett (commentary), Armand Denis, Michaela Denis.

OUT OF THE CLOUDS
February 1955 / Eastmancolor / 88 minutes
CREDITS: DIRECTOR: Basil Dearden. PRODUCERS: Michael Relph, Eric Williams. SCREENPLAY: John Eldridge, Michael Relph, Rex Rienits. *From the novel* The Springboard *by*: John Fores. DIRECTOR OF PHOTOGRAPHY: Paul Beeson. EDITOR: Jack Harris. ART DIRECTOR: Jim Morahan. WARDROBE SUPERVISOR: Anthony Mendleson. MUSIC: Richard Addinsell.
CAST: Anthony Steel (Gus Randall), Robert Beatty (Nick Millbourne), David Knight (Bill Steiner), Margo Lorenz (Leah Rosch), James Robertson Justice (Captain Brent), Eunice Gayson (Penny Henson), Gordon Harker (Joe Harvey), Marie Löhr (rich woman), Bernard Lee (customs officer), Isabel Dean (Mrs Malcolm), Abraham Sofaer (Indian), Megs Jenkins (Mrs Jones), Harold Kasket (Hafadi), Melissa Stribling (Jean Osmond), Michael Howard (Tom Purvis), Esma Cannon (rich woman's companion), Sidney James (Henry), Barbara Leake (Henry's wife), Jack Lambert (chief engineer), Cyril Luckham (Doctor Harman), Nicholas Phipps (Hilton-Davidson), Jill Melford (Eleanor), Terence Alexander (Bob Robins), Charles Farrell (Percy), Andy Ho (Chinese), Lloyd Lamble (Ben), Clifford Buckton, Douglas Stewart (passengers), Douglas Ives (waiter), John Pett (wireless operator), Mary Germaine (BEA receptionist).

THE NIGHT MY NUMBER CAME UP
March 1955 / Black and white / 94 minutes
CREDITS: DIRECTOR: Leslie Norman. ASSOCIATE PRODUCER: Tom Morahan. SCREENPLAY: R. C. Sherriff. *Based on a story by*: Victor Goddard. DIRECTOR OF PHOTOGRAPHY: Lionel Banes. EDITOR: Peter Tanner. ART DIRECTOR: Jim Morahan. WARDROBE SUPERVISOR: Anthony Mendleson. MUSIC: Malcolm Arnold. CONDUCTOR: Dock Mathieson.
CAST: Michael Redgrave (Air Marshal John Hardie), Sheila Sim (Mary Campbell), Alexander Knox (Robbie Robertson), Denholm Elliott (Fleet Lt McKenzie), Ursula Jeans (Mrs Robertson), Ralph Truman (Governor Bertie Wainwright),

Michael Hordern (Cmdr Lindsay), Nigel Stock (Walker), Bill Kerr, Alfie Bass (soldiers), George Rose (Walter Bennett), Victor Maddern (engineer), David Orr (Reggie), David Yates (navigator), Doreen Aris (Miss Robertson), Richard Davies (wireless operator), Charles Perry (Kent), Geoffrey Tyrrell (Bennett's secretary), Hugh Moxey (wing commander), Nicholas Stuart (commandant), John Fabian (traffic controller), Percy Herbert (REME sergeant), Robert Bruce (RAF sergeant), Philip Vickers (American radio operator), Yah Ming (barman), Graham Ashley (duty sergeant).

ARMAND AND MICHAELA DENIS ON THE BARRIER REEF
(aka: *On the Barrier Reef*)
March 1955 / Eastmancolor / 65 minutes
CREDITS: COMMENTARY WRITER: E. V. H. Emmett. PHOTOGRAPHY: Noel Monkman, Des Bartlett. EDITORIAL SUPERVISION: Jack Harris. EDITORS: Adrian De Potier, David Howes. MUSIC: James Stevens.
CAST: E. V. H. Emmett (commentary), Armand Denis, Michaela Denis.

THE SHIP THAT DIED OF SHAME
(aka: *Pt Raiders*)
April 1955 / Black and white / 94 minutes
CREDITS: DIRECTOR: Basil Dearden. PRODUCER: Michael Relph. SCREENPLAY: John Whiting, Michael Relph, Basil Dearden. *Based on the novel by*: Nicholas Monsarrat. DIRECTOR OF PHOTOGRAPHY: Gordon Dines. EDITOR: Peter Bezencenet. ART DIRECTOR: Bernard Robinson. WARDROBE SUPERVISOR: Anthony Mendleson. MUSIC: William Alwyn. CONDUCTOR: Dock Mathieson.
CAST: Richard Attenborough (George Hoskins), George Baker (Bill Randall), Bill Owen (Birdie Dick), Virginia McKenna (Helen Randall), Roland Culver (Major Fordyce), Bernard Lee (Sam Brewster), Ralph Truman (Sir Richard), John Chandos (William Frederick Raines), Harold Goodwin (customs officer), John Longden (detective), Alfie Bass (crewman), Stratford Johns (car mechanic).

TOUCH AND GO
(aka: *The Light Touch*)
September 1955 / Technicolor / 85 minutes
CREDITS: DIRECTOR: Michael Truman. ASSOCIATE PRODUCER: Seth Holt. SCREENPLAY: William Rose. STORY: William Rose, Tania Rose. DIRECTOR OF PHOTOGRAPHY: Douglas Slocombe. EDITOR: Peter Tanner. ART DIRECTOR: Edward Carrick. MUSIC: John Addison.
CAST: Jack Hawkins (Fletcher), Margaret Johnston (Helen), June Thorburn (Peggy), John Fraser (Richard), Roland Culver (Fairbright), Alison Leggatt (Alice Fairbright), Margaret Halstan (Mrs Pritchett), Henry Longhurst (Mr Pritchett), James Hayter (Kimball), Basil Dignam (Stevens), Bessie Love (Mrs Baxter), Richard Rogers (urchin).

ARMAND AND MICHAELA DENIS AMONG THE HEADHUNTERS
September 1955 / Eastmancolor / 65 minutes
CREDITS: COMMENTARY WRITER: E. V. H. Emmett. PHOTOGRAPHY: Des Bartlett. SUPERVISING EDITOR: Jack Harris. EDITOR: David Howes. MUSIC: James Stevens.
CAST: E. V. H. Emmett (commentary), Armand Denis, Michaela Denis.

THE LADYKILLERS
December 1955 / Technicolor / 97 minutes
CREDITS: DIRECTOR: Alexander Mackendrick. ASSOCIATE PRODUCER: Seth Holt. SCREENPLAY: William Rose. DIRECTOR OF PHOTOGRAPHY: Otto Heller. EDITOR: Jack Harris. ART DIRECTOR: Jim Morahan. COSTUME DESIGNER: Anthony Mendleson. MUSIC: Tristram Cary.
CAST: Alec Guinness (Professor Marcus), Cecil Parker (Major Courtney), Herbert Lom (Louis Harvey), Peter Sellers (Harry Robinson), Danny Green (One-Round Lawson), Jack Warner (police superintendent), Katie Johnson (Mrs Louisa Wilberforce), Philip Stainton (police sergeant), Frankie Howerd (barrow boy), Len Sharp (pavement artist), Harold Goodwin (left luggage clerk), Kenneth Connor (cab driver), Fred Griffiths (junkman), Evelyn Kerry (Amelia), Hélène Burls (Hypatia), Phoebe Hodgson (old lady), Edie Martin (Lettice), Jack Melford (Scotland Yard man), Robert Moore (constable), John Rudling (nervous man), Madge Brindley (large lady), Lucy Griffiths (Miss Pringle), Sam Kydd (cab driver), Neil Wilson (policeman), Ewan Roberts (constable in station), Michael Corcoran (burglar).

THE FEMININE TOUCH
(aka: *Lamp Is Heavy* / *The Gentle Touch*)
April 1956 / Eastmancolor / 90 minutes
CREDITS: DIRECTOR: Pat Jackson. PRODUCTION SUPERVISOR: Hal Mason. STORY:

Iain MacCormick. *From the novel* The Lamp is Heavy *by*: Sheila Mackay Russell. PHOTOGRAPHY: Paul Beeson. EDITOR: Peter Bezencenet. ART DIRECTOR: Edward Carrick. COSTUME DESIGNER: Anthony Mendleson. MUSIC: Clifton Parker. CONDUCTOR: Dock Mathieson.
CAST: George Baker (Jim), Belinda Lee (Susan), Delphi Lawrence (Pat), Adrienne Corri (Maureen), Henryetta Edwards (Anne), Barbara Archer (Liz), Diana Wynyard (matron), Joan Haythorne (home sister), Constance Fraser (assistant matron), Christopher Rhodes (Ted Russell), Mandy Miller (Jessie), Dorothy Alison (suicide), Beatrice Varley (Sister Snow), Joan Carol (theatre sister), Vivienne Drummond (second-year nurse), Richard Leech (casualty doctor), Newton Blick (Lofty), Dandy Nichols (skivvy), Mark Daly (gardener), Joss Ambler (Bateman).

WHO DONE IT?
March 1956 / Black and white / 85 minutes
CREDITS: DIRECTOR: Basil Dearden. PRODUCER: Michael Relph. STORY AND SCREENPLAY: T. E. B. Clarke. DIRECTOR OF PHOTOGRAPHY: Otto Heller. EDITOR: Peter Tanner. ART DIRECTOR: Jim Morahan. COSTUME DESIGNER: Anthony Mendleson. MUSIC: Philip Green.
CAST: Benny Hill (Hugo Dill), Belinda Lee (Frankie Mayne), David Kossoff (Zacco), Garry Marsh (Insp. Hancock), George Margo (Barakov), Ernest Thesiger (Sir Walter Finch), Denis Shaw (Professor Otto Stumpf), Frederick Schiller (Gruber), Jeremy Hawk (himself), Thorley Walters (Raymond Courtney), Philip Stainton (Jimmy), Warwick Ashton (PC Roberts), Stratford Johns (PC Coleman), Nicholas Phipps, Peter Bull, Gibb McLaughlin, Ernest Jay, Harold Scott (scientists), Norah Blaney (Flora Carlton), Charles Hawtrey (disc jockey), Irene Handl (customer), Terence Alexander (radio show official), Ewen Solon (police radio announcer), Ronnie Brody (shop assistant), Harold Goodwin (Pringle), Guy Longpre (singer), George Wilson (one-man band), Kim Kimber, Jean Alsop, Elinor Bennett (ice show girls).

THE LONG ARM
(aka: The Third Key)
June 1956 / Black and white / 96 minutes
CREDITS: DIRECTOR: Charles Frend. ASSOCIATE PRODUCER: Tom Morahan. SCREENPLAY: Janet Green, Robert Barr, Dorothy Christie, Campbell Christie. STORY: Robert Barr. DIRECTOR OF PHOTOGRAPHY: Gordon Dines. EDITOR: Gordon Stone. ART DIRECTOR: Edward Carrick. COSTUME DESIGNER: Anthony Mendleson. MUSIC: Gerbrand Schurmann.
CAST: Jack Hawkins (Det. Supt Tom Halliday), John Stratton (Det. Sgt Ward), Dorothy Alison (Mary Halliday), Geoffrey Keen (Chief Supt Jim Malcolm), Ursula Howells (Mrs Elliot), Newton Blick (Deputy Cmdr Harris), Sydney Tafler (Stone), Ralph Truman (Col. Blenkinsop), Maureen Delany (Mrs Stevens), Richard Leech (nightwatchman), Meredith Edwards (Mr Thomas), George Rose (Slob), Jameson Clark (Det. Supt Ogilvie), Ian Bannen (young workman), Maureen Davis (young workman's wife), Peter Burton (Creasey), Michael Brooke (Tony Halliday), Sam Kydd (police constable), Glyn Houston (detective sergeant in Q car), Arthur Rigby (Chester detective inspector), John Warwick (shipping office detective inspector), Joss Ambler (shipping office cashier), Barry Keagan (detective constable), Alec McCowen (house surgeon), Harry Locke (secondhand dealer), Nicholas Parsons (PC Bates), Warwick Ashton (newspaper circulation manager), David Davies (Welsh police constable), Julie Milton (newsagent's daughter), Harold Goodwin (Somerset House official), John Welsh (estate agent), Gillian Webb (housewife), William Mervyn (Festival Hall manager), Ursula Howells (Mrs Gilson), Richard Leech (Mr Gilson), Peter Welch (CID man), Roy Purcell (fingerprint man), Frazer Hines, Anthony Richmond (urchins), Stratford Johns (constable).

THE MAN IN THE SKY
(aka: Decision Against Time)
January 1957 / Black and white / 85 minutes
CREDITS: DIRECTOR: Charles Crichton. PRODUCTION COMPANY: Ealing Films Limited/Metro-Goldwyn-Mayer. ASSOCIATE PRODUCER: Seth Holt. SCREENPLAY: William Rose, John Eldridge. STORY: William Rose. DIRECTOR OF PHOTOGRAPHY: Douglas Slocombe. EDITOR: Peter Tanner. ART DIRECTOR: Jim Morahan. MUSIC: Gerbrand Schürmann. CONDUCTOR: Dock Mathieson.
CAST: Jack Hawkins (John Mitchell), Elizabeth Sellars (Mary Mitchell), Walter Fitzgerald (Conway), Eddie Byrne (Ashmore), John Stratton (Peter Hook), Victor Maddern (Joe Biggs), Lionel Jeffries (Keith), Donald Pleasence (Crabtree), Catherine Lacey (Mary's mother), Megs Jenkins (Mrs Snowden), Ernest Clark (Maine), Raymond Francis (Jenkins), Russell Waters (Sim), Howard

Marion Crawford (Ingrams), Jeremy Bodkin (Nicholas Mitchell), Gerard Lohan (Philip Mitchell), Esme Easterbrook (launderette assistant), Ann Johnson, Anne Dobson, Janet Davis, Jennifer Cuff, John Baddeley, Tom Elwell, S. K. Andrews (cyclists), Derek Butler (station fire officer), Gerry Cuff (Hollingsworth), Reginald Slater (ambulance man).

THE SHIRALEE
July 1957 / Black and white / 99 minutes
CREDITS: DIRECTOR: Leslie Norman. PRODUCTION COMPANY: Ealing Films Limited/Metro-Goldwyn-Mayer. ASSOCIATE PRODUCER: Jack Rix. SCREENPLAY: Neil Paterson, Leslie Norman. *From the novel by*: D'Arcy Niland. PHOTOGRAPHY: Paul Beeson. EDITOR: Gordon Stone. ART DIRECTOR: Jim Morahan. MUSIC: John Addison.
CAST: Peter Finch (Macauley), Dana Wilson (Buster), Elizabeth Sellars (Marge), George Rose (Donny), Rosemary Harris (Lily Parker), Russell Napier (Parker), Niall MacGinnis (Beauty Kelly), Tessie O'Shea (Bella), Sidney James (Luke), Charles Tingwell (Jim Muldoon), Reg Lye (Desmond), Barbara Archer (shop girl), John Phillips (doctor).

BARNACLE BILL
(aka: All at Sea)
December 1957 / Black and white / 87 minutes
CREDITS: DIRECTOR: Charles Frend. PRODUCTION COMPANY: Ealing Films Limited/Metro-Goldwyn-Mayer. ASSOCIATE PRODUCER: Dennis Van Thal. SCREENPLAY: T. E. B. Clarke. DIRECTOR OF PHOTOGRAPHY: Douglas Slocombe. EDITOR: Jack Harris. ART DIRECTOR: Alan Withy. DRESS DESIGNER: Sophie Devine. MUSIC: John Addison. DANCE MUSIC: Derek New. CONDUCTOR: Dock Mathieson.
CAST: Alec Guinness (Captain William Horatio Ambrose), Irene Browne (Arabella Barrington), Maurice Denham (Mayor Crowley), Percy Herbert (Tommy), Victor Maddern (Frank Figg), Allan Cuthbertson (Chailey), Harold Goodwin (Duckworth), Richard Wattis (registrar of shipping), Lionel Jeffries (Garrod), George Rose (Bullen), Lloyd Lamble (Supt Browning), Harry Locke (Peters), Mike Morgan (Larry), Max Butterfield (Phil), Donald Churchill (Roy), Jackie Collins (June), Frederick Piper (Harry), Fred Griffiths (bus driver), Gerald Case (commander), William Mervyn (captain), John Horsley (first surgeon), Derek Waring (second surgeon), Donald Pleasence (bank cashier), Newton Blick (bank manager), Junia Crawford (Evie), Warren Mitchell (Artie White), Frank Burdett (bald man), Martyn Woodman (Reggie Skinner), Susan Gibson (Sheila), Diana Chesney (Mrs Figg), Miles Malleson (angler), Charles Lloyd Pack (Tritton), Eric Pohlmann (Liberamanian consul), Charles Cullum (Major Kent), Joan Hickson (Mrs Kent), Alexander Harris (Adrian), Sam Kydd (frogman), Toke Townley (Timmins), Elsie Wagstaff (Mrs Gray), Anthony Sagar (coxswain), Alec Guinness (Ambrose's six ancestors), George Butler (Sir Francis Drake), John Benn (Drake's messenger), Paul Cole, Gordon Bennett (cadets).

DAVY
December 1957 / Technirama, Technicolor / 85 minutes
CREDITS: DIRECTOR: Michael Relph. PRODUCTION COMPANY: Ealing Films Limited/Metro-Goldwyn-Mayer. PRODUCER: Basil Dearden. SCREENPLAY: William Rose. DIRECTOR OF PHOTOGRAPHY: Douglas Slocombe. EDITOR: Peter Tanner. ART DIRECTOR: Alan Withy. COSTUME DESIGNER: Elizabeth Haffenden. MUSIC: Wagner, Puccini, Mozart. MUSICAL DIRECTOR: Eric Rogers.
CAST: Harry Secombe (Davy), Ron Randell (George), George Relph (Uncle Pat), Susan Shaw (Gwen), Bill Owen (Eric), Peter Frampton (Tim), Alexander Knox (Sir Giles), Adele Leigh (Joanna), Isabel Dean (Miss Carstairs), Joan Sims (Waitress), George Moon (Jerry), Kenneth Connor (Herbie), Gladys Henson, Elizabeth Fraser (waitresses), Charles Lamb (Henry), Arnold Marlè (Winkler), Clarkson Rose (Mrs Magillicuddy), Campbell Singer (stage door keeper).

DUNKIRK
November 1958 / Black and white / 135 minutes
CREDITS: DIRECTOR: Leslie Norman. PRODUCTION COMPANY: Ealing Films Limited/Metro-Goldwyn-Mayer. ASSOCIATE PRODUCER: Michael Forlong. SCREENPLAY: David Divine, W. P. Lipscomb. *Based on the novels* The Big Pick-Up *by*: Elleston Trevor; *and* Dunkirk *by*: Lt Col. Ewan Butler, Major J. G. Bradford. DIRECTOR OF PHOTOGRAPHY: Paul Beeson. EDITOR: Gordon Stone. ART DIRECTOR: Jim Morahan. MUSIC: Malcolm Arnold.
CAST: John Mills (Cpl Tabby Binns), Richard Attenborough (John Holden), Bernard Lee (Charles Foreman), Robert Urquhart (Mike Russell), Ray Jackson (Barlow), Ronald Hines

(Miles), Sean Barrett (Frankie), Roland Curram (Harper), Meredith Edwards (Dave Bellman), Michael Bates (Froome), Rodney Diak (Pannet), Michael Shillo (Jouvet), Eddie Byrne (commander), Maxine Audley (Diana Foreman), Lionel Jeffries (medical colonel), Victor Maddern (merchant seaman), Anthony Nicholls (military spokesman), Flanagan and Allen (themselves), Kenneth Cope (Lt Lumpkin), Denys Graham (Fraser), Barry Foster (Don R), Warwick Ashton (battery sergeant major), Peter Halliday (battery major), John Welsh (staff colonel), Lloyd Lamble (staff colonel), Cyril Raymond (Gen. the Viscount Gort, VC), Nicholas Hannen (Vice Adm. Ramsay), Patricia Plunkett (Grace Holden), Michael Gwynn (Cmdr Sheerness), Fred Griffiths (old sweat), Dan Cressy (Joe), Christopher Rhodes (sergeant on beach), Harry Landis (Dr Levy), John Horsley (padre), Patrick Allen (sergeant on parade ground).

NOWHERE TO GO
December 1958 / Black and white / 87 minutes
CREDITS: DIRECTOR: Seth Holt. PRODUCTION COMPANY: Ealing Films Limited/Metro-Goldwyn-Mayer. ASSOCIATE PRODUCER: Eric Williams. SCREENPLAY: Seth Holt, Kenneth Tynan. *Based on the novel by*: Donald MacKenzie. DIRECTOR OF PHOTOGRAPHY: Paul Beeson. EDITOR: Harry Aldous. PRODUCTION DESIGNER: Peter Proud. ART DIRECTOR: Alan Withy. MUSIC: Dizzy Reece.
CAST: George Nader (Paul Gregory), Maggie Smith (Bridget Howard), Bernard Lee (Victor Sloane), Geoffrey Keen (Insp. Scott), Bessie Love (Harriett Jefferson), Harry Corbett (Jerry Sullivan), Andree Melly (Rosa), Howard Marion-Crawford (Cameron), Arthur Howard, John Welsh (the Dodds partners), Maggie McGrath (Rosemary), Harry Locke (George Bendel), Glyn Houston (box-office clerk), Lionel Jeffries (pet shop owner), Noel Howlett (Uncle Tom).

THE SIEGE OF PINCHGUT
(aka: Four Desperate Men)
August 1959 / Black and white / 104 minutes
CREDITS: DIRECTOR: Harry Watt. PRODUCTION COMPANY: Ealing Films Limited/Associated British Picture Corporation. ASSOCIATE PRODUCER: Eric Williams. SCREENPLAY: Harry Watt, Jon Cleary, Alexander Baron. STORY: Inman Hunter, Lee Robinson. DIRECTOR OF PHOTOGRAPHY: Gordon Dines. EDITOR: Gordon Stone. ART DIRECTOR: Alan Withy. MUSIC: Kenneth V. Jones. CONDUCTOR: Dock Mathieson.
CAST: Aldo Ray (Matt Kirk), Heather Sears (Ann Fulton), Neil McCallum (Johnny Kirk), Victor Maddern (Bert), Carlo Justini (Luke), Barbara Mullen (Mrs Fulton), Alan Tilvern (Supt Hanna), Gerry Duggan (Pat Fulton), Kenneth Warren (police commissioner), Richard Vernon (under secretary), Grant Taylor (Constable Macey), Ewan MacDuff (naval captain), Martin Boddey (brigadier), Max Robertson (motorcycle policeman), John Pusey (small boy), Fred Abbott (constable), Deryck Barnes (Sgt Drake), Barry Foster (trapped sailor), George Woodbridge (newspaper editor).

INDEX

Note: page numbers in *italic* refer to illustrations. *n* = endnote.

À nous la liberté (1931) 102
Aardman Animatioons 229–30
ABFD (Associated British Film Distributors) 19
actors
 Ealing repertory company 8, 19–20
 non-professional, use of 66–7
Addinsell, Richard 104
Addison, John 108
The Adventures of Robin Hood (TV 1955–9) 221
The Adventures of Sir Lancelot (TV 1956–7) 221
Africa, films shot/set in 9, 32–3, 165, 170
The African Queen (1951) 5
Against the Wind (1948) 9, 32, 83, 106, 189
Åkermark, Arne 119
Alison, Dorothy 194
All Hands (1940) 59, *59*
Allied Film Makers 220
Allison, Dorothy 89
Alwyn, William 108
Among the Headhunters (1955) 69
An Ideal Husband (1999) 230
Anderson, Lindsay 13, 89, 212
Another Shore (1948) 9, 32, 93–4, 106, 140–1, *141*, 177, 240*n22*
 costumes 111, 116, *116*
 music 101, 106

Anstey, Edgar 66
Archer, Barbara 192
Ardizzone, Edward 95, 97
Arnold, David L. G. 227–8
Arnold, Malcolm 108
Arp, Hans 96
Ashby, Sam 100
Asquith, Anthony 123, 161
The Assassination Bureau (1969) 220
ATP (Associated Talking Pictures) 4, 16–18, 102, 217, 234*n12*
Attack the Block (2010) 218, 253*n6*
Attenborough, Richard 8, 123, 220
Auric, Georges 11, 101–10, *102*
 arrival at Ealing 105–6
 background 102–3
 colleagues' comments on 109–10
 manuscript scores 110
 Phèdre (ballet) 108
Auric, Michèle 110
Australia, films shot/set in 9, 31–2, 159, 165–74
Auten, Harold 18, 234*n10*
Autumn Crocus (1934) 19
The Avengers (TV 1961–69) 221

Babuscio, Jack 131
The Back Room Boy (1942) 161
Baddeley, Hermione 186
Bainbridge, John 97
Baker, George 56, 193

Baker, Reginald 12, 15, 32, 36, 98, 99, 171
Baker, Stanley 57
Balcon, Aileen 27, 91, 244*n19*
Balcon, Chandos 30, 32
Balcon, Michael 4–13, *5*, 15, 27, 37, 52, 61, 95, 104, *127*, 135, 223, 231, 239*n13*
 archive 26–38, 91, 207–9
 and Australian productions 170, 173
 comments on colleagues 46, 71, 97, 125
 comments on documentary 58, 69
 comments on Ealing/British cinema 8, 38, 44–5, 135, 144, 165, 215, 245*n9*
 comments on film treatments of women 185, 186, 192, 194
 comments on marketing 91, 97, 99, 100
 control of operations 29–31, 36, 217, 228
 favourite films 33–4, 38
 and ladies' hats 244*n19*
 personality 37–8
 public profile 92
 relations with government 61–2
 relationship with Cavalcanti 84–5
 relationship with Tennyson 39–40, 44, 45–6
 relationship with Tynan 206–9, 211–13, 215
 self-assessments 38

Ball, Sir Joseph 61
Bank Holiday (1938) 234n33
Banks, Monty 20–1, 28
Barker, Will G. 3, 4, 217
Barnacle Bill (1957) 12, 57, 88, 94, 140, 154, 209, 215–16, 224, 240n22
Barr, Charles 1, 4, 5, 12, 15, 39, 58, 74, 76, 81–2, 84, 88, 125, 136, 142, 145, 146–7, 174, 175, 181, 189, 191, 219, 220, 223–4
Barr, Patrick 5
Bartlett, Basil 53
Bass, Alfie 121
Bates, H. E., *The Jacaranda Tree* 212
The Battle of the Sexes (1960) 228–9
Bawden, Edward 95, 96–7
Beatty, Robert 8, 52, 94, 111, 141, *141*, 177
Beaverbrook, Lord 44, 74, 237n22(Ch 5)
Beck, Ron 113
Beddington, Jack 61, 95
Beecham, Sir Thomas 102
Beeson, Paul 198, 203
La Belle et la bête (1946) 102, 108
The Bells Go Down (1943) 6, 7, 29, 30, 49–52, *50*, 64, 67, 84, 96
The Beloved Vagabond (1936) 22
Below the Sahara (1953) 70
Benda, Georges K. 118
Benedek, Laszlo 211, 252n10
Bennett, Charles 25, 40
Bennett, Compton 64
Bergman, Ingmar 210–11
Bergman, Ingrid 36
Bernac, Pierre 106
Berners, Lord 178
Bevan, Tim 229
Bhaji on the Beach (1993) 226
The Big Blockade (1942) 7, 49, 62, 64, 65–6
 music 104
Biggar, Helen 63
Billy Elliot (2000) 226
Birdman of Alcatraz (1962) 219
Bitter Springs (1950) 7, 9, 108, 165, 169–70, 173
The Black Sheep of Whitehall (1942) 48
Blakeston, Oswell, *Extra Passenger* 102
Blewitt, Bill 65, 66–7, 68, *68*

Bliss, Arthur 103
Blithe Spirit (1945) 5
The Blue Lamp (1950) 9, 29, 55–6, 78, 82, 84, 86, 87, 90, 97, 158, 214–15, 220, 221–2
 costumes *115*, 116
Bogarde, Dirk 8, 56, 88, *115*, 116, 221, 223
Bogart, Humphrey 247n30
Boland, Bridget 210–11, 250n6
bombsites *see* World War II: depictions of aftermath
Bond, Derek 8, 187, 240n16
book tie-ins 93–4
Boomerang (1947) 214
Borchers, Cornell 88
Borrodaile, Osmond 198
Boswell, James 95, 97, 99
Boughton, Rutland 103
Boulting, John/Roy 66, 178
Bower, Dallas 103
Boyce, Frank Cottrel 227
Branaghan, Sim 95, 97
Brancusi, Constantin 96
Brand, Christianna 250n6
Brando, Marlon 252n10
Brassed Off (1996) 218, *226*
Brecht, Bertolt, *The Caucasian Chalk Circle* 208–9
Bridge, Joan 117, 196
The Bridge on the River Kwai (1957) 154, 215
Brief Ecstasy (1937) 234n32
Brief Encounter (1945) 55, 129
Brigadoon (1954) 225
Brilliant, Alfredda 43, 73
British Commonwealth Film Corporation 31
Britten, Benjamin 104
Brook, Clive 45, 47
Brooke, Michael 159
Brooks, Louise 207
Brown, Geoff 11
Brunel, Adrian 60–1
Bryanston Films 212, 228–9
The Buccaneers (TV 1956–7) 221
Burke and Hare (2010) 231
Burne, Nancy 23
Burton, Alan 69, 79
Bush Christmas (1947) 168
Buss, Robin 123
Butler, David 175, 179
Byrne, Peter 221
Bywaters, Frederick 87

Caesar and Cleopatra (1945) 102, 105, 109
Cage of Gold (1950) 10–11, 33, 78, 84, 87, *191*
 music 101, 108
 treatment of women 189–91
Calder, Angus 52, 53
Calendar Girls (2006) 218, 227
Calvert, Phyllis *162*, 191, *192*
Cameron, David 2
camp, nature of 131–2
Campbell, Judy 45
A Canterbury Tale (1944) 134
Capaldi, Peter 228
The Captive Heart (1946) 9, 33, 55, 84, 85, 87, 157
 marketing 94, 97, 99
Cardiff, Jack 123, 198, 219
'Careless Talk' trilogy 59–60
Carné, Marcel 105, 108
Carrick, Edward 20
Carroll, Madeleine 40
Carry On series 193
Carson, Johnny 207
Carstairs, John Paddy 47, 59–60, 61
Cattaneo, Peter 218
Cavalcanti, Alberto 6, *6*, 11, 29, 49, 52, 55, 58, 61, 69, 84–7, 101, 105, 107, 157, 160, 164, 208–9, 239n13, 240n15
 departure from Ealing 32–3, 85–6
 move to Ealing 62, 66, 70
 relations with Balcon 84–5
 wartime shorts 62–4, 65
Chadha, Gurinder 226
Chaffey, Don 123
Champagne Charlie (1944) 85, 93, 94, 113, 136
Chang, Brilliant 24
Chapman, Edward 41, 43, 71
Chapman, James 51
Cheer Boys Cheer (1939) 5, 136, *136*
Chevalier, Maurice 22
Chicken Run (2000) 229
Chifley, Ben, PM 168
children, portrayals of 155–64
 categories 155
 en masse *vs* individual 158–9
 principal actors 159–60
 social background/implications 155–7

INDEX 283

children, portrayals of *cont.*
 in wartime 157–9, 160–1
The Christmas Tree (1969) 102
Churchill, Diana 119
Churchill, Winston 53, 57
Ciornwall-Clyne, A., Major 196, 197–8
The Citadel (1938) 40
Citizen Kane (1941) 207
Clair, René 11, 102, 105, 108, 240n22
Clare, Mary 41
Clark, Jim 10
Clark, Kenneth 59, 61
Clark, Petula 189
Clarke, T. E. B. 'Tibby' 6, 12, 33, 56, 137, 140, 157, 214–15, 219, 229, 240n31, 245n6, 246n10
class (social)
 backgrounds of Ealing personnel 71, 186, 233n32
 depictions in Ealing films 45, 74–5, 74–80, 83
 and portrayals of children 155–7
 see also working classes
Clayton, Jack 110
Clements, John 45, 47–8, 77
Clifford, Peggy Ann 128
Close Quarters (1943) 84
Coal Face (1935) 69, 84
Cocteau, Jean 102, 106
Coen, Joel/Ethan 227–8
Cohen, Harry 23
Cole, George 161
Cole, Nigel 218
Cole, Sidney 6, 65, 179, 181
 TV work 221
Colleano, Bonar 189
Collins, Joan 10, 223
colour 195–205
 Ealing output 195
 link with modernity 201–3
 'Techicolor black' 203–4
 theories of 196–9
Come On George (1939) 5
Comfort, Lance 161
Cone of Silence (1960) 82
The Constant Nymph (1928) 15–16
Convoy (1940) 39, 44–5, 46, 47, 63, 64
Conway, Gordon 112
Cook, Pam 191

Cork, Richard 100
Cornelius, Henry 6, 11, 106, 108, 137, 219
Cornish, Joe 218
Corri, Adrienne 192, 202, *202*
costumes 111–24
 supply firms 112–13
Cottage to Let (1941) 161
Coultass, Clive 53
Courtauld, Stephen 12, 15, 32
Coward, Noel 45, 134
Craigie, Jill 12, 186, 194
Crichton, Charles 6, 29, 65, 67–8, 108, 138, 140, 143, 157, 164, 181–2, 239n7, 240n22
 comments on Ealing 82, 239n13
 directorial style 81–4, 88–90
 post-Ealing work 219, 221, 223, 225
Cronin, A. J. 40
Crown Film Unit 66, 69, 70
Croydon, John 61, 237n13(Ch 5)
The Cruel Sea (1953) 33, 38, *56*, 56–7, 83, 87, 89, 99, 107, 185, 189
Crutchley, Edith 113
Cukor, George 211
Cummins, Peggy 182, *182*, 190, 204
Currie, Finlay 49–50
Curtis, James 41
Curzon, George 17, *17*
Cutts, Graham 16
Czinner, Paul 103

Dahl, Roald 230
Daldry, Stephen 226
Dalrymple, Ian 61, 66
The Dam Busters (1955) 209
Dance Hall (1950) 10, 33, 108, 189, 190, *190*, 233n34, 250n22
Danger Man (TV 1960–67) 221
Dangerous Comment (1940) 59
Danischewsky, Monja 5, 6, 65, 91–4, 95, 96, 97, *98*, 98–9, 100, 101, 186, 246n23
Davis, John 12, 35, *35*, 56, 86, 99, 170, 173, 230
Davy (1957) 57, 84, 88, 143, 195, 209, 215–16, 247n37
 use of colour 199, 202–3
Dawson, Frederick 118
Day, Frances 179

de Mornay, Derrick 42
Dead of Night (1945) 1, 6, 10, 33, 84, 85, *85*, 94, 129, 157, 160
 fantasy elements 175, 176, 177, 183–4
 music 101–2, 106–7
Dean, Basil 4–5, 8, 10, 15–22, 25, 27–8, 65, 102, 112, 135, 217, 234n12
Deans, Marjorie 105
Dearden, Basil 6, 13, 29, 48, 49, 55, 65, 67, 123, 143, 179, 180
 directorial style 81–2, 84, 87, 116
 post-Ealing work 219, 220, 221
Death Drives Through (1935) 234n34
Decker, Diana 178
'Deep England', depictions of 53–4, 55
Defoe, Daniel, *Moll Flanders* 208–9
Dehn, Paul 86, 142, 240n20
Dench, Judi *231*
Denis, Armand/Michaela 69–70
Department S (TV 1969–70) 221
Desmond, Florence 21
Les Deux Gosses (The Two Little Vagabonds) (1924) 102
The Devil's Disciple (1958) 219
di Sica, Vittorio 72
Diaghilev, Sergei 102, 105
A Diary for Timothy (1945) 162
Dickinson, Thorold 13, 18–19, 52–3, 64, 67, 70, 223, 234n15
Dighton, John 149
Dines, Gordon 6, 136
Dior, Christian 116
Disney, Walt 123
The Divided Heart (1954) 82, 83, 88, 157, 192, 208–9, 240n30
 music 101, 104, 110
Dixon of Dock Green (TV, 1955–76) 9, 29, 221–2, *222*
Doctor in the House series 193
documentaries 6–7, 58–70
 Balcon's comments on 58, 69
 Ealing's contribution to genre 70
 influence on style of Ealing features 8, 28, 44, 46, 48, 64–8, 69, 176
 postwar decline 70

documentaries *cont.*
 'story-documentary' 66–7, 70, 84
 wartime 58–67, 84
Dollimore, Jonathan 131, 132
Donald, James 190
Donat, Robert 13, 40, 202
Doonan, Patric 115, *123*
Dorian Gray (2009) 231
Dors, Diana 10, 189, *190*, 223, 233*n*34
Douglas, Paul *224*
Dowling, Joan 9
Drayton, Alfred 178
Drazin, Charles 126
Driver, Betty 136
du Maurier, Daphne 209, 210–11, 220
du Maurier, George, *Trilby* 32
Du rififi chez les hommes (1955) 110
Dunkirk (1958) 36, 57, *57*, 88–9, 194, 209–10
Durgnat, Raymond 87

'Ealing comedies' 9, 135–44
 borderline cases 139–40
 canon 137–8
 'dark' *vs* 'light' 14, 81–2, 137–8
 defined 15
 distinguished from 'comedies made at Ealing' 135–6, 140–4
 diversity 223–4
 later films compared with 218, 223–8
 popular perceptions 1–2, 47
 remakes 227–8
Ealing Studios 3, 11
 (alleged) unity of style 81–2
 closure 36, 90, 100
 creative team's post-Ealing careers 219–23
 'dark side' 10, 81–90
 decline 12–13, 86–7, 143, 211
 departures 5
 distinguishing characteristics 9–10
 facilities 4–5
 'family' image/atmosphere 10, 125, 127–8, 165, 228
 finance 34
 generic range 2–3, 9, 82–3, 223
 history 3–13, 217
 legacy 217–31

Ealing Studios *cont.*
 locations 3, 11–12, 31–3, 68–9, 155–6
 output 135–6, 223
 public esteem 217–18
 relocation 12
 reopening (2001) 217, 230–1
 social/professional hierarchy 10, 186, 233*n*32
 successor studios 228–31
Easy Virtue (2008) 231
Eckersley, Tom 97
Edward, Prince of Wales (later Edward VIII) 18
Edwards, Henryetta 192
Edwards, Meredith 8
Eisenstein, Sergei 73
Eldridge, John 219, 225
Elizabeth, Princess (later Elizabeth II) 93, *93*
Elliott, Denholm *182*, 183, *202*
Ellis, John 220, 225
Elsaesser, Thomas 128
Emergency: Ward 10 (TV 1957–67) 69
Emil and the Detectives (US, 1935) 137
Emil und die Detektiven (Germany, 1931) 107
The Entertainer (1960) 212, 216
Escape (1931) 16, 233*n*3
Escape Me Never (1935) 103
Eureka Stockade (1949) 9, 31, 165, *168*, 169–70, 173
Europe (continental), Ealing's associations with 10–12, 101, 106, 189
Evans, Clifford 11, 49, *51*
Evans, Peggy *115*

Les Fâcheux (1923) 105
The Fairy of the Phone (1936) 84
fantasy 175–84
 defined 175–6
Farrar, David 55, 189–90
Farrar, Ernest 113
Father Ted (TV 1995–98) 228
Feist, Harry 130
Fellner, Eric 229
The Feminine Touch (1956) 69, 185–6, 192–4, *193*, 195
 marketing 194
 use of colour 199–200, 203, 204, 243*n*13

Fiddlers Three (1944) 10, 29, 30, 136, 176, 178–9, *179*
Fields, Gracie 15, 17, 20–1, *21*, 22, 27–8, 60, 72, 103, 112, 135
Finch, Peter 170, *171*
Find, Fix and Strike (1942) 64
Fires Were Started (1943) 64, 66, 84
The First Gentleman (1948) 87
A Fish Called Wanda (1988) 225
Fitton, James 95, 97
Fitzgerald, Walter 50
'Five Minute Films' (wartime) 60–1, 63
Flanagan, Aubrey 72
Food for Thought (1940) 60–1
Foot, Michael 63, 237*n*22(Ch 5)
For Them That Trespass (1949) 87
For Those in Peril (1944) 6
Forbes, Bryan 220
Ford, John 219
Forde, Walter 4, 5, 29, 48, 61, 63, 136, 245*n*3
The Foreman Went to France (1942) 7, 11, 49–52, *51*, 65–6, 67, 82, 83, 84, 104, 105, 157
Formby, Beryl 21
Formby, George 6, 7, 15, 20–2, *22*, 27–8, 48, 60, 103, 108, 135, 188, 234*n*29
Forsyth, Bill 218
Foster, Ben 113
The Four Feathers (1939) 48, 209
The Four Just Men (1939) 5
49th Parallel (1941) 103
Four Weddings and a Funeral (1994) 229
Fowler, Harry 54, 55, 108–9, 157, 159, 161
Fox, Charles H. 112
Fox, William (later known as James Fox) 156–7, *156*, 159
Francis, Vera 161
Frankel, Benjamin 108
Frankenheimer, John 219
Fraser, John *199*
Frears, Stephen 226
Freedman, Barnett 95
French cinema, links with Ealing style 106
French Communique (1941) 63
Frend, Charles 6, 29, 40, 49, 53, 65, 67, 81, 137, 139, 164, 187, 221, 240*n*22
 directorial style 81–4, 87, 239*n*9

Freud, Sigmund 102, 106
Frieda (1947) 55, 82, 84, 86, 87, 96, 189
Fruchtmann, Uri 217
The Full Monty (1997) 218
Furby, Jacqueline 175
Fyrse, Jill 41

Gadd, Renée 77
Gainsborough Pictures 184, 187, 195
Galsworthy, John 16
The Gaunt Stranger (1938) 4, 5, *5*, 30, 103
Gay Times 134
Gayson, Eunice *112*
Genevieve (1953) 219
The Gentle Gunman (1952) 82, 89, 191
George, Muriel *54*, 63
George VI 103
Geraghty, Christine 155, 189
Geraldo 108
Gerhard, Roberto 110
Gert and Daisy's Weekend (1942) 161
The Ghost of St Michaels (1941) 48
Gibbs, C. Armstrong 103
Gideon's Day (1957) 219
Gilliam, Terry 229
Gilliat, Sidney 5, 86, 123, 219
Gingold, Hermione 113
Gladstone, W. E. 4
glamour, treatments of 10, 122, 185–7, 189–90
Goldcrest Films 229
Goldfinger (1964) 86
Golding, Louis 73
Golding, William, *Lord of the Flies* 212–13
Goldsmith, Charles 99
The Good Companions (1933) 40
The Goose Steps Out (1942) 29, 48
Go to Blazes (1942) 63
Gough, Michael 118
government, Ealing's relations with 53, 61–2
GPO Film Unit 62, 66, 69, 84
Granger, Stewart 94, 116–17, 118, *118*, 187
Graves, Robert, *I, Claudius* 212
Great Expectations (1946) 5
The Great Mr Handel (1942) 102
Green, Danny 123, *124*

Green, Guy 123, 196, 197–8, 220
Green, Hughie 20
Greenbaum, Mutz 101
Greene, Graham 20, 22, 42–3, 44
Greenwood, Joan 94, 126, 132, 176, *186*
 costumes 117, *117*, 119, *120*, 121, 122, 244*n19*
 screen persona 186–7
Greenwood, John 101
Greenwood, Walter 21
Grenfell, Joyce 126
Grierson, John 34, 62, 66, 67, 84
Grimble, Rosemary 97
Grossmith, Lawrence 24
Group production scheme 34
Grow Your Own (2007) 227
Guess Who's Coming to Dinner (1967) 219
Guests of Honour (1941) 63
Guilty Men (1940) 63
Guinness, Alec 8, 33, 84, 97, 139, 140, 210–11, 215, 223
 costumes 113, 121–3
 criticisms 145
 performances 137, 145–54
 sexuality 127, 132–3
 in *Kind Hearts and Coronets* *120*, 121, *123*, 127, *129*, 132–3, *148*, 148–51, *149*
 in *The Ladykillers* 122–3, *124*, 201
 in *The Lavender Hill Mob* 109, 121–2, *122*, 151–4, *152*
 in *The Man in the White Suit* 122, 145–8, *146*, 176, *186*, 186–7
Gwenn, Edmund 19, 59

Hale, Sonnie 5, 178–9, *179*
Halfway House (1944) 67, 106, 157, *160*, 160–1, 180
 fantasy elements 176, *177*, 177–8
Hall, Irma P. 227
Hall, Ken G. 168, 170
Hallam, Julia 226
Hallmark Productions 219
Hamer, Robert 6, 13, 63, 65, 84, 86, 106, 108, 119, *126*, 127, 137, 149, 160, 179
 alcoholism/death 10, 81, 86–7, 123, 126, 129, 134, 239*n13*
 comments on Ealing 82, 125
 as director of women 186, 187

Hamer, Robert *cont.*
 directorial style 81, 82, 132, 150–1
 outsider status 125, 211, 240*n25*
 sexuality 126, 127, 129, 134, 239*n13*
Hamilton, Guy 219
Hamlet (1912) 4
Hammer Films 23, 230, 235*n41*
Handel, Georg Friedrich 102
Handmade Films 229
Hanley, Jimmy 41, *42*, 43, 55–6, 116, 221
Happy Family (1939) 59
Hardwicke, Sir Cedric 19
Hardy, A. Forsyth 32–3
Harman, Jympson 185–6
Harmony Heaven (1930) 196
Harper, Sue 194, 204, 230
Harrison, George 229
Hasse, Charles 65
Hawkins, Jack 3, 8, *56*, 57, *83*, 90, 99, 143, *162*, 174, 191, *192*, 220, 223, 247*n34*
Hay, Will 7, 29, 63, 65, 67, 135
Haynes, Manning 23
Head, Edith 124
Heartbeat (TV 1992–2010) 222
Heath, Ted (bandleader) 108
Hecht-Hill-Lancaster 219–20
Hell Unltd (1936) 63
Heller, Otto 122, 138, 195
Hemmingway, Wayne 1
Henry, Ben 19
Henry, Leonard 23
Henry V (1944) 104, 196
Henry VIII (1911) 4
Henson, Gladys 8, 10, 56
Hepburn, Audrey 122, *122*, 185, *185*
Hepworth, Barbara 96
Hermon, Mark 218
Hicks, Seymour 25
The High Command (1938) 234*n15*
A High Wind in Jamaica (1965) 220, 240*n30*
Higson, Andrew 226
Hill, Benny 82, 143
Hillier, Bevis 96, 99, 100
Hinds, William 235*n41*
Hines, Claire 175
Hird, Thora 63

His Excellency (1952) 69
Hitchcock, Alfred 40–1, 42
Hitler, Adolf 7, 10, 45, 48
Hobson, Valerie 121, *121*, 129, *130*, 132, 244n20
Holloway, Stanley 8, *122*, 126, 141, 153, 181, 223
Hollywood
 departures from Ealing to 5, 12, 219–20
 domination of British market 28, 30
 'quasi-Ealing' productions 220
 use of Ealing facilities 23
Holt, Jean 126
Holt, Seth 6, 13, 89, 213–15, *214*, 216, 241nn32–3
Honegger, Arthur 103
Hope, Vida *123*
Hopper, Victoria 19–20
Hordern, Michael 183
Horn, Marion 112
Horniman, Roy, *Israel Rank* 131
Houston, Donald *139*, 189
Howard, Peter 237n22
Howes, Sally Ann 159–61, *160*
Hue and Cry (1947) 1, 8–9, 41, 55, 68, 83, 86, 88, 106, 131, 137, 139, 140, 220
 depictions of children 156, 157–8, *158*
 marketing 96–7
 music 101, 105, 107, 108–9
Hughes, Richard 240n30
Hunted (1952) 88, 89
Hunter, Carl 227
Huntley, John, *British Film Music* 104
Huntley, Raymond 8, 77
Hurry, Leslie 95
Huston, John 102
Hyde, Marina 2
Hylton, Jack 34
Hylton, Jane 186, 189

I Believe in You (1952) 10, 69, 82, 240n22
The Impassive Footman (1932) 16–18, *17*
The Importance of Being Earnest (2002) 217, 230, *231*
In Which We Serve (1942) 5, 45
The Innocents (1960) 110

Ireland, John 107
Irving, Ernest 5, 65, 102, *102*, 103, 107, 109–10
The Islanders (1938) 103
It Always Rains on Sunday (1947) 8–9, 32, 33, 41, 68, 81, 86, 106, *188*, 189, 211
 characterisation 188
 costumes 112, *114*, 114–16
 marketing 94, *94*, 97, 99
 music 101, 108
The IT Crowd (TV 2006–) 228
It Happened in Paris (1936) 22, 23
Italian neo-realism 130–1
It's a Mad Mad Mad Mad World (1963) 219
Jackson, Gordon 8, 182, 187, 222
Jackson, Pat 66, 69, 84
James, Sid 121, 223
Jassy (1947) 196
Jaubert, Maurice 105
Java Head (1934) 21
Jeayes, Allan 17, *17*
Jennings, Humphrey 64, 66, 84, 162
Jericho (1937) 43
Jerome, Jerome K. 16
Jesse, F. Tennyson 50–1
John, Rosamund 25
Johnny Frenchman (1945) 11, 53, 67, 83, 105, 106, 237n20(Ch 5)
Johns, Glynis 177
Johns, Mervyn 8, 52, 53, 106, 177
Johnson, Katie 122, *124*, 138, 185, 201
A Jolly Bad Fellow (1963) 123
Jones, Jack 73
Jones, Terry 229
Jordan, Neil 229
Journey's End (1929) 209
Joyce, James, *Finnegans Wake* 208
Junge, Alfred 40, 112

Kalmus, Natalie 117, 196
Kästner, Erich 107
Kearins, Tommy 159, *159*
Keep Your Seats, Please (1935) 21
Keller, Hans 104, 108, 109
Kellino, Roy 65
Kellner, William 119, 121–2
Kemp, Philip 1, 10, 79, 164, 191, 207, 239n15

Kempson, Rachel 99
Kendall, Kay 142
Kennedy, Harlan 154
Kent, Jean 187
Kenya *see* Africa
Kersh, Gerald 85
Khartoum (1966) 220
Kimmins, Anthony 5, 21, 61
Kind Hearts and Coronets (1949) 1, 33, 34, 36, 81, 89, *129*, *130*, *133*, 137, 211, 226
 costumes 111, 119–21, *120*, *121*, 244n19
 marketing 97, 100
 moral stance 150–1
 music 107
 performances/characterisation 148–51, 153–4, 186–7
 queer analyses 125, 126, 128–34
King Kong (1933) 24
Kneale, Nigel 36, 212–13
Knight, Esmond 178
Knowles, Bernard 40
Knox, Alexander *182*, 183
Korda, Alexander 6, 25, 48, 95, 101, 103
Koval, Francis 82, 86
Kracauer, Siegfried 86, 240n18
Kramer, Stanley 219
Krampf, Günther 101
Kuhn, Annette 162

Laburnum Grove (1936) 19
Ladri di biciclete (Bicycle Thieves) (1948) 72
The Ladykillers (1955) 9, 12–13, 41, 81, 100, 137, 138, 154, 185, 195, 212, 225, 226
 compared with remake 227–8
 costumes 111, 122–3, *124*
 stage adaptation 228
 use of colour 199, 201–2, 205
The Ladykillers (2004) 227–8
Lai, Annie 24
Lambert, Gavin 207
Lambert, Jack 51
Lambert, Johnny 116
Landis, John 231
Lane, Anthony 176
Lane, Philip 110
Lang, Fritz 87, 214
Last of the Summer Wine (TV 1973-2010) 223

Launder, Frank 86, 123, 219
Laurie, John 8
The Lavender Hill Mob (1951)
 1, 9, 11–12, 33, 36, 41, 68,
 83, 88, *152*, 185, 220
 costumes 113, 121–2, *122*, 123
 music 101, 106, 108–9
 performances/characterisation
 151–4
 proposed musical version 34
Lawrence, Delphi 192
Lawton, Jack 59
Laxdale Hall (1953) 225
Laxton, Richard 227
The League of Gentlemen (1960)
 220
Lean, David 24, 25, 45, 87, 154,
 164, 223
Lease of Life (1954) 13, 83, 195
 use of colour 199–201, 202
Lee, Belinda 192
Lee, Bernard 8, 57
Lee, Jack 84
Leigh, Adele 203
Lejeune, C.A. 60, 67, 181
Lester, Richard 123
Let George Do It! (1940) 7, 10, 47,
 48
Let Me In (2010) 230
Let's Be Famous (1939) 5, 135–6,
 136
*The Life and Adventures of Nicholas
 Nickleby* (1947) 6, 8, 32, 69,
 86, 93, 97, 157
Linehan, Graham 228
Lister, Moira 111, 112, 116, *116*,
 139, 141, *141*, 177
Local Hero (1983) 218, 224–5,
 225
Lockwood, Margaret 20, 22, 87,
 188
Loder, John 23
Lola Montès (1955) 110
Lom, Herbert 123, *124*, 247n30
Loncraine, Richard 229
London Films 95, 101
*The Loneliness of the Long Distance
 Runner* (1962) 212
The Lonely Road (1936) 19–20
The Long Arm (1956) 68–9, 83,
 83, 89, 90, 123, 159
The Long Good Friday (1979) 229
The Long Memory (1952) 81, 84,
 87, 89

Look Up and Laugh (1935) 20
Lord, Peter 229
Lorna Doone (1934) 19–20, 103
Love, Life and Laughter (1934) 20
The Love Lottery (1954) 83, 143,
 175, 176, 179, 181–3, *182*,
 190, 195, 240n22,
 247nn29–30
 use of colour 199–200, 203, 204
The Loves of Joanna Godden
 (1947) 83, 86, 107–8, *188*
 characterisation 187–8
Love on the Spot (1932) 16
Loyalties (1933) 18
Ludwig, Otto 16
Lumière, Louis/Auguste 4

MacArthur, Colin 224–5
MacDougall, Roger 136, 245n4
Macfarlane, Brian 218, 239n7
Mackendrick, Alexander 6,
 12–13, 81, 86, 119, 122, 125,
 137, 140, 162–4, 207, 211,
 212–13, 216, 224–5, 228,
 233n34, 240n25
 post-Ealing work 220, 223
Mackenzie, John 229
Maclaine, Shirley 124
Macnab, Geoffrey 98, 218, 223,
 231
MacPhail, Angus 5, 177, 178–9,
 239n13
Made in Dagenham (2010) 218
Madeleine (1950) 87
The Maggie (1954) 81, 140, 159,
 159, 224, 224–5
The Magnet (1950) 9, 68, 83, 89,
 97, 112, 139–40, 156–7
Mainwaring, Bernard 23
'making of' books 94
Malleson, Miles 126
Man in a Suitcase (TV 1967–8)
 221
Man in the Moon (1960) 123
The Man in the Sky (1957) 12, 82,
 83, 89–90, *90*, 159
The Man in the White Suit (1951)
 9, 81, 102, *103*, 137–8, 163,
 176, *186*, 229–30
 costumes 122
 moral ethos 147–8
 music 108
 performances/characterisation
 145–8, 153–4, 186–7

The Man Who Knew Too Much
 (1934) 40
Mander, Kay 186
Mandy (1952) 13, 89, 159,
 161–4, *162*, 191–2, *192*
 cinematography 162
Manvell, Roger 55
Manzie, F. Keith 167
Marcus, Lee 234n10
Margaret, Princess 93, *93*,
 243n16
Marianne *see* Horn, Marion
marketing 91–100
 artwork 95–7
 product tie-ins 93–4
 women-oriented 191, 194
Marsh, Garry 48
Marshall, Herbert 43, 73
Martin, Edie 10, 123, 146–7
Mason, Elliot 8
Mason, Hal 32, 36, *127*
Mason, Herbert 161
Mason, James 50, 52
Masters, Erica 233n32
Mastery of the Sea (1940) 62, 63,
 64
Matabeleland, Bishop of 34
Mathews, Arthur 228
Mathieson, Dock 110
Mathieson, Muir 103, 110
A Matter of Life and Death (1946)
 196
Matthews, A. E. 77
Maxwell, John 21
McArthur, Colin 1
McCallum, John 115, 187, 188
McCarthy, Joseph, Senator 74
McDonald, Dan 116
McLaren, Norman 63
McNeile, H. C. *see* 'Sapper'
Meade, Walter 140
Meet Mr Lucifer (1953) 97,
 141–2, *142*, 176, 181,
 246n23, 250n28
Mendleson, Anthony 6, 111–24,
 112
 background 113
 freelance work (post-Ealing)
 123–4
Menzies, Robert 170
Mercanton, Louis 102
merchandising 94
Merchant Ivory 229
Merrit, George 5

288 **EALING REVISITED**

Meyer, Ernst 105
Michael, Ralph 8, 50, 75, 106
Michell, Roger 229
Middleton, Guy 8, 178
Midshipman Easy (1935) 20, 22
Miles, Bernard 67, 161, 238*n*35
Milhaud, Darius 103, 105
Miller, Mandy 159, 161–4, *162*
Millions Like Us (1943) 226
Mills, John 8, 33–4, *57*, 59, *59*, 119, 198
The Mind Benders (1963) 123
Ministry of Information, Ealing's severing of ties with 61–2
Minneli, Vincente 211, 225
Minns, Adam 230
Minton, John 95
The Missionary (1981) 229
Mitchell, John 22–3
Mitchell, Yvonne 88, *88*, 192
Momma Don't Allow (1955) 212
Mona Lisa (1986) 229
Monks, Noel 49
Monserrat, Nicholas 56–7
Monty Python's Life of Brian (1979) 229
Moore, Henry 96
Morahan, Jim 122
Morgan, Diana 30, 126, 177, 178–9, 189
 on Ealing's treatment of women 186
Morgan, Sidney 22
Morgan, Terence 191, *192*
Mosley, Leonard 143
mother–child relationship, depictions of 191–2
Moulin Rouge (1952) 102
Mowbray, Malcolm 229
Mozart, George 235*n*41
Mozart, Wolfgang Amadeus 20, 102, 103
Muñoz, José Esteban 127
Murphy, Robert 48, 52, 67
Murray, Barbara 186
Murray, Charles 99
Murray, Stephen 157
music 72–3, 101–10
 recording sessions *109*
 stable of composers 107–8
Mussolini, Benito 63
My Beautiful Laundrette (1985) 226
My Learned Friend (1940) 84

Nader, George 89, *214*, 215
Neagle, Anna 188
Neame, Ronald 5, 136
New Wave (British) 89, 212–13, 220
Newell, Mike 229
Newton, Michael 1, 126, 132
The Next of Kin (1942) 30, 52–3, 64, 67, 94, 104
Nicholas Nickleby (1947) see *The Life and Adventures of Nicholas Nickleby*
Nicholson, Ben 96
Night Mail (1935) 69, 84
The Night My Number Came Up (1955) 10, 176, *182*, 183–4, 209
Nine Men (1943) 6, 49–52, 58, 64, *68*, 84, 166
 casting 67
Nine Till Six (1932) 16
Niven, David 8, 143, 182, *182*, 190, 204, 247*n*29
No Limit (1935) 21, *22*
No Orchids for Miss Blandish (1948) 87
Nolbandov, Sergei 46, 67, 101
Norman, Leslie 88–9, 159, 171, *171*, 183, 209–10, 212–13, 221
North Sea (1938) 66
Nous, les gosses (1941) 107
novel adaptations, book tie-ins 93–4
Now You're Talking (1940) 59, 59–60
Nowell-Smith, Geoffrey 128, 129
Nowhere to Go (1958) 13, 89, *89*, 90, 209, 213–15, *214*
 'un-Ealing-like' characteristics 214–15, 241*n*32

O'Connor, Pat 92
O'Dea, Jimmy 136
Ogden, Denis, *The Peaceful Inn* 160, 177
Oh Calcutta! 206
Olivier, Laurence 18, 206
On the Barrier Reef (1955) 69
Opportunity Knocks (TV) 20
Orphée (1950) 106
Orwell, George 126, 177
Osborne, John 211–12
 The Entertainer 216
 Look Back in Anger 211, 216

Out of the Clouds (1955) 12, 82, 195
 use of colour 199–200, 203, 205
The Overlanders (1946) 9, 31, 68, 85–6, 107, 165, *166*, 166–9, 171, 173
Owen, Bill 223
Owen, Frank 63, 237*n*22(Ch 5)

Painted Boats (1945) 67–8, 96
Palin, Michael 225
Palmer, Ernest 65, 221
Park, Nick 229
Parker, Al 23
Parker, Cecil *103*, 122, 123, *124*
Parker, Oliver 230–1
Parry, Natasha 189
Pascal, Gabriel 102, 103
Passionate Summer (1958) 240*n*24
Passport to Pimlico (1949) 1, 9, 33, 86, 131, 137, 138, 176, 219, 224
 costumes 113, 244*n*21
 music 101, 106, 108
 portrayal of women 186
 settings 11–12, 41, 55, 68
 social content 56, 78, 80, 114
Payne, Lily 113, 243*nn*4–5
Pelissier, Anthony 141, 164, 246*n*23
The Penguin Pool Murder (1932) 23
Penny Paradise (1938) 234*n*33
Penrose, John 132
Perceval, Hugh 22
The Perfect Flaw (1934) 23
Perfect Understanding (1932) 18
Perry, George 1, 4, 5, 15, 54, 92, 99, 178, 181, 182, 201, 204
The Persuaders (TV 1971–72) 221
Pertwee, Michael 29
Pertwee, Roland 5, 29
Petley, Julian 175
Petrie, Duncan 200
Pett and Pott (1934) 84
Picasso, Pablo 96
Pick, Frank 95
Pilbeam, Nova 40, 42, 44
Pilgrim Street (TV 1952) 238*n*45
Pink String and Sealing Wax (1945) 33, 81, 96, 160, 187
Piper, Frederick 52
Piper, John 95, 96
Pitt, Ray 63

INDEX 289

A Place of One's Own (1945) 178
The Pleasure Garden (1925) 41
Plunkett, Patricia 115
Polanski, Roman 123
Pollard, Chief Engineer 50–1
Ponting, Herbert G. 119
Pool of London (1951) 9–10, 41, 55, 68, 84, 97, 116, 220
Porter, Vincent 204, 230
Postlethwaite, Pete 226
Poulenc, Francis 105–6
Pout, Dudley 99
Powell, Dilys 46, 192
Powell, Michael 40, 86, 119, 184, 195
Pressburger, Emeric 86, 119, 184, 195
Prévert, Jacques 105, 108
Préville, Gisèle 189
Price, Dennis 119, *120*, 128, *130*, *133*, *148*, *149*, 187
 sexuality 126, 127, 132, 133–4
Priestley, J. B. 19, 20, 29, 40, 107, 179, 234n26
Pritchett, V. S. 29
A Private Function (1984) 229
The Professionals (TV 1977–83) 222
propaganda, wartime 7, 29, 58–65, 74–5, 178
 adverse criticism 60
 critical approval 63, 64
 later repuation/influence 64–5
The Proud Valley (1940) 29, 39, 43–4, *44*, 71–4, 72, 73, 93
 Beaverbrook's boycott of 44, 73–4
 critical/popular response 72
 social/political themes 71–2, 74–5, 76, 80
 use of music 72–3
Pride and Prejudice (TV 1995) 230
The Public Life of Henry the Ninth (1935) 23
Puttnam, David 229
Pygmalion (1938) 103

queer theory 125–34

Rachmaninov, Sergei 129
Radclyffe, Sarah 229
Radford, Basil 8, 55, 106–7, 186
Rafferty, Chips 167

Raid on France (1942) see *The Next of Kin*
The Rainbow Jacket (1954) 13, 195, 199
Rambert, Marie 113
Randall and Hopkirk (Deceased) (TV 1969–70) 221
Randell, Ron 167
Rank Organisation 56, 95
 marketing deal with Ealing 12, 34–6, 98–9, 170, 229
 monopoly of British market 30–1, 35, 98
Rawsthorne, Alan 107, 110
Ray, Aldo *172*, 172–3
Ray, Rene 24
Read, Jan 29, 214–15
Read, Piers Paul 133
realism 9–10, 87, 175
 see also documentaries
Reddin, Kenneth, *Another Shore* 93–4, 140
Redgrave, Michael 55, *85*, 99, 183
Reed, Carol 19, 20, 21–2, 23, 164
Reeve, Ada 77
Reeves, Matt 230
Reinhardt, Max 11
Reisz, Karel 13, 212
Reith, Lord 34
Relph, Michael 6, 13, 65, 123
 comments on colleagues 81, 84–5
 as designer/producer 84, 112, 116, 117, 180, *180*, 196–7, 198–9, 200–1, 205
 as director 57, 87, 143
 post-Ealing work 219, 220, 223
Return of the Vikings (1944) 65
Return to Yesterday (1940) 29
Rhodes, Cecil 220
Richardson, Tony 212, 229
Ridley, Arnold 246n23
Rien que les heures (1926) 84
Rigby, Jonathan 176
The Right to Live (1934) 23
Riley, Tommy 94
River Plate, Battle of 44–5
The Road to Hong Kong (1962) 124
Roberts, Yvonne 1–2
Robeson, Paul 43–4, 71, 72
 and political controversy 44, 73–4, 93
Robinson, Bruce 229
Robson, Flora 187

Rockets Galore! (1958) 220
Rogers, Maclean 161
Rolling In Money (1934) 23
Rome, Open City (Roma, citta aperta) (1945) 107, 130–1
Rosay, Françoise 11, 101, 106, 117, 118, *118*, 178, 187
Rose, William 11, 12, 33, 137, 138, 140, 219
Rosmer, Milton 24–5
Rossellini, Roberto 107, 130–1
Rowe, Frances 77
A Run for Your Money (1948) 9, 107, 112, 139, *139*, 151, 240n22
Rutherford, Margaret 124, 126, 186

Sabotage (1936) 40
Sailors Three (1940) 48
The Saint (TV 1962–9) 221
Salvage with a Smile (1940) 61
Sammy Going South (1963) 212, 220, 228–9
San Demetrio, London (1943) 6, 29, 49–52, 58, 64, 67, 68, 71, 75–6, 76, 80, 82, 83, 84, 226
Le Sang d'un poète (1932) 102
'Sapper' (H. C. McNeile) 16–17
Sapphire (1959) 220
Saraband for Dead Lovers (1948) 9, 32, 82, 84, 87, 176, 187
 costumes 112, 116–19, *117*, *118*
 marketing 94, 195
 use of colour 195, 196, 197–8, 203, 204, 205
Saturday Night and Sunday Morning (1960) 89, 212, 216, 229
Saville, Victor 40
The Saving of Bill Blewitt (1936) 65, 66–7
The Scapegoat (1958) 36, 82, 87, 209, 210–11, 220, 252n8
Schurmann, Gerard 110
Scott, Robert Falcon 8
Scott of the Antarctic (1948) 8–9, 32, 83, 185, 189, 196
 archive material 33–4
 cinematography 198–9
 costumes 119
 music 107–8
Scriabin, Alexander 107, 180

Sea Fort (1940) 61
Searle, Ronald 97
Sears, Heather *172*
Secombe, Harry 57, 143, 203
The Secret of the Loch (1934) 15, 24–5, *25*
Secret People (1952) 13, 185
Sellars, Elizabeth 89–90
Sellers, Peter 123, 124, *124*, 228
sexual themes, treatment of 10, 23, 84
 see also glamour; queer theory; women
Shaw, Susan *114*, 115, 202
Shelley, Norman 77
Sherriff, R. C. 183, 209–10
Shingleton, Wilfrid 5
The Ship that Died of Shame (1955) 56–7, 68–9, 84, 90
Ships with Wings (1941) 5, 29, 30, 46, 47–8, 53, 58
 critical response 48–9
 music 104
The Shiralee (1957) 12, 88–9, 159, 165, 170–2, *171*, 173
The Show Goes On (1937) 20
The Siege of Pinchgut (1959) 13, 36, 100, 156, *172*, 172–3, 174, 217, 220
Siegel, Don 123
The Sign of Four (1932) 16
Signoret, Simone 11, 101, 189
Silent Dust (1948) 108
The Silent Village (1943) 96
Silverstein, Eliot 'Red' 216
Sim, Alastair 126, 154, 157
Sim, Sheila 203
Simmons, Jean 189–90, *191*
Simons, William 222
Sinfield, Alan 131
Sing As We Go (1934) 17, 20, *21*, 21–2, 72, 234n26
Siodmak, Robert 87
Skillan, Hugh 119, 243n16
Slocombe, Douglas 6, 65, 122, 162, 195, 196–200, *201*, 205
 theories of colour 197–8, 203–4
The Smallest Show on Earth (1957) 123, 219, 220
Smart, Ralph 31, 167, 169
Smiley (1956) 171
Smith, Dodie 19
Smith, Maggie 215

Smith, Matthew 198
Somlo, Joseph 31
Song of Freedom (1936) 43
Sons and Lovers (1960) 219
Sontag, Susan 131, 132
Spare a Copper (1940) 48, 60
Spice World (1997) 230
The Spider and the Fly (1950) 81, 84, 87
Spiegel, Sam 213
Spiers, Bob 230
The Spy Who Came in from the Cold (1966) 86
The Square Ring (1953) 82
St Trinians (2007) 231
Stanley, Phylis 41
Stead, Peter 72
Steel, Anthony 222
Sten, Anna 22
Stephens, Martin *88*
Stern, Ernst 113
Stevenson, Robert 5, 29, 61
Stonewall Riots (1968) 131
Studiocanal 218, 230
Summer of the Seventeenth Doll (1960) 219
Sutherland, Duncan 116
The Swan (1956) 154
Swanson, Gloria 18
The Sweeney (TV 1975–8) 222
Sweet, Matthew 233n27
Sweet Smell of Success (1957) 12, 220
Sword of Freedom (TV 1958–60) 221
Swynnoe, Jan 101–2
La Symphonie pastorale (1946) 102

Take My Life (1947) 5
Tallents, Stephen 95
Target for Tonight (1941) 66, 84
A Taste of Honey (1961) 212, 229
Tawny Pipit (1944) 161
Taylor, A. J. P. 71
Taylor, John Russell 145
Taylor, Philip M. 53
Tearle, Godfrey 163
television
 influence of Ealing on 220–3, 238n45, 246–7n25
 viewing figures 246n24
Tennyson, Alfred, 1st Baron 39, 92–3
Tennyson, Charles 39

Tennyson, Hallam, 2nd Baron 39
Tennyson, Pen 5, 6–7, 39–46, *40*, 47, 63
 directorial career 41–5
 early career 39–40
 marketing 92–3
 naval service/death 45–6, 61
Teoplitz, Ludovico 22
Terry, Mabel 77
Terry-Thomas 124
There Ain't No Justice (1939) 5, 39, 41–3, *42*, 92
Thesiger, Ernest 102, *103*, 122, 126
They Came to a City (1944) 29, 67, 71, 78, 107, *180*
 criticisms 181
 fantasy elements 175, 176, 179–81
 response in left-wing press 79–80
 social/political themes 77–80, 181, 239n15
They Drive By Night (1938) 41–2
They Made Me a Fugitive (1947) 86, 87
 criticisms 86, 240n20
Things to Come (1936) 103
The Third Clue (1934) 23
The Thirty-Nine Steps (1935) 40
Thompson, Barnaby 217, 230–1
Thompson, Edith 87
Thorburn, June *199*, 202
Those Kids from Town (1941) 161
Three Men in a Boat (1933) 16, 18, 234n13
Three Minute Wonder (TV 2005) 227
Thunder Rock (1942) 178
Thunderball (1965) 123
Tiger Bay (1933) 23–4, *24*
Time Bandits (1981) 229
The Titfield Thunderbolt (1953) 12, 13, 83, 137, 138, 195, 223, 224
 marketing 96–7
 music 101, 108, 109, *109*
 use of colour 199–201, *201*
To Brighton with Gladys (1933) 23
Tom Jones (1963) 212
Tompkinson, Stephen 226
Touch and Go (1955) 89, 143, 174, 195, *199*, 202, 247n34
 use of colour 199–201, 202

Tourneur, Jacques 87
A Town Like Alice (1956) 171
Train of Events (1949) 9, 84
Tree, Sir Herbert Beerbohm 4
Trinder, Tommy 7, 29, 48, 52, 67, 85, 94, 135, 157, 169, 178–9, *179*, 223
Trois chansons de résistance (1943) 105
Trouble Brewing (1939) 5
Truman, Michael 6, 81, 143, 221
Turned Out Nice Again (1941) 6, 28
Tynan, Kathleen 207
Tynan, Kenneth 13, 33, 36, 123, 137, *206*, 206–16
 comments on Ealing 185, 207, 211
 and *Nowhere to Go* 213–15
 relationship with Balcon/Ealing system 206–9, 211–13, 215–16
 script editing 209–11, 252n8
 unfilmed projects 208–9, 211–13

Under the Southern Cross (1954) 69
Undercover (1943) 67
Unsworth, Geoffrey 198
Upstairs Downstairs (TV 1971–5) 222
Ustinov, Peter 165

Van Gogh, Vincent 198
Varnel, Marcel 48
Vaughan Williams, Ralph 103, 107–8, 109
Vernon, Anne 203, 247n30
Vesselo, Arthur 86
Victim (1960) 134, 220
Victoria, Queen 4
Vidal, Gore 211
Vidor, Charles 154
Vidor, King 40
violence, treatment of 84–5
Violent Playground (1957) 220

Walkins, Colin 99
Wallace and Gromit films 229–30
Walsh, Kay 112, 157
Walton, William 103, 104
The Ware Case (1938) 5
Warner, Jack 8, 9, 55, 56, 87, 115, 116, 157, 189, 221–2, *222*
Warren, Betty 186
Waterson, Chris *214*
Watkins, James 230
Watling, Jack *142*
Watt, Harry 6, 29, 49, 58, 66–7, 68, 84, 87, 240n22
 Australian films 31–2, 36, *166*, 166–70, 172–3
 comments on Ealing/Crown Unit 70
 move to Ealing 66, 70
 post-Ealing work 220–1
The Way Ahead (1944) 55, 192
The Way to the Stars (1945) 55
Wayans, Marlon 228
Weinstein, Hannah 221
Welch, Elizabeth 179
Welles, Orson 87
Wells, 'Bombardier' Billy 23, 95
Went the Day Well (essay collection) 46
Went the Day Well? (film, 1942) 1, 30, 52, 53–5, *54*, 67, 85, 100, 104, 156, 157, 161, 176, 239n14
West of Zanzibar (1954) 32, 167, 173, 195, 220, 222
 use of colour 199–200, 203
Western Approaches (1944) 64, 66, 84
Where No Vultures Fly (1951) 9, 32, 167, 173, 198, 220, 222
 use of colour 199–200
Whisky Galore! (1949) 1, 9, 81, 87, 97, 100, 107, 137, *138*, 140, 186, 220, 225
 costumes 111
White Corridors (1951) 69
Whiteley, Jon 88

Whitman, Walt 181
Whittingham, Jack 240n30
Who Done It? (1956) 82, 84, 143, 247n37
Whom the Gods Love (1935) 20, 102
Wilcox, Pamela, *Between Hell and Charing Cross* 126
Wilcoxon, Henry 22
The Wild One (1953) 252n10
Wilde, Oscar 131, 133, 230–1
 The Importance of Being Earnest 217
Wilding, Michael 41
William Tell (TV 1958–9) 221
Williams, Eric 'Bungy' 31, 169, 172–3
Willis, Ted 29, 221
Wills, James Elder 235n41
Wilson, Dana 159, 171
Wilson, David 1
Wilson, Harold 34
Wings of the Morning (1937) 196
Wisdom, Norman 124
Withers, Googie 8, 10, 69, 77, 96, 112, *114*, 115, *188*, 191
 screen persona 187–9, 222
Within These Walls (TV 1974–8) 222
Withnail & I (1986) 229
The Wizard of Oz (1939) 181
A Woman Alone (1936) 22
The Woman in Black (2012) 230
Woman in Bondage see *The Impassive Footman*
women 10, 185–94
 criticisms of Ealing portrayals 185, 190, 193–4
 employment as writers 186, 250n6
 minor role in Ealing films 185–6
 presentation in colour 202–3
 as star performers 186–91
 see also glamour; mother–child relationship; sexual themes

Wong, Anna May 24, *24*
Wontner, Arthur 16
Wood, Edward D., Jr 25
Woods, Arthur 41–2
Woods, S. John 92, 95, 96–7, 100
Woolf, C. M. 39
working classes, depictions of 41–3, 45, 59–60
Working Title 229
World War II, in Ealing films 6–8, 29–31, 44–5, 47–57
 appeals for US involvement 29
 call-up of Ealing personnel 61
 calls for unity/cooperation 49–50, 53–4, 74–6, 78

World War II *cont.*
 and childhood 157–9, 160–1
 depictions of aftermath 8–9, 55, 68–9, 77–80, 157–9, *158*
 documentaries 7, 58–67
 locations 49
 output 58–9
 see also government; propaganda
Worsley, John 97
Wright, Basil 66
Wright, Geoffrey 104
Wyler, Robert 22
Wyndham, Bray 22, 23–5
Wynyard, Diana 193

Yellow Caesar (1941) 6, 63
The Yellow Rolls-Royce (1964) 124
Young, Terence 102, 123
Young and Innocent (1937) 40, 42
Young Man's Fancy (1939) 5
Young Veteran (1940) 62, 63, 64, 65

Z Cars (TV 1962–78) 222
Zetterling, Mai 101, 189

THE VERY BEST OF EALING STUDIOS
DIGITALLY RESTORED AND REMASTERED

AVAILABLE ON BLU-RAY™ & DVD

THE GOLDEN AGE OF BRITISH CINEMA

STUDIOCANAL